Picasso / Marx

Picasso / Marx

and socialist realism in France

Sarah Wilson

LIVERPOOL UNIVERSITY PRESS

First published in 2013 by
Liverpool University Press
4 Cambridge Street
Liverpool
L69 7ZU

British Library Cataloguing-in-Publication data
A British Library CIP record is available

ISBN 978-1-84631-939-6

Typeset by Carnegie Book Production, Lancaster
& Adrien Sina, Paris
Printed and bound by Short Run Press Ltd, Exeter

The oldest hath borne most: we that are young
Shall never see so much, nor live so long.

Shakespeare, *King Lear*, V, iiii, 1623*

*'Le plus vieux parmi nous est celui qui aura le plus souffert.'
Edgar Morin, *Autocritique* (Paris: Julliard, 1959), epigraph.

Contents

List of Illustrations viii

Introduction 1

1 Picasso to Marx: art moves to the red belt 18

2 *14 July*: a stage curtain for the Popular Front 46

3 *Guernica*, agit-prop and the grand style 66

4 *Le Charnier* or *Buchenwald*? Communism and the Holocaust 91

5 *Stalin Cheers*. Responses to the Bomb 122

6 *Massacre in Korea*, massacres in Algeria 154

7 Godless Picasso: 'From Marx to Stalin' 183

8 Success and Failure? Picasso in Moscow / Aragon in Paris 210

Postface and acknowledgements 244

Bibliography 251

Max Raphael, 'Picasso', 1933 294

Index 318

List of Illustrations

Front cover

Dora Maar, *Portrait of Picasso, studio at 29 rue d'Astorg, Paris,*
 winter 1935–36, flexible negative with markings
 Musée national d'Art moderne – Centre Georges Pompidou, Paris
 Photo © Centre Pompidou, MNAM-CCI, Dist. RMN-Grand
 Palais / image Centre Pompidou, MNAM-CCI
 Copyright © Estate of Dora Maar / DACS, London 2013

Figures

1 Pablo Picasso, *Karl Marx*, 1964, lithograph xvii
 Collection Gérard Gosselin
 Copyright © Succession Picasso / DACS, London 2013

2 Fred Stein, Max Raphael, 1943 2
 Photo © Estate of Fred Stein
 Copyright © Estate of Fred Stein / DACS, London 2013

3 Inessa Shkolnikov, poster for Lene Berg's 'Stalin by 13
 Picasso or Portrait of a woman with moustache',
 designed for Cooper Union, New York, 2010
 Copyright © Lene Berg / DACS, London 2013

4 Cecil Beaton, Pablo Picasso, 1932 19
 Photo © Sotheby's Picture Library / Cecil Beaton Studio Archive

5 Konstantin Melnikov, Soviet pavilion, Exposition des Arts 25
 décoratifs, Paris, 1925, postcard
 Author's collection

6 André Lurçat, Karl Marx School, Villejuif, 1933 31
 Photo © Institut français d'architecture
 Copyright © Estate of André Lurçat / DACS, London 2013

7 Karl Marx School, Villejuif, opening ceremony, 9 July 1933 33
 Photo © Institut français d'architecture
 Copyright © Estate of André Lurçat / DACS, London 2013

8 Pablo Picasso, *La Dépouille du Minotaure* (used for *14 July* 49
 curtain), 28 May 1936, ink with gouache on paper, 44.5 × 54.5 cm
 Musée Picasso, Paris
 Photo © Musée Picasso / Scala, Florence
 Copyright © Succession Picasso / DACS, London 2013

9 Max Vladimirovich Alpert, Ukraine, farmers' meeting, 1929 51
 Photo © RIA-Novosti / akg-images

10 David Seymour, demonstration at the Federates' Wall, 56
 Père-Lachaise cemetery, 24 May 1936
 Photo © David Seymour/Magnum Photos

11 Albert Harlingue, *Prometheus strangling the vulture* 59
 by Jacques Lipchitz, Paris World Fair 1937
 Photo © Albert Harlingue / Roger-Viollet

12 Paris World Fair, looking towards the Eiffel Tower, 1937 67
 Postcard, author's collection

13 Fred Stein, *Guernica* in the Spanish pavilion, 73
 Paris World Fair, 1937. Photo © Estate of Fred Stein
 Copyright © Estate of Fred Stein / DACS, London 2013

14 Pierre Jeanneret and Le Corbusier, exterior view, Pavillon des 76
 Temps Nouveaux (New Times pavilion), Paris World Fair, 1937
 Photo © Institut français d'architecture

15 Pierre Jeanneret and Le Corbusier, interior view, Pavillon des 77
 Temps Nouveaux (New Times pavilion), Paris World Fair, 1937
 Photo: © Institut français d'architecture

16 Aleksandr Mikhaylovich Gerasimov, *Stalin at a Meeting* 81
 with Commanders, 1937
 Tretyakov State Gallery, Moscow
 Photo © Tretyakov State Gallery / Igor Golomstock
 Copyright © Estate of Aleksandr Gerasimov / DACS, London 2013

17 Unknown photographer, entrance to the international exhibition 97
 'Bolshevism against Europe', Salle Wagram, Paris, 1942
 Musée de la Résistance Nationale, Champigny-sur-Marne

18 Pablo Picasso, *Monument to the Spaniards who Died for France*, 102
 late 1945 to 31 January 1947, 1947, oil on canvas, 195 × 120 cm
 Museo Nacional Reina Sofía, Madrid
 Photo © The Bridgeman Art Library
 Copyright © Succession Picasso / DACS, London 2013

19 *Nouveaux destins de l'intelligence française* 127
 (Paris: Éditions du Ministère de l'Information, 1942), pp. 124–25
 Author's collection

20 Pablo Picasso, poster for the World Peace Conference, 132
 Paris 20–23 April 1949, 1949, offset and letterpress, 79.7 × 70 cm
 Collection Gérard Gosselin
 Copyright © Succession Picasso / DACS, London 2013

21a Pablo Picasso, *Stalin, Your Health*, 1949, 136
 pen and ink on paper, 21.5 × 14 cm
 Musée Picasso, Paris
 Photo © RMN-Grand Palais / Béatrice Hatala
 Copyright © Succession Picasso / DACS, London 2013

21b Pablo Picasso, *Stalin, Your Health*, 1949, 136
 pen and ink on paper, 21.5 × 14 cm
 Musée Picasso, Paris
 Photo © RMN-Grand Palais / Béatrice Hatala
 Copyright © Succession Picasso / DACS, London 2013

21c Pablo Picasso, *Stalin, Your Health*, 1949, 137
 pen and ink on paper, 21.5 × 14 cm
 Musée Picasso, Paris
 Photo © RMN-Grand Palais / Béatrice Hatala
 Copyright © Succession Picasso / DACS, London 2013

21d Pablo Picasso, *Stalin, Your Health*, 1949, pen and ink on paper, 137
 as printed in *Les Lettres françaises*, 298, 9 February 1950
 Collection Gérard Gosselin
 Copyright © Succession Picasso / DACS, London 2013

22 Auguste Herbin, *Lenin–Stalin*, 1948, oil on canvas, 195 × 130 cm 141
 Musée départemental Matisse, Le Cateau-Cambrésis
 Photo © Musée départemental Matisse, Le Cateau-Cambrésis /
 Florian Kleinefenn
 Copyright © Estate of Auguste Herbin / DACS, London 2013

23 Wojciech Fangor, *Peace inviting the dockers of imperialist* 158
 countries to throw their murderous armaments into the sea, 1950–51
 Location unknown
 Photo © Wojciech Fangor / Stefan Szydlowski
 Copyright © Wojciech Fangor

24 Hilaire-Germain-Edgar Degas, *Young Spartans Exercising*, 160
 c.1860, oil on canvas, 109.5 × 155 cm
 National Gallery, London
 Photo © National Gallery, London

25 André Fougeron, *Atlantic Civilisation*, 1953, 171
 oil on canvas, 380 × 559 × 70 cm
 Tate, London
 Photo © Tate, London 2013.
 Copyright © Estate of André Fougeron / DACS, London 2013

26 Reproduction of Picasso's Massacre in Korea in the streets 175
 of Warsaw, 1956
 Copyright © Succession Picasso / DACS, London 2013

27a Nikolai Nikogosyan, *Louis Aragon*, 1953, 187
 bronze, 93 × 55 × 43 cm
 Collection of the artist
 Photo © David Nikogosyan
 Copyright © Nikolai Nikogosyan

27b Ida Kar, Nikogos Nikogosyan, 1957 187
 Photo © National Portrait Gallery, London

28 Pablo Picasso, *Beloyannis*, 1952, 188
 print on paper, 24 × 17 cm
 Musée d'art et d'histoire – Saint-Denis
 Photo © Musée d'art et d'histoire – Saint-Denis /
 Irène Andréani
 Copyright © Succession Picasso / DACS, London 2013

29 Boris Taslitzky, decor for the twelfth PCF congress 191
 Gennevillers, April 1950
 Copyright © Estate of Boris Taslitzky

30 *L'Humanité*, 8 March 1953, front page 192
 Archives départementales de la Seine-Saint-Denis, Bobigny
 Copyright © Archives de l'Humanité

31 Pablo Picasso, *Joseph Stalin*, commissioned by Louis Aragon 193
 for the cover of *Les Lettres françaises*, 12 March 1953
 Collection Gérard Gosselin
 Copyright © Succession Picasso / DACS, London 2013

32 Frédéric Longuet, *Gratitude to Engels. Karl Marx and* 196
 Friedrich Engels, founders of scientific socialism with Madame Marx
 and their three daughters, 1953, oil on canvas, 206 × 232 cm
 Musée de l'Histoire Vivante, Montreuil-sur-Seine
 Photo © Musée de l'Histoire Vivante, Montreuil-sur-Seine

33 Pablo Picasso, *Peace*, 1952, oil on hardboard, 447 × 1011 cm 199
 Musée National Picasso, Chapel of War and Peace, Vallauris
 Photo © RMN-Grand Palais (Musée Picasso de Vallauris) /
 Patrick Gérin
 Copyright © Succession Picasso / DACS, London 2013

34 Inge Morath, Pablo Picasso at the inauguration of his mural 216
 at the UNESCO building in Paris, 1958
 Photo © The Inge Morath Foundation/Magnum Photos

35 Pablo Picasso, *Djamila Boupacha*, 1961, 218
 charcoal on paper, 50 × 29.5 cm
 Private collection
 Photo © Photo Archives Picasso Estate
 Copyright © Succession Picasso / DACS, London 2013

36 Renato Guttuso, after Picasso's *Man with a lamb*, 1973, 227
 pen and wash drawing
 Private collection
 Photo © Estate of Renato Guttuso
 Copyright © Estate of Renato Guttuso / DACS, London 2013

PLATES

1 Grapus collective, Karl Marx School, Villejuif, 1976 78A
 Photomontage
 Courtesy Jean-Louis Cohen

2 Pablo Picasso, *Nude, Green Leaves and Bust*, 1932, 78B
 oil on canvas, 162 × 132 cm
 Private collection
 Photo © Christie's Images / The Bridgeman Art Library
 Copyright © Succession Picasso / DACS, London 2013

3 Pablo Picasso with Luis Fernandez, stage curtain for *14 July*, 78C
 after a gouache of 1936, 830 × 1325 cm
 Les Abattoirs, Toulouse
 Photo © les Abattoirs / Auriol-Gineste
 Copyright © Succession Picasso / DACS, London 2013

4 Pablo Picasso, *14 July*, 1936, graphite on paper, 68 × 67 cm 78C
 Musée Picasso, Paris
 Photo © RMN-Grand Palais / Thierry Le Mage
 Copyright © Succession Picasso / DACS, London 2013

5 Nadia Khodossievitch-Léger, *Self Portrait*, 1936, 78D
 oil on canvas, 73 × 92 cm
 Private collection
 Photo © Estate of Nadia Khodossievitch-Léger / Jacques L'Hoir
 Copyright © Estate of Nadia Khodossievitch-Léger / DACS,
 London 2013

6 Interior of Melnikov pavilion, Paris, 78D
 printed in *Appel des Soviets*, July 1930
 Courtesy Jean-Louis Cohen

7 Boris Taslitzky, *Commemoration of the Paris Commune at the* 78E
 Père-Lachaise cemetery in 1935, 1936, oil on canvas, 195 × 130 cm
 Musée d'Art Moderne de la ville de Paris, Paris
 Photo © Musée d'Art Moderne de la ville de Paris / Roger-Viollet
 Copyright © Estate of Boris Taslitzky / DACS, London 2013

8 Fernand Léger, *Maud Dale*, 1935, oil on canvas, 100 × 79 cm 78E
 National Art Gallery Washington, DC
 Photo © Board of Trustees,
 National Gallery of Art, Washington, DC
 Copyright © Estate of Fernand Léger / DACS, London 2013

9 Boris Iofan, Soviet pavilion 78E
 with Vera Mukhina's *Worker and Kolkhoz-Woman*, 1937,
 postcard, author's collection

10 Pablo Picasso, *The Charnel House*, 1944–45, 78F
 oil and charcoal on canvas, 200 × 250 cm
 Museum of Modern Art, New York
 Photo © The Museum of Modern Art, New York / Scala, Florence
 Copyright © Succession Picasso / DACS, London 2013

11 André Zucca, corner of the rue de Tilsitt 78F
 and the avenue des Champs-Élysées, 1942
 Photo © André Zucca / BHVP / Roger-Viollet

12 Boris Taslitzky, *Professor Halbwachs a few days before* 78F
 his death at Buchenwald, 1945, graphite on paper
 Private collection
 Photo © Estate of Boris Taslitzky
 Copyright © Estate of Boris Taslitzky / DACS, London 2013

13 Boris Taslitzky, *The Small Camp, Buchenwald*, 1946, 78G
 oil on canvas, 300 × 500 cm
 MNAM – Centre Pompidou
 Photo © Centre Pompidou, MNAM-CCI,
 Dist. RMN-Grand Palais / Adam Rzepka
 Copyright © Estate of Boris Taslitzky / DACS, London 2013

14 Boris Taslitzky, *The Death of Danielle Casanova*, 1950, 78G
 oil on canvas, 195 × 308 cm
 Musée de l'Histoire Vivante, Montreuil-sur-Seine
 Photo © Musée de l'Histoire Vivante, Montreuil-sur-Seine
 Copyright © Estate of Boris Taslitzky / DACS, London 2013

15 André Fougeron, *Homage to André Houiller*, 1949, 78H
 oil on canvas, 250 × 375 cm
 Pushkin Museum, Moscow
 Photo © Puskhin Museum / Andrei Koudriavitzky
 Copyright © Estate of André Fougeron / DACS, London 2013

16 André Fougeron, peace poster for the PCF, 1948 78H
 Author's collection
 Photo © The Bridgeman Art Library
 Copyright © Estate of André Fougeron / DACS, London 2013

17 *The Dove that Goes BOOM!*, first anti-communist poster 78H
 by the 'Peace and Liberty' movement, 1950, lithograph, 80 × 60 cm
 Paix et Liberté Collection, Princeton University Library
 Photo © Princeton University Library

18 Pablo Picasso, *Massacre in Korea*, 1951, oil on plywood, 190A
 110 x 120 cm. Musée Picasso, Paris
 Photo © RMN / Jean-Gilles Berizzi
 Copyright © Succession Picasso / DACS, London 2013

19 Nadia Khodossievitch-Léger, *War in Korea*, 1952, 190A
 oil on canvas, 112 × 194 cm
 Private collection
 Photo © Dobiaschofsky Auktionen AG
 Copyright © Estate of Nadia Khodossievitch-Léger / DACS,
 London 2013

20 Wojciech Fangor, *Korean Mother*, 1951, 190A
 oil on canvas, 131 × 201 cm
 National Museum, Warsaw
 Photo © National Museum, Warsaw
 Copyright © Wojciech Fangor

21 Boris Taslitzky, *Women of Oran*, 1952, 190B
 oil on canvas, 114 × 147 cm
 Private collection
 Photo © Estate of Boris Taslitzky / Isabelle Rollin-Royer
 Copyright © Estate of Boris Taslitzky / DACS, London 2013

22 Mireille Miailhe, *Young agricultural workers*, 1952, 190B
 oil on canvas, 210 × 280 cm
 National Museum of Art, Bucharest
 Photo © National Museum of Art, Bucharest / Cosmin Ungureanu
 Copyright © Estate of Mireille Miailhe

23 Pablo Picasso, *War*, 1952, oil on hardboard, 448 × 1011 cm 190C
 Musée National Picasso, Chapel of War and Peace, Vallauris
 Photo © RMN-Grand Palais (Musée Picasso de Vallauris) /
 Patrick Gérin
 Copyright © Succession Picasso / DACS, London 2013

24 Mireille Miailhe, poster for 'Algérie 1952', 1953 190C
 Photo © Adrien Sina
 Copyright © Estate of Mireille Miailhe

25 Eugène Delacroix, *Fanatics of Tangiers*, 1837–38, 190C
 oil on canvas, 95.5 × 128.5 cm
 Minneapolis Institute of Arts
 Photo © Minneapolis Institute of Arts,
 Bequest of J. Jerome Hill, 73.42.3

26 *Les Lettres françaises*, 12 March 1953 190D
 Collection Gérard Gosselin

27 Albert Prigent, *Marx*, 1953, oil on canvas, 75 × 100 cm 190E
 Musée de l'Histoire Vivante, Montreuil-sur-Seine
 Photo © Musée de l'Histoire Vivante, Montreuil-sur-Seine

28 Stoekel, *Stalin*, [undated], oil on canvas, 54 × 65 cm 190E
 Musée de l'Histoire Vivante, Montreuil-sur-Seine
 Photo © Musée de l'Histoire Vivante, Montreuil-sur-Seine

29 Geneviève Zondervan, *Lenin*, 1953, oil on canvas, 20 × 27 cm 190E
 Author's collection
 Copyright © Geneviève Zondervan

30a New Soviet Pavilion, Moscow, 2012 190F
 Copyright © Olga Sinodova

30b New Soviet Pavilion, Moscow, 2012 190F
 Copyright © Olga Sinodova

31 Interior, New Soviet Pavilion, with model of Boris Iofan's 190F
 pavilion, 1937, Moscow, 2010
 Copyright © Alex Rytov

32a 'Masterpieces from the Musée national Picasso, Paris', 190G
 Pushkin Museum, 2010
 The great staircase, with *Guernica* designed by Boris Messerer
 Copyright © Musée national Picasso Paris / Béatrice Hatala, 2013

32b 'Masterpieces from the Musée national Picasso, Paris', 190G
 Pushkin Museum, 2010
 Installation view, works from 1950–1972.
 Copyright © Musée national Picasso Paris / Béatrice Hatala, 2013

32c 'Masterpieces from the Musée national Picasso, Paris', 190H
 Pushkin Museum, 2010
 Installation view, war paintings, 1939–1951.
 Copyright © Musée national Picasso Paris / Béatrice Hatala, 2013

33 Mikhail Lifshitz and Lidia Reinhardt, *The Crisis of Ugliness,* 190H
 from Cubism to Pop Art (Moscow, 1968)
 Courtesy Dmitri Gutov

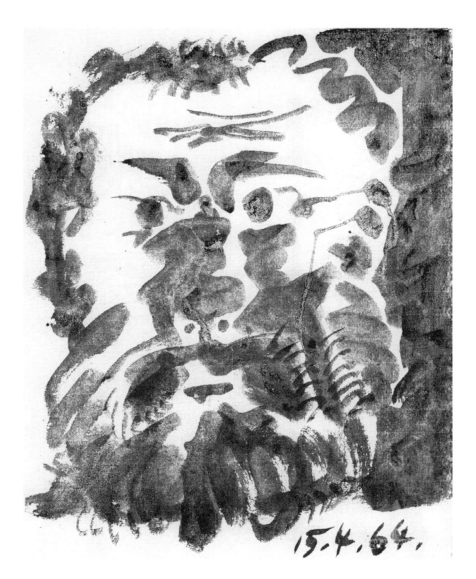

Figure 1: Pablo Picasso, *Karl Marx*, 1964

Introduction

The twentieth century will enter history as the century of totalitarianism

Jean Cassou, 1953[1]

In April 2010 Picasso's *Nude, Green Leaves and Bust* was sold for $106.5 million (£70.2 million) by Christie's, New York, while the world was living through a recession unparalleled since the global impact of the Wall Street financial crash in the 1930s (plate 2).[2] As *Nude with Blue Curtain*, it was displayed to an international audience in the Kunsthaus, Zurich in 1932, where it was seen by the refugee Marxist art historian from Berlin, Max Raphael (fig. 2). He took the catalogue with him to Paris; in 1933 he published *Proudhon, Marx, Picasso.*

This book pays homage to Raphael and his pioneering Marxist critique of Picasso's work. It follows the major tribute by John Berger, *Success and Failure of Picasso* (1965), in which Raphael appears only in his enigmatic dedication as 'a forgotten but great critic'.[3] Berger, writing while the artist was still alive, embraced over thirty years more of Picasso's production. I aim to re-establish a larger political context for Picasso, going beyond the lifespan of the artist, and challenging the monographic focus of recent studies.

Like Raphael, I aim to be polemical. I will not attempt to cite all past or current Picasso literature (both Raphael and Berger wrote with no references), but to offer a denser, dialectical view of the context of major works which mark the artist's production through the twentieth century: *Nude with Blue Curtain*, *14 July*, *Guernica*, *The Charnel House*, *Massacre in Korea* and the *War* and *Peace* diptych, together with his notorious homages to Stalin. They respond specifically to the threat of fascism in the face of collapsing economies, civilian bombing, the Nazi Holocaust,

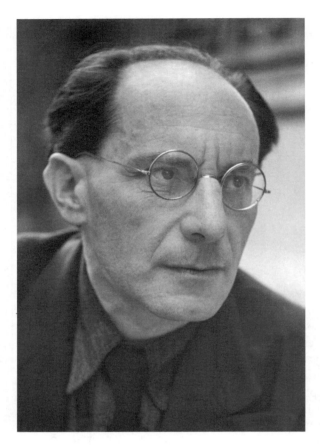

Figure 2: Fred Stein,
Max Raphael, 1943

colonial war, the dialectics of war and peace and the cult of personality. As such their 'success and failure' had a contemporary resonance and has a resonance for today. In our equally chaotic times, each focus of disturbance is inscribed within far older narratives of political and religious violence.

Max Raphael could not have anticipated the impact of Stalinism on French political and cultural life (Berger underestimates it radically). This is why I feel compelled to offer a 'counter-history'; a complement to *Paris, Capital of the Arts, 1900–1968* which I curated in 2002, which demonstrated the extraordinary artistic creativity and exuberance of the city which is the essential background to this often more sombre narrative.[4] Here I distinguish my contribution from Gertje R. Utley's *Picasso, the Communist Years* (2000), despite the cross-over of our

interests.[5] Richly illustrated, this offers only three black-and-white images of French socialist realism, the movement which for me frames Picasso's work from 1936 onwards as a 'dialectical other'. I wish to emphasise not only the power of the Soviet and French Communist Parties as they impact upon the later twentieth century, within and beyond their own boundaries (in Poland, Korea or Algeria for example), but the way in which this field of study has had a lasting impact and a structuring influence upon French intellectual life that is still apparent today. *Picasso, Peace and Freedom*, curated by Linda Morris and Christoph Grunenberg for Tate Liverpool in 2010 (before travelling to Vienna and Louisiana, 2010–2011), offers another complementary vision, new scholarship and magnificent illustrations; yet Mikoláš Aleš' *The Hussite Camp* (1887, National Gallery, Prague) is the only realist work visible here.[6] Time frames differ significantly; my story ends in the present.

France's open society, capitalist model and freedom of speech meant that, contrary to Soviet compliance with academic models and 'positive' content, French socialist realist painting was critical and polemical as regards the State; the high moment of Stalinism marks a paroxysm. While reappraised 'sociologically' from Raphael onwards, this movement continues to be disavowed; new initiatives have had no impact on France's own post-war narrative of art production.[7]

In the light of continuing debates around the so-called *Black Book of Communism*, first published in France in 1997 for the eightieth anniversary of the Russian Revolution, and the *Livre noir du colonialisme* (Black Book of Colonialism), the wider context is important.[8] In particular, art historians, or indeed the publics of Picasso exhibitions in Liverpool, Vienna, Moscow or New York, are unaware of the generations of dense scholarship around the Communist problem in France – or alternatively the 'new' Marx, currently celebrated within an 'idea of Communism' that too often evacuates history.[9] The new Marx is perhaps younger than Picasso. It is in the context of the contemporaneity of this massive figure in world history that I attempt here to give Picasso, who is likewise a monument, a harder, more polemical edge: hence *Picasso / Marx*.

Picasso was the first global art superstar. At the very beginning of the televisual age, his name – synonymous with 'modern art' – was recognised almost everywhere in and beyond the so-called First World. Specific works in reproduction, notably *Guernica* and *Massacre in Korea*, were used as recognisable symbols of political protest. These were used by Communist parties in western and eastern Europe for ideological

reasons – and *against* the USSR in specific cases, notably the invasion of Hungary in 1956. In France, while the relationship with Stalinism in the arts has remained a well-kept secret, the success and impact of the cultural policies of the French Communist Party (PCF) have been given little external recognition as a vital populist model that coexisted with – and contested – the evolution of André Malraux's grandiose, State-driven Ministry of Culture. Malraux's restorations, commissions, dramatic exhibitions, new spaces and projects such as the Biennale de Paris were countered with an aspiration towards a mass 'high' culture for a worker-based public.[10] Here Picasso played a crucial role.

Since 1912, when Marxist theorist Georgi Plekhanov was confronted with Fernand Léger's cubist *Woman in Blue* at Paris's Autumn Salon, Marxist reflection theory has been an object of contention within art history.[11] Superseding Hegel's concept of *Zeitgeist*, in which a work of art partakes of 'the Spirit of the Age' (if not entirely 'turning it on its head' – the classic description of Marx's operation on Hegel), reflection theory appeared as a proposition in Paris at exactly the moment of Max Raphael's book.

A painting both does and does not reflect the spirit of its times. It was the pluralistic situation of already-evolved styles (abstraction, surrealism, neo-classical and expressionist realisms), their different Salons and appeal to clients, which brought this point sharply home to Raphael. He wrote with a Marxist point of view, yet fresh from contesting Carl Jung's negative critique of Picasso's 1932 Zurich show, hence at an explicitly post-psychoanalytic moment. It is precisely the disjunction between the representations that an era produces, historical events and invisible historical drives at play which are of interest. When Henry Rousso applied the psychoanalytic concept of repressed mourning (*un deuil refoulé*) not to an individual but to the whole people of France after 1945, he set a precedent which went beyond Maurice Halbwachs' notion of 'collective memory'.[12] Halbwachs was a disciple of the sociologist Emile Durkheim and a contemporary of Picasso; he was a prisoner in Buchenwald concentration camp with the painter Boris Taslitzky.[13] Their poignant relationship is discussed in Chapter 4.

France's schizophrenia in the post-war years was exemplified by the symptom of Communist 'doublethink' within the PCF itself, compounded by war trauma, guilt and tensions between past traditions and an accelerating technological future. How could Stalinism in its purest form flourish in a country massively dependent on American Marshall aid and an expensive and forward-looking 'reconstruction

culture'? The once fiercely Communist historian, Annie Kriegel, devised the term 'counter-society' to describe the French Communist operation as it flourished within capitalism.[14] This is what distinguishes the 'French exception' from the theorisings on Communism and indeed 'Communist postscripts' which look only at the lives of citizens and artist-citizens in the USSR and its satellite countries.[15] Both Moscow and New York generated military and cultural operations involving vast budgets, with ruthless rationalism and precise aims. Within a world arena of intense Cold War tensions, however, the French revolutionary model at home remained a comforting and 'patriotic' palimpsest for the turn to the USSR as 'another place' with all its affects. And the model of the *guerre franco-française*, internecine French-on-French warfare generated by the Revolution, with its class-based subtext, was played out again and again, via the Communist counter-society.[16]

History as a practice and its relative, art history, preserve, contextualise and examine representations which have often drifted loose of the forces and the emotions which shaped their production. Such, I argue, is the case with Picasso, despite the countless exhibitions and catalogues devoted to his work. His paintings not only 'reflected' but masked the 'real', including traumas that could not be articulated in this era of Holocaust victims, returned deportees, young French soldiers forced to torture in Algeria, and above all the vision of Hiroshima and the fear of nuclear destruction. Retrospectively, representations have the power to mask 'history' itself, often becoming the sole interface with the thought and politics of those years: Picasso's *Massacre in Korea* is a case in point. Not only are issues of memory and 'writing history' at stake but ethical and moral considerations: irrevocable events, inexpiable crimes – yet no pardon, no forgiveness can be given for the forgotten.[17] In Picasso's case, narratives have focused on successive styles; events have become substrata of artistic periods. Biography, studios, châteaux, 'Picasso at home', indeed 'Picasso's 'women' have become periodising factors, with history 'off-scene': a Picasso eclipsing history altogether.

The cult of personality is a conundrum at the heart of this book. In the context of the 'return to Marx' and the sense of loss after the death of Jacques Derrida – signalling the end of the period of the greatest brilliance in French thought since the eighteenth century – new 'superstars' have appeared. 'The Future of Marxism' has been displaced by the 'Idea of Communism' as a trope for conferences and publications; Alain Badiou and Jacques Rancière are France's new intellectual heroes on an international stage.[18] Yet their political and philosophical energies

were shaped during Picasso's last decade, inheriting the problems of the troubled years I discuss, followed by the Cold War aftermath to 1989. Their early thought is as decontextualised outside France as is, say, that of Louis Althusser, Rancière's precursor and *bête noire*. Badiou, like Althusser, is troubled by history as the recapitulation of proper names, a litany of 'great men' emerging via chance and unpredictable swerves which challenge straightforward Marxist materialist analyses (the notion of reflection theory as static). 'Hölderlins, Goethes and Hegels come into the world conjointly'. Napoleon rose and fell, specific encounters were catalysts for the Russian Revolution, Althusser argued.[19] Badiou likewise asks 'Why Spartacus, Thomas Müntzer, Robespierre, Toussaint Louverture, Blanqui, Marx, Lenin, Rosa Luxembourg, Mao, Che Guevara and so many others?'[20] Each of these names, he says, historically symbolises, in the form of an individual, a 'pure singularity' of body and mind, 'a rare and precious network of ephemeral sequences of politics as truth' (*séquences fuyantes de la politique comme vérité*).[21] Now Badiou and Rancière have themselves become magic names, linked to new philosophical mantras.

'Picasso', I argue, also functions polysemantically as a proper name, linked to magic thought and to 'genius'. The construction of the 'artist-genius' from the Romantic period onwards is a cliché; Picasso, with his bohemian and politically anarchist beginnings, fits the bill perfectly; yet the quantity, quality, variety and agreed value of his *œuvre* was exceptional by human standards, separating Picasso from his artist peers. This explains the fascination and myth-making, indeed the discourse of 'genius' around him. His international stature put him on a par with Einstein, Stalin and Mao: major shapers of the twentieth century; major actors in the Cold War debate.

Less is more? Undoubtedly Marcel Duchamp has been the more influential artist since the 1960s. A dimension of his power and influence has been his resolute elevation of art to the condition of philosophy and his 'antipolitics', both so suitable for American university establishments during the Cold War and after. But there is a peculiar correspondence between our times of economic crisis and the uncertainties of the era in which Max Raphael challenged Picasso. We too – despite all the odds, despite the unmasking of Communism, the collapse of the Soviet empire – have found intellectuals all over the world returning to Marx, this time with the sobering knowledge of what followed the 1930s. Hence a return to Picasso (as opposed yet again to Duchamp) is accompanied with

an uncanny sense of foreboding: his trajectory is in itself a monument and, in the word's etymological sense, a warning for the future.

'Picasso' signifies Paris without Paris. Duchamp's evident desire to escape Paris and his native language, like James Joyce's desire to escape Ireland, or Samuel Beckett's desire to escape English as a language, is telling. 'Paris', like 'Picasso', is an overdetermined construction. I marvel at Paris's landscape of museums and monuments, its ephemeral landscapes of celebrations and demonstrations, its tremendous *joie de vivre*. I salute the care, enthusiasm and dedication of its historians and curators; my bibliography, a tribute, conveys the richness of their gift to posterity. Alas, after the great years of intellectual brilliance in the 1970s and 1980s, Paris lacks younger contemporary artists of great stature; it falls prey to the melancholy of retrospection. Yet Paris signifies the heart of the Revolution, the Commune and the aforementioned *guerre franco-française* which structure its political and material heritages. Parisian debates were at the very origins of politics' right and left, the decapitation of inherited power, the question of fair governance. Paris was the living crucible for Marx's theory of class struggle prior to his engagement with the paradigm of the Industrial Revolution in England; *Marx à Paris*, a major study, appeared in 1962.[22] After Marx, Lenin, too, spent the 'cubist years' 1909–1912 in Paris; before Picasso's death, Lenin's centenary was celebrated with a huge retrospective in Paris's Grand Palais in 1970; Sergei Yutkevich's *Lenin in Paris* was produced by Mosfilm in 1981, before the fall of the USSR.

Paris created modernism and the philosophical structures of postmodernism. Its position was unique after 1945 where André Malraux's Paris-centred *musée imaginaire* (the 'imaginary museum') coincided with Alexander Kojève's arguments for a global 'end of history'.[23] Paris, once the centre of Enlightenment thought, now became the centre for reflection upon the decline of humanism:

> Through its decline, humanism freed a space for a series of conceptual reorganisations in atheism, in philosophical anthropology, in the understanding of the history of modern thought, and also in a host of problems in contemporary metaphysics and epistemology. The very process of thinking and defining the human imploded a conceptual foundation of modern thought into an unstable category, a figure, even an aporia.[24]

These ideas take Paris as a centre of thought and experiment far beyond the tired 'Paris–New York' debates of the late Cold War era.[25]

Picasso's trajectory maps the end of the humanism debate; Europe by 1973 had become a different place.

'Paris, capital of the nineteenth century' as a concept enjoys an aura bestowed by Walter Benjamin; Benjamin's own Paris of the 1930s still reigned supreme, in particular after challenges from Moscow or Berlin were annulled by the rise of totalitarianisms. The metropolis was centripetal, a focus for the exchange of ideas, for intellectual immigration, but also a springboard for sending into the world its thoughts and forms, ideas and manpower. In the arts, the Janus-faced term 'École de Paris' or School of Paris marked the city in the 1920s and 1930s as a global centre, even as the term (distinguished from the 'French School') contained elements of a racism that would lead to its disintegration. The School of Paris with its brilliant profusion and joyful energies before and after 1945 is hardly taught in art-historical curricula.[26] Yet it is the vortex with Picasso at its centre – despite his later years on the Riviera. Picasso related to the day-by-day intellectual and political life of Paris from 1900 to 1973: the shorter twentieth century. 'Paris' plus 'Picasso' thus signify far more than the problem of 'Picasso's Communist years' beginning in 1944, the subject of Gertje Utley's study.

From 1933, the year of Hitler's accession to power, the Reichstag fire in Berlin and the persecution in Germany of Communists and Jews, Paris was the heart of Comintern operations in the West. This was the year of Raphael's *Proudhon, Marx, Picasso*. The long Franco-Russian relationship continued: having started with interchanges between courts and traders, it was subsequently premised upon the 1917 Soviet Revolution and the founding of the French Communist Party at the Congress of Tours in 1920. Communism's penetration of the publishing scene, from the editing of Marx and Lenin to militant tracts or Comintern-backed luxury multi-language photographic magazines such as *l'URSS en Construction*, has been the focus of study since the late 1970s. These publications were intimately linked to the Party-orientated structures that not only created militants, but made Party affiliation a crucial means of upward social mobility towards the status of *intellectuel*. Thus Edouard Pignon, the miners' son and Picasso's friend, André Fougeron, with his 'anarcho-syndicalist' background, Boris Taslitzky, the half-orphaned *pupille de la Nation* (his Russian father killed fighting for France), all became 'Communist intellectuals', the authors of important articles, signatories to political tracts, strong Party voices in the 1950s. The same could be said for the photographer Willy Ronis, for example. What has subsequently been called 'humanist photography' shared the Communist adventure

from the 1930s onwards. This was a deep engagement, consistently 'disappeared' from contemporary photographic retrospectives: to add its crucial dimension to this discussion would have necessitated a volume twice as large.[27]

The dialectical juxtapositions which structure my chapters do not aim, principally, to rehabilitate French socialist realism. They demonstrate political counter-activities in art both 'with and against' Picasso which have been hidden from view (if *monstrum*, 'monster' or 'portent', is etymologically contained in *monstrare*, to show, so be it…). Even the more comprehensive catalogues, such as Germain Viatte's *Paris–Paris* of 1981 (which showed the geometric abstraction excluded from both *Aftermath, France 1945–1954* [1982] and *Paris Post War, Art and Existentialism* [1992]), or my own exhibition *Paris, Capital of the Arts, 1900–1968* of 2002, actually omit the most characteristic painting of the 1940s, such as the works of André Marchand or the artists of La Ruche, for example, who are so close to Fougeron's painting in their 'period style'.[28] Moreover, Soviet socialist realism is at last getting the scholarly attention and broader exhibition-going public in western Europe that it deserves. Without rehearsing the politics and displays of the long exhibition revival of the early 1990s, one could argue that following the movement's 'staging' (for example Boris Groys' *Dream Factory Communism*, Frankfurt, 2004), the exhibition *Socialist Realisms, Soviet Painting, 1920–1970* in Rome (2011) showed a strong, decade-based selection of Soviet painting as painting, not merely as ideological décor.[29] French production in this area likewise deserves our attention. Actively involving Paul Signac and Maximilien Luce in the 1930s, it continued its industrial epic in paint to the 1970s and beyond. In 2010 Guillaume Désange selected Boris Taslitzky's drawings of Italian and Algerian workers manning industrial furnaces and Jean Amblard's three-metre-long oil paintings on the subject together with Jean-Luc Godard, sub-commander Marcos (the leader of the Zapatistas), Chris Moukarbel and Walid Raad. There will always be 'Vigils, Liars, Dreamers': the title of his show.[30]

The strength of the Franco-Soviet relationship extended through and beyond the Cominform years and the years of de-Stalinisation to 1989. This twentieth-century relationship was almost entirely disavowed for the official Franco-Russian year of exchanges, under Nicolas Sarkozy and during Vladimir Putin's post-presidential period as Russian prime minister.[31] Its spectacular climax was the Picasso retrospective in Moscow in February 2010, which attracted over 250,000 visitors. While beyond France, the 'picture' of French Stalinism, its evolution, highpoint and

legacy remains relatively unknown, it is at the heart of several French university dynasties and debates. It is a motivating dynamic for more than two generations of distinguished historians, in particular those involved with the questions of Communism and anti-Communism and French memory: the late Annie Kriegel, François Furet, Pierre Nora, Annette Becker, Annette Wieworka, Henry Rousso, Stéphane Courtois, Laurent Gervereau and their epigones. The release of French Communist and Soviet archive material over the last decades has structured their research, their competitive polemics and wider public reception.[32] The older scholars here are the direct contemporaries of the Badiou–Rancière generation of philosophers, produced via the same cultural pressures.

History or 'philosophy'? This split in intellectual production and university disciplines, practice and prestige is epitomised by the concept of a historian's practice as *scientifique* (resolutely positivist and empirical) versus Badiou's notion of 'History' (*Histoire*) as 'symbolic fiction'.[33] Memory, archives, history, 'last survivors', oral history, philosophy or 'theory': France's story in this arena makes it the perfect example for an interrogation of historical practice *per se*. Picasso or 'Picasso', Marx or 'Marx' function here as signs within large semantic fields and complex histories of usage – like Badiou's 'communism' with its two-centuries old past. Still-living protagonists from the period of French high Stalinism, such as Edgar Morin, add their voices to constant commemorative events, as did until recently Henri Alleg or Jorge Semprun, the Buchenwald survivor, later Spain's first Minister of Culture, who visited *Paris, Capital of the Arts* with me. Every Picasso exhibition is also, of course, a commemorative event. And *Picasso / Marx* opens the way, I hope, for new studies: I am supremely aware that the empirical dimensions of my account fail to give the economic basis of so many operations by Soviet, French and American intelligence and cultural organisations. Massive budgets were at stake; much data is of course irretrievable; the urgency to publish overrides my undoubted inadequacies in this area.

In 1947, after the fall of the 'iron curtain' across a divided Europe, Maurice Merleau-Ponty published *Humanism and Terror, an essay on the Communist problem*. Spurred by Arthur Koestler's recent *Darkness at Noon*, a parable based on the Moscow purges of 1937–38, it posed the age-old question of whether the end justifies the means.[34] France itself was emerging from a period of Nazi terror, the mass deportation of its Jewish civilian population (with the collaboration of its citizenry), torture, the reprisal shooting of randomly selected hostages, bombing and the emblematic burning of an entire village population in a church

at Oradour. More terrifying in their implications were the thousands of
French-on-French reprisal killings of the purge period or *épuration*, the
shaving and branding of women, *les tondues*, and France's own respon-
sibility for an *extermination douce*: the 'soft' extermination (officially
condoned starvation) of mental patients during the war – a 'theatre of
cruelty' where Antonin Artaud himself was once a victim.[35] This 'ugly
carnival' of human behaviour dissolved boundaries between patriot and
enemy, and as Georges Bataille argued, between victim and torturer or
executioner. The French Communists (dishonoured by the Nazi–Soviet
pact of 1939) re-emerged as the noble *parti des fusillés*, the party proud of
its credentials with '75,000' shot Communist Resistants at the Liberation
(when the USSR was still an ally).[36] Then followed the unthinkable: the
revelation of the concentration camps followed by the atomic bomb.
Millions of deaths; evidence on screen. 'Who is my neighbour?', writer
Pierre Klossowski asked again in 1947. He made the impermissible
parallel between recent terror and that of the French Revolution itself.[37]

Jean Cassou, Picasso's friend and contemporary, spoke of the 'century
of totalitarianism' in 1953 (see my epigraph). Cassou, a fellow Spaniard,
shaper of Popular Front cultural policy, Resistant and director of the
French National museum of modern art after the war, by this date saw
Nazi and Stalinist totalitarianisms as equally evil. A more frightening
problem traverses this period then: how to deal with the memory of
terror and its double, 'the fascism within ourselves' (*le fascime qui est en
nous*) defined in 1937 by the writer Jean-Richard Bloch in the militant
periodical *Commune*.[38] Four years after Cassou's article was published in
the CIA-backed journal *Preuves*, the Catholic thinker Bernard Lonergan
conceptualised the idea of *scotosis*, a metaphor relating to the retinal
'blind spot'. Scotosis he defines as an aberration of both understanding
and censorship, a repression preventing 'the emergence into consciousness
of perspectives that would give rise to unwanted insights'. It operates
in the categories of both inhibition and performance: 'The *persona* of
the dispassionate intellectual is coupled with a sentimental *anima*.'
I first encountered Lonergan's concept in the study *Merleau-Ponty and
Marxism, from Terror to Reform* (1979); scotosis may be usefully extended
from a consideration of Merleau-Ponty to the problem of the French left
and Communism to 1989 and beyond.[39]

The incompatibility between the humanist legacy and the terror
inscribed in hearts, minds, eyes and the imagination at this period
gave rise to metaphors of blindness, the unspeakable, the unnameable
(anticipated by the blind Minotaur of Picasso's *Vollard suite* in the 1930s).

In Paris after the Second World War, these notions or affects were themselves incompatible with, or overwhelmed by, the material culture of reconstruction: a world of plastics, electoral posters, steak and chips, Greta Garbo – all emblematically analysed in Roland Barthes's *Mythologies* (1957) – to which, of course, one must add the insouciance and embrace of the future by a younger generation.

The idea of blindness and incomprehension joins the Stalinist trope of self-criticism or *autocritique* as apologia in a spate of autobiographies, from Edgar Morin's *Autocritique* of 1959 to those of the late 1970s and after, written by the Communist actors in this drama, such as *J'ai cru au matin* ('I believed in the morning', Pierre Daix, 1976), or *Ce que j'ai cru comprendre* ('What I thought I understood', Annie Kriegel, 1991). Like much French theoretical writing, notably Maurice Blanchot's *Writing the Disaster* (translated 1986) or Lyotard's *Heidegger and the 'Jews'* (translated 1988) these were generally produced after my first, empirically trained attempts to make sense of the Communist narrative within French culture, starting with contributions to the Pompidou Centre exhibition *Paris–Paris, 1937–1957.*[40]

'Can capitalism be pictured?' This was the question asked at the Courtauld Institute in 2012 by the dissident Hungarian intellectual and politician Gáspár Miklos Tamás:

> Labour *is* capital. Depicting history and power that is purely conceptual is a problem for both theory and art. So much so, that some came to doubt that either history or power is part of reality which is supposed to be visible. Personifying capitalism is arguably an error. Should art and theory be as elusive as capital itself in order to give it its true measure?[41]

Many of the artists in Picasso's Paris attempted to answer this question, turning their backs on the traditional genres of landscape, nude or portrait. Yet representations of the world of work or the labouring body could not – cannot – fully represent the 'systemic violence' of capitalism (as recently analysed by Slavoj Žižek).[42] Picasso, their contemporary, used myth and the disturbing analogy of sexual violence to bring depiction from the time-specific to general and symbolic realms. Our secular, materialist Western art world has seen 'too much Picasso'; yet so very recently Picasso has rejoined contemporary debates on terror, memory and censorship.

In 2008 Lene Berg's art piece *Stalin by Picasso or Portrait of Woman with Moustache*, consisting of three banners, was removed from the façade of

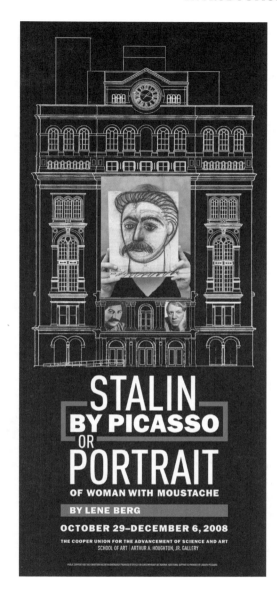

Figure 3: Inessa Shkolnikov, poster for Lene Berg's 'Stalin by Picasso…', 2010

the Cooper Union building in New York. Picasso's 'disappeared' portrait of Stalin, mightily enlarged, was held over the breast of the female artist (Stalin thereby experiencing a sex-change). This image was suspended above well-known photographs of Picasso and the Soviet leader (fig. 3). Outcry from various quarters generated international press coverage.[43]

As well as a supposed violation of city permit regulations, the Cooper Union was made aware that 2008 year marked the '75th anniversary of the Holodomor, the decimation of the Ukrainian population through imposed famine, which took place in 1932–33 under Joseph Stalin's rule'.[44]

As a mark of respect for the neighbouring Ukrainian New York community, the banners were taken down, and following the artist's wishes the gallery 'went dark'. Suddenly an image, an evocation of terror, memories of annihilation, impinged upon the everyday life of a community in New York: a New York aware since 2001 that it, too, could endure acts of terror, wage a 'war on terror', or be forced to confront an alternative sacred, the motor of that terror.

Three years later, in 2011, 'Picasso in Palestine' demonstrated anew Picasso's power as symbol against war. Picasso's *Bust of a Woman* (1943) was displayed in Khaled Hourani's art school in Ramallah, in the occupied Palestinian Territory. From Eindhoven the work travelled by air to Tel Aviv, then with police escort through the Qualandia checkpoint. Reactions were mixed:

> Everyone has a different opinion about what the painting means. I overheard the security guards discussing it and they came to the conclusion that it was a woman cradling her child in time of war as she has one eye on the child and one eye on the surrounding danger.[45]

'One eye on the child and one eye on the surrounding danger.' Nothing could better exemplify Max Raphael's procedure as he attempted to bring Marx to Picasso: in his *Guernica* essay, for example, with its double focus on content and its palimpsests as expressed in the contrast between the painting's energetic surface and its historical political context. This double focus mirrored his creativity in exile, as he wrote in Paris, travelled through France, thought about art in the Gurs internment camp, thought about ruined Europe and its heritages from America. It is a method I hope to honour here. Terror and the power of art coexist with history in the present; this book is written for today.

Notes

1 Jean Cassou, 'Enquête sur le réalisme socialiste II', *Preuves*, 15 (May 1952), p. 46.

2 Christie's Fine Art Auction House, Lot 6, Sale 2410, New York, 16 April 2010. http://www.christies.com/LotFinder/lot_details.aspx?intObjectID=5313319 (accessed 8 July 2013).

3 John Berger, *Success and Failure of Picasso* (Harmondsworth: Penguin, 1997 [1965]); he gives the reference to *Proudhon, Marx, Picasso* with an asterisk.

4 See Sarah Wilson, ed., *Paris, Capital of the Arts, 1900–1968* (London: Royal Academy of Arts, 2002), English, French, German and Spanish editions.

5 My extensively footnoted doctorate was available from 1992, together with several articles – see bibliography; cf. Gertje R. Utley, *Picasso, the Communist Years* (New Haven, CT, and London: Yale University Press, 2000).

6 Christoph Grunenberg and Linda Morris, eds, *Picasso, Peace and Freedom* (London: Tate Publishing, 2010), p. 51.

7 Following Jules Monnerot, *Sociologie du Communisme* (Paris: Gallimard, 1949), see Jeannine Verdès-Leroux, *Au Service du Parti: Le parti communiste, les intellectuels et la culture, 1944–1956* (Paris: Fayard / Minuit, 1983); *Le Réveil des somnambules: le parti communiste, les intellectuels et la culture, 1956–1985* (Paris: Fayard, 1986); and Gérard Vincent, 'Communism as a Way of Life', in *A History of Private Life*, ed. P. Aries and G. Duby (Cambridge, MA: Harvard University Press, 1991), pp. 315–45.

8 Stéphane Courtois et al., *Le Livre noir du Communisme: crimes, terreur, répression* (Paris: Laffont, 1997); Marc Ferro, ed., *Le Livre noir du colonialisme* (Paris: Laffont, 2003).

9 See Grunenberg and Morris, eds, *Picasso, Peace and Freedom*; Costas Douzinas and Slavoj Žižek, eds, *The Idea of Communism* (London and New York: Verso, 2010); Boris Groys, *The Communist Postscript* (London: Verso, 2009); Bruno Bosteels, *The Actuality of Communism* (London: Verso, 2011); and Alain Badiou, *The Communist Hypothesis*, trans. D. Mackey (London: Verso, 2010), pp. 229–60.

10 Augustin Girard and Geneviève Gentil, eds, *André Malraux ministre, les affaires culturelles au temps d'André Malraux* (Paris: Documentation française, 1996).

11 Georgy V. Plekhanov, *Art and Social Life* (Moscow, 1912), trans. A. Fineberg as *Unaddressed Letters: Art and Social Life* (Moscow: Foreign Languages Publishing House, 1957).

12 Henry Rousso, *Le Syndrome de Vichy* (Paris: Seuil, 1987), trans. A. Goldhammer as *The Vichy Syndrome: History and Memory in France since 1944* (Cambridge, MA: Harvard University Press, 1991).

13 Maurice Halbwachs, *La Mémoire collective* (Paris: PUF, 1950).

14 'A Western Communist party is a party not in power, which operates with an industrial society which possesses all the signs of modernity (science, technology, a working class, social-democracy, and which (enjoys) the promise as heritage of all factors of European identity.' Annie Kriegel, *Le Système communiste mondial* (Paris: PUF, 1984), p. 144 (my translation).

15 See Serge Regourd, *L'Exception culturelle* (Paris: PUF, 2002); Groys, *The Communist Postscript*.

16 Louis-Dominique Girard, *La Guerre franco-française* (Paris: André Bonne, 1950).

17 See Jacques Derrida, *Pardonner. L'impardonnable et l'imprescriptible* (Paris: Galilée, 2012), in response to Vladimir Jankélévitch, *L'Imprescriptible: pardonner? Dans l'honneur et la dignité* (Paris: Seuil, 1986).

18 'Whither Marxism', University of California, Riverside, 1993; Terry Eagleton, at 'The Future of Marxism', University of London, 13 July 1999, http://www.ganahl. info/s_sl_eagleton.html; and 'The Idea of Communism', London, Institute of Education, 12–15 May, 2009.

19 'Quand nous naissent conjointement des Hölderlin, des Goethe et des Hegel'; Louis Althusser, 'Le Courant souterrain du matérialisme de la rencontre' (1982), in *Écrits philosophiques et politiques*, vol. 1, ed. François Matherin (Paris: Stock/IMEC, 1994), p. 569.

20 Badiou, *Communist Hypothesis*, p. 250.

21 Badiou, *Communist Hypothesis*, p. 251.

22 Auguste Cornu, *Karl Marx et Friedrich Engels, Leur vie et leur œuvre*, vol. 3: *Marx à Paris* (Paris: PUF, 1962).

23 See Boris Groys, *After History. Alexander Kojève as a Photographer* (Utrecht: BAK, 2012).

24 Stefanos Geroulanos, *An Atheism that is not Humanist Emerges in French Thought* (Stanford, CA: Stanford University Press, 2010), p. 2.

25 These are epitomised by Serge Guilbault, *How New York Stole the Idea of Modern Art* (Chicago and London: University of Chicago Press, 1983).

26 See Wilson, ed., *Paris, Capital of the Arts*; Natalie Adamson, *Painting, Politics and the Struggle for the École de Paris, 1944–1964* (Farnham: Ashgate, 2009).

27 See Laure Beaumont-Maillet et al., *La Photographie humaniste, 1945–1968* (Paris: Bibliothèque Nationale de France, 2006), and the apolitical Marta Gili, ed., *Willy Ronis: une poétique de l'engagement* (Paris: Democratic Books, 2010).

28 See Pierre Brossat, *The Rebels of Modern Art. La Jeune Peinture, Paris 1948–1958* (Flassans-sur-Issole: Un Certain Regard éditions, 2009).

29 Matteo Lafranconi, ed., *Socialist Realisms, Soviet Painting 1920–1970*, exhibition catalogue, Palazzo delle Palazzo esposizioni, Rome, 2011 (Geneva: Skira, 2012).

30 Guillaume Désanges, ed., *Les Vigiles, les menteurs, les rêveurs* (Paris: Lea Plateau/ Frac Île-de-France, 2010).

31 See, however, Pascal Huynh, ed., *Lénine, Staline et la musique*, exhibition catalogue (Paris: Cité de la Musique, 2010), and chapter 8.

32 Frédérick Genevée's *La Fin du secret, histoire des archives du parti communiste français* (Paris: Les Éditions de l'Atelier, 2012) offers the essential complement to recent Communist historiography, insisting on the Party's desire to create its own historic memorial, from the larger edifice to 'biographical control', with the corresponding police archives (p. 31).

33 Alain Badiou, *Le Réveil de l'histoire* (Paris: Nouvelles éditions lignes, 2011).

34 See Arthur Koestler, *Darkness at Noon* (London: Scribner, 1941), French trans. *Le zéro et l'infini* (Paris: Calmann-Lévy, 1945); Maurice Merleau-Ponty, *Humanisme et terreur: essai sur le problème communiste* (Paris: Gallimard, 1947), trans. J. O'Neill as *Humanism and Terror: An Essay on the Communist Problem* (Boston: Beacon Press, 1969).

35 See Alain Brossat, *Les Tondues: un carnaval moche* (Levallois-Perret: Manya, 1992), and Max Lafont, *L'Extermination douce: la cause des fous 40 000 malades mentaux morts de faim dans les hôpitaux sous Vichy* (Latresne: Le Bord de L'eau, 2000 [1987]); Philippe Boudrel, *L'Épuration sauvage, 1944–1945* (Paris: Perrin, 2008 [2002]), p.649: 50,000 court cases, 7,037 death sentences, 791 carried out.

36 See Jean-Pierre Besse and Thomas Pouty, *Les Fusillés: répression et exécutions pendant l'occupation, 1940–1944* (Paris: Atelier, 2006), for disputed and mythical statistics.

37 Pierre Klossowski, *Sade mon prochain* (Paris: Seuil, 1947), p.175.

38 Jean-Richard Bloch, 'Le fascisme qui est en nous', *Commune*, Paris, 15 January 1937, reproduced in G. Viatte, ed., *Paris–Paris, créations en France, 1937–1957*, exhibition catalogue (Paris: MNAM / Centre Georges Pompidou, 1981), p.52.

39 See Bernard J.F. Lonergan, *Insight. A Study of Human Understanding* (London: Longmans, Green, 1957), pp.191–94; Bradley Cooper, *Merleau-Ponty and Marxism: From Terror to Reform* (Toronto: University of Toronto Press, 1979), p.25.

40 Sarah Wilson, '1937, problèmes de la peinture en marge de l'Exposition internationale', 'La Vie artistique à Paris sous l'Occupation', 'Les Jeunes Peintures de tradition française', 'Débats autour du réalisme socialiste', in Viatte, ed., *Paris–Paris, 1937–1957*, pp.42–44, 96–100, 106–12, 206–12.

41 Gáspár Miklos Tamás, 'Can Capitalism be Pictured?', paper presented at the Courtauld Institute of Art, University of London, 14 February 2012.

42 Slavoj Žižek, *Violence: Six Sideways Reflections* (London: Profile Books, 2009).

43 See Sam Frank and Lene Berg: 'The Stalin by Picasso Case', http://canopycanopy-canopy.com/pieces/legacy_piece/57 (accessed 8 July 2013).

44 Eli Dvorkin, 'New York City Takes Down Stalin, AKA The Walrus', 12 November 2008, http://flavorwire.com/2594/new-york-city-takes-down-joesph-stalin (accessed 8 July 2013).

45 Conal Urquart, 'Picasso Coup for Tiny Art School in Occupied Palestinian Territory', *The Guardian*, 24 June 2011, http://www.guardian.co.uk/world/2011/jun/24/picasso-coup-for-palestine (accessed 8 July 2013).

Picasso to Marx:
art moves to the red belt

The perversion of Picasso's historical instinct reached its culminating point in the surrealist period ... Thus, what has not been born is already outmoded, for the motive force of history is already on the other side of the barricade.

Max Raphael, 1933[1]

In spring 1932 the London society photographer Cecil Beaton took at least thirty-two shots of Pablo Picasso in the artist's sumptuous residence at 23 rue La Boétie in Paris. The most striking shows the mature artist in suit and spotted bow tie, cigarette in hand, the *Nude, Green Leaves and Bust* (or *Nude with Blue Curtain*) behind him (fig. 4). His profile rhymes with that of the painted white plaster bust on a plinth. Recently completed, the *Nude* is unframed. Picasso's pose as *grand bourgeois* is undone by this lack of decorum; moreover the gold-framed, seated portrait of his Russian wife Olga Khokhlova, a masterpiece of 1917, has been taken down and propped unceremoniously on the floor. The displacement (of his wife by his mistress, Marie-Thérèse Walter) was explicit; any glimpse of Olga was omitted or cropped from Beaton's subsequent images.

With Picasso as the initial catalyst, the most extraordinary events come together in this chapter. Explaining both the genesis of Max Raphael's *Proudhon, Marx, Picasso* and the climate of its reception, they mark a significant moment in the historiography of Marxism and Marxist art criticism. They are framed by the apotheosis and rejection of the bolshevik style in architecture under Stalin in the USSR, and, in Paris, by Comintern penetration, German immigration unparalleled since the 1870s and a swerve in revolutionary surrealism. The career of Max Raphael marks the point of convergence; it is he who creates the first bridge between Picasso and Marx.

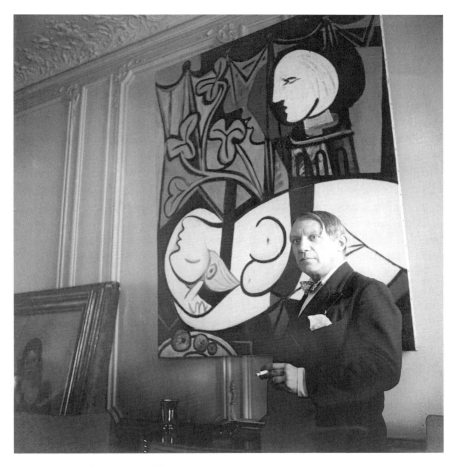

Figure 4: Cecil Beaton, Pablo Picasso, 1932

Picasso was building up to the most important moment in his professional career: his first major retrospective in the salons of the Galerie Georges Petit in June, followed by his fiftieth birthday museum retrospective in Switzerland. The Galerie Georges Petit event hoped to repeat the success of Henri Matisse's show there the previous year. Picasso himself hung his works in double and triple rows. He eschewed the black-tie banquet in his honour, attended by artists Georges Braque and Fernand Léger and American collectors such as Chester Dale. The *Nude*, as *Nu à la draperie bleue*, dated March 1932, was the last item in the richly designed and documented catalogue.[2] As *Akt vor blauem*

Vorhang, the work was displayed to a greater international audience at the Kunsthaus, Zurich from September through October (there would be 34,000 visitors).[3] The art politics and logistics at stake in organising this first monographic blockbuster, originally conceived as a 'Braque, Léger, Picasso' show, were impressive.[4] Here, with other paintings of the same series, a young Marxist art historian from Berlin contemplated Picasso's *Nude*. Max Raphael would have noted how Picasso placed Marie-Thérèse's curved white sleeping body, startlingly slashed with black bands and complemented by her wide-awake bust, against a blue curtain and rampant green philodendron leaves. Any tenderness in the painting of the body was offset by the sharp, black contours around each shape, which contrasted with the rhythms of the vertical curtain divisions and energised the surface as a whole (plate 2). This new work revealed an entirely different Picasso from the cubist with whom Raphael was so familiar in pre-1914 Paris.

In contrast with Picasso's voluptuous nude, the architect André Lurçat's Karl Marx School in the Communist suburb of Villejuif, subsequently hymned by Raphael, seems to come from another universe. The horizontally planned, 'bolshevik'-style girls' and boys' school, with interior murals painted by Lurçat's brother Jean, was far away from the centre, in Paris's workers' 'red belt'. How could these two worlds, two works be related? Within the space of four years, Picasso would make a spiritual and intellectual move, from the Galerie Georges Petit and his Zurich public to the Bastille, in the heart of revolutionary Paris. The Wall Street Crash of 1929, the resulting worldwide economic crisis and the consolidation of both Nazi and Soviet totalitarian regimes had huge repercussions upon individuals as well as on national politics. France's divided political responses would lead to the formation and triumph of the Popular Front in 1936; Picasso's presence at the centre of the action would be crucial for the most militant younger artists.

Max Raphael was well versed in both French and German modernism. Orphaned at ten, brought up by his grandparents in Berlin, he came from humble origins: his father was a tailor in the segregated Jewish community within Schönlanke (now Trzcianka in Poland).[5] He was trained first in Munich in 1907 (Kandinsky and Wilhelm Worringer arrived the following year). The German expressionist painter Max Pechstein became a close friend.[6] He returned to Berlin to follow courses by Georg Simmel and Heinrich Wölfflin, prior to his first Paris visit in 1911, where he became a disciple of Henri Bergson and Emile Mâle. He was back in Paris from 1912 to late 1913; his encounter with Picasso changed

his life. *Von Monet zu Picasso*, published in 1913, divided theoretical from practical discourses and demonstrated the development from Monet (through the post-impressionists and pointillists, Cézanne, Gauguin and Matisse) to Picasso. Works from Wilhelm Uhde and Kahnweiler's collection figured, indicating Raphael's first-hand acquaintance and discussions with Picasso's dealers and the German expatriate circle. His mention of Paul Signac's *D'Eugène Delacroix au néo-impressionisme* (Paris, 1899) and Fritz Bürger's *Cézanne und Hödler* (Munich, 1912) demonstrate his evolutionary attitude towards style at this point, as does his notion of 'forward-looking painting' (*zukünftige Malerei*). Almost one-third of the thirty illustrations were by Picasso, ending with a collage of 1913.[7]

Mobilised in 1915, Raphael fled from the army to Switzerland in 1917, returning to Germany in 1920. While he went on trips to Italy and Sicily and spent some time in sanatoria, these years in Berlin were years of revolutionary turmoil: the vitality of the Communism of Karl Liebknecht and Rosa Luxembourg. Raphael had already been deeply impressed by the 1905 revolution and Kronstadt mutiny in Russia. However, his *Idee und Gestalt*, written in 1919 and published in 1921, and subtitled 'A Guide to the Nature of Art', seemed untouched by politics. Change was rapid. From 1924 he taught in the Volkshochschule Gross-Berlin (an 'open university') and the Gross-Berlin Marxist Worker's School (Marxistische Arbeiter Hochscule, known as MASCH). Here, the director introduced him to the Hungarian Marxist philosopher and aesthetician György Lukács, whose *History and Class Consciousness: Studies in Marxist Dialectics* had been published in 1923.[8] After a scientific interlude (studying Newton), Raphael gave seminars on the dialectical methods of Hegel, Marx and Lenin but also the philosopher-sociologist and pacifist Max Scheler. Raphael's work on the Doric temple and the origins of dialectical materialism in ancient Greece followed Marx's own interest in Epicureanism and the ancients.[9]

The intellectual context in Berlin offered an important initiation to both Soviet culture and questions of 'marxology': the available writings by Marx. Following the nineteenth-century publications during Marx's and Engels' lifetimes, there was a huge problem of dispersed manuscripts, drafts and personal papers and indecipherable handwriting: the challenge of a vast editing enterprise. The Odessa-born David Riazanov would make this his life's work. He published in German from 1913, returning to Russia to join the Bolshevik party in 1917. He aspired to a systematic organisation of the archives, supported financially and politically by the Revolutionary government, becoming founding director of the

Marx-Engels Institute in 1920; Sergei Cernysev's impressive Marxism-Leninism Institute in Moscow (1926) would house the enterprise. In 1925 a publishing programme was coordinated with the Institute of Sociology in Frankfurt and the German Social Democratic Party, according to Riazanov's scrupulous principles. Thus, the first two volumes of the complete works of Marx and Engels appeared in Frankfurt and Berlin from 1927 to 1930.[10] Would Raphael have encountered the third volume published in 1932 before his departure for Paris? He would certainly not have known why the project changed editorship. In July 1931, however, the Parisian readership of *La Critique Sociale*, produced by the dissident émigré Boris Souvarine, would have been shocked to read the account of Riazanov's arrest, deportation without trial to Saratov, and the destruction of a study centre 'unique in the world' (it is here, translating the Soviet newspaper *Pravda*, that Souvarine apologises for the neologism *marxologie*).[11]

In 1932, teaching at the Volkshochschule, Raphael proposed a course on Marx's *Capital* and the sociology of modern art.[12] It was politely suggested that he choose other subjects. Alert to increasing antisemitism within German institutions, he left Berlin for Paris via Switzerland, stopping of course for the Picasso show in Zurich.[13] (He had saluted Picasso's fiftieth birthday with an article recalling their encounter, published in August 1931).[14]

In conjunction with the exhibition he gave at least two lectures. A summary of 'Picasso, the Unity and Logic of his Development' was published in the *Neue Zürcher Zeitung*.[15] 'Picasso as a Sociological Problem', however, was given not to an exclusively museum public, but to a 'workers' school' (*Gewerberschule*) audience, an event sponsored by *Das neue Russland*, a Berlin-based periodical backed by the Comintern.[16] This was the kernel of the 'Picasso' text published the following year in *Proudhon, Marx, Picasso. Three essays in Marxist aesthetics*. In addition, reviewing the Kunsthaus show, Raphael described Carl Jung's attack on Picasso for the Zurich journal *Information*.[17] Jung equated Picasso's 'psychic problems' with those of his schizophrenic patients: 'it is the ugly, the sick, the grotesque, the incomprehensible, the banal that are sought out' he declared.[18] Raphael, who had lived the German expressionist adventure in his youth, was surely sensitive to the resonances of this statement. In the current eugenics-obsessed climate, Hitler was about to be elected chancellor of Nazi Germany.

Raphael's Berlin at this time was also the centre of western European Comintern operations, with the powerful and enigmatic figure of

Willi Münzenberg at its centre.[19] With the Reichstag fire of February 1933 (the deliberately engendered pretext for Hitler's crackdown on the German Communist Party, the KPD), the Comintern headquarters would move to the French capital. Münzenberg himself joined the huge influx of German refugees to Paris, immediately transposing and reconfiguring his operations.[20] A round figure of 40,000 German émigrés in France is estimated before 1939, with information agencies, bilingual presses, daily and weekly newspapers.[21] A parallel may thus be established with Marx's own Paris where at least 40,000 Germans lived by 1844, with their publishing houses and professional networks.[22] The 1930s German-speaking intellectual community, including Walter Benjamin, Wolf Franck, Alfred Kantorowicz and Gerda Taro, sat for photographic portraits by Fred Stein, who worked in Paris from October 1933, contributing articles to the daily *Pariser Tagzeitung*. (Stein would continue this project in New York, where he photographed Raphael [fig. 2].)[23] Publishing activities, including translations and political works, expanded hugely with Münzenberg's financial support, beginning with *The Brown Book of the Reichstag Fire*, an international bestseller, and ultimately including *Die Kommunistisches Internationale* and *Die Freie Deutschland*.[24] The Frankfurt School's *Zeitschrift für Socialforschung* had a second life in Paris, with editor Félix Alcan.

In 1932 Münzenberg embraced French pacifist-based initiatives led by Henri Barbusse and Roland Rolland. The 'World Congress against Imperialist War' was held in Amsterdam in August; it would fuse with the 'European Congress against Fascism and War' held in the Salle Pleyel, Paris in June 1933 (with Münzenberg behind the scenes). Active anti-fascist campaigning by intellectuals affiliated to the 'Amsterdam–Pleyel movement' provides a context for both Raphael and Picasso's work from 1932 to 1934.[25] The equation between pro-Soviet and anti-fascist positions was evident.

To understand Raphael's *Marx, Proudhon, Picasso* in the context of its first public, it is important to sketch out Soviet-inspired cultural structures in Paris; a context far from evident in the most recent studies of France in the 1930s.[26] The Russian Revolution (in which French Communards had participated) spurred both avant-garde and worker-based initiatives in France.[27] Emigration from Russia to Paris began after the 1905 revolution, comprising the *émigration blanche* or the 'white Russian' emigration of aristocrats (not all impoverished) and the 'red' worker-émigrés, an crucial source of manpower after the First World

War in the car and cinema industries around Billancourt, for example.[28] From 1909 and the explosion of Diaghilev's Ballets Russes in Paris, there was a strong Russian presence on the cultural scene. The 'Whites' were soon involved with dealing, especially as intermediaries for Russian art works which soon found their way to American collections on a 'treasures into tractors' basis.[29]

Picasso played his part. His Ballets Russes lover and then wife, Olga, was in contact with her parents throughout the most dangerous moments of the Revolution; so, obliquely, was Picasso.[30] His painting was superlatively represented in the collections of Sergei Shchukin and Ivan Morosov, nationalised after the Revolution and brought together in the State Museum of New Western Art. Following Cézanne, Gauguin and van Gogh in Moscow, his work caused a cataclysm in Russian art and criticism.[31] Ivan Aksenov's illustrated *Picasso* was published in Moscow in 1917.[32] The 1920s School of Paris was well known in Russia and interchange with Soviet artists and artist-émigrés still fluid: a substantial article appeared with a letter from Picasso in the review *Ogoniok* in 1926.[33]

The Comintern's Department of Agitation and Propaganda was established in 1919 under the aegis of the Executive Committee (IKKI). There was an intense two-way traffic with France, and with the Ukrainian famine, the Workers' International Relief organisation (WIR *Mezhrabpom*) was set up as a cover for Münzenberg's growing empire. Lenin died in January 1924; Édouard Herriot's new French government abandoned the anti-bolshevik stance and recognised the USSR in October, despite vexed trading relations.[34] The co-option of French artists and intellectuals was all-important from a strategic point of view. The review *Clarté* was founded as a 'review of proletarian culture' with Victor Serge sending articles on Soviet proletarian literature from Moscow. The 'Nouvelles amitiés Franco-Russes' friendship society was also founded in 1924; the periodical *Les Amitiés Nouvelles* gave an image of Soviet cultural life. Le Corbusier and Amadée Ozenfant (whose wife was Russian) opened the pages of *L'Esprit Nouveau* to the USSR at this time. The art critic Waldemar George later recalled the 1920s heyday of elegant ambassadors, gilded salons with émigré stars such as Chagall or Jacques Lipchitz, intellectual exchanges, exhibitions, theatre tours and talks by Trotsky's sister, Mme Kamieniena.[35] Along with more recognised figures, painters such as the Georgian David Kakabadze or the Ukrainian Nicolas Gloutchenko established themselves in Paris, as did dealers such as Katia Granoff.[36]

Figure 5: Konstantin
Melnikov, Soviet
pavilion, Exposition
des Arts Décoratifs,
Paris, 1925

Many initiatives were in place, then, prior to the impact of Russian Constructivism at the great Art Deco exhibition of 1925. Here, Konstantin Melnikov's red Soviet pavilion, created by the 'Charpentiers de Paris' guild of carpenters in glass and wood, was a sensation, along with Rodchenko's workers' library and a second model of Vladimir Tatlin's *Monument to the Third International*.[37] The pavilion (fig. 5) was designed to 'translate the idea of the USSR, give an idea of the new mode of Soviet life, give feelings of the new life, militantism, collectivism'; it housed competition drawings for a workers' palace, a red stadium, theatres, factories, clubs and 'izba-library'.[38] Yet the fate of these 'wooden barracks' is less well known: moved to the avenue Mathurin-Moreau, in the precinct of the CGTU trades' union headquarters, it became the nerve centre for Comintern and Soviet propaganda, and headquarters of the so-called Secours Rouge (the WIR), so easily confused with the Red Cross.[39]

A policy of *bolchevisation* was energetically pursued. The *Cahiers du Bolchevisme* (1924–44) started publishing in conjunction with initiatives for workers' education.[40] Special schools were set up and public lectures delivered on the basic premises of Marxism/Leninism. VOKS, the all-Union Society for Cultural Relations with Foreign Countries, founded 'from above', attempted to recruit non-aligned intellectuals; it invited writers to celebrate the tenth anniversary of the Revolution in 1927; the 'trip to Moscow' became an important literary genre; the imagined USSR a source of political power and persuasion.[41]

The *Appel des Soviets* ('Call of the Soviets'), subtitled 'a monthly review for the defence and illustration of Soviet Russia', was published from 1928, with an international remit from Turkestan to China and Siberia. It covered the first national congress of the Friends of the Soviet Union, held in Melnikov's pavilion, in July 1930. A photograph reveals the makeshift wooden beam construction, clearly visible, with Rodchenko's Workers' Club reading desk displaying the *Appel des Soviets* itself; there are propaganda graphs with photomontage, a bust of Lenin and Antoine Pevsner's metal sign combining iron hammer, sickle and five-pointed star, originally suspended on Melnikov's pavilion exterior (plate 6).

An International Bureau of Revolutionary Literature (1926), a 'bottom-up' organisation, became the International Association for Revolutionary Writers in 1930 following the Kharkov conference in the USSR in November (attended by a French delegation). The resolutions made in Kharkov appeared in the October and November 1931 numbers of the propaganda organ *Literature of the World Revolution*, published in four languages, with writing examples by the *rabkor* or worker correspondent and new 'shock brigade' methods. Revolutionary graphics and protest works spread with the new literature throughout Comintern-influenced countries. It was in Melnikov's pavilion that the Comintern, agitated by France's celebrations of the so-called 'Centenary of Algeria' in 1930, launched the first anti-colonial exhibition. France's economic dependence on its colonies – and its racism – were amply demonstrated at the Colonial Exhibition in the Bois de Vincennes in 1931.[42] The Comintern's 'Truth about the Colonies' show, with an important contribution from the Surrealists, including Louis Aragon and their manifesto 'Don't visit the Colonial Exhibition!', 'reversed' French propaganda, documenting colonial exploitation, with a section dedicated to the USSR's 'liberation' of parts of Asia and the benefits of its federal as opposed to colonial structure.[43]

After Kharkov, an Association of Revolutionary Writers (AÉR, Association des Écrivains Révolutionnaires) was set up in Paris, initially for writers only. The Provisional Bureau of the French Section launched a manifesto in December 1931. In an attempt to provide a theoretical basis for change, extracts from Georgi Plekhanov's *Art and Social Life* (1912–13), published in the French version of *Literature of the World Revolution* (3 and 4), were discussed in the Communists' newspaper *L'Humanité* in January. The AÉR came into being formally in March 1932.[44]

Thus, Picasso finished painting *Nude with a Blue Curtain* and prepared for the glittering Galerie Georges Petit show in a time of desperate recession, mounting political activism – and in some parts of Paris almost inconceivable poverty.[45] The secretary general of the AÉR, Paul Vaillant-Couturier, espoused the aggressive language of Kharkov, originating in earlier Proletkult theory, to dramatise the political and cultural situation:

> Two worlds confront each other ... everywhere fascism rips the mask of democratic governments; Geneva's crooked pacificism can no longer hide the growing antagonism between states, nor the politics of aggression against the USSR ... Inheriting the accumulated cultural values of humanity [the proletariat] must pass these through the sieve of marxist-leninist critique and retain only what is useful for its revolutionary goals ... There is no more a neutral art, a neutral literature or a neutral science than there is a neutral State above class ... the role of proletarian culture in a period of capitalist dictatorship ... is to develop the conscience of the proletariat to the state of a veritable class heroism.[46]

The hardline AÉR was not to last. As early as April 1932, the Central Committee of the Soviet Communist Party passed a resolution 'On the reorganisation of literary and artistic organisations', abolishing the RAPP (the Association of Soviet Proletarian Writers) because of 'the cultivation in the cultural field of a fortress mentality among groups'. A single Union of Soviet Writers was created; a unified Association for Soviet Artists was also set up, incorporating the militant and obstreperous RAPKh, the Russian Association of Proletarian Artists (1931–32).[47]

At the precise moment of Max Raphael's arrival in Paris, in December 1932, the French Association of Revolutionary Writers and Artists (AÉAR, Association des Écrivains et des Artistes Révolutionnaires) was founded. Responding to the dissolution of RAPP it promoted a more liberal, pluralistic position; it was evidently in close contact with

its Soviet counterparts and under Communist Party auspices. Paul Vaillant-Couturier remained general secretary; Louis Aragon directed cultural policy. The AÉAR was a meeting place 'beyond class'; eminent writers such as André Gide or André Malraux, proletarian writers such as Tristan Rémy, émigré intellectuals from Germany or elsewhere and various fellow travellers were all allowed into the ranks, anticipating the political overtures of the Popular Front.[48]

Raphael's first appearance as a writer (previously unrecognised) sees him incorporated into the Surrealist milieu of the new review *Minotaure*, its first cover of June 1933 blazoned with Picasso's *Minotaur* collage made with leaves, a doily and crushed silver-foil. Here we find poets Paul Éluard, René Crevel and Pierre Reverdy; the Marquis de Sade expert Maurice Heine; ethnologist Michel Leiris; fellow Germans (the manuscript of Kurt Weil's *Seven Deadly Sins*); artist André Masson's *Massacres*; and Salvador Dalí on Millet's *Angelus*, together with Jacques Lacan.

Picasso dominated; while in Paris and Zurich his paintings had been the talk of the summer, here his sculpture was revealed.[49] The Hungarian photographer Brassaï showed the magnificent disorder of his Paris atelier (an alternative space in the rue La Boétie), especially night photos of iron pieces in the garden at Boisgeloup. The audacity of recent works was astonishing: the collage with real butterfly, crazy *bricolage*, the wire *Hommage to Apollinaire* and, following on from the plaster version of his *Cock*, the double-page spread of bony, Grünewald-inspired *Crucifixion* drawings, leading straight into the suite called *An Anatomy*. Surrealist leader André Breton's text 'Picasso in his element' attempted to provoke viewers beyond astonishment, emphasising *la mésure*, the measured scope and breadth of Picasso's thought.[50]

Raphael's piece on the panther-flanked, fanged Gorgon with twisted snake belt decorating the façade of the Temple of Artemis in Corfu preceded Breton. His writing was framed by the surrealist 'marvellous', as was his second article, 'Remark on the Baroque', illustrated with dark and massively peopled Tintoretto battle scenes. His repudiation of a vulgar 'reflection theory' is clear: he calls the equation between a single style and a period a prejudice which loses sight of the dialectical evolution of history; he describes the abundance of tensions which dominate the elevation of concepts from the material base to the heights of ideology.[51]

Raphael's writing, however, references 'dialectical evolution' as the essential feature of Greek thought. He laments current neglect of 'the dialectical method which Heraclitus, Plato and Aristotle have so

magnificently developed'. His Marxist inflections seem uncomfortable at the moment when *Minotaure*, with its articles on Old Master painting and pasted colour reproductions, represented surrealism's *embourgeoisement*. Future commissioned covers by Dali, Magritte, Ernst, Masson and Diego Rivera would emphasise their anti-fascist position through allegories of the labyrinth and the bull. But Raphael's preoccupations were already elsewhere: reverting from ancient Corfu to the present, he concludes his first piece with an oblique reference to the emergence of a Stalinist neoclassical architecture:

> Precisely at this moment of the debacle, Russian bolshevism seems to be throwing itself into the same adventure, acting in perfect ignorance of the fact that the renaissances of antiquity throughout Christian history were attached to a developing bourgeoisie: its origins in feudalism and its fall back into reaction.[52]

His turn from surrealism and a cult of Picasso to architecture is significant: there was international anxiety about Stalin's consolidation of power. Raphael's 'renaissances of antiquity' – the neoclassical turn in Soviet architecture – expressed this as a symptom. While editing *Proudhon, Marx, Picasso*, working on the translation and, one imagines, attending AÉAR events, Raphael was also making regular visits to a huge building site on the 'red' outskirts of Paris in the commune of Villejuif. Having published two articles on Le Corbusier in 1930, he now claimed to be preparing a book on the architect and making site visits – while writing to his rival, André Lurçat.

In 1927 Lurçat, not Le Corbusier, was shown in the First Exhibition of Contemporary Architecture in Moscow.[53] (Le Corbusier was engaged upon the epic Centrosoyuz project there from 1928 onwards.[54]) Like Le Corbusier, Lurçat had made his name as modernist architect of villas for private clients (including his brother, the painter Jean Lurçat) in the Villa Seurat complex of artists' houses with studios, 1925–27; however, his working-class housing project for Villeneuve-Saint Georges (1926) may be placed in a French lineage going back from Tony Garnier to Charles Fourier's phalansteries.

From 1925 and the Melnikov pavilion sensation, Soviet architecture was discussed in the journals *L'Esprit Nouveau, L'Amour de l'Art, L'Architecture vivante,* and *Cahiers d'Art*.[55] The USSR's notionally 'bolshevik' style was in fact international – highly indebted to French modernism, Bauhaus elements, with New York as a model for the 'new Moscow', and Moscow-based foreign expertise. German architects and Le Corbusier

submitted projects for the official socialist reconstruction of Moscow (1930–32).[56] The new journal *L'Architecture d'Aujourd'hui* organised a twenty-day Russian study tour in late 1932 under VOKS auspices.[57] Thus the international architectural community, modernist and russophile, was shocked when the Palace of the Soviets commission (a response to Geneva's Palace of Nations) was awarded to Boris Iofan's neoclassical fantasy, topped with a giant Lenin. (*King Kong*, the film, with its skyscraper-perched gorilla, opened in New York in March 1933. Iofan was announced as winner in May.) Le Corbusier was subject to planned attacks in the French Communist press as Lurçat's star rose (anticipating the latter's first ten-week trip to the USSR in December 1933).[58]

Lurçat won the Villejuif school competition known as the Groupe scolaire Jean-Jaurès in 1930, long before this neoclassical turn. He was a founding member of the AÉAR; its leader, Paul Vaillant-Couturier, was elected mayor of Villejuif in 1929. The school project implemented municipal improvement policies outlined by the PCF in 1924 and in a Comintern directive of February 1930 (though much of Villejuif was still rural).[59] Work began in late 1931 – the same year as the beginnings of polemics against 'bolshevist' architectural style.[60]

The surrealist painter Kurt Seligmann took Raphael to the site in December 1932. Following intense discussions with Lurçat, Raphael apparently sent his critique of the Palace of the Soviets' neoclassicism straight to Stalin![61] His Marxist take on the Greeks and architectural modernism impressed Lurçat, who opened a new international studio with over fifty students (conceived as a Soviet-style architectural 'shock brigade') in May 1933. Here Raphael lectured on philosophy, art history and sociology in a radical critical and theoretical forum.[62]

With Lurçat's project nearing completion, its name was brusquely changed to Groupe scolaire Karl Marx, the Karl Marx School on Karl Marx Avenue. It was the most openly bolshevik-style architecture ever created for France (fig. 6).[63] Long and low, with load-bearing walls, it exemplified the most recent eugenic and pedagogical principles, involving light, space, sunroofs, sports and recreational areas, nursery room, a gymnasium/cinema and electric hand dryers. There was modern, wood and metal school furniture; Lurçat designed clock faces and their numbers; he supervised the use of colour. Max Raphael introduced the commemorative spring-bound photo album, which followed all those involved with the production, from bare plot to final achievement.[64] Materials and their suppliers were listed, from the largest cement manufacturers and glaziers to the boiler installers and bolt-makers,

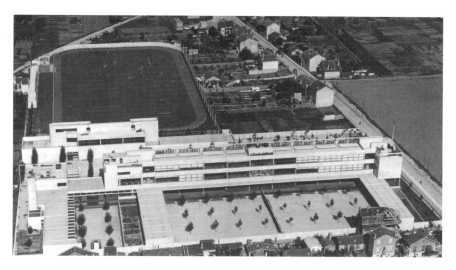

Figure 6: André Lurçat, Karl Marx School, Villejuif, 1933

featuring every worker's name. This 'materialist' insistence extends to
Raphael's own language as prefacer; at one point he compares Picasso's
cubist armatures and stuck-on collage with the 'dualism' of the concrete
structure and filling material, concluding:

> Our critical reflections wish to demonstrate that modern architecture
> in France is closely linked to the capitalist basis in its programmes
> as much as in the use of materials ... this critique of functional
> idealism is based on dialectical materialism: this guarantees univer-
> sality against dissociation, unity against dualism, and also the spirit
> against matter...[65]

Idealism, leads, Raphael concludes, to 'moral suicide'. Was Raphael's
attack on 'functional idealism' paradoxically designed to defend the
delicate painted nursery and canteen decorations by Jean Lurçat, or the
sculpted figure, *Stella*, on the façade by Henri Laurens? 'Every great
architecture,' he said, 'whether Greek or Christian Egyptian or Hindu
has managed to create a unity of different arts...'[66] (One should note
that Le Corbusier's Swiss Pavilion for the Cité Universitaire with its
Calvinist, ascetic façade was inaugurated two days earlier on 7 July.
Raphael would later develop the Catholic versus Protestant contrast.)[67]

The school's inauguration on 9 July 1933 showed the complete panoply
of AÉAR activities as a breathtaking, Villejuif-based mass spectacle

in praise of the USSR. It signalled the PCF's municipal responsi-
bility and maturity, while demonstrating the effective penetration of
Soviet organisational models into the Paris worlds of art and culture.
Commune, the AÉAR's intellectual mouthpiece and an important Paris–
Moscow conduit for ideas and people, was also set up in July 1933.
This visible expansion of the political agenda and the AÉAR's directing
role coincided, one must point out, with the arrival in Paris of
Münzenberg, and with him the Comintern funds he controlled.[68]

The Karl Marx School inauguration was distinctive: a popular,
urban celebration, involving the whole Communist municipality with
thousands of workers bussed in from other parts of Paris. Party leader
Maurice Thorez followed official speeches by Paul Vaillant-Couturier.
The coordination of local activities with Communist-affiliated groups was
demonstrated in the official programme. AÉAR sections for architecture,
music, theatre, cinema and photography as well as art participated.
There were open-air film projections about building the school, not to
mention pigeons, balloons, illuminations of the site and a huge firework
display (plate 1). There was, of course, a tradition of popular fêtes for the
working class (picking up on saints' day carnivals, medieval fairs, royal
pageants, the *fête champêtre* and revolutionary traditions), revived in
politicised mode from 1919 and combining the rural picnic with political
organisations and speeches. The annual 'Fête de l'Humanité' (a living
tradition today) was consolidated in 1932.[69] But here, 25,000 people were
involved in a modernist 'total work of art' inaugurated with Soviet-style
panoply: a huge white bust of Marx, red flags, young schoolgirls in white
dresses (fig. 7). Euphoric articles, extending to the USSR, were produced
by authors such as Carlo Levi in Italy, and Aldous Huxley in Britain
(Villejuif as a brave new world?) The Karl Marx School inauguration was
the greatest mass event in France involving public participation, before
the 'mysteries', restagings and political demonstrations of the Popular
Front period.[70]

In striking contrast to the 'Picasso summer' of 1932, it was in this
Sovietised context that *Proudhon, Marx, Picasso* appeared in 1933 in July
or after.[71] Raphael begins in the present:

> Any visitor to Paris familiar with Marxist criticism, will be surprised
> to discover to what extent Proudhon's ideas still influence the French
> 'Communist' politicians, intellectuals and even artists. But a little
> reflection will reveal that there is nothing surprising in this. Most
> artists are petty bourgeois in origin, and their Communism serves

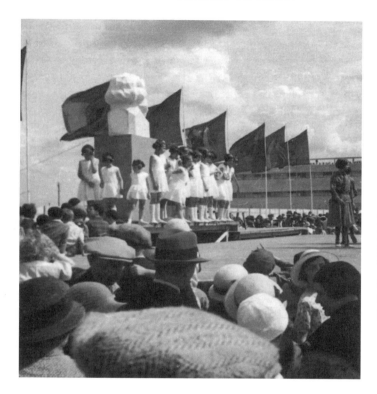

Figure 7:
Karl Marx
School,
Villejuif,
opening
ceremony,
9 July 1933

to provide them with emotional support, rather than with weapons useful in their practical activities. In point of fact, they are Proudhonian, although – or perhaps because – they have never read Proudhon.

He continues:

Instead of striving to bring the tradition as close as possible to Marxist theory; at least in their works, they indulge in a fantasy Communism; what they actually do is to produce 'concrete abstractions' or to practice 'revolutionary surrealism'. Reflecting petty-bourgeois aspirations in well-organised paintings, or the artist's escape into unreality, such activities pursued while monopoly capitalism is collapsing all around them show that French artists have remained Utopians...[72]

Utopians, then, like Proudhon himself. Raphael's term *abstractions concrets* in fact designates the geometric abstract art of the Abstraction-Création group with its growing international salon (Auguste Herbin, its founder, signed the first AÉAR artists' manifesto in August 1933).

As for 'revolutionary surrealism', Raphael points to the adepts of *Le Surréalisme au Service de la Révolution* (SASDLR; Aragon, Breton, the poet Paul Éluard and others joined the Communist Party in 1927). But the attempt to be a 'Communist surrealist', an adept simultaneously of both Marx and Freud, was bound to fail. Louis Aragon first repudiated surrealism at the Kharkov writers' congress in the USSR in 1930 (his seditious poem 'Red Front' heralded his new hard-line profile). Breton's 'Misery of Poetry' tract in Aragon's defence – a deliberate play on Marx's 'Misery of Philosophy' attack on Proudhon – coincided with Party attempts to impose censorship on SASDLR. (The Surrealists' own initiative for an AAÉR [*sic*] foundered, despite statutes sent to the Agit-Prop section of the Party; they briefly entered the AÉAR, and were co-signatories of three 'Red Tracts' of February and March 1933).[73]

Thus, Raphael's critique was actively engaged with the contemporary art milieu and the studio visits he mentions. He attempts to analyse Proudhon's *Principles of Art and its Social Destination* as a 'neutral terrain' to discuss the contemporary: his criticism of salons as disguised artists' fairs, for example. But idealism prevails, both in Proudhon's case and with contemporary *proudhoniens*. Proudhon could not accept the relationship between art and the collapse of religion, he argues, despite his desire to set fire to works of Romantic art as monuments of the counter-revolution. And ultimately Proudhon's attitude to property was not abolitionist. Raphael ends by quoting Marx's critique of Proudhon as *petty bourgeois*. 'So far as Proudhon's political and philosophical writings are concerned they all show the same contradictory, dual character as his economic works. Moreover their value is purely local, confined to France.'[74] (Compare the 'contradictory, dual character' of the Karl Marx School's ideology and fanfare, contrasted with the dozens of participating small and medium-sized capitalist businesses involved in the enterprise, down to the Maison Grenet's lightning conductors). Mirroring Marx's own desire to chastise Proudhon thoroughly on Parisian terrain – one could call this a 'critical doubling' – Raphael indicates none of his reading.[75] Yet Proudhon was indeed contemporary in his resonance and critical interest, as proved here by the length and engagement of the analysis, and Raphael's speed in finding a publisher.[76]

'The Marxist Theory of Art', the second essay, previously published in 1932, mediates between Proudhon and Picasso.[77] Raphael, writing again from the position of contemporary pluralism, rehearses the problematic of the gap 'between the economic basis and the artistic ideology' and a series of mediating elements, such as the different speeds of

technological versus artistic developments. His tone and explanatory progressions recall the public lectures at the origin of these exposés (Marx is neither historicised in a nineteenth-century material context nor 'applied' beyond the dialectical clash of the 'mythology-orientated group and the non-mythological' after 1789, or beyond Gauguin and Cézanne). The 'permanent value of Greek art' continues to perplex Raphael as it did Marx (one would have liked a discussion of the European neoclassical revival, including Picasso, for example). 'We shall conclude that a Marxist theory of art cannot be a pure theory of the subject nor a pure theory of form …'

The Picasso essay is based on minutely detailed chronological notes made evidently while studying Picasso's retrospective at first hand in Zurich.[78] It is uncompromising from the start: 'The Marxist theoretician is confronted with a twofold task, he must analyse the bourgeois ideologies, and he must further the development of the proletarian revolution.'[79] Picasso receives the lash:

> Today the bourgeois of America and Western Europe recognise to what extent this artist symbolises their class, how well he reflects their state of mind. Obtuse denigration has now been superseded by total admiration, but at no point have the actual limitations of the art been considered … For the Marxist, however, it is a matter of utmost importance to determine the exact relationships which exist between the work of art and the total socio-historical context, and thereby, its class limitations. With respect to Picasso, our task is to investigate the material and ideological conditions that have influenced him and how he has reacted to them in his art.

He continues: 'Picasso was born in Spain in 1881. His youth was passed during the years when free-enterprise was being supplanted by monopoly capitalism …' The representation of death and sleep (Blue period) give way to 'a determination to measure and to express simultaneously the most varied functions of an object' (Cubism).[80]

While Raphael's analyses, evidently abbreviated through citation, may appear reductive, one aspect seems to impinge upon Picasso's choices of style during the pluralistic 1930s. Nineteenth-century eclecticism is characterised as

> a constant alternation between mythological historical tendencies (one of them Greek and Roman, the other medieval-Christian) and a specifically bourgeois art developing away from these in the direction of realism. As a result we can see extremely heterogeneous conceptions

side by side in the work of the most advanced artists, which are only reconciled, if at all, in an eclectic, non-dialectical manner.[81]

And within the same, prolonged argument: 'At a time when the rest of the European bourgeoisie had become a bourgeoisie of "grocers", Spain was still waging heroic battles against feudalism and the church. We may add that the Spanish proletariat, largely anarchist and syndicalist, was not yet capable of conducting great common action...' (How tragically prescient this would become after 1936.) The transition from Spain to Paris, Raphael argues, offered Picasso two heritages: Courbet's materialism and Cézanne's dialectics (he offers a surprising analysis of the Courtauld Institute's *Mont Sainte-Victoire*): 'Later we shall see that both materialism and dialectics are completely absent in Picasso, a fact that defines his position in modern social history...' The 'state of mind' reflected by Picasso's work, he claimed, was catalysed by Picasso's spectacular prices. And of the *Nude with Blue Curtain* period: 'Picasso's latest, (Surrealist) period presents sociological interest only to the extent that, in its relations to Gothic stained-glass windows and by the methodical consummation of his initial mysticism, it confirms our classification of his work as reactionary and in the Christian-European tradition...'[82]

Conforming with the decorum and the authoritative tone of fellow Marxist writers at the time, Raphael simply refuses to confront questions of desire, sexual energy, violence and power relations as configured in Picasso's colour, line and representation here, Was the artist's insistence on subjectivity and repetition in the Marie-Thérèse series, seen in Zurich, simply too great a political irrelevance at this point? Raphael concludes:

> At a moment when the most powerful artists have entirely lost their instinct to play with ordinarily valid contents ... the level of knowledge of an epoch is so much above bourgeois potentialities that even its highest artistic production, considered as historical action, falls short of the requirements of the times. Thus, what has not yet been born is in a sense already outmoded, for the motive force of history is already on the other side of the barricade...[83]

A wake-up call to Picasso?

Raphael in no way conveys to the public his visual and visceral experiences of the Swiss retrospective, though he refers to particular works by the Paris and Zurich catalogue numbers in the French text.[84] In fact his determined repression of subjectivity, it has been argued,

finds its 'revenge' in texts which read all the more as 'Jewish, German and profoundly unhappy...'[85] Yet the length and stark differences in tone between this unillustrated essay and contemporary eulogies are such that, surely, Raphael's critique was brought to Picasso's attention, if not in 1933 then later.[86]

The force of *Proudhon, Marx, Picasso* strikes today's reader, despite the outmoded nature of some of its contents or language (a problem Raphael himself found with Marx's still unresolved theory of Greek art, after Hegel's *Aesthetics*).[87] During this period the writings of Marx, Engels, Lenin and Stalin were being scoured for *obiter dicta* on art.[88] In Russia, Mikhail Lifshitz's *Philosophy of Art of Karl Marx* was also published in 1933.[89] (It was translated in 1938 for an American Marxist public, the readers of *New Masses*, a journal corresponding to the AÉAR's *Commune*.)[90]

While all these analyses were highly literature-based, Raphael – unlike Plekhanov, unlike Lifshitz – was trained by the most brilliant minds of the period as an art historian and an active critic; he daringly embraced the contemporary art scene. *Proudhon, Marx, Picasso* is also marked, conversely, by its historical depth and ambition as a triad: the book holds together three major figures in history.

The inscription of the memory of the past in the present, rehearsed via the Commune's presence within the Russian Revolution, corresponded entirely with future Popular Front strategies. Raphael's stirring call to the barricade chimed with the times. His understanding of Marx's engagement with the heritage of the French Revolution, the class struggles of 1848, the 'Civil War' of the Commune, and his antagonistic relationship with Proudhon lead him to frame Picasso – and contemporary art debates in time of crisis – as dialectically situated between two poles: the longer French heritage of revolution, utopian projects and left-wing struggle, and a post-Soviet Marxist critique. Raphael's bringing of Marx to Picasso within a current 'sociology of art' ends in 1933; his mission continues here.

Notes

1 'La perversion de l'instinct historique de Picasso atteindra son point culminant au cours de sa phase surréaliste [...] Ainsi, ce qui n'est pas encore né est, dans un certain sens, déjà dépassé, parce ce que la force motrice de l'histoire se trouve déjà à l'autre côté de la barricade [...]' Max Raphael, *Proudhon, Marx, Picasso. Trois études sur la sociologie de l'art* (Paris: Éditions Excelsior, 1933), pp. 227–28, 237; Max Raphael, *Proudhon, Marx, Picasso. Three essays in Marxist aesthetics*, ed. John Tagg, trans. Inge Marcuse (London: Lawrence and Wishart, 1980), pp. 140, 145.

2 *Exposition Picasso. Documentation réuni par Charles Vrancken*, 16 June–29 July 1932, Galerie Georges Petit, 8, rue de Sèze, Paris; see Simonetta Fraquelli, 'Picasso's Retrospective at the Galerie Georges Petit, Paris 1932: A Response to Matisse', in Christian Geelhaar, ed., *Picasso: His First Museum Exhibition 1932* (Munich: Kunsthaus Zurich, Prestel, 2010), pp. 77–93.

3 *Akt vor blauem Vorhang*, listed in Wilhelm Wartmann, ed., *Picasso: ausführliches Verzeichnis mit 32 tafeln*, Zurich, Kunsthaus (11 September–30 October 1932), no. 217, (canvas dated 6 March 1932), p. 16.

4 See Christian Geelhaar, 'Picasso, the First Zurich Exhibition', in *Picasso: His First Museum Exhibition*, pp. 27–45, and for the show's origins and Picasso's intervention, Johannes Nathan, '"für Picasso mindestens 240 Meter..." Zur Zürcher Picasso-Austellung von 1932', in M. Fehlmann and T. Stooss, eds, *Picasso und der Schweiz* (Bern: Kunstmuseum Bern, Stämpfli Verlag, 2001), pp. 65–73.

5 Raphael's biography is under construction; see Hans-Jurgen Heinrichs, ed., *Max Raphael, Lebens-Errinerungen. Briefe Tagebucher, Skizzen, Essays* (Frankfurt: Qumran, 1985), Patrick Healy's important unpublished work relating to Raphael's own biographical study, and Raphael's papers in Nuremberg and the Getty Research Institute, collection no 920050.

6 Crucially, Raphael was first to use the term 'expressionism', and published his early texts under the pseudonym Schönlanke (his birthplace).

7 Max Raphael, *Von Monet zu Picasso* (Munich: Delphin Verlag, 1913, 2nd edn 1919), p. 126, for references including *zukünftige Malerei*.

8 See György Lukács, *Geschichte und Klassenbewußtsein: Studien über marxistische Dialektik* (Berlin: Malik Verlag, 1923). Biographical material provided by Claude Schaefer with whom Raphael corresponded, in Max Raphael, *Trois essais sur la signification de l'art parietal paléolithique*, ed. Patrick Brault (Paris: Kronos, 1986).

9 Karl Marx, *The Difference between the Democritean and Epicurean Philosophy of Nature* (written 1841, published 1902), in *Marx-Engels Collected Works*, vol. 1 (London: Progress Publishers, 1975).

10 David Riazanov, ed., *Karl Marx, Friedrich Engels: Historisch- Kritisch Gesamtausgabe* (Frankfurt and Berlin, 1927–32) and MEGA (The Marx-Engels-Gesamtausgabe) project. See Maximilien Rubel, 'D. Riazanov et la Mega', in Rubel, *Bibliographie des œuvres de Karl Marx* (Paris: Librarie Marcel Rivière, 1956), pp. 28–31; Sankar Ray, 'MEGA, the Recovery of Marx and Marxian Path', *Kafila*, 22 June 2012, http://kafila. org/2012/06/22/mega-the-recovery-of-marx-and-marxian-path-sankar-ray/ (accessed 8 July 2013).

11 Boris Souvarine, 'D.B. Riazanov', *La Critique sociale*, 2 (July 1931), pp. 49–50, http://www.marxists.org/archive/riazanov/bio/bio01.htm (accessed 8 July 2013).

12 Max Raphael, *The Demands of Art*, trans. N. Guterman (London: Routledge and Kegan Paul, 1968), pp. 185–87.

13 Did Raphael stay in the Zurich villa of the Hungarian art collector, Marcel Fleischmann, who sheltered the writer Ignazio Silone, a founder of the Italian Communist Party? Raphael's 'Picasso' is dedicated 'To Marcel Fleischmann'.

14 Max Raphael, 'Grosse Künstler II. Erinnerungen zum Picasso zu dessen 50 Geburtstag', *Davroser revue 6*, 11 (15 August 1931), pp. 325–29

15 Max Raphael, 'Picasso, Einhheit und Logik seiner Entwicklung', 6 October 1932, summary published as 'Max Raphael über Picasso', *Neue Zürcher Zeitung*, 7 October 1932, p. 6, in Geelhaar, ed., *Picasso: His First Museum Exhibition*, p. 44.

16 Max Raphael, 'Picasso als sociologisches Problem', 17 October 1932, referred to as published in *Proudhon, Marx, Picasso*, in Geelhaar, ed., *Picasso: His First Museum Exhibition*, p. 36.

17 Max Raphael, 'C.G. Jung begreift sich an Picasso', *Information* (Zurich), 6 December 1932, pp. 4–7.

18 Carl Gustav Jung, *Neue Zürcher Zeitung*, 13 November 1932, p. 2; see *Collected Works of C. G. Jung*, vol. 15 (London: Routledge & Kegan Paul, 1966), pp. 135–41, and web. org.uk/picasso/jung_article.html (accessed 8 July 2013).

19 See Serge Wolikow's monumental *L'Internationale Communiste (1919–1943). Le Komintern ou le rêve déchu du parti mondial de la révolution* (Paris: Les Éditions de l'Atelier/Éditions Ouvrières, 2010). With appendices and a CD-Rom 'Dictionnaires biographiques des Kominterniens', it analyses and supersedes all previous studies of the 'global party of revolution', with, of course http://www.comintern-online.com/ (accessed 8 July 2013).

20 Willi Münzenberg had been editor of Berlin-based trilingual *Sowietrussland im Bild* (1921–23); *Das neue Russland* (1922), *Sichel und Hammer* and *Chronik der Fascismus* followed (1923–24); *A I Z- Arbeiter Illustrierte Zeitung* (1924–33) and dailies, *Welt im Abend* and *Berlin am Morgen*, as well as being the distributor for the Russian film industry, Meshrabprom Russ. See in particular for Comintern –KPD links, Stéphane Courtois et al., *Willi Münzenberg 1889–1940: Un homme contre* (Aix: La Bibliothèque Méjanes/Pantin: Le Temps des Cerises, 1993) (conference 1992).

21 Barbara Vormeier, 'Études et perspectives de recherches relatives aux réfugiés en provenance d'Allemagne 1939–1945', in *Matériaux pour l'histoire de notre temps*, 44 (1996), pp. 24–26. Vormeier insists on the fluctuating and imprecise nature of these statistics; see also Gilbert Badia, 'Heurs et malheurs des émigrés allemands dans la France de 1933 à 1939', *Annales des la société des amis de Louis Aragon et Elsa Triolet*, 3 (2001), pp. 202–16.

22 See Jacques Grandjonc, *Marx et les communistes allemands à Paris, 1844: contribution à l'étude de la naissance du marxisme* (Paris: F. Maspero, 1974), pp. 11–12 and bibliography 'Opposition, Émigration, Marxisme', pp. 253–54; Lucien Calvié, *Le Renard et les raisins: la Révolution française et les intellectuels allemands, 1789–1845* (Paris: Études et documentation internationales, 1989).

23 Anne Egger, ed. (with Alain Badiou et al.), *Fred Stein, Portraits de l'exil, Paris–New York; Dans le sillage d'Hannah Arendt* (Paris: Musée de Montparnasse, Arcadia Éditions, 2011).

24 See Gilbert Badia et al., *Les Barbelés de l'exil. Études sur l'émigration allemande et autrichienne (1938–1940)* (Grenoble: Presses universitaires de Grenoble, 1979),

especially Hélène Roussel, 'Éditeurs et publications des émigrés allemands (1933–1939), pp. 357–413 and annexes pp. 414–17.

25 See, for example, David James Fisher, *Romain Rolland and the Politics of Intellectual Engagement* (Berkeley: University of California Press, 1988), pp. 148–204.

26 For example, Dudley Andrew and Steven Ungar, *Popular Front Paris and the Poetics of Culture* (Cambridge, MA: Belknap Press of Harvard University Press, 2005), or Mark Antliff, *Avant-garde Fascism: The Mobilisation of Myth, Art and Culture in France, 1900–1939* (Durham, NC: Duke University Press, 2007) – splendid works.

27 See Marcel Body, *Les Groupes communistes français de Russie* (Paris: Éditions, 1988) (an eyewitness account); and Hui-Kyung An, 'Working with History: Images of the Paris Commune in Soviet Visual Art and Culture during the Civil War and the First Five Year Plan', MA dissertation, Courtauld Institute of Art, 2008.

28 Nina Nikolevna Berberova, *Chroniques de Billancourt* (Arles: Actes Sud, 1999).

29 See Alexandre Jevakhoff, *Les Russes blancs* (Paris: Taillandier, 2007), and Anne Odom and Wendy R. Salmond, eds, *Treasures into Tractors: The Selling of Russia's Cultural Heritage, 1918–1938* (Washington, DC: University of Washington Press, 2009).

30 Olga's correspondence with her parents is preserved by Bernard Picasso.

31 See the reactions of Alexandre Benois, S. Khudakov, Sergie Bulgakov and Ivan Aksenov to Picasso from 1912, and reactions to Cubism, in Ilya Doronchenkov, ed., *Russian and Soviet Views of Modern Western Art, 1890s to Mid-1930s* (Berkeley: University of California Press, 2009), pp. 108–56.

32 Ivan Aksenov (Axionov), *Pikasso I okresnosti, sdvenadca'ju meccotintogravjurami s kartin mastera* (Moscow: Centrifuga, 1917) (and see note 31).

33 Picasso, in *Ogoniok*, 20 (16 May 1926); 'Lettre sur l'art', *Formes*, 2 (February 1930), pp. 2–5 retranslated from the Russian by C. Motchoulsky.

34 Stanislas Jeannesson, 'La Difficile Reprise des relations commerciales entre les URSS et la France, 1921–1928', *Histoire, économique et société*, 3 (2000), pp. 411–29.

35 Waldemar George, 'La Farce tragique du réalisme-socialiste', *Le Peintre*, 1 October 1950, p. 4.

36 See Henry Poulaille, *Gloutchenko* (Paris: Éditions Stanislas, 1933); Swiatoslaw Hordinsky and Pawlo Kowzun, *Gloutchenko* (Léopol, 1934); V.V Beridze et al, *David Kakabadze* (Tbilisi: Sov. khudozhnik, 1989).

37 See Frederick Starr, *Melnikov. Solo Architect in a Mass Society* (Princeton, NJ: Princeton University Press, 1978).

38 Vigdaria Khazanova and Oleg Chvidkovski, 'L'Architecture soviétique', in P. Hulten, ed., *Paris-Moscou, 1900–1930* (Paris: Gallimard, 1991 [1979]), pp. 389–90.

39 See André Marty, 'Qu'est-ce que le Secours rouge internationale?', in *Éditions du Secours rouge internationale, section française* (Paris: 12 Avenue Mathurin-Moreau, n.d.); Anatole Kopp, 'Avenue Mathurin-Moreau, il y a 45 ans, Constantin Melnikov' (undated), *Archiwebture*, Dossier 225 Ifa 3, Fonds Kopp, Anatole.

40 *Le Cahiers du Bolchevisme: organe théorique du Parti communiste français (S.F.I.C.)* http://gallica.bnf.fr/ark:/12148/cb327356292/date (accessed 8 July 2013). See Danielle Tartarowsky, *Les Premiers Communistes françaises: formation des cadres et bolchevisation (1920–1923)* (Paris: PFNSP, 1980); for French Communist Party publications see Marie-Cécile Bouju, *Lire en Communiste. Les Maisons d'édition du Parti Communiste français, 1920–1968* (Rennes: Presses Universitaires de Rennes, 2010).

41 VOKS (*Vsesoiouznoe Obschchestvo Koultournoï Sviazi s sagranitzeï*); see Fred
 Kupfermann, *Au pays des Soviets, le voyage français en URSS, 1917–1939* (Paris:
 Gallimard-Julliard, 1979); Ludmilla Stern, *Western Intellectuals in the Soviet Union,
 1920–40, From the Red Square to the Left Bank* (London: Routledge, 2007); Michael
 David-Fox, *Showcasing the Great Experiment, Cultural Diplomacy and Western Visitors
 to the Soviet Union, 1921–1941* (Oxford: Oxford University Press, 2011); Sophie Cœuré,
 'Le Voyage en URSS, un exercise du style', in V. Jobert and L. de Meaux, eds,
 Intelligentsia, entre France et Russie, Archive inédits du XX^e siècle (Paris: Beaux-Arts de
 Paris, 2012), pp. 116–52.

42 Patricia A. Morton, *Hybrid Modernities: Architecture and Representation at the 1931
 Colonial Exposition, Paris* (Cambridge, MA: MIT Press, 2000); Laure Blévis et al., *1931
 – Les Étrangers au temps de L'Exposition coloniale* (Paris: Cité Nationale de L'Histoire
 de l'Immigration/Gallimard, 2008).

43 'La Vérité sur les colonies', 19 September 1931–February 1932, at the 'Pavillon des
 Soviets', 12, avenue Mathurin-Moreau, 5,000 visitors; Charles-Robert Ageron, in
 Pierre Nora, ed., *Les Lieux de mémoire* (Paris: Gallimard, 1997), pp. 493–515. Five
 photographs of the interior are now in the 251, Los Angeles.

44 See Jean Peyralbe (Léon Moussinac), 'Les Thèses de Plekhanov. Appel aux artistes',
 L'Humanité, 14 January 1932, and 'Les Arts. Les Thèses de Plekhanov', *L'Humanité*,
 21 January 1932, pp. 4ff., again a discussion article.

45 For example, the Cité Jeanne d'Arc's slums, 13th arrondissement (riots occurred there
 on 1 May 1931 and 1 May 1934).

46 'Deux mondes s'affrontent […] le fascisme crève partout le masque des gouvernements
 démocratiques, l'escroquerie pacifiste de Genève ne peut plus parvenir à dissimuler les
 antagonismes croissants entre États, ni la politique d'agression contre l'U.R.S.S. […]
 Héritier de toutes les valeurs culturelles accumulées par l'humanité, il doit les passer
 au crible de la critique marxiste-léniniste et ne retenir que celles qu'il peut utiliser à ses
 fins révolutionnaires […] Il n'y a pas plus d'art neutre, de littérature neutre, de science
 neutre qu'il n'y a d'État neutre, au-dessus des classes […] La culture prolétarienne
 s'attache en période de dictature capitaliste, en partant de la douloureuse expérience
 des travailleurs, à développer la conscience du prolétariat jusqu'à l'héroïsme de classe';
 Paul Vaillant-Couturier, in Paul A. Loffler, *Chronique de l'AÉAR* (Rodez: Subervie,
 1971), pp. 18–19.

47 See Matthew Cullerne-Bown, *Art under Stalin* (London: Phaidon, 1991), chapter
 I, 'Reconstruction and Industrialisation, 1924–32'; and Joseph Stalin, 'On the
 Reorganisation of Literary and Artistic Organisations', p. 234, note 14.

48 I discuss the AER and AÉAR, origins in the Abbaye de Créteil movement, conflicts
 with the 'proletarian' writer Henri Poulaille, his alternative strand of 'proletarian'
 activism and the review *Proletariat* in 'Art and the Politics of the Left in France,
 1935–1955', PhD thesis, Courtauld Institute of Art, University of London, 1991,
 Chapter 1, pp. 24–99 and Annexe 1, pp. 409–12. See also Jean-Paul Morel, *Le Roman
 insupportable : L'internationale littéraire et la France, 1920–1932* (Paris: Gallimard, 1985).

49 Compare Picasso's representation in *Minotaure*, 1, with previous extensive coverage in
 Documents: see Georges Didi-Huberman, 'Le bref été de la dépense : Carl Einstein,
 Georges Bataille et l'économie-Picasso', *Cahiers du Musée national d'art moderne*, 120
 (summer 2012), pp. 12–43.

50 'Le merveilleux, irrésitible [*sic*] courant! [...] la *mesure* admirable d'une pensée qui n'a
 jamais obéi qu'à sa propre, qu'à son extrême tension [...]'; André Breton, 'Picasso dans
 son élément', *Minotaure*, 1 (1933), p. 30.

51 Max Raphael, 'A Propos du fronton de Corfou', *Minotaure*, 1 (1933), pp. 6–7 (referencing
 Valentin Miller, *Frühe Plastik in Griechenland un Kleinasien* and Carl Weickert,
 Typen der archaischen architektur in Griechenland und Kleinasia, both Filser, 1929);
 'Remarque sur le Baroque', pp. 48–49.

52 Raphael, 'Corfou', p. 7: 'précisément à ce moment de débâcle le Bolchevisme russe
 semble se lancer dans la même aventure, agissant dans la méconnaissance totale du fait
 que les renaissances de l'antiquité au cours de l'histoire chrétienne étaient rattachées
 au développement de la bourgeoise: à son origine le féodalisme et à sa rechute dans la
 réaction.'

53 See Frederick Starr, 'Le Corbusier and the USRR', *Cahiers du monde russe et soviétique*,
 21/2 (April/June 1980), pp. 209–21; Jean-Louis Cohen, *Le Corbusier et la mystique de
 l'URSS, théories et projets pour Moscou, 1928–1936* (Liège: Pierre Mardaga éditeur, 1987),
 pp. 54–55.

54 Cohen, *Le Corbusier*, pp. 86–139.

55 Cohen, *Le Corbusier*, pp. 20–31.

56 Cohen, *Le Corbusier*, pp. 190–91; see also L.M. Kaganovich, *L'Urbanisme soviétique,
 le réorganisation socialiste de Moscou et des autres villes de l'URSS* (Paris: Bureau
 d'Éditions, 1932).

57 See Guillemot Saint-Vinebault, 'L'Architecture soviétique à l'occasion d'un voyage
 d'architectes français en Russie', *La Construction Moderne*, 23 October 1932, pp. 52–59
 (thanks to Nicholas Bueno de Mesquita for this reference).

58 See Cohen, *Le Corbusier*, pp. 204–43, also illustrating alternative entries.

59 Jean-Louis Cohen, *André Lurçat, 1894–1970, Autocritique d'un moderne* (Liège: Pierre
 Mardaga, 1995) refers to Jean Garchery's 'Programme municipale' of 1924 and Pierre
 Selard, 'Un tournant décisif de notre politique municipale', *Cahiers du bolchevisme*,
 April 1930, pp. 144–45.

60 See Alexander von Senger, *Le Cheval de Troie du Bolchevisme* (Bienne: Éditions du
 Chandelier, 1931); Le Corbusier, 'Bolche ou la notion du grand *Prélude*', 1932 (anthol-
 ogised 1935); von Senger, 'Der Baubolschewismus', *Nationalsozialistische Monatshefte*,
 5 (1934), pp. 497ff.; von Senger, *Rasse und Baukunst* (Munich: Gäßler, 1935); Camille
 Mauclair, *La Crise du 'panbétonnisme intégral'. L'Architecture va-t-elle mourir?* (Paris:
 Nouvelle Revue Critique, 1934). Lurçat was aware of precursor school projects around
 Paris in Suresnes, in Germany and the Netherlands.

61 Max Raphael, 'Das Sowjetpalais, eine marxistische Kritik an einer reaktionären
 architektur' (1932), in Raphael, *Für eine demokratisches Architektur, Kunstsociologische
 Schriften*, ed. J. Held (Frankfurt: S. Fischer, 1976), pp. 53–151; and Cohen, *André
 Lurçat*, pp. 171–72.

62 Cohen, *André Lurçat*, pp. 143–75, 'Les Utopies pédagogiques, l'école de Villejuif et
 l'atelier de la Rue Daguerre, 1933–1934': the definitive study, extending his 'L'École
 Karl Marx à Villejuif: la cité future aura un toit terrasse', *Architecture Mouvement
 Continuité*, 40 (September 1976), pp. 31–38: *mes hommages*.

63 Cohen describes Communist press build-up during 1932, but says the name-change
 was 'le premier geste des communistes de Villejuif' at the start of 1933. While
 Le Matin (13 November 1933, cited in Cohen, *André Lurçat*, p. 157, note 37) salutes State

and departmental funding, I deduce (but cannot prove) Münzenburg's conduits and significant funds from Moscow in circulation.

64 See André Lurçat archives, Cité de l'architecture et du patrimoine, http://archiwebture. citechaillot.fr/fonds/FRAPN02_LURAN/inventaire (accessed 8 July 2013); in addition to Cohen, *André Lurçat*, see Chapter 5, 'De Karl Marx…', in Pierre and Robert Joly, *L'Architecte André Lurçat* (Paris: Picard, 1995), pp. 91–113.

65 'Nos réflexions critiques veulent démontrer que l'architecture moderne en France est étroitement lié aux données capitalistes, aussi bien dans ses programmes que dans l'emploi de ses matériaux […] cette critique d'idéalisme fonctionnel est basée sur la matérialisme dialectique: celui-ci garantit l'universalité contre la dissociation, l'unité contre le dualisme et aussi l'esprit contre la matière'; Max Raphael, *Groupe Scolaire de Villejuif, de l'avenue Karl Marx. André Lurçat architecte* (Paris: Éditions de l'Architecture d'Aujourd'hui, 1933), pp. 5–16.

66 'Pourtant chaque grand architecture, qu'elle soit grecque ou chrétienne, égyptienne ou hindoue, a su réaliser sous sa direction une unité des différents arts'; Raphael, *Groupe Scolaire*. In 1938 Raphael wrote 'Quatre dessins de Henri Laurens' (unpublished).

67 See Max Raphael, 'Är den moderna arkitekturen internationell?', *Byggmästaren*, 88 (1935), pp. 48–54; 'Ist die moderne Architektur international? Eine Anmerkung zu André Lurçat Schulgruppe in Villejuif', in *Für eine demokratischer Architektur*.

68 · See Wolfgang Klein, *Commune, revue pour la défense de la culture, 1933–1939* (Paris: CNRS, 1988).

69 See Noëlle Gérôme and Danielle Tartakowsky, *La Fête de l'Huma, culture populaire, culture communiste* (Paris: Messidor, 1988).

70 Sophie Bowness, 'The Presence of the Past, Art in France in the 1930s with Special Reference to Le Corbusier and Braque', PhD thesis, Courtauld Institute of Art, 1996, is especially strong on the revival of mass spectacles and 'mystères'.

71 The essay on Proudhon was finished before March 1933; the book had appeared by 22 July.

72 '[Q]uiconque arrive à Paris imbu de critique marxiste s'étonnera de constater l'influence qu'exercent encore les idées de Proudhon sur les politiciens, les intellectuels et même les artistes "communistes". Mais, à la première réflexion, on découvre qu'il n'y la rien de surprenant, car la plupart des artistes viennent de la petite bourgeoisie, et leur communisme leur sert d'avantage à étayer leur sentiment qu'à armer leur activité pratique. Ce sont, en réalité, des proudhoniens, bien qu'ils n'aient jamais lu les œuvres de Proudhon, ou peut-être, parce qu'ils ne les ont jamais lues […] Au lieu de s'efforcer, tout au moins dans leur travail, de rapprocher le plus possible la tradition de la théorie du marxisme, ils se précipitent par l'imagination dans le communisme et, en pratique, font, les uns, des "abstractions concrètes", les autres, du "surréalisme révolutionnaire". Les premiers représentent, en un tableau bien ordonné, les vœux du petit bourgeois, les seconds, sa fuite dans l'arrière-monde, cependant qu'autour d'eux s'écroule le capitalisme du monopole.' Raphael, *Proudhon, Marx, Picasso*, pp. 5–6, English edn, p. 3.

73 José Pierre reproduces the three AÉAR 'red tracts', in *Tracts Surréalistes et déclarations collectives, 1922–1939*, vol. 1 (Paris: Eric Losfeld, 1982), pp. 238–40.

74 'En ce qui concerne les écrits politiques et philosophiques de Proudhon, on y retrouve partout le même caractère contradictoire et ambigu que dans ses œuvres économiques.

De plus, elles n'ont qu'une valeur locale limitée à la France.' Karl Marx, quoted by Raphael in *Proudhon, Marx, Picasso*, p. 120, English edn, p. 71.

75 I take the term 'critical doubling' from François Furet's discussion of Marx's own 'installing himself within the Feuerbachian critique of Hegel', *Marx and the French Revolution* (Chicago: University of Chicago Press, 1988 [1984]), p. 4.

76 Raphael writes on Proudhon with authority and 'from the text' with no notes; but see J.-M. Guyau, *L'Art au point de vue sociologique* (Paris, 15th edn, 1930); Jeanne Duprat, *Proudhon, sociologue et moraliste* (Paris: Alcan, 1929); Jeanne Duprat, *Proudhon et le mutuellisme* (Paris, 1933); and (after Raphael), Jean-Georges Lossier, *Le Rôle social de l'art selon Proudhon* (Paris: J. Vrin, 1937), with full bibliography including Marx and Durkheim.

77 See Max Raphael, 'Zur Kunsttheorie der dialektischen Materialismus', *Philosophische Hefte*, Berlin, 3/3–4 (1932), pp. 125–52.

78 A copy of Raphael's manuscript notes was kindly sent me by Patrick Healy.

79 'Le théoricien marxiste se trouve devant une double tâche: il doit analyser les idéologies bourgeoises et favoriser l'épanouissement de la révolution culturelle du prolétariat.' Raphael, *Proudhon, Marx, Picasso*, p. 188, English edn, p. 115.

80 'Aujourd'hui, la bourgeoisie d'Amérique et de l'Europe occidentale reconnaît combien cet artiste symbolise sa classe et à quel point il reflète son état d'âme. Au dénigrement le plus obtus succéda une totale admiration sans qu'à aucun moment on ait considéré les limites réelles de son art [...] Par contre, il est de la plus haute importance pour un marxiste de déterminer précisément les rapports de l'œuvre d'art avec l'ensemble social historique et, partant, les limites de classe. Il s'agit, en ce qui concerne Picasso, de rechercher les conditions matérielles et idéologiques dont il a subi les influences et comment, en créant, il a réagi sur elles [...] Picasso est né en Espagne en 1881. Sa jeunesse se déroule durant les années où le capitalisme monopolisateur se substitue à celui de la libre concurrence [...] pendant sa période cubiste – la volonté de mesurer et d'exprimer simultanément les fonctions les plus différentes d'un objet [...]' Raphael, *Proudhon, Marx, Picasso*, pp. 188–90, English edn, pp. 116–17.

81 'L'existence d'une oscillation permanente entre deux tendances historiques mythologiques (l'une grecque ou romaine, l'autre médiévale chrétienne), et un art proprement bourgeois qui se développe entre ces deux tendances en s'orientant vers le réel, de telle sorte que chez les artistes les plus avancés, nous voyons l'une à côté de l'autre les conceptions les plus hétérogènes ou bien celles-ci sont conciliées, mais d'une manière éclectique, non dialectique.' Raphael, *Proudhon, Marx, Picasso*, p. 191, English edn, p. 117.

82 'Alors que la bourgeoisie européenne était déjà devenue une bourgeoisie "d'épiciers", l'Espagne luttait encore héroïquement contre la féodalité et l'Église. Nous devons ajouter que le prolétariat espagnol, – en grande partie anarchiste et syndicaliste, – n'était pas encore capable de mener une grande action commune [...] Nous constaterons plus tard chez Picasso un manque complet, tant de matérialisme que de dialectique, ce qui délimite ainsi sa position au sein de la vie sociale moderne [...] La dernière période (surréaliste) de Picasso n'offre un intérêt sociologique que dans la mesure où, par sa relation avec les vitraux gothiques et par l'achèvement méthodique de sa mystique du début, elle complète le classement de son œuvre dans la tradition chrétienne-européenne et dans la réaction [...]' Raphael, *Proudhon, Marx, Picasso*, pp. 198, 226, English edn, pp. 118–19, 139.

83 'Au moment où les artistes les plus puissants vident toujours plus leur instinct de jeu de tout contenu communément valable [...] Le niveau des connaissance de l'époque est tellement au-dessus des possibilités bourgeoises que même leur production artistique la plus élevée demeure, en tant que action historique, au-dessous des exigences du temps. Ainsi, ce qui n'est pas encore né est, dans un certain sens, déjà dépassé, parce que la force motrice de l'histoire se trouve déjà de l'autre côté de la barricade [...]' Raphael, *Proudhon, Marx, Picasso*, pp. 236–37, English edn, p. 145.

84 These are omitted, with no reference to Paris or Zurich shows, in the 1978 English-language edition.

85 Dieter Hornig, 'Max Raphael: théorie de la création et production visuelle', *Revue germanique internationale*, 2 (1994), pp. 165–78, http://rgi.revues.org/466 (accessed 8 July 2013).

86 The only review I have traced is by Germain Bazin, *L'Amour de l'Art*, 9 (1935), p. 342, noting penetrating psychological insights, but an orthodox Marxism not afraid of *la cocasse...*

87 Patrick Healy discusses Raphael's discomfort at Marx's 'petty bourgeois' thinking, close to Jacob Burkhardt, on the 'Greeks as normal children' passage in the *Critique of Political Economy*, for example. See Healy, 'Max Raphael, Dialectics and Greek Art', *Footprint*, autumn 2007, p. 58 and note 3, p. 75.

88 Jean Fréville ('Eugène', i.e. Yevgeny Schkaff, born in Ukraine, 1895) was completing his translations and editions of *Sur la littérature et l'art. Karl Marx et Frédéric Engels* and *Sur la littérature et l'art. Lénine, Staline* (Paris, Éditions Sociales Internationales, 1936 and 1937) at this time, apparently independently of Lifshitz, though both working in the same archives.

89 See Mikhail Lifshitz, *K voprosu o vzglyadah Marksa na Iskusstvo* [On the question of Marx's views on art], (Moscow, Leningrad: Khudozhestvennaya literatura, 1933).

90 Lifshitz's *Philosophy of Art of Karl Marx* was translated (New York: Critics' Group, 1938), *The Philosophy of Art of Karl Marx* (London: Pluto Press, 1973). See Dmitry Gutov, *Lifshitz Institute* (video, 45 minutes, 2004–2005; chapter 8). See also Rachel Sanders, 'Realism and Ridicule, the Pictorial Aesthetics of the American Left, c. 1911–1934', PhD thesis, University College London, 2012, for a review-based (but Comintern-deficient) context.

14 July: a stage curtain for the Popular Front

The fundamental form of bourgeois art, easel painting, is threatened from two opposite directions: on the one hand, by aspirations to monumentality which are by no means founded on modern architecture but on an outworn religion; and on the other, by the actual disintegration of the aesthetics upon which easel painting was founded (unity of place, time and action). This disintegration, which may well have been inspired by the cinema, by photomontage, by poster art etc., can only lead to a breaking up of the picture surface, such as obtained at the very beginning of easel painting.

Max Raphael, 1933[1]

Sensationally, we find Picasso in 1936 at the Bastille, the symbolic centre point of Popular Front demonstrations, four years after his apotheosis in Paris's right bank gallery world and a major Swiss museum. Here, the 14 July celebrations coincided with the anniversary of the triumph of the United Left Front the previous year, which had paved the way for the Popular Front victory on 4 May 1936, and the formation of Léon Blum's ministry on 4 June. Ministerial approval for a Bastille Day performance, with a very substantial budget, followed on 5 June. On 14 July Picasso's stage curtain rose over the production of Romain Rolland's eponymous play, *14 July* (plate 3). It was the Popular Front's greatest mass spectacle.

Picasso's uncomfortable position as regards the USSR-driven 'realism debate' is at the centre of this chapter. It was symbolised by the encounter between Picasso and the young painters who exhibited with him in the *14 July* theatre foyer. His rejection of a 'realist' solution for the stage curtain and choice of a more poetic Spanish allegory shows a certain prescience: he opted for myth as a transhistorical strategy. His position of both proximity to and distance from historical events and their 'realist'

representation begins at this point, and will be repeated throughout his career in conjunction with the key events of Communist Party history.

The festivities at the Alhambra theatre near the Bastille (formerly the Théâtre de la République, renamed the Théâtre Populaire) marked a high point in Popular Front mythology and Picasso's prestige on the left. Original scores were written for *14 July* by Jacques Bert, Georges Auric, Darius Milhaud, Albert Roussel, Arthur Honnegger, Charles Koechlin and Daniel Lazarus; the famous actress Marie Bell joined Picasso, participating in the Popular Front's greatest 'total work of art'.[2] The Spanish-born writer, art historian and anti-fascist Jean Cassou was now officially in charge of contemporary art on behalf of Jean Zay, the new Minister of National Education and Fine Art. The *14 July* event was a huge and early commission; Cassou proclaimed in the newspaper *L'Humanité* 'what official academe has refused to recognise and admit, living art and the courage and anxieties of genius, all can now find a refuge as part of a popular festival'.[3]

Romain Rolland, author, First World War pacifist and Nobel prize winner, was a founder member of the active Amsterdam–Pleyel anti-fascist movement (Stalin had enjoyed talks with 'the greatest writer in the world' on the occasion of Rolland's longed-for VOKS-sponsored trip to the USSR in 1935.)[4] His *14 July* spectacle commemorated the 1789 revolution; originally performed in 1902, it was one of the first in which the 'masses' played a role. For the Bastille in 1936, over two hundred professional and amateur actors were involved, in a theatre seating two thousand. Restaging this immense scene in which the people of Paris seized symbolic power blurred the boundaries between art and the current political situation. Here, the 'victory of Communism' was implicit. The performance echoed the experience of 'living' or reliving the Revolution – the reference point being 14 July 1790, and the 'Fête of the Federation' on the Champ-de-Mars in Paris, with its altar raised to the Nation.[5] Just as French Revolutionary and Commune imagery had been used as décor for the Russian Revolution, and just as Sergei Eisenstein had recreated the storming of the Winter Palace after the events of 1917, France's revolution was now restaged. In 1924 the Communist flag offered to France from the USSR was emblazoned with the memory of the Commune. The concept of 'revolutionary theatre' with mass participants was now developed using Soviet examples such as Erwin Piscator, with the Fête de l'Humanité itself as a stage. Ciné Liberté's take on the 14 July 1935 celebrations had already been screened for the 'Fête de l'Huma' that followed in the autumn (with its

huge red star at the entry, Soviet village, bust of Stalin and 'streets' named after Marx, Engels, Stalin and Dimitrov), prior to the 1936 revisiting of the triumph.[6] Later Jean Renoir's costume-drama *La Marseillaise* (1938), with the people of Paris dressed as revolutionaries, would repeat the *14 July* idea in film.

On the first night of Rolland's *14 July* an austere and moving portrait of the seventy-year-old pacifist was taken by the German émigré photographer Fred Stein.[7] The conclusion to the play, 'Obscure forces of the world: at last we have tamed you,' was to be tragically countered by events, for the night of the third and final performance coincided with the *coup d'état* in Spain – the beginning of Civil War.[8]

The *14 July* curtain was Picasso's greatest large-scale statement for more than a decade. Fourteen metres long, it came after his stage curtains for the ballets *Parade* (1917), *Tricorne*, (1919), *Le Train bleu* and *Mercure* (both 1924). The techniques and ideas for working on this grand scale were deployed just eight months before the creation of *Guernica*. Picasso's invitation to Dora Maar to make a visual reportage of him at work on the curtain was a historic first. Recently discovered photographs demonstrate his full engagement with the *14 July* project, including painting the figures.[9] The young Spanish artist Luis Fernandez, who squared up Picasso's small gouache of 28 May 1936, also known as *The body of the Minotaure in harlequin costume* (fig. 8), has previously been given all credit for realising the full-scale work except for finishing touches.[10]

Picasso's had experimented with a more 'realist' revolutionary composition. Only in 1995 was an alternative *14 July* proposition, left as a pencil sketch, revealed to the public (plate 4). It was shown in an exhibition held in Orléans to honour Popular Front minister Jean Zay's powerful contribution to museum and popular culture (he was murdered by Vichy militia in June 1944). Completely rooted in the contemporaneity of Rolland's Bastille Day theme and Communist militancy, the sketch is dated 13 June and follows the first official contacts with Picasso regarding the major project on 9 June.[11] We see the Bastille in flames, collapsing as the people wave fists and a hammer and sickle; history melts into an insistent present. An anti-fascist placard proclaims 'Save Thaelmann!' (Ernst Thälmann, German Communist Party director, was arrested in 1933); a young girl, bottom right, embraces a Communist flag, its insignia clearly visible. The dramatic perspective, the stridency (mouths are open and shouting) adds to a sense of visual confusion. The drawing was enlarged with bands of paper on which were drawn

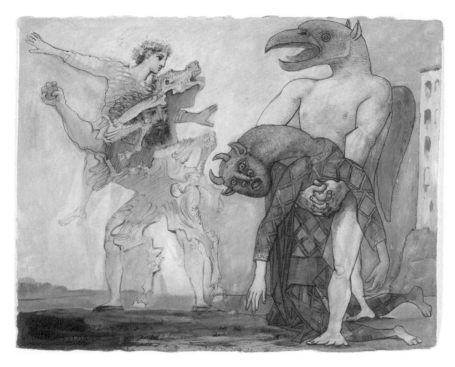

Figure 8: Pablo Picasso, *La Dépouille du Minotaure*, 28 May 1936

raised arms, clasped hands and fists, possibly at the moment Picasso joined the PCF in late 1944.[12] The drawing was never used for the 1936 curtain.

The decision to use the foyer of the Théâtre Populaire for a contemporary art exhibition thrust the current debate on realism, already well-known through the press, straight into the public eye and *14 July* context. Boris Taslitzky recalls:

> In the theatre foyer we had organised a big exhibition which included Matisse, Léger, Picasso, Lurçat, Lipchitz, Goerg, Gromaire, and André Lhote. Pignon, Amblard and I were hanging the pictures. We were full of embarrassment: should we mix the senior artists with the young ones? We were hanging and changing our minds all the time when Matisse and Picasso arrived. Matisse was hesitant about what to do. Picasso assured us that he liked the 'mixed *charcuterie*' effect and said go ahead.[13]

Fernard Léger, who showed *Composition with Three Figures* (1933) (robust naked females on a yellow ground) had wanted a hierarchical hang; he was overruled.[14]

The realism 'quarrel' (*la querelle du réalisme*), as the debate was known, offers a key to the style wars at stake through its title. The late seventeenth-century 'quarrel of the Ancients and the Moderns', hatched in the Académie Française, pitted the *anciens* who wished to imitate the classical writers of antiquity against the *modernes* who looked to contemporary precursors and advocated new artistic forms. The *querelle* already implied a conflicted attitude among contemporaries towards the presence of the past and the role of art in contemporary times. In the 1930s, a 'contemporary' position looked back not only at the revolutions of 1900–18, cubism, futurism and dada, but also at the more recent 1920s neoclassical revival and the jazz age (not to mention surrealism). These innovations seemed equally out of tune with economic crisis.

Moreover Cézanne's desire to 'do Poussin after nature', or Picasso's reworking of Ingres after his cubist phase, showed how the *querelle* could be played out within the work of a single artist. Even a young woman like the determined Wanda Khodossievitch-Grabowska had evolved from Suprematist beginnings in Smolensk with Streminksi and Malevich, biomorphic abstraction in avant-garde Poland and a turn to militant realism in Paris. She exhibited with the AÉAR delegation of works sent to Moscow for 1 May 1933, along with Lurçat's *End of Idealism* and, already, a *Lenin*.[15] By the time she painted her self-portrait with twisting red Communist flag and trellis of 1936 (plate 5), she was managing Fernand Léger's studio (she would become Nadia Léger in 1952). What a telling contrast may be made between Léger's statuesque *Mrs Maud Dale* (1935) (plate 8), commissioned by the millionaire industrialist Chester Dale, *doyen* of the New York Stock Exchange, and Nadia's 'proletarian' self-portrait, showing her militant, apprehensive, in an outside space with trellis and steps, a red Communist flag twirled around a pole. Their origin in Léger's studio and colour and stylistic proximity crystallises the problems of the so-called 'realism debate'.[16]

At stake was Marxist reflection theory (*Widerspiegelungstheorie*).[17] In the Soviet Union the move from Suprematism and Constructivism to a realism that became part of Stalin's 'total work of art' would be imposed by force.[18] The logic of socialist realism in a largely illiterate country is well illustrated, for example, by Max Alpert's staged scene of peasants in the Ukraine learning about politics, personalities and progress through a display of posters, including reproduced paintings of

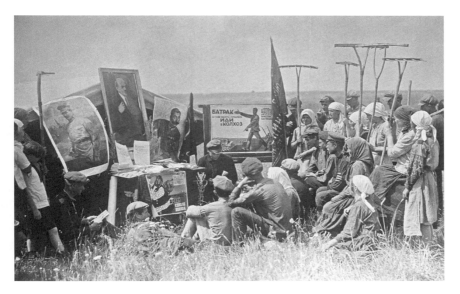

Figure 9: Max Alpert, Ukraine, farmers' meeting, 1929

Soviet leaders (fig. 9). Here we see how paintings' 'use value' is entirely dependent upon their reproduction and distribution by the thousands; concepts such as 'authorship', 'possession', 'decoration', 'beauty', indeed 'value' have no meaning.[19] (Alpert's charming propaganda piece precedes Stalin's Ukrainian 'terror-famine' of 1932–33; mean death estimates for the territory he pictured are currently 7.5 million.)[20] No contrast could be more striking than between rural Ukraine in 1929 and capitalist, metropolitan Paris. The Communist Party's impossible task was to transfer edicts from the USSR to France in this situation.

Max Raphael's predictions of crisis were well founded. In the global hub of artists and intellectuals in the late 1920s, fame, charisma and signature style had created values relating to a buoyant Parisian art market and dealer system which were no longer viable. Once, the variety of the French school, together with the immigrant School of Paris (from the expressionist Chaim Soutine to Amadeo Modigliani, painter of erotic nudes), offered something for everyone. Avant-garde patrons could opt for Léger's *modern style* paintings in a stripped interior by Le Corbusier; the enlightened bourgeois in his grand *hôtel particulier* could commission a Kees Van Dongen portrait, visiting the artist's ostentatious atelier, rue Juliette-Lamber. In an avenue Foch mansion, Raoul Dufy's light oils would harmonise with Louis XV furniture (Dufy was also the choice

of the rich English tourist in Nice). As Raphael and Walter Benjamin discovered, the Paris art scene embraced a mixture of late modern, abstract, expressionist, surrealist and realist styles attached to various Salons, reviews, commercial galleries and clientèles.

The contrast is striking between Raphael's so-called 'concrete abstractions' and 'revolutionary surrealism' (the Abstraction-Création group and the Surrealists with their 1930s exhibitions in London, Brussels, New York, Mexico or the Canaries). Both groups claimed allegiances on the left: the socialist utopianism of De Stijl passed from Mondrian to French artists, for example Jean Hélion, who espoused his geometric style directly. The surrealist automatism of André Masson likewise claimed to be revolutionary. The economic crisis, the rise of fascism and the mobilisation of intellectuals around anti-fascist causes changed everything. Soviet art appeared for the first time in Paris: Alexandr Deineka, '23 Soviet Artists' and also 'Soviet Art of the Five Year Plan', under the auspices of André Malraux, who was elected honorary president for the World Congress against war and fascism in September 1933.[21] A 'Return to the Subject' show took place at the beginning of 1934, a year that saw Courbet's *Atelier* installed in the Louvre, David, Ingres and Géricault exhibitions at the École des Beaux-Arts, 'Masters of Reality in the 18th Century' moving from the Venice Biennale to the Orangeries, and the brothers Le Nain in the Petit Palais.[22]

In 1934 the AÉAR was transformed into the Maison de la Culture with a remit to spread the model – similar to Soviet 'workers' clubs' – over France and North Africa.[23] Aragon and Malraux attended the first Union of Soviet Writers' Congress in August 1934. Here Stalin's definition of the writer as an 'engineer of the soul' was put forward by his cultural spokesman Andrei A. Zhdanov, along with the equation between socialist realism and 'revolutionary romanticism':

> the truthfulness and historical concreteness of the artistic portrayal should be combined with the ideological remoulding and education of the toiling people in the spirit of socialism. This method in belles lettres and literary criticism is what we call the method of socialist realism ... To be an engineer of human souls means standing with both feet planted firmly on the basis of real life ... Our literature, which stands with both feet planted on a materialist basis, cannot be hostile to romanticism, but it must be romanticism of a new type, revolutionary romanticism ...[24]

Aragon's book *Pour un réalisme socialiste* ('For a Socialist Realism') collected lectures given through 1935, following his return from the USSR. The rhetoric on behalf of a new style was impressive, ranging from Mayakovsky to Victor Hugo, from the Soviet 're-education' of artists to the writers' congress-inspired formulas of 'socialist realism' – but no examples or models for art were offered. Indeed, Aragon's most striking lecture promoted John Heartfield's anti-fascist photomontage, as published in the Comintern's German workers' magazine, *AIZ* (*Arbeiter Illustrierte Zeitung*). Shown at the Maison de la Culture, Heartfield's work was the epitome, Aragon claimed, of a new 'revolutionary beauty'. This completely undermined the case for painting, precisely as Max Raphael had predicted. *Commune*, the AÉAR review, printed Aragon's lectures month by month. The Heartfield essay appeared in the May–June 1935 number, posing a challenge, with all Aragon's authority, to the painting survey in the same number: *Où va la peinture?* ('Whither painting?'). Here Jean Cassou wrote on Manet, Courbet and Daumier; Léon Moussinac (the Soviet cinema expert) on 'Painters Confront the Subject', followed by a survey on fascism and art, and book, cinema and exhibition reviews. Georgi Plekhanov's founding Marxist analysis of eighteenth-century drama and French painting, written around 1905, seemed anachronistic here. The painting survey range was broad: the theatrical Christian Bérard enthused about figurative Picasso versus cubism. Giacometti drew a worker raising his fist in a militant salute. Paul Signac, the great anarchist post-impressionist, still president of the Salon des Indépendants, gave surely his last interview; he offered a moving tribute to Maximilien Luce's project for a trades' union protest, with builders and red flags, comparing the work to Bastille celebrations.[25]

Stalin's strategic and unexpected pact with minister Pierre Laval regarding 'mutual assistance' in May 1935 came as a shock to the Communists, allying them with France's policy of 'national defence'.[26] In June Aragon's 'return to reality' speech, resonant with these debates, was delivered to a distinguished international audience of intellectuals at the Comintern-backed Congress of Writers for the Defence of Culture.[27] (The deliberate sabotage of the Surrealist presence at the Congress was a sideshow.) It is here that Aragon made a crucial elision between 'socialist realism' and 'revolutionary romanticism'. He strategically transformed Soviet writer Maxim Gorky's reference to a nationalist, Russian folktale-orientated romanticism, instead embracing the Revolutionary history of France and painting from David to Delacroix. Thus he amalgamated Soviet cultural policy with the PCF's 'national defence' rhetoric.

'For this synthesis to be possible', he said, 'capitalism has to collapse and the socialist economy has to triumph over one sixth of the globe.'[28]

Aragon's rhetorical turn at the June Congress anticipated the public demonstrations proclaiming the unity of the left, fully realised in the Popular Front celebrations of 14 July 1935, with thousands of demonstrators marching from the Bastille. As with the Karl Marx School celebrations, the question of budgets should be raised. The AÉAR certainly orchestrated the procession of young revolutionary artists who bore portraits of Revolutionary painters, philosophers and politicians in processions. This first hand-account was again provided by Boris Taslitzky:

> We took the museum into the street, and, by reproducing [Daumier's] *Rue Transonain* or [Goya's] *3 May* in colossal dimensions, we gave back to the people a knowledge of the most noble images, at the time when Aragon and other writers were giving them Hugo and France ... We rediscovered all those faces triumphant, in the popular march for July 14th, wearing red-paper phrygian bonnets and tricolour cockades, proud, disciplined and chanting songs. One million people led the great farandole for bread, peace and liberty. The Place de la Bastille became the focus for decoration. We had painted huge portraits of Robespierre, Marat, Saint-Just and Mirabeau propped up against the July column; each was framed with decorative motifs and emblems whose models were provided by Lurçat and from the top to the base of the column which served as flagpole, the oriflammes of the French provinces fluttered against a brilliant blue sky. We advanced in procession, cheered by everyone in festive spirit, with at our head, Aragon, Gromaire, Lurçat, Moussinac, Lipchitz, J. Richard Bloch, Sauveplane, hundreds of writers, musicians, painters, intellectuals, singers, scientists, actors ... We, the young ones, bore aloft the greatest thinkers or artists in our history. I held Jacques Callot – a cameo portrait by Gruber; he held my Daumier.[29]

An analogy was also made with the procession of Cimabue's Madonna through the streets of Florence. For reasons of economy and transportability many young painters' works resembled small predella panels, recalling their origin: prolonged sessions of copying at the Louvre. (Taslitzky copied Rubens, David, Delacroix, Géricault and Zurburan, but also, following Diderot's advice, made sketches of street processions, worked up subsequently in the studio.) Little Popular Front ephemera remains, but the effigies in straw and rag or portraits on cardboard or wood of political adversaries, the bosses or the workers, masks, signs,

corporate or trades union emblems – even guillotines – all used on floats recall the propaganda and agit-prop techniques of the Soviet revolutionary period.[30]

The following year the greatest ever homage was paid on 24 May 1936 to the victims of the Commune with a procession to the Père-Lachaise cemetery where they had been shot; the so-called 'Federates' Wall' became again a place of pilgrimage for 600,000 people headed by Popular Front premier Léon Blum and Communist leader Maurice Thorez.[31] Thus, a living sense of affiliation was made vivid through commemoration on the actual sites of memory (*lieux de mémoire*), and in procession, re-enactment and reproduction.[32] Photography's role in the Commune uprisings had been important: historic photographs fused now with contemporary photojournalism, effecting an elision between epochs. And the contemporary reached across space to the revolutionary brotherhood of the Soviets: Gorky's image jostled in the street along with Voltaire, Courbet, Signac and Barbusse.[33] Not 'art' itself, but the signs for art were performed on the street, not admired in the museum, while this 'living cinema' was captured by photography and film.

It is here that the photograph by David Seymour ('Chim') was taken (fig. 10), demonstrating the symbolic affiliation between contemporary artists, their realist and Revolutionary precursors and the great encyclopedists. Fernand Léger's viewpoint, however, was more ironic: he vividly portrayed the mix of Marx and capitalist advertising:

> The great apéritifs enter the dance and participate in the procession: Picon, Dubonnet. Broken up by the banners and placards figures, bottles, soap bars, braces appear and disappear, and enormous letters slide between figures of Marx, Hegel and Victor Hugo, which wobble gently above the slogan 'Suze, friend of the stomach'.[34]

The 'sites of memory' were rivalled by the sites of industrial production, such as the famous Renault factory on the Île Seguin where 30,000 laid down their tools on 28 May. Taslitzky's small oil, the *Renault Strike Committee*, portrayed the long machine corridors converted with tarpaulins into a strikers' offices – no match today, perhaps, for Robert Doisneau's rediscovered photographic Renault factory project showing the vast interiors, the cars, the gleaming machinery. Revealing a network of production, products and production relations, Doisneau demonstrated an industrial aesthetics, which again threatened bourgeois easel painting (as Raphael predicted).[35] The Renault factory, site of a political awakening via Marx, Lenin and PCF leader Maurice Thorez

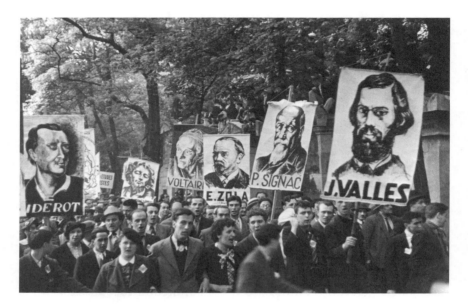

Figure 10: David Seymour, demonstration at the Federates' Wall,
Père-Lachaise cemetery, 24 May 1936

for workers and trade unionists, was the site of disastrous losses for the
captains of industry and the French economy during the strike period.
With finally two million off work, the climate became dangerously
unstable; there were genuine fears of a bolshevik revolution. Historic
reforms would be implemented, such as the forty-hour week and paid
holidays, which are at the very core of classic Popular Front iconography.
But the government functioned within a capitalist system dependent on
international political and trade relations and colonial imports. Almost
immediately it would be forced to compromise.

Picasso kept a distance until the moment of his June 1936 commission.
Curiously, the militant Galerie Billiet-Vorms, with its Soviet connections,
was his neighbour at 30, rue La Boétie. It was from here that Joseph Billiet,
a veteran of the avant-garde Abbaye de Créteil movement at the turn of
the century, had organised the great exhibition of French painting in
Moscow in 1928.[36] Several of 'his' artists went on VOKS-supported tours
of the USSR. The gallery, generator of the realism debate (published as
La Querelle du réalisme), was also the promoter of the Forces Nouvelles
group, who, inspired by the 'Painters of Reality' 1934 show, wavered in
their relationship to tradition and the Left.[37]

Evidently, Picasso was aware of the great debates, orchestrated over three days in 1936, just prior to his full engagement with the Popular Front. On 14 May Marcel Gromaire, Edouard Goerg and the ubiquitous Jean Lurçat dominated the first debate; Gromaire's iconic painting *Man on the Dole*, known as the *Striker*, echoed Lurçat's proposal that the 'realist painter should charge his work with the arsenal of the needs, feelings and demands of his times'.[38] Aragon gave an account of the technical developments of photography, leading to contemporary *reporteurs-photographes* (documentary photographers), the despair of painters, he said.[39] The critic Georges Besson compared the excitement to the furore at the première of Stravinsky's *Rite of Spring*, the first performances by Marinetti and Kurt Weill.[40] In the general tumult, Léger asked Aragon to organise an evening for the 'opposition'. On 31 May Léger, Le Corbusier, André Lhote and Jean Labasque were the chief speakers: Le Corbusier's and Léger's attacks on Soviet socialist realism were censored from the *Querelle du réalisme* publication. The date was fixed at this event for the younger painters debate.

For financial reasons the third debate's proceedings were not published (and were omitted from republications). The youngest artists (featured in the 'Salon of the Artist's of Labour' [1933], the AÉAR anti-fascist show of 1934 and Billiet's 'Return to the Subject' [1934]) were shown in 'Realism and Painting' at the Galerie Billiet-Vorms from 3 July, prior to moving to the Bastille. The *L'Humanité* newspaper critic noted the influence of Daumier's *La Rue Transnonain*, Delacroix's *Barricade*.[41] Here Boris Taslitzky showed his *Père-Lachaise Procession* (plate 7), which depicted different groups marching to the Federates' Wall. His bird's-eye view offers an archetypal image of Popular Front unity; figures in the foreground perch on tombstones and up trees to watch; branches are in blossom, fists are raised.[42]

Yet on 14 July, when the public and painters entered the Théâtre Populaire's huge auditorium, Picasso's curtain showed not the storming of the Bastille, or Popular Front good cheer, but a strange mythical scene. Against a large expanse of sky over a bare landscape with a ruined tower on a promontory (suggesting Spain), a winged and eagle-headed naked figure carried a dead minotaur dressed in a harlequin's costume in its arms. A youth – the forerunner of Picasso's Peace warriors of the 1950s – straddled the shoulders of a bearded man, himself disguised in the skin of the corrida horse or white mule. The dead minotaur, the dead horse make a disturbing mirroring, though the horse's head grimaces with a living energy. Both man and boy raise their arms – the man holds

a stone he is about to throw; yet the sharp-beaked eagle monster looks distinctly the stronger.

Picasso opts, then, for monstrosity as a trope which looks towards an uncertain future. Evidently the *14 July* curtain gave grandiose format to motifs whose link to horror and the sacred he was currently exploring in the Vollard suite and through the permutations of the Minotaur itself. As Jacques Derrida said, 'the future cannot be anticipated except in the form of absolute danger. It is what breaks absolutely with what constitutes normality, and can only begin to form, to present itself under the aspect of monstrosity.'[43] Picasso aligns himself here with other painters of monstrous figures of apprehension (*monstrare* as to both show and to warn), a trope so characteristic of the end of the 1930s, from Max Ernst's *Hordes* series and his 'haunting spectre' the *Angel of the Hearth* (1937), to the array of covers for the Surrealist journal *Minotaure*.[44] There are deeper readings of course, linked to animal desire and fear, to sacrifice and the sacred, or the violent struggle between master and slave (reworked with brutal actuality in Nazi Germany). Georges Bataille and Alexandre Kojève were contemporaries of Picasso who aimed to give broader philosophical meanings to this moment, poised before the coming debacle, as Hegel's 'end of history'.[45] If Picasso's strong, eagle-headed figure were also to represent fascism in Spain and Germany, the implications of his imagery were all the more premonitory.

Not until 1937 would Lenin's article 'Tolstoy, Mirror of the Russian Revolution' appear in French, using the mirror as an extended metaphor in Jean Fréville (Yevgeny Schkaff's) 'Great Marxist texts' series, a selection of writings by Lenin and Stalin on art.[46] Louis Aragon would mention a 'reflection theory' (*théorie du reflet*) in his socialist realism talk the same year.[47] The blueprint for realist practice was partly stymied, then, not only by contemporary pluralism, but by the militant artist hero Picasso's specific rejection of its precepts for a major, political, commissioned work. Max Raphael's Marxist theory directly confronted this intractable situation.

Looking forward, it is instructive to compare Picasso's *14 July* curtain, with its figure of a concealed enemy disguised, with Jacques Lipchitz's large sculpture *Prometheus Strangling the Vulture* (fig. 11). A World Fair commission standing outside the Palace of Discovery, Lipchitz's work was destroyed in 1938. Lipchitz, unlike Picasso, was Jewish, an émigré born in Lithuania; he was constrained to a limited market as a 'foreign sculptor' (entitled to a mere 1% of State commissions in 1934).[48] His *David and Goliath* (1933), an Old Testament allegory resonant

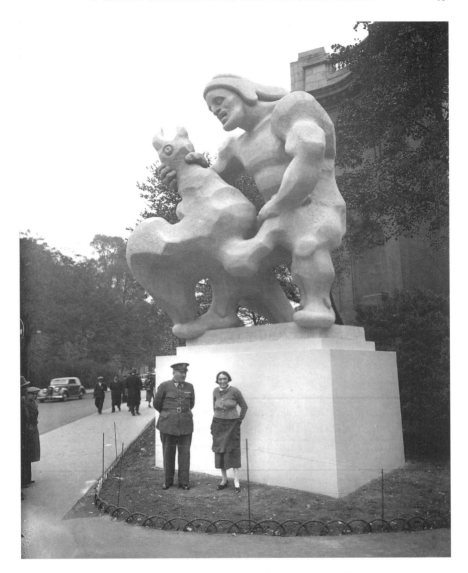

Figure 11: Albert Harlingue, Lipchitz's *Prometheus strangling the vulture*, 1937

with protest against fascism and antisemitism, joined works by Léger, Jean Lurçat and younger artists at the first major demonstration of a 'revolutionary' art by the AÉAR, at the Porte de Versailles large fair and exhibition space in 1934.[49] His heavy, broad-chested Prometheus for the 1937 fair strangles the eagle: the hero's vulture is elided with the Nazi emblem.

The explicit use of classical myth and the apparent 'monstrosity' of this not-quite-human creature clashes uncomfortably here with the contemporaneity of Prometheus's phrygian bonnet, as worn in Popular Front processions. A disturbing slippage is intimated between militant anti-fascism and 'avant-garde fascism', its opposite.[50]

Whatever its ambiguities, *Prometheus Strangling the Vulture* was the antithesis of the neoclassical female nudes by Charles Despiau or Aristide Maillol, promoted by the review *Combat*, the declared enemy of the AÉAR.[51] Parallels with Picasso are many, but Lipchitz's work, perceived as cumbersome, standing in front of the Grand Palais architecture, was derided by *Le Matin* newspaper as 'what happens to French taste under bolshevik influence'. It became the target of a hate campaign in April 1938 during the dismantling of the World Fair pavilions. Former students of the École des Beaux-Arts signed a petition: it was taken down, smashed, the pieces carried away. Outraged, the Maison de la Culture debated 'Artistic Liberty' and compiled a press dossier of the affair. By this time, the Popular Front government, rapidly compromised over non-intervention in Spain, had been defeated. With Édouard Daladier's Radical Socialists in power, the Munich crisis loomed. Not only increasing xenophobia, antisemitism and the discourse on 'degenerate art', but France's desire to placate Germany played a part in this act of iconoclasm.[52]

Iconoclasm is always related to fear of the power of images. To move from Picasso's *14 July* stage curtain to *Guernica*, produced within the space of a year, is in one way to transcend the debates around realism linked to easel painting (or indeed to the new Salon for mural art).[53] It is to see painting itself aspiring to monumentality and to the sacred, to see painting itself enacting the 'disintegration of aesthetics' upon which it was founded – in a context of cinema, photomontage and poster art at the Paris World Fair, precisely living up to Max Raphael's prediction in the epigraph to this chapter.

* * *

Picasso's *14 July* curtain remained in the Théâtre Populaire, serving as a backdrop, especially for Spanish popular dance evenings, until September 1939. Louis Aragon took it back to Picasso's studio. In 1952 it was used as a backdrop for one of the Communist Party's great 'Bataille du livre' book festivals. It was not seen again until 1965, when Denis Milhau, son of the hard-line socialist realist painter Jean Milhau, conceived 'Picasso and the Theatre', a show of unrepeatable magnificence,

in Toulouse. This brought several stage curtains and costume designs together with drawings and paintings, and musical recreations in the theatre. It involved Picasso and Jacqueline Roque, the dancers Boris Kochno and Serge Lifar, and a symbolic reunion with Jean Cassou, still director of Paris's National Modern Art Museum: all part of a highly Communist 'Messidor 65'.[54] Picasso left the curtain to Toulouse. In 1998 the Abattoirs held an exhibition to showcase the restoration of the *14 July* curtain, and its re-installation in a special wing designed by Antoine Stinco and Rémi Papillault.[55] Never again were its meanings to resonate with foreboding as in 1936: it was a curtain indeed that, beyond the realism debate, concealed political tumult, France's huge and unstable clashes of left and right, its mass demonstrations, policed and dangerous: the cacophony of an epoch.[56]

Notes

1 'La forme fondamentale de l'art bourgeois, la peinture de chevalet, est menacée de deux côtés opposées: d'une part, par des intentions monumentales nullement fondées sur l'architecture moderne, mais basées sur une religion périmée; d'autre part, par la déségrégation directe de l'esthétique particulière à la peinture de chevalet (unité de lieu, de temps et de l'action). Cette décomposition, qui peut être inspirée de film, le photo-montage, l'affiche etc., etc., ne mène qu'à une division de surface, telle qu'elle était coutumière au début de la peinture de chevalet.' Max Raphael, *Proudhon, Marx, Picasso. Trois études sur la sociologie de l'art* (Paris: Éditions Excelsior, 1933), p. 199; Max Raphael, *Proudhon, Marx, Picasso. Three essays in Marxist aesthetics*, ed. John Tagg, trans. Inge Marcuse (London: Lawrence and Wishart, 1980), p. 122.

2 Alain Mousseigne, 'Le Quatorze-Juillet', lists the musicians and conductor Roger Desormière; *Picasso, Le Quatorze-Juillet* (Toulouse: Les Abbattoirs/Milan, Skira, 1998), p. 7.

3 'Ce que l'académisme officiel se refuse à reconnaitre et à admettre, c'est-à-dire l'art vivant et les hardiesses et inquiétudes du génie, tout cela peut désormais trouver asile dans une fête populaire.' Jean Cassou, in *L'Humanité*, 16 July 1936, quoted by Anne Baldessari, *Picasso/Dora Maar, il faisait tellement noir...* (Paris: RMN / Flammarion, 2006), p. 119.

4 See the photograph of Aledander Arossef (VOKS director) with Stalin, Rolland and Maria Koudacheva (Stalin's wife) at the Kremlin, RGAKFD (photographer unknown) in Boris Frezinski, 'Staline et les écrivains français – Staline et Romain Rolland', in Véronique Jobert and Lorraine de Meaux, eds, *Intelligentsia, entre France et Russie, archives inédites du XXᵉ siècle, Paris*, exhibition catalogue (Paris: Beaux-Arts de Paris, 2012), pp. 172–83 (p. 177).

5 See Christopher Green, *Architecture and Vertigo* (New Haven, CT, and London: Yale University Press, 2005), pp. 92–93 for the important discussion of Michelet's *Le Peuple* (1846) and *Histoire de la Révolution Française* (1847–53), in this context.

6 Noëlle Gérôme and Danielle Tartarovsky, *La Fête de l'Humanité, culture communiste, culture populaire* (Messidor: Éditions Sociales, 1988), p. 60.

7 See Anne Egger et al., *Fred Stein. Portraits de l'exil Paris–New York: dans le sillage de Hannah Arendt* (Paris: Musée de Montparnasse/Arcadia Éditions, 2011), pp. 40–41, 65.

8 'Forces obscures du monde, nous vous avons domptées.' Romain Rolland, *Théâtre de la révolution: Le Quatorze Juillet* (Paris: Albin Michel, 1936). Preface written in June 1901. First performed 21 March 1902. Set in the Palais Royal, the Faubourg St Antoine and the Bastille, between 12–14 July 1789.

9 Anne Baldessari, *Picasso: Life with Dora Maar. Love and War 1935–1945* (Melbourne: National Gallery of Victoria, 2006), pp. 119, 121.

10 Christopher Green discusses the gouache and Rolland's plot in the context of Michelet, however, as a sign of 'Picasso's refusal to come close to the people in any large sense of the term' (which I refute); *Architecture and Vertigo*, pp. 109–11.

11 Pascal Ory, *La Belle Illusion, culture et politique sous le signe du Front Populaire 1935–1938* (Paris: Plon, 1994), p. 104 for the commission.

12 See E. Moinet, ed., *Le Front Populaire et l'art modern: hommage à Jean Zay*, exhibition catalogue (Orléans: Musée des Beaux-Arts, 1995), no. 115, pp. 174–75. The full range of Popular Front art policies and associated styles are discussed here.

13 Boris Taslitzky, 'Le Front Populaire et les Intellectuels', *La Nouvelle Critique*, December 1955, p. 15.

14 Christian Dérouet, ed., *Fernand Léger: Lettres à Simone* (Paris: Centre Georges Pompidou/Skira, 1987), p. 178 and note p. 265 (letter of 13 July 1936): 'J'accroche demain l'exposition de l'Alhambra – J'ai tout groupé: Matisse – Braque – Dufy, etc. donc je les ai tous compromis!'

15 AÉAR, 'Liste des participants à l'exposition internationale des artistes à Moscou, fixée au 1er mai, 1933', (undated), 'Nadja Khodasievich' no 14. See Maria Mileeva, 'Appendix 1: List of artists and artistic organisations abroad that have links with the Soviet Union dated 1 October 1934', in 'Import and Reception of Western Art in Soviet Russia in the 1920s and 1930s: Selected Exhibitions and their Role', PhD thesis, Courtauld Institute of Art, University of London, 2011, vol. 2, p. 11.

16 See Sarah Wilson, 'Nadia Khodassievitch Léger: la griffe du siècle', in *Hommage aux donateurs* (Biot: Musée Fernand Léger, 2010), pp. 17–20, http://www.musees-nationaux-alpesmaritimes.fr/library/catalogue/1-Catalogue%20en%20ligne%20DONATEURS.pdf (accessed 23 August 2013).

17 A distinction must be drawn: Ivan Pavlov's discovery of conditioned reflexes, combined with his militant materialism, fed into what was later called 'Soviet creative Darwinism' (with relevance to the creation – and representation – of the Soviet 'new man'). See E.A. Asratyan, *I. P. Pavlov, His Life and Work* (Moscow: Foreign Languages Publishing House, 1953 [Russian 1949]), especially pp. 78, 96, 137. The Bulgarian Todor Pavlov, teaching at Moscow's Institute of Philosophy, published *Theory of Reflection* (Moscow, 1936); his arguments would move from an initially biological to a cybernetic basis in the 1960s: *Theory of Reflection, Basic Problems of the Dialectical and Materialistic Theory of Knowledge* (Sofia, 4th edn, 1962).

18 I refer to Boris Groys, *The Total Art of Stalinism* (1988), trans. C. Rougle (Princeton, NJ: Princeton University Press, 1992).

19 See Christophe Barthélemy, 'Staline au miroir de l'affiche soviétique 1928–1953', *Communisme*, 90 (2007), pp. 9–30.

20 Robert W. Davies and Stephen G. Wheatcroft, *The Years of Hunger: Soviet Agriculture 1931–1933* (Basingstoke: Palgrave Macmillan, 2010); Andrea Graziosi, 'The Soviet 1931–1933 Famines and the Ukrainian Holodomor: Is a New Interpretation Possible, and What Would its Consequences Be?', *Harvard Ukrainian Studies*, 27.1/4 (2004–2005), pp. 97–115.

21 See *23 artistes soviétiques*, Galerie Billiet-Vorms, April–May 1933, preface by Paul Signac; *L'Art plastique soviétique du Plan quinquennal*, Galerie de la Nouvelle Revue Française, anticipating the Salon des Artistes du Travail, Galerie Billiet-Vorms, December 1933, with factory and building site themes; and 'Le retour au sujet', January 1934.

22 See *Maîtres de la Realité au XVII^e siècle*, (Paris: Orangerie des Tuileries, 1934); *Les le Nain – Peintures et dessins*, (Paris: Petit Palais, 1934).

23 See programme to *Naissance d'une Cité* (1937), back cover and Boris Taslitzky, 'L'Union des Maisons de la Culture, 1934–1939', *Faites entrer l'infini*, 12 December 1991.

24 Andrei A. Zhdanov, *The Soviet Writers Congress 1934: The Debate on Socialist Realism and Modernism* (London: Lawrence and Wishart, 1977), pp. 21–22.

25 See *Commune*, 21/2 (May–June 1935), pp. 937–60, with other artists' statements: Amedée Ozenfant, Léger, Max Ernst, Yves Tanguy, Marie Laurencin – and Courbet's exposition of his *Burial at Ornans*. 'Où va la peinture?' is reprinted in Aragon et al., *La Querelle du réalisme*, ed. Serge Fauchereau (Paris: Cercle d'Art, 1987), pp. 215ff. (there is no mention of the third debate).

26 See 'The Stalin–Laval Declaration', *New International*, 2/4 (May 1935), p. 144, http://www.marxists.org/history/etol/newspape/ni/vol02/no04/press.htm (accessed 13 September 2013), for the ambiguities of French press response.

27 See Wolfgang Klein, Sandra Teroni et al., *Pour la défense de la culture: les textes du Congrès international des écrivains, Paris, juin 1935* (Dijon: Éditions universitaires de Dijon, 2005); Fred Stein's photographic reportage of the Congress has been tragically lost.

28 'Réalisme socialiste ou romantisme révolutionnaire: deux noms d'une même chose, et ici se rejoignent le Zola de *Germinal* et le Hugo des *Châtiments*. Il fallait, pour que cette synthèse fut possible, l'écroulement du capital et la victoire de l'économie socialiste sur une sixième du globe [...]' Louis Aragon, 'Le Retour à la realité', in *Pour un réalisme socialiste* (Paris: Denoël et Steele, 1935), pp. 85–86.

29 'Le musée, nous le portions dans la rue, et c'est nous qui, en reproduisant à des dimensions colossales *La rue Transnonain* ou *Le Tres de Mayo*, avons rendu au peuple la connaissance de ses images les plus hautes, dans le temps où Aragon et quelques écrivains lui restituaient Hugo et la France [...] Tous ces visages nous les retrouvions triomphants au défilé populaire du 14 juillet, coiffés de bonnets phrygiens en papier rouge à cocardes tricolores, fiers, disciplinés et chantant. Un million de personnes bras-dessus bras-dessous menait la grande farandole du pain, de la paix et de la liberté. La place de la Bastille nous avait servi de motif de décoration. S'appuyant sur la colonne de Juillet, les portraits gigantesques de Robespierre, Marat, Saint-Just, Mirabeau avaient été brossés par nous; chacun d'eux était encadré de motifs décoratifs et emblématiques dont Lurçat avait fournit la maquette et, du haut en bas de la colonne servant de mât, s'envolaient dans un ciel d'un bleu éclatant les oriflammes des provinces françaises. Dans le cortège nous avancions acclamés par tout un peuple en fête, à notre tête Aragon, Gromaire, Lurçat, Moussinac, Lipchitz, J. Richard

Bloch, Sauveplane, des centaines d'écrivains, de musiciens, de peintres, de savants, de chanteurs, de scientifiques, d'acteurs… Nous les jeunes, nous portions les portraits des plus grands penseurs ou artistes de notre histoire. Je portais Jacques Callot peint en camaïeu par Gruber et lui un Daumier de ma main.' Taslitzky, 'Le Front Populaire et les Intellectuels', p. 15.

30 See Pierre Gaudibert, *1936–1976, Luttes, création artistique, créativité populaire* (Paris: Fédération du Parti Socialiste, 1976) and 'Les Années 30 et le style Front Populaire', in *Les Réalismes, entre Révolution et Réaction, 1919–1939* (Paris: Centre Georges Pompidou, 1981).

31 'Depuis 100 ans le mur' shows graphics and photographs of Communist celebrations at the Federates' Wall (1901, 1904, 1908, 1926, 1936, 1972, 1982), *La Commune*, 16 (January 1982), pp. 49–59; see also *La Commune*, 49 (2012).

32 Pierre Nora's celebrated *Les Lieux de Mémoire* (Paris: Gallimard, 1984–1992) was substantially triggered by such events linked to Revolutionary, Commune and Communist memory.

33 See *Front Populaire: photographies de Robert Capa, David Seymour 'Chim'* (Paris: Chêne/Magnum, 1976), with texts by Georgette Elgey, pp. 38–39.

34 'Les grands apéritifs eux aussi entrent dans la danse et participent au défilé: Picon, Dubonnet. Hachés par les banderoles et les pancartes apparaissent et disparaissent des figures, des bouteilles, un savon, des bretelles; des lettres énormes se glissent entre les figures de Marx, de Hegel, de Victor Hugo, qui, doucement, se balancent au dessus de "Suze l'amie de l'estomac".' Fernand Léger, 'La Marche vers le "mur"', in 'Deux inédits de Léger', *Les Lettres françaises*, 582 (31 August 1955), p. 3.

35 Following the works' first showing at the Grande Halle de la Villette. See R. Doisneau, *Doisneau/Renault* (Paris: Hazan, 1988); and Michael Koetzle, ed., *Renault in the Thirties* (London: Nishen, 1990).

36 Billiet surely helped send works by Léger and Ozenfant to the show 'Art of the Industrial Bourgeoisie' in the Museum of New Western Art, Moscow, in 1930 where Le Corbusier's *Centrosoyuz maquette* was displayed. See Mileeva, 'Import and Reception of Western Art in Soviet Russia', Appendix 13, for the catalogue of the Contemporary French Art Exhibition, *Sovremennoe frantsuzskoe iskusstvo. Katalog vustavki*, Moscow, 1928

37 For Billiet, the Abbaye de Créteil's continuing legacy and the Galerie Billiet-Worms, see Sarah Wilson, 'Art and the Politics of the Left in France, c.1935–1955', PhD thesis, Courtauld Institute of Art, University of London, 1992, Chapter 1. See also *Forces nouvelles* (Paris: Musée d'Art Moderne de la Ville de Paris, 1980); and Pierre Georgel, ed., *Orangerie, 1934: 'Les Peintres de la Realité'* (Paris: RMN/Musée de l'Orangerie, 2007), commemorating *Les Peintres de la réalité en France au XVIIᵉ siècle*, organised by Paul Jamot and Charles Sterling.

38 See Louis Aragon et al., *La Querelle du réalisme* (Paris: Éditions Sociales, 1936); Fauchereau, ed., *La Querelle du réalisme*; Wilson, 'Art and the Politics of the Left in France', pp. 64–67; and Nicole Racine, 'La Querelle du réalisme', *Sociétés & Représentations*, 15 (2003), pp. 113–31.

39 Aragon, *La Querelle du réalisme*, p. 86. He refers to his photography text *La Peinture au défi* (1930) and despair, p. 87.

40 Georges Besson, *Commune*, August 1936, pp. 1541–43; see Aragon's reference to Malraux's improvised, unpublished speech in 'Le Réalisme à l'ordre du jour', *Commune*, 37 (September 1936), p. 21.

41 See Georges Besson, 'Les Expositions: la querelle du réalisme', *L'Humanité*, 19 July 1936. He names Kuss, Mérangel, Gruber, Amblard, Jahn, Schoedlin, Pignon and the sculptor Haby.

42 Boris Taslitzky's *Le défilé du Père-Lachaise* (1936) was exhibited as *Le mur des Fédérés*, in *1936: crises et espérances: les peintres et l'actualité*, Musée de Saint-Brieuc in 1986, along with *La grève* (1936) under the alias *Les Grèves de Juin* (now in Tate, London), *Le massacre des chômeurs d' Haïti* (1937) and *Grève chez Renault contre le diktat de Munich* (1939).

43 'L'avenir ne peut s'anticiper que dans la forme du danger absolu. Il est ce qui rompt absolument avec la normalité constituée et ne peut donc s'annoncer, se *présenter*, que sous l'espèce de la monstruosité'. Jacques Derrida, *De la Grammatologie* (Paris: Minuit, 1967), p. 14. (English: author's translation).

44 *Monstra, ostenta, portenta, prodigia appeluntur quoniam monstrant, portendunt et preodicunt*; Cicero, *De divinatione*. See Gilbert Lascault, *Le Monstre dans l'art occidental* (Paris: Klincksieck, 1973).

45 See Lisa Florman, *Myth and Metamorphosis. Picasso's Classical Prints of the 1930s* (New York: MIT Press, 2000), pp. 140–208, 158–60, 208.

46 V.I. Lenin, 'Tolstoï, miroir de la révolution russe', in *Les Grands Textes du marxisme sur la littérature et l'art V. I. Lénine, J. Staline*, trans. and ed. Jean Fréville (Paris: Éditions sociales internationales, 1937), pp. 48–69.

47 See Louis Aragon, 'Réalisme socialiste, réalisme français', *Europe*, 183 (1938), p. 293; and Wolfgang Klein, *Commune, revue pour la défense de la culture (1931–1939)* (Paris: Éditions du CNRS, 1988), p. 118 and note 404, p. 146.

48 See *Art et Artisanat*, 7, (January 1936), concerning the employment of foreigners and the law of 16 May 1934.

49 Lipchitz, *David et Goliath*, in AÉAR, *Exposition des artistes révolutionnaires* (Paris: AÉAR 1934), p. 2, Porte de Versailles, 27 January–18 February 1934.

50 See Mark Antliff, *Avant-garde Fascism. The Mobilisation of Myth, Art and Culture in France, 1909–1939* (Durham, NC, and London: Duke University Press, 2007).

51 Robert Brasillach's and Jean Loisy's attacks in the context of the Lipchitz debate are detailed by Antliff, *Avant-garde Fascism*, pp. 227–39.

52 See *Peintres et sculpteurs de la Maison de la Culture*, 7, 'La Liberté dans l'Art', 1938, for press reports and statements; and Wilson, 'Art and the Politics of the Left in France', pp. 131–33.

53 See René Dauthy, 'L'Art mural (1935–1949)', http://www.sam-saint-maur.com/artmural.html (accessed 8 July 2013).

54 See Denis Milhau, ed., *Picasso et le théâtre* (Toulouse: Musée des Augustins, 1965). Exhibition dates 22 June–15 September 1965.

55 See Antoine Stinco and Rémi Papillault, *Les Abattoirs, histoires et transformation* (Toulouse: Les Abattoirs éditions, 2000).

56 The dense argumentation of both Antliff, *Avant-garde Fascism*, and of Zeev Sternhell's celebrated *Neither Right nor Left: Fascist Ideology in France* (Princeton, NJ: Princeton University Press, 1995, with new preface) must be indicated here. See also the Archives de la Police, Paris, Box BA 1867.

Guernica, agit-prop and the grand style

A gigantic show of the state of progress at a tragic moment for the world.

Amedée Ozenfant on the Paris World Fair, 1937[1]

Art reflects each exterior time (historic time as well as cosmic time, however diverse these might be) in a class consciousness and an individual consciousness, that is to say that in one and the same moment of objective time many subjective times may correspond. Time as a form of configuration is always an equation between a single and objective time (historical) and the multiplicity of times of interpretation, socially and individually conditioned. And these, at first, are still in the state of content, but a content which immediately conditions the form of time, the time of configuration. What is the nature and the relationship in Picasso between objective time, the time of interpretation and the time of configuration?

Max Raphael on *Guernica*, New York, 1940s[2]

Picasso's *Guernica* is the masterpiece remaining from the Paris World Fair of 1937, the 'International Exhibition of Arts and Technology of Modern Life' (fig. 12).[3] During *Guernica*'s long exile in the Museum of Modern Art, New York, it was a constant source of speculation and solace for Max Raphael, and surely *the* tangible link to his harrowing past. Installed permanently in the Reina Sofía museum in Madrid, it was the centrepiece of the exhibition *Encounters with the 1930s* in 2012. *Guernica*'s influential tour beyond Paris and impact in London in 1938 was evoked in the same year by Tate Britain's *Picasso in England*.[4] The painting continues to dominate fresh readings of the period, notably

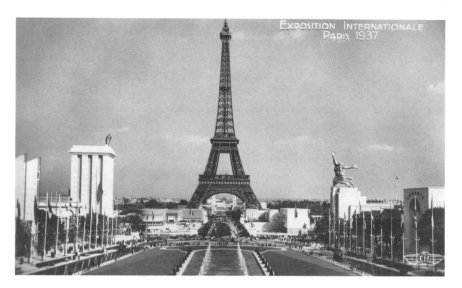

Figure 12: Paris World Fair, 1937

Romy Golan's *Muralnomad: The Paradox of Wall Painting, Europe 1927–1957* or artist Goshka Macuga's *The Nature of the Beast*, which used not only the United Nations' tapestry version of *Guernica* but 1937 World Fair pavilions' material to promote an anti-war message (both 2009).[5]

The object of this chapter is not to rehearse the available material around the World Fair and Picasso's installation in the Spanish pavilion, but the implications of the plurality, the heterogeneity, 'heterochrony' and the anachronistic reversals of style linked to totalitarian ideologies that provided its context. Stylistically, then, 'left' implies both a prolonged 'bolshevik', modernist style and, concurrently and subsequently, the academic style of socialist realism. A 'sociology of art', in Raphael's sense, is impossible to pursue, particularly around Picasso's developing career, if this dichotomy remains unclear. Bolshevik or anti-bolshevik arguments, radically metamorphosed through Stalinist terror, provide a background which continues in the following chapter, where the anti-bolshevik pavilion, constructed in Paris after Hitler's invasion of Russia, reverses the meaning of the USSR pavilion of 1937, while preserving its material forms and methods of display.

The Paris World Fair seen as a whole was an inimitable 'total work of art'. With its grandiosity, universal scope, stylistic heterogeneity and political resonances, it marked one of the major moments when

competing governments and ideologies invested huge sums in art and
architecture. The totalitarian powers of Nazi Germany and Soviet Russia
saw fine art and architecture as essential sites of investment and represen-
tation. The pavilions, solid buildings in various 1930s styles, were erected
and dismantled through a period of intense economic depression (where
the absorption of mass unemployment through jobs on the vast building
site was significant). There followed the crises of non-intervention, the
collapse of the Popular Front consensus, appeasement strategies and
finally war – and the deportation from Paris of the very immigrant
workforce which had been involved in creating the show. The Paris of
chantiers, the gaping pits and débris of the dismantled fair spread over a
huge area, was a sight the humanist photographers of pre- and post-war
Paris (many non-French) have spared posterity.

Evidently the World's Fair concept had its well-known nineteenth- and
twentieth-century precedents. Once again, it turned the metropolis into
an international magnet. Paris's Art Déco exhibition of 1925 and Colonial
exhibition of 1931 were still present as material and cultural legacies –
with a panoply of new colonial structures built for 1937 representing
France 'Outre-mer' on the Île aux Cygnes in the river Seine. More than
at any time previously, however, the 1937 Fair offered a microcosm and
living example of 'heterochrony': the simultaneous presence of different
objects and spaces in one time. Beyond any imaginative possibility at
the moment of the 'whither painting?' debate in 1935, the realism debate
extended, in 1937, into three-dimensional reality: a global concentration
of major buildings, commissioned sculptures and murals, housing the
best national art of all countries, whose origins related to different times
and different ideologies.

Only three years separate the World Fair from Henri Focillon's
publication *Vie des formes* (*The Life of Forms in Art*, 1934), which argued
almost Darwinistically for a linear and developmental history of styles,
and participated in the renewal of taste for the romanesque and the
medieval. In contrast, the kaleidoscope of World Fair contributions were
commissioned with a 'democratic' attitude; programmes were fixed in
November 1934, with Louis Hautecœur, curator of the Luxembourg
museum, promoting a broad eclecticism. Yet the immense panoply
of creativity and energy displayed at the Fair was countered by an
ominous, increasingly right-wing atmosphere. By June 1937 the Popular
Front government was beaten; by April 1938 the Radical Socialists under
Édouard Daladier were in power, with the Munich compromise five
months away.

How might one grasp the scope of an enterprise involving an array of venues and displays so vast it would have taken days, if not weeks, to experience? A virtual tour of the pavilions of the exhibition demonstrates the fallacy of beginning or ending an account by focusing on *Guernica* and the Spanish pavilion – hardly the first destination of most tourists.[6] Art-historically speaking, one could radiate out from the new permanent buildings of the Palais de Chaillot (built over and incorporating the old Trocadéro) and the twin-winged Palais de Tokyo museum building.[7] Here, for the first time, the 'Masterpieces of French Art' exhibition presented a French tradition at the nationalistic heart of the World Fair, challenging the Italian-dominated narrative of the Louvre.[8]

Nationalistic tensions implicit in the notion of a French tradition were exemplified by the contrast between the notionally French 'Masters of Independent Art' exhibition in the Petit Palais and the 'School of Paris' (immigrant school) show in the Jeu de Paume, called 'Origins and Development of Independent Art'.[9] Was the greatest French contemporary artist Raoul Dufy, whose *Electricity Fairy* (1937) painting – 600 square metres for Robert Mallet-Stevens' Palace of Light – paraded as a twentieth-century Raphael or Tintoretto?[10] Or might one have opted for Robert Delaunay, whose solid loops of coloured abstraction suggested the aeronautic feats of France's new planes, in the Pavilion of the Air? What of the astonishing array of national pavilions and their contents on the Champ-de-Mars? Striking ideological contrasts could be observed at first hand, for example between the modern fascist Italian contribution and the pious and conservative Vatican pavilion. Once again, British and American contributions (France's colonial and imperial challengers) were underwhelming; the Mexican or the 'Jewish Palestine' pavilions, politically significant in themselves, must be rescued from oblivion. Should one begin at the periphery with Le Corbusier's Pavillon des Temps Nouveaux (New Times pavilion), the Rural Centre's photo murals and work inwards? Should one alternatively work outwards from the central Peace pavilion, masterminded by the Comintern – a warlike Trajan's column flanked by the wings of a building containing militant murals by Frans Masereel and Max Lingner, and connected to the RUP movement for 'Universal Peace'?[11]

The most famous views of the Fair see the Eiffel Tower as the central dividing point between two imposing neoclassical edifices: Albert Speer's Nazi pavilion and Boris Iofan's Soviet pavilion. This served as a giant pedestal for Vera Mukhina's steel *Worker and Kolkhoz-Woman*, brandishing hammer and sickle against the sky, drapery swirling in their

wake in the rushing wind of change (plate 9). The USSR proclaimed itself a world superpower with this building and its positioning, just twelve years after Melnikov's constructivist pavilion with its revolutionary ideals, and a mere twenty years after the Russian Revolution (Iofan's Palace of the Soviets model of 1933 was displayed in the interior). Yet not only the Spanish pavilion which hosted Picasso's *Guernica*, but Le Corbusier's New Times pavilion on the periphery of the exhibition, still exemplified bolshevik, agit-prop styles and techniques.

Declared on 18 July 1936, the day after General Franco's military coup, the Spanish Civil War lasted for three years, claiming some half million lives. From the moment when King Alfonso XIII abdicated in 1931, arguments had raged over what form Spanish democracy should take. Anarchists, Socialists, Communists and old-fashioned liberals quarrelled, while their opponents, Falangists, Monarchists, Carlists and Catholics, were equally divided: the claims of Basque and Catalan nationalists became involved. There was elation when the Frente Popular came to power in the democratic elections of February 1936. Yet almost immediately, the original Spanish confrontations were obscured in the world press: the conflict was polarised into reds versus fascists, while foreign intervention from Germany, Italy and Russia turned Spain into a military and tactical testing ground. A new war seemed imminent. After the 14 July celebrations of 1936, there was outrage when Léon Blum's government refused aid to its fellow popular front in Spain, joining forces rather with Britain, the United States and the violators, Italy and Germany, in a non-intervention pact.[12] International compromise heralded Europe's demise, as World Fair euphoria increased.

While negotiations for a Spanish pavilion had begun in late 1934, it was only under Largo Caballero's Republican government of autumn 1936 that Louis Araquistáin was appointed as ambassador in September, with the brief to persuade France to sell arms to the Republic under a previous non-intervention agreement.[13] The project for the Spanish pavilion was rekindled in Civil War conditions. The unity of the Republican cause had to be stressed to the world.[14] Araquistáin would resign with his government's defeat in May 1937, preceding the pavilion's inauguration on 12 July, on a prime, sloping site near those of Germany, Norway, Poland and the Vatican. After the June defeat of the Popular Front government under Blum, the presence of the Spanish pavilion was a political embarrassment for the French authorities. There was no mention of the Spanish Civil War in the commemorative World Fair album, the *Livre d'or*. The *Rapport Général*, eleven volumes written from

1938 to 1940, during which time the political situation progressively deteriorated, managed to omit all reference to Picasso.[15] Yet *Guernica* was one of the sensations of the 1937 exhibition: it denounced not only civilian bombing but – it must be emphasised – an illegal crime of aggression. Germany and Spain had not declared hostilities. *Guernica* was the ultimate indictment of the non-intervention pact.[16]

While publicity itself was enshrined in the Press pavilion, the Radio pavilion and the rather vulgar Publicity pavilion, the Spanish pavilion aimed to publicise the heroic Republican Civil War effort.[17] It was jointly conceived by Josep Lluís Sert and Luis Lacasa. Sert had taken Le Corbusier's ideas and publications back to Spain in 1926, with great impact on a younger generation of architects. He had previous experience of prefabricated buildings, and used a dry-assemblage principle involving modular units, non-supporting wall partitions and curtain walls of glass. The building had a 'U'-shaped ground plan and a Le Corbusier-like ramp of poured and reinforced concrete rising up to the second floor. Lacasa's background was one of Communist sympathies. He had visited the Soviet Union officially in the early 1930s and at the outbreak of the Spanish Civil War worked for the agit-prop section of the Communist-organised fifth regiment in Madrid. He would spend a considerable time subsequently in exile in the USSR – like Alberto Sanchez, whose Gaudi-like biomorphic sculpture, *The Way of the Spanish People Leads towards a Star*, twisted upwards besides the block-like edifice.[18]

Soviet agit-prop precedents were evident, in particular the Vesnin brothers' project for the *Leningradskakaia Pravda* (Moscow, 1924), designed to be read as a 'mobile newspaper'.[19] It was the Spanish photomontage artist and militant Josep Renau who was responsible for the photomontage murals on the exterior of the pavilion, breaking up the white and sienna red of the exterior with grey.[20] The photomontage images were complemented by quotations in capital letters: the entrance bore a stark and unadorned statement: 'There are more than a half / million Spaniards / with bayonets / in the trenches / who will not be a walkover. / President Azana.'[21] The back façade of the building bore a continuation of the 'pedagogical missions'' first-floor display about schools and the literacy campaign.[22]

Julio Gonzales's life-size *Montserrat*, a peasant woman holding a sickle with a child against her shoulder, stood harsh and proud at the entrance, welded in iron. She looks up, scanning the sky for warplanes; the child's body doubles as a shield.[23] Entering the pavilion, the visitor was confronted by Picasso's *Guernica*, three-and-a-half metres high

by seven metres long, lit from above, as we see in Fred Stein's little-known photograph (fig. 13). (Anthony Blunt recalls that when he saw the painting in mid-July, the pavilion was still unfinished.)[24] Opposite was an enlarged photograph of Federico García Lorca, 'poet shot and killed in Granada'. In the centre of the portico, the American artist Alexander Calder's pitch-lined *Mercury Fountain* demonstrated, with its slow, perpetual motion, the abundance of mercury from Almaden in Spain (at the time used for making pivots for heavy artillery). On the left a display of books and magazines covered contemporary Spanish literature, science and propaganda, beside the administrative offices and an information desk. The patio, like the stage, could be covered at will by electronically operated awnings. Throughout the exhibition, groups of singers and dancers and working artisans from the various regions in Spain alternated with films.

Guernica's screen-like size, its static/dynamic, black-and-white flickering, complemented constantly projected films (including Luis Buñuel's *Madrid '36* and Joris Ivens's *Spanish Earth*) opposite: a confrontation that dramatically confirmed the specifics of painting versus cinema. Action, pain and death filmed and particularised in time contrasted with Picasso's transhistorical statement. Picasso was subsequently to be attacked for not representing a triumphalist Republican victory. Yet the panoply of death in *Guernica* was countered by its dialectical transformation: manichean contrasts of light and dark, sharp and exploding shapes and gestures reaching out from the basic pyramidal construction. Not death but nativity imagery was somehow familiar: beasts in the stable, a babe in arms, awestruck onlookers and energy flooding from the star-like shape above.[25]

Lecturing and writing later from New York, Max Raphael would look at the painting and see the clash between the triptych breadth of a medieval altarpiece and the triangular structure of a Greek pediment, burst at its summit:

> The Christian altarpiece and the Greek pediment negate each other as the artist searches for a still older form – the acute angle open either at the top or at the bottom … Three features are particularly expressive: the gap in the pediment, which effectively rules out the aimed-at completeness of a self-contained work; the treatment of surface and depth as symmetrical, so that both cancel each other in romantic irony; finally, the fragmentation of the vertical axis that transforms a potential meeting line into a source of disorientation and uncertainty.[26]

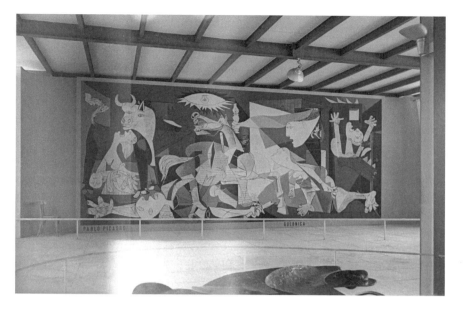

Figure 13: Fred Stein, *Guernica*, Spanish pavilion, Paris World Fair, 1937

Almost immediately, *Guernica* was seen as a major work and a political statement; almost immediately, it was contested. While the uninitiated may have had some difficulty with the dislocated and cut-out shapes in a flat space (with its cubist collage origins), even the most unsophisticated of visitors was struck by the overall impression: 'the collapse of the world in the horrors of war' as was explained on the back of the *Guernica* postcards on sale.[27] Subsequent Anglo-American debates centred on a Marxist response to the work's lack of 'realism'; yet any explicit 'realism' would doubtless have occasioned a diplomatic incident and censorship. In striking contrast, the inaugural speech concentrated in a significant way on *Guernica's* supremely legible content.

Look at this painting attentively, profoundly, let us not be intimidated by its difficult appearance and extreme colours. Look, workers, at this figure on the right; this falling woman, desperate. The genius of the painter in order to give the sensation of ruin and emptiness, has rent her with greys, has shortened her summarily, in falling ... And in order to accentuate this fury of man, of the painter, against the destruction, Picasso has imprisoned in a room a neighing horse

who kicks the body of a militiaman while a woman leans out futilely with a light, made of heads and hands, in a superhuman effort, while her body remains in the window and she herself becomes a torch. See, further to the left, that furious bull and that woman with her dead son on her knees. Forming the base of the painting, the assassinated militiaman brandishes in his fist a sword now useless. And in order to express all his feeling Picasso needs to show both eyes of his characters, even when in profile. To those who protest saying that these things are not thus, one must answer asking if they do not have two eyes to see the terrible reality of Spain ...[28]

In the Basque section of the exhibition there was another tribute to Guernica: photographs of this most ancient town, heart of the Basque population, in ruins; 1,654 civilians had been killed and 889 injured by the Nazi Junkers and Heinkel bombers and Messerschmitt fighter planes; a terrorist act demonstrating their pinpoint accuracy.[29] Pictures of the civilian dead had been published in *L'Humanité* on 28–29 April; Picasso's first preparatory drawings were dated 1 May, Labour Day, and the day of the bullfight in Spain. The significance of Goya's painting of the Second of May, showing the confrontation between North African troops and the Spanish people, and above all his celebrated *Tre Mayo* (3 May), did not escape Picasso.[30] Paul Éluard's poem 'The Victory of Guernica' was displayed on a wall panel in conjunction with the photographs in the Basque section. As Picasso had in paint, it used transformational devices: antitheses of dark and light, fire and night, despair and hope.[31]

It was after the impact of *Guernica*, then, that visitors encountered the displays of art in contemporary Spain. The *Rapport Général* describes the second floor with its fine art exhibition; both recognised artists and younger generations were shown in the painting and sculpture section, while in an updatable section there were paintings, drawings and posters, themed small shows of Catalan and Basque painting, and the Spanish School of Paris.[32] Artists Solana, Horacio Ferrer and Regoyos, realist painters of the older generation, have been identified. Artists Francisco Pérez Mateos and Emiliano Barral, who died defending Madrid in November 1936, were honoured. Installation photographs show academic busts and heads next to huge blown-up portrait photographs of the heroes.[33] Costumes, lace and pots indicated the wider context of regional arts and crafts. (Later Max Raphael, now an expert on prehistoric art, would read into *Guernica* magic reminiscences of 'prehistoric Spanish ceramics and in palaeolithic cave paintings. With his extraordinary

empathy for the artistic vocabulary of other epochs he might have sensed their significance as magical signs.')[34]

A stairway led down to the first floor, entirely devoted to graphics and statistics using photographs and photomontage to represent Spain's people, its national products and Republican ideology, with displays about schools in Catalonia, the defence of national heritage during the war (focusing on museums and libraries) and the 'pedagogical mission' to spread knowledge of classical art throughout the Peninsula. Through a double space the height of the stairwell and facing the staircase, the demonstrations of facts and figures were confronted by Joan Miró's five-metre-high *Spanish Peasant in Revolt*, also known as *Segadou* (The Reaper) flanked by quotations from Cervantes.[35] Like his *Still Life with Old Shoe* at the Jeu de Paume exhibition, the work was bathed in a bloody and apocalyptic light.[36]

Agit-prop style propaganda at the fair did not only relate to Spain's anti-fascist panoply for the Republican cause. Le Corbusier's New Times pavilion also stood in conspicuous contrast to the solid national pavilions with their 1930s-style, stripped neoclassicism. It was paradoxically the most 'bolshevik' of all his constructions. Le Corbusier's apparent militancy here is striking both in the light of official rejection of his plans for a Modern Art Museum for the World Fair and the modernist pavilions of his contemporaries, such as Alvar Aalto's Finnish pavilion, those of Norway, Sweden, Czechoslovakia, the metal pavilion for the Modern Artists Union or the Saint-Gobain pavilion, its façade entirely made of glass bricks. His New Times pavilion was the product of continually changing plans, failed projects and name changes. Ultimately, however, 'New Times' (with its ring of the Soviet *Novy Mir*, New World) coresponded to Popular Front ideals, while the promotion of 'popular education' replaced urbanism and the original idea of 'contemporary aesthetics'.[37] After innumerable delays and debates on deadlines and budgets, Pierre Jeanneret, the architect's cousin, erected the huge canvas tent on the Porte Maillot site, near their collaborator Charlotte Perriand's Rural Centre (fig. 14). In his negotiations with the Popular Front government, Le Corbusier could bank not only on an important Moscow network around his *Centrosoya* building for Soviet cooperatives, but personal friendships with Paul Vaillant-Couturier and Louis Aragon, director of the Maison de la Culture. This had generated the campaign for 'Corbu-1937'. (The young architects, 'Jeunes 37', also wished to collaborate with him.) Le Corbusier also asked the architect Jean Nicolas, secretary of the Maison de la Culture, for ideological

slogans for the interior. Following the project's final relaunch, in budget version, Jeanneret's specific experience of tent construction prevailed.[38] The agit-prop ethos of a collapsible museum space able to be dismantled, packed and transported through France by train was maintained; the tent and pylon construction anticipated the tension structures of the post-war period.

The interior was conceived as a 'leisure centre with multiple functions' with a system of internal ramps, display boards, an 'artificial mound', an orators' tribune, gym spaces and so on; all, ultimately, a huge advertisement for Le Corbusier's projects and theories. Highly coloured, the exterior made up a red, white and blue national flag.[39] Fernand Léger's photomontage murals for the interior – a new departure for the artist – were also based on agit-prop Soviet precedents: El Lissitsky and Sergei Senkin's photomontage murals for the USSR pavilion at the 1928 'Pressa'

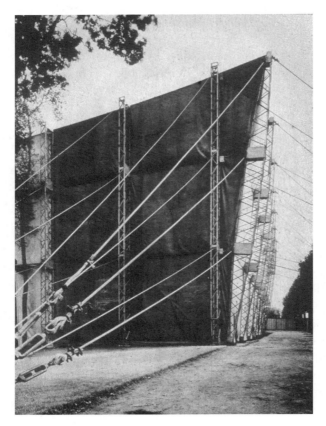

Figure 14:
Pierre Jeanneret
and Le Corbusier,
New Times pavilion,
Paris World Fair,
1937

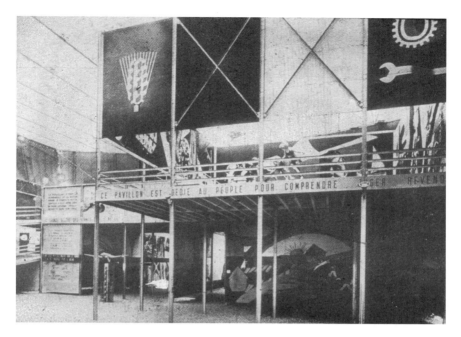

Figure 15: Pierre Jeanneret and Le Corbusier,
New Times pavilion, Paris World Fair, 1937, interior

exhibition in Cologne, and the 1929 'Film und Photo' exhibition in
Stuttgart.[40] Lucien Mazenod, whose murals complemented Léger's, had
been the first to mix photomontage and painting for advertising. Léger's
Travailler (*Work*), a companion piece to Mazenod's *Recréer* (*Recreation*)
was mounted at right-angles to it on a mezzanine, supported on thin
metal stilts; a slogan declared the pavilion was dedicated to the people
'to understand, judge, and to claim their rights' (*Revendiquer*) (fig. 15).
Work used blown-up photographs from agencies of pylons, high-tension
cables, axles, pulleys and a man at the centre of a wheel-type conveyor
belt. Vertiginous viewpoints collided; the flat coloured planes of the
background at oblique angles increased the sensation of dynamism
and the autonomous movement of the dislocated elements. In contrast,
Léger's twin open-air 'Agriculture' panels in the Rural Centre used
natural imagery, with rainbow target and fists clutching roses: a salute of
hope in the spirit of the Popular Front programme as Charlotte Perriand
agreed.[41] (Arguably these 'portable photomurals' with their disintegrated
surfaces, their sense of speed, urgency and cinematic black-and-white

with blown-up faces, were easier for the popular public to read than painting, such as Léger's huge, colourful *Transport of Forces* in the Palace of Discovery, or his contours of shovels on monochrome ground in the 'Solidarity' pavilion.) Finally Le Corbusier's publication of 1938, *Des canons, des munitions? Merci! Des logis... S.V.P.* (Cannon? Munitions? No thanks! Housing please!), with missiles and bomber planes on the cover, transformed the pavilion's commemorative brochure into an aggressive-looking political manifesto.[42]

Léger and Le Corbusier had been precisely the voices raised against Aragon in the realism debate, arguing for an accelerated, media-inspired modern sensibility. The realist – and indeed socialist – counter-argument was exemplified 'for the workers' by the 'House of Labour' (Maison du Travail), whose ornate exterior sheltered a 'Hall of Peace'. Here, gigantic sculpted heads on plinths represented the fathers of the trades union movement. Karl Marx's great grandson, Karl-Jean Longuet, created the ten-metre-high bust of Jules Guesde, the disciplinarian leader of France's first workers' party (following his busts of Marx of 1930 and 1936).[43] The cult of patriarchy, of ancestors here was comparable with the heads of Marx and Lenin in the Soviet pavilion. Displays and documents about proletarian alliances made with English trades unions at London's Great Exhibition of 1862 situated the present as part of the long struggle for workers' emancipation, long before the Russian Revolution or the current agenda of the Soviet state under Stalin.

With Stalin's terror reaching its apogee, the USSR pavilion opened in 1937 to receive thousands of visitors (reason enough for Picasso's aloofness from any Party-political Communist engagement). Countering the Communist encomia of the 1930s were the voices of major, politically experienced anti-Stalinists such as Victor Serge and Boris Souvarine – and of course Leon Trotsky in exile. Trotsky was championed by the Surrealists, and by Souvarine in *La Critique Sociale*, a forum for writers such as Michel Leiris and Georges Bataille, both close to Picasso.[44] Their crusade was waged not against only the politics, but the by now substantial cultural edifice of the French Communist Party and its ideologies. Paul Vaillant-Couturier, Henri Barbusse and others praised the New Russia throughout the Five Year Plan period.[45] Barbusse, the respected pacifist of *Le Feu* (*Under Fire*, 1916, translated 1917), published *Staline. Un monde nouveau à travers un homme* ('Stalin: a new world via one man') in 1935.[46] Souvarine riposted with *Staline. Aperçu historique du Bolchevisme* ('Stalin. A historic vision of bolshevism'), a meticu-lously documented, 500-page biography. Any serious challenge to Stalin,

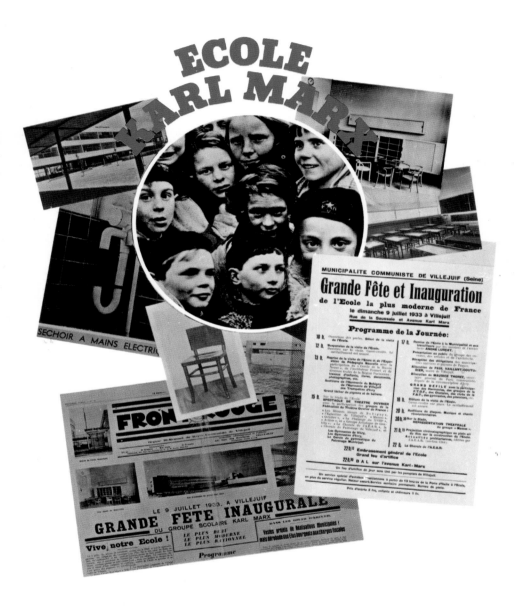

Plate 1: Grapus collective,
Karl Marx School,
Villejuif, 1976

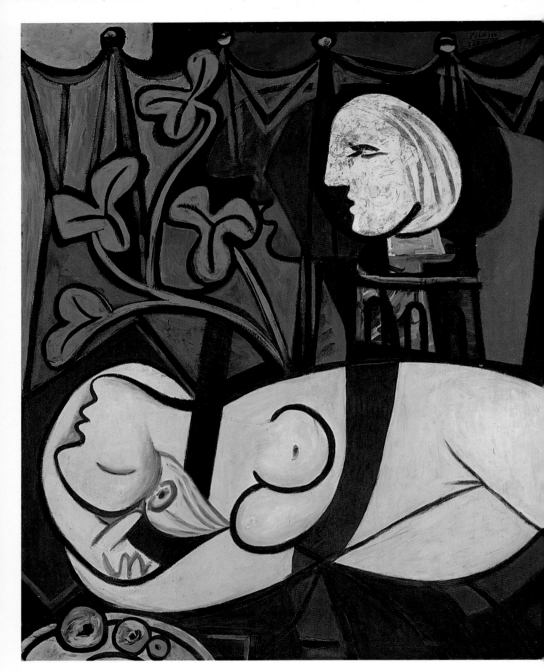

Plate 2: Pablo Picasso,
Nude, Green Leaves and Bust
(*Nude with Blue Curtain*),
1932

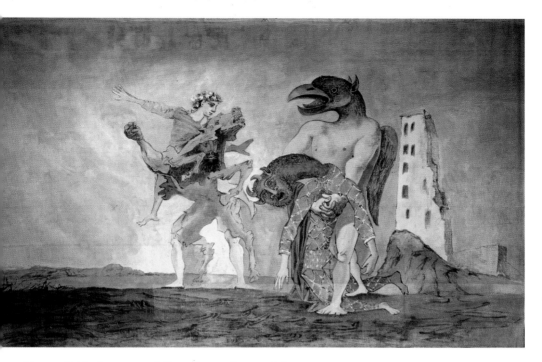

Plate 3: Pablo Picasso with Luis Fernandez, *14 July*, 1936

Plate 4:
Pablo Picasso,
14 July, 1936

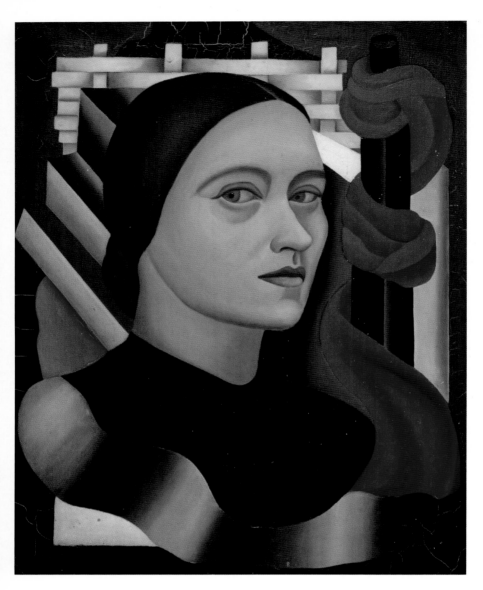

Plate 5: Nadia
Khodossievitch-Léger,
Self Portrait, 1936

Plate 6: Konstantin Melnikov,
pavilion interior,
Paris, July 1930

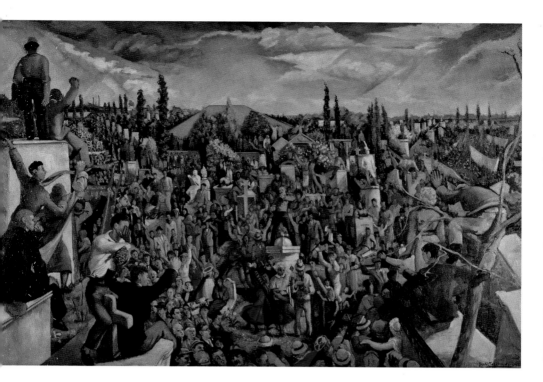

Plate 7: Boris Taslitzky,
At the Père-Lachaise cemetery in 1935, 1936

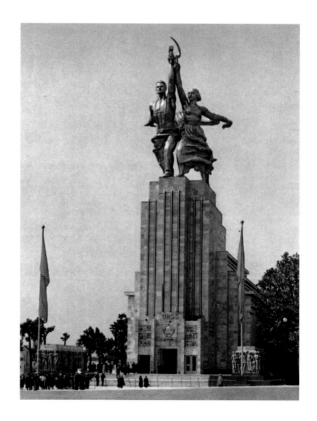

Plate 8: Fernand Léger,
Maud Dale, 1935

Plate 9: Boris Iofan,
Soviet pavilion,
Paris World Fair, 1937

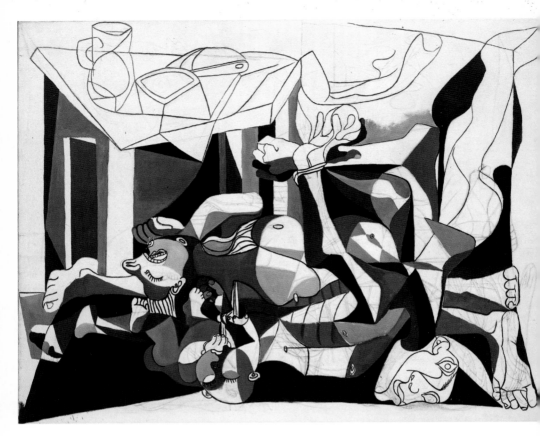

Plate 10: Pablo Picasso,
The Charnel House, 1944–45

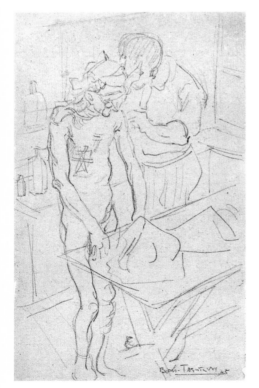

Plate 12: Boris Taslitzky,
Professor Halbwachs,
Buchenwald, 1945

Plate 11: André Zucca, view
of the Champs-Élysées, 1942

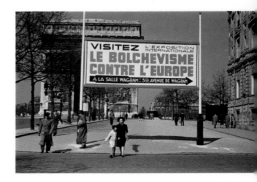

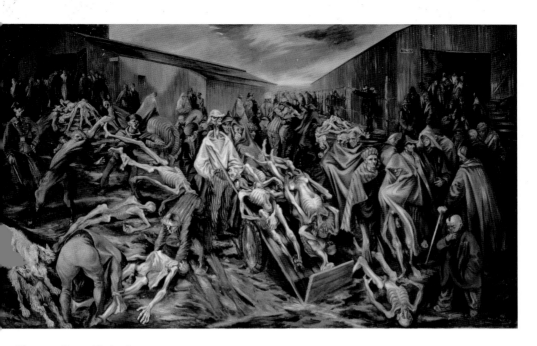

Plate 13: Boris Taslitzky,
The Small Camp, Buchenwald, 1946

Plate 14: Boris Taslitzky,
The Death of Danielle Casanova, 1950

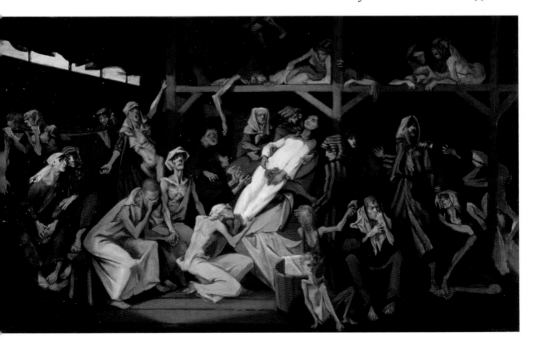

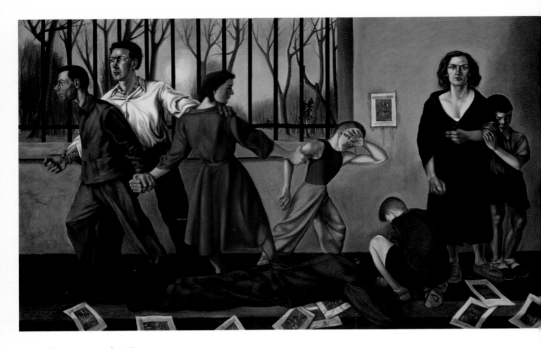

Plate 15: André Fougeron,
Homage to André Houiller, 1949

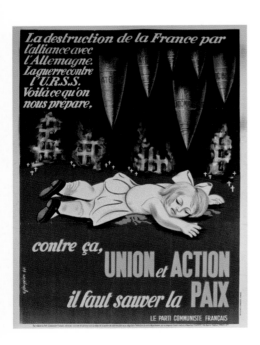

Plate 16: André Fougeron,
peace poster, 1948

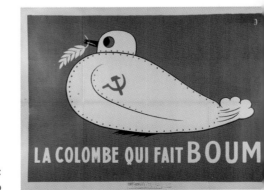

Plate 17:
The Dove that Goes BOOM!, 1950

he claimed here, would lead to suicide or assassination; life or death decisions depended constantly upon bureaucracies, clans and cliques.[47]

The show trials and executions of Zinoviev and Kamenev were denounced by André Breton, the Surrealist leader, at a mass meeting in September 1936.[48] He protested against the second wave in January 1937.[49] Trotksy's *La Révolution trahie* ('the Revolution betrayed') appeared in 1936: 'Facts are deformed, documents hidden or on the contrary fabricated, reputations are forged or destroyed ... The life of Soviet art is a martyrology. After the directive from *Pravda* against formalism, an epidemic of repentance has begun among writers, painters, theatre producers, even opera singers.'[50] The influential novelist and intellectual André Gide, who had opened the Writers Congress in June 1935, had a worldwide impact with his unanticipated denunciation, *Back from the USSR* in November 1936 (to be followed in 1937 by his sequel with its horrifying statistics).[51]

All the while Iofan's USSR pavilion rose steadily on the Champ-de-Mars. His project compelled Albert Speer to modify his own designs for the Nazi pavilion opposite.[52] Like a giant and functional Malevich *Architecton*, the building ascended triumphantly as metaphor of the progress and conquests of socialism while providing a giant plinth for Vera Mukhina's ten-metre-tall, flamboyant stainless steel sculpture.[53] Visitors were dazzled. At its base, flanking the entrance, were Joseph Chaikov's massive twin proplyea decorated with bas reliefs representing the eleven republics of Stalin's 1936 constitution: men and women in traditional costume bearing regional attributes from wheat to oil derricks, separated by heraldic medallions. Inside the pavilion on a wall under a barrel vault, Stalin's ominous words of 'peace' resonated with his insistence on the Soviet Union's right to its own territories.[54] The interior by one of Malevich's disciples, Nikolai Suetin, was 'modern-style' with cool, high spaces and a total absence of ornament. His pillars and free-standing elements (again based on Malevich's 1920s *Architectonies*) rhymed the space and the ascending steps like staggered obelisks. Great mural painting schemes masterminded by Aleksandr Deineka aimed at a hallucinatory realism: a sculptured Stalin in the centre of the room was surrounded by cheering crowds depicted on every side. As with every national pavilion, the huge receding hall space held an exhibition of Soviet painting, history paintings of the civil war, Red Army works, together with sculpture, theatre designs and craft: regional offerings from the Urals or Tadjikistan. On special tables albums reproduced the most important works from the Hermitage,

the Tretyakov Gallery and the Museums of Western and Oriental Art. The new Lenin Museum created in Moscow in 1936 was highlighted. Public sculptures by Sergei Merkurov showed socialist realism at an apogee: a seated, turning Lenin (hints of Michelangelo's *Moses*) complemented his Stalin standing Caesar-like with floor-length greatcoat. Gustav Klucis's panoramic photomontage, *Soviet Citizens Voting for Stalin's Constitution* (with tribune and ghostly bust of Lenin), demonstrated how photomontage, including snapshot portraits, could function dialectically; how this new, quasi-cinematic form could be used as a transitional stage 'backwards' from modernism, as aids for traditional oils, such as Alexander Gerasimov's photography-based, painted Stalins.[55]

Gisèle Freund, the anti-fascist photographer and friend of Walter Benjamin, emphasised the dominance in the pavilion of 'monumental photography', its links with cinema and correspondences with Marxist theories of realism.[56] In contrast, the satirical review *Le Crapouillot* chose Gerasimov's oils as its political target. Its 'Brainwashing' number reproduced Gerasimov's *Stalin at a Meeting with Commanders* (fig. 16). It was captioned:

> Exhibited in the USSR Pavilion, this painting in the best tradition of the 'Artistes français' of 1890, represents the principal Russian military leaders. The game is to calculate the exact number of generals who have been shot since the opening of the exhibition.[57]

News circulated: on 11 June 1937 Stalin executed Toukhatchevsky, a marshal attached to the Ministry of Defence in charge of the Red Army's armaments and strategy.[58] Subsequent executions involved two more marshals, eleven commissars from Defence, thirteen of Stalin's fifteen army generals and 35,000 officers.[59]

French Communist cultural policy and the push for socialist realism confronted this context, once again, with a strategy of nationalisation. Rather than promoting a revolutionary romanticism in harmony with the street militancy of 1936, a patriotic equivalence was rhetorically stage-managed involving the French tradition. In the prestigious Comédie des Champs-Élysées on 5 October, Louis Aragon's speech 'French realism, Socialist realism' attempted to de-Sovietise his previous rhetoric, specifically relating his examples to the 'Masterpieces of French Art' – while subtly distancing *Guernica*:

> Pablo Picasso was a great Spanish painter, whether he wishes it or not. And this is his grandeur today while Spain is bleeding, and it will be

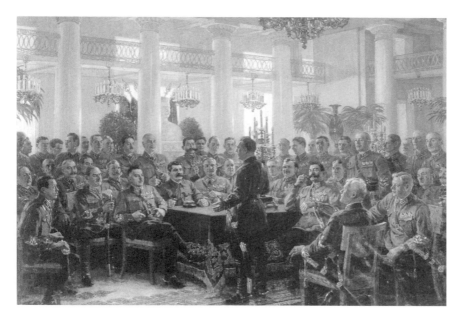

Figure 16: Alexandr Gerasimov, *Stalin at a Meeting with Commanders*, 1937

his grandeur tomorrow when it will have chased away the foreigners thanks to the miners of Asturias and the goldwashers of Pennaroya ... Socialist realism will only find its universal value by plunging its roots into the particular national realities of the soil from which it springs.[60]

As literally millions of tourists enjoyed Paris's huge transformation with new architecture, art and sculpture, news had arrived, following the bombing of Guernica, that affected perceptions of Albert Speer's German pavilion. In the first *Cahiers d'Art* magazine of 1937, editor Christian Zervos denounced the new art structures in Germany, persecution and censorship. Reports on the *Entarte Kunst* 'degenerate art' show in Munich reached the French public through the summer.[61] Yet the general response to the pavilion continued to be one of admiration. Speer's soaring arrangement of twelve neoclassical columns (Germany's first international statement since the Berlin Olympics) evoked precursors from Wagner and Bruno Taut to the 'light-architectures' in early German cinema when illuminated at night.[62] Kurt Schmid-Ehmen's nine-metre-high bronze Imperial eagle, which topped the pavilion, won a French Grand Prix. The perron was flanked with muscular sculptures by Josef

Thorak of *Friendship* and *Genius*. Tapestries and paintings lined the interior space, lit by imposing chandeliers, where academic, realist styles and the cult of medievalism were celebrated – with a white Mercedes in the middle of the hall. This streamlined technology embodied a will to power which belied the unifying functions and nationalist, backward-looking messages of folklore and tradition.[63] The Nazi and Soviet neoclassicism at the Fair legitimated not only current power and desires for domination, but concepts of a longer *durée*: the thousand-year Reich or the dialectic between an Eternal Russia and the timeless utopia of 'socialism achieved'. The clash with revolutionary teleology (and new technology) is clear; the 'bolshevik-style' pavilions' deliberate political and aesthetic choices also point to questions of 'heterochrony': different time-ideas clashing in an arena (the 1937 fair) which brought together different spaces. This problematic appears again in Picasso's 'modernist versus Marxist' 1940s.

Picasso's work now functioned as a sign of resistance; his prestige was now aureoled with anti-fascist allegiances and was co-opted in the second number of *Cahiers d'Art* for 1937 to confront developments in Nazi Germany: Paul Éluard's poem 'The Victory of Guernica', illustrated with Picasso's lithographs of *Dream and the Lie of Franco*, preceded a review of the official French art show sent to Berlin – illustrated with two of Hitler's watercolours; subsequently Hitler's attitudes to modern art as *judeobolchevik* were attacked.[64] Yet the French right disconcertingly echoed Nazi sentiment: Ralph Soupault's caricatures of the 'Ideal Exhibition' in *L'Action Française* of 6 June 1937 parodied 'bolshevik' modernist buildings flying the Franco-Soviet flag; an obese, 'Jewish' Muse was shown presiding over the 'Pavilion of the Fine Arts'; premier Léon Blum himself was the butt of scornful antisemitism.

The Dream and the Lie of Franco appeared again in the December 1937 show 'Cruel Art' at the Galerie Billiet-Vorms, where the young André Fougeron appeared as Picasso's acolyte with a satirical *Homage to Franco*. It was as newly-appointed director of the Prado Museum in Madrid that Picasso sent a telegram to the Congress of American Artists in New York on 17 December to tell them that the Republican government had taken all necessary steps to protect Spain's artistic heritage.[65]

Between May and the end of November 1937, the World Fair sites received over 34.5 million visitors.[66] Walter Benjamin's thoughts at this moment are pertinent. More powerful, surely, than any discussion of a work of art's lost 'aura' was his prediction of the 'revenge of technology' in his 1936 essay on reproduction.[67] This intuition is the crux of meaning

of Picasso's *Guernica* and all future Guernicas, here framed by Paris's politicised art world during the years 1936–37. Now, reflecting upon the large-scale workers' strikes of November 1937, he reverted to his early critique of Georges Sorel's *Reflections on Violence*, and the dialectic between State-sanctioned violence and violence opposed to, and by, the State.[68] This was played out for real in the contrast between massive popular protest and the huge crowds at the fair, dazzled by the signs of power materialised in architecture, painting and sculpture.[69] The mass demonstrations in France, extending from the first fascist riots of February 1934 through the Popular Front period, created arenas where joyful celebrations, funeral processions and strikes and the possibility of violence came together, blurring issues of 'the left', 'anti-capitalism', 'workers' rights', mourning and filiation, often disturbingly close to analogous mass events elsewhere. Zeev Sternhell's controversial *Neither Right nor Left* documents these parallels, in which there was always the potential for ideological reversals.[70]

All eyes were upon Spain, Germany, Russia: the Spanish stage rightly perceived as a rehearsal for a greater world war. Art, too, became a victim: Spain's art and architectural heritage was menaced. The contents of the great modern German museums started to be destroyed or exported. France was apprehensive: evacuation plans for the Louvre were drawn up as early as 1936.[71]

On 31 January 1938 'Five Years of Hitler Dictatorship', organised by the anti-fascist Thaelmann Committee, opened on 10 rue de Lancry. Generally documentary in nature, it included photomontages by John Heartfield. A forty-page album, *Cinq ans de dictature hitlérienne*, was published with nine engravings by Kivitz, and texts including statements by Goethe, Heine, Barbusse, Romain Rolland and Hitler himself.[72] The German embassy used the situation to pressurise the French government, insisting that four works be covered up and the album withdrawn from sale. There was an agitated political and press response; the publicity left none in doubt about the atrocities current in the Reich.[73]

A full report on the state of affairs in Germany was sent by the New Germany League to the Maison de la Culture artists' journal, *Peintres et Sculpteurs de la Maison de la Culture* (*PSMLC*). 'Degenerate Art. Freedom of the Spirit under the Fascist Regime' was published in its fifth issue of May 1938. Hitler's speech of 18 July 1937 was quoted from the *Voelkischer Beobachter* (this appeared in French and reviewed all the exhibitions held in Germany in 1937). The *PSMLC* article listed the closing of modern art sections in all museums, the relegation of works

by Liebermann, Corinth, Franz Marc, Paula Modersohn, Lehmbruck, Barlach, Paul Klee, Kokoschka, Max Beckmann and Chagall to storage, and their replacement by academic works to the Führer's taste, with more witch-hunt details and epithets – Rembrandt as 'ghetto-painter', for example. It was reported that 'degenerate' artists were no longer allowed to exhibit in the Reich. The prohibition of the works of Max Liebermann in October 1934 was extended to Ernst Rohlfs in 1937. (Each artist was eighty-seven years old at the time, and both were to die shortly afterwards.)[74] The Maison de la Culture's little-known 'Free German Art Show' coincided with reports in France of *Kristallnacht* 9–10 November 1938 – the 'Night of Broken Glass', in which business were smashed, Jewish property ransacked and destroyed, and as many as 30,000 arrests and deportations to camps took place, radically transforming the nature of the Nazi threat.[75]

* * *

On 8 November 1938 the synagogue in Max Raphael's native town of Schonlanke was burned to the ground; the entire Jewish population was deported.[76] In France, Raphael himself was arrested and released in 1939, then sent to the internment camps for aliens: first to Gurs with his wife Emma Dietz, then alone to the Camp des Milles; he continued to write about art. He managed to reach the border with Spain and, unlike Walter Benjamin, escaped via Portugal to New York. After his life-changing encounter with the Nazification of the German art establishment, the grotesque persecution of 'degenerate art' and artists, and his experience of antisemitism at its most profound, Raphael had been forced to confront his Marxist ideals with the Molotov–Ribbentrop non-aggression pact that allied the USSR with Nazi Germany.

Willi Münzenberg's mighty empire collapsed: it was he who had generated a visual world which offered the industrial masses their first opportunity for self-representation in photography, photomontage and film. He was replaced as Comintern leader in Paris in December 1936; he denounced Stalin after the Nazi–Soviet pact. He was interned by the Daladier government before escaping. In June 1940, in a forest in the Isère (Rhône-Alpes), his decayed corpse was found with a rope around its neck, his death disguised as a suicide.[77] The vast international Comintern project was formally dissolved by Stalin in 1943.

Notes

1 'Une gigantesque exposition de l'état de progrès en un moment tragique du monde.' Amédée Ozenfant, 'Notes d'un touriste à l'exposition', *Cahiers d'Art*, 8–10 (1937), pp. 241–47.

2 My translation amends that in Max Raphael, *The Demands of Art*, trans. N. Guterman (London: Routledge and Kegan Paul, 1968), p. 169.

3 *Exposition Internationale des Arts et des Techniques de la vie moderne*, 25 May–25 November 1937, Paris.

4 *Encounters with the 1930s*, 3 October 2012–7 January 2013, Museo Reina Sofía, Madrid; *Picasso & Modern British Art*, 15 February–15 July 2012, Tate Britain, London.

5 Romy Golan, *Muralnomad: The Paradox of Wall Painting, Europe 1927–1957* (New Haven, CT, and London: Yale University Press, 2009). Iwona Blazwick ed., *Goshka Macuga: The Nature of the Beast*, (London: Whitechapel Art Gallery, 2010, Bloomberg Commission, 2009).

6 See http://www.worldfairs.info/expopavillonslist.php?expo_id=12 (accessed 9 July 2013), which significantly develops the scope suggested by the exhibition and catalogue *Paris 1937: Cinquantenaire de l'Exposition Internationale des arts et des techniques de la vie moderne*, ed. B. Lemoine (Paris: Institut Français d'Architecture, 1987).

7 See http://www.expositions-universelles.fr/1937-exposition-internationale-chaillot. html (accessed 9 July 2013) for a visual comparison of the Palais de Chaillot and Palais de Tokyo, Paris.

8 *Chefs-d'œuvre de l'art français*, organised by Georges Huisman, Directeur Général des Beaux-Arts under Léon Blum; Palais National des Arts: 1,300 items (paintings, drawings, sculptures, tapestries and objets d'art, from Gallo-Roman times to the Douanier Rousseau).

9 See Raymond Escholier, *Maîtres de l'art indépendant* (Paris: Arts et métiers graphiques, 1937); Danielle Molinari, ed., *Paris 1937, Art indépendant* (Paris: Musée de la Ville de Paris, 1987); and Yvonne Zervos, *Origines et développement de l'art international indépendant* (Paris: Musée du Jeu de Paume, 1937).

10 See Martine Contensou, *La Fée électricité* (Paris: Paris-Musées, 2008).

11 See Rachel Mazuy, 'Le Rassemblement universel pour la Paix, 1931–1939. Une organisation de masse?', *Matériaux pour l'histoire de notre temps*, 30 (1993), pp. 40–44; and the RUP archives, International Social History Association, Amsterdam.

12 It was France that actually suggested a policy of non-intervention to Britain on 2 August 1936; the treaty, signed 8 August, was ratified in September.

13 See Catherine Blanton Freedberg, *The Spanish Pavilion at the Paris World's Fair*, 2 vols (New York and London: Garland Publishing, 1986), vol. 1, p. 122.

14 Martha Thome, 'Espagne', in *Cinquantenaire de l'Exposition Internationale*, p. 146.

15 The *Livre d'or de l'exposition* gives a mere half page to the Spanish pavilion. Picasso and *Guernica* are not mentioned. See F. Chapsal et al. eds, *Livre d'or officiel de l'exposition internationale des arts et des techniques de la vie moderne, Paris, 1937* (Paris: Spec, 1938).

16 Freedberg's *Spanish Pavilion* involved extensive collaboration with Josep Lluís Sert among others, but was written before additional material was released in 1986–87 under the 'fifty year rule'.

17 See Shanny Peer, 'Presse', 'Publicité', 'Radio', in *Cinquantenaire de l'Exposition Internationale*, pp. 238, 240, 242.

18 Freedberg, *Spanish Pavilion*, vol. 1, pp. 174–81; on Sert and Lacasa, pp. 174–75, and notes pp. 223–26.

19 Freedberg, *Spanish Pavilion*, vol. 1, p. 284: 'In effect they (the photomontages) formed a gigantic mural magazine whose contents were to be continuously updated in order to report the unfolding events in Spain.' Freedberg does not make the important analogy with the Pravda building (or, for example, the Oskar Nitzchke 'Maison de la Publicité' project 1935, constructed on the same principles).

20 See Albert Forment, ed., *Josep Renau* (Valencia: IVAM, 2004) especially for the debt to John Heartfield as a photomontage artist and his role in protecting Spain's cultural heritage.

21 'Il y a plus d'un demi / million d'espagnols / avec des baïonnettes / dans les tranchées / qui ne se laisseront / pas marcher dessus. / President Azana.'

22 The panel from 'Missions Pédagogiques', photo Bonney, is reproduced in *Paris 1937*, p. 38; see also Jordana Mendelson, *Documenting Spain: Artists, Exhibition Culture, and the Modern Nation, 1929–1939* (University Park, PA: Pennsylvania State University Press, 2005), p. 145.

23 See Magdalena Dabrowski, '*González,* Montserrat and the Symbolism of Civil War', in W.H. Robinson et al., *Barcelona and Modernity. Picasso, Dali, Miró, Gaudi* (Cleveland, Ohio: Cleveland Museum of Art with, New Haven, CT, and London: Yale University Press, 2006), pp. 468–73.

24 Anthony Blunt, *Picasso's Guernica* (Oxford: Oxford University Press, 1969), p. 59, note 2.

25 Rosi Huhn, in *Cinquantenaire de l'Exposition Internationale*, p. 403, refers to the discussions of the influence of the mass-media on *Guernica* as discussed in Jean-Louis Ferrier, *De Picasso à Guernica, généalogie d'un tableau* (Paris: Hachette Littératures, 1985), and Waltraud Brodersen, 'Medien reflexion als Methode künstlerischer Arbeit', in H.J. Neyer, ed., *Absolut Modern Sein – culture technique in Frankreich 1889–1937* (Berlin: Elefanten Press Verlag, 1985).

26 Raphael, *Demands of Art*, pp. 139, 140–41.

27 'la désagrégation du monde en proie aux horreurs de la guerre'; full postcard text given in Freedberg, *Spanish Pavilion*, vol. 1, p. 455.

28 Quoted by Freedberg, *Spanish Pavilion*, vol. 2, in English as part of Appendix IV, pp. 785–87: 'Words spoken in French at the Inauguration of the Spanish Pavilion at the Paris World Exposition, in the Spring of 1937.' See also an alternative reference, p. 635 (both unsourced).

29 Freedberg, *Spanish Pavilion*, vol. 1, p. 669 note 72, and eyewitness report by George Steer for the London and New York *Times* (Bilbao, 27 April, in Freedberg, *Spanish Pavilion*, vol. 1, pp. 664–68). See Herschel Chipp, *Picasso's Guernica: History, Transformations, Meanings* (Berkeley: University of California Press, 1988); and Ellen C. Oppler, *Picasso's Guernica: Illustrations, Introductory Essay, Documents, Poetry, Criticism, Analysis* (New York and London: Norton, 1988). See also Gijs van Hensbergen, *Guernica. The Biography of a Twentieth-Century Icon* (London: Bloomsbury, 2004).

30 The Nativity analogy and the relationship with Goya in *Guernica* was first pointed out by Toni del Renzio at the Art Historians Association Conference, 31 March 1985.

31 'Hommes réels pour qui le désespoir / Alimente le feu dévorant de l'espoir / Ouvrons ensemble le dernier bourgeon de l'avenir. / Parias la mort la terre et la hideur /

De nos ennuis ont la couleur / Monotone de notre nuit, / Nous en aurons raison.' Paul Éluard, 'La Victoire de Guernica', 1937.

32 *Rapport Général*, reprinted in Freedberg, *Spanish Pavilion*, vol. 2, Appendix 1. Subsequent quotations are from this source.

33 See the installation photographs in Freedberg, *Spanish Pavilion*, vol. 2, p. 1058, figs 17 and 17a, Spanish pavilion: third floor, Emiliano Barral and Pérez Mateos exhibition.

34 Raphael, *Demands of Art*, p. 141.

35 See Freedberg, *Spanish Pavilion*, vol. 1, chapter 7 with a very extensive discussion of *Le Faucheur* with notes, pp. 525–601.

36 François Moulignat, 'Les Artistes en France, face à la Guerre d'Espagne et la montée du fascisme, 1936–1939', PhD thesis, Paris-Sorbonne I, 1977, takes as its initial premise a *rejection* of the 'reflection theory' which he equates with an almost primitive form of nostalgia (p. 43).

37 The title 'Musée d'Éducation Populaire' replaced 'Musée d'Urbanisme' and the original 'Musée de l'Esthétique Contemporaine'.

38 Jeanneret had created canvas vacation houses responding to Popular Front 'paid holiday' reforms, and tents commissioned by the Maison de la Culture for the Communist autumn 'Fête de l'Humanité'.

39 See Gilles Ragot, 'Le Pavillon des Temps Nouveaux', in *Cinquantenaire de l'Exposition Internationale*, pp. 250–53; Jean-Louis Cohen, 'Architectures du Front populaire', *Le Mouvement social: bulletin trimestriel de l'Institut français d'histoire sociale*, January–March 1989, pp. 49–59; and above all Danilo Udovikci-Selb, 'Le Corbusier and the Paris Exhibition of 1937. The Temps Nouveaux Pavilion', *Journal of the Society of Architectural Historians*, 56/1 (March 1997), pp. 42–63.

40 See El Lissitzky, *Entwurf fur die 'Pressa'* (1927), in Evelyn Weiss, ed., *Russische Avant-Garde, 1919–1930* (Munich: Prestel Verlag, 1986), pp. 82–83.

41 For the Agriculture pavilion photomontage and Charlotte Perriand, see Golan, *Muralnomad*, pp. 152–56, figs. 108, 109, 110, 112, 113.

42 Le Corbusier, *DES CANONS, DES MUNITIONS? MERCI! DES LOGIS... S.V.P.* (Boulogne: Éditions de l'Architecture d'Aujourd'hui, 1938).

43 See Jean-Marie Dubois, 'Travail', in *Cinquantenaire de l'Exposition Internationale*, pp. 258–59; *Le Populaire*, 24 May 1937; and F. Goerig-Hergott et al., *Karl-Jean Longuet et Simone Boisecq* (Lyons: Fage éditions, 2011), pp. 37 (busts of Karl Marx, 1930, 1936, illus.), 41 (bust of Guesde, illus.).

44 See Michel Surya, *Georges Bataille, la mort à l'œuvre* (Paris: Librarie Séguier, 1987), pp. 167–78.

45 Henri Barbusse, *Russie* (Paris, Flammarion, 1930), p. 164.

46 See Frank Field, *Three French Writers and the Great War. Studies in the Rise of Communism and Fascism* (Cambridge: Cambridge University Press, 1975), p. 7: he asserts that Alfred Kurella was the badly treated author of Barbusse's *Staline*.

47 Boris Souvarine, *Staline. Aperçu historique du Bolchevisme* (Paris: Libraire Plon, 1935), pp. 530–31, 544: 'un état de choses où tout antagonisme sérieux doit conduire tôt ou tard au suicide, comme celui de Skyrpnik, ou à l'assassinat, comme celui de Kirov, sous une forme ou sous une autre. Entre fractions bureaucratiques différenciés, leurs Staline de toutes tailles et leurs Molotov de tous calibres, entre leurs clans et leurs cliques, la question de vie ou de mort est posée en permanence.'

48 See 'Appel aux hommes', and 'Déclaration lue par André Breton le 3 septembre 1936 au meeting: "la Vérité sur le Procès de Moscou"', in José Pierre, ed., *Tracts Surréalistes et déclarations collectives* (Paris: Le Terrain Vague, 1982), vol. 1, pp. 304–07, and notes pp. 509–13.

49 See 'Discours d'André Breton à propos du Second Procès de Moscou', in Pierre, ed., *Tracts Surréalistes*, pp. 308–11, wrongly dated '16 janvier'. This is corrected to '26 janvier 1937' in the notes pp. 513–19, which detail more executions.

50 'Les faits sont déformés, des documents cachés, ou au contraire, fabriqués, les réputations forgées ou détruites [...] La vie de l'art soviétique est un martyrologie. Après l'article directive de la *Pravda* contre le formalisme, on voit commencer parmi les écrivains, les peintres, les régisseurs et même les chanteuses d'opéra, une épidémie de repentir.' Leon Trotsky, *La Révolution trahie*, trans. Victor Serge (Paris: Bernard Grasset, 1936), p. 209. See also Victor Serge, *Destin d'une révolution, U.R.S.S., 1917–1936* (Paris: Bernard Grasset, 1937), pp. 153ff.

51 André Gide, *Retour de l'U.R.S.S.* (Paris: Gallimard, 1936) was followed by *Retouches à mon retour de l'U.R.S.S.* (Paris: Gallimard, 1937), where he claims to have been brought documentation and statistics from Soviet sources by Trotsky and Victor Serge among others. Anton Ciliga's *Au Pays du grand mensonge* (Paris: Gallimard, 1938), was translated into English as *The Russian Enigma* (London: Routledge, 1940).

52 M. Philippe Lamour, quoted in Chapsal et al., *Livre d'or officiel*, p. 514. See also Albert Speer, *Au cœur du troisième Reich* (Paris: Fayard, 1971), p. 117.

53 Matthew Cullerne-Bown, *Art under Stalin* (Oxford: Phaidon, 1991), p. 82: 'It became the great symbol of Stalin's USSR, defined in the new constitution of December 1936 as "a state of workers and peasants"' ... completely hand-made, laboriously fashioned in individual sections, each shaped on a carved wooden template.'

54 See *Cinquantenaire de l'Exposition Internationale*, p. 187, and Chapsal et al., *Livre d'or officiel*, p. 514, where the report on the Soviet pavilion, pp. 491–505, is complemented by the *Rapport Général*, vol. 10, 'Les Sections Etrangères, Deuxième partie: L'U.R.S.S.'

55 Chapsal et al., *Livre d'or officiel*, p. 504.

56 Gisèle Freund, 'La photographie à l'Exposition', *Arts et Métiers Graphiques*, 62 (1938), p. 38.

57 'Exposé au Pavillon de l'U.R.S.S., ce tableau, dans la meilleure tradition des de 1890, représente les principaux chefs militaires russes. Le jeu consiste à calculer le nombre exact de généraux qui ont été fusillés depuis l'ouverture de l'Exposition.' *Le Crapouillot*, 20 (1937), 'Le Bourrage de Crânes', p. 50.

58 This information is quoted in Philippe Rivoirard, 'Le Pacifisme et le Tour de la Paix', *Cinquantenaire de l'Exposition Internationale*, p. 316.

59 Cullerne-Bown, *Art under Stalin*, p. 109, notes that the major Industry of Socialism exhibition was due to open in 1937 for the twentieth anniversary of the Revolution and the start of the third Five-Year Plan. Stalin's purges required the continual repainting of group portraits, delaying the opening until 1939. The story was the same for the All-Union Agricultural exhibition with its various regional pavilions, including a 'Gulag' pavilion devoted to the constructive achievements of the prison camp administration! This was also postponed to 1939.

60 'Pablo Picasso [...] fut un grand peintre espagnol, qu'il le veuille ou non. Et c'est aujourd'hui sa grandeur, quand l'Espagne saigne, et ce sera sa grandeur demain quand elle aura chassé les étrangers grâce aux mineurs des Asturies et aux laveurs

d'or de Pennaroya [...] Le réalisme socialiste ne trouvera dans chaque pays sa valeur universelle qu'en plongeant ses racines dans les réalités particulières, nationales, du sol duquel il jaillit.' Louis Aragon, 'Réalisme socialiste, réalisme français', *Europe*, 183 (March 1938), pp. 301, 303.

61 Quoted in *Cahiers d'Art*, 8–10 (1937) (special Exposition Internationale number). See also *Le Temps*, 21 July, quoted in *Journal des peintres SMC*, 5 (May 1938), p. 50: 'Art Allemand Libre' was held at the Maison de la Culture from 4–18 November 1938, coinciding with Kristallnacht, and sent later to London.

62 Dieter Bartezko, in *Cinquantenaire de l'Exposition Internationale*, pp. 134–39, with bibliography.

63 See the relevant illustrations in Berthold Hinz, *Art in the Third Reich* (Oxford: Basil Blackwell, 1980) (revision of the 1974 German version).

64 Ch. Zervos, 'Réflexions sur la tentative d'esthétique dirigée du IIIᵉ Reich', *Cahiers d'Art*, 6–7 (1937), pp. 51–61. José Bergamin, 'Tout et rien dans la peinture', *Cahiers d'Art*, 6–7 (1937), p. 62, illustrated with Goya etchings, reveals, significantly, that both Hitler and Goebbels boycotted the exhibition of 'Art Français Moderne' which opened at the Prussian Academy of Fine Arts in Berlin on 1 June 1937.

65 *Journal des peintres SMC*, 2 (1937), p. 1.

66 Alexandre Labat, 'Le Projet de reconduction', in *Cinquantenaire de l'Exposition Internationale*, p. 479.

67 Walter Benjamin, 'L'Œuvre d'art à l'époque de sa reproduction mécanisée', trans. Pierre Klossowski, in *Zeitschrift für Sozialforschung*, vol. V (Paris: Félix Alcan, 1936), p. 28.

68 See Walter Benjamin, 'Critique of Violence' (1921), in Benjamin, *Reflections; Essays, Aphorisms, Autobiographical Writings*, ed. Edmund Jephcott (New York: Schocken Books, 1986), pp. 277–300, and Victor Sartre, *Georges Sorel, élites syndicalistes et révolution prolétarienne* (Paris: Éditions Spes, 1937): 'Les grèves ouvrières viennent de remettre le nom de Georges Sorel à l'ordre du jour' (preface).

69 Chryssoula Kambas, 'Walter Benjamin lecteur des "Réflexions sur la violence"', *Cahiers Georges Sorel*, 2 (1984), pp. 71–89.

70 See Benjamin, letter to Lieb, 31 December 1937, Fritz Lieb archives, Basel; Kambas, 'Walter Benjamin lecteur', p. 85; and Zeev Sternhell, *Ni droite ni gauche, l'idéologie fasciste en France* (Paris: Seuil, 1983), trans. D. Maisel as *Neither Right nor Left: Fascist Ideology in France* (Princeton, NJ: Princeton University Press, 1995).

71 See Adeline Hulftegger, 'Les Musées en guerre', *Jardin des Arts*, 32/2 (June 1957), pp. 496–503.

72 N. Marceau et al., *Cinq ans de dictature hitlérienne* (Paris: Éditions du comité Thaelmann, 1938).

73 See Gilbert Badia, ed., *Les Bannis de Hitler: accueil et luttes des exilés allemands en France (1933-1939)* (Paris: Presses universitaires de Vincennes, 1984), pp. 260ff, involving extensive use of French police archives.

74 *Journal des peintres SMC*, 5 (5 May 1938): 'L'art dégénéré – La Liberté de l'esprit en régime fasciste'.

75 See Hélène Roussel, 'Les Peintres allemands emigrés en France et l'Union des artistes libres', in Badia, ed., *Les Bannis de Hitler*, pp. 286–326.

76 Account in *Paul Müller, Der Netzekreis: altpommersches Grenzland* (Lütt, 1966); my thanks to William Remus and Irma Erhart for this source and translation.

77 See Stéphane Courtois, ed., *Communisme*, 38–39 (1994) (Münzenberg number); and
 Sarah Wilson, 'Comintern Spin Doctor', *English Historical Review*, CXXVII/526
 (June 2012), pp. 662–68, for a critical review including Stephen Koch's *Double Lives:
 Spies and Writers in the Secret Soviet War of Ideas Against the West* (New York: Free
 Press, 1994); Sean McMeekin's *The Red Millionaire: A Political Biography of Willi
 Münzenberg, Moscow's Secret Propaganda Tzar in the West* (New Haven, CT: Yale
 University Press, 2003); and Alain Dugrand and Frédéric Laurent, *Willi Münzenberg,
 artiste en révolution 1889–1940* (Paris: Fayard, 2008).

4

Le Charnier or *Buchenwald*?
Communism and the Holocaust

In the *Charnel-House* there are no symbols and, perhaps, no prophecy. Its figures are facts – the famished, waxen cadavers of Buchenwald, Dachau and Belsen. The fury and shrieking violence that make the agonies of *Guernica* tolerable are here reduced to silence. For the man, the woman and the child this picture is a *pietà* without grief, an entombment without mourners, a requiem without pomp.

<div align="right">

Alfred H. Barr, 1946[1]

</div>

They died because cowardice and collaboration were the servile instruments of the terrifying project of their executioners. France lost part of its soul at that time...

<div align="right">

Bertrand Delanoë, 2006

</div>

Picasso's *Charnel House*, with its agonised twist of jumbled, inverted figures, is usually perceived as a 'postscript to *Guernica*'. Its strangely anachronistic title adds to its historical opacity. It seems to be a still life of body parts with a table. Rather than contours around strong paint areas, the lines here delineate a pitcher, a bowl: the ghosts of objects, not objects. The mass of toes, faces, torsos which might attempt to rise is pressed down by white nothingness. Even the pentimenti or the unusually blurred grey edge on the right of the bound wrists corroborate the sense of spectral presence (compare the upright fist salute in Dora Maar's first two photographs of *Guernica*). The lines speak of energies stilled; the almost black areas which tumble down from the right like a drapery, like the empty whiteness, bind the painting to silence (plate 10).

Max Raphael would have seen the reproduction of the unfinished work in Alfred H. Barr's *Picasso, Fifty Years of his Art* (1946), and read

Barr's final tribute. His thoughts would no doubt have turned to his own brother who died in Auschwitz, his family disappeared, so many friends and colleagues perished.[2] Yet rather than explicitly reconsidering *Guernica* in the light of the *Charnel House*, Raphael, as he continued to lecture before the painting in the Museum of Modern Art, New York, was more fascinated by Picasso's prescience in 1937; by the moment of shock whose power relates to the rapidity with which paralysing fear is engendered in the viewer, or to the abyss between empirical emotion and metaphysical consciousness which could produce only extreme affects such as the scream.[3]

The Holocaust was at the heart of the debate on realism and Communist cultural policy in 1945; the comparison between Picasso's work and Boris Taslitzky's *Buchenwald*, based on drawings and his survivor's experience of the concentration camp, demonstrates the high stakes of this encounter. Following the controversy around Picasso's show at the Salon of the Liberation (initiated by his future adversary André Fougeron), the Holocaust, its representation, France's role in deporting its citizens, the role of the *déporté* – the returned deportee – the represen-tation of the Holocaust and its usage are discussed in this chapter.

The Nazi occupation of Paris invaded the city structurally, visually, linguistically, focusing minds upon the enemy and on the Vichy govern-ment's capitulation; yet the relationship with the Soviet Union was constantly an issue. Anti-bolshevik propaganda produced in Germany had ceased with the shocking Molotov–Ribbentrop non-aggression pact of August 1939. After Hitler's unanticipated breach of the pact and surprise invasion of the USSR in June 1941, however, the Soviets became the Nazis' enemies: anti-bolshevik propaganda was relaunched by the German occupiers in Paris with a vengeance. Inversely, the Soviets once more became the imaginary brothers-in-arms of French Communist Resistance fighters. The Communist Party, which had been deeply compromised by the Nazi–Soviet pact, henceforth put all its efforts into the Resistance. Specifically selected as hostages for reprisal shootings, the Communists became members of 'the Party of the 75,000 martyrs of the firing squad' (*75,000 fusillés*) at the Liberation. Anti-bolshevism followed by Communist resistance, rather than any persisting Marxism, impacted upon the occupied populations of Paris; Marxism would be reclaimed as part of the relation with the Soviet Union after the war (*La Nouvelle Critique* was set up as a 'review of militant Marxism' in 1948).

Picasso's stance following the declaration of war, the invasion of France and the fall of Paris was admirable.[4] After the period spent in Royan,

he returned to Paris in August 1940, two months after the German occupation, moving to his studio at 7 rue des Grands Augustins. His relationship with Dora Maar (the 'weeping woman' of the works relating to *Guernica*) deteriorated; the sombre and aggressive heads he painted at this period are well known, as is his play, *Desire Caught by the Tail* in 1941 and its reading with Jean-Paul Sartre, Simone de Beauvoir and others in 1944 (photographed by Brassaï). Picasso's new life with Françoise Gilot would now begin. Our access to Picasso's mind through his poetry and war writing at this period is particularly illuminating.[5] Scholars continue to debate the mystery of his access to bronze casting during the war: his tragic, brutalised *Skull* in bronze and the *Bicycle Saddle and Handlebars*, transformed into a bull's head, date from this time.[6] Named simply *Object*, the latter was illustrated on the cover of the clandestine neo-surrealist periodical which Picasso supported, *Les Pages libres de la Main à Plume*. Its twelfth issue reproduced *Guernica*, works of 1913, 1939 and the *Object*, again, of 1942.[7] This appeared when the 'Main à Plume' group's political position was confused: their surrealist allegiances were swerving towards Communism: a key member, for example, was the writer André Stil, a future Stalin prize laureate.

L'Art en guerre. France 1938–1947. De Picasso à Dubuffet commemorated the energy and the tragedy of these years with a large exhibition in 2012.[8] Beyond Picasso and the artistic life that managed to flourish in Paris with its artists' studios, official Salons, brave galleries and clandestine networks, the dense texture of occupation and collaboration in the capital must be emphasised. Parisian nerves were – and are – still raw in this area; the ethical questions still burning. The reality of an emptying, scared and starving Paris was described by a dismayed art lover in *l'Art français*, the journal of the resistant National Front of the Arts:

> I ask myself are we really in 1942, and if it's really true that outside, in this foggy morning, long queues of shivering women wait outside empty shops; that a million prisoners, forced into hard labour, starving, are wracked with anxiety in the camps; if it's true that at the same moment, trucks pull up in front factories, spilling out men with helmets, boots, machine guns, to sweep up 100 to 200 frail Frenchman; if it's really true that somewhere, at this very moment, guns are firing, hostages are falling …?[9]

In contrast, André Zucca's Agfacolour photographs for the propaganda magazine *Signal* showed Parisian life under the Nazis as elegant, sunny and unperturbed. These works caused bitter scandal when shown,

brightly and contentiously restored, in an exhibition of 2008 (plate 11).[10] In contrast, *Ville lumière, années noires* by Cécile Desprairies, published the same year, takes the reader building by building, arrondissement by arrondissement, though a city horribly violated and appropriated, so many of its citizens 'disappeared'. Convoy after convoy of men, women and children were sent to Germany via Pithiviers, via Drancy: poets such as Robert Desnos or Max Jacob, painters such as Otto Freundlich with so many other artists of the School of Paris, met their deaths in Poland or en route.[11] 'Montparnasse deported' was the title of a major show with a catalogue in 2005.[12]

In this context, four Nazi-inspired exhibitions must be highlighted which Picasso could not have ignored: the Anti-Freemasonry exhibition of 1940; the 'Exhibition of European France' (1941); 'The Jew and France' (1941); and, following Hitler's invasion of the USSR, the 'International Exhibition: Bolshevism against Europe' (1942). Their scope and popularity (with the exception of 'The Jew and France') seem to have escaped most scholars of art during the French Occupation.

It is well known that Picasso chose to leave 23 rue La Boétie, where he had moved partly to be close to his dealer, Paul Rosenberg. He returned from Rohan to live in the cold rue des Grands Augustins studio. But has it been sufficiently emphasised that Rosenberg's magnificent *hôtel particulier*, 21 rue La Boétie (also the address of the Galerie Wildenstein), was requisitioned by the police on 4 July 1940, his works of art confiscated, and that, on 11 June 1941, the Institute for Jewish Questions (IEQJ – Institut d'étude sur les questions juives) was inaugurated there, literally next door to Picasso?[13] The Institute was financed by the German Embassy and the 'Gestapo for Jewish questions', who had appropriated a Rothschild mansion on the avenue Foch.

Just as in 1937 the Nazi and Soviet pavilions functioned politically, so art politics immediately played a role in occupied Paris. The 'return' of German national treasures and the 'return' of Spanish art to Franco from museum collections was organised; Monets from Berlin and Bremen were added to the Monet–Rodin retrospective in November 1940. The great buildings inaugurated for the Paris World Fair of 1900, the Grand Palais and Petit Palais, were disfigured with highly popular propaganda shows. Opening in October 1940 at the Petit Palais, the anti-freemasonry exhibition with its recreations of the interiors of masonic lodges, paintings of skulls or odalisques and crude explanatory slogans (in Hitler's 'Degenerate Art' show mode) attracted a public of many thousands of visitors.[14] The 'Exhibition of European France'

opening at the Grand Palais on 1 June 1941 resembled a mini World Fair, displaying the future of French industry, agriculture, urbanism and transport under collaboration, with an accent on regionalism and artisanal skills. The Vichy government's payment of massive sums to support the German occupation (initially set at 20 million Reichsmarks daily) and the effective de-industrialisation of France was the unspoken subtext: 1.5 million French soldiers – key manpower – remained German prisoners of war.[15] For this exhibition there were over 600,000 paying visitors.

'Jewish-Marxist' (*judéo-marxiste*) as well as *zazou*, a 'punk' term, were also epithets thrown at the so-called 'Young Painters of the French Tradition', once known as the 'Indelicates'. Fougeron, Maurice Estève, Edouard Pignon and their peers, the militant young AÉAR artists of the 1930s, were now working in a Matisse–Picasso mode. They first showed their work at Galerie Braun in May 1941 and continued to exhibit through the Occupation. Their patriotic red and blue tonalities, sense of musicality and post-cubist armatures became dominant in post-war Parisian painting of the later 1940s.[16]

Evidently, after June 1941 and Hitler's invasion of the USSR, the name 'bolshevik' once more became a term of abuse. The French Communist Party, in disarray following the Nazi–Soviet pact, had been plunged into clandestinity; Maurice Thorez, the Party leader, effectively deserted and escaped to Moscow – unbeknownst to the rank and file. The Party's war record is a continual source of debate, modified recently by the publication in 2003 of Comintern telegrams from 1939–41 and more national furores in France such as right-wing president Nicolas Sarkozy's 'appropriation' of Resistance hero Guy Moquet in 2007.[17]

'The Jew and France' opened at the 1930s Palais Berlitz in September 1941. It was prepared at the IEQJ, 21 rue La Boétie, and based on precedents in Germany such as *Le Juif éternel* ('Eternal Jew') show held in Munich in 1937. George Montandon, the Swiss-born anthropologist and racist writer (once a bolshevik sympathiser), was a key collaborator; his *Comment reconnaître le Juif?* ('How to recognise the Jew') had been published in November 1940.[18] The campaign of hatred had as its motto 'Judaism aims at world hegemony'.[19] Designed to run from September 1941 to January 1942, the exhibition was prolonged because of its success to 13 November 1942.[20] In the first three days 13,000 visitors were recorded. Again, painting and sculpture – much produced in France – played their role among other forms of propaganda.[21]

From 8 August 1941 the Salle Wagram (a former dance and banqueting hall with *belle-lettriste* associations and a cinema from 1939) became the site of the 'crusade against bolshevism'. A demonstration on 24 October 1941 involved 8,000 demonstrators; the 'Bolshevism against Europe' show opened on 1 March 1942, its precursors the *Die Grosse antibolchevistische Austellung der Reichspropaganda-leitung* (Nuremberg, 1937) and the itinerant exhibition *Die rote Weltpest der Bolchevismus* ('Bolshevism as the Red World Plague').[22] The USSR pavilion at the Paris World Fair was grotesquely parodied: the façade on the avenue Wagram was extended and transformed, then topped with a parodic Mukhina sculpture in what must have been a considerable and costly operation (fig. 17).[23] During its run from 1 March to 15 June 1942, 'Bolshevism against Europe' received 370,323 visitors; the Vichy minister Doriot was photographed shaking hands with the 100,000th arrival. An enormous history painting showed Hitler and Pétain shaking hands in the Salle Montoire. An academic sculpture was the centrepiece of the room. Over two million tracts, brochures and postcards were distributed inside and outside the exhibition.[24] The Paris exhibition was again arranged like a mini World Fair – Hungary, Romania, Finland and Spain had their own stands. Tableaux were constructed with models, such as the scene of deprivation labelled 'A corner in the room of a Soviet paradise'. Visual proof was offered of 'A women's concentration camp in the USSR' or 'Religious persecution in the USSR'. Skills deployed for the Paris World Fair of 1937 were again required: the French artists, craftsmen, graphic designers, photomontage specialists (charts and statistics abounded), along with sign-painters and carpenters worked as they might have for the Soviet pavilion of 1937, only – dialectically – the propaganda messages were reversed.[25]

Picasso's paintings themselves became victims. On 27 May 1943, in the gardens of the Jeu de Paume museum, his canvases, together with works by Masson, Miró, Picabia, Klee, Ernst, Léger and others, were slashed and destroyed by fire. Almost 22,000 other works, mostly from Jewish collections, were simply expropriated and sent to Germany.[26] In a climate terrorised – but also collaborationist and ostensibly germanophile – how many may have recalled the poet Heinrich Heine's famous words in *Almansor* (1821), linked to a previous auto-da-fé and German nationalism: 'That was merely the beginning. Where they have burned books, they will end in burning human beings'?[27]

The news of concentration camps – and extermination camps – arrived, Louis Aragon recalled, during the summer of 1943.

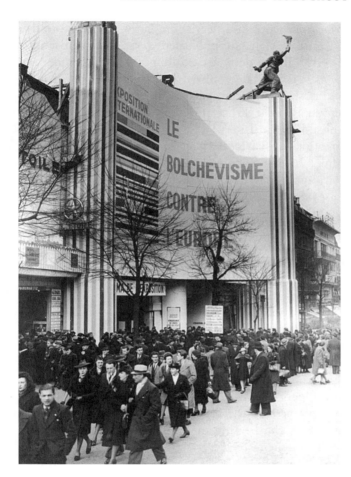

Figure 17:
Unknown
photographer,
'Bolshevism
against Europe',
Salle Wagram,
Paris, 1942

His poem 'Le Musée Grévin', smuggled to Boris Taslitzky in his transit prison camp at Saint-Sulpice – a terrible premonition – provided the texts inscribed on six rough, large-format murals, together with one of Christ before the cross, that Taslitzky painted for the benefit of Gaullist fellow prisoners (his passion for the 'Jewish Christ' was evident here).[28] Using his Resistance pseudonym, 'François la Colère', Aragon published the poem in October 1943, speaking of Auschwitz's 'blood-drenched syllables', the limits of hunger and strength, a way of the cross more terrible than Christ's.

Parisians knew. And extreme antisemitism continued. Picasso himself, constantly subject to rumour, was a target. Following the former fauvist painter Maurice Vlaminck's attack of 1943 (Picasso had 'dragged French

art towards negation, impotence and death'), in early 1944 the prolific, now ageing critic Camille Mauclair published a viciously antisemitic description of the 'crisis in modern art', calling Picasso, Braque and Chagall 'mad'. *Je vous hais!* ('I hate you!') a souvenir collection of more than five hundred antisemitic articles, was published in April 1944; its title quoted the Jewish Popular Front president Léon Blum, who was deported to Buchenwald in April 1943.[29]

With the insurrection of Paris all was to change. The National Resistance committee, having occupied the Beaux-Arts headquarters in the rue de Valois, appointed Joseph Billiet, of the militant Galerie Billiet-Worms (Picasso's rue La Boétie neighbour) as General Director of Fine Arts, an appointment which recognised his service from 1936 onwards and throughout the war. As 'Raoul', Billiet had founded the clandestine Museums' National Front and *L'Art français* (edited and printed clandestinely by André Fougeron with a run of 1,500–2,000 copies).[30] During the insurrection of Paris, the links between Billiet and Fougeron became even closer. Billiet took up his post on 21 August 1944 in the midst of the battle for Paris. While Billiet would be brusquely deposed by General de Gaulle, Fougeron would be the force behind the purging (*épuration*) programme as the general secretary of the Communist National Art Front (FNA), an organisation shortly to fall under Picasso's aegis. The album *Vaincre* was also Fougeron's responsibility. Here, Edouard Goerg's *Auschwitz* explicitly referenced the camps; Boris Taslitzky's maltreatment in the French transit prison of Riom was presented anonymously as the beating of an already emaciated victim (he was by this time in Buchenwald).[31]

Picasso's glorious or unfortunate role as president of the National Art Front within this context is omitted from accounts of his wartime and post-war achievements. The FNA had no need of a presidential figurehead until the moment of German withdrawal; Maurice Denis, the Nabi, was first chosen: he could unite 'ten times as many people as Picasso' but upon his death in a car crash in November 1943, Fougeron turned to Picasso himself.[32] An action plan for reprisals against collaborationist artists had been drawn as early as 15 March 1944. As Picasso's right hand, Fougeron, as general secretary of the FNA, was charged by Billiet with handing out convictions and punishments: arrests included Georges-Henri Rivière, curator of the Museum of Arts and Popular Traditions, who had run a scheme linked with Vichy's regionalist and arts and crafts policies for unemployed intellectuals during the Occupation.[33] Georges Grappe, curator of the Musée Rodin and head of the arts

section of the 'Collaboration' group, was also punished along with the venerable sculptor Charles Despiau, ghost author of a monograph on Arno Breker. Breker, Hitler's sculptor chosen for the Olympics and the Berlin Chancellery, had 'occupied' the Orangerie des Tuileries with a hugely successful retrospective of his massive homoerotic sculptures from May to August 1942; perhaps the most sensational exhibition in occupied Paris's busy art world. Additional penalities were handed out to four teachers from the École Nationale Supérieure des Beaux-Arts, and two from the École Nationale des Arts Décoratifs. Specially targeted were the artists, including Derain, Vlaminck and Despiau, who had toured Germany in November 1941 – a still contentious propaganda trip, roundly denounced in the first number of *L'Art français*.[34] Pleas were made to the 'Picasso and Co.' committee. Desperate letters were written directly to Picasso, for example by the former fauvist painter Othon Friesz.[35]

The vice-president and organiser of the Autumn Salon, Paul Montagnac, was anxious to exclude collaborators from the newly rebaptised Liberation Salon of 1944. Retrospectives were normally granted to French artists only; Fougeron, however, suggested to Billiet that the Salon should stage a Picasso retrospective – and to Montagnac that this was the wish of 'the minister and the artists'.[36] Thus, this historic Picasso exhibition with its 70 canvases, associated scandal and protest, was at the core of the original Picasso–Fougeron relationship – the relationship which would polarise the Communist dialectic of painting and commitment in the 1940s. The events following Picasso's FNA presidency, in the passion of the *épuration* climate, surely added pressure to the momentous decisions he was about to make.

On 4 October, now a historic date, the eve of the Liberation Salon opening, Picasso became a member of the French Communist Party. *L'Humanité*'s front-page coverage showed Picasso joining the Party, with texts by the venerable Marcel Cachin and poet Paul Éluard. Picasso's work, however, caused a riot: the canvases were attacked.[37] A police guard was installed in the Salon (photographed by Robert Doisneau). The following declaration (signed by Pignon and Fougeron among others) appeared in *Les Lettres françaises* for 21 October 1944, under the rubric 'Picasso and the CNE' (National Writers Committee):

> At the Autumn Salon of 1944, six weeks after the Liberation of Paris, the canvases of a painter refused exhibiting rights by the Germans for four years, were taken down, sullied and physically attacked by

an organised band who were able to operate unpunished, and later to boast to the press about this actions, which so well conforms to national-socialist methods and theories ...[38]

The assault was condemned as a vestige of the German Occupation: enemy (collaborationist) action. With this support from the National Art Front, and the array of Communist Party intellectuals who came to the prestigious show, it would have been unthinkable for Picasso to demur over the subsequent purge policy; many meetings now took place in his studio in the rue des Grands Augustins.[39]

Picasso's cable to the American *New Masses* ('Why I became a Communist') published on 24 October 1944, was immediately conveyed to Soviet security forces.[40] The US Federal Bureau of Investigation started to keep its own dossier on Picasso's activities with worldwide informants (file no. 100-337396); a first report of 19 December on his Communist affiliations came from Los Angeles. Tellingly it coincided with the final summary of COMRAP, an investigation of the Comintern Apparatus (dissolved 1943), describing a 'vast, illegal and conspiratorial Russian-controlled and dominated International Communist Organisation, Comintern Apparatus' promoting 'Soviet Russia's goal of world domination'.[41] FBI surveillance of Picasso, persistent if ineffectual – a significant and huge waste of human resources – continued up to the 1960s and has been missed by Picasso scholars (including Pierre Daix in his revised 2012 Picasso dictionary).[42] Picasso's *New Masses* statement was notably quoted by FBI director J. Edgar Hoover in his communication to a special agent in Paris on 16 January 1945, requesting surveillance in the light of a possible lecture invitation (presumably from Alfred Barr to the Museum of Modern Art, New York). Picasso's declaration on 23 March, in *Les Lettres françaises*, about painting as an 'offensive and defensive weapon against the enemy' was again reported internationally.[43]

The Liberation was presented by the Communists as a victory for the Soviet Union over Nazi Germany.[44] The France–USSR alliance was celebrated at the Vélodrôme d'Hiver on 19 January 1945. Victorious posters were produced, such as Fougeron's tricolour reworking of Daumier's *Republic* or one showing the Allies strangling the fascist eagle.[45] Official celebratory gestures towards a friendly ally coincided with a brief moment of cultural openness in the Soviet Union.[46]

The euphoria vanished with the arrival in France of the first newsreels and photographs from Dachau, liberated by the Americans in April 1945.[47] Yet almost immediately images of the *charniers* (in French

usage not 'charnel houses' but the ditches of unburied, decomposing bodies) were instrumentalised for anti-Vichy purposes, such as in the FPTF (Francs Tireurs et Partisans Français, the Communist Resistance sharpshooters) poster: 'Our shot and deported heroes, our martyrs claim one sole act of justice, DEATH for Pétain the Hitlerite.'[48] Just as the anti-bolshevik show ideologically 'reversed' the 1937 Soviet pavilion message, during 1945 and 1946 there was a mirror-image reversal of the artistic events of the war years: in June 1945 the 'Hitler's Crimes' exhibition opened at the Grand Palais, with subsidiary exhibitions such as 'Murdered France: Master Paintings and Photographic Documents' opened by Mlle Geneviève de Gaulle in the same month.[49] The works of art stolen from French museums throughout the Occupation – those not destroyed in the Jeu de Paume bonfire, lost or damaged – were exhibited as 'rediscovered masterpieces' at the Orangerie des Tuileries in 1946.[50]

Picasso, evidently moved by these photographic records of atrocity, completed *The Charnel House* from late April to May 1945. Started in early 1945 at a period when he was engrossed in a series of still lives with skulls, it was moreover a macabre gloss on *Desire Caught by the Tail*. Picasso's Occupation play in dadaistic mode had focused obsessively on food and the lack of it: it was implicit, of course, that beyond domestic confines unspeakable horrors were a regular occurrence.[51] (Dora Maar's recollection of a source for *The Charnel House* in a contemporary Spanish film showing the annihilation of a family in its kitchen offers Republican resonances and is another link to the 'filmic' aspect of *Guernica*.)[52] Pierre Daix relates how Paul Éluard took him to see *The Charnel House*: he was at the time a returned deportee from the Mauthausen concentration camp. Picasso was curious to see a survivor's reactions, he recalls; the artist called the work simply 'my massacre'.[53]

The Charnel House was shown unfinished in the major exhibition 'Art and Resistance' at the Museum of Modern Art in February 1946.[54] Picasso also contributed the smaller and sombre, though more conventionally colourful, *Homage to the Spaniards who Died for France*, with its bust, armaments, trombone, potted plants, framed inscription and skull and crossbones, begun in December 1945 (fig. 18). (Picasso would never relinquish the Spanish Republican cause.)[55] The Committee of Honour included new Communist ministers. A special publication of *Arts de France* with a central spread reproducing *The Charnel House* had Taslitzky's painting *I Salute You France...* (words from Aragon's 1943 poem) on the back cover.[56] The official opening photograph showed Picasso standing rather diffidently under Taslitzky's large gouache: two

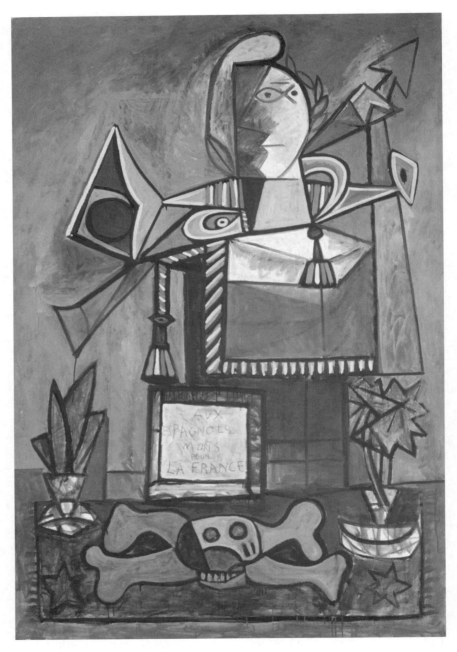

Figure 18: Pablo Picasso,
Monument to the Spaniards who Died for France, 1945–47

female figures and a youth display their bare arms freed from ropes and chains against a background inscribed with the names of the extermination camps: Auschwitz, Dachau, Buchenwald, Dora – but also the transit camps in France: La Santé, Compiègne, Saint-Sulpice (an indictment of collaboration).[57] Taslitzky's drawings made in Buchenwald at the risk of his life, on scraps of target-practice paper or bills to worked-up portraits, were now visible. Miraculously rescued and sent to Paris, they had been edited, with Aragon's support, as *Onze cent dessins de Buchenwald*.[58] In book form, or reproduced in the Communist Press such as *Arts de France*, they now reached a broad public.[59] The discourse of martyrdom in the exhibition 'Art and Resistance' effected a continuity between victims and the Communists' political legitimacy: beyond their role as Resistance fighters and hostages it was as martyrs for France that the Communists had immediately taken their place in de Gaulle's government.[60] Georges Besson, writing in *Arts de France*, implied that Picasso, Bonnard and Matisse had been responsible for soliciting over three hundred works (including children's drawings) for the exhibition; he lamented the lack of heroic, Resistance sentiments and the joy of Liberation: painters had preferred to paint death, and the dark hours of fear.[61]

Picasso's four pen-and-ink drawings of Maurice Thorez, the Communist Party leader, made on 23 May 1945, acknowledged his role as official Party artist and the encounter of both celebrated figures. The portraits were used constantly in later years to signal Picasso's participation in hard-line Party exhibitions which he might otherwise have boycotted.[62] Yet, astonishingly, Picasso was the focus of abuse at the Communist Party conference in June 1945. Roger Garaudy's speech, 'Communism and the Renaissance of French Culture', called him a painter who had passed from a healthy realism to pastiche and baroque monsters.[63] Picasso was now compared unfavourably with Taslitzky, whose sketches were being worked up into grandiose oils. Watercolours of extraordinarily distressing scenes, made rapidly on the spot at the moment of the liberation of the camp (his pocket paintbox retrieved), were the source for *Buchenwald, the Small Camp, February, 1945*. (In February 1945 a convoy arrived with two hundred corpses in the train.)[64] The 'Small Camp' or Camp II was a quarantine camp for contagious diseases, an increasingly overcrowded isolation camp for the ill and dying: Taslitzky shows piles of decaying corpses piled on to wagons by fellow prisoners. (The mortality rate at the camp was estimated at 15,400 deaths from January to 5 April 1945.)[65]

Buchenwald was an epic history painting, five by three metres, based on a receding perspective with a tipped-up cart of bodies in the foreground, amalgamating several compositions into a panorama of horror. Géricault's *Raft of the Medusa* with its heap of emaciated bodies was the precedent. In contrast with *The Charnel House*'s monochrome variations, here political denunciation depended for its pathos upon the human body. While Géricault's stacked pyramid of limbs mounted towards a sky symbolising hope, in *Buchenwald* the vanishing point, giving on to the same yellow sky, is blocked by the recession of the interminable barrack buildings of the Small Camp. The ruined, bituminous surfaces of Géricault's masterpiece unify his composition today: a dark light is cast over still-muscular limbs. Taslitzky, however, attempted to bear witness to his lived experience: the clash of clothed and naked bodies, active, watching or limp in death. While his few watercolours from February 1945 retain a certain transparent decorum, the oil painting presents a vivid, even garishly coloured world, where prisoners wear stripes, where the pale green of angular, decomposing cadavers is set off by the green uniforms of the *Lagerschutz* or camp guards. Many drawings included colour notes. The Small Camp was known as a place of colour, pattern and business, and noise – the strain of an orchestra heard through a Babel of languages; the rendezvous of nations is represented here by contrasting costumes and features: the Spaniard, the Hungarian Jew, the little gipsy boy. By implicating the viewer in its space, via its scale, the work poses unaskable questions about deportation and its aftermath, offering no answers. Unresolved mourning; incomplete catharsis; the determination to endure and the guilt of the survivor: ineradicable memories were surely relived within the duration of its painting. 'I spat out the deportation in my canvases', Taslitzky said. The theme would recur in his work obsessively, particularly after a copy of *Buchenwald* was made for the Yad Vashem Holocaust museum in Israel in 1981.

Here were all the hierarchies, the complexities of what David Rousset would describe in 1946 as the 'concentrationary universe'.[66] Far later, Jorge Semprun, a member of the same deported group of Communist Resistants and intellectuals (who were significantly not Jewish), would offer additional testimony with his celebrated account *Literature or Life*.[67] *Buchenwald* was purchased by Robert Rey at Taslitzky's exhibition 'Witness' (*Témoignage*), opened by various ministers and intellectuals (including many of Taslitzky's fellow deportees), among whom were Aragon and Jean Lurçat, in June 1946.[68] The painting instantly became

the centrepiece of the Resistance room when Jean Cassou reopened the National Museum of Modern Art in 1947.[69]

The nature of the Holocaust in representation at this moment when the status of former deportee (*ancien déporté*) added to a Communist's prestige was the very opposite of its later tropes as 'ineffable', unutterable. A spate of camp memoirs were produced to 1950, including Robert Antelme's *The Human Race* (1947) (the catalyst for Giorgio Agamben's powerful political analysis of 'bare life' today).[70] Shaming the collaborationist right, the Communist Party offered a symbolic – and patriotic – family for those deported citizens, mostly Jewish, who, like Taslitzky, returned with nothing (indeed it has been argued that Jewish Communists, including those within the Yiddish community, constituted a micro 'counter-society' within the Communist 'counter-society').[71] It was a forum for conviviality, representation and discourse blessed, as Picasso himself said, by 'the greatest scientists, the greatest poets, and all the beautiful faces of the Paris insurgents'.[72] It was a survival mechanism and a place to mourn, a provider of much-needed ritual, Yet even mourning and the sites of commemoration, such as the tomb of the Unknown Soldier beneath the Arc de Triomphe or the Père-Lachaise cemetery, where ashes from Auschwitz were ceremonially buried in 1946, became subject to intensely vested interests. Different political groupings disputed different camps as the focus for their commemorations: Buchenwald, Auschwitz or Ravensbruck? Serge Barcellini describes the three conflicting memories of deportation at stake: the memory of former combatants uniting in silent rituals; the theatricalised arena of memory responding to de Gaulle's rhetoric; and Communist memory: one of affiliation and present demands for justice and action.[73]

Picasso's own visit to Auschwitz has remained obscure. Might his turn from depicting political subjects to becoming 'the man of the dove' (and turning to pottery) be related in part, to its traumatic impact? When, in late August 1948, Picasso took his first ever aeroplane flight to Wroclaw, he joined Fernand Léger, poets Paul Éluard and Aimé Césaire, writer Ilya Ehrenburg and the Italian realist Renato Guttuso at the International Peace Congress.[74] Significantly, he saw Wanda Jakubowska's vivid film *Ostatni etap* (*The Last Stage*) before he visited the camp. A survivor, and student from the Lodz film school, Jakubowska recreated camp conditions using local inhabitants as extras: she was forced to demand that they trample the now-flowering site back into filthy mud. The film contained horrifying vignettes of day-to-day atrocities – despite the lack of corpses or running vermin and a semi-fictional plot.[75]

The Auschwitz (Oswiecim) site, handed back to Poland by Soviet forces, had opened, purged and modified, in July 1947. Picasso's official visit, with a group of dignitaries, six days after his arrival was gruelling and unforgettable: he kept close to the young Mauthausen survivor whom he had once invited to comment upon *The Charnel House*, Pierre Daix. Daix insisted that beyond the confines of the new museum, with its arranged heaps of spectacles and human hair, they be shown the bleak and abandoned Birkenau extermination site: dozens of blocks multiplying to the horizon. Picasso henceforth would use only a euphemism 'You remember Kracow' to refer to this event.[76]

This shared secret was surely a powerful catalyst for future engagement, with repercussions far greater than those visible in Picasso's tenth anniversary lithograph for Auschwitz of 1955.[77] Jakubowska's film, as *La Dernière étape*, was promoted in France from 1948 onwards, with the support of the National Deportees and Resistants and Communist organisations, circulating in ciné-clubs to the 1960s (it was an essential reference and source of quotation for Alain Resnais' celebrated film about Auschwitz, *Night and Fog*, 1955).[78]

Anger, and the cumulative psychic weight of these insistent representations – in newsreels, in photographs, film, memoirs, in art, in political propaganda, ritual and public ceremony – overwhelmed the 'unspeakable': the moral and ethical problems, the relationship between 'bare life' and the State, Vichy complicity, individual deaths or the continuing life of the survivor. Jean-Paul Sartre's philosophy of existentialism, insisting upon an individual anguish without God, the need for life to go on and, crucially, the absurd, offered propositions – if not a solution – for a new generation. Existentialism could not help deportees themselves, however, in what one must still designate as a pre-psychoanalytical society.

The tensions around collaboration famously analysed by Henry Rousso as those between *résistancialisme* (the Gaullist and Communist myth of France as predominantly Resistant) and *résistantialisme* (linked to the Vichyist disparaging of this strategy) were more complex when violent imagery specifically evoked French guilt.[79] Taslitzky's *The Monthly Weigh-in at the Riom Central Prison* was hung in obscurity at the back of the show of contemporary French art at the Musée du Luxembourg in September 1946.[80] Far more than the litany of names, including French camps, in *I Salute you France*, its realistic depiction of emaciated, half-alive prisoners (many of whom perished there) clearly demonstrated French collusion with the Nazis; starvation on home territory preceded deportation.[81]

'Marxism isn't a prison' declared Roger Garaudy, architect of the Communist Party's cultural renaissance programme in November 1946, who now revised his position.

> The Communist Party has no fixed aesthetic ... And let's not hear any more about the debate between 'formalism' and realism ... A Communist painter has the right to paint like Picasso. Or otherwise. And a Communist can like either work of Picasso or of an anti-Picasso. Picasso's painting isn't the aesthetic of Communism. Neither is Taslitzky's.[82]

This moment of the PCF's cultural openness, at the height of its popularity and elections to the Assemblée Nationale, contrasts with the grim *zhdanovshchina* in the USSR, where art purges were already reported in the French press.[83] Andrei Zhdanov was at the helm of a Soviet socialist realist programme, involving restrictions, antisemitic persecutions and domination by the Academy of Arts. Louis Aragon, as cultural conduit to the USSR (enhanced by his Jewish-Russian wife Elsa Triolet's connections), retorted to Roger Garaudy that for his part the Communist Party did have an aesthetic: realism.[84] (His wartime friendship and work with Henri Matisse was momentarily 'disappeared'.)[85]

The Picasso / Taslitzky confrontation could not, at this point, be considered without reference to *Buchenwald*. The moment crystallises an immense discomfort, surely, with some notion of 'truth to experience', of individual testimony (*témoignage*) versus style. Submerged recollections of Marxist reflection theory in contemporary pronouncements clashed with the inadequacies of *any* representational system (the rare photographs of the camps that have been recovered are, likewise, mere metonymic fragments of an ungraspable whole). Nor could the 'Jewish question' (addressed by Karl Marx in 1843) disappear. It is implicit in *Buchenwald* with its sense of place. 'Like the pyramids of the Acropolis, Auschwitz is the fact, is the sign of man. The image of man is henceforward inseparable from a gas chamber', declared Georges Bataille in his review of Sartre's *Réflexions sur la question juive*.[86] The PCF's nationalistic programme and celebration of French culture (the culture that sustained the French deportees in the camps) bears a complex relationship to this issue and to its political worker base involving first- and second-generation émigrés.

Aragon would effectively establish a two-tier system, a class system in all but name, for French Communist artists. Socialist realist hard-liners and their epigones would exhibit at the Autumn Salon, the Maison

de Métallurgie (Metallurgists' headquarters), factories and so on.
The elite modernist artists, Picasso, Léger, Matisse and André Lurçat,
the tapestry maker, would show at the Communist-backed Maison de
la Pensée Française (House of French Thought), a luxurious eighteenth-
century mansion just off the Champs-Elysées and provocatively near the
presidential palace, established in April 1947.[87]

The dichotomy was immediately apparent in *Arts de France*, a monthly
review linked to the 'Encyclopedia of the French Renaissance' project,
first appearing in December 1945. The same Revolutionary references,
Daumier's *Republic*, David's *Marat* and Courbet's *Stonebreakers* and
Burial at Ornans, continued the dialogue with engaged art of the past,
with contemporary and proletarian painting. Soviet art would again
feature regularly.[88]

How should one explain the psychological – indeed epistemological
– gap between the deportees' return and the assimilation and creativity
linked to the problematic of the Holocaust after the late 1950s? The status
of *déporté*, a mark of honour, is itself complex. It is distinct from both
camp victim and survivor and indeed from the feminine (*Les Femmes
oubliées de Buchenwald*, the forgotten women of Buchenwald, were
commemorated with an exhibition in 2005).[89] Yet, I would argue, it was
both a metonymic means of overriding the issue of French complicity at
the heart of the crime and of eradicating the number of the 'vanished'
via the substitution of 'those who were deported but have now come
back'. The word 'Holocaust' was little used at the time, 'Shoah' not
at all; 'deportation' was a euphemistic, entirely passive substitute. The
returning male deportees from Buchenwald took up influential posts
on their return in Communist political or cultural arenas, adding an
additional intellectual and political aura to the notion.[90] Jean-Paul
Sartre, in 'Portrait of an Antisemite' (1945), first intimated the relation
of deportation and genocide issues to the Jewish question; his analysis
of stereotypes (based on pre-war sources) and philosophy of the 'Other'
proposed no urgent imperatives, however, for national self-examination.[91]

With less specific yet arguably more powerful forms of response, such
as Alberto Giacometti's sculptures, the Holocaust continued as a powerful
trope in art into the 1950s. Yet, just as the early posters I described
co-opted photographs of the liberated camps to the anti-Pétainist cause,
Holocaust images soon became part of the propaganda for or against
the rearmament of West Germany, with wider Cold War repercussions.
Picasso, along with 90 intellectuals including Pignon, Jean Cassou, Aragon
and Elsa Triolet, signed a manifesto in favour of German disarmament in

January 1947, just prior to the announcement of the Truman Doctrine of economic and military aid to Europe in March, and George Marshall's call in June for a European Recovery Programme (a bulwark to be created against the Communist bloc). The Berlin blockade, which lasted from June 1948 to May 1949, required Western airlifts to the population of Berlin, countering Soviet desires for expansion: the first major Cold War crisis. On 24 October 1950 the French prime minister, René Pleven, attempted to launch a European army which would include German forces. The political initiative to create a European Defence Community (EDC) meant not only the re-establishment of German industry but rearmament. In this context, anti-German rhetoric – none stronger than Holocaust imagery – was redeployed by the French Communist Party.

For almost four years to August 1954, the Communist Party waged a propaganda war against this alliance, which it was quick to link with memories of the Nazi occupation. In this context (where the new female vote was essential) Taslitzky's *Death of Danielle Casanova* was commissioned for the Communist women's organisation, the Union des Femmes Françaises, commemorating the wife of Party arts spokesman Laurent Casanova (plate 14).[92] A charismatic feminist, active in Communist youth organisations and founder of the 'Union of the Young Women of France', she perished in Auschwitz in 1943, becoming a posthumous heroine and martyr, consecrated by Aragon with a speech in the Salle Wagram (site of the anti-bolshevik exhibition) in 1946. Taslitzky's painting was exhibited in honour of PCF leader Maurice Thorez's fiftieth birthday on 28 April 1950. (This extravagant imitation of Stalin's birthday celebrations of 1949 was partly recreated as *Le Don des militants*, 'The Gift of the Militants', in 2009.)[93] In contrast to *Buchenwald*, or indeed Picasso's *Le Charnier*, the work demonstrates how Catholic, eschatological structures were harnessed to Communist discourses, with all their affective resonance. Here, in the grill-like frame of the grim barracks, Danielle, dressed in white, lies diagonally across the picture plane, surrounded by distraught and gesticulating mourners. The scene is based on Francisco de Zurburán's *Saint Bonaventure on his Bier* (1629, Louvre), a work Taslitzky had copied in 1938. Yet Taslitzky's work is a layering of palimpsests: he was also commemorating his beloved mother Anna Rosenblum, who was deported from Paris in 1942 and died in Auschwitz.[94] The relationships between surface, style, memory and possible psychoanalytic readings – the seen, the obscene and the unseen, the scene of public encounter – raise huge questions here. The cult of Danielle Casanova complemented that of Stalin and Thorez.

She served as a focus for Communist women and girls – a displaced Joan of Arc and Mary figure, given the role of intercessor. For four or five years, multitudes of women with lilac in their arms demonstrated in May processions in her honour. Streets were named after her; the Foyer Danielle-Casanova became the focus for exhibitions and debates; the feminist press had meetings there.[95] Charlotte Delbo's survivor account of her arrest and the convoy to Auschwitz of 24 January 1943 has brought Danielle Casanova's story into contemporary Holocaust studies.[96]

Signatures of protest were collected in front of Taslitzky's *Buchenwald* upon the signing of the EDC treaty on 27 May 1952.[97] Significantly, the Resistance Room in the National Museum of Modern Art (director Jean Cassou's own initiative) was taken down within a week: *Buchenwald* has never been seen in public since. The Communist campaign of protest against the EDC continued. In 1954 a poster showing a photograph of a Jewish camp victim, crowned, Christ-like, with barbed wire against a background suffused with red, white and blue and the slogan 'Frenchmen, remember' was used in protest against the possible ratification of the Bonn–Paris agreement. The statistics quoted were still powerful: '180,000 Frenchmen were deported from 1941–1944, 120,000 were Jewish, only 3,000 came back!'[98] The Communist victory against the EDC in 1954 was short-lived, however. By 1955 the first armed forces of the Bundeswehr had been set up and Germany became a member of NATO.

The political instrumentalisation of Holocaust imagery is disturbing. Moreover, while deportees' testimony remains always sacred, the period from 1949 to 1951 was deeply involved in arguments about the Soviet gulag. It is almost unthinkable to posit a relationship between the PCF's claim to Holocaust memory, its powerful structures of belief and rhetoric, and the submerging of revelations about the Soviet camps. Such, however, was the subtext of the Kravchenko trial and its aftermath, beginning with the publication of the memoirs of the Soviet defector in the US; ending in the confrontation between a Mauthausen survivor, Pierre Daix, for the Communists, and a Buchenwald survivor, David Rousset, on behalf of gulag internees. These were obscene clashes – conducted as legal proceedings – which retrospectively could claim only the trope of blindness as an alibi: see the titles of the PCF protagonists' biographies, as quoted in my introduction.

Samuel Beckett's *Innommable* (*The Unnameable*) would not appear until 1953. Alain Resnais's film *Night and Fog* (1955), with its submerged quotations from Jakubowska's *The Last Stage*, became an initiatory

rite of passage for generations in France. Following the Eichmann trial and Hannah Arendt's publications in French upon the nature of totalitarianism, the piled shaving brushes of Arman in 'New Realist' mode, the 'vanishing' games of novelist Georges Perec and the poignant photographic displacements of Christian Boltanski became powerful responses to the Holocaust created in the 1960s and 1970s. In 1975 Jochen Gerz's 'Exit' project, with its contemporary photographs of Dachau, interrogating museum-making itself in relation to forgetting, was exhibited, following Boltanski, in the Musée d'Art moderne de la Ville de Paris. Holocaust memory had become conceptual.[99]

Following Jean-Luc Nancy's engagement with the issue of the camps and Holocaust memory, the philosopher Jacques Rancière collaborated with Esther Shalev-Gerz in Buchenwald in 2006.[100] In 2010 in Paris, her videos and installation of Buchenwald museum objects reframed as *Ton image me regarde* ('Your image looks at me') coincided with a posthumous retrospective of Taslitzky's Buchenwald drawings, which he had helped prepare.[101] Was the issue 'the work of the image' (as Rancière argues) or rather the *témoignage*, the witness statement 'I was there', signalled by the drawings made in Buchenwald itself, which separated Taslitzky irrevocably from Picasso in 1945?

Picasso's *Charnel House* relates again in its abstraction and non-specificity to all 'charnel houses', all sites of anonymous burial. A depiction of an interior, a table, bodies, it relates to atrocities in which normal life is shattered, people taken or massacred on the spot in their homes, their bodies left to rot, disposed of – or as was the case in 1945, picked up by bulldozers and buried in mass graves by the Allies. Permanently exhibited in New York since 1971, it has been powerfully transmitted through history, despite its ambiguities.[102] Taslitzky's *Buchenwald* is hidden in a museum store, despite its dominant position in France's national museum from 1946 to 1952; it has been excluded from successive exhibitions, notably *L'Art en guerre, 1938–1947* (2012). Experience of *The Charnel House*, the Buchenwald drawings or indeed the *Buchenwald* painting, in all their materiality – however different, however 'unnameable' their masked contents – is also separated through their context from the disturbing pathos and appeal of contemporary conceptual Holocaust artworks and Holocaust museology.

Communist memory, it has been argued, changed from memory and witness (1945–47) to the memory of deportation as an autonomous phenomenon (1947–84), to become, since 1984, inextricably linked with human rights issues. On 16 July 1993, on the site of the Vel d'Hiv

cycle track, the location of the 'Grand Rafle' (the largest round-up during the Occupation), ceremonies were held on the first National Day to commemorate racist and antisemitic persecutions committed with the authority of the so-called 'government of the French State'. In 1995 President Jacques Chirac spoke at ceremonies on that sacred day of an 'irreparable act'. Paris's Jewish Museum of art and history opened in 1998, in the eighteenth-century Hôtel Saint-Aignan in the Marais area (near the Hotel Sully which houses the Musée Picasso), after a century of existence as an industrial site and sweatshop for Eastern European labour. Many inhabitants were deported in 1942; their names and professions are commemorated, written as though upon tablets scattered over a courtyard wall, in a permanent installation by Christian Boltanksi. It was not until 26 January 2005 that the 'Wall of Names' was inaugurated at the Shoah Memorial, also in Marais. It bears 76,000 names including that of Anna Rosenblum, Taslitzky's mother, and those of 11,000 children, mostly deported victims who died in Auschwitz. In June 2006 the 'Wall of the Just', those who helped save and protect, was inaugurated on the external wall of the memorial by the mayor of Paris, Bertrand Delanoë (see the epigraph to this chapter). In 2012, the seventieth anniversary of the Vel d'Hiv round-up of 1942, two exhibitions honoured deported children in Paris, and there were displays of the police archives for the Vel d'Hiv, 'Cinema in 1942' and the graffiti of the Drancy transit camp, while in Champigny's Resistance museum, 'We Who Are Alive' continued to investigate resistance in Nazi camps.[103] 2013 opened with an investigation of the State's despoliation of Jewish property at the Shoah Memorial.[104]

In the months before Taslitzky died in 2005, I showed him the video accompanying Paris's Jewish Museum's homage to the celebrated Soviet photographer Evgueni Khaldi.[105] I had forgotten the sequence in Soviet archives around the 'Doctors' Plot', Stalin's antisemitic purges and plans for mass displacement of Soviet Jewish populations: an atrocious confirmation of betrayal for the artist whose parents had fled the Russian pogrom of 1905 – one hundred years previously.[106] Two biographies remained unread in his apartment: new studies of Maurice Halbwachs, the sociologist of collective memory, and Jean Kanapa, the archetypal hard-line French Stalinist; surely recent gifts.[107] Halbwachs, the son of a teacher of German, was a Durkheimian sociologist deported on the last convoy to Buchenwald in August 1944. Confident in his authority as a recently elected professor at the Collège de France and a non-Jew originating from Rheims, he was arrested in Lyons while trying to

discover the fate of his father-in-law, Victor Basch. Halbwachs had worked during the Occupation years on a 'legendary topography of the Holy Land'; it proposed an 'imagined' Holy Land steeped in belief and ritual to which reality later conformed: the 'invention of tradition' which becomes part of a collective memory.[108] His major study, *La Mémoire collective*, was published posthumously in 1950; it has been crucial for contemporary scholarship on the Holocaust, memory studies and on constructions of history. Taslitzky drew Halbwachs, his fellow inmate in the Buchenwald Small Camp, bowed, naked and humiliated in the sanatorium, awaiting an injection (plate 12). He witnessed his death.

And Marx? Jean Kanapa, the 'fanatic' of the second biography, rose from modest beginnings within a Jewish family and was trained as a philosopher during the Occupation; he offered the riposte to his mentor Jean-Paul Sartre's proposition 'existentialism is a humanism' of 1946. It was he who became founder and director of the 'review of militant Marxism', *La Nouvelle Critique*, from 1948 (his complex trajectory after 1956 would lead him to Eurocommunism). During the post-war period he embodied the extreme hard-line Stalinist position within the French Communist Party. His biography traces the French cultural and intellectual formations that could lead to this point. Among so many publications, Dominique Desanti's *Les Staliniens* (1974), written from the point of view of witness and ex-participant, demonstrates the huge Stalinist consensus in post-war France, where Kanapa was a leading player. In a new post-Holocaust world, together with Halbwachs' caution of collective memory and forgetting, Kanapa represents the *repoussoir* of prevailing Stalinist orthodoxies against which Picasso's strategies and reception must be re-evaulated.

Notes

1 Alfred H. Barr, ed., *Picasso, Fifty Years of His Art* (New York: Museum of Modern Art, 1946), p. 250.

2 Max Raphael, 'Biographie', unpublished, Raphael papers, Germanisches Nationalmuseum, Nüremberg.

3 Max Raphael, *The Demands of Art*, ed. H. Read, trans. N. Guterman (London: Routledge and Kegan Paul, 1968), pp. 145, 157ff.

4 Steven A. Nash, ed., *Picasso and the War Years, 1937–1945* (New York: Solomon R. Guggenheim Museum, 1999); Anne Baldessari, *Picasso: Life with Dora Maar. Love and War, 1935–1945* (Melbourne: National Gallery of Victoria, 2006); Frederic Spotts, *The Shameful Peace: How French Artists and Intellectuals Survived the Nazi Occupation* (New Haven, CT: Yale University Press, 2008); and Sarah Wilson, 'Art and the Politics of the Left in France, c.1935–1955', PhD thesis, Courtauld Institute of Art, University of London, 1992, chapter 4, 'Occupation, Collaboration, Épuration'.

5 See Kathleen Brunner, *Picasso Rewriting Picasso* (London: Black Dog, 2004); Lydia C. Gassman, *War and the Cosmos in Picasso's Texts, 1936–1940* (ebook, iUniverse, 2007).

6 See editorial, 'Connoisseurship, Bronze Casts and Transposition between Media', *Museums Management and Curatorship*, 13 (1994), pp. 3–8, and Clare Finn, 'Rumours of War: Rudier and Art Bronze Casting during the Second World War', *Sculpture Journal*, 22.2 (2013).

7 Raoul Ubac, photograph of Picasso's *Objet, la conquête du monde par l'image* (June 1942, as 'April 1942'); for the 'Main à Plume', see Michel Fauré, *Histoire du surreálisme sous l'Occupation* (Paris: La Table Ronde, 1982).

8 Laurence Bertrand Dorléac and Jacqueline Munck, eds., *L'Art en guerre. France 1938–1947. De Picasso à Dubuffet* (Paris: Musée d'Art Moderne de la Ville de Paris, Pairs-Musées, 2012); see also Laurence Bertrand-Dorléac's *Histoire de l'art: Paris, 1940–1944, ordre national, traditions et modernités* (Paris: La Sorbonne, 1986) and *L'Art de la défaite: 1940–1944* (Paris: Seuil 1993), translated into English as *Art of the Defeat, 1940–1944* (Los Angeles: Getty Research Institute, 2008).

9 '[J]e me demandais si nous sommes bien en 1942, s'il est bien vrai que dehors, dans ce matin brumeux, de longues files de femmes grelottantes attendent devant des boutiques vides, qu'un million de prisonniers, astreints aux travaux forcés, affamés, se morfondent dans les camps; s'il est bien vrai qu'à ce même moment des cars s'arrêtent devant des usines, déversant leur contenu de chasseurs d'hommes, casqués, bottés, armés de mitraillettes pour y rafler 100, 200, frères français, s'il est bien vrai que, quelque part, dans cette minute même, claquent des fusils et tombent des otages [...]?' 'Propos d'un amateur', *L'Art français*, 3 (November 1942), n.p.

10 Jean Baronnet and Jean-Pierre Azéma, *Les Parisiens sous l'Occupation. Photographies en couleur d'André Zucca* (Paris: Gallimard / Bibliothèque historique de la Ville de Paris, 2008).

11 See Hersch Fenster's *Undzere farpainikte Kinstler* (Our artist martyrs, in Yiddish) (Paris, 1951), expanded by Nadine Nieszawer et al., *Peintres juifs de Paris, 1905–1939* (Paris: Denoël, 2000), and Serge Klarsfeld's lifetime oeuvre on deportation and the Holocaust.

12 Nadine Nieszawer ed., *Montparnasse déporté* (Paris: Éditions Le Musée du Montparnasse, 2005).

13 Cécile Desprairies, *Ville lumière, années noires: Les lieux du Paris de la collaboration* (Paris: Denoël, 2008), pp. 176–77; Anne Sinclair, *21, rue La Boétie* (Paris: Grasset, 2012).

14 See 'Expositions Anti-Maçonniques', Paris, Petit Palais, 2 October–30 November 1940; Bordeaux, Musée de la Peinture, 22 February–27 March 1941 (49,428 visitors); Lille ('masonic headquarters') 9 August–5 September 1941 (42,805 visitors); BDIC, Paris.

15 Finn, 'Rumours of War'.

16 See Sarah Wilson, 'Les Jeunes Peintres de tradition française', in *Paris–Paris* (Paris: Centre Georges Pompidou, 1981); Michele C. Cone, 'Abstract Art as a Veil: Tricolor Painting in Vichy France', *Art Bulletin*, 78 (June 1992), pp. 81–99; see also Bertrand-Dorléac, *Art of the Defeat*, pp. 276–93; and Natalie Adamson, *Painting, Politics and the Struggle for the École de Paris, 1944–1964* (Farnham: Ashgate, 2009).

17 See Roger Bouderon, *Le PCF à l'épreuve de la guerre, 1940–1943. De la guerre impérialiste à la lutte armée* (Paris: Syllepse, 2012), and in interview, *Les Lettres françaises*, 95 (4 July 2012), p. 8.

18 See 'Le juif éternel, Grosse politische Schau im Bibliotheksbau des deutschen Museums zu München ab 8 november 1937', poster, BDIC; George Montandon, *Comment reconnaître le Juif?* (Paris: Les Nouvelles Éditions Françaises, 1940), in a series *Les Juifs en France*, re-edited online, March 2008, by LENCULUS, http://archive.org/stream/CommentReconnaitreLeJuif/CommentReconnaitreLeJuif_djvu.txt (accessed 13 September 2013).

19 'Le judaïsme tend à l'hégémonie mondiale', photograph, 10 March 1942, Agence Fulgur, Deutsches Bundesarchiv, Bild 183-2004-0211-500.

20 For the prolongation, see Archives de la Police, Paris, Box BA 1817.

21 See Raymond Bach, 'L'identification des Juifs: l'héritage de l'exposition de 1941', *Revue d'histoire de la Shoah*, 173 (2001), pp. 170–91; and Diane F. Afoumado, *L'Affiche antisémite en France sous l'Occupation* (Oxford: Berg International, 2008).

22 See *Die Grosse antibolchewistische Ausstellung der Reichspropagandaleitung NSDAP*, Nuremberg, 1937, and *Die Rote Weltpest der Bolchevismus* (Bayerische Hauptstaatsarchiv).

23 The comité d'Action anti-Bolchevique was directed by Paul Chak with André Chaumet, director of the review *Revivre*, of the Institut d'étude des questions juives.

24 See also *Das Sowjetparadies: Austellung der Reichspropagandaleitung der NSDAP: En Bericht in World und Bild* (Berlin: Zentralverlag der NSDAP, Franz Eher Nachf, 1942), 'Die GPU – das Terrorwerkzeug des juedischen Bolschewismus' (the GPU [secret police] – the terror apparatus of Jewish bolshevism), including condemnation of the Soviet Union as a 'backwards Hellhole'.

25 Exposition contre le Bolchevisme: photographic records, Musée de la Résistance Nationale, Champigny-sur-Marne.

26 Before the end of the war Rose Valland had the names of all the Einsatzstab Reichsleiter Rosenberg depots such as Neuschwanstein and Hohenschwangau. The ERR report for 14 July 1944 listed 21,903 works inventoried since the beginning of operations, including 10,890 paintings, watercolours and drawings, and 583 sculptures, medallions etc. See *Les Chefs-d'œuvre des collections privées françaises retrouvés en Allemagne par la Commission de récupération artistique et les services alliés* (Paris: Ministère de l'Éducation Nationale, 1946); Rose Valland, *Le Front de l'art,*

défense des collections françaises, 1939–1945 (Paris: Plon, 1961; Réunion des Musées Nationaux, 2013); Bertrand-Dorléac, *Art of the Defeat*, pp. 36–37.

27 'Das war Vorspiel nur. Dort, wo man Bücher verbrennt, verbrennt man am Ende auch Menschen'; Heinrich Heine, *Almansor* 1821, line 243, referring to the book-burning at the Wartburg Festival of 1817.

28 See Louis Aragon, 'Le Maître de Saint-Sulpice', *Regards*, February 1945 (repr. *Notre Musée*, 114 [April 1989], n.p.), and Boris Taslitzky, 'Barraque 5', *La Nouvelle Critique*, 4 March 1949, pp. 32–33.

29 Maurice de Vlaminck, 'Opinions libres sur la peinture', *Comœdia*, 1 (June 1942), p. 6; Camille Mauclair, *La Crise de l'art moderne* (Paris: CEA, 1944). *Je vous hais* was produced by the team responsible for the IEQJ's *Cahiers jaune* (5 November 1941–February 1943); authors included Montadon and Henri Coston.

30 See R. and P. Roux-Fouillet, *Catalogue des périodiques clandestins, 1939–1945* (Paris: Bibliothèque nationale, 1954), p. 38, for *L'Art français*. See also P. Betz, ed., 'Les Imprimeries clandestines', *Le Point*, 31 (1945), photographs by Robert Doisneau, showcased in 'Robert Doisneau et les imprimeurs clandestins. Des mots pour résister', Musée de la Résistance, Champigny-sur-Marne, 2013.

31 André Fougeron, ed., *Vaincre* (Paris: Front national des Arts, 1944).

32 'le nom de Maurice Denis était capable de rassembler dix fois plus de gens que Picasso'. Conversation with André Fougeron, 27 November 1990.

33 See Bertrand-Dorléac, 'Quatre chantiers intellectuels du Musée des Arts et Traditions Populaires', *Histoire de l'art*, pp. 78–80.

34 Derain's studio was overrun by Nazis with guns beforehand; Paul Landowski, director of the École des Beaux-Arts, hoped to liberate his students working in Germany – a complex issue.

35 Othon Friesz, letter to Picasso, 6 October 1944 (typescript), Annexe 4i, in Wilson, 'Art and the Politics of the Left in France', p. 415, André Fougeron archives.

36 André Fougeron in conversation, 14 November 1979 and 27 November 1990, when he said that the idea was proposed as an FNA initiative to Billiet.

37 'Exposition Pablo Picasso': 74 paintings, five sculptures (*Head, Cock, Cat, Skull, Bicycle Saddle*); Salon d'Automne, Palais des Beaux-Arts de la ville de Paris, 6 October–5 November 1944.

38 'Au Salon d'Automne de 1944, six semaines après la libération de Paris, les toiles d'un peintre, auquel les Allemands avaient pendant 4 ans refusé le droit d'exposer, ont été décrochées, salies et détériorées par une bande organisée qui a pu opérer impunément et se vanter ensuite jusque dans la presse d'une action si conforme aux méthodes et aux théories national-socialistes.' *Les Lettres françaises*, 21 October 1944, p. 7.

39 The letter to the Préfet de Police of 3 October specifically says the committee director was 'réuni à Paris sous la présidence de M. Picasso'.

40 RGASPI, F 495, Op. 270 D. 359, l. 61. Document reproduced in V. Jobert and L. de Meaux, eds, *Intelligentsia, entre France et Russie, archives inédites du XXᵉ siècle, Paris*, exhibition catalogue (Paris: Beaux-Arts de Paris, 2012), p. 417.

41 Athan Theoharis, *The Quest for Absolute Security. The Failed Relations among U.S. Intelligence Agencies* (Chicago: Ivan R. Dee, 2007), pp. 66–67.

42 Sarah Wilson, 'Loyalty and Blood: Picasso's FBI file', in Jonathan Harris and Richard Koeck, eds, *Picasso and the Politics of Visual Representation: War and Peace in the Era of the Cold War and Since* (Liverpool: Liverpool University Press, 2013), pp. 110–24.

43 'Non, la peinture n'est pas faite pour décorer les appartements. C'est un instrument de guerre offensive et défensive contre l'ennemi.' *Les Lettres françaises,* 23 March 1945.

44 See Philippe Buton and Laurent Gervereau, eds, *Le Couteau entre les dents* (Paris: Chêne, 1989), p. 13: in November 1944, 61% of the population thought the USSR had played the most important role in the defeat of Germany.

45 Buton and Gervereau, eds, *Le Couteau entre les dents,* p. 135.

46 V. Stamboulov, 'L'art français à Moscou', *Les Lettres françaises,* 23 March 1945.

47 Fauré, *Histoire du surréalisme sous l'Occupation,* p. 238, credits the poet André Verdet as the first to bring photographs of *déportés* in the camps back to an incredulous public. *Les jours, les nuits et puis l'aurore,* published at the Liberation, included poems written from March 1944 to April 1945 in the Fresnes prison, Auschwitz and Buchenwald.

48 'Nos fusillés, nos déportés, nos martyrs exigent une seule justice: LA MORT pour Pétain l'hitlérien'; Buton and Gervereau, eds, *Le Couteau entre les dents,* p. 26.

49 'La France meurtrie: Peintures de maîtres et documents photographiques', Femmes de la Libération Nationale, for the Centres d'Accueil pour les prisonniers et les déportés, Galerie Barde, 185 Faubourg Saint Honoré, Paris, 16–30 June 1945, Larionov archives, M.N.A.M., Centre Georges Pompidou.

50 *Les Chefs-d'œuvre des collections privées françaises retrouvées en Allemagne par la Commission de récupération artistique et les services alliés,* Paris, Orangerie des Tuileries, June–November, 1946.

51 *Le Charnier* had its origins in the meeting between Paul Éluard, the poet Eugène Guillevic and Picasso in the artist's studio. A *Charniers* project involving the lithographer Mourlot was suggested. A subsequent visit by the two poets to Léger's studio resulted in the illustrated book of poems *Coordonnées* (1948), with Léger's own 'Charnier' illustrations to Guillevic's evocations of Treblinka.

52 See originally William Rubin, *Pablo Picasso: A Retrospective* (New York: Museum of Modern Art, 1980), p. 380.

53 See Pierre Daix, *Le Nouveau dictionnaire Picasso* (Paris: Robert Laffont, 2012), p. 180.

54 *Art et résistance. Exposition organisée par les amis des Franc-Tireurs et Partisans Français au profit de leurs œuvres,* Musée des Arts Modernes, 15 February–15 March 1946. The opening declaration was published in *Les Lettres françaises,* 22 February 1946, p. 5.

55 Picasso's FBI file details support for the Committee for Aid to the Spanish Republicans, Committee of French Intellectual Friends of Spain, French Committee for the 'Defense of the Twelve', Joint Anti-Fascist Refugee Committee, Spanish Refugee Committee of the Joint Anti-Fascist Refugee Committee, Spanish Republicans in France etc.

56 *Arts de France,* special number, texts by Paul Éluard, Henri Mougins, Montézin, George Besson.

57 See F. Frascina and C. Harrison, *Liberation and Reconstruction. Politics, Culture and Society in France and Italy, 1943–1954* (Milton Keynes: Open University, 1989), Plates, 40 A, 40 B, Vernissage, Plate 41, 1989 – a course textbook whose French section and illustrations are constructed from Viatte's unacknowledged *Paris–Paris* and Wilson and Viatte's *Aftermath.*

58 Boris Taslitzky, *Cent-onze dessins fait à Buchenwald* (Paris: La Bibliothèque Française, 1946); luxury re-edition, Association Française Buchenwald-Dora – Hautefeuille-S.A., 1989.

59 See Henri Mougins, 'Boris Taslitzky, ou les jeudis des Enfants d'Ivry', *Arts de France*, 15 March 1946, p. 30.

60 Jeannine Verdès-Leroux, *Au service du Parti: Le Parti communiste, les intellectuels et la culture, 1944–1956* (Paris: Fayard/Minuit, 1983), p. 522 note 60, mentions monstrous inflation of the *parti des 75,000 fusillés* when a French official at Nuremberg quoted 29,660 *in toto*, a number thought to be exaggerated in 1964. See also introduction, note 32.

61 As note 56.

62 A Thorez drawing was displayed at the Maison de Métallurgie in April 1950 for Thorez's fiftieth birthday show, used as the frontispiece/cover of the luxury illustrated edition of Thorez's ghosted autobiography, *Fils du Peuple*, and as Picasso's contribution to the exhibition 'De Marx à Staline' in May 1953.

63 Roger Garaudy, *Le Communisme et la renaissance de la culture française* (Paris: Éditions Sociales, 1945). It is here that he announces the project for an *'Encyclopédie de la renaissance française'*. See also R. Cogniot, *Les Intellectuels et la renaissance française* (Paris: Éditions du Parti Communiste Français, 1945).

64 Information from Buchenwald musem director; video in the Esther Shalev-Gerz exhibition, Paris, June 2010.

65 See Christophe Cognet et al., *Boris Taslitzky: Dessins faits à Buchenwald* (Paris: Adam Biro, 2009), and Sarah Wilson, 'La Mémoire longue, la mémoire courte', in N. Hazan-Brunet, ed., *Boris Taslitzky, l'arme du dessin* (Paris: Musée d'Art et d'Histoire du Judaïsme, 2006), pp. 44–47.

66 David Rousset, *L'Univers concentrationnaire* (Paris: Éditions du Pavois, 1946), followed by *Les jours de notre vie* (Paris: n.p., 1947).

67 For an embellished first-hand account of the death of Maurice Halbwachs in his arms in Buchenwald, see Jorge Semprun, *L'Écriture ou la vie* (Paris: Gallimard, 1994); translated as *Literature or Life* (New York: Viking, 1997).

68 'Témoignage par Boris Taslitzky', La Gentilhommière, 1–25 June 1946.

69 MNAM, *dossier d'œuvre* for *Buchenwald*; Jean Cassou created the Resistance room for the museum opening of 1947; confirmed by Taslitzky's recollections, Archives sonores, MNAM, 1981, p. 16 of typed transcript.

70 For example, Suzanne Birnbaum's *Une française juive est revenue* (Paris: Éditions du Livre Français, 1945); *Birkenau, bagne de femmes par le matricule 55310*, Petite Encyclopédie de la Résistance (1945); or *Témoignages sur Auschwitz*, prefaced by Jean Cassou, with illustrations by François Reisz (Paris: Amicale des Déportés d'Auschwitz, 1946). See Annette Wieviorka, *Déportation et génocide, entre la mémoire et l'oubli* (Paris: Pluriel, 2003 [1992]) with its annexe of camp memoirs published to 1950.

71 Taslitzky, baptised accidentally at birth, could not be circumcised, a fact which saved his life; after experiencing Jewish and Catholic practices as a child, he adopted the French Republican lay tradition. See Annette Wieviorka, *Ils étaient Juifs, résistants, communistes* (Paris: Denoël, 1986), and Wieviorka, 'Les Communistes juifs immigrés', in Jean-Pierre Bernard, *Paris rouge, 1944–1964: Les Communistes français dans la capitale* (Paris: Champ Vallon, 1991), pp. 155–67 (topographical and extending to figures such as Georges Perec in the 1960s).

72 Picasso to Pol Gaillard, *New Masses*, c. 20 October 1944, in Barr, ed., *Picasso. Fifty Years of His Art*, p. 247.

73 Serge Barcellini, 'Sur deux journées nationales commémorant la déporation et les persécutions des années noires', *Vingtième siècle*, 45 (January–March 1995), pp. 76–98 ('three memories', p. 79).

74 *Picasso w Polsce* (Cracow: Wydawnicto Literackie, undated), various authors, English summary, p. 262. Mieczyslaw Bibrowski, a journalist, went to Vallauris as initiator of the Congress to convince Picasso that he must go to Poland. Letters from Arcos (influential in the organisation of the exhibition of *Guernica* in 1937) and letters to the leader of the Spanish Communist Party were brought to Picasso by Helena Syrkus, who with her husband Szymon Syrkus was the creator of Polish 'functionalist' architecture. See also Dominique Desanti, *Nous avons choisi la paix* (Paris: Pierre Seghers, 1949), who claims the initiative came simply from Ilya Ehrenburg.

75 Wanda Jakubowska, *Ostatni etap* (Film Polski) Poland, March 1948; see http://venusfebriculosa.com/?p=542 (accessed 9 July 2013); see J. Marek Haltof, 'The Monstrosity of Auschwitz in Wanda Jakubowska's *The Last Stage* (1948)', in Haltof, *Polish National Cinema* (New York: Berghahn Books, 2002); and Ewa Mazierska, 'Wanda Jakubowska: The Communist Fighter', in Mazierska and Elizbieta Ostrowska, eds, *Women in Polish Cinema* (New York: Berghahn Books, 2006), pp. 149–65.

76 Pierre Daix, *Tout mon temps, mémoires* (Paris, 2001), pp. 297–99.

77 Picasso, drawing for the 10th anniversary of the liberation of Auschwitz, *Humanité-Dimanche*, 23 January 1955; see Gérard Gosselin, *Picasso et la presse* (Paris: Cercle d'Art and Humanité, 2000), p. 159,

78 Thanks to Annette Wieviorka for her chapter on *La Dernière Étape*.

79 Henry Rousso, *Le Syndrome de Vichy. De 1944 à nos jours* (Paris: Seuil, 1990), pp. 18–19, 42–43.

80 'Exposition de l'Art Français Contemporain', Musée du Luxembourg, 1946, organised by the Union des Arts Plastiques: 150 painters, 35 sculptors, 60 graphic artists. Catalogue, André Fougeron archives.

81 See Isabelle Von Bueltzingsloewen, ed., *Morts d'inanition, famines et exclusions en France sous l'Occupation* (Rennes: Presses Universitaires de Rennes, 2005).

82 'Il n'y a pas une esthétique du Parti Communiste. Voilà ce qui est dit. Et qu'on ne nous assourdisse plus de cette querelle du 'formalisme' et du réalisme [...] Qu'est-ce qui est 'marxiste'? Les recherches d'avant-garde ou le 'sujet'? Ni l'un ni l'autre. L'un et l'autre [...] Un peintre communiste a le droit de peindre comme Picasso. Et il a le droit de peindre autrement. Et un communiste a le droit d'aimer, soit l'œuvre de Picasso, soit celle de l'anti Picasso. La peinture de Picasso n'est pas l'esthétique du communisme. Celle de Tatzlitsky [*sic*] non plus [...] Le marxisme n'est pas une prison [...]' See Roger Garaudy, 'Artistes sans uniforme', *Arts de France*, 9 (1946), pp. 17–29.

83 Zhdanov's decree of 14 August 1946, 'On the Journals *Zvezvda* and *Leningrad*', attacked Leningrad reviews, Mikhail Zoshchenko and Anna Akhmatova. See Matthew Cullerne-Bown, *Art under Stalin* (Oxford: Phaidon Press, 1991), pp. 204ff.

84 Louis Aragon, 'L'Art, zone libre?', *Les Lettres françaises*, 29 November 1946. See also René Guilly, 'Faut-il une esthétique du Parti Communiste?', *Juin*, 10 December 1946, p. 7.

85 See Louis Aragon, 'Matisse-en-France', in *Henri Matisse. Dessins. Thèmes et variations* (Paris: Martin Fabiani, 1943); and 'Apologie du luxe' (preface), in *Matisse*, Les Trésors de la peinture française (Geneva: Skira, 1946).

86 'Comme les pyramides ou l'Acropole, Auschwitz est le fait, est le signe de l'homme. L'image de l'homme est désormais inséparable d'une chambre de gaz.' Georges Bataille, 'Jean-Paul Sartre. Réflexions sur la question juive', *Critique*, 12 (1947), discussed in Michel Surya, *Georges Bataille, la mort à l'œuvre* (Paris: Libraire Séguier, 1987), pp. 362–63.

87 For the Maison de la Pensée Française, see Solange Bouvier-Ajam, 'Picasso et la Maison de la Pensée', *Europe*, 492–93 (April–May 1970), Picasso number, pp. 71–75, and 'Fernand Léger et la Maison de la Pensée Française', *Europe*, 508–09 (August–September 1971), Fernand Léger number, pp. 165–67.

88 See Joseph Billiet, *La Culture artistique en U.R.S.S.*, lectures given on 4 January and 1 February 1945 to the Jeudis de France-U.R.S.S. Éditions France-U.R.S.S and *Arts de France*, 5 and 6 (April–June 1946).

89 G. Docoloné et al., *Les Femmes oubliées de Buchenwald*, Mémorial du maréchal Leclerc de Hauteclocque et de la Libération de Paris (Paris: Paris-Musées, 2005).

90 Julien Cain returned to the Bibliothèque Nationale; Maurice Hewitt to the Paris Conservatoire; Marcel Paul became Minister of Industrial Production under de Gaulle; all three, drawn by Taslitzky in Buchenwald, were officially present at the opening of his 'Témoignage' show, with Aragon, Casanova, etc.

91 Jean-Paul Sartre, 'Portrait de l'antisemite', *Les temps modernes*, November 1945; *Réflexions sur la question juive* (Paris: Paul Morihien, 1946), pp. 83–86. See Jonathan Judaken, *Jean-Paul Sartre and the Jewish Question. Anti-semitism and the Politics of the French Intellectual* (Lincoln, NE: University of Nebraska Press, 2007).

92 For Communist women, see Renée Rousseau, *Les Femmes rouges: Chronique des années Vermeersch* (Paris: Albin Michel, 1983). Taslitzky received 200,000 francs, the mean annual salary of a secretary, for *Danielle*. For his Stockholm Appeal poster with *déportés* and Mireille Miailhe's Danielle Casanova poster in this context, see Wilson, 'Art and the Politics of the Left in France', chapter 6.

93 'Le Don des militants', Musée de l'Histoire vivante, Montreuil, 2009 (no catalogue); see also http://www.fonds-thorez.ivry94.fr/expo/2-anniversaire.swf (accessed 9 July 2013).

94 'Madame ROSENBLUM Anna née le 15/05/1889 à TALUSE déportée par le convoi n° 34 le 18/09/1942 à Auschwitz', Shoah Memorial, Paris; her name is on the Wall of Names.

95 See Louis Saurel, *Bertie Albrecht, Danielle Casanova* (Paris: Petite Encyclopédie de la Résistance. Les Femmes héroïques de la Résistance, 1945); Simone Téry, *Au soleil plein le cœur. La vie merveilleuse de Danielle Casanova* (Paris: Éditions Hier et aujourd'hui, 1949); Marie-Louise Coudert, *Elles. La Résistance* (Paris: Messidor–Temps Actuels, 1985); Pierre Durand, *Danielle Casanova l'indomptable* (Paris: Messidor, 1990); Paul Tillard's satirical novel, *Le Rançon des purs* (Paris: René Julliard, 1960); and Bernard, *Paris rouge*, pp. 106–09 (within the section 'Le Paris Communiste des Femmes', pp. 99–132).

96 Charlotte Delbo, *Le Convoi du 24 janvier* (Paris: Minuit, 1965); and *Auschwitz and After* (New Haven, CT, and London: Yale University Press, 1997).

97 See Bernard Lavergne, *Les Accords de Londres et de Paris. Le réarmement intégral de l'Allemagne, la bombe à hydrogène, la note soviétique du 24 octobre 1954. La France éliminée des Grandes Nations?* (Paris: Nouvelles Éditions Latines, 1955).

98 '180,000 Français ont été déportés / en 1941–1944 parmi eux 120,000 sont Juifs / 3,000 seulement sont revenus!'. 'Français Souvenez-vous!', poster, BDIC, Paris.

99 Suzanne Pagé, ed., *Jochen Gerz, Les Pièces* (Paris: Musée d'Art Moderne de la Ville de Paris, 1975).

100 Jean-Lucy Nancy, ed., *L'Art et la mémoire des camps. Représenter exterminer* (Paris: Seuil, 2001); Esther Shalev-Gerz with Jacques Rancière, *Menschen Dinge. The Human Aspect of Objects* (Weimar: Stiftung Gedenkstaätten Buchenwald und Mittelbau Dora, 2006).

101 Lisa Le Feuvre, Marta Gili and Jacques Rancière, *Esther Shalev-Gerz* (Paris: Galerie Nationale du Jeu de Paume, Fage Éditions, 2008). Rancière, 'Le travail de l'image', first published in French in *Multitudes*, June 2008.

102 *The Charnel House* was bought by Walter P. Chrysler from Picasso's studio in 1954.

103 See Sarah Gensburger, ed., *C'était des enfants. Déportation et sauvetage des enfants juifs de Paris* (Paris: Flammarion, 2012), an exhibition at the Hôtel de Ville, Paris; 'Au cœur du génocide. Les enfants dans le Shoah', 'Cinéma, l'année 1942', 'Des noms sur des murs. Les graffitis des camps de Drancy', exhibitions, Mémorial de la Shoah, 2012. 'Le Shoah, Les enfants aussi', supplement to *Le Point*, 21 June 2012, replaced a catalogue. See also the exhibitions 'Le rafle du Vel d'Hiv', 'les archives de la police', Mairie du 3ᵉ arrondissement, July 2012; and '"Nous qui sommes encore vivants", André Ulman, Ebensee 1945. Résister dans les camps nazis', exhibition, Musée de la Résistance Nationale, Champigny-Sur-Marne, 2012.

104 *La Spoliation des Juifs: une politique de l'État* (Paris: Mémorial de la Shoah, 2013).

105 'Evgueni Khaldei, Photographe de l'armée rouge', Paris, Musée d'art et d'histoire du judaïsme, June–August 2005 (no catalogue); see Marc-Henri Wajnberg dir., *Evgueni Khaldi, Photographer under Stalin* (Belgium, 1997) (DVD Homevision, 2001). A photographer at Yalta, Khaldi was dismissed from his job in October 1948.

106 See also Arkadi Vaksberg, *Staline et les Juifs: l'antisémitisme russe, une continuité du tsarisme au communisme* (Paris: Robert Laffont, 2003).

107 Annette Becker, *Maurice Halbwachs, un intellectuel en guerres mondiales 1914–1945* (Paris: Agnès Viénot, 2003); Michel Boujut, *Le Fanatique qu'il faut être, l'énigme Kanapa* (Paris: Flammarion, 2004); see also Gérard Streiff, *Jean Kanapa 1921–1978. Une singulière histoire du PCF* (Paris: L'Harmattan, 2001).

108 Maurice Halbwachs, *La Topographie légendaire des Évangiles en Terre Sainte, étude de mémoire collective* (Paris: PUF, 2008 [1941]); Halbwachs, *On Collective Memory*, trans. and ed. Lewis A. Coser (Chicago: University of Chicago Press, 1992).

5

Stalin Cheers.
Responses to the Bomb

In modern wars man no longer confronts his fellow man, but rather, the abstract powers of money and the machine, powers which serve his progress only for a time, the better to destroy him in the end. No representational style is adequate, perhaps, to portray these new powers which have degraded mankind to mere material and have elevated bombs to the metaphysical status of a new omnipotent devil.

Max Raphael, New York, 1940s[1]

The back, the pouting breast and the belly made the form of a tank; the tail feathers were exhaust fumes. The head was a turret and the beak a cannon, the hammer and sickle brand was on the shoulder. There was a simple five word caption: 'The Dove that goes Boom'. All Paris laughed and the Communists were ridiculed.

Washington Post, 17 February 1952 (Picasso FBI file)[2]

The powerful PCF rhetoric against the bomb should have been hoist with its own petard. In this chapter I contrast André Fougeron's anti-bomb history painting, *Hommage to André Houllier, Communist militant, killed at the age of 54 while putting up anti-war posters*, and Picasso's dangerously light-hearted drawing, *Staline à ta santé*: a toast with a raised glass. These were exhibited together in Paris in December 1949 in a huge show of seventieth birthday gifts to Stalin, later joining the international homage at the Pushkin museum in Moscow. The extent of Picasso's involvement with the first Communist peace congresses forms the wider context. Here, he was the 'genius of the arts' in conjunction with Nobel prize-winning scientist Frédéric Joliot-Curie's role as 'genius of science'. Picasso was silent in public – his proliferating doves spoke for him worldwide.

However, Joliot-Curie (his wife, Irène, was the daughter of Marie Curie, the discoverer of radium) spoke constantly and at length about the atom bomb. Joliot-Curie, the first signatory to the Moscow-backed Stockholm Appeal against atomic warfare and a committed Communist, would nonetheless direct France's Centre of Atomic Energy (CEA) until 1950 and eulogise Stalin in 1953. As was the case for their contemporary publics, the twin messages of Picasso and Joliot-Curie must be received and analysed together.

America dropped the atomic bomb *Little Boy* on Hiroshima on 6 August 1945; a catastrophic end to the Second World War. Mass civilian bombing, multiplying unimaginably the casualty figures of *Guernica*, raises huge questions. The entry of the Soviet Union into the war and its declaration of war on Japan on 8 August made Japanese surrender inevitable; the Nazi enemy was displaced by the almost-defeated Japanese. Why, then, was the second American bomb, *Fat Man*, dropped on Nagasaki on 9 August?[3] 'Technological civilisation has just reached its final degree of savagery,' wrote Albert Camus. 'We will have to choose, in a relatively near future between collective suicide and the intelligent use of scientific conquests.'[4]

France and Western civilisation as a whole faced a double paradigm change: the termination of any progressive notion of modernity with the Nazi extermination camps and the bomb – and simultaneously, the promise of a new atomic age. The dream of harnessing nuclear power as an energy source balanced nuclear fears. The issues are still topical, with ageing nuclear stockpiles on potentially hostile territories, the threat of new nuclear powers and the Fukushima nuclear disaster of 2011, which impacted upon energy strategies worldwide.

Military supremacy after 1945 in a newly global war arena was the key Cold War issue: US president Harry Truman's statement, 'We have spent two billion dollars on the greatest scientific gamble in history and won', is at the heart of this chapter.[5] Not only nuclear research-related sciences, but cybernetics – the man–machine relationship, popularised by 1946 – became East–West issues with cultural as well as scientific dimensions.[6] The Soviet's *First Lightning* (*Pervaya Molniya*), a 22-kiloton atomic bomb exploded in Semipalatinsk, Kazakhstan, was announced to the world by President Truman on 23 September 1949. The Cold War superpower confrontation began. The Soviet bomb implied wartime penetration of the American Los Alamos site and the Manhattan project (during the period when the USSR had declared itself an ally), effective continuous espionage and equivalent scientific expertise.[7]

'If the atomic monopoly was beset with anxiety, the dominant emotion in the duopoly was flat out fear.'[8]

Superpower parity impacted immediately upon Cominform-directed propaganda and the US-generated response, involving intellectuals worldwide; Picasso was the most prominent. I argue that Picasso's peace dove, in its relationship to the millions of signatures of the Stockholm Appeal and the artist's prominence at international peace congresses from 1948–1950, involved his publics in a form of 'magical thought' that 'disappeared' the Soviet bomb, the Soviet atomic programme and military expansionism. Moreover Soviet bombs, demanding, beyond espionage, the equivalents in material, technology and labour to their American rivals, were possible to achieve only with extensive gulag labour (an estimated 70,000 slave labourers were used to construct first Soviet reactor, for example).[9] While this frightening equation remained invisible at the time, the existence of the gulags was at the heart of Communist versus anti-Communist confrontations in Paris. Yet the Soviet gulag controversy was also 'disappeared' via the effectiveness of pro-USSR strategies and broad local and national issues of class, culture, patriotism and Holocaust memory connected with the French Communist Party. Picasso studies, via monographs and monographic exhibitions, perpetuate the erasure of this background, and perpetuate the disappearance of bomb and gulag. (This was the case with the *Picasso, Peace and Freedom* show in Europe and the Pushkin Museum retrospective, both in 2010.)

When Jean-Paul Sartre described Alberto Giacometti's scored and emaciated sculptures as the encounter between 'the man of Altamira' and 'the martyrs of Buchenwald', he pointed to an alarming continuity of primitive human drives.[10] A humanism rich with pathos traversed the conflicting yet porous discourses of Catholicism, Communism and existentialism in the early post-war period. 'Existentialism is a humanism', declared Sartre. 'Existentialism is not a humanism', Jean Kanapa retorted from a Marxist point of view in 1947. Merleau-Ponty's *Humanism and Terror, An Essay on the Communist Problem* of the same year, predicated upon the 1930s Moscow show trials, was preoccupied with the one-on-one situation of torture as a crux of the political. Never again! *Plus jamais!* André Malraux's inaugural lecture for the newly formed UNESCO was also premised on this theme.

Picasso's art likewise, whether political or Mediterranean, about war or peace, fully participated in a humanist discourse focused on 'man'. Humanism was internationally debated in 1949 in Geneva, where

the convention on human rights was established for the treatment of combatants and civilians in war.[11] (At the height of the Cold War, the notorious US 'Family of Man' exhibition circulated throughout western and eastern Europe, the USSR and beyond. The glowing explosion of H-bomb *Ivy Mike* – a room-high, colour photograph, 'Operation Ivy, Enewetak Atoll', shown in New York in 1955 – was tactfully omitted from the Tokyo venue in 1956.)[12]

In no way should the climate of fear during the post-war period be ignored. In discussing *la grande peur de l'après-guerre*, a parallel has been made with the 'great fear' of 1789 and concomitant phenomena of mass irrational behaviour; news of the American secretary of defence James Forrestal's nervous breakdown in April 1949, for example, intensified fears around 'finger on the button' diplomacy.[13] Nor should one underestimate the genuine wishes of millions for world peace, for the non-proliferation of atomic warfare and for scientific cooperation. Unsurprisingly, however, the thirst for scientific knowledge, Walter Benjamin's prediction of the 'revenge of technology', international competition and the desire for conquest would prevail.

The distinguished Marx scholar Raymond Aron, professor of politics and director of the liberal newspaper *Le Figaro*, reacted thus to the news of the atom bomb on 3 October 1949:

> Moscow will continue to think that time is on its side, working for the 'Fatherland of socialism.' With more or less brutality, the strategy will continue with the same goals: to weaken Western democracies as much as possible from the inside, to conquer territories in Asia via civil war, to reinforce the Soviet military arms set-up while carefully avoiding any provocation to war in general. Some well-meaning observers suggest that the USSR's leaders suffered from an inferiority complex and overcompensated for their fear via aggression. Delivered from the haunting envy of the atomic bomb, they would present a new face to the world. This hypothesis has no basis, and belongs to what the English call 'wishful thinking'; interpreting desires as reality.[14]

His tone in conjunction with his argument and *Le Figaro*'s appeal to a conservative centre were quickly rejected as right-wing propaganda by Communist Party members and fellow travellers. Aron produced *Le Grand Schisme* (1948) and *Guerres en chaîne* (1951) at this time; his collected editorials appeared as *La Guerre froide* (1990). Marxism, he would argue in 1955, was the 'opiate of the intellectuals' (replacing religion as the 'opium of the people' in Marx's own day).[15]

Aron was Jean-Paul Sartre's worthy rival and exact contemporary. Of course, the vast cultural budgets put into play by both the USA and the USSR during this period were collateral 'soft power' weapons in a hard power game. Intellectuals, as in the Münzenberg years before 1939, would play key roles.

Many countries including Britain, Germany, France and the USSR were working on nuclear fission in the late 1930s, when the politics of cooperation and competition had their impact (compare the trajectories of the Italian physicists Ettore Majorana, who 'disappeared', and Bruno Pontecorvo, who worked with Joliot-Curie, ultimately defecting to the USSR in 1950). At the 1937 World Fair, Joliot-Curie directed the installation of a Van der Graaff generator in the Palace of Discovery, its metres-long spark amazing visitors. During the Popular Front period (and thanks to Irène Joliot-Curie's short-lived role as the first female minister) his budgets increased and he innovated sponsorship policies and exchange programmes with Berkeley and Copenhagen. Astonishingly, his Laboratory of Nuclear Chemistry, installed in the deep basements of the Collège de France, continued to function during the Nazi occupation, with scientific equipment under the control of his former student Wolfgang Gentner. This situation was by no means transparent in the showcase publication for Marshall Pétain's Vichy regime, *Nouveaux destins de l'intelligence française* ('New destinies of French intelligence'), magnificently illustrated by the photographer Robert Doisneau in 1942. Dedicated to the 'Maréchal', decorated with the golden *francisque* or double-headed axe, this publication enshrined Pétain's words, indicated with a star at the beginning of each section. The science section proclaimed: 'Science, free and disinterested will occupy an eminent place in the new France.' It continues:

> M. and Mme Joliot have brilliantly studied the 'transuranian elements' due to the bombardment of uranium by neutrons and they have managed to split a uranium core in two. M. Joliot is currently the driving force of a Laboratory of Atomic Synthesis, which possesses high-energy neutron and X-Ray emitters. At the Collège de France where he teaches, he has built a cyclotron producing powerful bursts of heavy hydrogen (seven and a half million electron volts) ... The remarkable photographs reproduced here illustrate his current experiments with the explosion of the atom.[16]

Joliot-Curie's own photographs, captioned 'bombardments and atomic explosions', are reproduced here, together with Doisneau's plunging view

Figure 19: *Nouveaux destins de l'intelligence française*, 1942, pp. 124–25

of the three-million-volt generator in Ivry, first deployed experimentally in 1935; he shows a technician dwarfed by the huge installation (fig. 19).[17] In fact the Ivry laboratory ceased to function and suffered Allied bombing in 1943.[18] It was only thanks to industrial engineers from Germany and their replacements and adjustments to the Collège de France cyclotron that it functioned at all during the Occupation – by which time it was already obsolete. The most recent version, conceived by its inventor, Ernest Lawrence, at Berkeley, one hundred times bigger than Joliot-Curie's, was actively producing the plutonium for the Nagasaki bomb.[19]

'At the dawn of the atomic age, our country is placed in an inferior position', declared the first editorial of the popularising review *Atomes* in 1946. 'To ensure its prestige, France cannot simply recall the spiritual radiance (*rayonnement*) of its past. Without a belt of factories and laboratories, the cultural centre of gravity as a whole is under threat.'[20] French *nuclear* exceptionalism, then, with its redemptive rhetoric of 'French radiance', was linked to the consolidation of new projects for atomic research within the Atomic Energy Commission (CEA). The desire to negotiate a 'third way' between the two superpowers was also nuclear; a parallel may be made with France's negotiated status as 'cultural exception' in the context of the Blum–Byrnes' agreement of 1946 which impacted severely on cinema.[21]

France's sense of pride and national identity was deeply involved, following its exclusion from discussions at Yalta about the future map of Europe, the aftermath of Occupation and the evident debt to the Anglo-American war effort. The three European Recovery Program years of the US Marshall Plan's massive economic aid to France, from July 1948 to June 1951, coincided with both the first phase of France's Monnet plan for reconstruction and the highpoint of French Stalinism.[22] After Pétain, it would be the Communists themselves who would reclaim from Vichy the notion of *intelligence française*, with the 'Renaissance' and the Encyclopedia project referring to the Enlightenment illumination of French philosophers (*les illuminés*).[23] 'The bomb' and 'Peace', were used as metonyms within these wider confrontations.

In May 1947 the Communists were forced out of the government, notionally over policy in Indochina; henceforth they would be entirely oppositional.[24] (The USSR had no illusions: 'the real reason for the ousting of the Communists from the Government was the preliminary condition needed if France was to receive American credits'.)[25] Louis Aragon's 'call for realism' in art at this moment – echoed at similar moments over Communist and non-Communist Europe – focused upon Resistance hero André Fougeron, whose rise seemed unstoppable.[26] The artist's illustrations to Prosper Mérimée's *La Jacquerie* (1946) had been prefaced by Aragon's discussion of the origins of class struggle in France.[27] Aragon now declared that Fougeron's portraits (a dusky housewife holding a symbolic cockerel, for example) were a key to the 'destiny of figurative art ... the destiny of the world', prefacing his remarks by denouncing the 'new tyranny' of abstraction.[28]

The debate continued in June with a speech 'Communism, Thought and Art' at the eleventh Party Congress in Strasbourg. Laurent Casanova, Picasso's friend, replaced Roger Garaudy, though his pronouncements on 'practical effort with the people' and so forth still sounded dogmatic.[29]

Picasso and Matisse were again denounced as bourgeois and decadent in the USSR: the socialist realist painter Alexander Gerasimov renewed his attack on 'formalism' in the Soviet newspaper *Pravda* in July 1947, as the Academy of Arts of the USSR moved from Leningrad to Moscow.[30] Caught between obedience and his modernist allegiances, Aragon reluctantly pursued the fateful polemic in Moscow in September.[31]

Following the advent of the iron curtain dividing Europe, the Comintern (Communist International) would be partially resurrected as the Cominform (Communist Information Bureau). Its constitutive assembly was held in Poland in September 1947, directed by Georgi

Malenkov and Andrei Zhdanov, the aim being to coordinate the activities of the Communist parties of the USSR, Italy, France and Eastern Europe against the 'Truman–Marshall Plan'. Zhdanov's rhetoric of accusation was directed against the United States' atomic warfare programme aimed at the Soviet Union. His 'two-camp' doxa would significantly displace the emphasis on class struggle as a motor for overthrowing capitalism: he described a world divided between the imperialist and anti-democratic camp (the USA and its allies) versus the anti-imperialist and democratic camp (the USSR and its satellites) which aimed to promote a 'durable, democratic peace' through a demilitarised Germany, armaments reduction and a prohibition of the bomb.[32]

As Zhdanov spoke, workers in the mines of East Germany, Czechoslovakia, Bulgaria and Poland – countries accessioned by Stalin at the Yalta conference – were extracting uranium for the Soviet nuclear weapons programme. The 'uranium gulag', essentially a mining enterprise, would extend through Central Asia; the parallel 'atomic gulag' required more specialised skills to create atomic reactors, radiochemical plants and plants to separate uranium isotopes: contamination was of course a constant threat. From 1945 all decisions required Stalin's personal signature, proving the priority of the atomic project for the USSR.[33]

The Comintern directives were translated for the October/November issue of *Cahiers du Communisme*. Three artists' sessions were held to discuss the situation.[34] Back in Paris at the Autumn Salon of 1947, rife with stylistic debates, Fougeron's large-scale *Women of Italy* (women in headscarves at a market), with its post-cubist construction and light colours, still showed Picasso's formal influence. With his National Art Prize (recognising his Resistance role) Fougeron had been on a first trip to Italy. Here he encountered early Renaissance painting with its sharp forms, didactic message and humble protagonists in everyday dress; he discussed art and politics with Communist painters Renato Guttuso, Giulio Turcato and Emilio Vedova. It would be a whole year before the Autumn Salon of 1948, where *Parisians at the Market* (wives in his local Montrouge disputing the price of fish) demonstrated his new style. It involved realistic portraits (his wife Henriette), and women's clothes in clashing bright colours – though painted 'under the dictates of Zhdanov' according to the press; the scandal was considerable.

1948 marked two celebrations, each of which may be seen to impact upon French socialist realist art. For the centenary of the Communist manifesto, a profile of Karl Marx's great grandson, Karl-Jean Longuet, in his Paris studio, 'filled with busts of his illustrious ancestor', featured in

Regards.[35] 1948 was also the bicentenary of Jacques-Louis David's birth, celebrated with a major retrospective in the Orangeries throughout the summer; David would provide the revolutionary, moral and academic model for French socialist realism: the antithesis to Communist modernism.[36]

Picasso's Mediterranean world seems distant. In August 1948, however, he became the star of the Wrocław First International Peace Congress – a Polish initiative one must emphasise, distinct from international diplomacy.[37] (France could not be represented at the Yalta, Potsdam or Moscow conferences of 1945 but was involved in Allied discussions at the reparations-based Paris peace conference of 1946; its emblem also a dove.) In Wrocław, Picasso offered ceramics from Vallauris to the National Museum; he made pilgrimages to Auschwitz and to the Warsaw ghetto.[38] Endorsing the new Poland, Communist, anti-American but also 'folklorised', he was decorated with the star of the Order of the Polish Republican Renaissance by President Bolesław Bierut.

The exhibition of 17 'Contemporary French Painters' held in both Wrocław and Warsaw included both his 1939 portrait of Dora Maar and Taslitzky's realist *Delegates* of 1948 ('Picasso's woman and Boris Taslitzky's workers speak the same language...' the catalogue explained).[39] Picasso was angered by the vicious attack on Sartre by Stalin Prize-winner Alexander Fadeyev.[40] The doyen of contemporary Marxist criticism, György Lukács, aired unorthodox opinions about aesthetic developments in secret. The devastating news of Zhdanov's death arrived before the delegates' departure; Aragon (who had refused to join the French delegation) would write an orthodox elegy.[41] FBI reports in the Picasso file radically underestimated the significance of this grouping of international intellectuals in Poland.[42] In contrast, the 'House Unamerican Activities Committee' (HUAC) was quick to register a real threat.[43]

Back in France, Picasso was honoured by the interior minister Jules Moch with the silver medal of gratitude (*la Reconnaissance Française*), for services rendered to France. He would subsequently exhibit one-tenth of his ceramic production at the Maison de la Pensée Française near the Champs-Elysées, which he supported with significant financial aid; here he was filmed with the president of the United Nations (one notes certain symmetries with his Polish experiences).

Around late October, the Communist Party commissioned Fougeron to make a poster attacking French government policy in Europe. Six bombs labelled 'atomic' (explicit if improbable) were shown poised above an unconscious female child against a background of smouldering ruins

(plate 16). The slogan reads: 'The destruction of France through alliance with Germany. War against the URSS. That's what they're preparing for us. Against this UNITY AND ACTION. Preserve PEACE. The French Communist Party.' Banned immediately by Jules Moch, minister of the interior (but widely publicised, including a *New York Times* photo), the same poster was reissued without the words 'French Communist Party', titled 'Down with war', and signed 'a group of patriots and friends of Peace'. On 12 or 13 December 1948 a Communist militant, André Houllier, flyposting copies of this image at dawn, was shot dead by a non-uniformed policeman who remained unprosecuted.[44]

Frédéric Joliot-Curie inaugurated the first French nuclear reactor in the fort of ChaTillion on 15 December – Houllier's highly politicised funeral followed three days later, involving a cortège with full panoply of the Communist hierarchy: the suburb of Saint-Mandé was a mass of red flags.[45] President Vincent Auriol visited Joliot-Curie's reactor *Zoe* one week later (Z for zero power, O for oxide of uranium, E for heavy water, *eau lourde*), saluting France's *rayonnement*. Evidently, beyond Joliot-Curie's Faustian pact with nuclear power, his Communism implied split allegiances; a violent conflict with the PCF direction took place on 21 January 1949; on the twenty-fifth anniversary of Lenin's death, Party official Jacques Duclos insisted that each Communist had *deux patries*, two fatherlands.

The World Congress of Peace, Paris–Prague, held in late April 1949 under explicitly Communist auspices, involved speakers from 45 countries.[46] It was at this point that Louis Aragon's choice of Picasso's pigeon – a soft wash drawing on a black ground – became the worldwide symbol for international peace (fig. 20). (Bearing in mind the Communist coup in Prague in February 1948, the 'overflow' Prague conference for those unable to enter France confirmed the installation of the new Communist regime: it was already enforcing unwelcome agrarian and industrial reforms, not to mention the intimidation or liquidation of opponents.) Programmed to win hearts and minds, the international event in Paris involved not only proceedings in the Salle Pleyel, but ritual wreath-laying, a commemorative trip to the martyr-town site of Oradour, and processions in the Buffalo Stadium (with its 20,000 capacity) of youthful international groups such as the friendship groups France–Vietnam, France–Spain, France–Roumania, Franco-Polish friendship. There were loudspeakers, flags, slogans and stars on the tribune: Picasso, Joliot-Curie and Wanda Jakubowksa, the filmmaker. A month-long peace exhibition in central Paris's Winter Circus (Cirque d'Hiver) and a series of gala

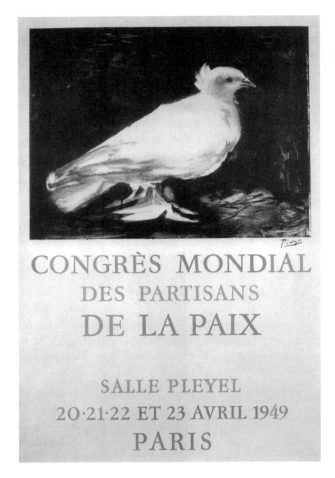

Figure 20: Pablo Picasso, poster for the World Peace Conference, 1949

evenings and shows complemented the event.[47] Press coverage effectively eclipsed the signing of the North Atlantic treaty for collective defence in Washington on 4 April: the birth of NATO.

Picasso's Paris presence was affirmed again with a major exhibition at the Maison de la Pensée Française in July 1949: 64 canvases painted over the last four years, with the bronze of a *Young Girl*.[48] Alain Resnais' film *Guernica*, with a voiceover by Paul Éluard and the music Georges Auric had composed for Éluard in 1937, was also released in 1949, spreading Picasso's fame again among cinema audiences, while reminding them not only of his political allegiances, but of his commitment to 'reality' in a Paris where another war – between 'hot' (gestural) and 'cold' (geometric) abstractions – increasingly dominated the artistic scene.[49]

The bomb poster scandal simmered, however. Fougeron had been formally charged in May 1949 with 'participation in an attempt to demoralise the army and the nation with an attempt at undermining national defence'. The following day a clampdown on the liberty of the press extending to visual images, provoked outrage and a protest manifesto signed by around fifty artists, including Picasso.[50] Fougeron subsequently aimed at triumph in the next Autumn Salon, with the Houllier scandal as catalyst for national, pro-Communist protest against censorship. He would bring together the French revolutionary painting of David and socialist realism, as Aragon had prescribed. The republication in *La Nouvelle Critique* of Aragon's 1937 speech 'Socialist realism, French realism' was surely no coincidence.[51] 'New realism' now supplanted 'socialist realism'; another attempt at subliminal de-Sovietisation at a time when policy was hardening.[52] Obviously Houllier himself was one of the Cold War's first, innocent victims.

Homage to André Houllier, communist militant, killed at the age of 54 while putting up anti-war posters would indeed dominate a whole room of socialist realism at the 1949 Salon (plate 15). Its performative role and subsequent invisibility make it the exemplary French socialist realist history painting. Houllier's corpse at the bottom of the large canvas lies life-size, below a frieze of angry figures reacting to the tragedy. Three figures to the left link hands in class solidarity, a desire for vengeance, and spell out a patriotic tricolour. The widow's black symbolises anarcho-syndicalism. The prostrate militant's body parallels that of the dead child in the poster on the wall; his posters, scattered along the base of the canvas, repeat 'Down with war!' The painting is disturbing in its rigidity, its silence versus the dynamic play of diagonals, bright colour acting on a grey background, the repression of action into the flat plane of the frieze and not least the painting's sexual polarisation, a typical Davidian device reflecting the Party's own ambivalent if not negative attitude to sexuality and the woman's role. The name 'Houllier' recalls *houilleur* (collier) and the PCF discourse centred on the miner as both stakhanovite, the super-productive worker, and as martyr. Dominique Desanti called Fougeron's canvas *The death of Antonin Barbier at Firminy-Loire* in her first-hand account, *Les Staliniens*. She unconsciously elided the intense drama around the historic miners' strikes of 1948 (involving casualties such as Barbier) and the bomb issue and Houllier's death – as was intended.[53] Not only dangerous accidents linked to production goals, but death and injury linked to police fire had intensified conflict and class conflict around the mines. Once the Communists had been expelled from

government, the protest strikes multiplied to vast proportions across the
nation by the end of the year. Desanti recorded press figures quoting two
million strikers in 1947; repeated tragedies in 1948.[54]

At over two-and-a-half metres by four metres, and representing
almost a year's work, the painting was subsidised heavily by the Party
(Fougeron had a wife and three children to support).[55] The plan was
to recoup expenditure by setting up a subscription for purchase by the
Parisian Federation of the PCF and postcard sales; the work would then
be offered to Stalin. The Communist press response was tumultuous.
Socialist realism had now attained *grande peinture* history painting
status: the work was a triumph.[56]

Truman's announcement of the Soviet bomb explosion, seven days
before the Salon opened, utterly sabotaged Fougeron's message.[57] Critics
asked ironically if Houllier's tracts were against a 'still not officially
Stalinist atom bomb...'[58] And the gulag question erupted at this moment,
just following Picasso's posed photograph with a large Stalin poster at
the plenary Peace Partisans Congress in Rome.[59] The 'Soviet Penal Code
for forced labour' was published in the *Figaro Littéraire* of 12 November
1949 by David Rousset, who brought to bear all his moral force as author
of *L'Univers concentrationnaire*. Pierre Daix, a Mauthausen survivor, was
given the task of repudiating 'lies' for the Communists in *Les Lettres
françaises*. The resulting libel trial, charges and counter-charges deflected
attention from unimaginable gulag statistics.[60] Compare the ironic
response of the writer in the serious Catholic review, *Esprit*, in mid-1948,
to the claims of the Soviet defector Kravchenko, author of *I Chose Liberty*
which had catalysed gulag investigations: 'Thirty million prisoners!
Famines in the USSR are organised by the government and are the worst
in the world, etc.'[61] Rousset's gulag accounts were received with similar
irony and incredulity, despite their source (the Soviet State Gospolitizdat
publishing house). Gulag survivors such as Julius Margolin, his memoirs
published in France, came over from Israel to offer appalling testimony
at the libel trial.[62] Yet Dominique Desanti recalls how, despite her shock
at Margarete Buber-Neuman's searing evidence, she 'didn't for an instant
believe in the truth of all the witness statements' in Kravchenko's book;
and despite knowing Rousset as a Resistant, she did not believe him
either. 'Can personal tragedy put communism in question?'[63]

Eulogies continued for Fougeron's *Hommage to Houllier*. Maurice
Thorez offered official Party praise in a report to the Central Committee
on 10 December 1949. The painting was then displayed in the 'gifts to
Stalin' exhibition held in December at the Metallurgists headquarters,

94 rue Jean-Pierre Timbaud, along with commissioned tapestries by Lurçat and Marc Saint-Saëns and Buchenwald drawings by Taslitzky.[64]

To organise the nationwide tribute ultimately destined for Moscow, Jean Chaintron became secretary of a 20-man committee, which appointed in turn an honorary committee of 700 'personalities' or trade union representatives. His memoirs recall the intense propaganda campaign orchestrated via the press, brochures, radio, speeches, 500,000 tracts and 30,000 posters, with ten decorated lorries criss-crossing France to popularise the event and pick up messages and presents (2,978 according to the 13 December communiqué with 4,000 in the following days). Inside the exhibition space, 23 mural panels constituted a wall painting illustrating the 13 themes of Stalin's life, illuminated by projectors, dominated by an immense portrait. The show opened on 6 December; during the fortnight that followed, 40,000 people signed the visitors' book.[65]

Picasso's drawing *Staline à ta santé* ('Stalin, Your health' or 'Stalin, Cheers') was exhibited in this context (fig. 21d). He attended the event. Chaintron recalls that a bar was set up to toast Stalin; hearty recorded music by the 'Chants du Monde' group played in the background and the atmosphere was festive. Picasso's preliminary experiments made in November demonstrate how the phrase *à ta santé* moves across his glasses from the bottom, to the centre, to the top before resting sagely in the wineglass itself (increasingly darkened to represent the worker's rough glass of red, or *ballon de rouge*); the hand becomes more carefully shaded, 'realistically' clasping the stem (figs. 21a, b, c). The least exuberant version, finally selected, was visible in the PCF's commissioned film of the birthday gifts show. It was reproduced on the 'Franco-Soviet friendship' page of *Les Lettres françaises*, and as a postcard; 200, individually numbered, were for sale (as were *Hommage to Houllier* cards).[66] The chosen Picasso sketch was published by the 'Secours Populaire' journal *La Défense* on 21 December.

In Moscow the works were shown in a far more extensive international display: the Pushkin Museum and its contents became the model of a social, indeed global macrocosm, 'the scale and public resonance of which were unprecedented in Soviet history. It is difficult to find Muscovites over the age of sixty who did not attend it on school excursions or with their parents. Equally numerous visiting tours were sent from all over the country by work collectives, universities, army units, and so on.' These words are those of Nikolai Ssorin-Chaikov, who in 2006 co-organised *Gifts to Soviet Leaders* (including Stalin, 1949)

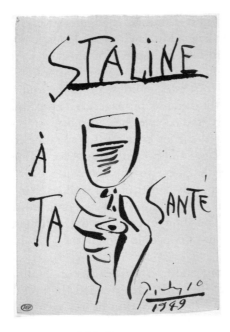

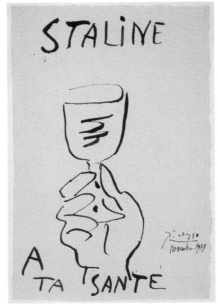

Figure 21a: Pablo Picasso,
Stalin, Your Health, 1949

Figure 21b: Pablo Picasso,
Stalin, Your Health, 1949

in Moscow's Kremlin Museum.[67] Fougeron's painting, confined to storage, along with Picasso's *Staline à ta santé* were conspicuous absences. Yet the anthropologist's complex consideration of 'heterochrony' – the different timescales at stake in the event (Michel Foucault's term related to 'heterotopias') could well be applied to Picasso and Fougeron's works in their French context.[68]

Chaintron's vast enterprise, its chain of command extending over the whole French territory, its astonishing economics in terms of both labour and time, may be compared and synchronised with the Moscow schedule with its global remit: ten days to pack up the entire fine art contents of the Pushkin, to coordinate, unpack, select and display the worldwide panoply, to organise the sequence and hierarchies of visitors. The psychic pressure of Stalin's immanence, his potential pleasure or wrath was the limit-experience impinging on individual performance. Ssorin-Chaikov describes the 'time collapsed or speeded up – of rush, taking its key analytical metaphor from the ten days in which the exhibition, itself a birthday gift to Stalin, was put together'.

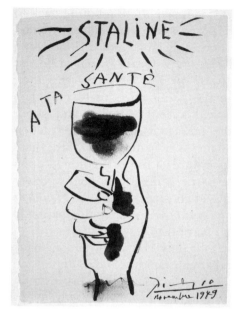

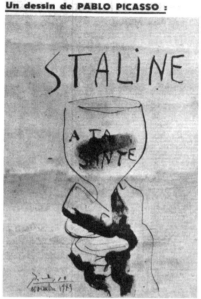

Figure 21c: Pablo Picasso,
Stalin, Your Health, 1949

Figure 21d: Pablo Picasso,
Stalin, Your Health, 1949

He speaks of the 'three temporalities that are simultaneously at work in the rush of this gift-giving': the political rhythm, the timelessness of the concept of socialist utopia which 'freezes' modernism, and teleology, the 'teleology of socialism, which reads the present from the point of view of the future'. Yet the 'material and temporal fragility of timelessness' is also involved: some gifts were broken in the rush of putting the exhibition together, and the exhibition itself, created 'for good', existed only until Stalin's death in 1953.[69]

Within *Homage to Houllier*, then, there are many times. First, the laborious time of its making, involving compositional drawings, the first published lithograph, oil sketches in the manner of David, the squaring up on to the history-sized canvas, the careful painting in oils, using an academic technique to cover the vast canvas like an Old Master. There followed the varnishing, moving the large canvas through Paris and the Metallurgists' headquarters show; transport to Moscow, the Pushkin display; move to a permanent Western contemporary room; anathema after 1953, the relegation of the work to the museum store and recent

reviewing. There are also the times of the image itself, referring back to the time of its conception. First, the post-assassination moment, blood still trickling from the corpse, the light still grey from a brightening dawn, the family and friends assembled, the wife still frozen in horror, yet the menfolk already turning away, already bent on vengeance, *revendication*. The time contained in the poster refers us to Houiller's flyposting, his belief in Party and peace, his sacrifice of sleep and labour for the cause before first light. Yet the message itself – 'The destruction of France through alliance with Germany. War against the USSR. That's what they're preparing for us' – looks towards a future predicated upon an image of the atomic bombs of the past – hence a continuous present of horror and nuclear fear. And the Davidian time, the time of *Houiller's* palimpsest, inscribes the work into a *longue durée*, an extending past, still vivid in the present, of revolution and patriotism.

Picasso's drawing, however, insults not only Fougeron, but so many other lovingly crafted gifts through its extreme rapidity, and its impression (however false) of spontaneity. It captures a moment: the worker's toast at the bar. Above all it represents the moment of a gaffe. Only in the Picasso Moscow retrospective of 2010 was one able to sense Ehrenburg's exasperation: why did Picasso not send Stalin a plate with a dove?[70] Worse than the offhand caricature was the graver fault of *lèse-majesté*. Why had Picasso written *ta santé* (the familiar form of address, not *votre santé*) as though Stalin, too, was a comrade, not the Leader? Picasso was implicitly putting himself on Stalin's level. This too, could have blown up into a 'Picasso–Stalin' scandal; but the vested interests of 1953 were not yet at stake. According to Pierre Daix, Picasso's disrespect caused consternation, but Maurice Thorez and Laurent Casanova were thrilled: Picasso's goodwill was enough.[71] The material fragility of the work, nonetheless, and its slogan mean that it has never been seen again. Was it, in fact, ever exhibited in Moscow? Or was it spirited away as an embarrassment like the broken or mouldering and decaying gifts Ssorin-Chaikov describes? (Ehrenburg's presumably saw the work. Was he the censor?) Both *Staline à ta santé* and *Homage to Houllier*, compromised by post-Stalinist years of disgrace, have remained well-kept secrets.[72]

And Marx? Fougeron's self-criticism (or *autocritique* in the Stalinist show-trial genre), published in *Arts de France* in late 1949, aspired to be a model of Marxist art history, with a dialectical twist. All the right sources sauced the artist's most substantial text to date: the nineteenth-century critic Vissarion Belinsky, Lenin on Party literature, Maxim Gorky, Aragon and Zhdanov quoting Engels (on the analysis of the conditions

of existence of social classes which precedes any conceptions in the political, legal, aesthetic, philosophical, religious or social domains). Added to these, pell mell, were Pierre Daix, Laurent Casanova, Georgi Plekhanov, Taslitzky, Maurice Thorez, art critic Eugène Fromentin... Expressions such as 'all aesthetic decadence is first expressed by a progressive detachment from content' and 'infantile malady' were confronted with a panoply of illustrations from Gross through Seurat and Cézanne to the cubists and Matisse – *Art de France*'s 'encyclopedic' and educational remit once again overriding Soviet positions. Fougeron ends with a justification of 'a new history painting' (his own): 'Proudhon was a contemporary of David ... History painting knew its hour had come when history, overburdened with injustice, was written brutally with the blood and tears of those who wanted to change its course ...' Even the earlier statement 'Art criticism is a criticism of class in the service of class' is used against the critics of the Autumn Salon.[73]

Like Aragon, Fougeron nationalised socialist realism. The required humility and repentance in this 'Criticism and Self-Criticism' retained a hint of characteristic pugnacity, absorbing his own, contentious work into a great tradition. 'I wanted to show everything; yes absolutely everything; the women, the family, sadness in the face of the unpunished crime, *but also the reasons for my conviction*. Beyond my capabilities? Perhaps, and yours?'[74] His mythic description here of the 'summons to act' is significant; Aragon's gentle exhortation about what Fougeron should do for the next Autumn Salon, relayed to the grieving artist over Houllier's grave, deliberately evokes the revolutionary call to commemorate the assassination of Marat delivered by the National Assembly to David. Aragon had used this trope, recalling Jacques Duclos's summons for his own *Le Témoin des martyrs*, which bore witness to the reprisal executions of Communists at Chateaubriand during the Occupation. (Fougeron's first lithograph seems based on a composition showing the death of resistance hero Gabriel Péri, a similar lineage.)[75]

Was Aragon's revising hand involved in Fougeron's 'self-criticism', a way of eschewing authorship himself, but keeping the work in the news? The calling to apostolate may be seen, of course, as a transposition of religious discourse; the 'self-criticism' parallel to religious abjection.[76] The Party prolonged the fervour by celebrating the 125th anniversary of David's death in 1950, for which Fougeron wrote 'David for today' ('David and ourselves') in *Arts de France*, just before the review folded. 'Yes, David was the painter of the Nation, the painter of national aspirations within a glorious hour of our country's history.'[77]

As in Max Raphael's 1930s with its 'concrete abstractions' and 'revolutionary surrealism', art in post-war Paris was characterised by a stylistic pluralism: a burst of new energies which form the backdrop to this chapter. The UNESCO international show of modern art in 1946 (incorporating 'Advancing American Art' sent from the US State Department) showed diverse work from 26 countries.[78] The Salon system revived and proliferated after the war with the May and October Salons, and the 'Salon of New Realities' for geometric abstraction, concurrently with the rebirth of the gallery system. The powerful evolutionary argument for abstraction was such that former AÉAR revolutionary artist, the venerable Auguste Herbin, protesting against Communist policy, painted an entirely abstract *Lenin–Stalin* of intersecting triangles and discs in 1948 (fig. 22).[79] Complementing the Catholic review *Esprit*'s special number 'Open Marxism or Scholastic Marxism?' in May 1948, György Lukács's article 'Free Art or Directed Art?' followed in September.[80] (The younger Communist and Resistant Jean Dewasne would create an entirely abstract mural, *Apotheosis of Marat*, in 1950, that countered Fougeron with an alternative homage to the revolutionary painter David.)

The clash of 'old' and 'new' abstractions created new styles and vocabularies for 'cold', geometric abstraction (Victor Vasarely) or 'hot', lyrical or gestural abstraction (André Lanskoy or Georges Mathieu), while the more stippled technique was called 'tachism' (Henri Michaux). 'Is abstract art an academicism?' a critic asked in 1950.[81] Likewise, following the major International Surrealist exhibition in Paris in 1947 under the aegis of both André Breton and Marcel Duchamp, the dissident Revolutionary Surrealists and the COBRA group flourished. Paris reborn looked forward to the 1950s; an expanding market was again postulated on the power of the signature style.

The Communist Party in this context managed an entirely alternative cultural economy. This included major commissions such as *Buchenwald* or *Hommage to Houillier* (one annual salary for an artist created months of scandal), its own exhibition venues (the Maison de la Pensée Française, the Metallurgists' headquarters) or, alternatively, the coopting of pre-existing spaces, catalogues and Salon procedures, for example their cooption of Paris's Autumn Salon, the historic birthplace of Fauvism. It used alternative circuits and commissioned large-scale decors for Communist venues, posters, leaflets and postcards. Its distinguished press and art and literary critics responded to the productions of its own celebrated cultural figures. Finally, the concept of art as 'solidarity' entailed the

Figure 22:
Auguste Herbin,
Lenin–Stalin, 1948

gift of artworks as a form of allegiance, whether professional, amateur or children's art, produced via the organisation of Communist cells and Parisian arrondissements: witness the 14th arrondissement's album for Stalin's seventieth birthday, treasured after the birthday gifts show in the Pushkin Museum's print room.[82] Picasso's major patronage of the Maison de la Pensée Française, of the Cercle d'Art publications and of the newspapers for which he did special front pages, was a crucial bonus.

In fact Stalin never visited his birthday show at the Pushkin Museum with its gifts from France in 1949; he had other, more urgent priorities. The dearest present, in all senses, for the leader's seventieth birthday was not a history painting, not a drawing by Picasso, not the accumulated international homage of world Communism piled high in Moscow: it was the Soviet bomb itself.[83]

The year 1950 opened with an editorial in *Les Temps Modernes*:
'It is now an established fact that Soviet citizens can be deported
in mid-trial with no judgement and for an unlimited time ... And
it's established that the repressive apparatus has assumed the status
of a distinct power in the USSR. We state that that there is no
socialism when one in twenty citizens is in a camp.'[84] The riposte
in *Cahiers du Communisme* was the great poet Paul Éluard's most
Stalinist poem.[85] Estimates of the total number of gulag prisoners in *Les
Temps Modernes*' official Soviet source were between 10 and 15 million;
Sartre and Merleau-Ponty themselves, the major non-Communist
intellectuals on the Parisian scene, now espoused Rousset's cause.
By 1951 a SFIO socialist party poster was circulating in Paris: it marked
the camps of the gulag with relative accuracy (showing emaciated
children in a photomontage insert).[86]

In the face of the enormity of the evidence – in the face of the
prestige of France's anti-Communist intellectuals and its Communist
ones – American politicians, the security forces, the FBI and the CIA
were dismayed:

> Where are they, the French? What are they saying? What are they
> doing? Have they lost all their critical spirit, all common sense? How
> can they accept the Stockholm Appeal and the Korean War, civili-
> sation and the forced labour camp, liberty and religious persecutions,
> the marriage of democracy and the Soviet secret police?[87]

The CIA, active in France since 1947, had focused its activities first on
the Congress for Cultural Freedom (Berlin, 1950). Intelligence would
be complemented by extensive military installations near Paris on the
Île de Saint Cloud and a vast underground bunker in Saint-Germain-
en-Laye.[88] Now, with some urgency, its well-funded 'Peace and Liberty'
campaign was launched in September 1950, fronted by the socialist
politician Jean-Paul David, undermining the Communist's own rhetoric
and exploding their humanist consensus with humour and irony. 'The
Dove that goes Boom!' (*La colombe qui fait boum!*) was their first and
most memorable coup: a poster with Picasso's white dove as a Soviet
tank, on a bright red ground (plate 17). The explosive slogan was soon
pasted all over the walls of Paris as Picasso's dove had been: the print run
was purportedly 300,000.[89]

The second World Peace Congress was scheduled for Sheffield, Great
Britain, in November 1950. Notoriously the left-wing British Labour
government under Clement Attlee banned the congress at the last

moment; all visas were refused except Picasso's as vice-president of the World Peace movement. The conference was transferred to Warsaw (Picasso drew a black dove 'in memoriam').[90] Two of the three official art exhibitions there were highly socialist realist in content ('Youth Fights for Peace' at the National Museum), yet it was Picasso who received the Stalin Peace Prize for his dove poster, not his painting. French government fears were entirely corroborated when Frédéric Joliot-Curie, ousted from his post at the head of the Centre for Atomic Energy on 28 April 1950 (after the Stockholm Appeal), also received a Stalin Peace Prize. The distribution of such prizes had become a veritable arm of Soviet foreign policy: Cominform policy outside the Soviet Union was totally at odds with the restrictions imposed upon Soviet artists, and the complex politics around their internal Stalin prizes for fine art.[91]

Pablo Neruda, the Chilean poet who received an International Peace Prize, declared:

> Picasso's dove flies over the world. The State Department menaces it with poisoned arrows, the fascists of Yugoslavia and Greece with their hands red with blood. MacArthur, the Assassin, launches incendiary napalm bombs on the heroic people of Korea. The satraps who govern Columbia and Chile wanted to prohibit entry to the country. In vain. Picasso's dove flies over the world, white and luminous, bringing sweet words of hope to mothers, waking the masses with the beating of its wings; reminding them that they are men, sons of the people, and we do not wish them to go to their deaths. The enemies of peace smiled at the dove's birth; now they watch it with fear, making a barrage of tanks at Sheffield.[92]

This was the magic of the 'man with the dove'. Neruda's words exemplify a sublimated world where doves' wings replace angels' wings, where an aerial perspective sheds an obliterating whiteness and light over the 'two camps' of a divided and fearful world. Soviet expansionism is implicit in Neruda's eulogy; but here there is no Soviet arsenal, no Soviet bomb, no gulag, no Zhdanov, no Beria, no Fadeyev, no Stalin. Similar to the impossibility of humanly 'imagining' Holocaust statistics was the impossibility of 'imagining' the bomb in terms of its making, its enormity or its destructive power. The universally recognised 'mushroom cloud' naturalised the bomb as a force of nature rather than a willed tool of destruction. And, as God the Father is simultaneously living Son and Holy Spirit as dove, Picasso is here transformed (with the dove as his attribute) from artist-genius to demiurge: the artisan-deity.

Just as Sartre had recalled the 'man of Altamira', the Marxists Max Raphael and Ernst Fischer, and subsequently Herbert Marcuse, all made recourse to the drives of prehistoric man in a search for contemporary explanations. Long after Raphael's suicide on 14 July 1952, in the Cold War context I describe, John Berger would summarise his theses: on art as a 'revolutionary undoing', 'the undoing of the world of things, the construction of a world of values, and hence the construction of a new world'.[93] Fischer claimed in *The Necessity of Art* (1959) that 'Western Europe in its denial of humanism and in the fetish-like character of its institutions reaches back to the fetishes of prehistory and constructs false myths to hide its real problems ... Man also dreams of working magic upon nature ...' Fischer discusses 'word-signs' (here 'peace' or 'dove' for example) as 'command signals'. 'The magic at the very root of human existence, creating a sense of powerlessness and at the same time a consciousness of power, a fear of nature together with the ability to control nature, is the very essence of all art.'[94] And Marcuse argues in *Soviet Marxism* 'cut off from its historical base, socialised without socialist reality, art reverts to its ancient prehistorical function: it assumes [a] magical character. Thus, it becomes a decisive element in the pragmatic rationality of behaviourism.'[95]

The power versus powerlessness dichotomy Fischer pinpoints was, I would argue, at the very basis of each ineffectual citizen's Cold War dilemma and espousal of political values. To see Picasso as the harbinger of salvation, 'peace and freedom' sublimates individual 'power' to the power of the demiurge. On the one hand the incantatory force of rhetoric such as Neruda's served to counter Communist 'newspeak' – in more resonant terminology, the *langue de bois*.[96] This is the language that points to a linguistic and mental edifice, saturated with ideology, hierarchy and bureaucracy, which structured the reactions of French Stalinists before 1953, from leader Maurice Thorez or hard-line Jean Kanapa to the young Dominique Desanti.[97] Picasso's dove acted as a 'command signal' not only for the discourses of peace but for this edifice as a whole, while suggesting certain counter-values, such as compassion, hope, beauty, even sexuality (Françoise Gilot's face, framed with dove wings as the Visage of Peace). On the other hand, the continuation of a rhetorical discourse from 1950 through the 1960s as part of the 'cult of personality' (*kul't lichnosti*) of Picasso himself raises different questions about his humanist art and its potential obsolescence as well as its power.

The 'A' bomb race would become the 'H' bomb race, launched via discussions in America as early as October 1949, the political and

scientific machinations well described by Dominique Desanti and her collaborators in *Bombe et paix atomique* (1950).[98] Following the Soviets' *First Lightning* (based on the USA's *Fat Man*), the first Soviet hydrogen bomb was exploded on 12 August 1953 (in the wake of the USA's *Ivy Mike* test of 31 October 1952). Eisenhower's 'Atoms for Peace' speech riposted in December. After the exhilaration of the first space flight, saluted by Picasso with portraits of the jovial cosmonaut Yuri Gagarin, Nikita Khrushchev announced a new series of nuclear tests in August 1961. The Soviet *Tsar* bomb, detonated on 30 October 1961, was 1,400 times greater than the Hiroshima and Nagasaki bombs together.

With his eye for mechanics and new technology, Robert Doisneau, who had photographed the Renault factory plant in the 1930s and Joliot-Curie's Collège de France cyclotron during the war, was by 1961 pursuing the cybernetic interface between art and science. He photographed not Picasso's work, but Nicolas Schöffer's 52-metre-high cybernetic tower in Liège, with its 22 revolving mirrors and complex control panels.[99] Cybernetics, with its man–machine feedback mechanisms, its military and space project applications, had entered both European and, controversially, Soviet discourses by this time.[100] (Schöffer dated his cybernetic art to 1954.) Not only socialist realism but also modernist painting itself – Picasso included – was increasingly anachronistic, like the pathos-based humanism of the immediate post-war years.

Notes

1 Max Raphael, 'Discord between Form and Content: Picasso/Guernica', in *The Demands of Art*, ed. Herbert Read (Princeton, NJ: Princeton University Press, 1968), p. 138.

2 Typewritten report 64-200-231-1 "Washington Post" 2/17/52 / (2) (pdf 3, page 32), in Richard Patricia's e-book *Pablo Picasso: Original FBI Files: Interesting FBI Paperwork Involving Cases*, http://permanent.access.gpo.gov/lps1461/picasso1.pdf (the page order of this version does not correspond with that of the earlier photocopy that I procured).

3 See Edward Demenchonok, 'Introduction', in *Philosophy after Hiroshima* (Newcastle: Cambridge Scholars Publishing, 2010).

4 'La civilisation mécanique vient de parvenir à son dernier degré de sauvagerie. Il va falloir choisir, dans un avenir plus ou moins proche, entre le suicide collectif ou l'utilisation intelligente des conquêtes de l'homme.' Albert Camus, 'Au lendemain d'Hiroshima', editorial, *Combat*, 8 August 1945.

5 'Truman informs the nation that an atomic weapon has been detonated in Japan. August 6, 1945', Harry S. Truman Library, 'Army press notes', box 4, Papers of Eben A. Ayers.

6 Norbert Wiener, *Cybernetics, Or, Control and Communication in the Animal and the Machine* (New York: John Wiley / Paris: Hermann, 1948).

7 See L.D. Râbeva, ed., *Atomnyj proekt SSSR*, vol. 1: *1938–1945* (Moscow: Nauka / Fizmatlit, 1998), with English summary of titles of 198 documents, including operating a cyclotron (November 1938), the storage of heavy water (June 1940), exchanges with the British Council (February 1942) etc. See also Vladimir Tchikov, with Gary Kern, *Comment Staline a volé la bombe atomique aux américains, Dossier KGB no 13676* (Paris: Robert Laffont, 1996): around 6,000 pages of secret material, correlated with US pre- and post-glasnost information.

8 Michael D. Gordin, *Red Cloud at Dawn. Truman, Stalin and the End of the Atomic Monopoly* (New York: Farrar, Straus and Giroux, 2009), p. 256.

9 Thomas B. Cochran and Robert S. Norris, 'A First Look at the Soviet Bomb Complex', *Bulletin of Atomic Scientists*, 47/4 (May 1991), pp. 25–31; statistics from Jaures Medevev, 'Le Goulag atomique', *Novoie Rousskoie Slovo*, New York, 12 August 1994, pp. 17–18.

10 Jean-Paul Sartre, excerpts from 'La Recherche de l'absolu', *Le Temps Moderne*, 3/28 (1948), pp. 153–63; reprinted as 'The Search for the Absolute', in *Alberto Giacometti* (New York: Pierre Matisse Gallery, 1948).

11 See Karl Barth et al., *Pour un nouvel humanisme*, Rencontres internationales de Genève (Neuchâtel: Les Éditions de la Baconnière, 1949), with contributions by theologian Karl Barth, the Marxist Henri Lefebvre, and the orientalist René Grousset.

12 Edward Steichen, *The Family of Man* (New York: Museum of Modern Art, 1955); see John O'Brian, 'The Nuclear Family of Man', http://www.japanfocus.org/-John-O_ Brian/2816 (thanks to Martina Caruso for this reference).

13 See François Fonvieille-Alquier, *La Grande Peur de l'après-guerre* (Paris: Robert Laffont, 1973), pp. 17–18.

14 'Rien ne permet de penser que, dans l'immédiat, un changement doive intervenir. On continue de penser, à Moscou, que le temps travaille pour la "patrie du socialisme". Avec plus ou moins de brutalité, la stratégie poursuivra les mêmes objectifs : affaiblir le plus possible de l'intérieur les démocraties occidentales, conquérir par la guerre civile les territoires d'Asie, renforcer l'armature militaire de l'Union soviétique en évitant soigneusement de provoquer la guerre générale. Quelques observateurs de bonne volonté suggèrent que les dirigeants de l'URSS souffraient d'un complexe d'infériorité et "surcompensaient" leur crainte en agressivité. Délivrés de la hantise de la bombe atomique, ils présenteraient au monde un visage nouveau. Cette hypothèse ne repose sur rien et appartient à l'ordre de ce que les Anglais appellent prendre ses désirs pour des réalités: wishful thinking.' Raymond Aron, 'L'URSS possède la bombe atomique', *Le Figaro*, 3 October 1949.

15 See Raymond Aron's *Le Grand Schisme* (Paris: Gallimard, 1948) and *Guerres en chaîne* (Paris: Gallimard, 1951) and pro-American articles in *Le Figaro* (collected in Aron, *La Guerre froide* [Paris: Bernard de Fallois, 1990]). Also Aron, *L'Opium des intellectuels* (Paris: Calmann-Lévy, 1955) and *Le Marxisme de Marx* (Paris: Éditions de Fallois, 2002).

16 'Enfin, M. et Mme Joliot ont brillamment étudié les éléments "transuraniens", dus au bombardement de l'uranium par les neutrons; et ils ont provoqué la cassure en deux d'un noyau d'uranium. D'autre part, M. Joliot est le promoteur d'un Laboratoire de Synthèse atomique qui dispose d'émetteurs de neutrons et de rayons X de grande énergie. Au Collège de France où il enseigne; il a fait construire un

cyclotron produisant de puissants faisceaux de noyaux d'hydrogène lourd (7 millions et demi électron-volts) […] Les remarquables photographies ci-contre illustrent ses expériences actuelles sur l'explosion de l'atome […]' Maurice de Broglié, 'La Recherche scientifique', in Paul Marion et al., *Nouveaux destins de l'intelligence française* (Paris: Édition du Ministère de l'Information, 1942), p. 124.

17 Doisneau's photograph no. 1819: 'Générateur de chocs 3MV dans la laboratoire de synthèses atomique d'Ivry sur Seine en 1937.' Three versions incorrectly dated 1958 exist in the Archives Joliot-Curie, Paris: G 152, one inscribed by Doisneau 'l'homme devenu tout petit à côté de la machine […]'

18 Michel Pinault, 'Aux débuts de la Big Science', in Pinault, ed., *Doisneau chez les Joliot-Curie. Un photographe au pays des physiciens* (Paris: Musée des arts et métiers, Cnam / Sommières: Romain Pages Éditions, 2005), p. 22.

19 Philippe Molinié, 'Les Machines atomiques: les instruments de la physique changent d'échelle', in Pinault, ed., *Doisneau chez les Joliot-Curie*, p. 37 (more than twenty cyclotrons were functioning in the United States by this time).

20 'A l'aube de l'âge atomique, notre pays est placé en conditions d'infériorité […] Il ne suffit plus à la France, pour assurer son prestige, de faire appel à un passé de rayonnement spirituel. Sans une enceinte d'usines et de laboratoires tout centre de gravité culturel est menacé.' *Atomes, Tous les aspects scientifiques d'un nouvel âge*, 1 (March 1946).

21 See Gabrielle Hecht's brilliant study, *The Radiance of France. Nuclear Power and National Identity after World War II* (Cambridge, MA: MIT Press, 2009 [1998]), and Serge Regourd, *L'Exception culturelle* (Paris: PUF, 2004).

22 See Nicolaus Mills, *Winning the Peace: The Marshall Plan and America's Coming of Age as a Superpower* (Hoboken, NJ: Wiley, 2008).

23 See the 'Manifeste de l'Encyclopédie de la Renaissance Française', *Regards*, July 1945, p. 21.

24 The decree of 4 May (*Journal Officiel*, 5 May) expelled Thorez and the Communist ministers of national defence, labour and social security, reconstruction and urban planning; the health minister resigned in solidarity; see Jacques Fauvet, *Histoire du Parti Communiste Français*, vol. II (Paris: Fayard, 1965), pp. 196–97.

25 G. Procacci et al., *The Cominform; Minutes of the Three Conferences, 1947, 1948, 1949* (Milan: Feltrinelli, 1994), First conference, Appendix A, p. 453.

26 Fougeron's first two-year contract was with the prestigious new Galerie René Drouin; he then had a successful one-man show at the Galerie Billiet in October 1946. See listings in Simone Flandin, 'André Fougeron, Le Parti-Pris du Réalisme, 1948–1953', MA thesis, University of Clermont-Ferrand, 1981–82.

27 Prosper Mérimée, *La Jacquerie* (Paris: La Bibliothèque Française, 1946); Aragon's preface links the term coined during the peasant revolts of 1358 to class struggle and the Commune.

28 'André Fougeron, dans chacun de vos dessins se joue aussi le destin de l'art figuratif, et riez si je vous dis sérieusement que se joue aussi le destin du monde.' Aragon, preface to *André Fougeron, album de dessins* (Paris: Les 13 Epis, 1947).

29 Laurent Casanova, *Le Communisme, la pensée et l'art* (Paris: Éditions du Parti Communiste Français, 1947).

30 See Françoise Levaillant, 'Note sur l'affaire de *Pravda* dans la Presse parisienne, août-septembre 1947', *Cahiers du Musée National d'Art Moderne*, 9 (1982), pp. 147ff.

31 See François Eychart, ed., 'La Controverse Aragon–Simonov (2 September 1947)', *Les annales de la Société des amis de Louis Aragon et Elsa Triolet*, 5 (2003), pp. 9–42 including extracts from Gerasimov, 'Contre le formalisme, pour un art élevé et engagé', pp. 38–42 (no Picasso–Matisse extracts).

32 A. Zhdanov, 'On the International Situation', in Proccacci et al., *The Cominform. Minutes of the Three Conferences, 1947, 1948, 1949*, pp. 225ff.

33 See Zhores A. Medvedev, 'Stalin and the Atomic Bomb', *The Spokesman*, 67 (1999), pp. 50–65 (originally published in *Obschaya Gazeta*, 19–25 August 1999); Medvedev, 'Stalin and the Atomic Gulag', *The Spokesman*, 69 (2000), pp. 91–111.

34 Three sessions of debate confirmed by Boris Taslitzky, Archives sonores, MNAM, 1981 (*Paris–Paris* exhibition), typescript, p. 12.

35 'L'atelier parisien du sculpteur Jean-Karl Longuet, arrière petit fils de Marx est peuplé de bustes de son illustre aïeul Longuet.' See Jean Fréville, 'Le Manifeste Communiste a cent ans', *Regards*, 134 (27 February 1948), p. 7.

36 Michel Florisonne, ed., *David: exposition en l'honneur du deuxième centenaire de sa naissance*, Orangerie de Tuileries, June–September 1948 (Paris: Éditions des Musées Nationaux, 1948).

37 Dominique Desanti describes Jerzy Borejsza's 'Peace A bomb', subsequently approved by Zhdanov, in *Les Staliniens, une expérience politique, 1944–1956* (Paris: Fayard, 1974), pp. 104–05.

38 M. Bibrowski et al., *Picasso w Polsce* (Krakow: Wydawnicto Literackie, n.d.), p. 262.

39 Jean Marcenac, catalogue introduction, reprinted in *Odrozenie*, 3 (1948), p. 4; quoted with an installation photograph in Katarzyna Murawska-Muthesius, 'Paris From Behind the Iron Curtain', in Sarah Wilson, ed., *Paris, Capital of the Arts, 1900–1968* (London: Royal Academy of Arts, 2002), p. 252.

40 Desanti, 'L'assaut Jdanov contre Sartre', in *Les Staliniens*, pp. 115–16; she discussed the realism issue directly with Hungarian theorist György Lukács at Wrocław, pp. 119–121.

41 Louis Aragon, 'Jdanov et nous', *Les Lettres françaises*, 9 September 1948.

42 FBI file references to Picasso's visit to the 1948 Warsaw peace conference appear in a translated article from *Démocratie Nouvelle* by Marcel Willard, and a Lithuanian newspaper from Toronto, but the summary has no idea of the scale or importance of this event. Ilya Ehrenburg's account of the Warsaw conference was reported from the American Embassy in Moscow to the FBI, though the New York *Daily Worker* is always the fullest source of information.

43 Dominique Desanti refers to the HUAC report 378, 1st session, 82nd Congress, and the committee of Anti-American Activities report on Communist infiltration of the US government, in *Les Staliniens*, p. 104.

44 For the poster, see Sarah Wilson, 'Deux affiches d'André Fougeron, Le point de vue de l'historien d'art', *Matériaux pour l'histoire de notre temps*, April 1991, pp. 109–16; and Lucie Fougeron, 'Propagande et création picturale. L'exemple du PCF dans la guerre froide', *Sociétés & Représentations*, 12 (2001), pp. 269–84.

45 For film footage of Houllier's cortège see 'Obsèques André Houllier', Ciné archives, Fonds audiovisuel du PCF: http://www.cinearchives.org/Films-447-152-0-0.html (accessed 12 July 2013).

46 André Fougeron confirmed Aragon said 'Make me a dove' ('Tu me fais une colombe'); interview, 27 November 1990.

47 For the exhibition and events, see *Regards*, 194 (6 May 1949), p. 4; and box BA 1779 Paix, Paris, Archives de la Police. The youth element was particularly important: see Guillaume Quashie-Vauclin, *L'Union de la Jeunesse Républicaine de France, 1944–1956* (Paris: L'Harmattan, 2009).

48 See *Œuvres récentes de Picasso*, Maison de la Pensée Française, July 1949 (two-page checklist).

49 See Alain Fleischer, 'A propos de Guernica', in Alain Fleischer, ed., *L'Art d'Alain Resnais* (Paris: Centre Georges Pompidou, 1998), with Paul Éluard's text 'Guernica' (*Europe*, 492–493 [April–May 1970]), pp. 67–70, 87–88.

50 '[P]articipation à une entreprise de démoralisation de l'armée et de la nation ayant pour objet de nuire à la défense nationale', official charge against André Fougeron, 16 May 1949. See 'Menaces contre la liberté d'expression', *Arts de France*, 25–26 (1949), pp. 41–43. Fougeron, who had already published 'Le Peintre à son créneau' in the first number of *La Nouvelle Critique*, December 1948, now wrote 'Le Rôle du sujet dans la peinture', *La Pensée*, July–August 1949, pp. 71ff.

51 See Louis Aragon:'Réalisme socialiste, réalisme français' (originally published in 1938), *La Nouvelle Critique*, 6 (May 1949), pp. 27–39.

52 See 'Tribune du nouveau réalisme', review of the 1949 Salon d'Automne, *Arts de France*, 28–29 (1949), pp. 80ff.

53 Desanti, *Les Staliniens*, pp. 131–32.

54 Desanti, *Les Staliniens*, pp. 88–89, quotes press figures: 130,000 miners on strike in the north (*L'Humanité*, 18 November), mounting to 300,000 the following day, and to two million (one million metallurgists) by 27 November 1947.

55 410 cm was the length of Fougeron's studio wall, 255 cm the height reached by making a golden rectangle. Detailed studies were made from December 1948 to May 1949. See André Fougeron, 'Le Peintre à son créneau: critique et autocritique', *Arts de France*, 27–28 (1949), pp. 33–70.

56 See Boris Taslitzky, 'Les Bouches s'ouvrent au Salon d'Automne, 1949', *Franc-Tireur*, October 1949.

57 *First Lightning* (*Pervaya Molniya*), the first Soviet atomic test, took place on 29 August 1949 in Semipalatinsk, north-east Khazakstan. Truman spoke on 23 September; the Salon opened on the 30th.

58 '[une bombe atomique] qui n'était point encore officiellement stalinienne', Jean Texcier, 'Le Parti Communiste et son peintre officiel', *Populaire-Dimanche*, 30 October 1949. For an extensive discussion of the Salon, see Sarah Wilson, 'Art and the Politics of the Left in France, c.1935–1955', PhD thesis, Courtauld Institute of Art, University of London, 1992, chapter 4.

59 See *Regards*, 221 (11 November 1949), p. 2, with caption 'Staline, le plus sûr ami de la paix' and report on the Rome assembly (28–31 October 1949).

60 The 'Code de travail correctif/forcé' (Corrective Labor Codex of the RSFSR) presented by Rousset was first shown by the British delegate to the United Nations in 1949. On the trial, see David Rousset et al., *Le Procès concentrationnaire pour la vérité sur les camps* (Paris: Éditions du Pavois, 1951); Rousset with G. Rosenthal and Th. Bernard, *Pour la vérité sur les camps concentrationnaires: un procès antistalinien à Paris* (Paris: Ramsey, 1990); and the report of Rousset's International Commission against Concentration Camp Practices (CICRC, Brussels), *Le Livre blanc sur les camps*

de concentration soviétique (Paris: Éditions du Pavois, 1951); see also Rousset with Paul Barton, eds, *L'Institution concentrationnaire en Russie, 1930–1957* (Paris: Plon, 1959). Anne Applebaum, *Gulag: A History* (New York: Doubleday, 2003), provides up-to-date statistics,

61 'Trente millions d'emprisonnés en URSS! Les famines en URSS sont organisé du gouvernement et sont les plus terrible du monde etc.', *Esprit*, 143 (March 1948); see V.A. Kravchenko, *J'ai choisi la liberté! La vie publique et privé d'un haut fonctionnaire soviétique*, trans. Jean de Kerdéland (Paris: Éditions Self, 1949).

62 See 'Jules Margoline', *La Condition inhumaine* (Paris: Calmann-Lévy, 1949); Julius Margolin, *Voyage au pays des Ze-ka* (Paris: le Bruit du Temps, 2010).

63 'Mais est-ce qu'une tragédie personnelle met le communisme en question?' (Desanti quoting Joanny Berlioz); 'je n'ai pas un instant cru à la vérité de ce que racontaient tous les témoins, de ce que résumait le livre signé par Kravchenko […]'; Desanti, *Les Staliniens*, pp. 169–170.

64 See Jean-Marie Goulemot, *Le Clairon de Staline (De quelques aventures du Parti Communiste Français)* (Paris: le Sycomore, 1981), chapter 1: 'Les Soixante-dix ans du camarade Joseph Staline', pp. 27–67. He mentions a 'fresque […] sur la vie et l'œuvre de Staline' over 80 metres long. Taslitzky offered a painting *Bataille Renault* (1938) and three Buchenwald drawings (Goulemot, *Le Clairon de Staline*, p. 53). Fougeron came to sign postcards of his painting on 12 December. Fougeron did not recall seeing the Pushkin Museum on his trip to Moscow in August 1949.

65 See Jean Chaintron, *Le Vent soufflait devant ma porte* (Paris: Seuil, 1993), pp. 292–98; Sophia Thompson, 'Power in Art, the Image of Stalin', MA diss., Courtauld Institute of Art, 1993; Nikolai Ssorin-Chaikov, 'On Heterochrony: Birthday Gifts to Stalin, 1949', *Journal of Royal Anthropological Institute*, 12/2 (2006), pp. 355–75.

66 Three versions illustrated in Gérard Gosselin, *Picasso et la presse. Un Peintre dans l'histoire* (Paris: Cercle d'Art and Humanité, 2000), pp. 84–85, figs 139 a-c, belong to the Musée Picasso; the fourth, fig. 141, published in *Les Lettres françaises*, 298 (9 February 1950).

67 Ssorin-Chaikov, 'On Heterochrony', pp. 358–72.

68 Michel Foucault, 'Des espaces autres' (Tunisia, 1967), *Architecture, Mouvement, Continuité*, 5 (October 1984), pp. 46–49.

69 Ssorin-Chaikov, 'On Heterochrony', pp. 358–72.

70 Ehrenburg's exchanges with Picasso were showcased in a documentary display in *Chefs-d'œuvre de la collection du musée national Picasso, Paris*, Moscow, Pushkin Museum, 22 February to 23 May 2010.

71 'Un tel irrespect fait tiquer les dévots, mais la bonne volonté de l'artiste suffit à Thorez et à Casanova, qui s'en réjouissent.' Pierre Daix, *La vie de peintre de Pablo Picasso* (Paris: Seuil, 1977), pp. 343 and 348, note 4.

72 Thanks to Madame Irina Antonova, former director of the Pushkin Museum, Moscow, and her staff, particularly Vitaly Mishin, for bringing *Hommage to Houiller* out of storage for a photograph by Andrei Koudriavitzky, and for Maria Starkhova's assistance, 2 April, 2008.

73 'Tout décadence esthétique s'exprime d'abord par un détachement progressif du contenu […] La critique artistique est une critique de classe au service d'une classe 53 […] Prud'hon a pu vivre contemporain de David et recueillir de grands succès. La peinture d'histoire connaît son heure quand l'histoire s'écrit brutalement avec

le sang et les larmes de ceux qui veulent changer son cours, jusque là traversé de trop d'injustices'; Fougeron, 'Le Peintre à son créneau: critique et autocritique', pp. 50, 53, 66.

74 '[M]ontrer tout, oui, absolument tout: le peuple, les femmes, la famille, la tristesse devant le crime impuni, *mais aussi les raisons de ma certitude.* Cela dépasserait mes moyens? Peut-être. Et les vôtres?' Fougeron, 'Le Peintre à son créneau: critique et autocritique', p. 62

75 My photocopy of Patrick Carpenter's *Death of Gabriel Peri (for Liberty)*, 1943, 43 × 60 cm (David King collection, London), published in the *Morning Star*, is included in correspondence to the artist of 6 May 1983, Fougeron archive, IMEC.

76 Fougeron, 'Le Peintre à son créneau: critique et autocritique', pp. 61–62. See the summons of the orator Guirault in response to the assassination of Marat (13 July 1793, reprinted in *Verve*, 1937–38, p. 31), reformulated as Jacques Duclos's behest to Aragon on the occasion of the latter's *Le Crime contre l'esprit*, an account of the reprisal executions at Chateaubriand: Aragon, *Le Crime contre l'esprit (les martyrs) par le témoin des Martyrs* (Paris: Presses de 'Libération', 1943).

77 'Oui, David fut le peintre de la Nation, le peintre des aspirations nationales à une heure glorieuse de l'histoire de notre pays'; André Fougeron, 'David et nous…', *Arts de France*, 33 (December 1950), p. 42.

78 *Exposition internationale d'art moderne, peinture, art graphique et décoratif, architecture*, Musée d'art moderne, Paris, 18 November–28 December 1946. This incorporated the 'Eastern Hemisphere' part of the 'Advancing American Art' show; a US State Department initiative: see Dennis Harper et al., *Art Interrupted, Advancing American Art and the Politics of Cultural Diplomacy* (Auburn, AL: Jule Collins Smith Museum of Fine Art, Auburn University, 2012).

79 See Herbin's *Premier manifeste du Salon des Réalités Nouvelles* and his 'plastic alphabet', in August Herbin, *L'Art non-figuratif, non-objectif* (Paris: Lydia Conti, 1949).

80 See György Lukács, 'Art libre ou art dirigé', *Esprit*, September 1948, following 'Marxisme ouvert contre Marxisme scholastique', *Esprit*, special number, May–June 1948; both discussed in Michel Winock, *Histoire politique de la revue Esprit, 1930–1950* (Paris: Seuil, 1975), pp. 288–89.

81 Charles Estienne, *L'Art abstrait est-il un académisme?* (Paris: Édition de Beaune, 1950). See Jean-Clarence Lambert, *Charles Estienne et l'art à Paris, 1945–1966* (Paris: Fondation Nationale des Arts Graphiques et Plastiques, 1984).

82 'P.C.F. Fédération de la Seine, Section du 14e, Montsouris. Ouvriers et intellectuels, artistes et artisans, jeunes travailleurs et étudiants du XIV^e arrondissement', album presented for Stalin's birthday, shown to me by Vitaly Mishin, Pushkin Museum, Moscow, 1 April 1994 (acquisition no 26/93).

83 'Le cadeau le plus cher pour les 70 ans du Chef', in Alexandre and Boris Poutko's novel, *Je pense donc je meurs. Silence atomique. Les arsenaux nucléaires sur les ruines de l'URSS* (Monaco: Éditions du Rocher, 1994), p. 11.

84 'Il est donc établi que des citoyens soviétiques peuvent être déportés en cours d'enquête, sans jugement et sans limite de temps […] Il est en outre établi que l'appareil répressif tend à constituer en URSS un pouvoir distinct […] Ce que nous disons, c'est qu'il n'y a pas de socialisme quand un citoyen sur vingt est au camp.' Jean-Paul Sartre and Maurice Merleau-Ponty, 'Les Jours de notre vie', *Les Temps Modernes*, 5 (January 1950). The information comes from the *Recueil chronologique des lois et des décrets du*

Presidium des Soviets suprême et Ordonnances du gouvernement de la RFSSR du 1ᵉʳ mars 1940, vol. 9, OGIZ (Union des maisons d'éditions d'État Gospolitizdat) – Article 44, Section II ('Privation de liberté'). The 127,000 prisoners involved in building the canal from the Baltic to the White Sea are mentioned. Estimates of the total number of prisoners range from 10 to 15 million; the authors choose 15 million. Today the figure is believed to be 18 million.

85 Germain Viatte, ed., *Paul Éluard et ses amis peintres* (Paris: Centre Georges Pompidou, 1982) bypasses Éluard's Stalinism, as does Jean-Charles Gateau's *Éluard, Picasso et la peinture, 1936–1952* (Geneva: Librairie Droz, 1983).

86 SFIO poster, reproduced in Philippe Buton and Laurent Gervereau, eds, *Le Couteau entre les dents* (Paris: BDIC–Chêne, 1989), p. 143.

87 'Où sont les Français? Que disent-ils? Que font-ils? Ont-ils perdu tout esprit critique et tout bon sens pour admettre à la fois appel de Stockholm et guerre de Corée, pour confondre civilisation et camp de travail forcé, pour concevoir liberté et persécutions religieuses, pour marier démocratie et guépéou?' 'Appel National', *Paix et Liberté*, 8 September 1950. Jean-Paul David masterminded *Paix et Liberté*, and fronted its radio programme. See Philippe Régnier, 'La Propagande anticommuniste de *Paix et Liberté*, France, 1950–1956', PhD thesis, Université Libre de Bruxelles, 1987.

88 See Frédéric Charpier, *La CIA en France, 60 ans d'ingérence dans les affaires françaises* (Paris: Seuil, 2008), pp. 21–22; for the vast underground military bunker in Saint-Germain-en-Laye, the 'NATO quarry', see http://ruedeslumieres.morkitu.org/espace_photos/ile_france/otan2/index_carriere.html (accessed 12 July 2013).

89 For a range of Paix et Liberté posters, see the Seeley G. Mudd Manuscript Library, Princeton University: http://www.princeton.edu/~mudd/exhibits/paix/design.html (accessed 12 July 2013).

90 See Linda Morris and Phillip Deery, 'The Dove Flies East: Whitehall, Warsaw and the 1950 World Peace Congress', *Australian Journal of Politics & History*, 48/4 (2002), pp. 449–68.

91 See Polly Jones, 'Du prix Staline au prix Lénine: l'émulation honorifique dans la Russie soviétique', *Genèses*, 2/55 (2004), pp. 41–61, and Oliver Johnson, 'The Stalin Prize and the Soviet Artist: Status Symbol or Stigma?', *Slavic Review*, 70/4 (2011), pp. 819–43.

92 'La colombe de Picasso survole le monde. Le Département d'État la menace de ses flèches empoisonnées, les fascistes de Grèce et de Yougoslavie de leurs mains rouges de sang. Sur le peuple héroïque de Corée, MacArthur, l'assassin, lance sur elle des bombes incendiaires au napalm. Les satrapes, qui gouvernent la Colombie et le Chili voudraient lui interdire l'entrée de ces pays. En vain. La colombe de Picasso survole le monde, très blanche et lumineuse, portant aux mères de douces paroles d'espoir et éveillant du battement de ses ailes les masses, pour leur rappeler qu'ils sont des hommes, des fils du peuple, et que nous ne voulons pas qu'ils aillent à la mort. À sa naissance, les ennemis de la paix souriaient, aujourd'hui ils la regardent avec crainte et font une barrière de tanks à l'entrée de Sheffield [...]' Neruda's speech of 22 November 1950 was reproduced in *Arts de France*, 33 (December 1950), p. 8.

93 John Berger, 'Revolutionary Undoing', reviewing Max Raphael's posthumous *Demands of Art*, in *Selected Essays and Articles: The Look of Things* (Harmondsworth: Penguin, 1971), pp. 201–29 (orig. pub. *New Society*, 1969). Just as Berger cannot précis Raphael, I cannot convey the richness and individuality of this essay here.

94 Ernst Fischer, *Von der Notwendigkeit der Kunst* (Dresden: VEB Verlag der Kunst, 1959); see also *Kunst und Menschheit* (Vienna: Globus Verlag, 1949); *The Necessity of Art* (London: Verso, 2009), with a preface by John Berger, pp. 21, 24, 41, 43.

95 Herbert Marcuse, *Soviet Marxism: A Critical Analysis* (1958) (New York: Columbia University Press, 1985); *Le Marxisme soviétique* (Paris: Gallimard, 1963).

96 Françoise Thom's brilliant analysis, *La Langue de bois* (Paris: Julliard, 1987) loses all the specificity of its PCF resonances and critique in translation as *Newspeak, The Language of Soviet Communism* (London and Lexington, KY: The Claridge Press, 1989).

97 In this context, see Dominique Desanti and Charles Haroche, eds, *Bombe ou paix atomique?* (Paris: Éditions Sociales, 1950), with letters by F. Joliot-Curie; Desanti, *Nous avons choisi la paix* (Paris: P. Seghers, 1949); *La Colombe vole sans visa* (Paris: Les Éditeurs Français Réunis, 1951).

98 'General Advisory Committee to the Atomic Energy Commission, majority and minority reports on building the H-Bomb, 30 October 1949', three-part report, http://www.pbs.org/wgbh/amex/bomb/filmmore/reference/primary/extractsofgeneral.html (accessed 12 July 2013); see also Desanti and Haroche, eds, *Bombe ou paix atomique?*

99 Schöffer's 50-metre prototype (collaborating with Phillips Electrics) had been installed in the Parc de Saint Cloud for the International Exhibition of Buildings and Public Works in 1955 (*Le Figaro*, 26–27 March 1955).

100 See Slava Gerovitch, '"Russian Scandals": Soviet Readings of American Cybernetics in the Early Years of the Cold War', *Russian Review*, 60/4 (2001), pp. 545–68, and *From Newspeak to Cyberspeak. A History of Soviet Cybernetics* (Cambridge, MA: MIT Press, 2002).

6

Massacre in Korea, massacres in Algeria

The most far-reaching decision made by the Permanent Committee
of the World Peace Congress at its meeting in Stockholm was the
launching of the world-wide drive for signatures to a so-called World
Peace Appeal. It is the boldest and most extensive piece of psycho-
logical warfare ever conducted by any organization on a world scale ...
The World Peace Appeal was launched 3 months before the outbreak
of Communist armed aggression against South Korea. Obviously
the appeal was intended as a smoke screen for such aggression. And
even though the Korean conflict completely exposed the falsity of
the Communists' 'peace' movement, the petition appeal is brazenly
continuing today.

> Report on the Communist 'Peace' offensive, Committee of
> Un-American activities, 1 April 1951[1]

Picasso's *Massacre in Korea* was shown to the public at the May Salon
of 1951. It disturbed, not because of its 'lack of realism', but because its
subject matter – men firing at naked women and children – was fraught
with ambiguity. It blurred sexual and political conflict and lacked
references to a specific place and time (plate 18). Highly improbable
from a 'people's' perspective, including the up-front viewpoint implying
participation in the scene, it was based upon a collision of reminiscences
with recognisable Old Master sources. It was very unlike a 'Picasso'. It
is contextualised in this chapter through contrast with socialist realist
works with an anti-colonialist theme: the Communists' denunciation of
actions in French Indochina at the Autumn Salon of 1951, their strategy
in Algeria involving on-the-spot 'embedded' *reportage* and counter-
Orientalist history painting, and lastly, the anti-colonial resonances
of André Fougeron's Cold War masterpiece, *Atlantic Civilisation* of

late 1953. French Communist Party cultural policy, overtly nationalist yet supporting colonial struggles (and thus Soviet expansionism via liberationist – Communist – groupings worldwide), found itself in a conflicted position both before and after the unexpected death of Stalin, at the height of the 'Peace and Liberty' counter-offensive orchestrated by the CIA.

Aggressive colonialist policies after 1945 were a retrospectively ill-fated attempt to avoid loss of territory and face (Britain's rapid withdrawal from India and then Palestine was surely ominous). In France, 8 May 1945 is commemorated with an annual holiday celebrating 'victory over the Nazis'. Yet on 8 May 1945 the military response to a nationalist demonstration against colonial rule in Sétif, Algeria, resulted in a huge massacre, despite the immense Algerian participation in the Allied war effort as a conscript army. A contemporary official estimate claimed 40,000 victims as a riposte to 102 French dead.[2]

The Sétif bloodshed was followed by repression in Guelma and Kherrata, and a prolonged suite of reprisals, sanctioned by de Gaulle and involving the Foreign Legion, colonial troops, aerial bombardment and machine guns in villages. The Sétif massacre would be constantly recalled during the subsequent Algerian 'events' of the later 1950s. Boris Taslitzky would draw Kalif Chabana, a peasant who lost a limb at Sétif, on his investigative trip in 1952.

On 9 August 1945, the very day the atomic bomb was dropped on Nagasaki, the 'Soviet Manchurian Offensive Strategic Operation' began in north-east Asia. With the end of the Soviet-Japanese war, the Soviets invaded inner Mongolia, resulting in significant casualties, terrorism, looting, rape and pillage. The Pacific theatre of war by this time, three months after the German capitulation, involved the Yalta powers, America, the USSR and their allies, in a huge play of interests. And in 1946, in the aftermath of Hiroshima and Nagasaki, France bombed restless civilians in Indochina, not for the first time. Following the Japanese capitulation, the Vietminh resistance led by Communist leader Ho Chi Minh had declared Vietnamese independence. Yet despite France's official recognition of a Vietnamese free state, growing mutiny and havoc led to the shelling of the port of Haiphong from three French warships on 23 November 1946: civilian casualties were estimated at 6,000.[3] Thus, during the time of Picasso's glory at the Liberation and in the 'Art and Resistance' show deriding Nazi atrocity, France had re-engaged on at least two fronts in brutal colonial conflict.

Picasso left Paris at this point, escaping the continuing climate of the *épuration*, the rancour and conflicts of the purge period. His idyll in Golfe-Juan and Antibes, his decoration of the walls of the Gallo-Roman museum in the Château Grimaldi offered him by the classicist Romuald Dor de la Souchère, his happiness with Françoise Gilot and the birth of his children Claude and Paloma come at this point. His embrace of Mediterranean themes, pipe-playing centaurs, dancing goats, Françoise as Dionysian hoyden or the tranquil *Femme-fleur* (flower-woman) would be recalled in his later *Peace* mural. His move to Vallauris and the adventure with ceramics and the Ramié family initiated a significant new phase in his production, and a new image of Picasso as 'humble artisan and peace worker', while his art for the Party remained contentious.[4] This period was followed with affection and admiration in the Communist press and art press in both Paris and the South.[5] Drawings were taken to Paris for reproduction in the press on an almost daily basis. The *décalage* – disparity – between this Riviera phase in Picasso's old age and the constraints of 'political work' are all too evident, perhaps, in *Massacre in Korea*, which was in progress already by September 1950; it was signed on 18 January 1951.[6]

Frédéric Joliot-Curie launched the Stockholm Appeal in March 1950 (to the dismay of the mayor of Stockholm). The list of intellectuals from France was impressive: signatories ranged from Picasso and Chagall to film stars Simone Signoret and Yves Montand and the future politicians Jacques Chirac and Lionel Jospin. From writers Ilya Ehrenburg and Thomas Mann to jazz musician Duke Ellington, the call for peace was indeed 'global'. A total of 273,470,566 people were deemed to have signed the appeal, including nine or ten million French voters – and the entire, coopted adult population of the USSR.[7] André Fougeron's anti-bomb poster was reissued with a Stockhom Appeal message.[8] After the Soviet atomic explosion and with divided Korea simmering, to believe in peace and goodwill, in the context of French colonial aggression, atom bomb stockpiling and the new 'H' bomb race, was extraordinarily idealistic. Joliot-Curie's leadership of the Peace movement – offering prestige and a 'European' scientific credibility – was evidently a conjuration of his Faustian pact with nuclear research (the consequences would stamp his late career with failure). Picasso's dove, as symbol of the global peace operation, was an equally brilliant public manoeuvre. The hope and belief that the Appeal might impact upon governments – the millions of signatures being the very expression of democracy in action – would be respected at all levels: from Communist and non-aligned intellectuals

to the women and children who demonstrated with home-made doves, or the 300 artists who participated in an 'Art and Peace' exhibition in Lyons in mid-1950, with war reportage on Korea at its most powerful.[9] Hence Washington's disquiet.

After prolonged talks in Moscow in April 1950, the North Korean people's army under leader Kim Il Sung, intent upon the reunification of his country, crossed the 38th parallel border into South Korea on 25 June. Stalin's initial reluctance to be involved in the Korean war gave way to participation.[10] (The volunteer French Battalion of the United Nations Organization in Korea – over 3,400 men placed under American operational control – offered distinguished service.) At stake for the West, following the Soviet aggression towards Europe demonstrated by the Berlin blockade (hence calls for German rearmament), were continuing fears of encroachment and fears about the Sino-Soviet pact of February 1950 with Mao's new China. Questions of both national identity and logistics concerned troop deployment and Britain and France's power to intervene: they were not the major players.[11] *Massacre in Korea* thus followed the Soviet-condoned offensive and South Korea's riposte with its massive backing from America and United Nations allies. When Picasso attended the fated second Sheffield–Warsaw peace congress in November 1950, he heard the moving oration of the Korean delegate Pak Den-Ai who claimed that 150,000 people had already been killed in battle.[12]

Cinema newsreels brought the conflict in Korea directly to citizens in France. Anti-Americanism escalated, as did the military stakes, involving non-deployed nuclear weapons or weapon-heads. The role of the Soviets' new MIG-15 fighter jets flown from China in downing American planes was at times decisive. Atrocities and maltreatment, thousands of military and civilian casualties have been recorded on all sides, while the deployment of troops, the logistics for transport and supplies so far from home territories, the repatriations and replacements involved massive operations.[13] Simultaneously reports arrived on the French war in Indochina, known as the 'dirty war' (*la sale guerre*): it deployed only volunteers from metropolitan France, but involved young soldiers from all over France's pre-1939 colonies and protectorates, during a post-war moment of intense liberation activity in these colonies themselves.

In the peace congress Warsaw show of late 1950, 'Artists for the Defence of Peace', Wojciech Fangor's history painting with tricolour flags, titled *Peace inviting the dockers of imperialist countries to throw their murderous armaments into the sea* (arms destined for Indochina)

Figure 23: Wojciech Fangor, *Peace inviting the dockers of imperialist countries* ...,
1950–51

(fig. 23), demonstrated how battles in France could inspire socialist
realism in Soviet satellite countries (the anti-colonialist subject matter
had been specified by Maurice Thorez at the twelfth Party congress at
Genevilliers in April 1950).[14] The Communist Party had been involved
in the struggle beyond 'the hexagon' since the beginnings of Comintern-
fomented revolution in its colonies. Ho Chi Minh had been the *protégé*
of Marcel Cachin at the moment of the Party's foundation, at the
Tours Congress of 1920. At the height of *négrophilie* in jazz-age Paris
(when posters of Josephine Baker vied with the Senegalese *Banania*
cocoa-man), anti-imperialist propaganda works were produced, though
on a small scale, such as 'The Truth about the Colonies' show in
Melnikov's 'barracks' in 1931 with Comintern funds. In the 1950s the
young anti-fascist painters of the 1930s realism debates reached maturity,
now engaging with anti-colonialist themes.

The Party had proved that oil paintings were extraordinarily cheap
to produce, to display, to tour; they generated international press
coverage and were infinitely reproducible; the failure of the econom-
ically challenged PCF film enterprise after 1945 bears witness to this.
The first priority had been to represent Communism's role in France's
reconstruction. The introduction of 'stakhanovite' super-worker ideals,
or later destabilising strike sabotage, were sensationally conveyed (with
tragic miners and police victims) in a 'revolutionary' Davidian style in
André Fougeron's *Mining Country* series (balanced with the 'modernist'

response, Fernand Léger's *Builders*).[15] France's industrial epic continued to be conveyed with socialist realist masterpieces such Jean Amblard's powerful trades union commissions.[16]

Picasso, with *Massacre in Korea*, now led the turn beyond France to the colonial arena. Communist artists who saw the painting at the May Salon in 1951 were surely primed or about to be primed for the well-orchestrated anti-colonial Autumn Salon scandal of October 1951 (after which the exhibition 'Algeria 1952', the socialist realist counterpoint to *Massacre in Korea*, as I shall argue, was in the planning stages). *Massacre in Korea*, whether suggested to Picasso or 'required' by the PCF, functioned therefore within a global framework of representations. 'It has been understood for some months now that Picasso was going to amaze us by becoming a "realist" painter in search of the third dimension and even a master of anecdote ...' said the press.[17]

Did Picasso disappoint? Was it clear that his men with machine guns (the plunderers, the rapists) were 'American imperialists'? Just as *Guernica* had no specific victims and aggressors, the confrontation is anonymous; it seems to bear no relationship with the warfare on the ground in Korea – or indeed Indochina, where the war of the jungle and the paddy-fields (*la guerre de la jungle et des rizières*) was engaged across a low horizontal terrain.[18] Why the verdant landscape with mountains in the distance and a watch-tower type ruin similar to that in the *14 July* stage curtain? The medieval-type armour for these large-footed men-machines, as opposed to combat fatigues, the naked, pregnant women, the firing squad (recollections of Manet's *Execution of the Emperor Maximilien* and Goya's *3 May*) all speak anachronism, the anachronism of face-to-face warfare, of confrontation at close quarters with civilian victims (the anachronism of warfare *tout court*).

The evident palimpsest in *Massacre in Korea* for the female versus male confrontation, however, is the adolescent stand-off in Degas's *Young Spartans* of 1860 (National Gallery, London, fig. 24). Here we have the same green landscape with mountainous background, the confrontational groups, the spread-leg strong postures of the boys. Yet though Picasso transformed Degas's taunting and challenging girls into pregnant women (with a stray twisting babe from Poussin), signifying the future and peace, the feminine as a trope disturbed, for it raised the problem of feminisation as victimhood (compare the 'feminisation' or abuse of victims of the Holocaust or male sexual humiliation as a tool of war today). Colonised territories as a whole, and 'greater France' (*la plus grande France* as France chose to nominate them), were

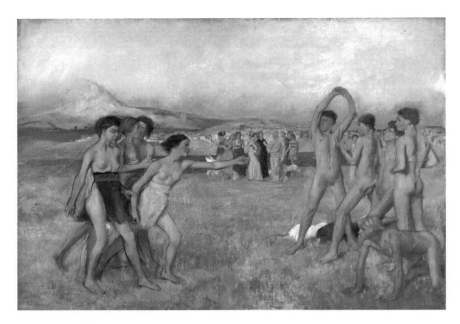

Figure 24: Edgar Degas, *Young Spartans Exercising*, c.1860

perceived as feminine precisely because of their lack of industrialisation (a colonial decision), the size, skin colour and dress of the inhabitants, and the gendered French language (*La France, la nature...*). The combat territory around Dien Bien Phu, site of the major French defeat in Indochina of 28 March 1954, would indeed be carved up according to the names of forces' sweethearts: *Gabrielle, Anne-Marie, Béatrice, Huguette, Dominique, Épervier, Claudine, Éliane* and *Isabelle*.[19] The PCF was evidently dismayed that combatants against the imperialist foe in *Massacre in Korea* had been replaced by women.[20] Where were their heroic fighters? Picasso's feminisation emphasised the classic colonial 'war of unequal opponents'. Conventional weaponry and aerial warfare were in fact destabilised by unconventional 'Third World' low-tech combat, stealth and guerrilla tactics. France, in all events, would lose these wars from a moral as well as a political point of view, just as the Americans would ultimately lose the war in Vietnam.

At the May Salon of 1951, *Massacre in Korea* was nonetheless promoted by the Communist press. *Ce Soir* declared: 'The representation of four women terrified or passive, transfixed or screaming with their children opposite impassive brutes from nowhere, with a style distinct from

Guernica, is the very stigmatisation of eternal disasters ...' The 'austere, Davidian composition in grey and green, born of the revolt of civilised man against the horrors of Korea, here reaches a universal dimension'.[21] Fernand Léger's *Builders* series (*Les Constructeurs*) opened at the Maison de la Pensée Française on 2 June 1951. Claude Roy felt compelled to mention Korea in the catalogue:

> I love the fact that in 1951, a year when the question is only about destruction, burning, annihilation (not just a 'question'), the year of Korea thrust through a firewall, villages blown up and razed to ashes, I love the fact that Léger sings 'construction' – not only through closed lips, but with the precise words of his joyful music.[22]

Here the hymn to reconstruction continued, with monochrome blue-sky backgrounds, the tough but sweet-faced builders, their muscles modulated with shadow echoed in puffy clouds. (Simultaneously Léger made a gesture towards Soviet modernism with the submerged constructivism of red, black and white and beams of scaffolding, and his calligraphed poem-painting, *Hands. Homage to Mayakovsky.*)

It was not Léger but his studio director and future wife Nadia Khodassievich who offered the anti-colonial counterpart to the positive *Builders.* Her own *Massacre in Korea* offered a catastrophic vision of fallen masonry in a Léger-like style, against a background half red with flames and trapped, injured or mourning bodies with Asiatic features (plate 19). In contrast, Wojciech Fangor's large *Korean Mother* was a major painting in classic socialist realist mode. Here the female victim is unambiguous: the mother struck dead, blanched yet still bleeding, leaves an orphan child to importune the viewer; his figures are strangely illuminated against a 'scorched-earth' landscape of empty grey and brown, smoke from a bombed village rising in the distance. The work was shown in December 1951 at the second National Art Exhibition in Warsaw where he recalls André Fougeron's critique of his work (plate 20). Of the three registers of response, each representative of a host of lesser artists, only Picasso's has survived, despite contemporary anathema.

The 7 June elections of 1951 saw de Gaulle's Rassemblement Populaire Français (RPF) win a majority of 117 seats, to the Socialists' 104 and the Communists' 101. De Gaulle was the instant target of propaganda. Fougeron designed a poster *De Gaulle, C'est le fascisme,* where he is seen strangling Marianne (France), with the names of the various opposition parties written on her gag. A 'Peace will triumph' evening, screening Joris Ivens' film *La Paix Vaincra* filmed at the second peace congress

at Warsaw, was held on 10 June, heroising Henri Martin, the young marine who had been witness to the shelling of Haiphong. Sentenced by the Brest military tribunal to five years in prison for protesting against the war in Indochina, Martin was the focus of a huge campaign, its catchword his slogan: 'It's for your millions that twenty-year-olds are sacrificed' (*C'est pour vos millions que vous sacrifiez nos vingt ans*). As political events deteriorated through 1951, militant painters responded, hoping to provoke maximum press attention.

In November 1951 the Autumn Salon once more became a site of violence and denunciation as it had with Fougeron's *Houillier* scandal of 1949. As was customary, the Salon was inaugurated by the president of the Fourth Republic, Vincent Auriol, but not before seven works by Communist painters with inflammatory subject matter touching Indochina, Henri Martin and the dockers' protests had been forcibly removed by the police (together with a threat to remove the Salon's State funding). The co-director of Léger's atelier, Georges Bauquier, was one of the six artist-victims. His formal debt to Léger was declared in *Not one boat for Indochina* ('Pas un bateau pour Indochine' was inscribed on the canvas). Boris Taslitzky's imposing *Riposte, Port-de-Bouc* (Tate Modern, London) presented a similar harbour riot of 1949, where CRS riot police unleashed their dogs on the dockers who refused to load armaments, together with a portrait of Martin in striped convict's costume, signed with the pseudonym Julian Sorel (from Stendhal). The 21-year-old Gérard Singer's *14 February, Nice* depicted dockers tipping a launching ramp for V2 rockets into the sea; a wartime allegory designed to show solidarity with contemporary dockers' actions in Marseilles. Pierre Abraham's socialist realist novel *Tiens bon la rampe!* here met Poussin's *Rape of the Sabines*.[23] Poussin's classical architectural background was replaced by a lurching rocket case, his calm orator by a boy waving a tricolour, creating a peak above a dense frieze of turning and gesticulating figures; a cowering boy in the foreground implied assailants in the viewer's space. Thus the Old Master revolutionary past was continually harnessed to suggest Communist patriotism – across two generations of militant painters.

Picasso joined Matisse and other artists in a protest against the police action. With the exception of the canvases by Bauquier and Singer, the government, using the Beaux-Arts' authority, ordered that five canvases should be rehung, withdrawing four again on the same day. The empty walls of the Salon articulated an absence rich with political content, but supplements to this absence abounded: outrage

at the so-called *décrochage*, published photographs of the empty walls with visitors staring at the gaps, publicity around the rehang, the exhibition of the banned canvases elsewhere, above all Louis Aragon's tract 'The Autumn Salon Scandal'.[24]

Aragon emphasised that the very day of the presidential visit to the Salon (6 November 1951) marked the official foundation of the association to defend the memory of maréchal Pétain, head of the Vichy government under the Occupation. A Mass had been held for the late Pétain at Notre-Dame in October. The police of the *décrochage*, he proclaimed, were the same police who truncheoned ex-Resistance protesters outside the cathedral.[25] Thus, simultaneously with anti-colonial protest, the voided wall of the Autumn Salon signified the divided France of 'franco-french warfare', the *guerre franco-française*, its roots lying deep in the French Revolution, pitching right against left, class against class.[26]

Anti-colonial painting rich with political content also affronted the monochrome-based gestural abstractions of the time, including the increasingly orientalised aesthetics of a Hans Hartung or Georges Mathieu, and affronted the art market of the bourgeois right as conceived by militant painters. The Autumn Salon protest paintings were not only Marxist in their 'reflection' of a political reality, but also Communist in their renunciation of the market. Their currency, however, functioned in the exhibition spaces of Eastern Europe. Aragon's manifesto 'Painting is no longer a game' appeared in the Polish review *Nova Kultura*; Singer's *14 February, Nice* and a version of Taslitzky's *Henri Martin* along with Picasso's *Massacre in Korea*, Léger's *Builders* and two more of the 'Seven Dangerous Compositions' (as they were called in a Polish poem), were sent to Warsaw. Here at the National Gallery in 1952, the pro-modernist curator Ryzard Stanislawski and poet Paul Éluard presented the work 'as the victory of progressive realism over the self-annihilating abstraction of French postwar art'.[27] It is essential to recall here that the vision of French art and culture in Moscow, Warsaw and other satellite capitals was entirely that of subsidised Communist publications such as *Poland* or *Les Lettres françaises*.

Décrochage – provocation via subject matter leading to police intervention and generating press scandal – subsequently became a strategy. In the build-up to the next major anti-colonial protest, 'Algeria 1952', *décrochages* would occur as ritual foretastes of the greater protest to come. What was the relationship between Korea, Indochina and Algeria at the time? The French UN battalion moved from Korea to Indochina as the Korean Regiment, where it suffered heavy casualties; subsequently,

like all defeated French troops in Indochina, it would move to Algeria with a displaced desire for vengeance. Contemporary French paternalist rhetoric grafted a 'modern' patriotism onto earlier Orientalist traditions in the case of both countries. The concept of conquest and then colonial management as creating *la plus grande France* meant that the liberation movement in Algeria was presented as 'civil unrest'.

The exhibition 'Algeria 1952', its preparation and reception fall within this conflict-ridden moment from late 1951 to early 1953, when the PCF's domination of the anti-colonial argument had become a powerful recruiting machine, but before the November 1954 escalation of hostilities, when French troops were subsequently conscripted to fight.[28] Initially hostile, Jean-Paul Sartre would turn from extreme anti-Communism (the Kravchenko trial and its aftermath) to espousing the Party as a fellow traveller; he would be faithful until the Soviet invasion of Hungary.

'Algeria 1952' repeated the successful strategy of Fougeron's *Mining Country* series, shown in 1951 at the prestigious Galerie Bernheim Jeune: this was aimed at a bussed-in proletarian workforce but staged to shock, at the very heart of Paris's bourgeois art world, prior to a tour of Eastern European satellite countries. Picasso's *Massacre in Korea* used Old Master quotation in disturbing configurations; in contrast, the works shown in 'Algeria 1952' occasioned the last grand history paintings explicitly bound to the French Orientalist tradition. Unlike Picasso's strange loss of a sense of place in *Massacre in Korea*, and avoidance of any 'orientalising' traits, the Orientalist affiliation in 'Algeria '52' was explicit: 'On the very sites where Chassériau, Delacroix, Eugène Fromentin and Constantin Guys were intoxicated with the miracle of the Orient, its fantasias and its exotic dancers, two great artists of our times, discovering the unfathomable misery of a people, celebrate its hopes and battles', wrote the Communist art critic Jean Rollin, in 1953.[29]

The picturesque tradition, at first linked to military and topographical imperatives, subsequently extended from exotic landscapes to the realm of the sexualised feminine. Here, the academic nude, as odalisque or *almée* (singer, dancer, poetess), was reframed within the imagined excess of the harem: the dream that was the 'Other' of colonial reality.[30] 'Algeria 1952' is a *détournement* of that tradition, a demonstration of its mis-representations. Via explicit reference to Delacroix it brought political 'reality' on to the dream-territory of the painted surface. Colonial rule enforced a regime of *symbolic* violence embodied in language; its picturing *in situ* demonstrated a *systemic* violence: the 'often catastrophic consequences' of the smooth functioning of the system (according to Slavoj Žižek's

analysis).[31] This violence, symbolic and systemic, preceded the eruption of what the administration called 'civil disobedience' and the first moments of real conflict studied here. This would be followed by guerrilla tactics and the one-on-one conflict of rape or torture in the Algerian 'war with no name': the *guerre sans nom*, beginning in 1954. As with Taslitzky's *Buchenwald*, and in contrast again with Picasso's response to the Korean War, it was imperative that public response should be to first-hand witness or *témoinage*. Militant work as embedded reportage and on-the-spot drawings preceded the passage to a high art form; visual presentation as political 'truth', ennobled as history painting.

The intense amount of preparation involved in this *témoignage* distinguishes 'Algeria 1952' from Picasso's *Massacre*, as does the contribution of a female painter, Mireille Miailhe. Artists such as Nadia Khodassievitch, Genviève Zondervan, Simone Baltaxé or Marie-Anne Lansiaux (wife of photographer Willy Ronis) were committed to militant PCF work; the Union des Femmes Françaises was a key organisation; 'couples' were an important structural factor in the political and cultural élite: Maurice Thorez and Jeannette Vermeesch, Louis Aragon and Elsa Triolet, the painter Edouard Pignon and critic Hélène Parmelin. Previously showcased artistic militancy was entirely masculine: 'Algeria 1952' is a unique case of a project conceived from the start with an equal female contribution.

Miailhe, ten years younger than Taslitzky, was born Mireille Glodek in Paris; she was likewise from a Jewish émigré family, and a former student at the École des Beaux-Arts. In 1942 she joined the Resistance in Toulouse; the scenes of revenge and denunciation she witnessed in the purge period informed her painting from 1945–46. Her fascination with the tribunal – a subject that would reappear in Algeria – was transformed by Honoré Daumier's satire (reinforced by his 1945 Musée Galliera retrospective in Paris, organised by the resistant National Arts Front).[32] The Algerian Communist Party expressly requested a female complement to Taslitzky to venture where men were forbidden. Throughout 1951 meticulous planning of the joint trip involved contact between the PCF and its Algerian counterpart to organise itineraries and the 400,000 franc budget for travel, subsistence and materials. Miailhe and Taslitzky were in Algiers by January 1952; the trip was semi-clandestine. He travelled eastwards from Algiers to Oran, Beni-Saf, Ain-Témouchant, Sidi-bel-Abbès, Tlemcen, then far across to the west, to Constantine, down to Biskra, Djema Setif and back to Algiers. Miailhe covered Algiers itself. Accompanied, as she recalled, by a Jewish *pied noir* (an Algerian-born guide of settler origin), she visited the streets

of the Casbah, the slums, the port where the dockers loaded up at dawn, and various families both Arab and European.

Travelling to Blida in February, she managed to attend the trial of the '56 de Blida', 56 nationalists of the clandestine OS (Special Organisation), by befriending women in the defendants' families. Like the nineteenth-century painter Henriette Brown, or later Lucie Ranvier-Chartier, Elisabeth Faure or Jeanne Thil, she was highly conscious of the tensions between reportage and her artistic heritage.[33] The nineteenth-century female orientalist aimed to penetrate the harem in native dress. Miailhe, veiled and in the djellaba, sketchbook hidden in its folds, was smuggled into the courtroom to depict the confrontation between defendants and *gendarmes*. 'I make my drawings discreetly. French lawyers are there to defend the accused.'[34] In *Tribunal*, the viewer takes up the position of these female spectators: a confrontation of the sexes is implicit.

In Cherchell, Miailhe was taken by her guide Mustapha to his home. She witnessed the life of an extended Muslim family, small-time cultivators, who themselves employed agricultural workers including children. The women in the family were illiterate; the boys attended the École Communale; the second son, a nationalist, was the treasurer of the National Liberation Front, which was at the time breaking away from the Algerian Communist Party. She was then invited to join the touring electoral campaign of Communist deputy Pierre Fayet, with Mustapha and a chauffeur. They visited Boghail, Djelfa, Laghouat and Bou-Saada. Appalled at the sight of starving children, Miailhe took photographs, not as an *aide-mémoire* for her painting, but as irrefutable evidence: 'the same misery everywhere', she recalled. Returning to Algiers she linked up again with *Alger Républicain* and its director, Henri Alleg (who had welcomed her), before flying back to France. 'I arrived morally shattered and out of things – certain that grave events were in preparation.'[35] The arduous task of squaring up sketches, working with colours and tonalities on a history painting-scale began: Miailhe's *Young agricultural workers in the area around Algiers* would be three by two metres: five boys in a row, ragged and unshod, hack with picks at a mound of hard earth in winter; the *colon* smokes his pipe; his son's back is turned (plate 22).

In June 1952 the Communist illustrated magazine *Regards* published a special number on North Africa, declaring: 'The conquest of Algeria was one of the most cynical cases of organised pillage of the last century … The conquest and the repression of rebellion were accompanied by terrible massacres … The spectacle of the misery of the North African people is one of the most poignant in the world.'[36]

The artists' photographs and drawings were used to illustrate the article 'Guided by a Blind Boy', by Resistance heroine and journalist Madeleine Riffaud (sent out on a reportage by the CGT trades union federation). A book, *Deux peintres et un poète, retour d'Algérie*, with Jacques Dubois's poem, appeared in July. Here, Taslitzky's sketches of striking dockers, children of the shanty-town *bidonvilles* and militants appeared first, including Kalif Chabana on crutches, with Hadj Omar, a Communist veteran of the 1919 Black Sea mutiny, and Tahar Ghomri, a Communist peasant from Tlemcen who would later die in the maquis.[37]

Miailhe's work followed. In the crude, rushed printing job, her notes were left visible. Goya joined Daumier in her sketches: the long crayoned titles such as *Cité Mahédinne in Algiers: seven drinking fountains for 30,000 people* acknowledged the tradition of Goya's *Disasters of War*. In *The Administration has just passed by* a homeless woman crouches among boulders, sheltered by the planks of her demolished shack, drawing meagre garments around her. *Her neighbour. It's here she'll give birth in a few days' time* recaptures a snatch of conversation between Miailhe, her female guide and the woman whose interior they enter. Jagged black contours conveyed anger: *88% of children without school*; yet with fluid wash, her works were more typically Orientalist. The squatting woman in *Woman and child*, or the cluster of figures in *Pause at noon, it's the colon who sells the bread*, recall similar figures in watercolour by Delacroix or Gérôme. The rough sketch of the *Child with trachoma* conveys the anxiety of Miailhe's own professional gaze: the boy's right eye, upturned, remains opaque; the relationship between pathos and voyeurism, blindness and insight, is here at its most problematic. Her lithograph *'Algeria will be free'. The arrival of the 56 patriots at the Blida Tribunal* was sold at the Fête de l'Humanité of 1952. *Deux peintres et un poète was* signed by Taslitzky at the National Writers' book sale at Paris's famed Vel d'hiv, in October. Miailhe's *Group of young Arabs in rags* was accepted for the Tuileries Salon but triggered a *décrochage* – another official removal before a Salon opening. The huge *Young agricultural workers in the area around Algiers* was refused at the Autumn Salon, and hence illustrated in the journal *La Patrie* with due outrage and publicity.[38] Thus 'Algeria 1952' would repeat for Algeria what the Autumn Salon scandal of 1951 had attempted for Indochina, in the wake of *Massacre in Korea*'s apparent failure.

In January 1953 the exhibition of 40 paintings and 60 drawings finally opened in the elegant Galerie André Weil. The poster and invitations for 'Algérie 1952' were designed by Miailhe (plate 24). As with Fougeron's

Mining Country series, two publications were produced: a cheap book was supplemented by a luxury folder of colour plates by Cercle d'Art editions.[39] Advance press appeared in the authoritative Communist daily *L'Humanité*. Étienne Fajon, member of the PCF politburo, eulogised Miailhe's *Young agricultural workers*; the visitors' book included Picasso's signature and touching tributes from Algerian workers and students. The right-wing Algerian press immediately denounced 'Algeria sullied by Communist painting ... a flagrant deformation of the truth.' Government action ensued.[40] A press release declared: 'By decree of the Minister of the Interior, the police service proceeded to remove the mast supporting the "Algérie '52" exhibition poster at 1.30 pm today.'[41] Two and a half thousand dockers in Algiers acknowledged the show's success as a work of truth and fraternity. Other dockers unions followed up the tribute.

Press response of course divided between left and right. To Etienne Fajon, 'Here is Mireille Miailhe's *Women's portrait*, their blind eyes empty with trachoma, like so many others in Algeria.' The *Journal d'Alger* (a staunch defender of 'French Algeria') proposed 'opthalmological consultation in the Bled'. 'We know (and the people know far better than we do) a whole cohort of doctors and medical auxiliaries who have devoted their lives to the struggle against trachoma.'[42] And Miailhe's uncaring master of the *Young agricultural workers* and her Daumieresque, toad-like police raise the problem of stereotypes. In *L'An V de la révolution algérienne* (1959) (deliberately referring to the French revolutionary calendar and the Terror in its title) the Martiniquais activist Frantz Fanon would expose the same problem.[43] He describes, for example, lesser *colons*, farmers or managers, often on the side of the revolutionaries, and family tensions and disintegration contrasting with the French artists' depiction of close parent–child relationships.[44] The shanty-town / rural emphasis of 'Algérie 1952' was as selective as its emphasis on the exploited and oppressed, French, Spanish and *arabo-berbères*: it was far from fully representative of the 'nation in formation'.[45]

Socialist realism was defined by Taslitzky in 1952 as a two-way revelation: subject matter into art, art into the visual world of the proletariat: 'The working class ... has torn off the veil which separated the world of the arts from its own concerns.'[46] The play of revelation and refusal, of sight and blindness was repeated across the range of works exhibited in 'Algérie 1952': the artist 'guided by the blind', the depiction of trachoma, the women peering through their veils at militant meetings. Most striking, surely, was the symbolic unveiling in Taslitzky's

Women of Oran: a long panorama of 2.45 × 0.45 metres, and a major painting of the central scene (plate 21). He explained:

> striking dockers found themselves in difficulty confronting the police who were savagely attacking them. Alerted, the women came out, went down to the port to help them, and in the midst of violent combat, before an Orient amazed, veils were removed from their customarily hidden faces … It was women's passion, marking an important step towards their liberation, both national and social, a plunge into the future.[47]

The colour, the gesticulating women with swirling draperies, above all the central figure with raised arms aiming a huge kerbstone at an armed *gendarme* recall Delacroix's *Fanatics of Tangiers* (1837) (plate 25). The 'unnatural' trope of the woman warrior evokes Jean-Jacques François Lebarbier's 1784 *Jeanne Hachette at the siege of Beauvais in 1472*, a source for Delacroix's *Liberty on the Barricades* which Taslitzky knew so well.[48] (Only after 1955 did the cooption of female terrorists involve a revision of attitudes towards the veil, when the 'Algerian woman … in conflict with her own body' became a 'link in the revolutionary machine'.)[49] Critics of both sexes were anxious to differentiate Miailhe's drawing as sensual and 'female' in contrast to Taslitzky's 'precision and hardness of an act of accusation'.[50] Writing on Miailhe for the *Algérie 1952* luxury print album, Taslitzky fluctuates between the exhortations of a professorial elder and a transferred 'self-criticism'.

As with Picasso's *Massacre in Korea*, an anxiety around femininity destabilised the Communist rhetoric of militancy. The differentiated critical response to Miailhe's work veils a disturbing perception of her closeness to her subject, her perception of the hidden matriarchy of Algerian society.[51] The sensual Orient implied the female time of tradition and repetition; the military vision, a male time of battle, terror, rape and torture.[52]

'Algérie 1952' was premonitory. 'For once colour, the picturesque and Orientalism in painting does not mask the pain of Algeria, and the reasons to fight. For once, painters have set up an unforgiving indictment of the colonial regime' the Algerian Communist Party proclaimed in 1953.[53] Yet inevitably the artists' structural position could override the signs of solidarity – including their perceptible Jewishness, a fact never mentioned explicitly, yet with its own Orientalist tradition in painting, responding to specific Algerian communities with a recent history of humiliation in Algeria during the Pétain regime in France.[54]

'Everywhere fear in their eyes and their gestures ... simply because the stranger who paints them is like those who have hurt them in his clothes and language.'[55] As Delacroix himself so quickly understood, figurative painting transgressed the Islamic prohibition against graven images.[56] Any regime of representation was the regime of the conqueror: a situation played out in the USSR itself as socialist realism was imposed upon its own Islamic peoples.[57]

When 'Algeria 1952' circulated as propaganda in USSR satellite countries, the works were received by a public familiar with France's Beaux-Arts academic tradition; they could 'read' the pictures within the 'correct' manichaean framework. Miailhe's *Young agricultural workers* and Taslitzky's *Algerian Father* were donated to the Museum of Fine Arts in Bucharest; Mialhe attended the inauguration; Taslitzky went to Budapest; both travelled for the opening to Prague.

The scandal around Picasso's portrait of Stalin exploded in March 1953. PCF leader Maurice Thorez's return from convalescence in the USSR not only calmed internal power struggles but, in a moment of disarray after Stalin's death, would impact upon culture. Thorez desired an end to socialist realist policy. Louis Aragon's humiliation in the Stalin portrait affair prepared the way for his devastating retaliation towards André Fougeron. It is all the more ironic, then, that Fougeron's great history painting, *Atlantic Civilisation*, was based iconographically upon a careful reading of an Aragon text. It links France's colonial wars, American politics and its politics of culture with kaleidoscopic brilliance. Revealed in a 'war' setting to the publics of Tate Modern, London, in 2000, it is the Cold War's greatest history painting.

Fougeron's break with the classical 'proscenium arch' space and its relationship not only to an academic past but the idea of the 'reflection' of a scene or staged event is crucial. While Aragon would deride 'old photomontage techniques', the colliding spaces precisely echo those of the American-financed exhibition of Mexican muralism, held at the Musée d'art moderne in May 1953.[58] Indeed, Julio Castellanos's *The Day of Saint Juan*, illustrated in the catalogue, with its exaggerated receding diagonal perspectives and turbulent array of bodies, is comparable in all but dimensions. In these collapsed, painted spaces, Fougeron could portray several narrative incidents at once, which require separate moments of attention or inattention – a clever transposition of the information and propaganda overload in the 1950s. The clash of contemporaneity and the forms of popular culture – cars, girlie magazines, political posters – with the history painting format in oils marks its position on the threshold

Figure 25: André Fougeron, *Atlantic Civilisation*, 1953

of a new era, anticipating Pop art and Narrative Figuration, and a turn to domestic television, all stamped with the imprint of Americanisation.

Fougeron's blueprint was Aragon's hymn of hatred against 'the civilisation which can only persist under the appalling shadow of Hiroshima, of atomic menace surrounded with a belt of napalm', in *Avez-vous lu Victor Hugo?* ('Have you read Victor Hugo?'). He reviles 'A Ford automobile in the Place Victor Hugo, here's the very symbol of the men who set up Eisenhower in Marly and their war installations in fifty-five departments of France – for the war which will continue in the Brittany arena transformed into a Korea ...'[59]

A magnificent blue Ford Consul MK1, larger than life, dominates *Atlantic Civilisation* (1953). Above is the electric chair, a godless throne, used to execute Julius and Ethel Rosenberg, atomic spies, whose faces were known worldwide thanks to Picasso's double portrait used in Communist campaigns (fig. 25). The Korean war's links to the Atlantic Pact were made explicit in Communist Party posters of 1951: in one, a bomb points down from, the sky on to a France in flames; across the bomb a slogan declares 'NO! France will not become scorched earth'; and, lower, 'Against the war politics of the Atlantic Pact, lethal for

France; act now for a Peace Pact.'⁶⁰ Fougeron's motifs of the mourning
Korean woman holding a dead baby on the right of the canvas, and
the French widow in black, correspond precisely to the pietà-like motif
in Paul Gilles' PCF poster of 1951, with its suggestively yellow ground
and mourning mother and son. (General Eisenhower's resonant words
were inscribed beneath her: 'We could withdraw our troops back to the
Britanny coastline' [*Nous pourrions replier nos troupes jusqu'à la presqu'île
de Bretagne*], with the response: 'NO! France will not be a new Korea!')⁶¹
Even the children dancing hand in hand in a ring at the top left of
Fougeron's composition – *les petits enfants d'Aubervilliers* of the popular
song – are the sons of the industrial proletariat who will be sent to die
as cannon fodder in Indochina: Henri Martin's prison in Melun looms
behind them.

The cost of colonial war is spelled out by the pensioners on the left,
still living in a tent in the *zone* area of Paris's outer terrains (where the
first tower blocks of communal flats were just rising to house 'bussed-out'
populations). Fougeron uses the same pensioner couple motif as in the
PCF poster of 1951, where they shelter in front of a huge armoured
tank, its telescopic lens out, searching for prey like a giant proboscis:
'To feed this mouth ... from Moch to de Gaulle ... we are sacrificing
these ones [the chatting pensioners]. Stop the arms race!' The poster,
financed through subscription in honour of a Resistance hero, implicitly
emphasised the war sacrifice of previous generations – as do Fougeron's
pensioners.⁶²

SHAPE, Supreme Headquarters Allied Powers Europe, functioned
from Paris and its environs from 1951; AFCENT, Headquarters Allied
Forces Central Europe, from Fontainebleau from 1953. In *Atlantic
Civilisation*, we see modern NATO blocks erected for American
personnel on 'occupied' French territory (possibly the Île Saint Germain
military compound). Their walls symbolically bear recruitment posters
for volunteer parachutists in Indochina: 'My future: glory. My domain
combat' (*Mon futur la gloire. Mon domaine la bagarre*), read by two
impressionable young boys. Lifesize, the posters implicate the viewer
in the space of the painting, while a repatriated coffin swings down
to refute their message. The major palimpsest, however, evident to the
contemporary Salon audience, though invisible today, is revealed by
Aragon's dazzling rhetoric, an involuntary paean to American capitalism:

A Ford car, the civilisation of Detroit, man on the conveyor belt, from
Mac Gee to the electric chair, with Einstein and Charlie Chaplin under

suspicion, the civilisation which can only persist under the appalling shadow of Hiroshima, of atomic menace surrounded with a belt of napalm. Here's the symbol in broad daylight of this subjection to the dollar, docilely applauded … Here's the lacquered God, the bull's eye of foreign industry, the Atlantic totem which chases away the glories of France for the profit of Marshall's stocks and shares, the varnished and chromium-plated statue of its imports, and, more arrogant than the Nazi iconoclast, the Yankee substitutes a machine for the poet … for poetry the Coca-cola of commercial deals, American advertising for *La Légende des Siècles*, the mass-produced car for the Genius, the Ford automobile for Victor Hugo![63]

The year 1952, 'Victor Hugo Year' for the French Communist Party, was the year Paris chose to celebrate two thousand years of its existence. In January it held a debate about the potential replacement of the grandiose monument to Hugo by Louis-Ernest Barrias, removed from the Place Victor Hugo by the Nazis and destroyed.[64] The CIA (whose first number of the review *Preuves*, March 1951, demonstrated the ugly incomprehension of Picasso's work by a high-ranking Soviet cultural apparatchik)[65] prepared their major Festival of Paris in May 1952, under the aegis of the Congress for Cultural Freedom. Mainly musical, this included 'Masterpieces of the Twentieth Century' from the Museum of Modern Art, New York, and works from private collections.[66] Anticipating this celebration, the eponymous Ford car, 'lit up by projectors like Notre-Dame de Paris', was placed on the very spot where Barrias's Hugo in bronze, encircled by voluptuous muses, had reigned from his Guernsey rock. The American car, in Fougeron's painting, symbolises French culture doubly sacrificed, first to the Nazis and then the Americans: a fat American capitalist takes off his hat and bows to the figure in the car with gun aimed: a rearmed German sniper. The psychological elision between Nazi and American 'occupant' is clear.

American culture overrides all other messages in Fougeron's painting, just as the American presence was spreading in installations all over the body of France: a vast launching pad for its airborne military ventures. Fougeron's *French peasants defend their lands* and Gérard Singer's *View of Laon* – its hilltop cathedral minuscule above a low plain dotted with American stationary missiles – made the point. Pascal Quignard's novel *L'Occupation américaine* (1995), later made into a film, would focus on Meung (won back by Joan of Arc from the English in 1429); Fougeron's *Atlantic Civilisation* features here emblematically.[67]

It was the subliminal meaning of *Atlantic Civilisation* that would triumph. Despite closely following Aragon's speech and new Soviet directives requiring more satire in painting, Fougeron anticipates – a year before France's defeat at Dien Bien Phu – the equations made in the very title of Kristin Ross's analysis of 1996: *Fast Cars, Clean Bodies: Decolonisation and the Reordering of French Culture.*[68] Denunciation is overridden by signs of the future: the inevitability of France's NATO alliance, the triumph of the pro-American arguments of Raymond Aron in *Le Figaro* and James Burnham's *The Managerial Revolution.*[69] The carnival of spaces and time frames implies acceleration forward: Stalin as dead as Victor Hugo. Aragon's revenge was the condemnation of Fougeron (in favour of Singer's *View of Laon*) at the Autumn Salon of 1953 and Party insistence that the artist, this time, should make a 'self-criticism'.[70] Internal Party politics have been roundly eclipsed by posterity's vindication of the work. Fougeron was never again so ambitious. Decolonisation, then, was the implicit condition for the reordering of French culture through the period of the Algerian War, the revolution of 1968 and beyond.

Picasso's last major works, *War* and *Peace*, were essential as a focus for the Communist Party's rehabilitation; reviving its anti-colonial stance in a wider arena. *Massacre in Korea*, conversely, would appear on Warsaw's main promenade as a sign of solidarity with Hungarians killed by Soviet tanks in Budapest in 1956 (fig. 26). (The invasion took place strategically while French and British expeditionaries were 'reclaiming' Suez: a doomed late colonial adventure which entirely compromised their moral high ground.) In Warsaw, then, *Massacre in Korea* was turned against its maker; its pro-Communist message reversed: a denunciation of Picasso's silence. At this moment of crisis, Picasso received desperate pleas to act from close friends such as James Lord and Michel Leiris and insider reports from Hélène Parmelin of turmoil in the anathematised French Communist Party.[71] Most moving of all was the plea from the Hungarian artist, Bela Czobel: 'you will see 50,000 buildings destroyed … I beg you to use your authority'.[72] Yet through its modernism, this reappearance of *Massacre in Korea* was also a harbinger of 'thaw' in Eastern European countries; Poland was the most advanced of these, though contemporary artists were turning from a Picasso / Beckmann-inspired figuration to the more contemporary *informel.*[73]

* * *

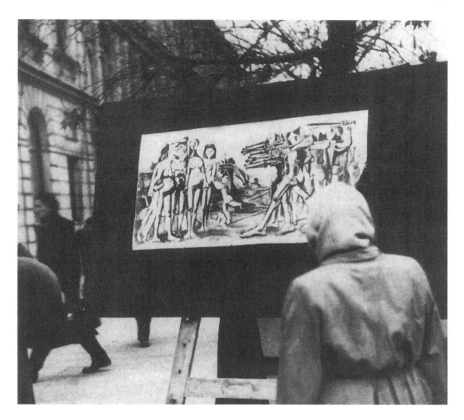

Figure 26: *Massacre in Korea* in the streets of Warsaw, 1956

Massacre in Korea, unsurprisingly, became a focus of the Picasso debate in Asia, where his themes of war and destruction resonated deeply; his work was shown in Japan in 1952, when Barr's *Picasso. Fifty Years of his Art* was translated and Yoshida Tadashi produced a monograph focusing on the later and contemporary work. Takeguchi Shuzo's *Picasso, War and Peace* (1956) offered detailed analysis of the mural paintings. Curator Inhye Kim takes up the Korean story, explaining that as Korea was under the rule of Japan until 1945, 'her cultural environment was dominated by the generation that experienced foreign culture through the Japanese language until the 1950s'. In his article 'The Art of Picasso' for the Seoul *Shin Mun* (daily newspaper) in 1953, the artist Mook Han used the phrase 'revolutionist fight' to describe the work of Picasso. And in 1957 he quoted in a magazine perhaps Picasso's best-known phrase:

'Painting is not done to decorate apartments. It is an instrument of war for attack and defence against the enemy.' Meanwhile, Picasso was also an object of political disputes in Korea where the dissension between the Left and the Right was extremely intense. Byungki Kim, one of the painters who studied in Japan, wrote a letter in which he critically reproached the communist activities of Picasso, focusing on *Massacre in Korea*, read it out in a café in Busan, and sent it to Picasso by mail.[74]

Again, Picasso did not reply. An Americanised, more formalist view of Picasso would prevail in South Korea, where even this work could have the power of its multiple meanings evacuated in favour of Picasso, ultimately, as a 'brand'. Marx, however, was and is far more dangerous. Alex Callinicos's *Revolutionary Ideas of Karl Marx* (1983), whose translation into Korean led to the imprisonment of the director of Chaekalpi publishers, was presented as 'book of the day' by the country's largest web navigator Naver on 14 March 2009 in the context of the world economic crisis; Lim Seung-soo's *Capital: Even a Monkey Could Read It* became a 2008 bestseller; Marxist works are still censored, however, as is access to certain North Korean websites.[75] North Korea's own modernist artists, trained in Germany or Paris, are only now being incorporated into a still firmly divided national canon.[76]

Notes

1 Report on the Communist 'Peace' Offensive: A Campaign to Defeat and Disarm the United States, 1 April 1951, Washington, DC, Committee on UnAmerican Activities, US House of Representatives, 82nd Congress, first session, online archive document.

2 The American consulate at the time claimed 40,000 dead (archives, Ligue des Droits de l'Homme, Toulon, 'Les massacres de Sétif et de Guelma'); Algerian official history maintained the exaggerated number of 45,000 dead, repeated (as the Algiers' American consulate figure) by Alleg in Henri Alleg, *Quarante ans après la guerre d'Algérie. Retour sur 'la question'. Entretien avec Gilles Martin* (Pantin: Le Temps des Cerises; Brussels: Aden, 2002), p. 29. For the 102 European dead, see Annie Rey-Goldzeiguer, *Aux origines de la guerre d'Algérie 1940–1945 : de Mers El-Kébir aux massacres du Nord-Constantinois* (Paris: La Découverte, 2002), p. 303; see also Boucif Mekhaled, *Chronique d'un massacre : 8 mai 1945, Sétif-Guelma-Kherrata* (Paris: Syros, 1995).

3 France itself had bombed civilians in 1930: on 16 February five Potez 35 biplanes killed more than half of the two hundred peasants protesting in response to fall-out from the Yen Bai revolt in Indochina. See Louis Roubaud, *Viet Nam : La tragédie de l'Indochine* (Paris: Librarie Vallois, 1931); and Andrée Viollis, *Indochine, S.O.S.* (Paris: Éditeurs Français Réunis, 1949 [1935]), with Yves Benot, *Massacres coloniaux* (Paris: La Découverte, 2001).

4 See Danièle Giraudy, *L'Œuvre de Picasso à Antibes*, centenary catalogue raisonné (Antibes: Musée Picasso, Château Grimaldi, 1981, 1986)

5 See Madeleine Riffaud, 'Au grand soleil de Picasso', *Arts de France*, 21–22 (1948), pp. 20–24; Jean Marcenac, 'Pour la première fois dans l'histoire', *Arts de France*, 33 (December 1950), a special issue of the Beaux-Arts Communist students' journal *Traits* on the Antibes idyll, etc.

6 See Claude Roy, *La Guerre et la paix* (Paris: Cercle d'Art, 1954), p. 11.

7 Stéphane Courtois and Marc Lazar, eds, *Histoire du Parti Communiste Français* (Paris: PUF, 1995), pp. 278–79.

8 Fougeron's Stockholm poster, signed 'Défendez la Paix!' is reproduced in Philippe Buton and Laurent Gervereau, eds, *Le Couteau entre les dents* (Paris: BDIC–Chêne, 1989), p. 96.

9 'L'Art et La Paix' organised by the Comité lyonnais pour la défense de la Paix in April 1950.

10 See Evgueni Bajanov, 'The Origins of the Korean War. An Interpretation from Soviet Archives', paper delivered at the conference 'The Korean War, An Assessment of the Historical Record', Washington, DC, Georgetown University, 24–25 July, 1995, http://www.alternativeinsight.com/Korean_War.html (accessed 22 August 2013).

11 For a complex view from France, see Philippe Devillers, 'Le Conflit vu d'Europe', *Revue française de science politique*, 6 (1970), pp. 1199–219.

12 World Peace Congress Bulletin, 20, 20 November 1950, p. 1, quoted by Linda Morris, 'War and Peace', in Christoph Grunenberg and Linda Morris, eds, *Picasso, Peace and Freedom* (London: Tate Publishing, 2010), p. 154.

13 See Lieut. Col. Christoph Bertrand, ed., *Algérie 1830–1962, avec Jacques Ferrandez* (Paris: Musée de l'Armée and Éditions Castermann, 2012), illuminating on complex logistics and an army point of view.

14 See Jean-François Laglenne, 'L'Art au Congrès de la Paix', *Arts de France*, 3 (4 January 1951).

15 For the context of Léger's *Constructeurs*, see Sarah Wilson, 'Fernand Léger, Art and Politics, 1935–1955', in N. Serota, ed., *Fernand Léger, the Later Years* (London: Whitechapel Art Gallery, 1987), pp. 55–75.

16 See Richard Bucaille et al., *Jean Amblard, artiste-peintre, 1911–1989* (Puy-de-Dôme: Carnets patrimoniaux du Puy-de-Dôme, 2011). Industrially themed exhibitions continue: see Patricia Perdrizet, ed., *Usine* (Antony: L'Usine nouvelle, 2000); Alexandre Courban, ed., *Artistes & métallos: quand l'avenir se dessine à l'atelier* (Paris: Institut d'Histoire sociale-CGT, 2011).

17 'Et Picasso? Il était entendu depuis quelques mois que Picasso devait nous épater en devenant un peintre "réaliste" en quête de la troisième dimension et même un maître d'anecdote […]', unsourced press cutting, Hélène Parmelin archives, IMEC.

18 Gilles Ferier, *Les Trois Guerres d'Indochine* (Lyons: Presses universitaires de Lyon, 1993), p. 52.

19 Ferier, *Les Trois Guerres*, p. 53; see also Alain Ruscio, ed., *La Guerre 'française' d'Indochine (1945–1954): Les sources de la connaissance, bibliographie, filmographie, documents divers* (Paris: Les Indes Savantes, 2002).

20 Corroborated by Pierre Daix, *Tout mon temps: révisions de ma mémoire* (Paris: Fayard, 2001), p. 340.

21 'La représentation de quatre femmes terrifiées ou passives, hébétées ou hurlantes avec leurs enfants en face des brutes impassibles de nulle part sont, avec une écriture différente de *Guernica* [...] la stigmatisation même des désastres de toujours [...] l'austère composition davidienne en gris et vert, née de la révolte de l'homme civilisé, contre les horreurs de la guerre de Corée, ici atteint l'universel'. *Ce soir*, undated press cutting, Hélène Parmelin archives, IMEC.

22 'J'aime qu'en 1951, année où il n'est question que de détruire, raser, annihiler (pas seulement "question"), année de la Corée passée au rouleau de feu, villes calcinées, villages soufflés, j'aime qu'il chante, et pas seulement, et plus seulement à bouche fermée, mais avec des paroles précises sur sa musique heureuse – la "construction".' Claude Roy, *Fernand Léger: Les constructeurs* (Paris: Falaize, 1951), n.p.

23 Pierre Abraham, *Tiens bon la rampe!* (Paris: Les Éditeurs Français Réunis, 1951); see also Olivier Huwart, *Du V2 à Véronique. La naissance des fusées français, où comment un petit groupe d'allemands anciens de Peenemünde ouvrit, en France, après la Seconde Guerre mondiale, la voie aux succès spatiaux européens actuels* (Rennes: Marines éditions, 2004).

24 See Sarah Wilson, 'Voids, Palimpsests, Kitsch: Paris before Klein', in M. Copeland and L. Le Bon, eds, *Voids* (Paris: Centre Georges Pompidou, 2009), pp. 192–98; I see *décrochage* as a politicised precursor to later avant-garde practices.

25 See Louis Aragon, *Le Scandale du Salon d'Automne, l'art et le sentiment national* (Paris: Éditions Les Lettres Françaises et Tous les Arts, 1951); Frédéric Le Moigne, '1944–1951: Les deux corps de Notre-Dame de Paris', *Vingtième siècle*, 78 (2003), pp. 75, 88.

26 Louis-Dominique Girard, *La Guerre franco-française. Le maréchal républicain* (Paris: André Bonne, 1950); Jean-Pierre Rioux, 'La Guerre franco-française', in M. Scriven, ed., *War and Society in Twentieth-Century France* (Oxford: Berg, 1992); Henry Rousso, *Le Syndrôme de Vichy de 1944 à nos jours* (Paris: Seuil, 1990), pp. 55–67.

27 See *Wystawa wspolczesnej plastyki franskuskiej* (Warsaw: Zacheta, 1952); Katarizny Murawska-Muthesius, 'Paris From Behind the Iron Curtain', in Sarah Wilson, ed., *Paris, Capital of the Arts, 1900–1968* (London: Royal Academy of Arts, 2002), p. 256 (with installation photograph); and Katariznya Murawska-Muthesius, 'How the West Corroborated Socialist Realism in the East: Fougeron, Taslitzky and Picasso in Warsaw', *Biuletyn Historii Sztuki*, February 2007, pp. 303–29.

28 See Anissa Bouayed, ed., *Un Voyage singulier. Deux peintres en Algérie à la veille de l'insurrection 1951–1952. Mireille Miailhe / Boris Taslitzky* (Paris: Art et mémoire au Maghreb, 2009), exhibition, December 2009, Nelson Mandela library, Vitry-sur-Seine; see Sarah Wilson, 'A Dying Colonialism, a Dying Orientalism, Algiers 1952', in Jessica Wardhaugh, ed., *Politics and the Individual: French Experiences 1930–50* (Oxford: Legenda, 2014) for a fuller consideration of 'Algeria 1952'.

29 'Aux lieux mêmes où des maîtres du siècle dernier, Chasseriau, Delacroix, Eugène Fromentin, Constantin Guys, s'enivraient au miracle de l'Orient, de ses fantasias et de ses almées, deux grands artistes de notre temps, découvrant l'insondable misère d'un peuple, célèbrent ses luttes et ses espoirs.' Jean Rollin, '*Algérie 52*, une remarquable exposition', in *Le Patriote de Sud-Ouest*, Toulouse, 13 January 1953, Miailhe archives.

30 See, for example, Caroline Bugler, '"Innocents Abroad": Nineteenth-Century Artists and Travellers in the Near East and North Africa', in M.A. Stevens, ed., *The Orientalists: Delacroix to Matisse* (London: Royal Academy of Arts, 1984); Jill Beaulieu and Mary Roberts, eds, *Orientalism's Interlocutors: Painting, Architecture,*

Photography (Durham, NC, and London: Duke University Press, 2002) – all work conscious of the role of Edward W. Said's *Orientalism* (1978).

31 Slavoj Žižek, *Violence, Six Sideways Reflections* (London: Profile Books, 2008), pp. 1ff.

32 See Pascale Froment and Isabelle Rollin-Royer, eds, *Mireille Glodek Miailhe* (Paris: Biro, 2007); nine 'fascicules': the first, 'Une vie', tells this story (n.p.).

33 France created an École des Beaux-Arts d'Alger in 1881; the Villa Abd-el Tif was set up as an equivalent of the Villa de Medici in Rome; see Michèle Lefrançois, 'Art et aventure au féminin', in E. Bréon, ed., *Coloniales 1920–1940* (Paris: Musée Municipal de Boulogne Billancourt, 1989–90), pp. 53–65; and for Henriette Browne, see Raina Lewis, *Gendering Orientalism, Race, Femininity and Representation* (London and New York: Routledge, 1996).

34 'Je dessine discrètement – des avocats français sont là pour la défense des accusés.' Letter to the author, 9 December 1991.

35 'J'arrive abasourdie et un peu déphasée mais certaine que des événements durs se préparent.' Letter to the author, 9 December 1991.

36 'La conquête de l'Algérie a été une des plus cyniques entreprises de rapine du siècle dernier […] La conquête et la répression ont été accompagnées de massacres effroyables […] Le spectacle de la misère du peuple en Afrique du Nord est un des plus poignants qui soit au monde […]' Pierre Courtade, 'Que se passe-t-il en Afrique du Nord?' (undated press cutting, from Miailhe archives); see also Madeleine Riffaud, 'Guidée par un aveugle', *Regards*, 350 (June 1952) (press cutting, Miailhe archives).

37 Alleg, *Un voyage singulier*, p. 9.

38 See Jean Rollin, 'Triomphe du réalisme au Salon d'Automne', *La Patrie*, 9 November 1952, with photograph of Miailhe's painting.

39 André Fougeron corroborated the suggestion that 'Algérie 1952' was created as a riposte to 'Les Pays de Mines', and that the alternation of exhibitions by Fougeron and Taslitzky constituted a PCF bipartite policy (interview, 18 April 1991).

40 'B', 'L'Algérie éclaboussé par la peinture communiste', 'Une déformation flagrante de la vérité', *Le Journal d'Alger*, 1 and 3 January 1953 (press cuttings, Miailhe archives).

41 'Par décision du Ministère de l'Intérieur, les services de police ont procédé, à 13h.30 aujourd'hui, à l'enlèvement du mât supportant l'affiche de l'exposition "Algérie 52".' Decree, 5 January 1953.

42 'Voici le *Portrait de Femmes*, de Mireille Miailhe, avec ses yeux d'aveugle vidé par le trachome, comme tant d'autres en Algérie', Etienne Fajon, *L'Humanité*, 30 December 1952 (press cutting, Miailhe archives); and '*La Consultation ophtalmologique dans le bled.* Nous connaissons (et le peuple le connaît encore mieux que nous) toute une phalange de médecins et d'auxiliaires médicaux qui ont voués leur existence à la lutte contre le trachome', 'B', 'L'Algérie éclaboussé', *Le Journal d'Alger* (press cutting, Miailhe archives).

43 Frantz Fanon, *L'An V de la révolution algérienne* (Paris: Maspero, 1959), with deliberate reference to the French revolutionary calendar and the Terror.

44 Fanon, *Révolution algérienne*, pp. 154–55; see also chapter 3 on the Algerian family.

45 See Jeanne Modigliani, *Deux peintres et un poète. Retour d'Algérie* (Paris: Cercle d'Art, 1952), p. 8; compare the idyllic film footage of Algeria, 1952: http://denisebd.wordpress. com/pied-noir-pionneer/%E2%80%A2-43-images-dalger-textes-et-poesies/film-alger-1952/ (accessed 12 July 2013).

46 'La classe ouvrière [...] a déchiré le voile qui séparait le monde des arts de ses propres préoccupations'; Boris Taslitzky, 'L'Art et les traditions nationales', *La Nouvelle Critique*, 32 (January 1952), p. 72.

47 'Les Dockers en grève, se trouvaient en difficulté face à une police qui les agressaient sauvagement. Alertées, les femmes sortirent et descendirent sur la porte pour leur porter secours et, au cours d'un combat violent, devant l'Orient stupéfait, les voiles s'écartèrent des visages que la coutume avaient cachés [...] C'est la passion des femmes, marquant un pas important vers leur libération, à la fois nationale et sociale, fonçant vers l'avenir.' Boris Taslitzky, *Algérie 52* (Paris: Éditions Cercle d'Art, 1953), n.p.

48 See Linda Nochlin, 'The Myth of the Woman Warrior', in *Representing Women* (London: Thames and Hudson, 1999); and Jean Vergnet-Ruiz, 'Une inspiration de Delacroix? La Jeanne Hachette de Lebarbier', *Revue du Louvre*, 2 (1971), pp. 81–85. Taslitzky knew only Delacroix's *Liberty leading the People*.

49 'l'Algérienne [...] en conflit avec son corps [...] est maillon, essentiel quelquefois de la machine révolutionnaire'; Fanon, *Révolution algérienne*, p. 30; Fanon, *A Dying Colonialism* (Harmondsworth: Penguin, 1965), p. 27.

50 'Les toiles de Taslitzky ont la précision et dureté d'un acte d'accusation'; Modigliani, *Deux peintres et un poète*, p. 8.

51 'Derrière le patriarcat visible, manifeste, on affirme l'existence, plus capitale d'un matriarcat de base.' Fanon, *Révolution algérienne*, p. 16; *A Dying Colonialism*, p. 15.

52 See Julia Kristeva, 'Le Temps des femmes', *34/44: Cahiers de recherche de sciences des textes et documents*, 5 (winter 1979), pp. 5–19.

53 'Pour une fois, les couleurs, le pittoresque et l'orientalisme ne masquent pas dans la peinture la douleur de l'Algérie et les raisons de lutter [...] Pour une fois, des peintres ont dressé un réquisitoire implacable contre la régime colonial.' Letter to Boris Taslitzky and Mireille Miailhe sent by the secretariat of the Algerian Communist Party, *L'Humanité*, 15 January 1953.

54 See Laurence Sigal-Klagsbald, ed., *Les Juifs dans l'Orientalisme* (Paris: Musée d'Art et Histoire du Judaïsme, 2012); and Anne Hélène Hoog, ed., *Juifs d'Algérie* (Paris: Musée d'Art et Histoire du Judaïsme, Skira / Flammarion, 2012); Pétain rescinded the 'décrets Crémieux' of 1870 which gave French citizenship to Algeria's 130,000 Jews; they were persecuted, fired and interned.

55 'Partout l'effroi dans leurs yeux et dans leurs gestes [...] tout simplement parce que l'inconnu qui les peint ressemble par son costume et son langage aux gens qui leur ont fait mal.' Étienne Fajon in *L'Humanité*, 30 December 1952.

56 Compare Eugène Delacroix, *Correspondance générale d'Eugène Delacroix*, ed. A. Joubin (Paris: Plon, 1935), vol. 1, pp. 175, 184: 'Leurs préjugés sont très grands contre le bel art de la peinture [...] l'habit et la figure de chrétien sont en antipathie à ces gens-ci, au point qu'il faut toujours être escorté de soldats.' ('They have great prejudices against the fine art of painting ... the clothes and face of the Christian so hateful to the people here, one must always have an armed escort.')

57 See Aliya Abakayeva de Tiesenhausen, 'Socialist Realist Orientalism? Depictions of Soviet Central Asia, 1934–1954', PhD thesis, Courtauld Institute of Art, University of London, 2010.

58 Jean Cassou, ed., *Art mexicain du précolombien à nos jours* (Paris: Musée d'Art Moderne, 1953).

59 Louis Aragon, *Avez-vous lu Victor Hugo?* (Paris: Éditeurs Français Réunis, 1952).

60 'Non! La France ne sera pas une terre brulée. Contre la Politique de guerre du Pacte Atlantique mortelle pour la France. Luttons pour un pacte de Paix.' PCF poster, 1951, in Buton and Gervereau, eds, *Le Couteau entre les dents*, p. 75.

61 'Nous pourrions replier nos troupes jusqu'à la presqu'île de Bretagne [...] G. Eisenhower. Non! La France ne sera pas une nouvelle Corée.' PCF poster, in Buton and Gervereau, eds, *Le Couteau entre les dents*, p. 70.

62 'Pour nourrir cette bouche de Moch à de Gaulle, on sacrifie celles-là! Arrêtons la course aux armements!' Poster published by the French Communist Party with funds from section XIV (Montrouge) in homage to the Resistance hero Croizat, in Buton and Gervereau, eds, *Le Couteau entre les dents*, p. 62.

63 See Aragon, *Avez-vous lu Victor Hugo?*, p. 37.

64 See *Les Lettres françaises* for 24 January 1952. Aragon's discussion of the crisis of contemporary French monumental sculpture in 'Il y a des sculpteurs à Moscou', 31 January 1952; 'Avez-vous lu Victor Hugo', 28 February 1952.

65 Anon., 'Un réquisitoire contre Picasso', *Preuves*, 1 (March 1951), pp. 5–7: quoting I.V. Kemenov, ex-president of the cultural organisation VOKS: epithets include 'bourgeois', 'reactionary', 'degenerate', 'aggressively antihumanist' etc. See Pierre Grémion, *Preuves, une revue européenne à Paris* (Paris: Julliard, 1989).

66 While the festival was mainly musical, 'L'Œuvre du XXᵉ siècle' involved artworks selected by James Johnson Sweeney. See Peter Coleman, *The Liberal Conspiracy: The Congress for Cultural Freedom and the Struggle for the Mind of Postwar Europe* (New York and London: The Free Press, 1989); Pierre Grémion, *Intelligence de l'anticommunisme. Le congrès pour la liberté de la culture à Paris, 1950–1975* (Paris: Fayard, 1995); Giles Scott-Smith, *The Politics of Apolitical Culture: The Congress for Cultural Freedom, the CIA and Post-War American Hegemony* (London: Routledge, 2002).

67 Pascal Quignard, *L'Occupation américaine* (Paris: Seuil, 1994); film by Alain Corneau, *Le Nouveau Monde* (1995).

68 See 'Le Rapport de Georges Malenkov', *L'Humanité*, 7 and 8 October 1952; and Kristin Ross, *Fast Cars, Clean Bodies: Decolonization and the Reordering of French Culture* (Cambridge, MA: MIT Press, 1996); see also Richard F. Kuisel, *Seducing the French: The Dilemma of Americanization* (Berkeley: University of California Press, 1993).

69 James Burnham, *The Managerial Revolution* (New York: John Day, 1941); French trans. *L'Ere des organisateurs* (Paris: Calmann-Lévy 1947); see also Denis Boneau, 'The Betrayal of the Intellectuals: Raymond Aron, the Atlantist prosecutor', Voltaire Network, 21 October 2004, http://www.voltairenet.org/article30054.html (accessed 23 August 2013).

70 Louis Aragon, 'Toutes les couleurs de l'Automne', *Les Lettres françaises*, 12 November 1953, pp. 1, 7, 8.

71 Letters from James Lord (11 November 1956), Michel Leiris (18 and 19 November, 1956) and Hélène Parmelin (24 November 1956), in Laurence Madeline, ed., *Les Archives de Picasso* (Paris: RMN, 2003), pp. 314–17.

72 Piotr Bernatowicz and Vojtěch Lahoda, 'Picasso and Central Europe after 1945', in Christoph Grunenberg and Linda Morris, eds, *Picasso, Peace and Freedom* (London: Tate Publishing, 2010), pp. 47–48.

73 See Piotr Piotrowski, 'Totalitarianism and Modernism: The "Thaw" and Informel Painting in Central Europe, 1955–1965', *Artium Questiones*, X (2000), pp. 120–74.

74 Kim Inhye, 'Picasso Seen in Asian Countries in the 1940s-1950s', in T. Akira, H. Michio et al., *Cubism in Asia, Unbounded Dialogues* (Toyko: The Japan Foundation, 2005), pp. 254–55 (I have changed her title *Korean War*).

75 See 'Lire Karl Marx à Seoul', *Korea Times*, 18 March 2009, http://www. amitiefrancecoree.org/article-29197489.html (accessed 23 August 2013).

76 Thanks to Kim Inhye for her lecture 'Korean Modernism? A Forced Choice, Examined through three Korean Modern Artists' (Unsong Pai, Que-de Lee, Wolyrong Byun), given at the conference 'Between Tradition, Modernity and Globalisation', Courtauld Institute, London, 29 June 2012; see also Unsong Pai, *Ungong Pai erzälht aus seiner koreanischen Heimat* (Darmstadt: Kulturbuch-Verlag, 1950); Jane Portal, *Art under Control in North Korea* (London: Reaktion, 2005).

Godless Picasso: 'From Marx to Stalin'

Paris, city of light, you have given your name to the school of Picassoid imposture, the school of corruption.

Cardinal Paul Scortesco, 1953[1]

This is what the commission proposes: Marx–Engels, Lafargue, Guesde, Lenin, Stalin, Dimitrov, Thorez, Mao-Tse-Tung, [portraits] of heroes dead or alive, of the leaders of Communist parties throughout the world.

Brief for 'Marx to Stalin', sent to Picasso, January 1953[2]

Picasso's lost portrait of Stalin has obscured the recognition or apprehension of French Stalinism proper and has become part of a complex 'Picasso joke' involving, directly or obliquely, distinguished curators, French historians and contemporary artists. It exercises an apotropaic function, as perhaps was originally intended. This chapter has two aims: to place the Stalin portrait in its contemporary context, in particular the 'Marx to Stalin' exhibition of May 1953, and to reconsider the *War* and *Peace* murals in the context of their creation, of their most magnificent setting in Milan, and as vectors of complex political operations. While the grand Romanian Cardinal Paul Scortesco was indeed the most reactionary of clerics, his book *Satan, voici ta victoire* ('Satan, here is your victory'), published in the fated year of 1953, with his *Saint Picasso, peignez pour nous* ('Saint Picasso, paint for us'), situates Communist culture – and specifically Picasso – as part of a 'godless' conspiracy against Christendom. This wider context links the *War* and *Peace* murals, installed in a deconsecrated chapel, to the arena of modern sacred art that involved both Communists and the Vatican in the 1950s.

Both the Stalinist cult of personality and *War* and *Peace* as moral panoramas for our times touch questions of the sacred.

On 29 January 1953 Picasso received a letter from Boris Taslitzky asking him, together with Françoise Gilot, to contribute to a major exhibition that would be part of the seventieth anniversary celebrations of the death of Karl Marx. A long official document was attached (see epigraph). The Commission of artists within the PCF had originally conceived of an exhibition designed to showcase 'the French contemporary portrait' to find out 'how Communist artists and their friends show themselves capable of translating the faces of the men of our times'. Subsequently, discussions around the Marx anniversary had modified the project; it would henceforth 'bring the spectator a view of the entire life of Karl Marx, his influence, the revolutionary impact of his work, the worldwide transformation it had effected upon peoples and individuals, and in particular its effect in our country'.[3] There was little time to spare:

> A great effort is required, commensurate with the subject, with the battles of our Party, under whose aegis this demonstration must achieve great artistic and political impact. We believe no vaster effort has ever been asked of us. We must face up to this honour. It is a task which will have a national and international impact, and the Commission emphatically brings to everyone's attention that it is doubtless the first time that such an enterprise has been undertaken … Within this project all talents can confront each other freely. It's important that *everyone* chooses his subject, so that the *ensemble* of works give as complete an account as possible of the *ensemble* of the subject whose kernel remains the art of the portrait. This poses the question of history painting. The painting of history is also the history of the present …[4]

After giving examples of acceptably themed still lives, bouquets, a small painting of a militant bookseller on the quai side by Notre Dame, the Commission once more underlined its desire for new creations based on 'ideological education', though it stated that the project should not be partisan but 'open to all who wish to honour Marx and Marxism. But this involves the personal responsibility of comrades who will contact our allies and all honest artists … giving ideological explanations on Marxism and our Party's politics…' And so the long directive continues, aiming for an April exhibition involving works from the provinces to be collected in Marseilles, Nice and Lyons.

The numerous accounts of Picasso's obituary portrait of Stalin published in *Les Lettres françaises* of 12 March 1953 do not frame the scandal in the context of other Communist portrait-based exhibitions, or of this show, the last major demonstration of the Stalinist cult of personality in France, held, finally, in May 1953. Curiously, Taslitzky's January 1953 request, reproduced in the Musée Picasso catalogue *Les Archives de Picasso* (2003), appears *before* an earlier, collective letter to Picasso of 24 April 1952. The curators' ignorance of the great April 1952 'Communist painters' rebellion' is addressed here.

The year 1952 had been one of crisis and confrontation. Two years after the 'revolutionary surrealist' Christian Dotremont published *Le Réalisme socialiste contre la révolution*, André Breton, the Surrealist leader, at long last made a focused attack.[5] In June 1950 he had reviled Paul Éluard for his moral weakness over executions in Czechoslovakia, recalling their trip there together in 1935.[6] Now he denounced socialist realism in two long and serious texts. The first, 'Why are they hiding contemporary Russian painting?', appeared in *Arts* on 11 January. This responded to the publication in *Les Lettres françaises*' New Year number of an article from *Art Soviétique* – cheekily illustrated by the editors with a picture of a Matisse self-portrait with pipe and a saucy caption by Picasso.

Breton, in contrast, showed illustrations such as Yuri Petrovich Kougach's *The Highest Decoration* – a returning hero receiving a manly embrace from his father and a bunch of flowers from a girl – and the Kukryniksy artist trio's *The End* (1947–48), a grotesque depiction of Hitler's suicide in the Reich's Chancellery bunker among drunken generals, with 'bourgeois' paintings in their gilded picture frames askew on the walls.[7] Breton repeated a criticism meted out to the painter of *J.V. Stalin at the tomb of V.I. Lenin* and scorned the necessity for a rehabilitation of the subject entirely at odds with historical development: works fell into the trap of the blandest, most kitsch or most sordid anecdote.[8] The titles he quoted demonstrated the limitations of Soviet art: subjects related to industry, agriculture, the cult of personality (portraits) and history paintings of events in the life of Lenin and Stalin. His challenge was specifically that *Les Lettres françaises* should reproduce Soviet art in lieu of the works of Picasso, Matisse or indeed Giotto or Grunewald; these would demonstrate an unbridgeable difference, 'an intolerable hiatus'.[9]

Aragon responded with a front-page reproduction of Sergei Konenkov's monumental wooden bust of Lenin for the 17 January issue. Aragon's series of 'Reflections on Soviet Art' followed. Returning from the USSR,

he had visited the December annual exhibition in Moscow ('What should I tell them? That I find everything awful …?')[10] This first article about the *problem* of Soviet art was followed by one on sculpture in Moscow (31 January), illustrated with Vera Mukhina's painted plaster group *We Demand Peace!*, winner of a Stalin Prize in 1951. Six figures comprised three friends – one white European, one African, one Asian – a blind war veteran and a Korean mother holding the corpse of her dead child, all walking against the direction of the wind. Aragon compares Schubert with Chinese music to justify the 'otherness' of Soviet art.[11] He omits to mention his sitting for the celebrated official sculptor Nikogos Nikogosyan during his recent trip, a sculpture which, cast in bronze, waistcoat and all, would be acquired by the Tretyakov State Gallery (figs. 27 a, b). Aragon's cultural power and prestige in the Soviet Union was inestimable: he represented 'Western culture'; his writing was translated by Elsa Triolet among others; he prefaced Russian translations into French; *Les Lettres françaises* circulated among the intelligentsia.

In early February the French government publication, *La Documentation française*, reproduced a long article on 'lenino-marxist aesthetics' from the review *Bolchevik* on socialist realism in art for the edification of its officials and diplomats.[12] Aragon's in-depth studies continued with 'Landscape, Fatherland, Tradition' (21 February), 'The Painter and Nature' (27 March), 'Genre Painting' (3 April), 'Photography and Portraiture' (17 April) and 'Battle Paintings' (24 April), all illustrated with Soviet socialist realist works.[13]

The Henri Martin scandal simmered throughout this period. By March 1952 national protest was so strong that Léger and Picasso headed the list of artists of all tendencies, figurative, surrealist and abstract, who participated in a large show in support of Martin which opened on 20 March in the Foyer Danielle Casanova, rue d'Astorg.[14] There were remarkable differences within a portrait-related brief: Picasso's hastily sketched head, Léger's careful, square-jawed line drawing, versus realist heads by 'Julian Sorel' (Taslitzky), Damiano, Fougeron and Mercier. 'Judge for yourselves if the Communist Party interferes with original talents' said the press.[15]

Picasso's head of Nikos Beloyannis, evidently based on a news photograph, was first published on 9 March in *L'Humanité-Dimanche* with signatures of protest by Picasso, Matisse and artists Raoul Dufy, Jacques Villon and Marcel Gromaire. The Greek anti-Nazi resistant, member of the central committee of the Greek Communist Party, was shot by order of the monarchist Greek government during the night

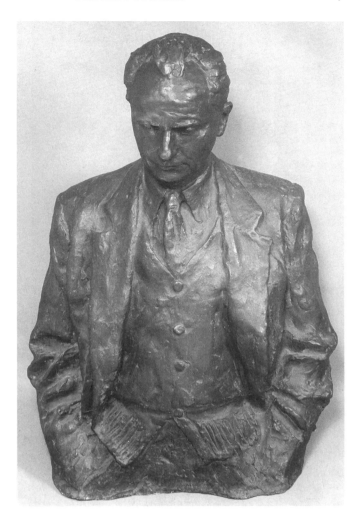

Figure 27a:
Nikolai
Nikogosyan,
Louis Aragon,
1953

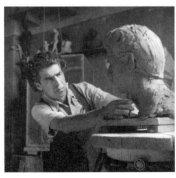

Figure 27b: Ida Kar, Nikogos
Nikogosyan, 1957

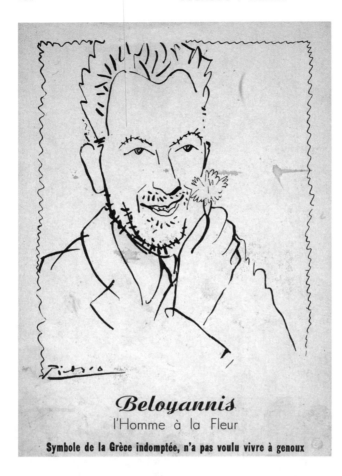

Beloyannis
l'Homme à la Fleur
Symbole de la Grèce indomptée, n'a pas voulu vivre à genoux

Figure 28:
Pablo Picasso,
Beloyannis, 1952

of 30 March, in the headlight glare of a military vehicle. Picasso's haste gives the zig-zag, electric contours of the young man holding a carnation a sense of urgency (fig. 28). Yet the almost too rapid drawing contrasts with the real power in the words of his hallucinatory vision of Beloyannis confronting the firing squad, fused with the white-shirted victim of Goya's *3 May*, a deeply imagined scene:

> The gleam of oil lanterns at night, in the Madrid of a May evening, lighting up the noble faces of a people shot by the rapacious foreigner in Goya's painting, has the same grain of horror sown in full fistfuls by projectors on the open breast of Greece by governments sweating death, fear and hatred. An immense white dove powders the earth with the anger of its mourning.[16]

By this time, Aragon's two-pronged cultural dictatorship – Picasso, Matisse, Léger balanced by hard-line socialist realism – no longer seemed tenable to a multitude of Parisian artists. His praise of the collective work by the Gritsai brigade, *A Session with the President of the Academy of Sciences*, in an article on the Stalin Prize (*Les Lettres françaises*, 17 April) finally precipitated the controversial 'Communist painters' rebellion'. Not only the *chromo* (coloured photograph) appearance but the lack of individual style in the Soviet work gave rise to vociferous criticism from Party painters. Aragon ordered a grand meeting at Party headquarters on 24 April, presided over by Laurent Casanova. Edouard Pignon led the revolt, with art critic Georges Besson, supported by sculptors Emmanuel Auricoste and Georges Salendre. It was another, deadly serious realism debate: the press were excluded. The closed session began after a three-hour wait for Picasso, who did not appear; neither did Matisse, nor Fernand Léger: 'the three greatest Communist painters boycotted the council; of the 200 Communist painters and sculptors who are PC members, fewer than 70 replied to the convocation' said a reporter.[17]

At the end of the meeting, two letters were dispatched: an anodyne salute to Picasso, the painter whose talents are put at the service 'of Peace and Socialism' (reproduced in *Les Archives de Picasso*, as above) and one to Maurice Thorez who was yet again absent in the USSR (recovering from a stroke). This recapitulated the Communist position on Korea, China, the Nevada atomic bomb manoeuvres and Henri Martin, and reaffirmed with approval Thorez's position on art in 1950.[18] George Plekhanov's style, typically 'newspeak' (*langue du bois*), the wooden language of Stalinist officialdom, expressed in his theoretical work *Art and Social Life*, translated in 1950, had been mirrored in Thorez's own words at the Gennevilliers Party conference of the same year.[19] This statement was reproduced again in the 1952 letter to the absent Party leader:

> Against the decadent work of bourgeois aesthetes, partisans of art for art's sake, pessimism with no solutions, and the retrograde obscurantism of existentialist philosophers; against the formalism of painters for whom art begins with paintings without content; we have opposed an art inspired by socialist realism which would be understood by the working class, an art which would help the working class in its struggle for liberation.[20]

Picasso apparently sent Françoise Gilot as his delegate on 24 April; his signature was finally added to the Thorez letter. *Humanité-Dimanche*

confidently mocked the avalanche of headlines in the hostile press: 'Aragon renounced by his peers, Picasso called to order, Matisse's defection is imminent, Léger's disgrace is assured.'[21] The furore was reported beyond France: in Italian and Dutch newspapers – even *The Daily Telegraph*.

As early as September 1950, before the second Peace congress, Picasso had expressed his desire to create a Temple of Peace in Vallauris's Roman chapel. *Man with a lamb*, his wartime bronze with its sacrificial resonances, had found a sacred setting in the chapel prior to its official inauguration (with full Communist pomp) in the village square.[22] He now plunged into work on his murals *La Guerre* and *La Paix*: an estimated 300 sketches were made between 28 April and 14 September.[23] André Breton continued his attack: 'On socialist realism, as a means of moral extermination' appeared in *Arts* on the hallowed 1 May labour day holiday. Aragon's tergiversations were condemned; the Soviet desire to crush art was inevitably Aragon's concern, Breton argued, the product of the regime which had alienated human liberty and eliminated protestors; the totalitarian regime should be judged as a whole.[24]

The *annus horribilis* for Picasso of 1952 continued with the death of his dear friend, the poet Paul Éluard, in November. Official state ceremonies were refused this prominent Communist. The Party's full pomp and circumstance, however, were deployed: huge blown-up photographs, official discourses, a long cortège of black cars piled high with flowers, the placing of wreaths from different official organisations, the procession to the Père-Lachaise cemetery. Each local Communist cell was decorated in mourning, followed a decorum soon to be magnified for Stalin himself (with relayed newsreel footage of events in Moscow).[25] Éluard's own Stalin portrait in verse had been written for the first number of *Cahiers du Communisme* in January 1950, with Maurice Thorez's homage and Taslitzky's double portrait: *Under Lenin's flag, under Stalin's direction*:

> And Stalin for us is here for tomorrow
> And Stalin can banish our sadness today
> His forehead of love bears the fruit of trust
> A perfect, reasoned harvest of perfection ...[26]

It was Éluard whose superb lyricism had effected a magic in parallel, often directly, with Picasso's dove ('the most naive promises are the most sublime', for example, in his script for the 1950 *Guernica* film).[27] His clear, simple poetry, like the images of Picasso or Léger, purified the complex, often painful subjects of labour and war, mourning or death.

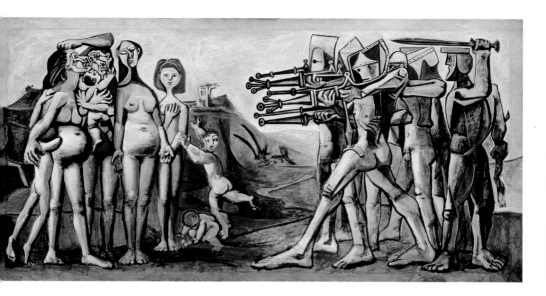

Plate 18: Pablo Picasso, *Massacre in Korea*, 1951

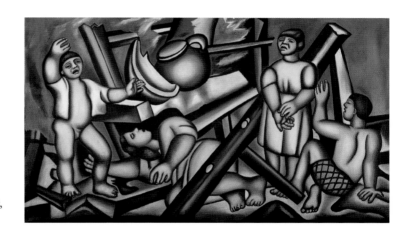

Plate 19: Nadia
Khodossievitch-Léger,
War in Korea, 1952

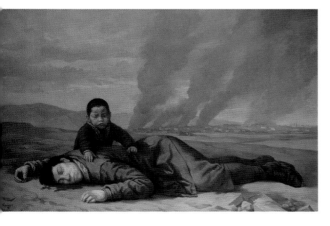

Plate 20: Wojciech Fangor,
Korean Mother, 1951

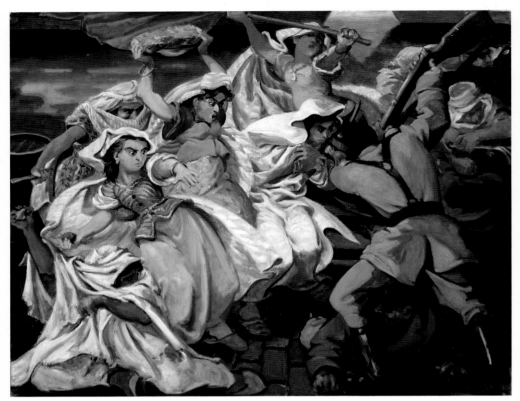

Plate 21: Boris Taslitzky, *Women of Oran*, 1952

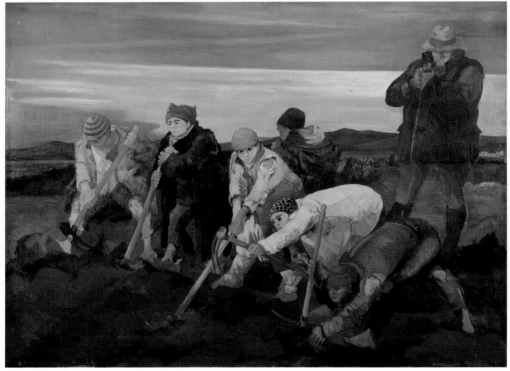

Plate 22: Mireille Miailhe, *Young agricultural workers*, 1952

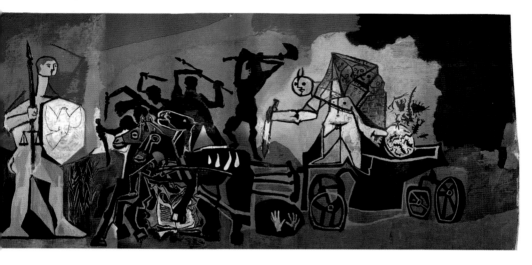

Plate 23: Pablo Picasso, *War*, 1952

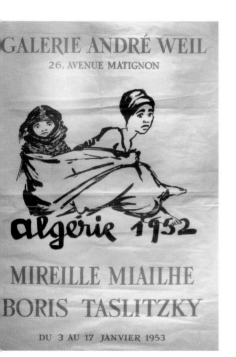

Plate 24: Mireille Miailhe,
poster for 'Algérie 1952', 1953

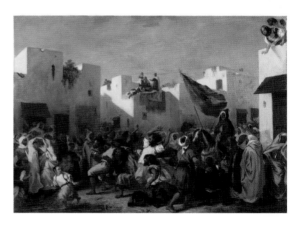

Plate 25: Eugène Delacroix,
Fanatics of Tangiers, 1837–38

Plate 26: *Les Lettres françaises*, 12 March 1953

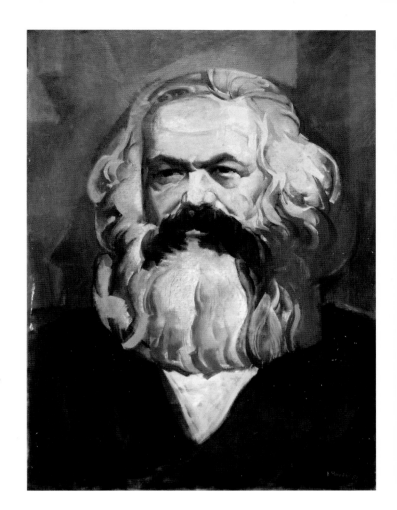

Plate 27: Albert Prigent,
Marx, 1953

Plate 28: Stoekel, *Stalin*
[undated]

Plate 29: Geneviève Zondervan,
Lenin, 1953

Plate 30b:
New Soviet Pavilion,
Moscow, 2012

Plate 30a:
New Soviet Pavilion,
Moscow, 2012

Plate 31: Interior,
New Soviet Pavilion,
Moscow, 2010

Plate 32a: Pushkin Museum, the great staircase,
with Boris Messerer, after *Guernica*, 2010

Plate 32b; Pablo Picasso,
works from 1950–1972,
Pushkin Museum, 2010

Plate 32c: Pablo Picasso,
war paintings, 1939–1951,
Pushkin Museum, 2010

Мих. Лифшиц, Л. Рейнгардт

КРИЗИС БЕЗОБРАЗИЯ

от кубизма к поп арт

Plate 33:
M. Lifshitz, L. Reinhardt,
The Crisis of Ugliness, 1968

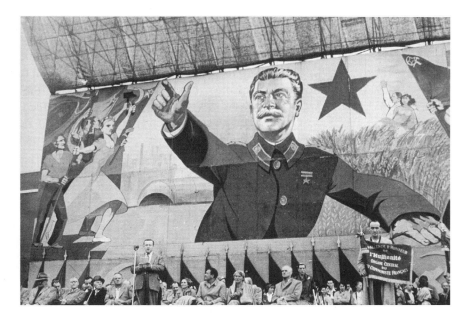

Figure 29: Boris Taslitzky, decor for twelfth PCF congress, 1950

Stalin himself as image, in painting or photography, represented on all manner of objects or enlarged to huge size, was a well-established convention. One recalls the effigy at the Fête de l'Humanité in 1935, the 23 panels demonstrating the 13 themes of Stalin's life painted as a backdrop for the birthday gifts exhibition in December 1949. Taslitzky's gigantic Stalin portrait over the speakers' platform dominated the decor for the twelfth PCF congress at Gennevilliers in April 1950, a collective enterprise under his supervision (fig. 29). Here Jean Chaintron also noted the traditional portraits of Marx, Engels, Lenin, Party leader Maurice Thorez and politicians Jacques Duclos and André Marty.[28] Thus a major Stalin cult – extending beyond image to rhetoric and other ritual practices – was promoted by the PCF well before Picasso's fated portrait. Nonetheless, at the moment of the 'Communist painters' rebellion', it was André Guérin in the right-wing *L'Aurore* who had had the prescience to ask:

> Just imagine commissioning a portrait of Stalin … *And* a real Picasso commission – at least from the supposedly real Picasso who makes such a fortune with rich collectors … Have you any idea of the reaction in Moscow?[29]

Stalin died on 5 March 1953. *L'Humanité*'s special edition published a half-page size photograph, bordered in black, announcing the 'Vel d'Hiv de deuil mardi', a mass mourning event at the huge Winter Velodrome (fig. 30).[30] *Les Lettres françaises* published a commemorative issue on 12 March. Picasso's Stalin portrait was on the front page: a young, smiling, moustachio'd Georgian, his contours decisively reaffirmed in charcoal (plate 26, fig. 31). It was not too dissimilar from an Italian woman he had drawn in January.[31] The sequence of events was first recounted in Françoise Gilot's *Life with Picasso*; she treated the whole affair as a nuisance, an interruption solved by the serendipitous discovery of a photograph of Stalin aged about forty to serve as model. The scandal has now been told many times. Accounts include those of Lucie Fougeron (the artist's granddaughter), based on discoveries in the Party archives; Gérard Gosselin's placing of the event within the entire panorama of the Communist press before and after the event (a significant contribution); and Annette Wievorka's synopsis for the exhibition *Picasso, Peace and*

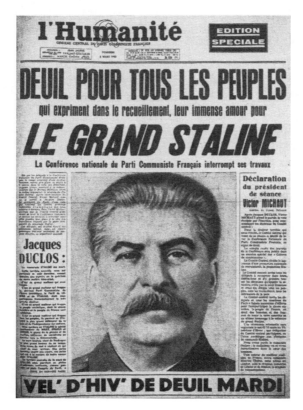

Figure 30: *L'Humanité*, 8 March 1953

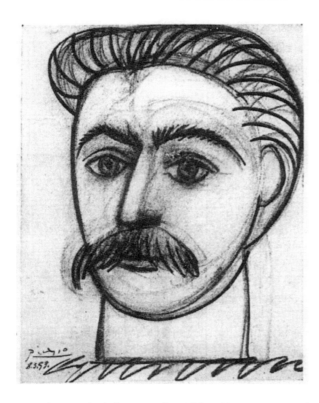

Figure 31: Pablo Picasso, *Joseph Stalin*, 8 March 1953

Freedom and Philippe Sollers' blog.[32] Pierre Daix has continually repeated the story of the telegram to Picasso requesting a 'text or drawing', the panic before the moment of going to press, the dismay at unexpected reactions.[33] Daix's elaboration of his memoirs continues, while the portrait accumulates a diverse critical posterity. Consider Jean Clair, when director of the Picasso museum: 'Picasso has left us a really wicked (*fort méchant*) drawing of the face of Stalin. Doll-like, a sort of baby with a moustache, a monster, of the bearded woman type, product of a genetic aberration, a chimera of fake innocence and very real ferocity...'[34]

The militant Marxist artist and critic Michel Dupré is surely the first, however, after Aragon, to pay the portrait due formal attention.[35] He offers a careful reading of each line and feature, and especially the anxious pentimenti that demonstrate both care and investment in the image. (These distinguish it clearly, of course, from the rapid line drawings of Henri Martin or Beloyannis.) Dupré deduces a palimpsest: not merely is there 'too much Picasso' in the drawing; rather, the drawing uses the trope of youth masking age to mask the confrontation

of two 'geniuses', two 'monsters', Picasso and Stalin; the autobiographical dimension perturbs. At the outset of *La moustache de Picasso*, Dupré states the egregious truth that outweighs all later commentaries: 'Intrusive, yet desired, the portraitist is fatally, entirely, inside the portrait.'[36] One could argue further that, in contrast with the signification of caricature (a witty or cruel exaggeration of features for a specific end), it was this act of interpenetration which was universally perceived as sacrilegious.

Picasso's drawing of 8 March appeared in *Les Lettres françaises* flanked by double columns of text; on the right, Aragon, 'Stalin and France'; on the left, 'Stalin, Marxism and Science' by Frédéric Joliot-Curie, now deposed from his position as head of France's national atomic energy programme. He wrote: 'Marxism, like every science, lives and develops ... to speak of living Marxism is to speak of Stalin ...' Here, 'science' and pure science merge; Joliot-Curie's rhetoric recalls the never-repudiated spectre of Lyssenkism – the promotion of spurious Soviet 'proletarian' agronomics (a debate that had split the French scientific establishment along pro- and anti-Communist lines from 1948).[37] Joliot-Curie's embarrassing paean demonstrates the fever pitch of pressure and emotion at the time, pressure which Picasso, ostensibly, ignored – at his peril.

André Fougeron publicly refused to consider Picasso's drawing in advance for the 'Marx to Stalin' memorial exhibition (a riposte, he revealed to me, to Picasso's needling rejection of his own Stalin portrait).[38] A photograph of the young Stalin had just been published in *Regards*.[39] At this moment when Stalin's image decorated every Communist cell in mourning in every arrondissement, Picasso's portrait challenged the norms of the cult of personality, but also, inevitably, the indexical presence of Stalin himself in photographs (a presence transmitted and subliminally acknowledged in photo-based, academic socialist realist oil painting).[40] The drawing was officially condemned in *L'Humanité* of 18 March:

> The Secretariat of the French Communist Party categorically repudiates the publication in *Les Lettres françaises* of 12 March of the portrait of great Stalin by Comrade Picasso. Without doubting the sentiments of the great artist Picasso, whose attachment to the working-class cause is known by all, the Secretary of the French Communist Party regrets that Comrade Aragon, member of the Central Committee and director of *Les Lettres françaises*, who in fact fights for the development of a realist art, permitted this publication.[41]

Aragon's humiliating 'self-criticism', in Stalinist mode, had to be published, together with letters condemning Picasso as an act of contrition.[42] Party leader Maurice Thorez's return from the USSR would solve the problem; he recognised the hijacking of the affair by vested interests who had profited from his absence (Aragon's brutal put-down of *Atlantic Civilisation* at the Autumn Salon is implicated in these power struggles: Fougeron's style and content was by no means the main issue). Fougeron's current hubris continued with 'For a Party art criticism', published in late April: 'how could one not see [in Picasso's drawing] ... a facile encouragement to continue the sterile games of aesthetic formalism?'[43]

On 18 April in *L'Humanité*, Edouard Pignon, Picasso's epigone and friend, was chosen to ask for more contributions for 'Marx to Stalin', from artists of whatever style.[44] Staged at the Metallurgists headquarters, as was the Stalin birthday gifts show, this exhibition demonstrated the apotheosis in France of the cult of personality, history painting with nineteenth-century subjects and violent anti-Americanism. Fougeron contributed an example of each: *Marx and Engels in the midst of a circle of socialist workers, Paris, 1844*; *French peasants defend their land* (dedicated to Stalin Prize-winning novelist and *L'Humanité* editor André Stil); *Scene from the American Occupation* (an American soldier sprawling in a French café); and, as a sign of allegiance to his former patron, a portrait drawing of Auguste Lecœur. Another major work was his *Funeral of Victor Hugo's Son, 18 March 1871*, with its horse-drawn catafalque and the salute at the barricades of the Père-Lachaise cemetery. (This work, used to illustrate socialist realism as a French artistic tendency in Robert Lebel's first 'global' survey of contemporary art in 1953, functions as a bizarre *punctum* within the modernist world of competing abstract and expressionist tendencies.)[45]

It is here that socialist realist portraits of Marx and Stalin were produced that throw Picasso's *Stalin* into sharp relief (his 1945 fine pencil portrait of Maurice Thorez was in the show). *Young Stalin*, a drawing by Louis Bancel, was accompanied by his *Ho Chih Minh*; Georges Bauquier's *Stalin* was accompanied by portraits of Éluard, Maurice Thorez and Etienne Fajon, and *The Death of Marx*; there were Stalins as drawings, paintings, busts, medallions, Stalins in conversation with Lenin, and Stalin's imaginary visit to Thorez's bedside by Taslitzky. Stoeckl's *Stalin* looked virile and cruel, his skin and raven hair knowingly highlighted; Albert Prigent's *Marx* was luxuriantly bewhiskered (plates 28, 27).[46] Geneviève Zondervan's small-scale *Lenin*, based,

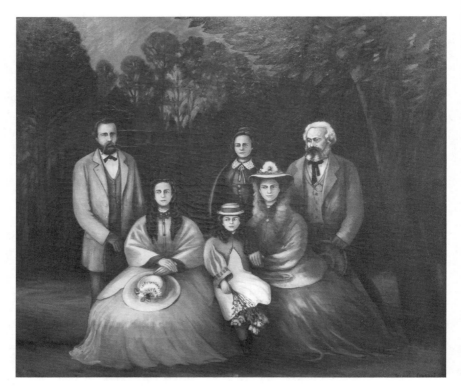

Figure 32: Frédéric Longuet, *Marx and Engels
with Madame Marx and their three daughters*, 1953

as always, on a well-known photograph, was subversive in its knowing
naivety, with its gaily painted frame of flowers (plate 29). Karl-Jean
Longuet's bust of Marx was accompanied by his cousin Frédéric's
Victorian family portrait of their mutual ancestors: *Gratitude to Engels.
Karl Marx and Friedrich Engels, founders of scientific socialism with
Madame Marx and their three daughters* (fig. 32). With the patina of
time, the few works preserved from this show possess an almost touching
anachronism; in 1953 the subtexts had more disturbing resonances.

'Marx to Stalin' was quite enough to refuel debate during the summer
months. The socialist realism issue of the CIA-funded review *Preuves* of
July 1953 contained a broad spectrum of negative opinion and specific
denunciations. While continuing the survey procedure of *Le Peintre* of
October 1950 (subtitled 'The tragic farce of socialist realism'), it began
with an illustrated reprint of Breton's 'Why are they hiding socialist

realism?', adding responses from an international array of painters and intellectuals (German, Italian and Mexican), the synopsis of a letter from Clement Greenberg, and a typically inflated contribution from André Malraux.[47] The progressive intellectuals around this international enterprise – what has been called 'the intelligence of anti-communism' (promoted in *Preuves*'s sister publications, *Encounter, Der Monat, Forum, Tempo Presente*) – were rarely right-wing Catholics.[48] Yet France, it must be emphasised, was a deeply Catholic country. The antithetical contrast between the Communist view of history and that of Paul Scortesco, a Vatican cardinal, should be elucidated for its resonances in the context of Picasso's *War* and *Peace*.

Within the world of Catholic belief and practice, the clampdown on the Church in Soviet satellite states was a serious issue. International attention had been focused upon the persecution and show trial of Cardinal József Mindszenty in Hungary and the McCarthyite opinions of Cardinal Francis Joseph Spellman in America. As Scortesco, a Romanian, put it with bitterness and irony:

> There are not several questions. There is only one which our century must answer: the disappearance of eight countries from the political and spiritual map of the world; the annihilation of millions and millions of human beings...
>
> Death, here is thy victory!
> And where?
> *In the very heart of Christianity.*
>
> It's so far away. Korea is so close. And there are so many of them; Czechs, Romanians, Hungarians, Bulgarians, Lithuanians, Estonians, Lettons, whatever...[49]

The dialectical opposition between Marxist and Catholic views of historical evolution are at stake here. Communist thinkers subscribed to a notion of progress, extending from the Renaissance to the Reformation, the French Revolution and the advent of 'universal' suffrage, followed by the atheistic, rationalist philosophy of the eighteenth-century Encyclopedists, culminating with the positive developments of Marxism and dialectical materialism. The PCF's post-1945 'French Renaissance' project for a new Encyclopedia was inscribed within this longer history.[50] Fernard Léger, for example, in a lecture given at the Sorbonne around 1950, contrasted his ideal of 'A dignified people, upright, standing firmly in the present, smiling at the future, marching harmoniously towards

its objective and rational destiny' with the people of the Christian era: 'on their knees, their head in the dust, awaiting a senseless miracle, wishing not to know their earthly fate...'[51] Right-wing clerics and opponents of modernism held a diametrically opposed view. Scortesco was clear in his denunciation: the very same progression from Renaissance and Reformation to revolution, atheism and dialectical materialism charted, on the contrary, the spiritual downfall of modern man, and beside the losses of two world wars, the loss to Christendom of the USSR and Communist Eastern Europe: 'the annihilation of millions and millions of human beings' refers to the Soviet famines, purges and gulags. He quotes John Foster Dulles, Secretary of State to Dwight D. Eisenhower (a remark of 29 September 1952): 'We accept that the Kremlin rules 800 million slaves, as long as it leaves us alone.'

There were older confrontations at stake here, dating from the French laws separating Church and state in 1905, indeed the very origins of the word *modernisme* in France. Picasso's *Demoiselles d'Avignon* was created in 1907, the year of Pope Pius X's encyclical *Pascendi Dominici Gregis* (Lord, Feed thy Sheep), subtitled 'on the errors of modernism' (agnosticism, positivist science and historicist biblical scholarship).[52] Secular versus religious education (a function of class) split the French as did the collapse of religious belief and influence in an age of increasing materialism and scientific rationalism.[53] Hence the Catholic 'mission' in the Communist 'red belt' suburbs, and debates on 'modern-style' churches; hence the 'open handshake' policy (*la main tendue*) between Communists and Catholics, launched and relaunched by Maurice Thorez (with an eye to the traditionalist, especially female, Catholic working-class vote).[54] Rapprochements with Marxists were a matter of great concern to Catholic intellectuals in France and Italy (see *Esprit*'s May–June issue of 1948, 'Open Marxism against scholastic Marxism').[55] Incredulity and horror, therefore, greeted the mass excommunication of Communists by decree, proclaimed by Pius XII on 1 July 1949: 'a massive historical error' said Emmanuel Mounier, *Esprit*'s director. The edict, impossible to effect, was a cause of great pain and soul-searching.[56]

The art world was split accordingly, between the Catholic right (painters such as Maurice Denis and his followers) and the Communist left, with confrontations from the late 1920s onwards. Pope Pius XI's inaugural speech of 1932 condemned amoral, ugly, distorted, caricatural and 'hallucinatory' art; Pius XII's encyclical *Meditator Dei et Hominem* (1947) declared that the Church should not be a place of experimentation, nor holy figures assailed by 'depravity' or 'deformations';

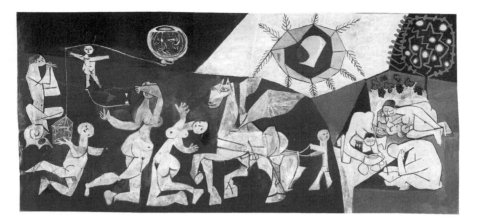

Figure 33: Pablo Picasso, *Peace*, 1952

the Vatican's edict *Dell'Arte sacra deformatrice* of June 1950 was a direct attack on ecumenical, modernist commissions such as the Church of Assy in Haute-Savoie, involving both Jews (Marc Chagall, Jacques Lipchitz) and Communists (Léger and André Lurçat). This 'new quarrel of images' once more rehearsed the arguments of the realism debate of 1935–36, which had been taken up by the Church itself in 1938.[57] Press response was international.

Picasso's desire for 'his' chapel must be inscribed, then, within a context of both intense debate about religious images – beauty, 'ugliness' and the sacred – and personal competition: not only the Assy enterprise but Fernand Léger's windows for the church of Courfaivre, Le Corbusier's Sainte-Baume project and the daring construction, in process, of his epoch-making modernist church at Ronchamp. In particular, Henri Matisse's Chapel of the Rosary in Vence, inaugurated in June 1951, with its stained glass, crucifix, images of saints and the Virgin, all designed by the artist, posed a challenge.[58] Dating for Picasso, as we know, was never arbitrary; while he had nursed the chapel project since July 1950, he chose to begin work on 28 April 1952, not only in the immediate aftermath of the 'Communist painters' rebellion' but of more Church edicts. Following Pius XII's pronouncement on 8 April that the Christian artist should be both elect and peace-loving (*pacifique*), 28 April was the day of the Episcopat insisting that the Christian artist should respect Church hierarchy directives. On 30 June 1952 came the 'Instruction of the Holy Office on Sacred Art': a formal condemnation of shocking

representations (*images insolites*), the mediocre and over-commercial. Faith, piety and the legislative powers of Canon Law regarding sacred art were emphasised as prerequisites for any artistic commissions.

'Picasso's seed covers the world with incubi and succubi' declared Scortesco, whose religious vision was manichaean to the point of demonism. Picasso's *War* and *Peace* offer a correspondingly manichaean dialectic, with black devils in *War* spreading (American) germ warfare (plate 23).[59] Each work, nearly five metres high and ten metres long, was designed to meet its counterpart, like a seam, at the top of the barrel vault. They would be perceived together as the viewer moved through the space.[60] Initially, Picasso envisaged this experience taking place in the dark, lit by candles or torchlight, similar to the discovery of ancient cave paintings – the viewer walking towards the sun.

Peace is a Golden Age painting, revisiting the nymphs and fauns, the loving scenes of maternity painted in Antibes (fig. 33). The Pegasus driven by a child is toy-like, preceded by Dionysian nudes; the brown sky versus blue earth inverts sky and sea; the carnivalesque inversion of fishbowl with flying birds in the air versus the birdcage full of fish, the magic child balanced on a fingertip, lighter than an hourglass – all indicate possibilities of reversibility, the precariousness of peace, the tipping of one state into its opposite; their mutual dependence and rhythm.

War is inevitably stronger, the side of masculinity, of aggression, of fire versus water. A mad, black chariot trundles forward; Picasso likened its progress to the lurching, chaotic progress of a provincial hearse passing through the narrow streets of a small town.[61] Aloft, a naked figure, with bloodied dagger, carries a sack of skulls; beneath, a globe, like a microscope lens, echoes the fishbowl of birds opposite. Microbes spill out like huge black centipedes: an image of biological warfare.

Fear and controversy surrounded this issue, relating to American strategy in both Korea and Indochina. It was treated at the highest political level, fronted by Joliot-Curie for the PCF, following Chinese reports delivered at the World Peace Council in Oslo on 29 March 1952.[62] It would lead to the mass demonstration against 'General Ridgeway the Plague' in Paris and a spate of posters and flyers. Books burn under the apocalyptic horses' hooves: an auto-da-fé linking the enemy to the Nazis. Picasso would have known about the passage of the plague and of German massacres inside the Vallauris chapel before its abandonment as a place of worship in 1791.[63]

Picasso's naked peace warrior stands like a bastion against this onslaught; the peace dove is inscribed upon his shield and, visible in

palimpsest through a semi-transparent glaze, so is the *Face of Peace* (the *Visage de la Paix* – Françoise Gilot's head framed with dove's wings). Yet the evolution of this image from a winged warrior helmet and the relationship with Perseus's decapitated Medusa head on the shield is clear. Moreover Pegasus (on the *Peace* side of the mural) belongs to the myth of Perseus and his warlike precursor Bellerophon. The almost chiastic structure of the murals as a twin-visioned 'tunnel experience', with these cross-overs in meaning, disturbingly interrogates the interdependent meaning of these manichaean opposites. György Lukács had a similar intimation at about the same time, when prefacing *Probleme des Realismus* (*The Meaning of Contemporary Realism*), published in 1955:

> Our starting point, then, is really the point of convergence of two antitheses: the antithesis between realism and modernism and the antithesis between peace and war. Yet, while emphasizing this identity, certain reservations must be made. The identity in question is essentially abstract. In individual cases it will appear in many differing, transitional forms. Indeed, it is of the essence of this complex problem that no strict polarization exists. It would be oversimplifying the matter to identify opposing or converging tendencies within individual movements or personalities. These tendencies are often to be found in one and the same individual. They are, not only as discrete stages in his development, but as *co-existent at one and the same time.*[64]

In May 1953, not so long after the Stalin portrait scandal – and coinciding with 'Marx to Stalin' – the National Gallery in Rome exhibited *War* and *Peace* as part of a major Picasso retrospective. Later, the sequence of grand masterpieces, with *Guernica* (brought from New York), the *Charnel House* and *Massacre in Korea*, was displayed symbolically in the ruined and fire-damaged shell of the Palazzo Reale in Milan, following Allied bombing of the city's Nazi occupants in 1943.[65] (How tragic that Max Raphael, who had programmed a summer trip to Europe in 1952 prior to his suicide on 14 July, could not have compared this retrospective to the Zurich show of 1932.)

'This miracle of Milan', as it was called, 'with its two hundred paintings, thirty four illustrated books, over forty sculptures and ceramics, fifty lithographs', offered the recognition that Picasso, as a Communist, had never enjoyed in France. Dithyrambic press articles declared Picasso's 'total reconciliation' with the French Communist Party. In November 1953, when the Italian director Luciano Emmer filmed Picasso drawing another figure of *Peace* in charcoal on prepared hardboard panels put up

inside the chapel, Hélène Parmelin could report that 100,000 people per month had walked past *War* and *Peace* in their Italian settings.[66]

War and *Peace* were not installed in the Vallauris chapel until February 1954. In March 1954 Claude Roy's magnificent volume, *La Guerre et la Paix*, with lithographs by the Mourlot studio, appeared, revealing the huge number of preparatory drawings for the work around various themes such as the eagle head sowing seeds of destruction or the four dancing little girls. Following Roy, in October, Hélène Parmelin's *Le Massacre des Innocents. L'Art et la guerre* ('The Massacre of the Innocents, Art and War', also for Cercle d'Art editions) presented Picasso's *War* and *Peace* murals within a 6,000-year historical trajectory; moving forward abruptly to the Nazi atrocity at Oradour, and the poems of Jean Tardieu, Aragon and Paul Éluard, her book addressed the present. Themes such as 'The child, the mother and the soldier' or 'War and battle', illustrated with Old Master works from throughout the ages, created a veritable *musée imaginaire* in reproduction, extending beyond European art to Persia, Syria, Angkor Wat and moving finally – after Poussin – to the stories of Delacroix, David, Rude, Daumier and Courbet. Two entire chapters were devoted to *Guernica* and the *War* and *Peace* murals. Parmelin concluded:

> It's not by chance that millions of doves fly over the world linked to the name of Picasso and that of Peace, It's not by chance that for the first time in art, it's Picasso who has replaced the massacre of the innocents with Peace in combat, stopping the chariot of war with his shield ... How could art in the twentieth century remain untouched by the great assembly of men fighting for peace? When it's a question of wars whose horror cannot be approached. When the incendiary bombs of Guernica are battered by the napalm bombs of Vietnam and Korea and by flame-throwers. When the atomic bomb annihilated Hiroshima and killed Nagasaki in a few seconds, when the bacteriological bombs sowed the most atrocious deaths by disease. When the hydrogen bomb prepared deaths still more spectacular ... While works of art, like men, die under the skies of war. Peasants in the fields of Korea like old temples. Pagodas of Vietnam like houses of straw or fishermen in their sampans. Cathedrals, sculptures, murals ...[67]

With a sonority echoing Malraux's, though not his politics, and indeed with a problematic *jouisssance*, Parmelin enunciated a new world order based on colonial and post-colonial violence. Paradoxically, in an age where impersonal technologies of destruction now surpassed

hand-to-hand combat, the Milan crowds in front of Picasso's *War* and *Peace* proved that the grand individual gesture, and indeed history painting as a practice, were not redundant.[68]

Picasso, apparently nonplussed by the lukewarm reception of his Temple of Peace after Italy, offered *War* and *Peace* to the nation via his friend, Georges Salles, director of the French Museums. A scheduled opening at Easter 1958 was postponed; he did not wish the murals to be associated with de Gaulle's return to power – or indeed with André Malraux, the culture minister, a former friend, now foe. At the moment of the potential inauguration of *War* and *Peace*, the access to the chapel was altered; Picasso was compelled to paint the *Four Corners of the World*, a panel that blocks and changes the envisaged experience of passage. Picasso did not attend the delayed opening in 1959, in the midst of the Algerian war.

War and *Peace* as a contemporary Sistine Chapel? Restored, the diptych was subject to new studies in 1998; Claude Roy's *La Guerre et la Paix* appeared, reformulated, just before the author's death in 1997.[69] Posterity would surely conclude, however, that the installations in Vallauris were ultimately not as perfect a 'late work' as Matisse's Chapel of the Rosary in Vence, and nowhere near as clairvoyant a total work of art as Le Corbusier's church at Ronchamp. Together with the ruined stump of Le Corbusier's Église Saint-Pierre in Firminy, commissioned in 1960 and left incomplete, the diptych bore eloquent testimony to the end of an era.

It is the *Stalin* portrait, not the *War* and *Peace* murals, which enjoys a powerful afterlife. Like Marcel Duchamp's *Fountain*, it exists and proliferates despite a lost original. Pierre Daix believes that the work, returned to Picasso and possibly put between the leaves of a book, was mislaid when his personal effects were removed from his chateau after his death.[70] Just so, as a 'Picasso', a Picasso with a moustache (Dupré), a bearded woman (Jean Clair), *Stalin by Picasso or Portrait of a Woman with Moustache* (Lene Berg), Picasso's *Stalin* has proved the artist's intuitions correct as regards its staying power. Curiously, the office of the Secretary General of the Communist Party, Georges Marchais, was for decades graced with a moustachio'd woman: not Picasso's *Stalin*, but the large version of Duchamp's *L.H.O.O.Q.* (1919–30). In 1979, the year Marchais condoned the Soviet invasion of Afghanistan, it was offered as a gift, a ghoulish joke and a *renvoi* to his own avant-garde past by Louis Aragon, Stalin's cultural emissary of the Cold War period.[71]

Notes

1 'Paris, ville-lumière, tu as donné ton nomme à l'école de l'imposture picassienne,
 à l'école de la corruption'; Cardinal Paul Scortesco, *Saint Picasso*. *Peignez pour nous,
 ou les deux conformismes* (Paris: Nouvelles Éditions Latines, 1953).

2 'voici celle que propose la commission: Marx–Engels, Lafargue, Guesde, Lénine,
 Staline, Dimitrov, Thorez, Mao-Tsé-Toung, ceux des héros morts ou vivants, ceux des
 dirigeants des partis communistes dans le monde'; Boris Taslitzky, letter to Picasso,
 29 January 1953, in L. Madeline, ed., *Les Archives de Picasso. On est ce que l'on garde!*
 (Paris: Musée Picasso – RMN, 2004), p. 304.

3 '(la Commission [...] pense) qu'il faut l'ouvrir [...] à tous qui veulent honorer Marx
 et le Marxisme. Mais ceci entraîne la responsabilité personnelle des camarades qui
 contacteront nos alliés et tous les artistes honnêtes'; ibid., p. 305.

4 'comment les artistes communistes et leurs amis se montraient aptes à traduire le
 visage des hommes de ce temps [...] L'effort demandé est très grand, à l'échelle
 du sujet, à celle de la lutte de notre Parti, dans la politique duquel s'inscrira cette
 manifestation qui doit avoir une haute portée artistique et politique. Nous ne croyons
 pas qu'un effort aussi vaste nous ai jamais été demandé. C'est là un honneur auquel
 il convient de faire face. C'est là la tâche qui aura une portée nationale et interna-
 tionale, et la commission souligne à l'attention de tous que c'est sans doute la première
 fois qu'une telle entreprise sera tentée [...] Dans ce projet tous les talents peuvent
 librement s'affronter, se confronter. Il importe que chacun choisisse son sujet afin que
 l'ensemble des œuvres rendent compte autant que possible l'ensemble du sujet, dont le
 noyau réside dans l'art du portrait. Ceci pose la question de la peinture d'histoire [...]
 La peinture d'histoire c'est aussi celle de l'histoire au présent.' Ibid., pp. 304–05

5 Christian Dotremont, *Le Réalisme socialiste contre la Révolution* (Brussels:
 Cobra, 1950).

6 André Breton, 'Seconde Arche' (Prague preface), and 'Lettre ouverte à Paul Éluard', 13
 June 1950, in *La Clé des champs* (Paris: Sagittaire, 1953), pp. 106–09 and 235–37.

7 André Breton, 'Pourquoi nous cache-t-on la peinture russe contemporaine?',
 Arts, 11 January 1952; reprinted (illustrated) in 'Problèmes de l'art contemporain,
 L'Esprit de la Peinture contemporaine. Enquête sur le Réalisme socialiste', *Preuves*,
 supplement to no. 29, July 1953; see also *La Clé des champs*, pp. 262–71 (unillustrated).

8 'la plus plate, ou la plus clinquante, quand ce n'est pas la plus sordide *anecdote*'; Breton,
 'Problèmes de l'art contemporain'.

9 'un hiatus intolérable [...]' Breton refers to Paul Éluard's new series 'Anthologie
 des écrits sur l'art', for example 'Sur le Maître de Saint-Savin, Giotto, Grunewald,
 Pieter de Hooch et Georges de la Tour', *Les Lettres françaises*, 3 January, p. 8; Éluard,
 Anthologie des écrits sur l'art (Paris: Cercle d'Art, 3 vols: *Les Frères voyants*, 1952; *Lumière
 et morale*, 1953; *La Passion de peindre*, 1953 and re-editions).

10 'Qu'est-ce donc que je leur dis? Que je trouve tout affreux ou que je leur annonce des
 nouvelles?' Aragon, 'Petit prologue où il n'est pas question des beaux-arts', *Les Lettres
 françaises*, c. 23 January 1953.

11 Aragon, 'Il y a des sculpteurs à Moscou', *Les Lettres françaises*, 31 January 1952, p. 10.

12 'L'URSS Presse soviétique. L'esthétique lenino-marxiste', *Articles et Documents,
 La Documentation Française*, 2336, 5 February 1952 (with A.A. Miasnikov's 'Les traits
 fondamentaux du réalisme socialiste', *Bolchevik*, 224, December 1951).

13 See *Les Lettres françaises* for 7 February: 'Un sculpteur soviétique vous parle. G. Manizer'; 14 February: 'Introduction à une peinture d'idées', with Répine's *Procession de baptême dans le gouvernement de Koursk* on the front page; 21 February: 'Le Paysage, la Patrie, la Tradition' (illus. p 10, Levitain, *Automne doré, Eau dormante, Le mois de mars*); 13 March: 'Nisski, ou les paysages choisis' (illus. p. 8, *Paysage Biélo-Russien*); 27 March: 'Introduction à la confession d'un peintre' (illus. p. 8, B. Ioganson, D. Tégune, N. Faidych-Krandevskaia, N. Tchebakov, *Lénine au congrès des Jeunesses Communistes de l'U.R.S.S.* and B. Ioganson, *La Fête de la Victoire*, 1947); 3 April: 'Le peintre et la nature'; 10 April: 'Peinture de genre' (illus. Pavel Andrévitch Fedotov, *La Demande en mariage du Commandant*); 17 April: front page, Provokov's weeping *Statue of Liberty* to illustrate Mayakovsky's *De l'Amérique*, with Aragon, 'Sur les Prix Staline', continued p. 12 (illus. by Gritsal, Etanov, Kotijarov, Maksimov, Stavitski, Sondakov, Chtcherbakov, *Une séance du presidium de l'Académie des Sciences*); 24 April: 'La photographie et la portrait'; 2 May: 'La peinture de bataille et l'autruche'. Following censorship in the 1981 edition, these articles are reproduced in Jean Ristat, ed., *Louis Aragon. Écrits sur l'art moderne* (Paris: Flammarion, 2011), pp. 157–255.

14 *Les Lettres françaises*, 27 March 1952, illustrated with Léger's *H. Martin*, lists the exhibitors at 12 bis rue d'Astorg.

15 Uncaptioned press cutting, Hélène Parmelin archives, IMEC.

16 'La lueur des lanternes éclairant, la nuit, dans le Madrid du soir de mai, les nobles faces du peuple fusillé par l'étranger rapace, dans le tableau de Goya, est le même grain d'horreur semé à pleines poignées de projecteurs sur la poitrine ouverte de la Grèce par des gouvernements suant la mort, la peur et la haine. Une immense colombe blanche saupoudre la colère de son deuil sur la terre.' Gérard Gosselin, ed., *Picasso, 145 dessins pour la presse et les organisations démocratiques* (Paris: L'Humanité, 1973), pp. 108–09.

17 'les trois plus grands peintres communistes ont résolument boudés le concile. Sur les deux cents peintres et sculpteurs communistes inféodés au P.C., moins de 70 avaient répondu à la convocation.' The 'Histoire de la fantastique rébellion des artistes communistes', so titled by Hélène Parmelin, extends from pp. 46–68 of her 1952 'Argus de la Presse' scrapbook of press cuttings, ascribed to specific newspapers, but often unsigned and undated; Hélène Parmelin archives, IMEC.

18 The full texts of the letters to Picasso and Thorez of 24 April are reproduced in *L'Humanité* (25 April?), the letter to Picasso in Madeline, ed., *Les Archives de Picasso*, pp. 306–07.

19 See Georges Plekhanov, *L'Art et la vie sociale*, trans. J. Fréville with two crucial studies (Paris: Éditions Sociales, 1950).

20 'Aux œuvres décadentes d'esthètes bourgeois, aux partisans de l'art pour l'art, au pessimisme sans issue et à l'obscurantisme rétrograde des philosophes existentialistes, au formalisme des peintres pour qui l'art commence là où le tableau n'a pas de contenu, nous avons opposé un art qui s'inspirait du réalisme socialiste et serait compris de la classe ouvrière, un art qui aiderait la classe ouvrière dans sa lutte libératrice.' Letter to Maurice Thorez, in 'Argus de la Presse' scrapbook of press cuttings, Hélène Parmelin archives, IMEC.

21 'Aragon renié par les siens', 'Picasso rappelé à l'ordre', 'La défection de Matisse est imminente', 'La disgrace de Léger est assurée'. *L'Humanité-Dimanche*, press cutting, Hélène Parmelin archives, IMEC. Other press cuttings insist on Matisse's Party affiliations, Gilot's presence etc.

22 For the 1950 origins, see Picasso interviewed by Georges Sadoul, 21–27 September 1950, manuscript in the Picasso archives, Paris; see Dominique Forest, Jean Lacambre et al., *La Guerre et la Paix: Vallauris-Picasso* (Paris: RMN, 1998), p. 42; see also Mady Ménier et al., *Picasso: l'homme au mouton* (Paris: RMN, 1999). Both were summer shows, Musée Picasso La Guerre et La Paix, Vallauris.

23 Claude Roy's estimate; Forest et al., *La Guerre et la Paix*, p. 43.

24 André Breton, 'Du réalisme socialiste comme moyen d'extermination morale', *Arts*, 1 May 1952.

25 Film footage of Éluard's cortège is at http://www.ina.fr/video/CAF97078279/ obseques-de-paul-Éluard.fr.html (accessed 21 August 2013).

26 Et Staline pour nous est présent pour demain
 Et Staline dissipe aujourd'hui le malheur
 La confiance est le fruit de son cerveau d'amour
 La grappe raisonnable tant elle est parfaite...'
 Paul Éluard, 'Joseph Staline', *Cahiers du Communisme*, 1 (1950), p. 4.

27 Paul Éluard, 'Les promesses naives sont les plus sublimes'; script of Alain Resnais and Robert Hessen's film, *Guernica*, 1950.

28 Jean Chaintron, *Le Vent soufflait devant ma porte* (Paris: Seuil, 1993), p. 306.

29 'Imaginez qu'on lui commande un portrait de Staline [...] Et qu'on le commande au vrai Picasso – enfin, à celui qui se prétend le vrai, et qui fait recette chez les riches [...] Vous avez une idée de ce que cela donnerait à Moscou?' André Guérin, *L'Aurore*, undated press cutting, Hélène Parmelin archives, IMEC.

30 The photograph of the *L'Humanité* issue, first published by *Regards* in March 1953, was reproduced in J.-P. Bernard et al., *Silex*, 20 (1981), p. 131, special issue 'Chronique sur les années froides'.

31 Picasso worked with the lithographer Mourlot on 18 January 1953. The direct stare and confidence of *L'Italienne* is similar to the Stalin. See Fernand Mourlot, *Picasso: Lithographe, III. 1949–1956* (Monte-Carlo: André Sauret, 1964), no. 238.

32 Françoise Gilot, *Life with Picasso* (New York: McGraw-Hill, 1964), pp. 347–50; Lucie Fougeron, 'Une "affaire" politique, le portrait de Staline par Picasso', *Communisme*, 53–54 (1998), pp. 118–49; Gertje R. Utley, *Picasso, The Communist Years* (New Haven, CT, and London: Yale University Press, 2000), pp. 181–90; Gérard Gosselin, 'L'Affaire du Portrait', in Gosselin et al., *Picasso et la presse. Un peintre dans l'histoire* (Paris: L'Humanité et Cercle d'Art, 2000), pp. 140–45; Annette Wieviorka, 'Picasso and Stalin', in Christoph Grunenberg and Linda Morris, eds, *Picasso, Peace and Freedom* (London: Tate Publishing, 2010), pp. 26–33; Wieviorka, 'Plus fort que Staline', *L'Histoire*, 335 (2008), p. 72. Gosselin, in interview with François Feret, offers dimensions of c.30 × 25 cm ('L'Affaire du Portrait', p. 140). André Breton's letter appears in Philippe Sollers' blog of 4 March 2013, 'Hommage au camarade Staline', see www.pileface.com.

33 Pierre Daix, *Tout mon temps, révisions de ma mémoire* (Paris: Fayard, 2001), pp. 331–32 and Chapter 8, 'Le *Portrait de Staline* et les arcanes de Moscou', pp. 336–55.

34 'Picasso nous a laissé un fort méchant dessin du visage de Staline. Poupin, une sorte de bébé moustachu, un monstre, genre femme barbe, produit d'une aberration génétique, chimère de feinte innocence et de très réelle ferocité.' Jean Clair, 'Cette chose admirable, le péché...', in G. Regnier, ed., *Corps crucifié* (Paris: RMN, 1993), p. 62.

35 Michel Dupré, François Derivery and the late Raymond Perret consituted the actively Marxist DDP artists' collective; they supported Fougeron in the 1980s and 1990s; see their website and publications.

36 'Intrus, et pourtant désiré, le portraitiste est tout entier dans le portrait, fatalement.' Michel Dupré, *La moustache de Picasso, 1953–2003* (Campagnan: EC Éditions, 2003), p. 10.

37 See Louis Aragon, ed., *Europe*, 33–34 (October 1948), pp. 3–24, special Lyssenko issue; J.-T. Desanti, 'La science. Idéologie historiquement relative', in F. Cohen et al., *Science bourgeoise et science prolétarienne* (Paris: La Nouvelle Critique, 1950); T.D. Lyssenko, *Agrobiologie* (Moscow: Langues Étrangères, 1953), p. 532; Denis Buican, *Lyssenko et le lyssenkisme* (Paris: PUF, 1988); Yann Kindo, 'L'affaire Lyssenko, ou la pseudo-science au pouvoir', *Science et Pseudo-Science*, 286 (July–September 2009).

38 In conversation (28 January 1990), Fougeron claimed he had drawn a portrait of Stalin himself for *Cahiers du Communisme*. His interview for the 'Archives sonores', MNAM, Centre Pompidou (before May 1981) reveals that Picasso had previously upbraided Fougeron for a bad drawing.

39 Pierre Daix recalls in *J'ai cru au matin* (Paris: Laffont, 1976), p. 37, that he had a photograph of 1903 or 1904 from *Regards* sent to Picasso. See the photograph *Staline en 1905 à l'age de 25 ans*, in Jean Fréville, ed., *Œuvres de J. Staline*, Vol. 1: *1901–1907* (Paris: Éditions Sociales, 1953).

40 See the decorated Communist cell in Véra Belmont's film *Rouge Baiser* (France 1985), which includes a discussion of Picasso's Stalin portrait.

41 'Le Secrétariat du Parti communiste français désapprouve catégoriquement la publication dans *Les Lettres Françaises* du 12 mars, du portrait du grand Staline dessiné par le camarade Picasso. Sans mettre en doute les sentiments du grand artiste Picasso, dont chacun connaît l'attachement à la cause de la classe ouvrière, le Secrétariat du Parti communiste français regrette que le camarade Aragon, membre du Comité central et directeur des *Lettres Françaises* qui, par ailleurs, lutte courageusement pour le développement de l'art réaliste, ait permis cette publication.' 'Communiqué du Secrétariat du Parti communiste français', *L'Humanité*, 18 March 1953.

42 Louis Aragon, 'A haute voix', *Les Lettres françaises*, 9 April 1953.

43 'Et comment ne pas voir là [...] un encouragement facile à continuer les jeux stériles du formalisme esthétique?' Letter and Fougeron's article, *Les Lettres françaises*, 9 April 1953.

44 Edouard Pignon, 'Célébrons par nos œuvres le 70e anniversaire de la mort de Karl Marx', *L'Humanité*, 18 April 1953.

45 Robert Lebel, ed., 'Premier Bilan de l'art actuel, 1937–1954', *Le Soleil noir. Positions*, 3–4 (Paris: Presses du Livre Français, 1953); includes 'Le réalisme socialiste: Yugoslavie, Tchécoslovaquie, Roumanie, Pologne, Bulgarie, Hongrie et U.R.S.S.', pp. 259–60, and Alexander Guerassimov, 'Les principes de l'art soviétique', pp. 260–63.

46 For Albert Prigent's watercolour of Stalin and Thorez in the *livre d'or* for Thorez's birthday celebrations, see http://www.fonds-thorez.ivry94.fr/expo/2-anniversaire.swf (accessed 21 August 2013).

47 See *Le Peintre. L'Officiel des Peintres et graveurs. Guide du Collectionneur*, 1 October 1950, with Waldemar George's article 'La Farce tragique du réalisme socialiste', and subsequently *Problèmes de l'art contemporain. L'Esprit de la peinture contemporain. Enquête sur le 'réalisme socialiste'*, supplement to the review *Preuves*, 29 (July 1953).

48 Jean-Pierre Grémion, *L'Intelligence de l'anticommunisme, Le Congrès pour la liberté de la culture à Paris, 1950–1975* (Paris: Fayard, 1995), offers the counter story.

49 'Il n'y a pas plusieurs questions. Il n'y en a qu'une à laquelle notre siècle devra répondre : La disparition de huit pays de la carte politique et spirituelle du monde : l'annihilation de millions et de millions d'êtres humains [...] Mort, voici ta victoire! / Et où ? / *Au cœur même de la chrétienté* / C'est si loin. La Corée est si proche. Et ils sont si nombreux [...] de Tchèques, des Roumains, des Hongrois, des Bulgares, des Polonais, des Estoniens, des Lithuaniens, des Lettons, que sais-je!' Cardinal Paul Scortesco, *Satan, Voici ta victoire* (Paris: Nouvelles Éditions Latines, 1953), prologue, n.p.

50 The *Encyclopédie de la Renaissance française* announced in 1945 never came to fruition.

51 'Un peuple digne, debout, de plan-pied dans le présent, souriant à l'avenir, marchant harmonieusement vers son destin objectif et rationnel'; 'à genoux, la tête dans la poussière, attendant un miracle insensé et qui veulent ignorer leur destinée terrestres [...] Les religions sont des "cocaïnes". C'est vouloir vivre les yeux fermées, nier la lumière, cultiver la nuit.' Fernand Léger, 'De l'Acropole à la Tour Eiffel', Sorbonne, c.1950, in Roger Garaudy, *Pour un réalisme du XX^e siècle [...] Dialogue posthume avec Fernand Léger* (Paris: Bernard Grasset, 1968), p. 231.

52 'Pascendi Dominici Gregis [...] sur les erreurs du modernisme' (alternatively 'on the doctrines of the modernists'), http://www.vatican.va/holy_father/pius_x/encyclicals/documents/hf_p-x_enc_19070908_pascendi-dominici-gregis_fr.html (accessed 21 August 2013).

53 Lilian Parker Wallace, *Leo XIII and the Rise of Socialism* (Durham, NC: Duke University Press, 1966); Dominique le Tourneau, *L'Église et l'État en France* (Paris: PUF, 2000).

54 See Maurice Thorez, *Communistes et catholiques: la main tendue* (Paris: Comité populaire de propagande, 1937); and *Pour l'union. Communistes et Catholiques* (Paris: Éditions Sociales, 1949).

55 For example, Walter Dirks, 'Le Marxisme dans une vision chrétienne', *Esprit*, May–June 1948, pp. 783 ff.

56 Excommunication of Communists by Pope Pius XII, 1 July 1949, http://geocities.ws/caleb1x/documents/communism.html (accessed 21 August 2013).

57 See Madeleine Ochsé, *La Nouvelle Querelle des images* (Paris: Le Centurion, 1952). The proposal to install 'modern' stained glass from the Paris World Fair pavilions in Notre-Dame cathedral in 1938 was quashed after much debate.

58 See also 'Bilan d'une querelle', *Art Sacré*, 9–10 (May–June 1952); William Rubin, *Modern Sacred Art and the Church of Assy* (New York: Columbia University Press, 1961); Sarah Wilson, 'La Bataille des "humbles"? Communistes et Catholiques autour de l'art sacré', in B. Jobert, ed., *Mélanges Bruno Foucart* (Paris: Éditions Norma, 2008), pp. 3–21.

59 The trope continues; see John Bellamy Foster and Robert D. McChesney, eds, *Pox Americana: Exposing the American Empire* (London: Pluto Press, 2004).

60 'Picasso ensemença le monde d'incubes et de succubes'; Cardinal Paul Scortesco, *Saint Picasso, Peignez pour nous* (1953), p. 79.

61 'la course dégingandée et cahotante d'un de ces corbillards de province, minables et grinçants, qu'on voit passer dans les rues des petites villes'; Picasso (unsourced),

in Dominique Forest, *Musée National Picasso La Guerre et La Paix, petit guide* (Paris: RMN, 1996).

62 See Kuo Mo-Jo, chairman of the Chinese People's Committee for World Peace, 29 March 1952, http://southmovement.alphalink.com.au/southnews/KUO-1952.htm (accessed 21 August 2013); Fréderic Joliot-Curie, 'Après le retour des la commission scientifique de Chine et de Corée', speech, 10 October 1952, Salle Pleyel, in *Œuvres scientifiques complètes* (Paris: PUF, 1961), esp. pp. 207–09; *Rapport de la commission scientifique internationale chargée d'examiner les faits concernant la guerre bactériologique en Corée en Chine* (Paris, 1952); and Frédérique Matonti, 'La Colombe et les mouches. Frédéric Joliot-Curie et le pacifisme des savants', *Politix*, 15/58 (2002), pp. 109–40.

63 René Batigné, 'Guerre et Paix', typescript diary (archives Leïla Voight-Batigne) in Forest et al., *La Guerre et la Paix*, p. 121: a history of the chapel: plague, 1750; German troops from Hesse retreating from Italy massacred Vallauris inhabitants in the chapel, 1709; deconsecrated after the Revolution, 1791.

64 György Lukács, *The Meaning of Contemporary Realism*, trans. John and Necke Mander (London: Merlin Press, 1962), p. 16; cf. *Probleme des Realismus* (Berlin: Aufbau-Verlag, 1955).

65 Lionello Venturi, ed., *Picasso* (Rome: Galerie Nazionale d'Arte Moderna, 1953); Franco Russoli, ed., *Picasso* (Milan: Palazzo Reale, 1953).

66 Hélène Parmelin, 'Picasso vient de tourner pour Luciano Emmer la naissance de la Guerre et la Paix', *Les Lettres françaises*, 488 (29 October–5 November 1953), in Marie-Laure Bernadac et al., *Picasso à l'écran* (Paris: RMN–Centre Georges Pompidou, 1992), p. 58.

67 'Que par millions volent sur le monde les colombes liées au nom de Picasso comme à celui de la Paix, ce n'est pas un hasard. Que pour la première fois en art, ce soit Picasso qui ait remplacé le massacre des innocents par la paix combattante arrêtant de son bouclier le char de la guerre, ce n'est pas un hasard [...] Comment l'art au XXe siècle pourrait-il demeurer indifférent au grandiose rassemblement des hommes en lutte pour la paix? Quand il s'agit des guerres dont rien encore n'approcha l'horreur. Quand les bombes incendiaires de Guernica se voient battues par les bombes au napalm de Viet-Nam et de Corée, par les lances–flammes. Quand la bombe atomique en secondes supprima Hiroshima et tua Nagasaki. Quand les bombes bactériologiques sèment les plus atroces des morts par maladie. Quand la bombe à hydrogène prépare des morts plus foudroyants encore [...] Tandis que meurt les œuvres d'art comme les hommes, sous les ciels de guerre. Les paysans dans les champs de Corée comme les vieux temples. Les pagodes du Viet-Nam comme les maisons de paille ou les pêcheurs dans les sampans. Les cathédrales, les sculptures, les fresques...' Hélène Parmelin, *Le Massacre des Innocents* (Paris: Cercle d'Art, 1954), p. 134.

68 Jean Cocteau went with Picasso to see the work in Italy after the official opening.

69 Forest, et al., *La Guerre et la Paix*, Musée National Picasso, La Guerre et la Paix, Musée Magnelli, Musée de la Céramique, Vallauris 27 June–5 October 1998. C. Roy, *La Guerre et la paix* (Paris: Cercle d'Art, 1997 [1954]).

70 Pierre Daix in conversation with the author, 27 March 2010.

71 At my request, PCF leader Robert Hue loaned the work to *Paris, Capital of the Arts*, Royal Academy of Arts, London, and Guggenheim, Bilbao, 2002. See Maurice Ulrich, 'L.H.O.O.Q. à Londres', *L'Humanité*, 25 January 2002, http://www.humanite.fr/node/445583 (accessed 21 August 2013).

8

Success and Failure?
Picasso in Moscow / Aragon in Paris

May this message bring Picasso's friendship to everyone. Long ago I said that I came to Communism as one goes to a fountain, and also that all my work led up to this point. I am delighted to see the Picasso exhibition open in Moscow for a large, popular public, and with recent works. I have often received messages from the Soviet Union, including messages from painters, which have profoundly touched me, and I'm using this public occasion to express my affection for them.

I regret that I can't be with you at this moment and I hope one day to undertake the beautiful journey in brotherhood that l must now ask my pictures to make on my behalf.

Picasso, Cannes, 17 October 1956[1]

This kind of dead temple built around him was part of the tragedy.

John Berger, Meussy, September 2012[2]

Success and failure, praise and condemnation, the good and the bad: the manichaean Cold War mindset extended to debates not only around style and content but the intention and moral being of the artist. The perils of reversibility, of meaning and of power, a recurring leitmotif of *Picasso/Marx*, culminate in my conclusion. How should a Marxist work, generated by edicts and texts and demanding criticism, be both critical and self-critical, to take up the terms of André Fougeron's first apologia, *critique et autocritique*? How should the artist be both master of his work, but slave to the Party? In Communist terms, is self-criticism a permanent mindset or is self-criticism required only at the point of 'failure'?

Might this be the point where personality or signature style impinge upon the subsumed individuality of an artist working for the Party?

Picasso, the epitome of success, of individuality, constantly celebrated and photographed, was subject constantly to critique, to reiterations of his 'failure', to invisibility in state institutions in France and in the eastern bloc. Henri Clouzot's *Le Mystère Picasso* of 1956, where Picasso draws live on film, reinforced the myth of the artist with the Midas touch whose every scribble could be turned to gold. As we have seen, from attacks at the Salon de la Libération in 1944, condemnations continued: by *Pravda* in 1947, by Alexander Fadayev at the Wroclaw Peace Congress in 1948, for *Massacre in Korea* in 1951, for the Stalin portrait in 1953 and beyond. Picasso's success and 'failure' were complicated by the general problem of *du Picasso*, the synonym for modern art as a whole. In the United States the perception that Picasso was a Communist engendered the fear of modern art as 'Communistic'. 'So-called modern art contains all the isms of depravity, decadence and destruction', claimed Senator George Dondero, echoing Cardinal Paul Scortesco in Paris or Alexander Gerasimov in the USSR.[3]

Though 'self-criticism' was evidently at the core of Picasso's constant serial practice, the artist never uttered any overtly self-critical statements; and the mythological, transhistorical dimensions of great works such as *14 July*, *Guernica*, *Massacre in Korea*, even the *Charnel House* were non-committal as regards specifics. André Fougeron's fate shadows Picasso's development: he was admired for his art and his Resistance role, summoned by Aragon to a position of authority with disciples; he created major history paintings, was forced to 'confess', martyred, then anathematised if not excommunicated. His work serves as a dialectical other to Picasso's, a scapegoat and reminder of the reversibility of fortune.

Fougeron fell, one might argue, not only for political reasons but at the point he abandoned (as the counter-Picasso) his Davidian *mise-en-scène* in paintings with possibilities of projected 'reflection' and eschatological completion. His satire and caricature in *Atlantic Civilisation* distorted 'reflection', adding an element of thespianism; its collapsed perspectives literally put gravity and *gravitas* into a spin, the aspiration towards a post-revolutionary future falling into a whirl of 'bad' (American) fantasy.

Prior to Aragon's repudiation of Fougeron at the Autumn Salon of 1953, Victor Prokoviev published 'Notes on progressivist art in France' in the hardline Party journal, *La Nouvelle Critique*. All forms of 'pseudorealist art, from naturalism to surrealism to primitivism' were condemned; Picasso's *Massacre in Korea* was stigmatised for its surrealist heritage

(as was Bernard Lorjou's mighty *Atomic Age*), Léger was denounced for his 'former constructivist method', Taslitzky for 'strong expressionist elements'.[4] Articles on Dufy and le Douanier Rousseau in *Les Lettres françaises* (under Aragon's direction) were 'deeply erroneous'. 'Formalism' was extended to aspects of realist painting again in *La Nouvelle Critique* in February 1954; Edouard Pignon's 'primitivist image' was added to the list of solecisms. Prokoviev declared (in capital letters):

> ONE ENTERS THE DOMAIN OF REALISM ONLY THROUGH PAIN ... And the battle against primitivism, Cézannism or impressionism is certainly even more difficult to wage than the battle against painting with no subject whose emptiness, sterility and anti-artistic character are obvious ... The indications of the directors of the Communist Party, the experience of Soviet art, the assimilations of national traditions, all this, without any doubt, will permit critics and artists to bring a just and profound solution to this problem.[5]

The Salon de Mai of 1954 heralded a triumphant return of abstract painting – and Picasso's *Goat skull and bottle* sculpture. *La Nouvelle Critique*'s painting 'tribune' (a kind of newspaper show trial) continued with Fougeron's second *autocritique* or self-criticism. Here he argued that his turn towards satire and the 'typical' (in paintings such as *American Occupation* or *Atlantic Civilisation*) was a response to directives by the formidable Georgy Malenkov, Stalin's confidant, at the nineteenth Party Congress of the USSR (October 1952). His text was suitably abject:

> I engaged too superficially and lightly as regards the profound contents of the (Malenkov) report concerning artists' creative work ... To sum up briefly in terms of the faults I allowed myself to commit, I want only to say that what I most successfully achieved belongs solely and entirely to the Party. And my faults, or if you like my bad paintings, are my principal responsibility, for not having better absorbed the Party's lessons.[6]

Only the most anodyne works were now acceptable: at the French Communist Party's thirteenth Party Congress in June 1954, Louis Aragon promoted the Ukrainian painter Iablonskaia's *On the river Dnieper*: newly planted trees and decently dressed citizens signified the general development of the Soviet economy, calm and order.[7] The last vestiges of authority of Auguste Lecœur, Fougeron's political patron, were removed at this June congress.[8]

Picasso, the vessel for renewal and the future, became once more the focus of controversy. Paradoxically, and for the first time in western Europe, his request for major loans of his work from Leningrad and Moscow museums was granted for an epoch-making show at the Maison de la Pensée Française. Then, suddenly, these were withdrawn from exhibition by the Soviet authorities; the art collector Sergei Shchukin's daughter, Madame Stchoukine de Keller, insisted upon claiming the pre-Revolutionary masterpieces. Picasso made up the gap in July with paintings from the Kahnweiler and Gertrude Stein collections, loans from friends and recent work. This necessitated a second catalogue with a remarkably weak preface by Aragon, 'King Oedipus', and a luxury publication a year later.[9] Léger succeeded Picasso at the Maison de la Pensée Française in November, continuing the modernist policy. (Aragon fatuously attempted to claim a last-minute 'realist' deathbed conversion on the part of Léger in 1955.)[10]

The fifteenth anniversary of the Nazi–Soviet pact fell on 23 August 1954, and was gleefully commemorated with large posters of Stalin and Hitler shaking hands by the CIA-backed 'Peace and Liberty' group.[11] By 1955, Fougeron's armed German sniper in *Atlantic Civilisation* had become a reality: Germany became a member of NATO. Ilya Ehrenburg's novel *The Thaw*, published as *Le Dégel* in 1954, suggested a new, post-Stalinist paradigm: within an industrial setting and love tangle, it contrasted the mediocre Party painter, Volodia Pukhov, with an unacknowledged 'authentic' artist of genius, Saburov. Announcing the cultural thaw in the USSR, it was nonetheless castigated by the end of the year at the Second Congress of Soviet Writers in Moscow.[12] Aragon and Elsa Triolet attended the congress; the extent of Soviet totalitarianism and the persecution of the artistic establishment was made quite clear to them by Lili Brik and others. Pierre Daix was their confidant:

> Numerous striking rehabilitations cruelly demonstrated the extent of the disaster and the current climate of correction and revision ... They informed me about the complete extent of persecutions, the annihilation of the most significant intellectuals from the peripheral Soviet republics and those who were Jews.[13]

Aragon, notwithstanding, published his dense and vivid *Littératures soviétiques* in 1955, with an account of the congress, celebrating twenty years of socialist realism.[14]

De-Stalinisation was notoriously slow, varying from country to country within the eastern European bloc, and within the parties of western Europe. 'Stalinist de-Stalinisation' described the oxymoronic frame of mind in France. With the National Museum of Modern Art ostentatiously shunning Picasso (or so it seemed), François Mathey, the adventurous curator of the Museum of Decorative Arts, offered him his first major retrospective in Paris, held throughout the summer of 1955, and including *Guernica* and *Massacre in Korea*.[15] The first relatively objective account of Soviet socialist realist art for the 'bourgeois' readership of the illustrated magazine *L'Œil* appeared in November.[16] The momentum for change achieved an unanticipated climax. Khrushchev's denunciation of Stalin's crimes and the cult of personality at the USSR's twentieth Party Congress of March 1956 shattered the beliefs of Communist parties worldwide. The first reaction by the PCF in France was denial (the text was first published in the USSR in 1989).[17]

Picasso's seventy-fifth birthday exhibition opened in Moscow in October 1956; it was masterminded by Ilya Ehrenburg as a harbinger of détente. The artist sent his best works, along with a message crayoned in rainbow colours (see the epigraph to this chapter). (In interview, Hélène Parmelin declared that it was she who wrote Picasso's message to the USSR. This throws doubt upon the authorship of all Picasso's political statements not in poetic vein like the Beloyannis text.)[18] The show was massively popular, indeed life-changing for many Soviet intellectuals. Yet it coincided – tragically – with the Soviet invasion of Hungary. Igor Golomstock still remembers the huge queues outside the Pushkin Museum and subsequent artists' meetings about the freedom of contemporary art. But at this tense political moment, he recalls almost no press, due to the prevailing climate of fear.[19]

The 'ozone of freedom' blew subsequently into Leningrad; the Picasso exhibition was transferred to the third floor of the Hermitage. The writer Anatoly Naiman recalls:

> We felt a rapture in those Picasso-ed halls; it softened the pain and sadness of understanding how, and for how many years, we had been sitting in a cave, seeing only with the minimum of light allowed us. And would keep sitting there. At least they let us see the power of light for a few days, we thought ... Total strangers found themselves bound together by an unexpected closeness, a feeling, a romantic adventure – and the reverse: pointless ties were broken, former friends fell away, arguments erupted. I had a sense that nothing like this could ever take place again.[20]

The simultaneous impact of the Hungary uprising, from protests in Warsaw to the horrified response of Picasso's friends, was partly described in Chapter 6. Picasso and Edouard Pignon were among the ten Communist intellectuals who finally signed a protest (composed by Parmelin) on 20 November 1956 to the Party Central Committee concerning the restricted news coverage of events in *L'Humanité*. Louis Aragon's socialist-realist project spanning over three decades (including, for example, his epic novel *Les Communistes*, 1949–51) seemed to be stymied. *Le Monument*, written by Elsa Triolet, his muse and wife, and serialised in *Les Lettres françaises*, was now perceived as a deputised 'self-criticism'. The Picasso portrait scandal was the model for the story, so Triolet claimed, but so also was the real-life predicament of the former Czech modernist Otakar Svec, forced to complete his giant Stalin statue after the dictator's death in 1953. Svec's suicide is not mentioned in Triolet's preface; she called her catalyst 'hearsay' (*un fait divers*), but with Aragon she would witness the dynamiting of Svec's massive ensemble in Czechoslovakia in October 1962.[21] In the novel, the artist Lewka – who would have liked to make a 'young Stalin' – finally completes his commissioned monument. It is so hideous that he likewise commits suicide, leaving his Stalin Prize money to the blind, who would never see his work disfiguring the town. Triolet's hero created a shock of recognition in the minds of many – militants such as Jean Kanapa or Boris Taslitzky, who were living through a convulsive period in the history of their Party.[22] In this context, and almost exactly one year after the Hungarian invasion in late October 1957, Aragon accepted an invitation to Moscow for an evening held in his honour; he accepted the Lenin Prize on his sixtieth birthday one month later.[23]

Picasso, perhaps significantly, chose the ultimate figure of hubris, Icarus, for his next major work, on 40 panels in acrylic, covering over 100 square metres (fig. 34). *The Forces of Life and the Triumphant Spirit of May*, called subsequently *The Fall of Icarus*, was a commission for UNESCO's Paris headquarters, which Picasso accepted during the directorship of the distinguished American, Luther H. Evans. The spread-eagled, black, falling shadow of Icarus inscribed with his electric white skeleton pierced a blue sea.[24] Daring expanses of blue, brown and white, signifying sea, earth and sky (recalling the *Peace* mural in the Vallauris chapel), were expanded into greater zones of flatness: inevitably one thinks of Matisse's boldest paper cut-outs. 'Difficult', intractable as to its meaning, formally bare, this major work, too, was received askance, both when first displayed in Vallauris and when unveiled in Paris.

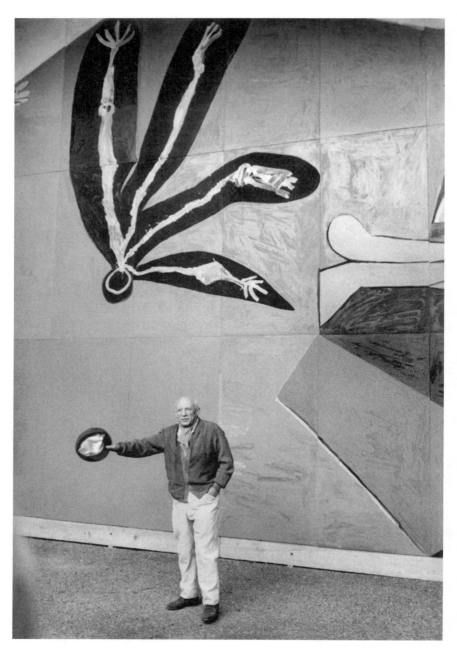

Figure 34: Inge Morath,
Picasso at the UNESCO inauguration, 1958

Has the symbolic choice of mythical subject on Picasso's part ever been given the attention it demands, in terms of context and reception?[25] The work was officially inaugurated before de Gaulle came to power in October 1958 in the midst of the Algerian War, and before the inauguration of the *War* and *Peace* murals in the Vallauris chapel (delayed for political reasons to September 1959).[26]

The Fifth Republic marked a new period in French cultural history. By 1958, France had finally achieved reconstruction. Yet the Algerian 'war with no name' involved terror on Paris's streets, corresponding to violence and the use of torture in Algeria. Henri Alleg's book *La Question* (1958), a first-hand account of his own interrogation and torture with electric shocks and waterboarding by French forces, brought the issue vividly into the French intellectual arena.[27]

At this time, definitions of both reality and *réalisme* were dramatically changing with the impact of new technologies, materials such as plastic and domestic television.[28] The society of Roland Barthes's *Mythologies* (1957) was emerging, in which desire rather than need created demand. The non-affiliated 'Nouveau Réalisme' movement exhibited political posters mixed with consumer adverts ripped off the walls (*affiches déchirées*) as 'ready-mades'. *La France déchirée* ('France torn apart') was the title of Raymond Hains's exhibition in 1961.[29] Racist, mass police violence reached a pitch with the massacre of 17 October 1961: peaceful Algerian protestors were beaten and their corpses thrown in huge numbers into the river Seine.[30]

Picasso's protest work continued at this point with his portrait of Djamila Boupacha (8 December 1961), the Algerian National Liberation Front activist who was raped and tortured by French soldiers (fig. 35). It was carefully elaborated, the charcoal accentuated or smudged; the look was very sixties, with Djamila's head with bouffant hair inclined, and her intelligent, over-large eyes. The image was skewed upright and reduced, and the signature displaced upon the book cover of *Djamila Boupacha*, the outraged defence published by the feminist Simone de Beauvoir and the Algerian lawyer Gisèle Halimi.[31] Picasso's energy and engagement during this period has been well documented; his variations upon classic masterpieces – Delacroix's *Women of Algiers*, Poussin's *Rape of the Sabines*, Manet and Velasquez – challenge overly historical readings, precisely through their timeless resonance in conjunction with their often humorous *renvoi* to 'greatness'.[32] Aged eighty in 1961, Picasso uniquely joined world leaders of past and present from Queen Victoria to Stalin and Mao Tse Tung in having his birthdays celebrated publicly and internationally.

Figure 35: Pablo Picasso,
Djamila Boupacha, 1961

In Moscow, the climate had changed radically under Khrushchev. The sixth International Youth Festival of 1957 was an exhilarating moment which introduced gestural painting to artists (among thousands of other attractions). Picasso's major travelling exhibition in America that year provoked FBI head-scratching and yet more embarrassment for Alfred Barr at the Museum of Modern Art, who offered a seventy-fifth birthday exhibition: it was still deemed far too dangerous for Picasso to be given a United States visa for a visit.[33] A rare collection of Picasso articles published that year in Moscow summarised the paradox: 'The borders of America are closed against the man and citizen Picasso, yet his works are welcome there. The borders of the USSR are open for the man Picasso, yet his paintings are not at all welcome in the USSR.'[34]

In 1959 the US State Department sent 'The Museum and its Friends: 18 Living American Artists', selected by the friends of the Whitney Museum, and the infamous 'Family of Man' photography exhibition to their exhibition in Sokolniki Park, an event now remembered for the commodity-based 'Kitchen Debate' between Khrushchev and Richard Nixon.[35]

This context of apparent openness frames the politics surrounding Igor Golomstock and Andrei Sinyavsky's first Picasso monograph in Russian; initially a work 'between two friends' begun in 1960, it became a commission by the central publishing house, Znanie, in its series on Soviet Laureates in view of Picasso's forthcoming Lenin Peace Prize (the editors had no grasp of modern art nor the trouble in store).[36] 'The production of this book at all stages – from the actual writing to distribution – took place in a situation which was characteristic of Soviet culture – with censorship control, political pressures and obstacles mounted by the official hierarchy of the Soviet art world', Golomstock reported.[37] The 40,000-word *Pikasso*, largely based on Russian collections, was hardly outrageous, detailing for example Mayakovsky's visit to Picasso's Paris studio in 1922, and *Guernica* as 'an agony of form itself'. It was well illustrated: graphics prevailed – there was no current political work, despite praise of Picasso's 'anti-imperialist' stands. Ehrenburg's preface detailed his struggle for recognition of Picasso in Russia, and Picasso's 'sarcastic' attitude to official Soviet art.[38] Yet only Ehrenburg's strategic handshake and reception of PCF congratulations on the publication in front of premier Kosygin – and a photographer – finally facilitated the distribution of 30,000 copies (one-third of the print run) outside Moscow.[39] 'It was repeatedly and sharply attacked in the press and caused great difficulties for the authors and the editors on many administrative levels including the loss of their jobs by the editors in charge of the book and by the editor-in-chief. The authors were accused of undermining socialist realism and very nearly of ideological subversion.'[40]

Picasso was proposed by Ilya Ehrenburg for the renamed Lenin Peace Prize in 1961; here Pablo Neruda's comment to the Soviet committee was surely clinching: 'If Picasso had been against peace, if he had been among our enemies, then he would have been a menace, for he costs thousands of people.'[41] This was the triumphant year of Yuri Gagarin's manned space flight (April), of dancer Rudolf Nureyev's defection (June) and a double exchange with Paris. Following the United States' 1959 triumph in Moscow and a British show, a French industrial exhibition was sent to the capital, with an arts pavilion directed by the venerable Georges-Henri Rivière, calculated to 'shame' Soviet socialist realism.[42]

In return, a great Soviet trade fair was held at the Porte de Versailles, with many positive repercussions.[43] In *Paris-Match*, readers saw Soviet citizens moving along a walkway over a miniature Île-de-France, and marvelling at the lyrical abstract painting of Alfred Manessier; the French were treated to feats of science and Sergei Gerasimov's heroic realism: *The Partisan's Mother* (1943).[44] Khrushchev's announcement of new nuclear tests in August arrived as a *fait accompli* in this context; his *Tsar* bomb exploded after the Paris show in late October. And at this symbolic point, Stalin's embalmed cadaver, next to Lenin, was removed feet first from his Kremlin mausoleum – a 'second death'.[45]

Louis Aragon, vice-president of the committee of the 'International Lenin Prize for the promotion of Peace among Peoples', took care to emphasise that the prize awarded to Picasso in April 1962 was for the entirety of his work, not just his dove.[46] (Ehrenburg would personally present the medal to the artist in Mougins, in April 1966, with much mutual merriment.) And in 1962 Aragon's 'parallel history' of the USSR was complemented by a history of the USA by the right-wing academician, André Maurois.[47]

The thaw continued: paintings by Italy's most celebrated Communist painter, Renato Guttuso, toured from the Hermitage to the Pushkin and to Novosibirsk in 1961; Fernand Léger's posthumous exhibition (with works by Nadia Khodassievich and Georges Bauquier) was held at the Pushkin Museum in January 1963 with great impact.[48] Yet despite authorising the publication of Alexander Solzhenitsyn's *One Day in the Life of Ivan Denisovich* (translated into French with an apologia by a 'reconstructed' Pierre Daix), Khrushchev would abruptly end this period of openness, turning against modern art. The famous *Manège* encounter with artists and his speech of 8 March 1963 was the most sweeping attack on art since Zhdanov's edicts of 1946.[49] Ehrenburg, too, received official opprobrium.

At some point in 1963 Golomstock, then senior researcher in the Pushkin Museum, was contacted by the Central Committee of the Communist Party to review an illustrated typescript in Russian on Picasso's *Guernica*. It transpired, Golomstock maintains, that this was by Anthony Blunt, with whose work and position Golomstock was familiar. 'It is apparent to me now', he wrote in 1999, 'that in 1963 the KGB was planning to "relocate" him to the USSR and, by means of the book on *Guernica*, was preparing to reintroduce him to the Russian intelligentsia as a progressive art historian and a supporter of the Soviet cause.'[50]

Picasso's early years had been widely discussed at the Courtauld Institute since the mid-1950s; in the early 1960s Blunt's annual lecture on *Guernica* was an emotional ritual, prefaced with images of Julian Bell and John Cornford, contemporaries who had died in the Spanish Civil War.[51] As his formal lectures on *Guernica* were not given until 1966 in Canada, one might speculate about the production of a book-length typescript in 1963. It would point not only to KGB masters being aware of MI5's 1963 revelation about Blunt (prior to his confession), but also an enlightened perception of Picasso's 'use-value' in these circumstances and an intriguing hands-on relationship with Blunt's unpublished work.[52] Implied here is the magnitude of Blunt's betrayal of Britain – now irrefutably confirmed – and the urgent need to move him to the USSR.[53] Blunt's unpublished memoirs do not mention this episode. His *Guernica*, published in 1969, is essentially a glorious concatenation of formal sources, from Greek Maenads and the Saint Sever apocalypse to Ingres. It never appeared in Russia.[54]

John Berger's *Success and Failure of Picasso*, first published in 1965, was written from the point of view of an alternative Marxist, aesthete and francophile, who in *Permanent Red* (1960) first spoke of the 'ideal critic and the fighting critic'.[55] Himself trained as a painter, with Frederick Antal, the émigré Marxist critic, as a spiritual mentor, Berger was a close friend of the realist artist Peter de Francia (whose *Battle of Sakiet*, 1958, is Britain's great Algerian War history painting). In marked contrast with Blunt, Berger was deeply involved in the British post-war realism debate on the left. He recalls seeing both the 1955 Museum of Decorative Arts Picasso retrospective in Paris and the Tate Gallery's major 1960 exhibition in London, facilitated by Roland Penrose and the indispensable Ehrenburg. Berger does not mention these experiences in his book, just as Max Raphael never mentioned the Zurich exhibition of 1932. Rather, the book's dedication to Max Raphael (along with Ernst Fischer and his muse, Fischer's translator, Anna Bostock) alone reveals the profound impact of *Proudhon, Marx, Picasso*.[56] (*Nude with a Blue Curtain* of 1932 has progressed through the various re-editions and translations of *Success and Failure*, always inverted left to right).

While Raphael's critical assessment of Picasso ended in 1932, Berger takes on the artist's full career to date, in a work that he recalls was 'attacked everywhere as being insolent, insensitive, doctrinaire and perverse. In England, the land of Gentlemen, it was also considered as being in bad taste.'[57] (One should note that Clement Greenberg's essay 'Picasso at Seventy-Five', with its frank denunciation of bad

paintings, Picasso's 'failure' and the Picasso myth, was republished in the widely disseminated *Art and Culture* in 1961, before Berger.)[58] Like Raphael, Berger does not divulge his reading; he is both omniscient narrator and self-consciously working upon his passionate, opinionated style.[59] He situates Picasso – as did Raphael – within provincial Spain's 'lateness', with its backward, unindustrialised economy, from where the artist mounts to Paris as a 'vertical invader' in 1900. The late work is finally condemned as 'a retreat ... into an idealised and sentimentalised pantheism'.[60] Ultimately, he says, 'the example of Picasso is also an example of the failure of revolutionary nerve – on his part in 1917, on the part of the French Communist Party in 1945'.[61] 'He asked for bread ... what they offered him was a stone ... What the communist movement offered him back was only the exhausted subject of himself. Picasso as Picasso as Picasso.'[62]

Berger's political judgements are post facto, and while I relish his commitment, I would argue that his aesthetic conclusions are occasionally quite wrong, such as the dismissal of the *Portrait of Mme H.P.*: 'What does it tell us about the sitter except that she has long hair?' he says, when, in fact, it is a marvellous likeness of the formidable and electric Hélène Parmelin.[63] Above all, with impressive panache, Berger tells yet another – illuminating and careful – monographic story based upon style and psychological readings, largely lacking the post-1935 Communist context revealed in this book. He is as prone as any other to introjection, Oedipal in his lack of consideration for Picasso's age; disparaging of the late work, yet offering a disproportionate number of illustrations from an erotic series of graphic works from early 1954; his own sexual gusto is constantly present. *La Réussite et l'échec de Picasso* appeared in French in 1968.[64] Only in 1969, following Herbert Read's editing of Max Raphael's *The Demands of Art*, did Berger's essay 'Revolutionary Undoing' offer a critical appraisal of Raphael, with no specific Picasso focus.[65]

The Success and Failure of Picasso preceded Picasso's triumph of 1966, with, at last, a double retrospective in Paris: paintings in the Grand Palais, drawings, ceramics and sculptures in the Petit Palais (his late sculptures were a revelation).[66] Yet just as Picasso's 1956 Moscow exhibition had been jinxed by the invasion of Hungary, so the Sinyavsky–Daniel trial in the USSR put 'his' Party on the line. Despite diplomacy – and a surprising Picasso loan to the Pushkin – another show trial, condemnation and repression heralded the period of Soviet stagnation.[67] None other than Andrei Sinyavsky, Golomstock's collaborator on *Pikasso*, was involved. Sinyavsky must be credited as the first voice from the USSR

to have denounced Soviet socialist realism in the West – anonymously, in the French Catholic review *Esprit* in February 1959 (in the wake of Boris Pasternak's 1958 Nobel Prize for *Dr Zhivago*). Here, he had linked socialist realism's millions of printed pages, its kilometres of canvas and film to a vision of the 'intellectual transfixed with fear', within a vast, crushing, teleological and quasi-theological system of positive heroics, described as being in parlous disarray after Stalin's death.[68]

Now Sinyavsky and his collaborator Yuri Daniel were banished to labour camps for seven and five years' hard labour, respectively, for 'conspiracy to have their works published abroad' (worse, their pseudonyms, Abram Tertz and Nikolai Arzhak, switched their Russian and Jewish identities, a heinous provocation).[69] Their refusal to admit criminal guilt 'shattered the innate belief among Russians that it was beyond an individual's power to defy authority', heralding a new generation of public dissidents, according to Golomstock, who helped compile the unofficial record of the trial for the West. (The very notion of 'Picasso in Russia' posed such an intriguing paradox that the possibility of publishing their *Pikasso* in the West with a framing introduction would later be discussed. A mirror-image of the Blunt proposition of 1963, this project facilitated Golomstock's emigration to London in November 1972.)[70]

In 'Aragon au défi', a speech given on 11 March 1966 by surrealist Jean Schuster to the Cercle Karl-Marx in Paris, Aragon's late remonstrations about the Sinyavsky–Daniel trial were met with derision. The speech was published with supporting documents. Aragon's approbation of the Moscow show trials of the 1930s was recalled; he was charged with using fiction to exculpate characters with semi-autobiographical features.[71] Edgar Morin provided a contemporary flavour: 'Thorez leafs through a Fernand Léger album ... The Stalinist concentration camps have become the subject of sad elegies ...' What humour history offers: anti-Stalinism stolen from the anti-Stalinists by the Stalinists...'[72] Morin's *Autocritique*, published on leaving the Party in 1959, had been the first significant turning of the 'self-criticism' genre against the PCF: he described the interpenetration of Marxism, Stalinism and 'magic thought':

> One must not forget that Marxism, born of the critique of the Holy Family, was above all a critical method. This paradox, in a sense, persists in the very depths of Stalinist religiosity. Those who subscribed to the most incredible magic were the same who read, studied and commented upon the texts of Marx, Engels, Lenin (and of course Diderot, Holbach etc.) ... Thus Stalinist magic is analogous

to calcite [a double-refracting crystal]: it permits belief in the transparency of the originary face of Marxism.[73]

Not only in 1966, 'Picasso's year', were Stalinists pilloried; the old guard were now challenged by young Althusserians, and by Louis Althusser himself. He disapproved of the Central Committee's third major debate on art and style and the Party's tardy approval of the free confrontation of all artistic tendencies. His adversary was the 'modernist' Roger Garaudy, whose *D'un réalisme sans rivages, Franz Kafka, Saint-John Perse, Pablo Picasso* (1963) was a contorted attempt to prove that a post-Stalinist, 'Marxist' critique could use the vocabulary of 'realism' to engage with previously 'forbidden' works.[74] (Garaudy had welcomed Soviet art to Paris in 1965.)[75] And in 1966 a new era was heralded by the commissioning of the late Le Corbusier's spiritual heir, Oscar Niemeyer, the Brazilian Communist architect, to design new Party headquarters at the Place du Colonel Fabien: contemporary 'bunker' architecture made surprisingly voluptuous, with its raised white dome in a concrete nest.[76]

To celebrate the eighteenth Party conference at Levallois at the beginning of 1967, an exhibition was staged in which Picasso's *Massacre in Korea* joined forces with Fougeron's bizarre *Victor Hugo's son's cortège* – along with geometric abstraction (Jean Dewasne), *tachisme*, sculpture and tapestries to demonstrate Party openness.[77] Under this new regime, Dewasne's once anathematised vision of abstract art itself as the evolutionary product of dialectical materialism, first publicly declared in a lecture of 1952, would be published in *La Nouvelle Critique* in 1968.[78] The Paris art world was already dominated by Pop, Nouveau Realisme and Narrative Figuration, Op and kinetic art. The Communists' late modernist turn would be abruptly spoiled by the Soviet invasion of Prague in the spring of 1968. The worker and student revolt of May '68 itself produced additional challenges for the PCF (not to mention the Vietnam War).[79] Despite a new leader, Waldeck Rochet, and in contrast to its modernising symbolism, the Party was perceived not only as ideologically frozen, but increasingly geriatric.

France's public institutions strangely mirrored the dichotomies at stake: Picasso in the Grand Palais in 1966 was followed by Matisse in 1970, a centenary homage celebrated from April to September. Glorious modernisms: yet during a brief interlude from May to June 1970, a centenary show was also offered to Lenin, involving socialist realist painting, including a version of Alexander Gerasimov's *Lenin on the Tribune*.[80] At this point, Aragon's two-volume *Henri Matisse, roman*

continued his tortuous path of 'redemption' through transposition, through the practice of writing. Collage and hypertext procedures bore witness to the clairvoyance and modernist taste (from 1943 onwards) of socialist realism's most powerful cultural figurehead.[81]

In fact Aragon, like Picasso, could have renounced the Party at any moment – with inestimable repercussions throughout the Soviet bloc – but did not. The old argument (ascribed to Sartre), *Il ne faut pas désespérer Billancourt*, 'the production-line factory workers of Billancourt must not be discouraged…', in combination with the weight of bureaucratic infrastructures and the lure of political power were arguments for maintaining an ultimately untenable status quo. There were myriad emotional and autobiographical scenarios at stake. But Aragon was not Picasso (who was now ninety years old). Despite the poetics of Aragon's intimacy with Matisse – his gift for empathy and transposition and his style – the promotion of socialist realism and what this implied in terms of sustaining the Soviet regime is the aporia which disfigures *Henri Matisse, roman*. Matisse serves Aragon here as a cultural alibi. He would continue to write lyrically about artists, such as Chagall or Paul Klee, in poetry or prose to the end of his life.[82] Elsewhere I have contrasted Aragon's moral position with that of Ilya Ehrenburg, as contemporaries of Sartre or Malraux, or of Raymond Aron. Both men's lives and writings were inextricably bound to the fate of the USSR; both were involved in intricate political manoeuvres and legerdemain. In contrast to Aragon's tergiversations, Ehrenburg, whose his secret life's work on behalf of persecuted Soviet Jews was published posthumously (*The Black Book of Soviet Jewry*), emerges as a man of true moral stature in dangerous and confusing times.[83] But perhaps Aragon's music, the music of those who sang Aragon to the tunes of Léo Ferré, is the most revealing voice of a certain France in the 1960s and 1970s.[84] His ambivalence emblematically deconstructs a national Cold War psychosis.

At this moment of the poststructuralist turn, Michel Foucault himself was solicited to write on Picasso's *Las Meninas* series, following his *mise-en-abyme* of Velasquez's masterpiece at the outset of *Les Mots et les choses* (*Words and Things*). His text, prepared in 1970, treated 'the disappearance of the painter' as opposed to the by now familiar trope of the death of the author. His description of the displacement of Picasso's Velasquez by a tiny red figure on the right of the Meninas, a *ludion* (a toy in a pressure bottle), signifies the displacement of the demiurge.[85] While Foucault delights in the poetic toils of the *préfacier*, the generational implications are clear (those that Aragon refused to pursue in his preface

'Œdipe-roi'). In contemporary thought, at this point before his death, Picasso, demiurge, king, was always, already 'disappeared'.

Yet his swashbuckling musketeers, though greeted with a certain dismay in the Palais des Papes in Avignon in 1970, were a vigorous sign of life: 'a savage explosion ... works disconcertingly youthful, as though time was before them, their appetite intact!'[86] The Louvre honoured Picasso for his ninetieth birthday in 1971, as did the National Museum of Modern Art in the Palais de Tokyo with, at last, a successful exhibition of 'Picasso in Soviet Collections'.[87] His FBI file demonstrates an up-to-date nonagenarian who offers a protest signature to Governor Ronald Reagan regarding the persecution of Angela Davis (joined by Foucault, Max Ernst and the doyen of the new wave novel, Alain Robbe-Grillet).[88] Perhaps this was all too much: the Maoist art journal *Peinture, cahiers théoriques*, belatedly promoting Clement Greenberg in 1972, reproduced his decades-earlier critique of Picasso's shortcomings.[89]

When death did come on 8 April 1973 it was a shock, almost like the 'second death' of Stalin: there was astonishment that Picasso could have had a physical body. Among the tributes, Renato Guttuso's fusion of Picasso's head of Stalin on top of the body of the *Man with a lamb* in the parodic lithograph series *Das Gastmahl* marks a convulsive high point: Stalin here becomes an emblem of peace and sacrifice; Guttuso 'becomes' Picasso; Picasso himself is depicted in a melee of doublings of man, artist, leader and beast (fig. 36).[90] Among younger artists, iconoclasm was permitted: 'Picasso and Peace', held throughout the late summer at Ceret in the south of France, marked Picasso's posthumous entry into French conceptual art mode. Hervé Fischer published a white page in the catalogue bearing the slogan 'Homage to Pablo Picasso ... Art Hygiene. Prevention campaign. Tear up this page.'[91] Worldwide, other conceptual artists joined in: Felipe Ehrenberg's *Picasso is Dead* was sent to Jan Chwałczyk's *Kontrapunkt* mail art project in Poland, for example.[92]

Following the Avignon Festival's second – obituary – tribute, the Fête de l'Humanité, in September 1973, brought together Picasso's significant body of work for the Communist press for the first time, thanks to Gérard Gosselin's private collection and publication.[93] The first 'sociological' studies of both Picasso and socialist realism would appear in Pierre Bourdieu's *Actes de recherches en sciences sociales*. In the November 1975 number, semiologist Louis Marin's pointed deconstruction of an exhibition catalogue used *Les cubistes*, with its obituary homage to Picasso (Bordeaux-Paris, 1973); in the same issue, Bourdieu's own equally

Figure 36: Renato Guttuso,
after Picasso's *Man with a lamb*, 1973

humorous 'Reading Marx', in *bande dessinée* mode (Marx as a cartoon
with speech bubbles) effects the same operation as Marin, but on Etienne
Balibar's critical reading of Althusser's *Reading Capital*. In each case,
rhetorical tropes and locutions are highlighted, revealing the subtending
games of power, of 'culture', of 'philosophy', of 'Marxism'. We read: 'the
dominating discipline is dominated by its own domination...' In each
case the jovial demiurge, Picasso – or Marx – is displaced but overpowers
his disciples.[94]

Bourdieu's own epigone, Jeannine Verdès-Leroux, broached the
Communist Party and its painters for his review in 1979, including a
list put together from *L'Humanité* and *L'Humanité-Dimanche* of works
in the notorious 'Marx to Stalin' exhibition. Her pioneering analysis
of 'hard-line' socialist realism is undialectical precisely in its omission
as regards the strategic use-value of the modern artists Picasso, Léger
or Matisse at the Maison de la Pensée Française.[95] Her lecture at the
cultural centre of Noroit in 1981, following Hélène Parmelin's, was
significant. In the context of the great Picasso donation to the state,
celebrated with a huge show at the Grand Palais, they were both speaking
to a popular but intellectual audience.[96] First Verdès-Leroux exculpates
Marx himself from 'Stalinist conceptions of art', and like all critics
laments his unsatisfying contribution in the arena of aesthetics. Picasso
appears solely as the subject of André Breton's interrogation by the
French Communist Party in 1927; the Communist landscape is divided

into *jdanoviens, prejdanoviens* (Zhdanov's followers and forerunners), *opportunistes* and *frondeurs*; she names Edouard Pignon, Paul Éluard, Claude Roy and Hélène Parmelin as these 'people on the fringe': figures who were in fact central to cultural policy, I would argue.[97] She offers a lot on novels, not on art.

Parmelin's talk, 'Picasso or difficult truths', given to the same audience, is on the contrary a surprising text, coming after decades of dithyrambic writing. The Party, under intense pressure from two generations, Parmelin's and Louis Althusser's, was beginning to crumble. After the Soviet invasion of Afghanistan and at a moment of extreme pressure in Poland (moreover directly following her husband Edouard Pignon's Pompidou Centre display with full Communist press coverage), the couple had left the PCF in December 1980. The 'difficult truths' she discusses demonstrate a switch in her discourse from the exultation of *Picasso Plain* to once more the trope of failure.[98]

Parmelin rehearses not the success but the successive assassinations of Picasso, using the analogy of the assassination of Van Gogh, Cézanne, the impressionists – from questions in the National Assembly about cubism to the present, she offers a litany of incomprehension, of insults or of delayed appreciation (*Guernica* used as a protest image in Prague, in Africa). She mentions the enthusiasm around the 'fantastic exhibition' accompanying the *14 July* at the Alhambra Theatre, the Occupation period attacks, the Liberation, the 'complex refusal' of this painting; 'Picasso became "modern art" and its absolute folly.' The dove, which added to general detestation 'another detestation, the detestation of Picasso the communist', she says, is balanced against the multiplication of doves from the USSR to China. Then there is 'Picasso the social man. Picasso worth hundreds of millions of dollars. Communist Picasso and at the same time Picasso opposed to the Communist Party from a certain period.' The *Charnel House*, the *Hommage to the Spanish Resistance*, *War and Peace*. Party members, she concludes (and here her self-criticism, her *autocritique*, is glimpsed), were finally not fascists, cretins or subjugated (*ni fascistes, ni crétins, ni soumis*): 'It wasn't a back-to-front manchaeism, it was the modern times we were living in, a terrible mix of manipulated ideas.'[99] Parmelin reserves a special place at this point to consider the wounding libel in Giovanni Papini's *Black Book* (*Le Livre noir*, 1953), where in a faked interview Picasso confessed he was a public buffoon who painted for money, exploiting contemporary imbecility and vanity.[100] His words were soon reported as the truth. They were surely reinforced in 1958 by David Douglas Duncan's unforgettable pictures of

Picasso clowning at La Californie in *The Private World of Pablo Picasso*, which reappeared in his massive *Goodbye Picasso* farewell tribute of 1974.[101] And in reaction to the 'Dation' exhibition (Picasso's 'gift' to the nation of works in lieu of tax), Parmelin expresses her horror at 'Picasso as museum': *Picasso était devenu musée*. Picasso knew his time was meted out, he wanted to keep as much as possible for painting, she declared. Hardly a self-criticism, Parmelin's calculated 'turn', using Picasso as anti-hero, nonetheless links vilification with redemption.

In May 1981 the Communists returned to government for the first time since 1936, in a power-share with François Mitterand. Picasso's *Aubade* of 1942 (given to Jean Cassou with nine other works in 1947 for a National Museum which had only one work of 1901 to its name) was exhibited shortly after the donation exhibition in Germain Viatte's *Paris–Paris, Créations en France, 1937–1957*. For once Picasso's power and presence was eclipsed by a scandal around the cancelled exhibit by Hitler's sculptor Arno Breker, and the first presentation in a national museum of French socialist realism.[102] Viatte's later exhibition, *Paul Éluard et ses amis peintres* of 1982, avoided any embarrassment around Stalinism or Communist politics with a huge hallucinatory installation, multiplying Picasso's 'Faces of Peace' (*Visages de la Paix*, Françoise Gilot's face as female Peace warrior) and an alphabetically ordered catalogue: the Picasso entry was a masterpiece of insouciance.[103]

The Picasso Museum in the restored Hôtel Salé became from 1985 a magnificent home for the artists' work and archives, a site for exhibitions and scholarship. Only *Massacre in Korea*, visible at the turn of a cellar staircase above a shabby vitrine of press cuttings, bore witness to the concerns of the present narrative. At this point in the mid-1980s, the formerly Maoist doyen of *Tel Quel*, Philippe Sollers, wrote 'Picasso's Time' for his reformed review *Peinture*. He sensed the importance of the sacred in debate with the profane that went beyond Cold War antagonisms: a 'religiosity' equivalent to the 'woman inside ourselves ... decomposed, dismembered, exploded everywhere and nowhere but dominating' (compare John Berger's almost misogynistic conclusion in *Success and Failure*, illustrated with Picasso's own, genitally obsessed late drawings). This implies a break, Sollers argues, with filial lineages: father–son, master–disciple. Ultimately he posited the female nude's challenge to the 'time of Rome'; its status as the expression of the desire to sack Rome, visible in Manet's *Olympia* as much as Picasso. Behind Rome, one could argue that Picasso's art, with its debate between figuration and abstraction, the conceptual and the sensual, raises

the question of the *iconomachia* at the very heart of the western Christian tradition. Picasso, repressed as an influence in the post-Duchampian and conceptual moments of the 1960s and 1970s, returned within French art (in the paintings of Louis Cane, for example) at this moment of the *transavantgarde*: a new time of and for Picasso, still pitting itself against what Sollers called the 'time of New York … the time of Empire'.[104] (A time of glasnost, too, in Soviet Russia, with a new Picasso monograph by Anatoli Savelievitch Podoksik, published in French in 1989.)[105]

A transatlantic consensus was achieved, however, by the now venerable Cold War generation of Picasso scholars, Bill Rubin, James Lord, John Richardson, David Sylvester – musketeers to a man – when *Le Dernier Picasso* in Paris and *The Late Picasso* in London rehabilitated the last, Avignon period works in 1988.[106] They were excited to discover the private, loosely handled expressionist paintings, whose subject matter reverted to the elemental conflicts between male and female, artist and model, now modulated with the pathos of old age, impotence and approaching death (Picasso's swashbuckling musketeers condensed this bathos). For David Sylvester in 1988, as for Philippe Sollers, as for Berger in 1965, the issue of Picasso's potency was an overriding consideration; the Cold War faded.

Obviously my account, highly partial, gives no idea of worldwide Picasso exhibitions from the late 1950s onwards, or recent scholarship regarding, for example, negotiations around *Guernica*'s return to Spain.[107] Rather I focus on specific, little-known moments of Picasso's reception, mainly in France, prior to the great series of superb shows and scholarly catalogues launched by the Picasso Museum, where the major works I discuss – *14 July*, *The Charnel House*, *War* and *Peace* – could not be present, and where 'success and failure' were no longer the issue. ('Picasso, the object of myth' was the subject of a colloquium at the École des Beaux-Arts edited in 2002.)[108] Glasnost inaugurated a period during which Picasso studies could start again in Russia. Ilya Doronchenkov, my colleague and interlocutor in the 1990s (when I rashly proposed a 'Picasso and Russia' show in Paris), finally published *Russian and Soviet Views of Modern Western Art, 1890s to Mid-1930s* in 2009: the view from the other side.[109]

Picasso Museum agendas aside – and despite a popular Picasso monograph in Moscow in 2007 – Picasso's return to Moscow in 2010 marked the cultural apogee of the year of Franco-Russian exchanges. Generated in the epoch of Putin's 'new Russia', the extraordinary panoply of Picasso's work was presented under the sovereign aegis of

Dmitri Mevedev and Nicolas Sarkozy – and of course the redoubtable Madame Irina Antonova, director of the Pushkin Museum since 1961. Antonova, a splendid veteran of the arts, was awarded the Red Labour Banner, the Order of the October Revolution, the Order of Friendship of the Peoples and the Order of Services to the Fatherland Classes I, II and III. She vividly recalls Picasso's 1956 moment of glory and his 1966 show under her direction.[110]

The Pushkin Museum, site of the massive international exhibition of gifts to Stalin in 1949, now offered its most splendid rooms for Picasso's triumphant return to Moscow. On the walls of the great staircase, the ascending dignitaries were flanked by *Guernica* itself, split diagonally in two, copied by the great stage designer, Boris Messerer, cousin of the famous ballerina Maya Plisetskaya (plate 32a). Under superb classical friezes, white on russet and gold, on specially erected grey walls, the works Picasso had kept for himself were once more reunited with the works that had left for the collections of the great merchants, Shchukin and Morosov. A large, decorative section on the Ballets Russes augmented these early paintings and sculptures. The neoclassical period included Picasso's almost Renoiresque, sentimental *Portrait of Madame Rosenberg and her daughter* (1918). At the heart of the exhibition, a large, darkened room showed *Massacre in Korea*, spotlit in sombre splendour, surrounded by aggressive or tragic wartime portraits and still lives, mostly monochrome, with the bronze *Deathshead* skull and the poignant *Man with a lamb* sculpture (plate 32c). Never, surely, had the painting looked more magnificent, more powerful. It invited serious contemplation in the midst of a celebration where quantity and variety, the rush of the crowds, and the late Mediterranean Picasso in the great white marble hall (plate 32b) inevitably led to a mixture of wonderment and dissipated attention. There was a wall text, sent from Paris, for this 'war room', covering the period 1946–51, a chronology with mention of the PCF and the Peace congresses, but no mention of Cold War specifics. Time was collapsed, the story of Soviet involvement eclipsed. No dove appears in the *Picasso Moscow* catalogue. The plaintive head of the young boy with paint stick, dated 14 April 1972, used as a poster for the obituary show in Avignon, marked the ending. A Picasso without Communism, then, for a new generation of Muscovites.

In Paris, likewise, for the 'Franco-Russian year' of 2010, evidence of the Franco-Soviet relationship extending from 1917 to 1989 and beyond was invisible. At the Louvre, 'Holy Russia', *La Sainte Russie*, re-established the sacred and religious origins of the country which,

under Putin, had so rapidly rebuilt the Cathedral of Christ the Saviour in Moscow (demolished to construct the unbuilt Palace of the Soviets). At the end of the year in Paris the exhibition 'Lenin, Stalin and Music' displaced the vexed issue of socialist realism to a backdrop; an argument around Shostakovich in the far-flung Cité de la Musique. Besides musical ephemera, posters, theatre design and photography, socialist realist painting at its best was on show: Arkadi Plastov's *Harvest scene in the kolkoz* (1937), Pavel Korine's wartime *Alexander Nevski* (1942), indeed Vasili Efanov's *Andrei Zhdanov* of 1947 (a powerful oil portrait fit for any Western boardroom) and Fedor Shurpin's Stalin, *The Morning of our fatherland* (1948). 'Art and artists in the gulag' merited its own essay, yet there was a disturbing lack of connection with France. At the entrance to the exhibition some broken fragments of sculpture were displayed, including a man with a violin, placed with a scattering of gravel on a low platform.

<p style="text-align:center">* * *</p>

With these broken shards, time performs the loop that brings one back to the heart of *Picasso/Marx* and the 1930s. For these were the miraculously rediscovered fragments of Joseph Chaikov's frieze around the grand plinths at the base of the Soviet pavilion at the Paris World Fair of 1937. Presented after the Fair to the CGT trades union, they were moved to the gardens of the chateau of Baillet (converted to a Popular Front-style holiday camp). During the war the chateau became a Pétainist youth centre; the works were smashed up as 'bolshevik' after Hitler's invasion of Russia, later displayed as a sign of fascist brutality when the CGT resumed its ownership, and finally buried in the old ice house (the *glacière* – a muddy bank) after Stalin's death.[111]

Following their discovery in 2004, their excavation, completed in 2009, coincided, uncannily, with the equally remarkable resurrection of Boris Iofan's Soviet pavilion in Moscow, topped with Mukhina's sculptures, superlatively restored: the *Worker and Kolkhoz Woman*, brandishing hammer and sickle, the peasant girl's scarf unfurling in the wind. A young Korean–Russian architect, Kim En-gir, director of the Arkhinzh bureau, has reconstructed a truncated Iofan-style pavilion, with postmodern pixellations (plates 30a, b). At the entrance, Chaikov's twin friezes of the Soviet republics (nominated by Stalin in 1936), reconstructed from drawings, adorn massive blocks flanking the entrance – now sculpted in red porphyry to brave the Russian winters.

Inside, an exhibition shows the Soviet competition entries and displays at the Paris World Fair (plate 31). Above, Russian refreshments are offered in the 'Café de Paris'. But Iofan's resurrected building and its magnificently burnished sculpture face no fascist adversary – just a void, a motorway and hoardings. In profile it serves as the sign and marker 'Russia', along the triumphant drive towards the Kremlin. Like the Pushkin's Picasso show, this mighty construction effects a resurrection without politics (there is the same nationalist subtext); another erasure of a past still repressed and unresolved.

The Marxian resurrection emanating from France, Alain Badiou's 'idea of Communism', the conferences held in its name, its precursors and offspring, likewise perform an ambiguous relationship with history in the present.[112] In 'Marx and the Aesthetic' (2012), the Paris Commune or contemporary Communist China as spectacle were welcome sites for debate.[113] Yet the Stalinist parable, even as a trope in history, a paradigm of real power or a negative example, is disallowed, omitted from discussion by the 1970s veterans. Their redemption and contemporary success disavows the lived failures of Soviet utopia and their own, intensely experienced *impasse* as revolutionaries within Western capitalism.

The resonance of the 'idea of Communism' and the future of the analytical tools of Marxism in this time of crisis and growing inequality are powerful, exhilarating: certainly artists and intellectuals have responded globally to the call. In France at least, however, the failure of the successful 'Franco-Russian year' to address a century of exchanges crosses over with the success of the 'idea of Communism' as an ever-failing project. As always, diplomatic elites counter the university; *Realpolitik*, economic and military, prevails.[114]

And the people? At la Courneuve in September 2012, the Fête de l'Humanité, with its 'world village' of stands, honoured the thirtieth anniversary of Louis Aragon's death, and the fiftieth anniversary of Algerian independence, with the exhibitions 'Blood and Hope' and Moustapha Boutadjine's portraits, *Femmes d'Alger*, including Djamila Boupacha and Germaine Tillion. The avenue Pablo Picasso extended into the avenue Missak Manouchian (Armenian poet, Citroën worker, *résistant* linked with the Nazi 'Red poster' plot and martyr). From Paul Vaillant-Couturier to Nelson Mandela (in front of the stage for Pete Doherty and Patti Smith), the heroes of Communist history were yet again inscribed upon this special territory. Debates involved the Arab Spring, Africa and neoliberalism, revolution and counter-revolution

in Latin America. At the Book Village, authors lined up to sign and discuss works in the traditions of the great 1950s 'battle of the books'. Here were *Les Lettres françaises* reborn: the review *Approches marxistes* with hammer and sickle logo (special numbers on Marx and Stalinism). New publications included *La Fin du secret*, a history of the PCF's archives, and, brand new, *La France rouge*, a century of Red France brimming with illustrations and precious facsimile documents, from a photograph and poem by anarchist heroine Louise Michel, to a Malagache membership card ('Colonial Bolcheviks'), or a May 1936 CGT poster, not forgetting '1000 presents for Thorez' or 'Stalin by Picasso, the scandal'.[115] Just as in the 1950s, when photographs of the Paris Commune seemed to inscribe the primal scene of rebellion into the present, so *La France rouge*, ending symbolically in 1989, negotiates its way between a vital contemporaneity, lived by the public of the Aragon 'Caf' concert' and the 'Fête de l'Huma', and a problematic, disingenuous status as folklore. Celebrations continued: the pinboard collages of life and art removed from the walls of Aragon's luxury apartment at 56 rue de Varenne were exhibited in the Maison Elsa Triolet–Louis Aragon and moved later to central Paris and the PCF's headquarters, renamed Espace Oscar Niemeyer.[116]

On the world stage, after Moscow, Picasso's works were shown for the first time in the red Shanghai Expo China Pavilion in 2011: a sound step for the Picasso Museum in Paris; a great leap for Chinese artists? New publics are greeted in this national showcase by a living socialist realist heritage of oil painting and sculpture. In the Russian pavilion of the Shanghai Biennale of 2012, Dmitri Gutov showed his elaborate installation and film on the life of Mikhail Lifshitz, the Soviet theoretician whose *Philosophy of Art of Karl Marx* preceded Jean Fréville's Parisian anthologies in the 1930s of the writings of Marx and Engels, Lenin and Stalin.[117] Lifshitz's *Crisis of Ugliness, from Cubism to Pop Art* (with Lidia Reinhardt, 1968) was a Soviet bestseller, equivalent to *The Success and Failure of Picasso* in the 1960s, partly because of its reproductions of art of the West such as Andy Warhol's soup cans. Picasso was, predictably, Lifshitz's *bête noire*: indeed the dark *Still Life with Bull's Skull* is used on the cover of his book as the paradigmatic instance of 'ugliness' through half a century of contemporary art (plate 33).[118]

Picasso's Picassos will return to his museum in the Marais, and a magnificently refurbished Hôtel Salé, in 2014. The sale of Picasso's *Marie-Thérèse by a Window* at Sotheby's in London, on 5 February 2013, fittingly provides the endpiece for this book. Painted three days after

Nude, Green Leaves and Bust (*Nude with a Blue Curtain*), also shown in Paris in the summer of 1932, and later contemplated by Max Raphael at the artist's Zurich retrospective, it fetched the sum of $44.8 million (£28.6 million).[119]

On the red belt, André Lurçat's Karl Marx School in Villejuif, hymned by Max Raphael, undergoes a 26 million euro facelift; it will again welcome students currently housed in a building in between Karl Marx Avenue and Yuri Gagarin Street, with its Gagarin aquatic centre.[120] In Nanterre, the angry Kray brothers rappers housed in the 'cloud towers' of the Cité Pablo Picasso continue their poetry and protests. The Paris workers of the 1930s are now displaced by the fringe: Paris's invisible dispossessed.[121]

DEDICASSE A MON BEAU PERE ET TOUS CEUX QUE JCONNAIS ET QUI SONT
L'ORGUEIL DES MECS DE NOTRE VILLE
ON DIT DE NOUS QU'ON EST VIOLENT ET INSOLENT MAIS QUAND TU VIS CA AU
QUOTIDIEN C'EST NOTRE AVENIR QU'ON CONDAMNE A L'ECHEC ON NOUS FORGE
A LA VIOLENCE ON NOUS FORGE A L'ECHEC
ON SE SERT DE NOUS POUR JUSTIFIER DES DEPENSES ET JUSTIFIER DES BUDGETS
NOTRE COMBAT C'EST LA REUSSITE POUR SORTIR DE L'OMBRE

Dedicated to my step'pa and all I know who're the pride of the
Guys of our city
They say about us that we're violent, insolent but when you live it
Every day it's our future they condemn to failure, they forge us
For violence they forge us for failure
They use us to justify spending and justify budgets
Our combat is success in quitting the shadow

Notes

1 'Que ce message apporte à tous l'amitié de Picasso. J'ai dit il y a longtemps que je suis venu au communisme comme on va à la fontaine, et aussi que toute mon œuvre m'avait mené à cela. Je me réjouis de voir s'ouvrir l'exposition Picasso à Moscou pour un grand public populaire, et avec des œuvres récentes. J'ai souvent reçu d'Union Soviétique des messages, parmi lesquels des messages de peintres, qui m'ont profondément touché, et je profite de cette occasion pour leur dire mon affection. Je regrette de ne pas me trouver parmi vous en ce moment, et j'espère un jour entreprendre ce beau voyage fraternel que je dois maintenant charger les toiles de faire à ma place. Picasso, Cannes, 17 October 1956.' Manuscript in coloured crayon, from *La Culture et la vie*, 1 (1956), reproduced in Gérard Gosselin, *Picasso et la presse* (Paris: Cercle d'Art/L'Humanité, 2000), p. 164.

2 John Berger, telephone conversation with the author, September 2012.

3 Senator George Dondero, 'Brush Off Bad Paint Charges', *Chicago Daily Sun Times*, 17 August 1949, FBI file page numbered 71; see http://permanent.access.gpo.gov/lps1461/picasso3.pdf (accessed 22 August 2013).

4 'art pseudo-réaliste, du naturalisme au surréalisme et au primitivisme [...] ancienne méthode constructiviste [...] forts éléments d'expressionnisme [...]' Victor Prokoviev, 'Héritage artistique et métier réaliste dans la peinture française actuelle', *La Nouvelle Critique*, September 1953, pp. 162–63.

5 'ON NE PASSE PAS SANS DOULEUR DANS LE DOMAINE DU RÉALISME [...] Et la lutte à mener contre le primitivisme, le cézannisme ou l'impressionnisme est certainement plus difficile encore que la bataille contre la peinture sans sujet dont le vide, la stérilité et le caractère antiartistique sont évidents [...] Les indications des dirigeants du Parti communiste, l'expérience de l'art soviétique du réalisme socialiste, l'assimilation des traditions nationales, tout cela, sans aucun doute, permettra aux critiques et aux artistes d'apporter à ce problème une solution juste et profonde.' V. Prokoviev and O. Nikitiouk, 'Notes sur l'art progressiste en France', *La Nouvelle Critique*, February 1954, pp. 136–38 (*Iskusstvo*, November–December 1953).

6 'Trop superficiellement je me suis engagé à la légère sur les données profondes contenues dans le rapport concernant le travail créateur des artistes [...] Pour résumer brièvement, à propos des fautes dans lesquelles je me suis laissé entraîner, je veux seulement dire que ce que j'ai pu faire de mieux, c'est au Parti tout entier et seulement au Parti que cela appartient. Et mes fautes, ou si l'on veut, mes mauvais tableaux, c'est moi qui en suis le principe responsable pour ne pas avoir mieux assimilé les leçons du Parti.' André Fougeron, 'Discussions sur la peinture', *La Nouvelle Critique*, May 1954, pp. 155ff.

7 Louis Aragon, 'Discours au XIIIᵉ Congrès du Parti Communiste Français, Ivry, 3–7 June 1954', *Cahiers du Communisme*, June–July 1954, p. 838.

8 Lecœur was definitely excluded in November 1965. See Auguste Lecœur, *L'Autocritique attendue* (Paris: Éditions Girault, 1955).

9 See Solange Bouvier-Ajam, 'Picasso et la Maison de la Pensée Française', *Europe*, 492–93 (April-May 1970), pp. 71-75; compare Maurice Raynal, *Picasso Œuvres, 1900–1914. Œuvres de Moscou et Leningrad et de quelques collections parisiennes* (Paris: Maison de la Pensée Française, 1954), with Louis Aragon, *Picasso, deux périodes, 1900–1914 & 1950–1954* (Paris: Maison de la Pensée Française, 1954) and D.-H. Kahnweiler with Hélène Parmelin, *Picasso. Œuvres des Musées de Leningrad et de Moscou et de quelques collections parisiennes* (Paris: Cercle d'Art, 1955).

10 Louis Aragon, 'Le Sourire de Léger', *Les Lettres françaises*, 582 (25–31 August 1955); see Sarah Wilson, 'Fernand Léger, Art and Politics, 1935–1955', in N. Serota, ed., *Fernand Léger, the Later Years* (London: Whitechapel Art Gallery and Prestel Verlag, 1987), p. 73.

11 Philippe Butor and Laurent Gervereau, eds, *Le Couteau entre les dents* (Paris: BDIC–Chêne, 1989), p. 104.

12 See Ilya Ehrenburg, *Le Dégel*, trans. Dagmar Steinova and Yvette Joye (Paris: Éditions Défense de la Paix, 1954); and Eleonory Gilburd, *The Thaw, Soviet Socialism and Culture during the 1950s and 1960s* (Toronto: Toronto University Press, 2012).

13 'De nombreuses réhabilitations éclatantes montrèrent cruellement l'ampleur du désastre et du courant actuel de redressement et révision [...] Ils m'apprirent toute l'étendue des persécutions, la quasi-destruction des intellectuels marquants des nationalités périphériques de l'Union et des Juifs.' Pierre Daix, *J'ai cru au matin* (Paris: Laffont, 1976), p. 352.

14 Louis Aragon, 'Double ouverture' and 'Vingt ans de réalisme socialiste', in *Littératures soviétiques* (Paris: Denoël, 1955), pp. 9–32, 44–59.

15 Maurice Jardot, ed., *Picasso, 1900, Paris, 1955* (Paris: Musée des arts décoratifs, 1955), exhibition June to October.

16 See *L'Œil*, 11 (November 1955), 'Numéro spécial, L'Art en Russie' (with 16 reproductions of socialist realist painting).

17 See 'XXᵉ Congrès du P.C. de l'Union Soviétique. Rapport de N. Krouchtchev', *Cahiers du Communisme*, 3 (March 1956), pp. 257ff. For the report's publication in *Izvestia* in 1989, see *Intelligentsia*, 2013, p. 307, note 51.

18 Interview with the author, 2 February 1981.

19 Golomstock in conversation, London, 23 July 2009.

20 Anatoly Naiman, 'Picasso in Russia', trans. Mark H. Teeter, in the online *Moscow News*, 15 June 2010, http://themoscownews.com/arts/20100615/187873959.html (accessed 22 August 2013).

21 Svec gassed himself three weeks before the work was inaugurated on 1 May 1955; http://www.radio.cz/fr/rubrique/faits/la-triste-histoire-dotakar-svec-sculpteur-de-staline-et-victime-de-son-epoque (accessed 22 August 2013).

22 *Le Monument*, originally called *Le Pari*, appeared in *Les Lettres françaises* from 4 April 1957. It was published by NRF/Gallimard in April 1957. Triolet's riposte, 'La Lutte avec l'ange', appeared in *Les Lettres françaises* of 5 September 1957. See also 'Entretiens sur l'avant-garde en art et *Le Monument* d'Elsa Triolet', *La Nouvelle Critique*, May 1958.

23 See the photograph of the evening in Aragon's honour in Moscow, 24 October 1957, and the decree giving him the Lenin Prize dated 11 November 1957, in Véronique Jobert and Lorraine de Meaux, eds, *Intelligentsia, Entre France et Russie, archives inédits du XXᵉ siècle* (Paris: Beaux-Arts de Paris, 2012), pp. 293, 291.

24 See Anon., 'Art: Skeleton for UNESCO', *Time Magazine*, 14 April 1958.

25 See Gaëtan Picon, *La Chute d'Icare de Pablo Picasso au Palais de l'UNESCO* (Geneva: Skira, 1971).

26 The Alpes-maritimes prefect prohibited an opening of the *War* and *Peace* murals on specious grounds, while the PCF was temporarily presenting a more 'patriotic', less critical façade. See Pierre Daix, *Dictionnaire Picasso* (Paris: Robert Laffont, 1995), p. 425.

27 Henri Alleg, *La Question* (Paris: Minuit, 1958) and re-editions.

28 See J. Quéval and J. Thévenot, *La Télévision* (Paris: Gallimard, 1957), and Bruno Sternberg and Evelyne Sullerot, *Aspects sociaux de la radio et de la télévision, revue des recherches significatives 1950–1964* (Paris and The Hague: Mouton, 1966).

29 'La France déchirée' was held at the Galerie 'J' in June 1961. See Tom McDonaugh, 'Raymond Hains's "France in Shreds" and the Politics of Décollage', *Representations*, 90/1 (spring 2005), pp. 75–97.

30 See Roland Barthes, *Mythologies* (Paris: Gallimard, 1957).

31 See Simone de Beauvoir and Gisèle Halimi, *Djamila Boupacha* (Paris: Gallimard, 1962) and re-editions.

32 See Linda Morris, 'The Women of Algiers', 'Las Meninas', 'Le Déjeuner sur l'herbe', 'Rape of the Sabines', in Christoph Grunenberg and Linda Morris, eds, *Picasso, Peace and Freedom* (London: Tate Publishing, 2010), pp. 168–69, 180–81, 190–91, 202–03, with much important new material.

33 See Alfred H. Barr, ed., *Picasso 75th Anniversary Exhibition* (New York: Museum of Modern Art, 1957).

34 Konrad Farner, 'Picasso and Borders of Critical Realism', magazin […] 1, 1956 from *Inostrannaya Literatura* (1957), p. 81; incomplete reference faxed by Leonid Sitnikov for Keith Alexander, producer, *The Picasso Files*, BBC2, spring 1994.

35 See *American National Exhibition in Moscow*, 25 July–1 September 1959; L. Goodrich, ed., *Painting and Sculpture from the American National Exhibition, Moscow* (New York: Whitney Museum of American Art, 1959); Edward Steichen, *The Family of Man* (New York: The Museum of Modern Art, 2003 [1955]).

36 See Andrei Sinyavksy and Igor Golomstock, *Pikasso* (Moscow: Znanie, 1960). Golomstock claimed in interview, 23 July 2009, that he had possibly read Herbert Read, but had no knowledge of Roland Penrose's *Life of Picasso* (1955) at this time.

37 Igor Golomstock, 'The Picasso Dossier', undated two-page synopsis (see also 'Daniel and Sinyavski by Igor Golomstock and David Burg'), trans. David Burg, Ed., The Lilly Library, Indiana University, Bloomington.

38 See David Burg, 'Igor Golomstock and Andrei Sinyavksi, *Picasso* (with preface by Ilya Ehrenburg), Moscow, 1960', Calder and Boyars Mss., The Lilly Library, Indiana University, Bloomington.

39 Golomstock in conversation, 23 July 2009. Supplication by Ehrenburg to the CPSU Central Committee prevented the pulping of the monograph (with his introduction).

40 Golomstock, 'The Picasso Dossier', as note 37.

41 Pablo Neruda, in 'Materials of the awarding committee of Lenin Prizes "For strengthening Peace among Peoples"', reference faxed by Leonid Sitnikov for Keith Alexander, producer, *The Picasso Files*, BBC2, spring 1994, dossier p. 3.

42 See Thomas Gomart, 'Une relation au grand jour: Les expositions de 1961', in *Double détente: les relations franco-soviétiques de 1958 à 1964* (Paris: Publications de la Sorbonne, 2003); and Henri Journu, *U.R.S.S. 1961: Perspectives dégagées par l'exposition française à Moscou* (Paris: Union des Industries chimiques, 1961).

43 'Exposition culturelle franco-soviétique', Paris, Parc de Versailles, 4 September – 3 October 1961; material in 'Les Archives Russes', Musée de la Préfecture de Police, Paris, 23 May 2011 prolonged to July 2012; see *Les Arts plastiques de l'URSS à l'exposition industrielle soviétique, Paris, 1961* (Moscow: Édition des Arts, 1961).

44 'Le Match des deux expos', *Paris-Match*, 649 (16 September 1959), pp. 44–49.

45 Hélène Carrère d'Encausse, *1956: La Deuxième Mort de Staline* (Paris, Éditions Complexe, 2006), p. 232 and conclusions.

46 Louis Aragon, *Les Lettres françaises*, 3 May 1962, in Gosselin, *Picasso et la presse*, p. 196.

47 See Louis Aragon, *Histoire parallèle U.R.S.S., 1917–1960*, and André Maurois, *Histoire des États-Unis de 1917 à 1961* (Paris: Presses de la Cité, 1962).

48 See Susan E. Reid, 'The Soviet Art World in the Early Thaw', *Third Text*, March 2006, pp. 161–75; and *Fernand Léger* (Moscow: Pushkin Museum, 1962) (text by Thorez).

49 See Priscilla Johnson, *Khrushchev and the Arts. The Politics of Soviet Culture, 1962–1964* (Cambridge, MA: MIT Press, 1965), with selected documents.

50 Igor Golomstock, 'The Forger and the Spy', *Commentary*, May 1999, pp. 37–41.

51 See Christopher Green, 'Anthony Blunt's Picasso', *The Burlington Magazine*, 147 (2005), pp. 26–33.

52 MI5 learned about Blunt from fellow Cambridge apostle Michael Straight in 1963; Blunt confessed only on 23 April 1964. Golomstock confirmed the 1963 date, interview 11 February 2013.

53 Nigel West and Oleg Tsarev, eds, *Triplex Secrets from the Cambridge Spies* (New Haven, CT, and London: Yale University Press, 2009), part 1, Anthony Blunt's MI5 documents.

54 Anthony Blunt, *Picasso's 'Guernica'* (London: Oxford University Press, 1969) (the Whidden lectures, 1966, McMaster University, Ontario), following Blunt with Phoebe Pool, *Picasso, The Formative Years. A Study of his Sources* (London: Studio Books, 1962). Both John Golding and Pool and were working on early Picasso for Courtauld doctorates (awarded 1958 and 1959).

55 John Berger, *Permanent Red. Essays in Seeing* (London: Methuen, 1960), introduction, p. 13.

56 See Peter de Francia, *Portrait of Anna Bostock* (oil, 1954), exhibited at 'John Berger, Art and Property Now', Inigo Rooms, Kings College, London 2012, and Ernst Fischer, *The Necessity of Art*, trans. Anna Bostock (London: Verso, 2010 [1971]).

57 John Berger, *Success and Failure of Picasso* (London: Granta Books, 1992), with author's preface of 1987, p. xv.

58 Clement Greenberg, 'Picasso at Seventy-Five' (1957), in *Art and Culture* (Boston: Beacon Press, 1961), pp. 62ff.

59 Sources for 'The Moment of Cubism' essay (1966–68) reveal familiarity with Daniel-Henry Kahnweiler's *Les Années héroïques du cubisme* (Paris: Braun, 1950) and John Golding's *Cubism*, (London: Faber, 1959); see John Berger, *The Moment of Cubism and Other Essays* (London: Weidenfeld and Nicolson, 1969), pp. 1–32.

60 John Berger, *Success and Failure of Picasso* (Harmondsworth: Penguin, 1997 [1965]), p. 183. Subsequent references are to this edition.

61 Berger, *Success and Failure*, p. 206.

62 Berger, *Success and Failure*, pp. 175, 177.

63 Berger, *Success and Failure*, pp. 152–53; see Georges Boudaille et al., *Picasso, portrait de Madame H.P.* (Paris: Binoche, 1994), sales catalogue.

64 John Berger, *La Réussite et l'échec de Picasso* (Paris: Les Lettres Nouvelles, 1968), (Paris: Denoël, 1968).

65 John Berger, 'Revolutionary Undoing. Max Raphael', *New Society*, 327/2,1 (1969), pp. 24–26, reprinted in *Selected Essays and Articles: The Look of Things* (Harmondsworth: Penguin, 1971), pp. 201–29.

66 Jean Leymarie, ed., *Hommage à Pablo Picasso* (Paris: RMN, 1966), exhibition November 1966–February 1967.

67 De Gaulle visited the USSR in June 1966; Soviet premier Alexei Kosygin went to France in December. For the Picasso show, see note 110.

68 Andrei Sinyavsky's 'Le Réalisme socialiste' (taken to France in 1956) appeared anonymously in *Esprit*, February 1959, pp. 335–66, and as *On Socialist Realism* by 'Abram Tertz' (New York: Pantheon Books, 1960).

69 See Max Hayward, *On Trial. The Soviet State versus 'Abram Tertz' and 'Nikolai Arzhak'*, (New York: Harper and Row, 1966).

70 Marion Boyars of Calder & Boyars, the London publishers, with David Burg (translator) corresponded with both Golomstock and Sinyavksy in late 1972, with advance royalties involved. *Pikasso* was never translated but Golomstock arrived safely in London. Calder and Boyars Mss., The Lilly Library, Indiana University, Bloomington.

71 'Aragon au défi', *Les Petits Écrasons*, 4 (Paris: Éditions Le Terrain Vague, 1966), p. 10.

72 'Thorez feuillette un album de Fernand Léger. Les camps de concentration staliniens sont devenus l'objet de tristes élégies [...] De quel humour est capable l'histoire: l'antistalinisme volé aux antistalinistes par les staliniens.' Edgar Morin, *Introduction à une politique d'homme suivi par Arguments politiques* (Paris: Seuil, 1965), quoted in 'Aragon au défi', as above.

73 'Il ne faut pas oublier que le marxisme, né de la critique de la Sainte Famille, était avant tout une méthode critique. Ce paradoxe, dans un sens, subsiste même au plus profond de la religiosité stalinienne. Les mêmes qui adherent aux plus incroyables magies lisent, étudient, commentent les textes de Marx, Engels, Lénine (et bien entendu Diderot, d'Holbach, etc.) [...] Aussi la magie stalinienne, est-elle analogue à la calcite: elle laisse croire en la transparence du visage originaire du marxisme...' Edgar Morin, *Autocritique* (Paris: Julliard, 1959), p. 98.

74 Roger Garaudy, *D'un réalismes sans rivages, Franz Kafka, Saint-John Perse, Pablo Picasso* (Paris: Plon, 1963), preface by Louis Aragon.

75 *Peintres d'Union Soviétique* (Paris: Galerie peintres du monde, 1965), exhibition June–July, with texts by Georges Soria, Boris Meilakh and Roger Garaudy.

76 See Janet Clark, 'From Pravda to Prada. Oscar Niemeyer's Parisian Architecture', MA thesis, London, Courtauld Institute of Art, 2002; Niemeyer died aged 105 on 5 December 2012; the Espace Oscar Niemeyer (formerly the PCF headquarters) remembered him on 12–13 January 2013.

77 *Exposition d'Arts plastiques au XVIIᵉ congrès du parti communiste français* (Paris: PCF, 1967).

78 Jean Dewasne, 'Art abstrait et objectivité', *La Nouvelle Critique*, 16, (1968) pp. 21–28 (a text of 1949 and lecture of 1952).

79 There is an extensive bibliography – but see, for example, Jacques Fath, responsible for the PCF's international relations, 'Réflexions sur 1968: Mai, Prague et le PCF' (15 May 2008), blog by Henri Moulinier (30 August 2008), http://www.moulinier.info/article-22358282.html (accessed 7 October 2013).

80 E. Sopine, M-J. Trouch, eds., *Vladimir Ilich Lénine, 1870–1924* (Paris: Les Presses artistiques, 1970), exhibition May to June, Grand Palais.

81 Louis Aragon, *Henri Matisse, roman* (Paris: Gallimard, 1971).

82 See Louis Aragon, *Écrits sur l'art moderne*, ed. Jean Ristat (Paris: Flammarion, 2010 [1981]).

83 See Ilya Ehrenburg and Vassily Grossman, *The Complete Black Book of Soviet Jewry*, ed. and trans. David Patterson (Piscataway, NJ: Transaction Publishers, 2002); Sarah Wilson, 'Entretien avec Sarah Wilson', in Josette Rasle, ed., *Aragon et l'art moderne* (Paris: Musée de la Poste/Beaux-Arts de Paris), pp. 23–29.

84 See *Léo Ferré chante Aragon*, vol. 11, *L'intégrale, 1960–1974* (Paris: allmusic, 1989).

85 Michel Foucault, 'La Disparition du peintre', in Philippe Artières et al., eds, *Les Cahiers de l'Herne, Foucault* (Paris: Éditions l'Herne, 2011), facsimile typescript, pp. 15–32.

86 'cet explosion sauvage […] Œuvres déconcertant de jeunesse, comme si le temps était devant elles; et qui leur appétit fût intact!' Gaëton Picon, '12 juillet 70, Écrit après l'exposition Picasso', in *Admirable tremblement du temps* (Geneva: Skira, 1970), p. 41; Yvonne Zervos, *Picasso œuvres de 1969 à 1970* (Avignon: Palais des Papes, 1970), exhibition May to October.

87 Jean Leymarie, ed., *Picasso dans les musées soviétiques*, Musée National d'Art Moderne, 1971 (Paris: Éditions des Musées Nationaux, 1971); see also *Chefs d'œuvre de la peinture française dans les Musées de Leningrad et de Moscou* (Paris: Ministère d'État Affaires culturelles, 1966).

88 Donna Ristorucci, 'Angela's Sister Reports on Waves of Rallies Abroad', unsourced press cutting including Picasso's signature, Picasso, FBI file, age stamped 'Dec 2 1971'. See http://permanent.access.gpo.gov/lps1461/picasso1.pdf (accessed 22 August 2013).

89 Clement Greenberg, 'Picasso à soixante-quinze ans' (1957), *Peinture, cahiers théoriques*, 2–3 (1972), pp. 107–14.

90 Wieland Schmied, ed., *Renato Guttuso, Der Gastmahl* (Bremen: Ullstein, 1973).

91 *Picasso et la Paix* (Ceret: Musée d'art Moderne, 1973), texts by Louis Aragon, Miguel Angel Asturias, Jean-François Bory, Jean Cassou, Victor Crastre, Pierre Daix, Hervé Fischer, Calsine Heering, Docteur Pierre Lacombe, Pablo Neruda and Madeline Petrasch.

92 See Jan Chwałczyk, *Kontrapunkt*, mail art project (with Felipe Ehrenberg's *Picasso is Dead* and Hervé Fischer), Warsaw, 1973; my thanks are due to Malgorzata Misniakiewicz, Courtauld Institute of Art for this information.

93 Gérard Gosselin, ed., *Picasso, 145 dessins pour la presse et les organisations démocratiques* (Paris: L'Humanité, 1973).

94 Louis Marin, 'La Célébration des œuvres d'art. Notes de travail sur un catalogue d'exposition'; Pierre Bourdieu, 'La Lecture de Marx ou quelques remarques à propos de "Lire le Capital"', *Actes de recherches en sciences sociales*, 5–6 (November 1975), pp. 50–64, 65–79.

95 Jeannine Verdès-Leroux, 'L'Art de parti. Le parti communiste français et ses peintres (1947–1954)', *Actes de recherches en sciences sociales*, 28 (June 1979), pp. 33–55.

96 See D. Bozo et al., *Picasso. Œuvres reçues en paiement des droits de succession* (Paris: RMN, 1979); followed by Gérard Regnier, ed., *Picasso, une nouvelle dation* (Paris: RMN, 1982), exhibition Galeries nationales du Grand Palais, 15 November 1980– 2 March 1981.

97 Jeannine Verdès-Leroux, 'Les Impasses de l'art de parti. Le parti communiste français et l'art: 1947–1954', *Noirot*, 259 (June–July 1981), reprinted in Jean-Pierre Greff, ed., *50 ans de réflexion et d'action en art contemporain à Noroit* (Arras: Centre Culturel Noirot, 1990), pp. 365–71.

98 Hélène Parmelin, *Picasso Plain. An Intimate Portrait* (London: St Martins Press, 1963).

99 'Picasso était devenu "l'art moderne" et sa folie absolue […] s'est ajoutée à la détestation […] une détestation autre, qui était: Picasso communiste […] Picasso homme social, Picasso qui valait des centaines de milliers de dollars, Picasso communiste et en même temps opposé au parti communiste à partir d'une certaine époque […] ni fascistes, ni crétins, ni soumis […] Ce n'était pas un manichéisme à l'envers, c'était les temps

modernes que nous vivons, c'est-à-dire un mélange terrible d'idées manipulées.' Hélène Parmelin, 'Picasso ou les vérités difficiles', *Noirot*, 255–56 (January–February 1981), reprinted in Greff, ed., *50 ans de réflexion et d'action*, pp. 332–40 (quotations, pp. 334–36, translation pp. 337–38).

100 'moi je ne suis qu'un amuseur public, qui a compris son temps et qui a exploité de son mieux l'imbécilité, la vanité et l'avidité de ses contemporains'. 'Visite à Picasso (ou: la fin de l'art), Antibes, 19 February', in Giovanni Papini, *Le Livre noir*, trans. Julien Luchaire (Paris: Flammarion, 1953), p. 147; see also Papini, *El Libro Negro / The Black Book* (Mexico: Epoca, 1998).

101 David Douglas Duncan, *The Private World of Pablo Picasso* (New York: Harper, 1958); *Le Petit Monde de Pablo Picasso* (Paris: Hachette, 1959); *Goodbye Picasso* (London: Times Books, 1974; Paris: Stock, 1975).

102 See Sarah Wilson, '1937, problèmes de la peinture en marge de l'Exposition internationale', 'La Vie artistique à Paris sous l'Occupation', 'Les Jeunes Peintures de tradition française', 'Débats autour du réalisme socialiste', in G. Viatte, ed., *Paris–Paris, créations en France, 1937–1957* (Paris: Centre Georges Pompidou, 1981), pp. 42–44, 96–100, 106–12, 206–12.

103 I alerted Germain Viatte to Jean-Charles Gateau's 'Paul Éluard et la peinture' (thèse d'État, 3 vols, Université de Paris-Sorbonne, n.d.) as crucial for this show, preceding his *Paul Éluard et la peinture surréaliste* (Geneva: Librarie Droz, 1982), and *Éluard, Picasso et la peinture* (Geneva: Librarie Droz, 1983); see Germain Viatte, ed., *Paul Éluard et ses amis peintres* (Paris: Centre Georges Pompidou, 1982), pp. 161–63 (Picasso entry), installation by Yasha David.

104 'une religiosité tout à fait reparable qui serait de "la femme en soi" mais décomposée, démembrée, explosée, partout et nulle part, mais régnante [...]' Philippe Sollers, 'Le Temps de Picasso' [29 December 1984], *Peinture*, 18–19 (1985), p. 28; see also the context: Supports-Surfaces artist Louis Cane's turn to Picassoid paintings and bronzes and Philippe Dagen on the *transavantgarde* in the same issue.

105 Anatoli Podoksik, *Picasso, la quête perpetuelle*, ed. Marina Bessonova (Leningrad: Aurora Art Publishers; Paris: Cercle d'Art, 1989), with a full historical and contemporary Russian bibliography; these are essays mostly of 1980; the author died in 1986.

106 Marie-Laure Bernadac, ed., *Le Dernier Picasso, 1953–1973* (Paris: Centre Georges Pompidou, 1988); *Late Picasso* (London: Tate Gallery, 1988).

107 See Gijs van Hensbergen's illuminating *Guernica: The Biography of a Twentieth-Century Icon* (London: Bloomsbury, 2004).

108 Laurence Bertrand-Dorléac and Androula Michael, eds, *Picasso, l'objet du mythe* (Paris: ENSBA, 2002).

109 I proposed an exhibition, 'Picasso et la Russie', with the collaboration of Ilya Doronchenkov (Saint Petersburg) and Hélène Lassalle, Musée Picasso, Paris (letter of 15 September 1994). See Ilya Doronchenkov, ed., *Russian and Soviet Views of Modern Western Art, 1890s to Mid-1930s* (Berkeley: University of California Press, 2009).

110 Irina Antonova et al., *Pablo Pikasso k 85 – letija, grafika, keramika, vy stavka is galerej Luizy Leris v Parize I moskovskih kollekcij* (Moscow: Sovetskij hudoznik, 1966). Expo Gosudarstvennyi Muzej Izobrazitelmyh Iskusstvimeni A. S. Puskina, 1966. (Graphic and ceramic work from the Galerie Louise Leiris, Paris and Moscow collections).

111 See Aurélia Dufils, 'Le Château de Baillet-en-France; une œuvre sociale des Métallurgistes CGT Parisiens', MA thesis, Université de Paris VIII, 2005; François Gentili, ed., *Les Statues soviétiques de l'exposition de 1937*; *Rapport final de l'opération Inrap* (Paris: INRAP / Centre Île-de-France, 2010); Marie Vacher, 'Joseph Moisseevitch Tchaikov (1888–1986), Sculptures et illustrations, 1910-1937, l'artiste, la forme, le matériau', mémoire de recherche, École du Louvre, 2010.

112 The refutation of François Furet's *Le Passé d'une illusion. Essai sur l'idée communiste au XX^e siècle* (Paris: Robert Laffont/Calmann-Lévy, 1995) is the continual subtext. In particular one should mention 'Puissances du Communisme', held in honour of the late Daniel Bensaïd, Université de Paris 8, Saint-Denis with the Société Louise Michel, 22–23 January 2010, with Etienne Balibar, Jacques Rancière, Slavoj Žižek etc.

113 As in the conference 'Marx and the Aesthetic', University of Amsterdam, 10–13 May 2012, with Kristin Ross, Boris Groys, Terrell Carver etc.

114 See 'Medvedev à Paris. France-Russie. Vers un accord stratégique politique, économique et bientôt militaire?', *Le Point*, 1 March 2010, http://www.lepoint. fr/actualites-monde/2010-03-01/france-russie-vers-un-accord-strategique-politique-economique-et/924/0/428987 (accessed 22 August 2013).

115 Frédérick Genevée, *La Fin du secret, histoire des archives du Parti Communiste Français* (Paris: Éditions de l'Atelier/Éditions Ouvrières, 2012); Bruno Fuligini, *La France rouge. Un siècle d'histoire dans les archives du PCF 1871–1989* (Paris: Les Arènes, 2011); Thorez's birthday, pp. 62–63; Picasso's *Stalin*, pp. 65–66.

116 '56 Rue de la Varenne' (with Claude Bricage's photographs), Maison Elsa Triolet–Louis Aragon, Saint Arnoult en Yvelines, 2012, moving to the Espace Oscar Niemeyer, Paris, December 2012.

117 Dmitri Gutov, *Lifshitz Institute* (video, 45 minutes, 2004–05), shown with a new installation, Moscow Pavilion; see Qiu Zhijie, ed., *Reactivation*, Ninth Shanghai Biennale (Shanghai: The Power Station of Art, 2012)

118 See Mikhail Lifshitz, *The Philosophy of Art of Karl Marx* (New York: Critic's Group, 1938; London: Pluto Press, 1973 [1935]) and (with Lidia Reinhardt), *Krizis bezobraziya. Ot kubizma k pop-art*, [The Crisis of Ugliness, from Cubism to Pop Art] (Moscow: Iskusstvo 1968); cover: Picasso's *Still Life with Bull's Skull*, 1942, Kunstsammlung Nordrhein-Westfalen, Dusseldorf.

119 See Picasso's *Akt in schwarzen Lehnstuhl*, dated 9 March 1932 (Galerie Georges Petit no. 221), listed in W. Wartman, ed., *Picasso*, Kunsthaus Zurich (Zurich: Buchdruckerei Berichthaus, 1932), p. 16; *Impressionist and Modern Evening Art Sale*, 5 February 2013 (London: Sotheby's Publications, 2013), Lot 12, Picasso, *Femme assise près d'une fenêtre* (1932), estimate of £25–35 million, sold for £28,601,250.

120 'Le collège Karl Marx sera réhabilité', 23 September 2010, http://www.leparisien.fr/ villejuif-94800/le-college-karl-marx-sera-rehabilite-23-09-2010-1079412.php (accessed 22 August 2013).

121 The Cité Pablo Picasso with its 'cloud towers', in the far-flung satellite conglomeration of Nanterre outside Paris, is a utopian social housing project conceived by Émile Aillaud (1972); now sadly dysfunctional. See http://freres-kray.skyrock. com/2807316009-CITE-PABLO-PICASSO-NANTERRE-92-nanterre-LAT-CEUX-QUE-TU-VOIS-JAMAIS-A.html (accessed 22 August 2013).

Postface and acknowledgements

The Picasso industry continues to fascinate, to generate new exhibitions, new scholarship and to make money. The context of production and reception of this book is closely related to two exhibitions in particular: *Picasso, Peace and Freedom*, Tate Liverpool; Albertina, Vienna; Louisiana Museum of Modern Art, 2010–11 (under director Christoph Grunenberg) and surely the most splendid Picasso show there will ever be, *Picasso-Moscou*, 2010, created with Paris's Picasso Museum collections and director Anne Baldessari, with the redoubtable Irina Antonova of the Pushkin Museum. One should also mention *Picasso-Cézanne*, Musée Granet, Aix en Provence, 2009 (with the opening of the Château de Vauvenargues); *Louis Aragon et l'art moderne*, Musée de la Poste, Paris, 2010; *Picasso, The Mediterranean Years 1945–1962*, Gagosian Gallery, London 2010; *Picasso and Marie-Thérèse* and *Picasso and Françoise Gilot: Paris–Vallauris 1943–1953*, Gagosian Gallery, New York, 2011 and 2012 respectively; *Pablo Picasso et Françoise Gilot, peintre et muse*, Musée du Vieux-Nîmes, 2012; *Picasso à l'œuvre. Dans l'objectif de David Douglas Duncan*, Musée d'Art et d'Industrie André Diligent, Roubaix, 2012; and *Intelligentsia: entre France et Russie, archives inédites du XXᵉ siècle*, Paris, École National Supérieure des Beaux-Arts, 2012.

Thrown into the crucible of a not-so-distant history from late 1979 onwards, I became close to France's leading socialist realist painters, Boris Taslitzky and André Fougeron, whose centenary years fell in 2011 and 2013, respectively. I knew the artists who were their contemporaries, from Edouard Pignon to the abstract painter Jean Dewasne, who decided the colour scheme for the Centre Georges Pompidou exterior. I accompanied *Paris–Paris* curator Germain Viatte to meet Arno Breker, Hitler's preferred sculptor, in Dusseldorf, prior to the 'Breker scandal' and the banishing of his work from our show. With the Centre Pompidou personnel, I travelled to Moscow and Leningrad in 1981, witnessing a 1 May procession in Brezhnevian gloom, and returned to Paris on the euphoric evening of François Mitterand's election:

the Communists' return to a fateful power-share. The celebrations coincided with the opening of *Paris–Paris, Créations en France, 1937–1957,* and French socialist realism's first official appearance in a state museum. I was unaware at that moment of the 'study days' on Stalinism, 13–16 May 1981, organised by Natacha Dioujeva and François George.[1] Both Hélène Parmelin, Pignon's wife and Picasso's eulogist, and Jeannine Verdès-Leroux, historian and associate of Pierre Bourdieu, were aghast at the scale of my responsibilities for *Paris–Paris.* I salute their contributions here. I attended the Communist Fête de l'Humanité in 1982, where I saw the commemorative exhibition 'Aragon et les peintres de son siècle'. In 2012 the 'Année Aragon' celebrated the thirtieth anniversary of his death.

Aragon, former surrealist poet, later Stalin's cultural spokesperson not only for western Communism in France and Italy but in eastern European satellite countries, is constantly fêted in Paris. The fiftieth anniversary commemoration of the death of Stalin (disguised as a conference around Picasso's portrait) took place in 2003, at the Maison Elsa Triolet–Louis Aragon, his former home in Saint-Quentin-en-Yvelines. I encountered a largely sentimental gathering of older *militants.*[2] My critical voice in *Aragon et l'art moderne,* 2010, was qualified as that of the outsider. The folkloric dimension of Aragon celebrations continues in France in theatre, recital and the Caf' Conc' shows of 2012, and the exhibition '56, rue de Varenne', showing the collages on the walls of his impressive Parisian apartment (Maison Elsa Triolet–Louis Aragon), which I visited with Serge Fauchereau, before they were removed in 1982. This cult, I would argue, obscures his grave responsibilities.[3]

In 2004 the 93-year-old Boris Taslitzky showed one of his last large-scale works in a gathering of one hundred painters at the 'Fête de l'Huma' for the centenary of the Communist daily newspaper ('Cent peintres pour cent ans de l'Huma'). I worked with 'last survivors'. Living witnesses remain, such as the Stalinist, anti-Stalinist and Picasso scholar Pierre Daix and some younger participants in the story: Esther Senot (Polish-born Ester Dzik) was in Auschwitz with Danielle Casanova, the late heroine of Taslitzky's commemorative painting of 1950. Esther attended the seminar on women's resistance on Women's Day, 8 March 2012. My friend, the artist Geneviève Zondervan died on 15 October 2013.

Despite the perpetual energy and challenge of Picasso's work and its power to transcend time, other narratives, other representations are rapidly disappearing. Three major paintings I discuss have been deliberately 'disappeared' from France's twentieth-century art narrative: Taslitzky's *Buchenwald,* 'disappeared' from French national collections;

André Fougeron's major atomic bomb painting, *Homage to Houiller*, 'disappeared' by the Pushkin Museum some time after 1950; and his *Atlantic Civilisation*, the Cold War's greatest history painting, 'disappeared' (back into the artist's store) in 1953. It became part of Tate Modern's inaugural display in 2000, where it hung with other major political works such as Richard Hamilton's Northern Ireland triptych.

Over this span of years, innumerable encounters have contributed to *Picasso/Marx* and its avatars. At the Courtauld Institute, Christopher Green and the late John Golding taught me to see and appreciate the beauty and complexity of Picasso's art, and to appreciate the powers of both scholarship and exhibition making, from Golding's definitive *Cubism* (1959) to the magnificent flowering of *Matisse Picasso* (2002); from Green's *Cubism and its Enemies* (1987) to the surprise and the anthropological twists of *Picasso, Architecture and Vertigo* (2006). After my unforgettable initiation in Paris, the politicised work of Communist artists came as a shock, yet a shock I knew had to be dealt with as part of Picasso's own history. Alan Bowness, another revered teacher (along with the late John House), was crucial for introductions to Paris. At the Pompidou Centre in its initial heroic era I met Germain Viatte my first patron, Jean Clair and Serge Fauchereau. I must signal Fauchereau's *La Révolution Cubiste* (1982, revised 2012) and Jean Clair's superb exhibitions at the Picasso Museum, where British paintings and scholarship surprisingly entered exhibitions such as *Corps cruficiés*, 1992. Madeleine Malraux and Alain Malraux remain firm friends and supporters from my first Paris period. These names figure in the extensive list of acknowledgements in 'Art and the Politics of the Left in France, 1935–1955', my doctoral thesis finally completed in 1991. It discussed the evolution and elaboration of socialist realism including Picasso's role in a pluralist art world in the very greatest of detail. Sander Gilman and Gillian Malpass (Yale University Press) offered crucial support at this time. Intellectual inspirations, archival discoveries, friendships and memories from that era remain forever vivid – and were rekindled when Norman Rosenthal asked me to curate *Paris, Capital of the Arts, 1900–1968*, for the Royal Academy, London, and the Guggenheim Museum, Bilbao (2002–03).

Picasso's drawings for the French Communist press were first published as *Picasso, 145 dessins pour la presse et les organisations démocratiques* for the Fête de l'Humanité in 1973, a great celebration following the artist's death. I recall my excitement at obtaining this book compiled by Gérard Gosselin (together with Picasso's Peace scarf for the Berlin 1951 Youth Festival) in the 1980s. Gosselin's *Picasso et la presse* was spurred by

shows at the Musée d'Antibes and the Fête de l'Humanité in 2000. His preservation of this heritage and his related scholarship has been insufficiently highlighted as the key visual source for the two publications on Picasso and Communism after 1944, Gertje R. Utley's *Pablo Picasso: The Communist Years* (2000) and Linda Morris and Christoph Grunenberg's exhibition and catalogue, *Picasso, Peace and Freedom* (2010).

Laurent Gervereau and his co-editors should be credited with the string of pioneering multidisciplinary exhibitions held at the Hôtel National des Invalides in conjunction with the Bibliothèque de documentation internationale contemporaine (BDIC), also insufficiently celebrated by the art world. They deserve international recognition; their dates are significant; their catalogues are exemplary: *Mai 68*, 1988; *Le Couteau entre les dents*, 1989; *La Propagande sous Vichy*, 1990; *Russie-URSS 1914–1991*, 1991; *La Course au moderne*, 1992; *La France en guerre d'Algérie*, 1992; *Images et colonies*, 1993; *La Déportation, le système concentrationnaire nazi*, 1995; *Les Sixties*, 1996. It was a privilege to be supported by the doyenne of Communist Party scholarship, the late Annie Kriegel, in the early 1990s, and to share excursions to Melun and to Rouen with her, Boris Taslitzky and her husband, Arthur Kriegel. My communist family now expanded to include Geneviève Zondervan who with Claude Ringot introduced me to photographer Willy Ronis. Bruno Gaudichon's André Fougeron centenary retrospective (La Piscine, Roubaix, 2014) will celebrate Ronis' contribution to this story. The artists and theoreticians François Derivery, Michel Dupré and Raymond Perrot of the DDP group have echoed my interests in their pioneering publications.

My earliest research for the MNAM, Centre Georges Pompidou was crucially sustained by a Leverhulme Trust grant. The foundation has generously supported me over the years, as has the University of London Central Research Fund. In particular a British Academy Small Research Grant awarded in 2008 enabled exchanges with Russian colleagues. Leonid Sitnikov's invaluable research assistance in Russian archives, and sojourns in Moscow, memorably at the French Embassy in 2009 where I was graciously hosted by the Ambassador's wife, Pauline Laboulaye, and was aided by the the *année franco-russe* team: thanks to Blanche Greenbaum-Salgas and Nicolas Chibaev. In Moscow, artist Dmitri Gutov demonstrated his twin passions for theoreticians Mikhail Lifshitz and Max Raphael; thank you Dima! Moscow friends, Alexei Sinodov and Alexander Yakimovich maintained the welcome and hospitality they have extended to me since the AICA art critics' conference in Moscow and Tbilisi in 1989; I met the Soviet scholars

Matthew Cullerne Bown and Ilia Doronchenkov in my '1990s' period: we continue to exchange ideas. I have renewed friendships with Vitaly Mishin from the Pushkin Museum and was honoured to receive the support of Irina Antonova, who allowed me and her staff to see Fougeron's *Hommage to Houiller*, and to Andrei Koudriavitsky for his photograph. I met Igor Golomstock in London, long after reading his work on totalitarian art. Didier Schulmann, my accomplice and director of the Pompidou's superb Bibliothèque Kandinsky, put me in touch with the archeologists lead by François Gentili and Paul Salmona of the Institut National de Recherches Archéologiques Préventives at the moment of the rediscovery of the 1937 Chaikov sculptural frieze. This led to memorable visits to the reconstructed Soviet pavilion in Moscow, with the help of Victoria Golembiovskaya, Vlad Kimcher, Max Seddon and Alex Rytov, and Olga Sinodova's photographs. Aurélia Dufils and Marie Vacher have developed important scholarship in this area.

Boris Groys's *Gesamtkunstwerk Stalin* in its French translation impacted upon my PhD at the very last moment of revision. Groys's visiting professorships at the Courtauld Institute in 2006–07 and 2011 have a legacy which continues to inspire and to tantalise. Thanks also to many more who commissioned essays which have expanded my knowledge of and engagement with the *Picasso/Marx* arena: Jean-Paul Ameline, Matthew Bown, Laurent Gervereau, Jonathan Harris, Nathalie Hazan-Brunet, Nicholas Hewitt, Matteo Lafranconi, Patrick Marsh, Jane Pavitt, Barthélémy Jobert and Yolande Rasle. Thanks to current French friends and colleagues, in particular all those from the Centre Pompidou; Henry-Claude Cousseau, former director of the École des Beaux-Arts; Françoise Levaillant and Dany Sandron, from Paris-Sorbonne IV; and my anglophile colleagues at the Centre d'Histoire Culturelle des Sociétés Contemporaines (CHCSS), Université de Versailles Saint-Quentin, particularly Diana Cooper-Richet and Christian Delporte. The latter two institutions have offered me precious time in Paris, with research funding at the CHCSS from the European Union Seventh Framework Programme (FP7/2007-2103) under grant agreement no. 246556. The Institut Mémoires de l'Édition Contemporaine (IMEC) now houses the papers of André Fougeron, Edouard Pignon, Hélène Parmelin and other important artists of the period: thanks to Olivier Corpet and Yves Chevrefils-Desbiolles.

The Équipe de Recherche Interdisciplinaire Elsa Triolet / Aragon (ERITA) with Daniel Bougnoux, has invited me to lecture in the Maison Elsa Triolet–Louis Aragon directed by Bernard Vasseur. This

inter-university research group created in 1996 has joined forces since 2009 with the ITEM – CNRS Aragon specialists (Institut des Textes et des Manuscrits Modernes – Centre National de la Recherche Scientifique). ERITA's website, offering a full range of online publications, includes Reynald Lahanque's state doctorate on French socialist realism, completed in 2002, put online in 2011; his literary analyses and bibliography supplement my work here, while thirty years after his death a revised Aragon bibliography has been put online.[4] While my PhD was a Sisyphean task in an age of the archive, the book and oral history, innumerable websites and new organisations with online access and archives now open the subject areas I broach, far beyond the remit of this short book. One should mention, for example, the Maurice Thorez archives in Ivry, the Fondation Gabriel Péri, the 'Séminaire Communismes', the Société Louise Michel, the online *Dictionnaire Maîtron* and the extraordinary Ciné archives (Fonds audiovisuel du PCF) which bring to life in film events I describe. I discover new websites almost daily such as *Marx au XXI^e siècle*. The resuscitated revolutionary writers and artists website – the AÉAR – was a particular surprise; the *increvable anarchiste* pursue virtually what is now a long tradition; they too are thinking about Proudhon and Marx, just as I invite a new audience to do here.

And of course there is the devotion evidenced in Boris Taslitzky's website created by his daughter Evelyne Taslitzky (another generous host) with Marie-Christine Auzou, and the collaboration of the 'family' devoted to his memory, in particular Christophe Cognet and Hélène Amblard. Hélène has worked tirelessly on the heritage of her father, Jean Amblard, Taslitzky's closest friend and collaborator. Isabelle Rollin-Royer is another daughter who has worked on the legacy of her father, critic Jean Rollin, who conceived the Musée d'Art et d'Histoire de Saint-Denis in a former Carmelite monstery (a heritage now cared for by Sylvie Gonzales). Rollin first gave me introductions to Fougeron and Taslitzky, so many years ago.

My most recent period of research benefited from precious input from Philippe Artières; Jean-Louis Cohen (who alerted me to *L'Appel des Soviets* and visual material); artists Lene Berg and Michel Dupré; Henri Froment-Meurice, former ambassador to Moscow; Michel Dreyfus and Elisa Martayan; Annette Wieviorka; Anne Baldessari, Emilie Augier-Bernard, Annabelle Ténèze and Laure Collignon at the Musée Picasso; Eric Lafon, Véronique Fau-Vincenti and Gilbert Schoon at the Musée d'Histoire Vivante in Montreuil; Natalie Pigeard-Micault at the Musée Curie (CNRS/Institut Curie); Carrie Pinto at the Musée Matisse,

Le Cateau-Cambrésis; Béatrice Hatala; Joanna Ling (Cecil Beaton Studio Archives); John Tagg at Binghampton University, NY, and Patrick Healy in Amsterdam for their scholarship on Max Raphael; Anca Oroveanu and Cosmin Ungureanu for research in Bucharest; Wojciech Fangor with Stefan Szydlowski in Warsaw; William Remus in Hawaii with Irma Erhart on Max Raphael's Schönlanke; Zach Downey, Lilly Library, University of Indiana; Peter Stein in Stanfordville, NY, and Nikolai Ssorin-Chaikov in Cambridge for his 'ethnographic conceptualism'. Thanks also to my accomplice, Inhye Kim, National Museum of Contemporary Art, Korea. Professor Caroline Arscott has been generous with a research grant from the Courtauld Institute for the preparation of the manuscript with the help of Gemma Rolls-Bentley and Vanessa Trioano, then Elizaveta Butakova and the formidable Thomas Scutt. Thanks to Courtauld alumni Johannes Nathan, Nicholas Bueno de Mesquita, Malgorzata Misniakiewicz, Maria Mileeva, Charles Miller, Maria Starkhova and Denis Stolyarov and to all my students whose research enhances my own. Xavier Douroux, director of Les Presses du réel has honoured me with his support. Alison Welsby of Liverpool University Press has been admirably patient and generous. Michael Kelly, an accomplice in 1980s Paris, has surprised me as first reader of *Picasso/Marx*. Andrew Kirk's editing has been impeccable. Adrien Sina has been the constant *agent provocateur* and *concepteur* in innumerable ways.

My late mother Mary Wilson endured the day-to-day, year–to-year *angoisses* of my doctorate so long ago, renewed as 'the book' came to life again in its present form; her love endures. My thanks again to you all.

Notes

1 Natacha Dioujeva and François George, eds, *Staline à Paris / Journées d'études sur le stalinisme français* (1981) (Paris: Ramsay, 1982); see also 'Trente ans plus tard', annexe to Jean Marie Goulemot's re-edition of *Pour l'amour de Staline: la face oubliée du communisme français* (Paris: CNRS éditions, 2009), pp. 229–38.

2 Alain Nicolas, 'Aragon-Picasso: Cinquante ans après témoins et historiens en débat', *L'Humanité*, 10 March 2003, http://www.humanite.fr/node/370304 (accessed 22 August 2013).

3 'Caf' Conc' Aragon devised by Bernard Vasseur, performed in the Party headquarters, February, and at the Fête de l'Humanité, September 2012.

4 Reynald Lahanque, 'Le Réalisme socialiste en France (1934–1954)', PhD dissertation, thèse d'État, Nancy II, 2002; in addition, the 'thirty years after' research update is available online http://www.louisaragon-elsatriolet.org/spip.php?rubrique106 (accessed 22 August 2013).

Bibliography

Archives

Archives, Bibliothèque Kandinsky, Centre Georges Pompidou, Paris
'Actualités Françaises' archives, Institut National d'Audiovisuel, Paris
Archives Joliot-Curie, Paris
Archives, Musée de la Résistance, Champigny-sur-Marne
Archives, Musée d'Histoire Vivante, Montreuil
Archives de la Police, Paris
'Archives sonores', *Paris–Paris* transcripts, MNAM, Centre Georges Pompidou, Paris
Calder and Boyars Mss., The Lilly Library, Indiana University, Bloomington
Ciné archives, Fonds audiovisuel du PCF, http://www.cinearchives.org
Fond 495, Fond 539, Agit-Prop
Fougeron archives, IMEC, L'Abbay d'Ardenne
Institut National d'Audiovisuel, Paris, http://www.ina.fr
Lurçat archives, Cité de l'architecture et du Patrimoine, Paris
Paix et Liberté archives, Seeley G. Mudd Manuscript Library, Princeton University
Parmelin archives, IMEC, L'Abbay d'Ardenne
Picasso archives, Musée National Picasso, Paris
Poulaille archives, Cachan
Raphael archives, Deutsches Kunstarchiv, Germanisches Nationalmuseum,
 Nuremberg; Getty Research Institute, Los Angeles
RGASPI Russian State Archive of Socio-Political History *Rossiiskii gosudarstvennyi
 arkhiv sotsial'no-politicheskoi istorii* (Comintern archive, formerly Marx-Lenin
 Institute)
Taslitzky archives, Paris
Thorez archives, Ivry, http://www.fonds-thorez.ivry94.fr
Vorms archives, Paris and Belvès

Periodicals

Approches marxistes. Revue d'analyse de la Gauche Communiste / PCF, esp. nos 4, 'L'incontournable Marxisme de Marx', and 5, ' Le Stalinisme du PCF' (2005), and no. 12?, 'Le Communisme et ses fondements marxistes qui ont donné naissance au parti commumniste sont-ils dépassés?' (2007)

Cahiers d'Art, esp. nos 8–10 (1937)

Les Cahiers du Bolchevisme, organe théorique du Parti communiste français (SFIC), 1924–42

La Commune. Revue d'Histoire / Bulletin de l'Association des Amis de la Commune de Paris, 1871, 16 (January 1982); 49 (2012)

Les Lettres françaises

La Nouvelle Critique, revue du marxisme militant

Regards

Published Works

1936: Crises et espérances: les peintres et l'actualité, Musée d'art et d'histoire des Côtes d'Armor (Saint Brieuc: Le nouveau musée, 1986)

Abadie, D., ed., *Les Années cinquante* (Paris: MNAM, Centre Georges Pompidou, 1988)

Abakayeva de Tiesenhausen, A., 'Socialist Realist Orientalism? Depictions of Soviet Central Asia, 1934–1954', PhD thesis, Courtauld Institute of Art, University of London, 2010

Abraham, P., *Tiens bon la rampe!* (Paris: Les Éditeurs Français Réunis, 1951)

Adamson, N., *Painting, Politics and the Struggle for the École de Paris, 1944–1964* (Farnham: Ashgate, 2009)

AÉAR, *Exposition des artistes révolutionnaires* (Paris: Association des Écrivains et des Artistes Révolutionnaires, 1934)

Aksenov, I., *Pikasso I okresnosti, sdvenadca'ju meccotintogravjurami s kartin mastera* (Moscow: Centrifuga, 1917)

Alary E., Vergez-Chaignon B., *Dictionnaire de la France sous l'Occupation*, (Paris: Larousse, 2011)

Alleg H., *La Question*, (Paris: Minuit 1958) and reeditions.
 Quarante ans après la guerre d'Algérie. Retour sur 'la question'. Entretien avec Gilles Martin, Paris, Le Temps des Cerises; Brussels, Aden, 2002

Althusser L., *Écrits philosophiques et politiques I*, (F. Matheron ed.,) (Paris: Stock/IMEC, 1994).

Althusser, L., *Écrits philosophiques et politiques*, ed. F. Matheron, vol. I (Paris: Stock/IMEC, 1994)

Andral, J.-L., et al. *La Révolution Picasso, 40ᵉ anniversaire de sa mort*, special number (Paris: l'Humanité, March 2013)

Andrew, D., and Ungar, S., eds, *Popular Front: Paris and the Poetics of Culture* (Cambridge, MA: Belknap Press of Harvard University Press, 2005)

Anon., 'Un réquisitoire contre Picasso', *Preuves*, 1 (March 1951)

Anon., 'Art: Skeleton for UNESCO', *Time Magazine*, 14 April 1958

Antonova, I., et al., *Pablo Pikasso k 85 – letija, grafika, keramika, vy stavka is galerej Luizy Leris v Parize I moskovskih kollekcij* (Moscow: Sovetskij hudoznik, 1966)

Antliff, M., *Avant-garde Fascism. The Mobilisation of Myth, Art and Culture in France, 1909–1939* (Durham, NC: Duke University Press, 2007)

Affron, M., and Antliff, M., eds, *Fascist Visions: Art and Ideology in France and Italy* (Princeton, NJ: Princeton University Press, 1997)

Afoumado, D.F., *L'Affiche antisémite en France sous l'Occupation* (Oxford: Berg International, 2008)

Alleg, H., *La Question* (Paris: Minuit, 1958)

— *Retour sur la question, Entretien avec Gilles Martin* (Paris: Le Temps des Cerises, 2001)

American Painting and Sculpture: American Nati Exhibition in Moscow, (1959)

An, Hui-Kyung, 'Working with History: Images of the Paris Commune in Soviet Visual Art and Culture during the Civil War and the First Five Year Plan', MA dissertation, Courtauld Institute of Art, 2008

Applebaum, A., *Gulag: A History* (New York: Doubleday, 2003)

Approches marxistes. Revue d'analyse de la Gauche Commumniste / PCF, esp. nos 4, 'L'incontournable Marxisme de Marx', and no 5, ' Le Stalinisme du PCF', 2005, and no 12, 'Le Communisme et ses fondements marxistes qui ont donné naissance au parti commumniste sont-ils dépassés?', 2007

Aragon, L., 'La Peinture au tournant', *Commune*, 22 (April 1935)

— ed., *Collection de l'Association Internationale des Écrivains pour la Défense de la Culture* (Paris: Éditions Denoël, n.d)

— *Pour un réalisme socialiste* (Paris: Éditions Denoël et Steele, 1935)

— et al., *La Querelle du réalisme* (Paris: Éditions Sociales Internationales, 1936); new edn, *La Querelle du réalisme*, ed. S. Fauchereau (Paris: Cercle d'Art, 1987)

— 'Le Réalisme à l'ordre du jour', *Commune*, 37 (September 1936)

— *Le Crime contre l'esprit (les martyrs) par le témoin des martyrs* (Paris: Presses de 'Libération', 1943)

— 'Réalisme socialiste, réalisme français', *Europe*, 183 (15 March 1938); repr. *La Nouvelle Critique*, 9 (1949)

— *Le Témoin des martyrs* (1942) (published clandestinely)

— ['François la Colère'], *Le Musée Grévin* (Paris: Éditions de Minuit, n.d.)

— 'Matisse-en-France' (preface), *Henri Matisse. Dessins. Thèmes et variations*, (Paris: Martin Fabiani, 1943)

— *Je vous salue, ma France* (Paris: Éditions FTPF, 1944)

— 'Le Maître de St-Sulpice', *Regards*, February 1945; repr. *Notre Musée*, 114 (April 1989)

— 'L'Art zone libre?', *Les Lettres françaises*, 29 November 1946

— 'Apologie du luxe' (preface), in *Matisse*, Les Trésors de la peinture française (Geneva: Skira, 1946)

— preface, in P. Mérimée, *La Jacquerie* (Paris: La Bibliothèque Française, 1946)

— preface, in *André Fougeron, album de dessins* (Paris: Les Treize Épis, 1947)

— 'Jdanov et nous', *Les Lettres françaises*, 9 September 1948

— *Les Communistes*, 6 vols (Paris: La Bibliothèque Française, 1949–1951)

— *Le Scandale du Salon d'automne. L'art et le sentiment national*
(Paris: Éditions Les Lettres Françaises et Tous les Arts, 1951)

— 'Il y a des sculpteurs à Moscou', *Les Lettres françaises*, January 1952 and weekly
articles to May 1952 (see Ristat J., ed.)

— *Avez-vous lu Victor Hugo?*, (Paris: Éditeurs Français Réunis, 1952)

— *L'Exemple de Courbet* (Paris: Cercle d'Art, 1952)

— 'À haute voix', *Les Lettres françaises*, 9 April 1953

— 'Toutes les couleurs de l'automne', *Les Lettres françaises*, 12 November 1953

— *L'Homme communiste II* (Paris: Gallimard, 1953)

— with M.-A. Lansiaux, J. Milhau and B. Taslitzky, 'Discussions sur la peinture',
La Nouvelle Critique, May 1954

— *Picasso, deux périodes, 1900–1914 & 1950–1954* (Paris: Maison de la Pensée
Française, 1954)

— 'Discours au *XIII^e* Congrès du P.C.F.', *Cahiers du Communisme*, June–July 1954

— 'Le Sourire de Léger', *Les Lettres françaises*, 582 (25–31 August 1955)

— *Littératures soviétiques* (Paris: Denoël, 1955)

— *Histoire de l'U.R.S.S. de 1917 à 1960*, with André Maurois, *Histoire des États-Unis
de 1917 à 1961* (Paris: Les Presses de la Cité, 1962)

— *Europe*, 454–55 (February–March 1967), Elsa Triolet and Louis Aragon issues

— *Henri Matisse, roman*, (Paris: Gallimard, 1971)

— et al., *Picasso et la paix*, (Ceret: Musée d'art Moderne, 1973)

— (Ristat J. ed.) *Louis Aragon. Écrits sur l'art moderne*, (Paris: Flammarion, 1981;
new edition 2011).

'Aragon au défi', *Les Petits Écrasons*, 4 (Paris: Le Terrain Vague, 1966)
(various authors)

Aron, R., 'L'U.R.S.S. possède la bombe atomique', *Le Figaro*, 3 October 1949

— *Le Grand Schisme* (Paris: Gallimard, 1948)

— *Guerres en chaîne* (Paris: Gallimard, 1951)

— *La Guerre froide* (Paris: Bernard de Fallois, 1990)

— *L'Opium des intellectuels* (Paris: Calmann-Lévy, 1955)

— *Le Marxisme de Marx* (Paris: Éditions de Fallois, 2002)

Arnauld, M.-P., and Regnier, G., eds, *Les Archives de Picasso 'on est ce que l'on garde'*
(Paris: RMN–Musée Picasso, 2003)

L'Art français, Paris, Front National des Arts (clandestine)

'L'Art en Russie', *l'Œil*, special number 11, November 1955, various authors

Art et idéologies, l'art en Occident 1945–1949, Université de Saint-Étienne,
Travaux XX (Saint-Étienne: CIEREC, 1976) (various authors)

Art populaire et loisirs ouvriers (Paris: Société des Nations, 1934)

*Art et résistance. Exposition organisée par les Amis des Franc-Tireurs et Partisans
Français au profit de leurs œuvres* (Paris: Musée des Arts Modernes, 1946)

'Art et résistance', *Arts de France*, special supplement, 1946 (various authors)

'L'Art sacré. Bilan d'une querelle', *Art Sacré*, 9–10 (May–June 1952), special issue
(various authors)

Les Arts plastiques en U.R.S.S. (Paris: Éditions Sociales Internationales, 1935)

Les Arts plastiques de l'URSS à l'exposition industrielle soviétique, Paris, 1961
 (Moscow: Édition des Arts, 1961)
Asratyan, E.A., *I. P. Pavlov His Life and Work* (Moscow: Foreign Languages
 Publishing House, 1953) (Russian 1949)
Atomes, tous les aspects scientifiques d'un nouvel âge, 1 (March 1946) (periodical)
Aucouturier, M., *Le Réalisme socialiste* (Paris: PUF, 1998)
Azéma, J.-P., Prost, A., and Rioux, J.-P., *Le Parti Communiste des années sombres,
 1938–1941* (Paris: Seuil, 1986)
Prost, A., and Rioux, J.-P., *Les Communistes français de Munich à Châteaubriant,
 1938–1941* (Paris: Seuil, 1987)
Bach R., 'L'identification des Juifs: l'héritage de l'exposition de 1941',
 in *Revue d'histoire de la Shoah*, no.173, 2001
Badia, G., ed., *Les Barbelés de l'exil. Études sur l'émigration allemande et autrichienne
 (1938–1940)* (Grenoble: Presses universitaires de Grenoble, 1979)
— ed., *Les Bannis de Hitler: accueil et lutte des exilés en France, 1933–9*
 (Paris: Presses universitaires de Vincennes, 1984)
— 'Heurs et malheurs des émigrés allemands dans la France de 1933 à 1939',
 Annales de la société des amis de Louis Aragon et Elsa Triolet, 3 (2001)
Badiou, A., *L'Écharpe rouge: roman-opéra* (Paris: Maspero, 1979)
— *Le Réveil de l'histoire* (Paris: Nouvelle éditions lignes, 2011)
— 'The Idea of Communism', in C. Douzinas and S. Žižek, eds,
 The Idea of Communism (London: Verso, 2010)
— and Žižek, S., eds, *L'Idée du communisme* (Paris: Lignes, 2010)
Baldessari, A., *Picasso/Dora Maar, il faisait tellement noir...,*
 (Paris: RMN/ Flammarion, 2006)
 Picasso: Life with Dora Maar. Love and War 1935–1945, (Melbourne:
 National Gallery of Victoria), (Paris: RMN / Flammarion, 2006)
— with Antonova, I., et al., *Picasso. Moskva: iz sobraniâ Nacional'nogo Muzeâ Pikasso,
 Pariz* (Moscow: Pushkin Museum / Paris: Musée National Picasso, 2010)
Balfour, M., *The Adversaries. America, Russia and the Open World, 1941–1962*
 (London: Routledge and Kegan Paul, 1981)
Bajanov, E., 'The Origins of the Korean War. An Interpretation from Soviet
 Archives', July 1995, http://www.alternativeinsight.com/Korean_War.html
 (accessed 22 August 2013)
Barbusse, H., *Russie* (Paris: Flammarion, 1930)
— *Staline, un monde nouveau à travers un homme* (Paris: Flammarion, 1935)
Barcellini, S., 'Sur deux journées nationales commémorant la déporation et les
 persécutions des années noires', *Vingtième siècle*, 45 (January–March 1995)
— and Wieviorka, A., *Passant souviens-toi! Les lieux de souvenir de al Seconde
 Guerre Mondiale en France* (Paris: Plon, 1995)
Baron, S.H., *Plekhanov, The Founder of Russian Marxism* (London: Routledge
 and Kegan Paul, 1963)
Baronnet, J., and Azéma, J.-P., *Les Parisiens sous l'Occupation. Photographies
 en couleur d'André Zucca* (Paris: Gallimard / Bibliothèque historique
 de la Ville de Paris, 2008)

Barr, A.H., ed., *Picasso, Fifty Years of His Art*
(New York: Museum of Modern Art, 1946)
— *Picasso, 75th anniversary exhibition* (New York: Museum of Modern Art, 1957)
Barth, K., et al., *Pour un nouvel humanisme* (Neuchâtel: Les Éditions de la
Baconnière, 1949)
Barthélemy, Ch., 'Staline au miroir de l'affiche soviétique', *Communismes*, 90/2
(2007)
Barthes, R., *Mythologies* (Paris: Gallimard, 1957)
Baschet, J., *Sculpteurs de ce temps* (Paris, 1945)
— *Pour une renaissance de la peinture française* (Paris: Éditions SNEP-Illustration,
1946)
Basset, P., *The Rebels of Modern Art? La Jeune Peinture, Paris 1948–1958*
(Flassans-sur-Issole: Un certain regard, 2009)
Bataille, G., 'Jean-Paul Sartre. Réflexions sur la question juive', *Critique*, 12 (1947)
Bauer, G., *Sartre and the Artist* (Chicago and London: University of Chicago Press,
1969)
Bauquier, G., *Fernand Léger. Vivre dans le vrai* (Paris: Adrien Maeght éditeur, 1987)
Bazin, G., Review of Max Raphael, *Proudhon, Marx, Picasso, L'Amour de l'Art*, 9
(1935)
Beaulieu, J., and Roberts, M., eds, *Orientalism's Interlocutors: Painting, Architecture,
Photography* (Durham, NC, and London: Duke University Press, 2002)
Beaumont-Maillet, L., et al., *La Photographie humaniste 1945–1968* (Paris,
Bibliothèque Nationale de France, 2006)
de Beauvoir, S., and Halimi, G., *Djamila Boupacha* (Paris: Gallimard, 1962)
Becker, A., *Maurice Halbwachs, un intellectuel en guerres mondiales 1914–1945*
(Paris: Agnès Viénot, 2003)
Becker, J.J., and Bernstein, S., *Histoire de l'anticommunisme*
(Paris: Olivier Orban, 1987)
Bédarida, F., and Gervereau, L., eds., *La déportation : le système concentrationnaire
nazi* (Nanterre: BDIC, 1995)
Beechey, J., and Stephens, C., eds, *Picasso and Modern British Art*
(London: Tate Publishing, 2012)
Benjamin, W., 'Critique of Violence' (1921), in Benjamin, *Reflections:
Essays, Aphorisms, Autobiographical Writings*, ed. E. Jephcott
(New York: Schocken Books, 1986)
— 'L'Œuvre d'art à l'époque de sa reproduction mécanisée', trans. P. Klossowski,
Zeitschrift für Sozialforschung, vol. V (Paris: Alcan, 1936)
— *Œuvres choisies* (Paris, 1959)
— *Écrits français*, ed. J.-M. Monnoyer (Paris: Gallimard, 1991)
Benot, Y., *Massacres coloniaux* (Paris: La Découverte, 2001)
Bensaid, D., *Passion Karl Marx. Les hiéroglyphes de la modernité* (Paris: Textuel, 2001)
Bérard, E., *La Vie tumultueuse d'Ilya Ehrenbourg, juif, russe et soviétique* (Paris:
Éditions Ramsay, 1991)
Berberova, N., *Chroniques de Billancourt* (Arles: Actes Sud, 1999)

Berdaiev, N., 'Vérité et mensonge du Communisme', *Esprit*, 1 (October 1932), special number 'Confrontations: Le Communisme devant l'Occident'
— *Les Sources et le sens du communisme russe* (Paris: Gallimard, 1963 [1938]).
Berelowitch, W., and Gervereau L., eds., *Russie-URSS 1914-1991: changement de regards* (Nanterre : BDIC 1991)
Beridze, V.V., et al., *David Kakabadze* (Tbilisi: Sov. khudozhnik, 1989)
Berger, J., *Permanent Red. Essays in Seeing* (London: Methuen, 1960)
— *Success and Failure of Picasso* (London: Granta Books, 1992 [1965])
— *La Réussite et l'échec de Picasso* (Paris: Les Lettres Nouvelles / Denoël, 1968)
— *The Moment of Cubism and Other Essays* (London: Weidenfeld and Nicolson, 1969)
— 'Revolutionary Undoing. Max Raphael', *New Society*, 1969; repr. in *Selected Essays and Articles: The Look of Things* (Harmondsworth: Penguin, 1971)
Bernadac, M.-L., et al., *Le Dernier Picasso, 1953–1973* (Paris: Centre Georges Pompidou, 1988); Eng. trans., *Late Picasso* (London: Tate Gallery, 1988)
Bernard, Jean-Pierre, *Paris rouge, 1944–1964: Les Communistes français dans la capitale* (Paris: Champ Vallon, 1991)
Bernard, Jean-Pierre, et al., *Silex*, 20 (1981), special issue 'Chronique sur les années froides'
Bernatowicz, P., and Lahoda, V., 'Picasso and Central Europe after 1945', in C. Grunenberg and L. Morris, eds, *Picasso, Peace and Freedom* (London: Tate Publishing, 2010)
Berthet, D., *Le P.C.F., la culture et l'art (1947–1954)* (Paris: La Table Ronde, 1990)
— *Proudhon et l'art. Pour Courbet* (Paris: L'Harmattan, 2001)
Bertrand, Ch., ed., *Algérie 1830–1962 avec Jacques Ferrandez* (Paris: Musée de l'armée / Casterman, 2012)
Bertrand-Dorléac, L., *Histoire de l'art Paris: 1940–1944* (Paris: Presses de la Sorbonne, 1986)
— *L'Art de la défaite 1940–1944* (Paris: Seuil, 1993); Eng. trans. *Art of the Defeat: France 1940–1944*, trans. J.M. Todd (Los Angeles: Getty Research Institute, 2008)
— 'Les Arts plastiques', in L. Gervereau and D. Pechanski, eds, *La Propagande sous Vichy, 1940–1944* (Paris: Éditions BDIC, 1990)
— and Michael, A., eds, *Picasso, l'objet du mythe* (Paris: ENSBA, 2002)
— and Munck, J., eds, *L'Art en guerre, Paris 1938–1947* (Paris: Musée de la Ville de Paris, 2012)
Beskin, O., *On Formalism* (Moscow: Izd. 'Vsekokhudozhnik', 1933)
— *The Place of Art in the Soviet Union* (New York: The American Russian Institute for Cultural Relations with the Soviet Union, 1936)
Besse, J.-P., and Pouty, T., *Les Fusillés: répression et exécutions pendant l'occupation, 1940–1944* (Paris: L'Atelier, 2006)
Besson, G., 'Les Expositions. La querelle du réalisme', *L'Humanité*, 19 July 1936
Betz, P., ed., 'Les Imprimeries clandestines', *Le Point*, 31, (Souillac: 1945); Underground Presses, (London, New York: Pentagram Design, 1986)
Bibrowski, M., et al., *Picasso w Polsce* (Crakow: Wydawnicto Literackie, n.d.)

Bibrowska, S., *Une Mise à mort. L'itinéraire romanesque d'Aragon*
(Paris: Denoël, 1972)

Billiet, J., *Frans Masereel, l'homme et l'œuvre* (Paris: Les Écrivains Réunis, 1925)

— *La Culture artistique en U.R.S.S.* (Paris: France–URSS, 1945)

Bizardel, Y., *Sous l'occupation. Souvenirs d'un conservatuer de musée*
(Paris: Calmann-Lévy, 1964)

Blanchot, M., *L'Écriture du désastre* (Paris: Gallimard, 1980);
Eng. trans. *The Writing of the Disaster*, trans. A. Smock
(Lincoln, NE: University of Nebraska Press, 1986)

Blazwick, I., et al., *Goshka Macuga: The Nature of the Beast*
(London: Whitechapel Art Gallery, 2010)

Blévis, L., et al., *1931 – Les Étrangers au temps de L'Exposition coloniale*
(Paris: Cité Nationale de L'Histoire de l'Immigration / Gallimard, 2008)

Bloch, J.R., 'Le Fascisme qui est en nous', *Commune*, 15 January 1937

Blunt, A., 'Art in Paris', *The Spectator*, 6 August 1937

— 'Picasso Unfrocked', *The Spectator*, 8 October 1937

— and Pool, P., *Picasso, The Formative Years. A Study of his Sources*
(London: Studio Books, 1962)

— *Picasso's Guernica* (London: Oxford University Press, 1969)

— Memoir (1979-1983); Memoir, revised draft, (1983) British Library manuscripts

Bodin, L., and Touchard, J., *Front Populaire, 1936* (Paris: Armand Colin, 1961)

Body, M., *Les Groupes communistes français de Russie* (text of 1919, Paris: Éditions
Allia 1988)

Bogdanov, A., *La Science, l'art et la classe ouvrière*, trans. B. Grinbaum
(Paris: Maspéro, 1976)

Boggs, J.S., 'Picasso and Communism', *Artscanada*, 236–37 (September/October 1980)

Boneau, D., 'The Betrayal of the Intellectuals: Raymond Aron, the Atlantist
Prosecutor', Voltaire Network, 21 October 2004, http://www.voltairenet.org/
article30054.html (accessed 10 July 2013)

Borland, H., *Soviet Literary Theory and Practice during the First Five-Year Plan,
1928–1932* (New York: Columbia University Press, 1950)

Bougnoux, D., *Aragon, le confusion des genres* (Paris: Gallimard, 2012)

Bouju, M.-C., *Lire en communiste. Les maisons d'édition du Parti Communiste
français, 1920-1968* (Rennes: Presses Universitaires de Rennes, 2010)

Bosteels, B., *The Actuality of Communism* (London: Verso, 2011)

Bouayed, A., with Alleg, H., *Un Voyage singulier. Deux peintres en Algérie
à la veille de l'insurrection 1951–1952. Mireille Miailhe / Boris Taslitzky*
(Paris: Art et mémoire au Maghreb, 2009)

Boudaille, G., et al., *Picasso. Portrait de Madame H.P.* (Paris: Binoche, 1994)

Boudrel, Ph., *L'Épuration sauvage, 1944–1945* (Paris: Perrin, 2008 [2002])

Bouderon, R., *Le PCF à l'épreuve de la guerre, 1940–1943. De la guerre impérialiste
à la lutte armée* (Paris: Syllepse, 2012)

Boujut, M., *Le Fanatique qu'il faut être. L'énigme Kanapa* (Paris: Flammarion, 2004)

Bourdieu, P., 'La Lecture de Marx ou quelques remarques à propos de
'Lire le Capital', *Actes de recherches en sciences sociales*, 5–6 (November 1975)

Bourguet, P., and Lacretelle, Ch., *Sur les murs de Paris: 1940–1944*
(Paris: Librarie Hachette, 1959)

Bouvier-Ajam, S., 'Picasso et la Maison de la Pensée Française', *Europe*, 492–93
(April–May 1970), special Picasso number

— 'Fernand Léger et la Maison de la Pensée Française', *Europe*, 508–09
(August–September 1971), special Fernand Léger number

Bown, M., and Lafranconi, M., eds, *Socialist Realisms. Soviet Painting 1920–1970*
(Geneva: Skira, 2012)

Bowness, S., 'Léger and Le Corbusier, 1928–1935', MA diss., Courtauld Institute
of Art, University of London, 1987

— 'The Presence of the Past, Art in France in the 1930s with Special Reference
to Le Corbusier and Braque', PhD thesis, University of London, 1996

Bozo, D., et al., *Picasso. Œuvres reçues en paiement des droits de succession*
(Paris: Réunion des Musées Nationaux 1979)

Brassaï (pseud.), *Conversations avec Picasso* (Paris: Gallimard, 1964)

Breker, A., *Paris: Hitler et moi* (Paris: Presses de la Cité, 1970)

— *Arno Breker, 60 ans de sculpture* (Paris: Jacques Damase éditeur, 1981)

Breteau-Skira, G., and Bernadac, M.-L., *Picasso à l'écran* (Paris: RMN /
Centre Georges Pompidou, 1992)

Breton, A., *Misère de la poésie, 'l'Affaire Aragon' devant l'opinion publique*
(Paris: Éditions Surréalistes, 1932)

— 'Picasso dans son élément', *Minotaure*, 1 (1933)

— *Position politique du surréalisme* (Paris: Sagittaire, 1935)

— 'Limites non-frontières du surréalisme', *La Nouvelle Revue française*, 281
(February 1937)

— *Le Clé des champs* (Paris: Pauvert, 1979 [1953])

— *Entretiens, 1913–1952* (Paris: Gallimard, 1969)

Brissaud, S., 'Les Arts dans *Les Lettres françaises* de la clandestinité à 1945',
MA thesis, Paris-Sorbonne I, 1980

Brodersen, W., 'Medien reflexion als Methode künstlerischer Arbeit',
in H.J. Neyer, ed., *Absolut Modern Sein – culture technique in Frankreich
1889–1937* (Berlin: Elefanten Press Verlag, 1985)

Brossat, A., *Les Tondues. Un carnaval moche* (Levallois-Perret: Manya, 1992)

Brunner, K., *Picasso Rewriting Picasso* (London: Black Dog, 2004)

Bruttmann, T., ed., *La Spoliation des Juifs: une politique de l'État*
(Paris: Mémorial de la Shoah, 2013)

Bucaille, R., et al., *Jean Amblard artiste-peintre 1911–1989*
(Puy-de-Dôme: Carnets patrimoniaux du Puy-de-Dôme, 2011)

Bueltzingsloewen, I. von, ed., *Morts d'inanition, famines et exculsions en France
sous l'Occupation* (Rennes: Presses Universitaires de Rennes, 2005)

Bugler, C., '"Innocents Abroad": Nineteenth-Century Artists and Travellers
in the Near East and North Africa', in M.A. Stevens, ed., *The Orientalists:
Delacroix to Matisse* (London: Royal Academy of Arts, 1984)

Buican, D., *Lyssenko et le lyssenkisme* (Paris: PUF, 1988)

Buisson, S., et al., *Montparnasse déporté, artistes d'Europe*
 (Paris: Musée de Montparnasse, 2005)
Burnham, J., *The Managerial Revolution* (New York: John Day, 1941); French trans.
 L'Ère des organisateurs, trans. Hélène Claireau (Paris: Calmann-Lévy, 1947)
Buton, P., and Gervereau, L., eds, *Le Couteau entre les dents*
 (Paris: BDIC–Chêne, 1989)
Cabanne, P., *Le Pouvoir culturel sous la Vᵉ République* (Paris: Olivier Orban, 1981)
Calvié, L., *Le Renard et les raisins. La Révolution française et les intellectuels*
 allemands 1789-1945 (Paris: Études et documents internationales, 1989)
Camus, A., 'Au lendemain d'Hiroshima', editorial, *Combat*, 8 August 1945
— *L'Homme révolté* (Paris: Gallimard, 1951)
Carrère d'Encausse, H., *1956: La Deuxième Mort de Staline*
 (Paris: Éditions Complexe, 2006)
Cartier, J.A., *André Fougeron*, Les Cahiers d'art – Documents, 7
 (Geneva: Pierre Cailler, 1955)
Casanova, L., *Le Communisme, la pensée et l'art*
 (Paris: Éditions du Parti Communiste, 1947)
— *Responsabilités de l'intellectuel communiste*
 (Paris: Éditions de la Nouvelle Critique, 1949)
— *Le Parti communiste, les intellectuels et la nation* (Paris: Éditions Sociales, 1949)
Cassou, J., 'De plus ou moins de réalité', *Arts de France*, 3 (February 1946)
— ed., *Témoignages sur Auschwitz.* (Paris: Amicale des Déportés d'Auschwitz, 1946)
— ed., *Le Pillage par les allemands des œuvres d'art et des bibliothèques appartenant*
 à des juifs en France (Paris: Éditions du Centre, 1947)
— et al., *L'Heure du choix* (Paris: Éditions du Centre, 1947)
— 'Enquête sur la réalisme socialiste II', *Preuves*, 15 (May 1952)
— ed., *Art mexicain du précolombien à nos jours* (Paris: Musée d'Art Moderne, 1953)
— *Une vie pour la liberté* (Paris: Éditions Robert Laffont, 1981)
Caute, D., *Communism and the French Intellectuals, 1914–1960*
 (London: André Deutsch, 1967)
— *The Fellow Travellers. A Postscript to the Enlightenment*
 (London: Weidenfeld and Nicolson, 1973)
— *The Dancer Defects. The Struggle for Cultural Supremacy during the Cold War*
 (Oxford: Oxford University Press, 2003)
Ceplair, L., *Under the Shadow of War. Fascism, Anti-Fascism and Marxists, 1918–1939*
 (New York: Columbia University Press, 1987)
Ceysson, B., ed., *André Fougeron à l'exemple de Courbet, 1913–1998*
 (Paris: Somogy / Musée d'art et d'histoire du Luxembourg, 2005)
Chabrol, V., 'Jeune France, une expérience de recherche et de décentralisation
 culturelle, novembre 1940–mars 1942', doctorate, Université de Paris-Sorbonne 3,
 1974
Chaintron, J., *Le Vent soufflait devant ma porte* (Paris: Seuil, 1993)
Chapman, R., *Henri Poulaille and Proletarian Literature, 1920–1939*
 (Amsterdam: Rodopi, 1992)

Chapsal, F. et al., eds, *Livre d'or officiel de l'Exposition Internationale des arts et des techniques de la vie moderne, Paris, 1937* (Paris: Spec, 1938)

Charpier, F., *La CIA en France, 60 ans d'ingérence dans les affaires françaises* (Paris: Seuil, 2008)

Les Chefs-d'œuvre des collections privées françaises retrouvés en Allemagne par la Commission de récupération artistique et les services alliés (Paris: Ministère de l'Éducation Nationale, 1946)

Chefs d'œuvre de la peinture française dans les Musées de Leningrad et de Moscou (Paris: RMN, 1966)

Chevrefils-Desbiolles, Y., 'André Fougeron et le "drame de la réalité"', http://web504.imec-archives.com/2010Fougeron.pdf (accessed 10 July 2013)

Chipp, H.B., *Picasso's Guernica, History, Transformations, Meanings* (Berkeley: University of California Press, 1988)

Ciliga, A.A., *Au Pays du grand mensonge* (Paris: Gallimard, 1938); Eng. trans. *The Russian Enigma*, trans. Fernand G. Fernier (London: Routledge, 1940)

Le Cinémathèque de l'oRTF. Archives provenant des actualités Françaises, no. 1, *La Guerre, 1939–1945* (Paris: Institut National de l'Audiovisuel, n.d.)

Clair, J. (pseud), 'Cette chose admirable, le péché…', in G. Regnier, ed., *Corps crucifié* (Paris: Réunion des Musées Nationaux, 1993)

Clark, J., 'From Pravda to Prada. Oscar Niemeyer's Parisian Architecture', MA thesis, London, Courtauld Institute of Art, 2002

Cochran, T.B., and Norris, R.S., 'A First Look at the Soviet Bomb Complex', *Bulletin of Atomic Scientists*, 47/4 (May 1991)

Cockroft, E., 'Abstract Expressionism, Weapon of the Cold War', *Artforum*, XII/10 (1974); repr. in F. Frascina, ed., *Pollock and After. The Critical Debate* (London: Harper and Row, 1985)

Cocteau, J., *Poèmes en allemand* (Paris, 1944)

Cognet, Ch., et al., *Boris Taslitzky. Dessins faits à Buchenwald* (Paris: Adam Biro, 2009)

Cœuré, S., 'Le Voyage en URSS, un exercise du style', in V. Jobert and L. de Meaux, eds, *Intelligentsia, entre France et Russie, archives inédites du XXᵉ siècle, Paris*, exhibition catalogue (Paris: Beaux-Arts de Paris, 2012)

Cogniot, R., *Les Intellectuels et la renaissance française* (Paris: Éditions du Parti Communiste français, 1945)

Cohen, F., et al., *Science bourgeoise et science prolétarienne* (Paris: La Nouvelle Critique, 1950)

Cohen, J.-L., 'L'École Karl Marx à Villejuif: la cité future aura un toit terrasse', *Architecture Mouvement Continuité*, 40 (September 1976)

— *Le Corbusier et la mystique de l'URSS, théories et projets pour Moscou, 1928–1936* (Liège: Pierre Mardaga, 1987); Eng. trans. *Le Corbusier and the Mystique of the USSR. Theories and Projects for Moscow*, trans. Kenneth Hilton (Princeton, NJ: Princeton University Press, 1992)

— 'Architectures du Front populaire', *Le Mouvement social: bulletin trimestriel de l'Institut français d'histoire sociale*, 13 (January–March 1989)

— *André Lurcat, 1894–1970, Autocritique d'un moderne* (Liège: Pierre Mardaga, 1995)

Coleman, P., *The Liberal Conspiracy: The Congress for Cultural Freedom and the Struggle for the Mind of Postwar Europe* (New York and London: The Free Press, 1989)

Comber, S., and Grand, Ph., 'Les Archives en France. Transparence et opacité (L'affaire du "Fichier des juifs")', *Lignes*, 23 (1994)

'Le Communisme, une histoire française', *Marianne,* November 2009, special number

Cone, M.C., 'Abstract Art as a Veil: Tricolor Painting in Vichy France', *Art Bulletin*, 78/2 (June 1992)

— *Art and Politics in France during the German Occupation, 1940–1944* (Ann Arbor, MI: Ann Arbor Press, 1989)

— *French Modernisms: Perspectives on Art before, during and after Vichy* (Cambridge: Cambridge University Press, 2001)

Conio, G., ed., *Le Formalisme et le futurisme russes devant le marxisme – problèmes de la révolution culturelle* (Lausanne: L'Âge d'Homme, 1975)

Cooper, B., *Merleau-Ponty and Marxism. From Terror to Reform* (Toronto, Buffalo, and London: University of Toronto Press, 1979)

Copleston, F.C., *Philosophy in Russia from Herzen to Lenin and Berdaev* (Tunbridge Wells and Indiana: Search Press, University of Notre-Dame, 1986)

Le Corbusier, *DES CANONS, DES MUNITIONS? MERCI! DES LOGIS... S.V.P.* (Boulogne: L'Architecture d'Aujourd'hui, 1938)

Cornu, A., *Karl Marx et Friedrich Engels, leur vie et leur œuvre*, vol. 3: *Marx à Paris* (Paris: Presses Universitaires de France, 1962)

Coston, H., ed., *Je vous hais!* (Paris: Institut d'études sur les questions juives, 1944)

Coudert, M.C., *Elles: la résistance* (Paris: Messidor, Temps Actuels, 1985)

Courban A. ed., *Artistes et Métallos, quand l'avenir se dessine à l'atelier* (Paris, Institut d'Histoire sociale-CGT, 2011)

Courcelles, P., 'Les Années 50', *Révolution*, 445 (9 September 1988)

Courtat-Kaleka, M., 'Les Arts plastiques dans Les Lettres françaises, 1947–8', MA thesis, Paris-Sorbonne 1, 1981

Courtois, S., *Le Communisme* (Paris: MA Éditions, 1987)

— ed., *Willi Münzenberg 1889-1940. Un homme contre* (Aix: La Bilbliothèque Méjanes, 1993)

— ed., *Communisme*, 38–39 (1994), special Münzenberg issue

— and Lazar, M., eds, *Histoire du Parti Communiste Français* (Paris: PUF, 1995)

— Werth, N., and Panné, J.-L., *Le Livre noir du Communisme, crimes, terreur, répression* (Paris: Laffont, 1997); Eng. trans. *The Black Book of Communism: Crimes, Terror, Repression*, trans. J. Murphy (Boston: Harvard University Press, 1999)

Couturier, M.-A., Capellades, M.-R., Rayssiguier, L.-B., and Cocagnac, A. M., *Les Chapelles du Rosaire à Vence par Matisse et de Notre-Dame de Haut à Ronchamp par Le Corbusier* (Paris: Les Éditions du Cerf, 1950)

Cullerne-Bown, M., *Art under Stalin* (Oxford: Phaidon, 1991)

— *Socialist Realist Painting* (New Haven, CT, and London: Yale University Press, 1998)

Dabrowski, M., 'González, Montserrat and the Symbolism of Civil War', in Robinson, W. H. et. al., *Barcelona and Modernity. Picasso, Dali, Miró, Gaudi*, (Cleveland, Ohio: Cleveland Museum of Art with New Haven and London, Yale University Press, 2006)

Daix, P., *Aragon, une vie à changer* (Paris: Seuil, 1975)

— *J'ai cru au matin* (Paris: Robert Laffont, 1976)

— *La Vie de peintre de Pablo Picasso* (Paris: Seuil, 1977)

— *L'Ordre et l'aventure. Peinture, modernité et répression totalitaire* (Paris: Arthaud, 1984)

— *Tout mon temps, révisions de ma mémoire* (Paris: Fayard, 2001)

— *Les après-guerres de Picasso (1945-1955) et sa rupture avec Aragon* (Paris: Ides et Calendes, 2006)

— *Le Nouveau Dictionnaire Picasso* (Paris: Robert Laffont, 2012)

David-Fox, M., *Showcasing the Great Experiment, Cultural Diplomacy and Western Visitors to the Soviet Union, 1921–1941* (Oxford: Oxford University Press, 2011)

Davies, R.W., and Wheatcroft, S.G., *The Years of Hunger: Soviet Agriculture 1931–1933* (Basingstoke: Palgrave Macmillan, 2010)

Debidour, V.-H., ed., *Problèmes de l'art sacré* (Paris: le Nouveau Portique, 1951)

Debord, G., *La Société du spectacle* (Paris: Gérard Lebovici, 1987 [1967])

Débu-Bridel, J., *La Résistance intellectuelle* (Paris: Julliard, 1970)

Degand, L., *Abstraction / Figuration. Langage et signification de la peinture*, ed. D. Abadie (Paris: Cercle d'Art, 1988)

Delbo, Ch., *Le Convoi du 24 janvier* (Paris: Minuit, 1965)

— *Auschwitz and After* (New Haven, CT, and London: Yale University Press, 1997)

Demenchonok E., ed., *Philosophy after Hiroshima* (Newcastle: Cambridge Scholars Publishing, 2010)

Denoyelle, F., and Cuel, F., *Le Front Populaire des photographes* (Paris: Terre Bleue, 2006)

Depresle, G., *Anthologie des écrivains ouvriers* (Paris: Éditions d'Aujourd'hui, 1925)

Dérouet, C., 'Les Réalismes en France, rupture ou rature', in J. Clair, ed., *Les Réalismes entre révolution et réaction* (Paris: MNAM / Centre Georges Pompidou, 1981)

— ed., *Fernand Léger: Lettres à Simone* (Paris: Centre Georges Pompidou / Skira, 1989)

— 'Le Nouveau Réalisme de Fernand Léger. La modernité à contre-pied', *Cahiers du Musée National d'Art Moderne*, 19–20 (June 1987)

— and Lehni, N., *Jeanne Bucher. Une galerie d'avant-garde 1925–1946. De Max Ernst à de Staël* (Strasbourg: Musées de la Ville de Strasbourg, 1994)

'Depuis 100 ans le mur', *La Commune*, 16 (January 1982)

Derrida, J., *De la Grammatologie* (Paris: Minuit, 1967)

— *Pardonner. L'impardonnable et l'imprescriptible* (Paris: Gallimard, 2012)

Désanges, G., ed., *Les Vigiles, les menteurs, les rêveurs* (Paris: Le Plateau / FRAC Île-de-France, 2010)

Desanti, D., *Nous avons choisi la paix* (Paris: Éditions Pierre Seghers, 1949)

— with Haroche, Ch., eds, *Bombe ou paix atomique?* (Paris: Éditions Sociales, 1950)

— *La Colombe vole sans visa* (Paris: Les Éditeurs Français Réunis, 1951)

— *Les Staliniens, une expérience politique, 1944–1956* (Paris: Fayard, 1974)

Despiau, Ch., *Arno Breker* (Paris: Flammarion, 1942)

Desnos, R., *Picasso: seize peintures 1939–1943* (Paris: Chêne, 1943)

Desprairies, C., *Ville lumière – années noires, les lieux du Paris de la Collaboration* (Paris: Denoël, 2008)

— *Paris dans la Collaboration* (Paris: Seuil, 2008)

— *Sous l'œil de l'Occupant, La France vue par l'Allemagne, 1940–1944* (Paris: Armand Colin 2010)

— *L'Héritage de Vichy. Ces 100 mésures toujours en vigeur* (Paris: Armand Colin, 2012)

Devaux, S., ed., *La Dernière Guerre vue à travers les affiches* (Paris: Grange Batelière, 1976)

Devillers, Ph., 'Le Conflit vu d'Europe', *Revue française de science politique*, 6 (1970)

Dewasne, J., 'Art abstrait et objectivité', *La Nouvelle Critique*, 16, new series (1968)

Didi-Hubermann, G., *Devant le temps. Histoire de l'art et anachronisme des images* (Paris: Minuit, 2000)

— 'Le Bref Été de la dépense: Carl Einstein, Georges Bataille et l'économie-Picasso', *Cahiers du Musée national d'art moderne*, 120 (summer 2012)

Dioujeva, N., and George, F., *Staline à Paris* (Paris: Éditions Ramsay, 1982)

Dioujeva, N., and Wolton, T. eds, *Recherches*, 39 (October 1979), special number 'Culture et Pouvoir Communiste: l'autre face de Paris-Moscou'

Dirks, W., 'Le Marxisme dans une vision chrétienne', *Esprit* (May–June 1948), special issue, 'Marxisme ouvert contre marxisme scolastique'

Doisneau, R., *Doisneau-Renault* (Paris: Hazan, 1988)

Domenach, J.-M., *La Propagande politique* (Paris: Presses Universitaires de France, 1950)

Donskaya, S., *Yu Ganph, Master of Soviet Caricature*, Soviet Artists no. 28 (Moscow, 1990)

Dorival, B., *Les Étapes de la peinture française contemporaine* (Paris: Gallimard, 1944)

Doronchenkov, I., ed., *Russian and Soviet Views of Modern Western Art, 1890s to Mid-1930s* (Berkeley: University of California Press, 2009)

Dotremont, Ch., *Le Réalisme socialiste contre la révolution* (Paris: Éditions Cobra, 1950)

Douzinas, C., and Žižek, S., eds, *The Idea of Communism* (London: Verso, 2010)

Drewes, W., 'Max Raphael und Carl Einstein, Konstellationen des Aufbruchs in die "Klassische Moderne" Im "Zeichen der Zeit"', *Études germaniques*, 53/1 (1998)

Dreyfus, M., et al., *Le Siècle des communismes* (Paris: Éditions de l'Atelier, 2000)

Drieu de la Rochelle, P., *Socialisme fasciste* (Paris: Gallimard, 1934)

Duclos, J., *Les Droits de l'intelligence* (Paris: Éditions Sociales Internationales, 1937)

Docoloné, G., et al., *Femmes oubliées de Buchenwald* (Paris: Paris-Musées Musée Jean Moulin, 2005)

Dugrand, A., and Laurent, F., *Willi Münzenberg, artiste en révolution 1889–1940* (Paris: Fayard, 2008)

Dufils, A., 'Le Château de Baillet-en-France; une œuvre sociale des Métallurgistes CGT Parisiens', MA thesis, Université de Paris VIII, 2005

Duncan, D.D., *The Private World of Pablo Picasso* (New York: Harper, 1958)

— *Le Petit Monde de Pablo Picasso* (Paris: Hachette, 1959)

— *Goodbye Picasso* (London: Times Books, 1974)

Duprat, J., *Proudhon, sociologue et moraliste* (Paris: Alcan, 1929)

Dupré, M., *La Moustache de Picasso, 1953–2003* (Campagnan: EC Éditions, 2003)

— *Le Syndrome Picasso. 32 études* (Campagnan: EC Éditions, 2010)

Durand, D., *Danielle Casanova l'indomptable* (Paris: Messidor, 1990)

Duthuit, G., 'Union et distance', *Cahiers d'art*, 1–4 (1939)

Egger, A., with Badiou, A., et al., *Fred Stein, portraits de l'exil, Paris–New York; dans le sillage d'Hannah Arendt* (Paris: Musée de Montparnasse, Arcadia Éditions, 2011)

Egorov, A., 'L'Idéologie marxiste dans l'art soviétique', *Articles et Documents, La Documentation Française*, 01 (23 October 1954)

Ehrenburg, I., *Duhamel, Gide, Malraux, Mauriac, Morand, Romains, Unamuno, vus par un écrivain de l'U.R.S.S.* (Paris: Gallimard, 1934)

— *Le Dégel*, trans. D. Steinova, Y. Joye, (Paris: Défense de la Paix, 1954)

—, with Grossman, V., *The Complete Black Book of Soviet Jewry*, ed. and trans. D. Patterson (Piscataway, NJ: Transaction Publishers, 2002)

Epstein, S., *L'Antisémitisme français aujourd'hui et demain* (Paris: Belfond, 1984)

Elgey, G., *Front Populaire, Robert Capa, David Seymour 'Chim'* (Paris: Chêne / Magnum, 1976)

Éluard, P., *Poèmes politiques* (Paris: Gallimard, 1948)

— et al., *Jean Amblard. Les maquis de France* (Paris: Éditions Cercle d'Art, 1950)

— *Anthologie des écrits sur l'art*, 3 vols (Paris: Éditions Cercle d'Art, 1952–54)

Engels F. ed. Karl Marx, *Capital. A critical analysis of capitalist production*, vol. 1. (London: Lawrence and Wishart, 1967, 2001)

Escholier, R., *Les Maîtres de l'art indépendant* (Paris: Arts et métiers graphiques, 1937)

Estienne, Ch., *L'Art abstrait est-il un académisme?* (Paris: Édition de Beaune, 1950)

Etchegoin, M.E., and Raffy, S., 'Ces Français qui ont livré les juifs', *Le Nouvel Observateur*, 1337 (21–27 June, 1990)

Europe, especially Picasso issue, April–May 1970; Léger issue, August 1971

Exposition des artistes révolutionnaires (Paris: Association des Écrivains et des Artistes Révolutionnaires, 1934)

Exposition de l'Art Français Contemporain, Musée du Luxembourg (Paris: Union des Arts Plastiques, 1946)

Exposition d'arts plastiques au XVIIᵉ Congrès du parti communiste français (Paris: Parti Communiste Français, 1967)

Eychart, F., ed., 'La Controverse Aragon–Simonov (2 September 1947)', *Les annales de la Société des amis de Louis Aragon et Elsa Triolet*, 5 (2003)

Fanon, F., *L'An V de la révolution algérienne* (Paris: Maspero, 1959)

— *A Dying Colonialism* (Harmondsworth: Penguin, 1965)

Farran, E., ed., *La Réalité retrouvée. La Jeune Peinture Paris (1948–1958)* (Saint-Rémy-de-Provence: Musée Estrine, 2010)

Fauré, M., *Histoire du surréalisme sous l'Occupation* (Paris: La Table Ronde, 1982)

Fauvet, J., with Duhamel, A., *Histoire du Parti Communiste Français*, vol. II:
 1939–1965 (Paris: Fayard, 1965)
Féliciano, H., *Le Musée disparu, enquête sur le pillage d'œuvres d'art en France
 par les nazis*, trans. S. Doubin (Paris: Gallimard, 2009 [1995])
Feigelson, K., ed, *Caméra Politique. Cinéma et Stalinisme*,
 (Paris: Presses Sorbonne Nouvelle, 2005)
Ferier, G., *Les Trois Guerres d'Indochine* (Lyons: Presses Universitaires de Lyon, 1993)
Ferro, M., ed., *Le Livre noir du colonialisme* (Paris: Laffont, 2003)
Ferrier, J.-L., *Pignon* (Paris: Les Presses de la Connaissance, 1976)
— *De Picasso à Guernica, généalogie d'un tableau* (Paris: Denoël, 1985)
Field, F., *Three French Writers and the Great War: Barbusse, Drieu de la Rochelle,
 Bernanos. Studies in the Rise of French Communism and Fascism*
 (Cambridge: Cambridge University Press, 1975)
Finn, C., 'Rumours of War: Rudier and Art Bronze Casting during the Second
 World War', *Sculpture Journal*, 22.2 (2013)
Fischer, E., *Von der Notwendigkeit der Kunst* (Dresden: VEB Verlag der Kunst, 1959)
— *Kunst und Menschheit* (Vienna: Globus Verlag, 1949)
— *The Necessity of Art* (London: Verso, 2010)
Fisher, D.J., *Romain Rolland and the Politics of Intellectual Engagement*
 (Berkeley: University of California Press, 1988)
Flandin, S., 'André Fougeron : le parti pris du réalisme, 1948–1953', MA thesis,
 Université de Clermont-Ferrand, 1981–82
Flament, A., *Cresson, le peintre des synthèses populaires* (Paris: Galerie Gilbert, 1931)
Fleischer, A., 'A propos de Guernica', in A. Fleischer, ed., *L'Art d'Alain Resnais*
 (Paris: Centre Georges Pompidou, 1998)
Florman, L., *Myth and Metamorphosis. Picasso's Classical Prints of the 1930s*
 (Cambridge, MA: MIT Press, 2000)
Focillon, H., *Vie des formes* (Paris: Presses universitaires de France, 1934)
 Eng. trans. *The Life of Forms in Art*, trans. G. Kubler., (New York: Schultz, 1948)
Fontugne, J., ed., *Karl Marx, philosophe matérialiste*
 (Paris: Librairie Jules Tallandier, 1975)
Fonvieille-Alquier, F., *La Grande Peur de l'après-guerre*
 (Paris: Éditions Robert Laffont, 1973)
Forest, D., *La Guerre et La Paix*, petit guide, Musée National Picasso
 La Guerre et La Paix (Paris: RMN, 1996)
Forest, D., Lacambre, J., et al., *La Guerre et la Paix: Vallauris-Picasso*
 (Paris: RMN, 1998)
Forestier S. Pablo Picasso 'La Guerre et la Paix',
 (Paris: Réunion des Musées Nationaux, 1995)
— et al., *Georges Bauquier, entre dessin et peinture un artiste de cœur*
 (Contes: Médiathèque de Contes, 2011)
Forment, A., ed., *Josep Renau* (Valencia: IVAM, 2004)
Foster, J.B., and McChesney, R.D., eds, *Pox Americana: Exposing the American
 Empire* (London: Pluto Press, 2004)

Foucault, M., 'La Disparition du peintre', in P. Artières et al., eds,
 Les Cahiers de l'herne, Foucault (Paris: Éditions l'Herne, 2011)
— 'Des espaces autres' (Tunisia, 1967), *Architecture, Mouvement, Continuité*, 5
 (October 1984)
Fouché, P., *L'Édition française sous l'Occupation, 1940–1944*, 2 vols (Paris: Bibliothèque
 de Littérature Française Contemporaine [Université de Paris 7], 1987)
Fougeron, A., ed., *Vaincre*, (Paris: Front National des Arts, 1944)
— 'Le Peintre à son créneau', *La Nouvelle Critique*, (1 December 1948)
— 'Le Rôle du sujet dans la peinture', *La Pensée*, (July–August 1949)
— 'Le Peintre à son créneau : critique et autocritique', *Arts de France*, 27–28 (1949)
— 'David et nous. Textes et légendes d'André Fougeron', *Arts de France*, 33 (1950)
— 'Discussions sur la peinture', *La Nouvelle Critique*, (May 1954)
— 'André Fougeron se souvient', in G. Viatte, ed., *Paris–Paris, créations en France,
 1937–1957* (Paris: MNAM / Centre Georges Pompidou, 1981)
Fougeron, L., Une "affaire" politique, le portrait de Staline par Picasso',
 Communisme, 53–54 (1998)
— 'Propagande et création picturale. L'exemple du PCF dans la guerre froide',
 Sociétés & Représentations, 12 (2001)
Florisonne, M., ed., *David: exposition en l'honneur du deuxième centenaire de
 sa naissance*, Orangerie de Tuileries, June–September, 1948 (Paris: Éditions
 des Musées Nationaux, 1948)
Fraenkel, B., ed., *Affiche-Action. Quand la politique s'écrit dans la rue*
 (Paris: Gallimard / BDIC, 2012)
Francia, P. de, *Fernand Léger* (New Haven, CT, and London: Yale University Press,
 1983)
Frascina, F., and Harrison, C., *Liberation and Reconstruction. Politics, Culture
 and Society in France and Italy, 1943–1954*, Arts: A third level course
 (Milton Keynes: Open University, 1989)
Fraquelli, S., 'Picasso's Retrospective at the Galerie Georges Petit, Paris, 1932:
 A Response to Matisse', in Ch. Geelhaar, ed., *Picasso, His First Museum
 Exhibition* (Munich: Kunsthaus Zurich / Prestel, 2010)
Freedberg, C.B., *The Spanish Pavilion at the Paris World's Fair*
 (New York and London: Garland Publishing, 1986)
Freund, G., 'La Photographie à l'exposition', *Arts et métiers graphiques*, 62
 (March 1938), 'Paris 1937–New York 1939'
Fréville, J. (pseud. Yevgeny/Eugène Schkaff), ed. and trans., *Sur la littérature et l'art:
 Karl Marx et Frédéric Engels* (Paris: Éditions Sociales Internationales, 1936)
— ed. and trans., *Sur la littérature et l'art: Lénine, Staline*
 (Paris: Éditions Sociales Internationales, 1937)
— 'Peintre de la classe ouvrière' (preface), in *Le Pays des Mines*
 (Paris: Éditions des Pays des Mines / Cercle d'Art, 1951)
— with Cogniot, G., *Œuvres de J. Staline*, vol. 1: *1901–1907*
 (Paris: Éditions Sociales, 1953)

Frezinski, B., 'Staline et les écrivains français – Staline et Romain Rolland',
 in V. Jobert and L. de Meaux, eds, *Intelligentsia, entre France et Russie,
 archives inédites du XXᵉ siècle, Paris*, (Paris: Beaux-Arts de Paris, 2012)
Froment, P., and Rollin-Royer, I., eds, *Mireille Glodek Miailhe* (Paris: Biro, 2007)
Froment-Meurice, H., *Journal de Moscou. Ambassadeur au temps de la guerre froide*
 (Paris: Armand Colin, 2011)
Fuligini, B., *La France rouge. Un siècle d'histoire dans les archives du PCF 1871–1989*
 (Paris: Les Arènes, 2011)
Fumaroli, M., *L'État culturel. Essai sur une religion moderne* (Paris: Éditions
 de Fallois, 1991)
Furet, F., *Marx et la révolution française* (Paris: Flammarion, 1986); Eng. trans.
 Marx and the French Revolution (Chicago: University of Chicago Press, 1988
 [1984])
— *Le Passé d'une illusion. Essai sur l'idée communiste au XXᵉ siècle*
 (Paris: Robert Laffont / Calmann-Lévy, 1995); Eng. trans. *The Passing
 of an Illusion. The Idea of Communism in the Twentieth Century*
 (Chicago: University of Chicago Press, 1999)
Galtier-Boissière, G., ed., *Le Crapouillot*, 20 (1937), 'Le Bourrage des Crânes'
Gandon, G., ed., *Année France-Russie 2010, l'album* (Paris: Institut Français, 2011)
Garaudy, R., 'Artistes sans uniformes', *Arts de France*, 9 (1946)
— *Le Communisme et la renaissance de la culture française*
 (Paris: Éditions Sociales, 1945)
— *L'Église, le communisme et les chrétiens* (Paris: Éditions Sociales, 1949)
— *Pour un réalisme du XXᵉ siècle. Dialogue posthume avec Fernand Léger*
 (Paris: Grasset, 1968)
— *D'un réalisme sans rivages, Picasso, Saint-Jean Perse, Kafka* (Paris: Plon, 1963)
— *L'Itinéraire d'Aragon* (Paris: Gallimard, 1961)
— et al., *Peintres d'Union Soviétique* (Paris: Galerie peintres du monde, 1965)
Gassman, L.C., *War and the Cosmos in Picasso's Texts, 1936–1940*
 (ebook, iUniverse, 2007)
Gateau, J.-Ch., *Éluard, Picasso et la peinture* (Geneva: Librairie Droz, 1983)
Gaudibert, P., with Ory, P., *1936–1976, Luttes, création artistique, créativité populaire*
 (Paris: Fédération de Paris du Parti socialiste, 1976), supplement to *Militant
 de Paris* (June)
— 'Les Années trente et le style du Front Populaire', in J. Clair, ed., *Les Réalismes
 entre révolution et réaction, 1919–1934* (Paris: Centre Georges Pompidou, 1981)
— 'La Peinture des années cinquante', *Silex*, 20 (1981), 'Chronique des années froides
 (1947–1956)'
Geelhaar, Ch., ed., *Picasso: His First Museum Exhibition 1932* (Munich: Kunsthaus
 Zurich / Prestel, 2010)
Genevée, F., *La Fin du secret. Histoire des archives du parti communiste français*
 (Paris: Les Éditions de l'Atelier, 2012)
Gensburger, S., ed., *C'était des enfants. Déportation et sauvetage des enfants juifs
 de Paris* (Paris: Flammarion / Hôtel de Ville, 2012)

Gentili, F., ed., *Les Statues soviétiques de l'exposition de 1937*; *Rapport final de l'opération Inrap* (Paris: INRAP / Centre Île-de-France, 2010)

Geoffroy, G., *Le Musée du soir aux quartiers ouvriers* (Paris: André Martée, n.d.)

Geoghegan, C., *Louis Aragon. Essai de bibliographie*, vol. 1: *1918–1959* (London: Grant and Cutler, 1979)

George, W., 'L'U.R.S.S. a banni la peinture cubiste', *La Littérature*, 23 November 1946

— 'La Farce tragique du réalisme socialiste', *Le Peintre*, 12 (October 1950)

Georgel, P., ed., *Orangerie 1934. Les 'peintres de la réalité'* (Paris: RMN / Musée de l'Orangerie, 2006)

Gerbe, L., *Cresson et la peinture prolétarienne* (Paris: Imprimerie R. Lescaret, 1935)

Gérôme, N., and Tartarovsky, D., *La Fête de l'Humanité, culture communiste, culture populaire* (Paris: Messidor / Éditions Sociales, 1988)

Geroulanos, S., *An Atheism that is not Humanist Emerges in French Thought* (Stanford, CA: Stanford University Press, 2010)

Gerovitch, S., '"Russian Scandals": Soviet Readings of American Cybernetics in the Early Years of the Cold War', *Russian Review*, 60/4 (October 2001)

— *From Newspeak to Cyberspeak. A History of Soviet Cybernetics* (Cambridge, MA: MIT Press, 2002)

Gervereau L., and Pechanski D., eds., *La Propagande sous Vichy, 1940-1944* (Nanterre: BDIC, 1990)

— with Rioux, J-P., and Stora, B., eds., *La France en guerre d'Algérie, novembre 1954– juillet 1962* (Nanterre: Musée d'histoire contemporaine-BDIC, 1992)

Gesgon, A., *Sur les murs de la France. Deux siècles d'affiches politiques* (Paris: Éditions du Sorbier, 1979)

Gide, A., *Retour de l'U.R.S.S.* (Paris: Gallimard, 1936)

— *Retouches à mon retour de l'U.R.S.S.* (Paris: Gallimard, 1937)

Gilburd, E., *The Thaw, Soviet Socialism and Culture during the 1950s and 1960s* (Toronto: Toronto University Press, 2012)

Gili, M., ed., *Willy Ronis: une poétique de l'engagement* (Paris: Democratic Books, 2012)

Gilot, F., with Lake, C., *Vivre avec Picasso* (Paris: Calmann-Lévy, 1965); Eng. trans. *Life with Picasso*, trans. C. Lake (New York: McGraw-Hill, 1964)

Gilzmer, M., *Mémoires de Pierre. Les monuments commémoratifs en France après 1944* (Paris: Autrement, 2009)

Girard, A., and Gentil, G., eds, *André Malraux ministre. Les Affaires Culturelles des temps d'André Malraux* (Paris: La Documentation française, 1996)

Girard, L.-D., *La Guerre franco-française, le maréchal républicain* (Paris: André Bonne, 1950)

Giraudy, D., *L'Œuvre de Picasso à Antibes*, centenary catalogue raisonné (Antibes: Musée Picasso, Château Grimaldi, 1986 [1981])

Gischia, L., 'Recherche d'une tradition', in G. Diehl, ed., *Problèmes de la peinture* (Paris: Confluences, 1945)

Gleizes, A., 'The Abbaye of Créteil, a Communistic Experiment', in Carl Zigrosser, ed., *The Modern School* (Skelton, NJ: Ferrer Colony, 1918)

Goerig-Hergott, F. et al., *Karl-Jean Longuet et Simone Boisecq, de la sculpture à la cité rêvée* (Lyons: Fage éditions, 2011)

Goggin, M.M., 'Picasso and his Art during the German Occupation, 1940–1944', PhD thesis, Stanford University, 1985

Golan, R., 'École Française, École de Paris', in K.E. Silver, ed., *The Circle of Montparnasse* (New York: Jewish Museum, 1983)

— 'A Moralised Landscape: The Organic Image of France between the Wars', PhD thesis, University of London, 1989

— *Muralnomad: The Paradox of Wall Painting, Europe 1927–1957* (New Haven, CT, and London: Yale University Press, 2009)

Golding, J., *Cubism: A History and an Analysis, 1907–1944* (London: Faber, 1959)

Golomstock, I., (trans. Chandler R.) *Totalitarian Art in the Soviet Union, the Third Reich, Fascist Italy and the People's Republic of China* (London: Collins Harvill, 1990)

— with Sinyavksy, A., eds, *Pikasso* (Moscow: Znanie, 1960)

— 'The Forger and the Spy', *Commentary*, May 1999, pp. 37–41

Gomart, T., *Double détente: les relations franco-soviétiques de 1958 à 1964* (Paris: Publications de la Sorbonne, 2003)

Goodrich, L., ed., *American Painting and Sculpture American National Exhibition*, (Moscow: 1959)

— *Painting and Sculpture from the American National Exhibition, Moscow* (New York: Whitney Museum of American Art, 1959)

Gordin, M.D., *Red Cloud at Dawn. Truman, Stalin and the End of the Atomic Monopoly* (New York: Farrar, Straus and Giroux, 2009)

Gorky, M., 'Soviet Literature', in *Soviet Writers' Congress, 1934* (London: Lawrence and Wishart, 1977)

Gosselin, G., ed., *Picasso: 145 dessins pour la presse et les organisations démocratiques* (Paris: Éditions Société Nouvelle du journal *L'Humanité*, 1973), supplement to *L'Humanité-Dimanche*, 126 (5–11 September)

— *Picasso et la Presse: un peintre dans l'histoire* (Paris: Cercle d'Art and L'Humanité, 2000)

Goulemot, J.-M., 'Candide militant. La littérature française et la philosophie des lumières dans quelques revues communistes de 1944 à la mort de Staline', *Libre*, 7 (1980)

— *Le Clairon de Staline (De quelques aventures du Parti Communiste Français)* (Paris: le Sycomore, 1981)

Grandjonc, J., *Marx et les communistes allemands à Paris, 1844: contribution à l'étude de la naissance du marxisme* (Paris: Maspero, 1974)

— *Communisme/Kommunismus/Communism. Origine et développement international de la terminologie communautaire prémarxiste des utopistes aux néo-babouvistes*, 2 vols, Schritten aus dem Karl Marx-Haus, 39/1–2 (Trier: Karl Marx-Haus, 1989)

Grappe, G., 'La Perennité de la collaboration européenne', *Bulletin Collaboration*, May–June 1943

— *Une année du groupe 'Collaboration' septembre 1940–septembre 1941* (Paris: Imprimerie Félix Béroud, 1941)

Grasskamp, W., 'The Denazification of Nazi Art. Arno Breker and Albert Speer Today', in B. Taylor and W. van der Will, eds, *The Nazification of Art* (Winchester: Winchester Press, 1990)

Graziosi, A., 'The Soviet 1931–1933 Famines and the Ukrainian Holodomor: Is a New Interpretation Possible, and What Would its Consequences Be?', *Harvard Ukrainian Studies*, 27.1/4 (2004–2005)

Green, C., *Architecture and 'Vertigo'* (New Haven, CT, and London: Yale University Press, 2005)

— 'Anthony Blunt's Picasso', *Burlington Magazine*, 147 (2005)

Greenberg, C., 'Picasso at Seventy-Five' (1957), in Greenberg, *Art and Culture* (Boston: Beacon Press, 1961); French trans. 'Picasso à soixante-quinze ans', *Peinture, cahiers théoriques*, 2–3 (1972)

Grémion, P., *Preuves, une revue européenne à Paris* (Paris: Julliard, 1989)

— *Intelligence de l'anticommunisme. Le Congrès pour la liberté de la culture à Paris, 1950–1975* (Paris: Fayard, 1995)

Grenouillet, C., 'Aragon, monument national', *La Vie des idées*, 16 January 2013 (online) http://www.laviedesidees.fr/Aragon-monument-national.html (accessed 22 August 2013)

Groys, B., *Staline, œuvre d'art totale* (Nîmes: Éditions Jacqueline Chambon, 1990)

— *The Total Art of Stalinism: Avant-garde, Dictatorship and Beyond*, trans. C. Rougle (Princeton, NJ: Princeton University Press, 1992 [1988])

— *The Communist Postscript* (London: Verso, 2009)

— *After History. Alexander Kojève as a Photographer* (Utrecht: BAK, 2012)

Grunenberg, C., and Morris, L., eds, *Picasso, Peace and Freedom* (London: Tate Publishing, 2010)

Guérin A. *La Résistance, Chronique illustrée, 1930-1950*, 5 vols. (Paris: Club Diderot, 1973)

Guilbaut, S., *How New York Stole the Idea of Modern Art: Abstract Expressionism, Freedom and the Cold War* (Chicago: University of Chicago Press, 1983)

— ed., *Reconstructing Modernism. Art in New York, Paris and Montreal, 1945–1964* (Cambridge, MA, and London: MIT Press, 1990)

Gumplowicz, Ph., and Klein, J.-C., eds, *Paris, 1944–1954, artistes, intellectuels, publics, la culture comme enjeu* (Paris: Autrement, 1995)

Gutov, D., 'Mikhail Aleksandrovich Lifshitz', biographies, Sovetika.ru, 2003, http://www.sovetika.ru/bio/lifsh.htm (Russian) (accessed 10 July 2013)

— *Lifshitz Institute* (video, 2004–05)

Guyau, J.-M., *L'Art au point de vue sociologique* (Paris: Éditions de Saint Cloud, 1930)

Halbwachs, M., *La Topographie légendaire des Évangiles en Terre Sainte, étude de mémoire collective* (Paris: PUF, 2008 [1941])

— *La Mémoire collective* (Paris: PUF, 1950)

— *The Collective Memory*, ed. Mary Douglas (New York: Harper Colophon Books, 1950)

— *On Collective Memory*, ed. and trans. L. Coser (Chicago: University of Chicago Press, 1992)

Hall, W.D., 'French Christians and the German Occupation', in G. Hirschfeld
 and P. Marsh, eds, *Collaboration in France, 1940–1944* (Oxford: Berg, 1988)

Haltof, J.M., *Polish National Cinema* (New York: Berghahn Books, 2002)

Harris, J., and Koeck, R.L., eds, *Picasso and the Politics of Visual Representation:
 War and Peace in the Era of the Cold War and Since* (Liverpool: Liverpool
 University Press, 2013)

Harper, D., et al., *Art Interrupted, Advancing American Art and the Politics
 of Cultural Diplomacy* (Auburn, AL: Jule Collins Smith Museum of Fine Art,
 Auburn University, 2012)

Hayward, M., *On Trial, the Soviet State versus 'Abram Tertz' and 'Nikolai Arzhak'*
 (New York: Harper and Row, 1966)

Healy, P., 'Max Raphael, Dialectics and Greek Art', *Footprint*, autumn 2007

Hecht, G., *The Radiance of France. Nuclear Power and National Identity after
 World War II* (Cambridge, MA: MIT Press, 2009 [1998])

Heinrichs, H.-J., ed., *Max Raphael, Lebens-Errinerungen. Briefe Tagebucher,
 Skizzen, Essays* (Frankfurt: Qumran, 1985)

—— *'Wir lassen uns dis Welt nicht zerbrechen'. Max Raphaels Werk in der Diskussion*
 (Frankfurt: Suhrkampf, 1989)

Heller, G., *Un allemand à Paris* (Paris: Seuil, 1985)

Herbin, A., *L'Art non-figuratif, non-objectif* (Paris: Galerie Lydia Conti, 1949)

Hemingway, A., *Artists on the Left. American Artists and the Communist Movement,
 1926–1956* (New Haven, CT: Yale University Press, 2002)

—— ed., *Marxism and the History of Art, from William Morris to the New Left*
 (London: Pluto Press, 2006)

van Hensbergen, G., *Guernica. The Biography of a Twentieth-Century Icon*
 (London: Bloomsbury, 2004)

Hindry, A., and Stoullig, C., *Doisneau's Renault* (Paris: Somogy /
 Musée des Beaux-Arts et d'Archéologie de Besançon, 2005, bilingual edn)

Hinz, B., *Art in the Third Reich* (Oxford: Basil Blackwell, 1980 [1974])

Hirschfeld, G., and Marsh, P., eds, *Collaboration in France, 1940–1944*
 (Oxford: Berg, 1988)

Histoire du PCF, manuel (Paris: Éditions Sociales, 1964)

Hobsbawm, E., and Ranger, T., eds, *The Invention of Tradition*
 (Cambridge: Cambridge University Press, 1983)

Hoog, A.H., ed., *Juifs d'Algérie* (Paris: Skira / Flammarion,
 Musée d'art et d'histoire du judaïsme, 2012)

Hordinsky, S., and Kowzun, P., *Gloutchenko* (Léopol, 1934)

Hornig, D., 'Max Raphael: théorie de la création et production visuelle',
 Revue germanique internationale, 2 (1994)

Hoving Keen, K., 'Picasso's Communist Interlude: The Murals of *War* and *Peace*',
 Burlington Magazine, 122 (July 1980)

Houssin, M., *Résistantes et résistants en Seine-Saint-Denis. Un nom, une rue,
 une histoire* (Paris: Les Éditions de l'Atelier, 2004)

Huisman, G., *Chefs-d'œuvre de l'art français* (Paris: Palais National des Arts, 1937)

Hulftegger, A., 'Les Musées en guerre', *Le Jardin des Arts*, 32/2 (June 1937)

Hultén, P., ed., *Paris–Moscou 1900-1930* (Paris: Centre Georges Pompidou, 1979; Gallimard, 1991)

Huraut, A., *Aragon prisonnier politique* (Paris: André Balland, 1970)

Huynh, P., ed., *Lénine, Staline et la musique* (Paris: Cité de la Musique, 2010)

Iavorskaia, N., 'Les Relations artistiques entre Paris et Moscou dans les années 1917–1930', in P. Hulten, ed., *Paris-Moscou, 1900–1930* (Paris: Centre Georges Pompidou, 1979)

'Les Indélicats', *Chômage, Guerre, Vivre la Vie, 14 juillet*, (1932), *Tabous, Colonisation, Crise*, (1933), *Sportifs, Élites* (1934), 9 linoprint albums, (Paris: 1932-4)

Impressionist and Modern Evening Art Sale, 5 February 2013 (London: Sotheby's Publications, 2013)

Jankélévitch, V., *L'Imprescriptible: pardonner? Dans l'honneur et la dignité* (Paris: Seuil, 1986)

Jakovsky, A., 'André Fougeron', *Le Point*, 36 (1947)

Jasiensky B. ed., *Literature of the World Revolution*, no 1 (Moscow, State Publishing House, 1931)

— *Second International conference of Revolutionary writers*, special number (Moscow, State Publishing House, 1931)

— *International Literature. Organ of the International Union of Revolutionary Writers*, (Moscow: International Union of Revolutionary Writers, (1932-45)

Jardot, M., ed., *Picasso, 1900, Paris, 1955* (Paris: Musée des arts décoratifs, 1955)

Jevakhoff, A., *Les Russes blancs* (Paris: Taillandier, 2007)

Jean, R., 'Art de Vichy', *Arts de France*, 5 (April/May 1946)

Jeannisson, S., 'La Difficile Reprise des relations commerciales entre les URSS et la France, 1921–1928', *Histoire, économique et société*, 3 (2000)

Joannes, V., 'Le Travail idéologique et politique dans le domaine de la littérature et des arts', *Cahiers du Communisme*, February 1953

Jobert, V., and de Meaux, L., eds, *Intelligentsia, entre France et Russie, archives inédites du XXᵉ siècle* (Paris: Beaux-Arts de Paris, 2012)

Johnson, O., 'The Stalin Prize and the Soviet Artist: Status Symbol or Stigma?', *Slavic Review*, 70/4 (2011)

Johnson, P., *Khrushchev and the Arts. The Politics of Soviet Culture, 1962–1964* (Cambridge, MA: MIT Press, 1965)

Joliot-Curie, F., 'Rapport de Frédéric Joliot, 18 août 1940', in M. Pinault, 'Frédéric Joliot, la science et la société: un itinéraire de la physique nucléaire à la politique nucléaire (1930–1958)', PhD thesis, Paris-8 Sorbonne, 1999, (Archives National de France 17–13385-3 f)

— *Œuvres scientifiques complètes* (Paris: PUF, 1961)

Joly, D., *The French Communist Party and the Algerian War* (London: Macmillan, 1991)

Joly, P., and Joly R., *L'Architecte André Lurçat* (Paris: Picard, 1995)

Jonge, A. de, *Stalin and the Making of the Soviet Union* (London: Collins, 1986)

Jones, P., 'Du prix Staline au prix Lénine: l'émulation honorifique dans la Russie soviétique', *Genèses*, 2/55 (2004), pp. 41–61

Joubin, A., ed., *Correspondance générale d'Eugène Delacroix* (Paris: Plon, 1935)

Journal des Peintres et Sculpteurs de la Maison de la Culture, especially no. 5, 'L'art dégénéré – La Liberté de l'esprit en régime fasciste', 5 May 1938

Journu, H., *U.R.S.S. 1961: Perspectives dégagées par l'exposition française à Moscou* (Paris: Union des Industries chimiques, 1961)

Jung, C.G., (on Picasso), *Neue Zürcher Zeitung*, 13 November 1932

Kambas, Ch., 'Walter Benjamin lecteur des "Réflexions sur la violence"', *Cahiers Georges Sorel*, 2 (1984)

Kaganovich, L.M., *L'Urbanisme soviétique, le réorganisation socialiste de Moscou et des autres villes de l'URSS* (Paris: Bureau d'Éditions, 1932)

Kahnweiler, D.H., *Les Années héroïques du cubisme* (Paris: Braun, 1950)

Kanapa, J., *Critique de la culture*. Vol. I, *Situation de l'intellectuel*. Vol. II, *Socialisme et culture* (Paris: Éditions Sociales, 1957)

Kauffmann, F.A., *La Nouvelle Peinture allemande* (Brussels, n.d.)

Kelly, M., *Pioneer of the Catholic Revival: The Ideas and Influence of Emmanuel Mounier* (London: Sheed and Ward, 1979)

— *Modern French Marxism* (Oxford: Basil Blackwell, 1982)

— 'Humanism and National Unity: The Ideological Reconstruction of France', in N. Hewitt, ed., *The Culture of Reconstruction: European Literature, Thought and Film, 1945–1950* (London: Macmillan, 1989)

— 'Les Lendemains qui pensent: French Marxism at the Liberation', in P. Marsh, ed., *The Conscience of the French. Intellectual Life in Post-Liberation France* (Oxford: Berg, 1992)

Kergoat, J., *La France du Front Populaire* (Paris: La Découverte, 1986)

Khazanova, V., and Chvidkovski, O., 'L'Architecture soviétique', in P. Hulten, ed., *Paris-Moscou, 1900–1930* (Paris: Gallimard, 1991 [1979])

Khrushchev, N., 'Rapport de N. Krouchtchev', *Cahiers du Communisme*, 3 (March 1956)

— *Krouchtchev et la culture: texte intégral du discours du 8 mars avec notes et commentaires,* (Paris: Preuves, 1964)

Kim, I., 'Picasso Seen in Asian Countries in the 1940s–1950s', in T. Akira, H. Michio et al., *Cubism in Asia, Unbounded Dialogues* (Toyko: The Japan Foundation, 2005)

Kindo, Y., 'L'Affaire Lyssenko, ou la pseudo-science au pouvoir', *Science et Pseudo-Science*, 286 (July–September 2009)

Klein, W., *Commune, revue pour la défense de la Culture (1933–1939)* (Paris: CNRS, 1988)

— with Teroni, S., et al., *Pour la défense de la culture: les textes du Congrès international des écrivains, Paris, juin 1935* (Dijon: Éditions universitaires de Dijon, 2005)

Klossowski, P., *Sade, mon prochain, précédé par Le Philosophe scélérat* (Paris: Seuil, 1947)

Koch, S., *Double Lives: Spies and Writers in the Secret Soviet War of Ideas Against the West* (New York: Free Press, 1994)

König, E., and Rittich, W., *Arno Breker* (Paris: Verlag der Deutschen Arbeitsfront, undated [1942])

Koestler, A., *Darkness at Noon* (London: Scribner, 1941); French trans. *Le Zéro et l'infini*, trans. J. Jenatton (Paris: Calmann-Lévy, 1945)

Koetzle, M., ed., *Robert Doisneau: Renault in the Thirties* (London: Nishen, 1990)

Kravchenko, V.A., *J'ai choisi la liberté! La vie publique et privé d'un haut fonctionnaire soviétique*, trans. Jean de Kerdéland (Paris: Éditions Self, 1949)

Kriegel, A., *Les Communistes français, essai d'ethnographie politique* (Paris: Seuil, 1968)

— *Communismes au miroir français* (Paris: Gallimard, 1974)

— *Les Communistes français, 1920–1970* (Paris: Seuil, 1985)

— *Ce que j'ai cru comprendre* (Paris: Robert Laffont, 1991)

— *Le système communiste mondial* (Paris: PUF, 1984)

Kristeva, J., 'Le Temps des femmes', *34/44: Cahiers de recherche de sciences des textes et documents*, 5 (winter 1979); Eng. trans. *Signs*, 7/1 (autumn 1981), trans. A. Jardine and H. Blake

Krushchev, N., *Krouchtchev et la culture: texte intégral du discours du 8 mars avec notes et commentaires* (Paris: Preuves, 1964)

— 'Rapport de N. Krouchtchev', Cahiers du Communisme, no.3, March 1956.

Kuisel, R.F., *Seducing the French: The Dilemma of Americanization* (Berkeley: University of California Press, 1993)

Kupfermann, F., *Au pays des Soviets, le voyage français en URSS, 1917–1939* (Paris: Gallimard-Julliard, 1979)

— *Les Premiers Beaux Jours, 1944–1946* (Paris: Calmann-Lévy, 1985)

Lafont, M., *L'Extermination douce, la cause des fous 40 000 malades mentaux morts de faim dans les hôpitaux sous Vichy* (Latresne: Le Bord de L'eau, 2000 [1987])

Laglenne, J.-F., 'Art au Congrès de la Paix', *Arts de France*, 34 (January 1951)

Lahanque, R., 'Le Réalisme socialiste en France, 1934–1960', doctorate, Université de Nancy, 2002

Laing, D., *The Marxist Theory of Art* (Boulder, CO: Westview Press, 1986 [1978])

Lambert, J.-C., *Charles Estienne et l'art à Paris, 1945–1966* (Paris: Fondation Nationale des Arts Graphiques et Plastiques, 1984)

Larrea, J., *Guernica, Pablo Picasso*, trans. A.H. Krappe (New York: Curt Valentin, 1947)

Lascault, G., *Le Monstre dans l'art occidental* (Paris: Klincksieck, 1973)

Laurent, J., *Arts et pouvoirs en France de 1703 à 1981* (Saint-Étienne: CIÉREC, 1982)

Lavergne, B., *Les Accords de Londres et de Paris. Le réarmement intégral de l'Allemagne, la bombe à hydrogène, la note soviétique du 24 octobre 1954. La France éliminée des Grandes Nations?* (Paris: Nouvelles Éditions Latines, 1955)

Lebel, R., ed., 'Premier Bilan de l'art actuel, 1937–1953', *Le Soleil noir. Positions*, 3–4 (Paris: Presses du Livre Français, 1953)

Lecœur, A., and Stil, A., *Les Pays des Mines* (Paris: Cercle d'Art, 1951)

— *L'Autocritique attendue* (Paris: Girault, 1955)

Lefèbvre, H., *Critique de la vie quotidienne* (Paris: Grasset, 1947)

— *Pignon* (Paris: Le Musée de Poche, 1970)

Lefranc, G., *Le Front Populaire* (Paris: PUF, 1965)

Lefrançois, M., 'Art et aventure au féminin', in E. Bréon, ed., *Coloniales 1920–1940* (Paris: Musée Municipal de Boulogne Billancourt, 1989–90)

Legendre, B., *Le Stalinisme français, qui a dit quoi* (Paris: Seuil, 1980)

Léger, F., 'De l'Acropole à la Tour Eiffel', Sorbonne, c.1950, in Roger Garaudy,
 Pour un réalisme du XX^e siècle. Dialogue posthume avec Fernand Léger
 (Paris: Bernard Grasset, 1968)

— 'Deux inédits de Léger', with 'Léger par Maïakovski' (from *Isvestia*, n.d.),
 Les Lettres françaises, 582 (31 August 1955), commemorative Léger issue

— *Fonctions de la peinture* (Paris: Éditions Gonthier, 1965)

Le Moigne, F., '1944–1951: Les deux corps de Notre-Dame de Paris',
 Vingtième siècle, 78 (2003)

Lemoine, B., ed., *Paris 1937: Cinquantenaire de l'Exposition Internationale des arts
 et des techniques de la vie moderne* (Paris: Institut Français d'Architecture, 1987)

Levaillant, F., 'Note sur l'affaire de *Pravda* dans la Presse parisienne, août-septembre
 1947', *Cahiers du Musée National d'Art Moderne*, 9 (1982)

Levèque, J.-J., 'Hommage de Nadia Léger à son premier maître',
 Hommage à Fernand Léger, special number of *XX^e siècle*, December 1971

Lewis, H., *The Politics of Surrealism* (New York: Taplinger Books, 1988)

Lewis, R., *Gendering Orientalism, Race, Femininity and Representation*
 (London and New York: Routledge, 1996)

Leymarie, J., ed., *Hommage à Pablo Picasso* (Paris: RMN, 1966)

— *Picasso dans les musées soviétiques*, Musée national d'art moderne
 (Paris: Éditions des Musées Nationaux, 1971)

Lifshitz, M., 'Marx on Esthetics', *Literature of the World Revolution*
 (Moscow: State Publishing House, 1931)

— *K voprosu o vzglyadah Marksa na iskusstvo* [On the question of Marx's
 views on art] (Moscow, Leningrad: Khudozhestvennaya literatura, 1933)

— *The Philosophy of Art of Karl Marx* (Wolfeboro, NH: Longwood Publishing
 Group, 1980 [1935])

— and Reinhardt, L., *Krizis bezobraziya. Ot kubizma k pop-art*,
 [The Crisis of Ugliness, from Cubism to Pop Art] (Moscow: Iskusstvo 1968)

— *Karl Marks. Iskusstvo i obshestvenny ideal*, [Karl Marx. Art and the Social Ideal,
 texts 1927-1967] (Moscow: Khudozhestvennaya literatura 1972)

— *Iskusstvo i sovremenny mir*. [Art and the Modern World]
 (Moscow: Izobrazitelnoe iskisstvo 1973)

— *In the World of Aesthetics* (Russian) (Moscow, 1985)

— *Complete Works* (Russian) (Moscow, 1984, 1986, 1988)

Lindey, Ch., *Art in the Cold War, From Vladivostok to Kalamazoo 1945-1962*
 (London: The Herbert Press, 1990)

Liot, D., et al., *Karl-Jean Longuet and Simone Boisecq, de la sculpture à la cité rêvée*
 (Lyons: Fage éditions / Rheims: Musée des Beaux-Arts, 2012)

Lissitzky, El, *Entwurf fur die 'Pressa'* (1927), in E .Weiss, ed., *Russische Avant-Garde,
 1919–1930* (Munich: Prestel, 1986)

Loffler, P.A., *Chronique de la littérature prolétarienne française de 1930 à 1939*
 (Rodez: Subervie, 1967)

— *L'Association des Écrivains et des Artistes Révolutionnaires.*
 (*Le mouvement littéraire progressiste en France*) (Rodez: Subervie, 1971)

Loiseau, J.C., *Les Zazous* (Paris: Sagittaire, 1977)

London, K., *The Seven Soviet Arts* (London: Faber and Faber, 1937)

Lonergan, B., *Insight. A Study of Human Understanding* (London: Longmans, Green, 1957)

Loudmer, G., et al., *Rétrospective Nadia Léger: 1967–1992* (Biot: Musée National Fernand Léger, 1992)

Lukács, G., *Geschichte und Klassbewusstsein: Studein über marxistische Dialektik* (Berlin: Malilk, 1923)

— 'Realism in the Balance' (1938), in *Aesthetics and Politics. Ernst Bloch, György Lukács, Bertolt Brecht, Walter Benjamin, Theodor Adorno* (London: Verso, 1986 [1977])

— 'Art libre ou art dirigé', *Esprit*, 9 (September 1948)

— *Probleme des Realismus* (Berlin: Aufbau-Verlag, 1955); Eng. trans. *The Meaning of Contemporary Realism*, trans. J. and N. Mander (London: Merlin, 1962)

Lyssenko, T.D., *Agrobiologie* (Moscow: Langues Étrangères, 1953)

Madeline, L., ed., *Les Archives de Picasso* (Paris: RMN, 2003)

McDonaugh, T., 'Raymond Hains's "France in Shreds" and the Politics of Décollage', *Representations*, 90/1 (2005)

Maitron, J., and Pelletier, C., *Dictionnaire biographique du mouvement ouvrier français*, 44 vols (Paris: Éditions de l'Atelier 1964–1997), continuing, now online

Malet, L., 'Portrait d'Ilya Ehrenbourg, le russe bleu, blanc, rouge', *Documents*, 34/2 (1934)

Malenkov, G., 'Le Rapport de Georges Malenkov', *L'Humanité*, 7 and 8 October 1952

Malraux, A., 'Sur l'héritage culturel', *Commune*, 37 (September 1936)

Maran, R., *Torture. The Role of Ideology in the French-Algerian War* (New York: Praeger, 1989)

Marceau, N., et al., *Cinq ans de dictature hitlérienne* (Paris: Éditions du comité Thaelmann, 1938)

Marcenac, J., 'Pour la première fois dans l'histoire', *Arts de France*, 33 (December 1950)

Marcuse, H., *Soviet Marxism: A Critical Analysis* (New York: Columbia University Press, 1985 [1958]); French trans. *Le Marxisme soviétique* (Paris: Gallimard, 1963)

'Margoline, Jules' [J. Margolin], *La Condition inhumaine*, trans. N. Berberova and M. Jounot (Paris: Calmann-Lévy, 1949)

Margolin, J., *Voyage au pays des Ze-ka* (Paris: le Bruit du Temps, 2010)

Marin, L., 'La Célébration des œuvres d'art. Notes de travail sur un catalogue d'exposition', *Actes de recherches en sciences sociales*, 5–6 (November 1975)

Marion, P., et al., *Nouveaux destins de l'intelligence française* (Paris: Édition du Ministère de l'Information, 1942)

Martelli, R., *Communisme français. Histoire vrai du Parti Communiste, 1920–1984* (Paris: Messidor / Éditions Sociales, 1984)

Martinet, M., *Culture prolétarienne* (Paris: Maspéro, 1976 [1935])

Marty, A., *Qu'est-ce que le Secours rouge internationale?* (Paris: Éditions du Secours Rouge Internationale, n.d.)

Marx, K., and Engels, F., *The Manifesto of the Communist Party* (1848)
 (Moscow: Progress Publishers, 1969)
— *The Class Struggles in France, 1848 to 1850* (1850)
 (Moscow: Progress Publishers, 1972)
— *Marx / Engels: Collected Works*, 50 vols
 (New York: International Publishers, 1974–2005)
Marx, U., et al., *Walter Benjamin Archives*
 (Paris: Klincksieck / Musée d'art et d'histoire du judaïsme, 2011)
'Le Match des deux expos', *Paris-Match*, 649 (16 September 1959)
Matonti, F., 'La Colombe et les mouches. Frédéric Joliot-Curie et le pacifisme
 des savants', *Politix*, 15/58 (2002)
Mauclair, C. (pseud.), *La Crise du 'panbétonnisme intégral'.
 L'Architecture va-t-elle mourir?* (Paris: Nouvelle Revue Critique, 1934)
— *La Crise d'art moderne* (Paris: CEA, 1944)
Mazierska, E., 'Wanda Jakubowska: The Communist Fighter', in E. Mazierska
 and El. Ostrowska, eds, *Women in Polish Cinema*
 (New York: Berghahn Books, 2006)
Mazuy, R., 'Les "Amis de l'URSS" et le voyage en Union soviétique.
 La mise en scène d'une conversion (1933–1939)', *Politix*, 5/18 (1992)
— 'Le Rassemblement universel pour la Paix, 1931–1939. Une organisation de masse?',
 Matériaux pour l'histoire de notre temps, 30 (1993)
McMeekin, S., *The Red Millionaire: A Political Biography of Willi Münzenberg,
 Moscow's Secret Propaganda Tzar in the West* (New Haven, CT: Yale University
 Press, 2003)
Medevev, J. (Zh), 'Le Goulag atomique', in *Novoie Rousskoie Slovo*, New York,
 12 August 1994
— 'Stalin and the Atomic Bomb', *The Spokesman*, 67 (1999) (originally published
 in *Obschaya Gazeta*, 19–25 August 1999)
— 'Stalin and the Atomic Gulag', *The Spokesman*, 69 (2000)
Méjean, P., *Vallauris. Golfe-Juan. 3,000 ans d'histoire et de céramiques*
 (Golfe-Juan: La Municipalité, 1975)
Mekhaled, B., *Chronique d'un massacre: 8 mai 1945, Sétif-Guelma-Kherrata*
 (Paris: Syros, 1995)
Mendelson, J., *Documenting Spain: Artists, Exhibition Culture, and the Modern
 Nation, 1929–1939* (University Park, PA: Pennsylvania State University Press,
 2005)
— et al., *Encounters with the 1930s* (Madrid: Museo Reina Sofía, 2012)
Ménier, M., et al., *Picasso: l'homme au mouton* (Paris: Réunion des Musées
 Nationaux, 1999)
Mercereau, A., *L'Abbaye et le Bolchevisme* (Paris: Éditions Figuière, n.d. [c.1922])
Merleau-Ponty, M., *Humanisme et terreur. Essai sur le problème communiste*
 (Paris: Gallimard, 1947); Eng. trans. *Humanism and Terror, An Essay
 on the Communist Problem*, trans. J. O'Neill (Boston: Beacon Press, 1969)
Miasnikov, A., 'L'Esthétique lénino-marxiste', *La Documentation Française*, 2336
 (5 February 1952)

Mileeva, M., 'Import and Reception of Western Art in Soviet Russia in the 1920s and 1930s: Selected Exhibitions and their Role', PhD thesis, Courtauld Institute of Art, University of London, 2011

Milhau, D., 'Présupposés théoriques et contradictions du nouveau réalisme socialiste en France au lendemain de la seconde guerre mondiale', in *Art et idéologies. L'Art en Occident 1945–54* (Saint-Étienne: CIEREC, 1976)

— ed., *Picasso et le théâtre* (Toulouse: Musée des Augustins, 1965)

Mills, N., *Winning the Peace: The Marshall Plan and America's Coming of Age as a Superpower* (Hoboken, NJ: Wiley, 2008)

Mitchell, D., *The Spanish Civil War* (London: Granada Publishers, 1982)

Modigliani, J., preface in J. Dubois, *Deux Peintres et un Poète. Boris Taslitzky Mireille Miailhe et Jacques Dubois. Retour d'Algérie* (Paris: Cercle d'Art, 1952)

Moinet, E., ed., *Le Front Populaire et l'art moderne, hommage à Jean Zay* (Orléans: Musée des Beaux-Arts, 1995)

Molinari, D., ed., *Paris 1937, art indépendant* (Paris: Musée de la Ville de Paris, 1987)

Monnerot, J., *Sociologie du Communisme* (Paris: Gallimard, 1949)

Monnier, G., *Des Beaux-Arts aux arts plastiques* (Besançon: La Manufacture, 1991)

Montandon, G., *Comment reconnaître le Juif?* (Paris: Les Nouvelles Éditions Françaises, 1940)

Morel, P., *Le Roman insupportable, L'Internationale littéraire et La France, 1920–1932* (Paris: Gallimard, 1985)

Morelle, P., *Un Nouveau Cadavre. Aragon* (Paris: La Table Ronde, 1984)

Morin, E., *Autocritique* (Paris: Julliard, 1959)

— *Introduction à une politique d'homme suivi par Arguments politiques* (Paris: Seuil, 1965)

Morris, L., and Deery, Ph., 'The Dove Flies East: Whitehall, Warsaw and the 1950 World Peace Congress', *Australian Journal of Politics & History*, 48/4 (2002)

Morton, P.A., *Hybrid Modernities: Architecture and Representation at the 1931 Colonial Exposition, Paris* (Cambridge, MA: MIT Press, 2000)

Mougins, H., 'Boris Taslitzky, ou les jeudis des Enfants d'Ivry', *Arts de France*, 15 March 1946

Moulignat, F., 'Les Artistes en France face à la crise et la montée du fascisme, 1936–1939', doctorate, Université de Paris-Sorbonne 1, 1977

— 'L'Art cruel', *Cahiers du Musée National d'Art Moderne*, 9 (1982), *Paris–Paris* issue

Moulin, R., *Le Marché de la peinture en France* (Paris: Minuit, 1967)

Mourlot, F., *Picasso: Lithographe, III. 1949–1956* (Monte-Carlo: André Sauret, 1964)

Mousseigne, A., and Ligot, J., eds, *Pablo Picasso: rideau de scène pour le Théâtre du Peuple dit 'Rideau de scène pour le Quatorze-Juillet' de Romain Rolland: la dépouille du minotaure en costume d'arlequin* (Milan: Skira / Toulouse, Les Abattoirs, 1998)

Moussinac, L., 'Les Peintres devant le sujet', *Commune*, 21 (May 1935)

Münster, A., *Antifaschismus, Volksfront und Literatur. Zur Geschichte der 'Vereiningung revolutionärer Schriftsteller und Künstler' (AÉAR) in Frankreich* (Hamburg: VSA, 1977)

Müller, P., *Der Netzekreis: altpommersches Grenzland* (Lütt: Husum, 1966)

Murawska-Muthesius, K., 'Paris From Behind the Iron Curtain', in S. Wilson, ed., *Paris, Capital of the Arts, 1900–1968* (London: Royal Academy of Arts, 2002)

— 'How the West Corroborated Socialist Realism in the East: Fougeron, Taslitzsky and Picasso in Warsaw', *Biuletyn Historii Sztuki*, February 2007

Naissance d'une Cité, 1937 programme, collection Musée National Fernand Léger, Biot

Nancy, J.-L., ed., *L'Art et la mémoire des camps. Réprésenter exterminer* (Paris: Seuil, 2001)

Naiman, A., 'Picasso in Russia', trans. Mark H. Teeter, *Moscow News*, 15 June 2010, http://themoscownews.com/arts/20100615/187873959.html (accessed 11 July 2013)

Nash, S.A., ed., *Picasso and the War Years, 1937–1945* (New York: Solomon R. Guggenheim Museum, 1999)

Nathan, J., '"für Picasso mindestens 240 Meter..." Zur Zürcher Picasso-Austellung von 1932', in M. Fehlmann and T. Stooss, eds, *Picasso und der Schweiz* (Bern: Kunstmuseum Bern, Stämpfli Verlag, 2001)

Neyer, H.J., ed., *Absolut Modern Sein. – culture technique in Frankreich 1889–1937* (Berlin: Elefanten Press Verlag, 1985)

Nieszawer, N., et al., *Peintres juifs à Paris, 1905–1939, École de Paris* (Paris: Denoël, 2000)

— ed., *Montparnasse déporté* (Paris: le Musée de Montparnasse, 2005)

Nikitiouk, O., 'Notes sur l'art progressiste en France, 1950–1953', *La Nouvelle Critique*, 52 (February 1954)

Nochlin, L., 'The Myth of the Woman Warrior', in Nochlin, ed., *Representing Women* (London: Thames and Hudson, 1999)

Nora, P., *Les Lieux de mémoire* (Paris: Gallimard, 1984–1992)

— *Realms of Memory* (New York: Columbia University Press, 1996–1998) (abridged)

La Nouvelle Critique, 130, November 1961, special Picasso number

O'Brian, J., 'The Nuclear Family of Man', http://www.japanfocus.org/-John-O_Brian/2816 (accessed 11 July 2013)

Ochsé, M., *La Nouvelle Querelle des images* (Paris: Le Centurion, 1952)

Oppler, E.C., *Picasso's Guernica, Illustrations, Introductory Essay, Documents, Poetry, Criticism, Analysis* (New York: W.W. Norton, 1988)

Ory, P., *Les Collaborateurs, 1940–1945* (Paris: Seuil, 1976)

— *La Belle Illusion, culture et politique sous le signe du Front Populaire 1935–1938* (Paris: Plon, 1994)

'Où va la peinture', *Commune*, 21 and 22 (May and June 1935) (various authors)

Des ouvriers écrivent (Paris: Éditions l'Humanité, 1934) (various authors)

Ozenfant, A., 'L'Art mural', *Cahiers d'Art*, 9–10 (1935)

— 'Notes d'un touriste à l'exposition', *Cahiers d'Art*, 8–10 (1937)

Pagé, S., ed., *Jochen Gerz, les pièces* (Paris: Musée d'Art Moderne de la Ville de Paris, 1975)

Palmier, J.-M., *Lénine, l'art et la révolution* (Paris: Payot, 1975)

— *Weimar en exil* (Paris: Payot, 1988)

Parmelin, H., *Matricule 2078. L'affaire Henri Martin* (Paris: Les Éditeurs Français Réunis, 1953)

— 'Picasso vient de tourner pour Luciano Emmer la naissance de la Guerrre
 et la Paix', *Les Lettres françaises*, 488 (1953)
— *Le Massacre des innocents, l'art et la guerre* (Paris: Cercle d'Art, 1954)
— with Kahnweiler, D.-H., *Picasso. Œuvres de Léningrad et de Moscou
 et de quelques collections parisiennes* (Paris: Cercle d'Art, 1955)
— *Picasso sur la place* (Paris: René Julliard, 1959)
— *Picasso Plain. An Intimate Portrait* (London: St Martins Press, 1963)
— *Voyage en Picasso* (Paris: Bourgois, 1994 [1980]).
— 'Picasso ou les vérités difficiles', in Jean-Pierre Greff, ed., *50 ans de réflexion
 et d'action en art contemporain à Noroit* (Arras: Centre Culturel Noirot, 1990)
— *Histoire de Madame H.P* (Paris: Marval, 1996)
Papini, G., *Le Livre noir* (Paris: Flammarion, 1953); Eng. trans. *El Libro Negro /
 The Black Book*, trans. Isidoro Martin (Mexico: Epoca, 1998)
Parinaud, A., et al., *Nadia Léger, Évolution première, peintures 1920–1926*
 (Paris: Galerie de l'Art International, 1971)
Pavlov, T., *Theory of Reflection, Basic Problems of the Dialectical and Materialistic
 Theory of Knowledge*, 4th edn (Sofia, 1962)
Peignon, S., 'La Critique de la peinture dans la presse communiste, 1947–8',
 MA thesis, Paris-Sorbonne I, 1980
Penihou, G., *Le Front National au travail pour la renaissance française*
 (Paris: Éditions Front National, 1946)
Perdrizet P. ed., *Usine* (Antony: L'Usine nouvelle, 2000)
Pérez Escolano, V., Lleó Cañal, V., González Cordón, A., and Martín, F.,
 'El Pabellón de la República Española en la Exposición Internacional de Paris,
 1937', in V. Bozal and T. Llorens, eds, *España. Vanguardia artística y realidad
 social, 1936–1976* (Barcelona: Gustavo Gili, 1976)
Perrot, R., 'Un Manifeste retrouvé: *Civilisation Atlantique*', *Manifeste*, 9 (March 1986)
— *Esthétique de Fougeron* (Paris: EC Éditions, 1996)
Peyralbe, J. (pseud., Léon Moussinac), 'Les thèses de Plekhanov. Appel aux artistes',
 L'Humanité, 14 January 1932
Picasso, P., 'Lettre sur l'art', trans. C. Motchoulsky, *Formes*, 2 (February 1930)
 (orig. pub. *Ogoniok*, 20 [16 May 1926])
Pick, D., *War Machine. The Rationalization of Slaughter in the Modern Age*
 (New Haven, CT: Yale University Press, 1993)
Picon, G., *Admirable tremblement du temps* (Geneva: Skira, 1970)
— *La Chute d'Icare de Pablo Picasso au Palais de l'UNESCO* (Geneva: Skira, 1971)
Pierre, J., ed., *Tracts surréalistes et déclarations collectives*, vol. 1: *1922–1939*, vol. 2:
 1940–1969 (Paris: Eric Losfeld, Le Terrain Vague, 1982)
Pignon, E., 'Célébrons par nos œuvres le 70e anniversaire de la mort
 de Karl Marx', *L'Humanité*, 18 April 1953
— 'Edouard Pignon raconte la bataille du FNA', in J. Débu-Bridel, ed.,
 La Résistance intellectuelle (Paris: Julliard, 1970)
Pinault, M., 'Frédéric Joliot, la science et la société: un itinéraire de la physique
 nucléaire à la politique nucléaire (1930–1958)', PhD thesis, Paris-8 Sorbonne, 1999

— ed., *Doisneau chez les Joliot-Curie. Un photographe au pays des physiciens*
(Paris: Musée des arts et métiers, Cnam, Romain Pages Éditions, 2005)
Piotrowski, P., 'Totalitarianism and Modernism: The "Thaw" and Informal
Painting in Central Europe, 1955–1965', *Artium Questiones*, X (2000)
Plekhanov, G.V., 'L'Art et la vie sociale', *Littérature de la Révolution Mondiale*,
3 and 4 (1931)
— *Le Rôle de l'individu dans l'histoire*
(Moscow: Foreign Language Publishers, 1946)
— *L'Art et la vie sociale*, ed. Jean Fréville (Paris: Éditions Sociales, 1950)
— *Art and Social Life* (London: Lawrence and Wishart, 1953)
— *Unaddressed Letters: Art and Social Life*, trans. A. Fineberg
(Moscow: Foreign Languages Publishing House, 1957)
Podoksik, A., *Picasso, la quête perpetuelle*, ed. M. Bessonova
(Leningrad: Aurora Art Publishers / Paris: Cercle d'Art, 1989)
Poitou, J.-C., ed., *Affiches et luttes syndicales de la C.G.T.*
(Paris: Éditions du Chêne, 1978)
Politzer, M., *Les trois morts de George Politzer* (Paris: Flammarion, 2013)
Price-Jones, D., *Paris in the Third Reich. A History of the German Occupation,
1940–1944* (London: Collins, 1981)
*Problèmes de l'art contemporain. L'Esprit de la peinture contemporain.
Enquête sur le 'réalisme socialiste'*, supplement to the review *Preuves*, 29 (July 1953)
Procacci, G., et al., *The Cominform; Minutes of the Three Conferences, 1947/1948, 1949*
(Milan: Feltrinelli, 1994)
Prokoviev, V., 'Héritage artistique et métier réaliste dans la peinture française
actuelle', *La Nouvelle Critique*, September–October 1953
Poulaille, H., *Nouvel Âge littéraire* (Paris: Georges Valois, 1930)
— *Gloutchenko* (Paris: Éditions Stanislas, 1933)
— and Chambert-Loir, H., eds, *Henry Poulaille et la littérature prolétarienne*
(Paris: Éditions Souverbie, 1974)
Poutko, A., and Poutko, B., *Je pense donc je meurs. Silence atomique. Les arsenaux
nucléaires sur les ruines de l'URSS*, trans. G. Ackermann and P. Lorrain (Monaco:
Éditions du Rocher, 1993)
Proudhon, *Du Principe de l'art et de sa destination sociale* (Paris: Garnier Frères, 1865)
Quashie-Vauclin, G., *L'Union de la Jeunesse Républicaine de France, 1944–1956* (Paris:
L'Harmattan, 2009)
'La Querelle du réalisme socialiste', *Révolution*, 64 (22 May 1981) (various authors)
Queval, J., and Thevenot, J., *La Télévision* (Paris: Gallimard, 1957)
Quignard, P., *L'Occupation américaine* (Paris: Seuil, 1994)
Râbeva, L.D., ed., *Atomnyj proekt SSSR*, vol. 1: *1938–1945* (Moscow: Nauka /
Fizmatlit, 1998)
Racine, N., 'La Querelle du réalisme', *Sociétés & Représentations*, 15 (2003)
Radford, R., *Art for a Purpose. The Story of the Artists' International Association*
(Winchester: Winchester School of Art Press, 1987)

Ragon, M., *Les Écrivains du peuple* (Paris: J. Vigneau, 1947)
— *Histoire de la littérature prolétarienne de la langue française*; *Littérature ouvrière*; *Littérature paysanne*; *Littérature d'expression populaire* (Paris: Albin Michel, 1974)
Rancière, J., *La Parole ouvrière 1830/1851* (Paris: La Fabrique éditions, 2007 [1975])
— *La Nuit des prolétaires. Archives du rêve ouvrier* (Paris: Fayard, 1981); Eng. trans. *Proletarian Nights. The Worker's Dream*, trans. J. Drury (London: Verso, 2012)
— with Shalev-Gerz, E., *Menschen Dinge. The Human Aspect of Objects* (Weimar: Stiftung Gedenkstaätten Buchenwald und Mittelbau Dora, 2006)
— 'The Work of the Image', in M. Gili, ed., *Esther Shalev-Gerz* (Paris: Fage Éditions, Galerie Nationale du Jeu de Paume, 2010)
Ramié, G., *Céramiques de Picasso* (New York: Skira, 1960 [1948])
Raphael, M., *Von Monet zu Picasso* (Munich: Delphin-Verlag 1913, 1919)
— *Max Raphael, Von Monet bis Picasso. Grundzuge einer Asthetik und Entwicklung der modernen Malerei*, ed. K. Binder (Frankfurt: Suhrkampf, 1989 [1983])
— *Idee und Gestalt, Ein Führer zum Wesen der Kunst* (Munich: Delphin-Verlag, 1921)
— 'Grosse Künstler II Enrinnerungen zum Picasso zu dessen 50 Geburtstag', *Davroser revue 6*, 11 (15 August 1931)
— 'Zur Kunsttheorie der dialektischen Materialismus', *Philosophische Hefte*, 3/3–4 (1932)
— 'Max Raphael über Picasso', *Neue Zürcher Zeitung*, 153/155 (7 October 1932)
— 'Carl Jung begreifft sich an Picasso', *Information* (Zurich), 6 December 1932
— 'A propos du fronton de Corfou', *Minotaure*, 1 (1933)
— 'Remarque sur le Baroque', *Minotaure*, 1 (1933)
— *Proudhon, Marx, Picasso. Trois études sur la sociologie de l'art* (Paris: Éditions Excelsior, 1933); Eng. trans. *Proudhon, Marx, Picasso. Three essays in Marxist aesthetics*, ed. J. Tagg (London: Lawrence and Wishart, 1980)
— *Marx; Picasso; die Renaissance des Mythos in der bürgerlichen Gesellschaft*, ed. K. Binder (Frankfurt: Suhrkampf, 1989)
— *Groupe Scolaire de Villejuif, de l'avenue Karl Marx. André Lurçat architecte* (Paris: Éditions de l'Architecture d'Aujourd'hui, 1933)
— *Zur Erkenntnistheorie der konkreten Dialektik* (Paris: Éditions Excelsior, 1934)
— *La Théorie marxiste de la connaissance*, trans. L. Gara (Paris: Gallimard, 1938)
— *Prehistoric Cave Painting*, trans. N. Guterman (Princeton, NJ: Princeton University Press, 1945)
— *Trois essais sur la signification de l'art pariétal paléolithique*, ed. P. Brault (Paris: Kronos, 1986)
— *Prähistorische Höhlenmalerei*, ed. W. Drewes (Cologne: Bruckner and Thünker, 1993)
— *The Demands of Art*, (trans. N. Guterman, ed., H. Read), (London: Routledge and Kegan Paul; Princeton, NJ: Princeton University Press, 1968)
— *Für eine demokratisches Architektur, Kunstsociologische Schriften*, ed. J. Held (Frankfurt: S. Fischer, 1976)
— *Max Raphael, Lebens-Errinerungen. Briefe Tagebucher, Skizzen, Essays*, ed. H.-J. Heinrichs (Frankfurt: Qumran, 1985)
— *Max Raphael, aufbruch in die Gegenwart. Begegnungen mit Kunst un den Kunstlern des 20 Jarhunderts*, ed. H.-J. Heinrichs (Frankfurt: Qumran, 1985)

— *Max Raphael, Die Farbe Schwarz, Zur materiellen Konstitutuierung der Form*,
ed. K. Binder (New York: Fragment / Frankfurt: Suhrkampf, 1989)

— *Wie will ein Kunstwerk Gesehen sein?* (Frankfurt: Suhrkamp, 1989)

— *Max Raphael. Questions d'art*, ed. and trans. D. Modigliani (Paris: Klincksieck, 2008)

Rapport Général, Exposition Internationale des Arts et Techniques de la vie moderne (Paris, 1938)

Rasle, J., ed., *Aragon et l'art moderne* (Paris: Musée de la Poste / Éditions Beaux-Arts de Paris, 2010)

Ray, S., 'MEGA, the Recovery of Marx and Marxian Path', *Kafila*, 22 June 2012

Raynal, M., *Picasso Œuvres, 1900–1914. Œuvres de Moscou et Leningrad et de quelques collections parisiennes* (Paris: Maison de la Pensée Française, 1954)

Reavey, G., ed., *Anthologie de la littérature soviétique, 1918–1934* (Paris: Gallimard, 1935)

Regnier, G., *Picasso, une nouvelle dation* (Paris: Réunions des Musées Nationaux, 1982)

Régnier, Ph., 'La Propagande anticommuniste de *Paix et Liberté*, France 1950–1956', PhD thesis, Université Libre de Bruxelles, 1986

Regourd, S., *L'Exception culturelle* (Paris: Presses Universitaires de France, 2002)

Reid, S.E., 'The Soviet Art World in the Early Thaw', *Third Text*, 20/2 (2006)

Rey-Goldzeiguer, A., *Aux origines de la guerre d'Algérie 1940–1945 : de Mers El-Kébir aux massacres du Nord-Constantinois* (Paris: La Découverte, 2001)

Riazanov, D., ed., *Karl Marx, Friedrich Engels: Historisch-Kritisch Gesamtausgabe* (Frankfurt and Berlin, 1927–1932)

— *Marx and Anglo-Russian Relations and Other Writings*, ed. B. Pearce (London: Francis Boutle, 2003)

Richardson, J., *The Sorcerer's Apprentice. Picasso, Provence and Douglas Cooper* (New York: Knopf, 1999)

— with McCully, M., *A Life of Picasso: The Triumphant Years, 1917–1932* (New York: Knopf, 2007)

— et al., *Picasso, the Mediterranean Years 1945–1962* (New York: Gagosian Gallery, 2010)

Rittich, W., ed., *Arno Breker* (Paris: Verlag der Deutschen Arbeitsfront, 1942)

Rioux, J.-P., 'La Guerre franco-française', in M. Scriven, ed., *War and Society in Twentieth-Century France* (Oxford: Berg, 1992)

Robin, R., *Le Réalisme socialiste. Une esthétique impossible* (Paris: Éditions Payot, 1986)

Robrieux, Ph., *Maurice Thorez, vie secrète, vie publique* (Paris: Fayard, 1975)

— *Histoire intérieure du Parti Communiste*, vol 1: *1920–1945* (Paris: Fayard, 1980)

Roger-Marx, C., 'Une Plastique de l'absurde, ou l'absence d'espoir dans la peinture contemporaine', *Figaro Littéraire*, 1 September 1951

Rolland, R., *Théâtre de la révolution. Le Quatorze Juillet* (Paris: Albin Michel, 1936)

Rollin, J., *André Fougeron* (Berlin: Henschelverlag Kunst und Gesellschaft, 1972)

Rorimer, J.J., *Survival, the Salvage and Protection of Art in War* (New York: Abelard Press, 1950)

Ross, K., *Fast Cars, Clean Bodies: Decolonisation and the Reordering of French Culture* (Cambridge, MA: MIT Press, 1996)

Rossi, A., *Autopsie du Stalinisme avec le texte intégral du rapport Khrouchthev* (Paris: Pierre Horay, 1957)

Roubaud, L., *Viet Nam, la tragédie de l'Indochine* (Paris: Librarie Vallois, 1931)

Rousseau, R., *Les Femmes rouges; chronique des années Vermeersch* (Paris: Albin Michel, 1983)

Roussel, H., 'Éditeurs et publications des émigrés allemands (1933–1939)', in G. Badia, ed., *Les Barbelés de l'exil. Études sur l'émigration allemande et autrichienne (1938–1940)* (Grenoble: Presses universitaires de Grenoble, 1979)

— 'Les Peintres allemands immigrés en France et l'Union des artistes allemands', in G. Badia, ed., *Les Bannis de Hitler* (Paris: Presses Universitaires de Vincennes, 1984)

Rousset, D., *L'Univers concentrationnaire* (Paris: Éditions du Pavois, 1946)

— 'Code du travail forcé soviétique', *Figaro Littéraire*, 12 November 1949

— et al., *Le Procès concentrationnaire pour la vérité sur les camps. Extraits des débats. Déclarations de David Rousset* (Paris: Éditions du Pavois, 1951)

— ed., *Le Livre blanc sur les camps de concentration soviétique* (Paris: Éditions du Pavois, 1951)

— with Barton, P., eds, *L'Institution concentrationnaire en Russie 1930–1957* (Paris: Éditions Plon, 1957)

— with Rosenthal, G., and Bernard, Th., *Pour la vérité sur les camps concentrationnaire (un procès antistalinien à Paris)* (Paris: Ramsay, 1990)

Rousso, H., *Le Syndrome de Vichy de 1944 à nos jours* (Paris: Seuil, 1990 [1987]); Eng. trans. *The Vichy Syndrome: History and Memory in France since 1944*, trans. A. Goldhammer (Cambridge, MA: Harvard University Press, 1992)

Roux-Fouillet, R., and Roux-Fouillet, P., *Catalogue des périodiques clandestins, 1939–1945* (Paris: Bibliothèque Nationale, 1954)

Roy, C., *Fernand Léger: les constructeurs* (Paris: Falaize, 1951)

— *La Guerre et la paix* (Paris: Cercle d'Art, 1997 [1954])

Rozès, S., 'La Permanence communiste dans l'imaginaire français', *Débat*, 156 (September–October 2009)

Robel, L., ed., *Correspondance Lili Brik – Elsa Triolet 1921–1970* (Paris: Gallimard, 2000)

Rubel, M., *Bibliographie des œuvres de Karl Marx* (Paris: Librairie Marcel Rivière, 1956)

— *Marx critique du marxisme* (Paris: Payot, 1974)

— and Manale, M., *Marx without Myth. A Chronological Study of his Life and Work* (Oxford: Basil Blackwell, 1975)

Rubin, J.H., *Realism and Social Vision in Courbet and Prudhon* (Princeton, NJ: Princeton University Press, 1980)

Rubin, W., *Modern Sacred Art and the Church of Assy* (New York: Columbia University Press, 1961)

— *Pablo Picasso, A Retrospective* (New York: Museum of Modern Art, 1980)

Ruscio, A., ed., *La Guerre 'française' d'Indochine (1945–1954)*.
 Les sources de la connaissance. Bibliographie, filmographie, documents divers
 (Paris: Les Indes Savantes, 2002)
Russoli, F., ed., *Picasso* (Milan: Palazzo Reale, 1954)
Ryabev, L.D, ed., *Atomny proekt SSSR: Documenty i materialy*,
 (Soviet Atomic Project) vol. 1, 1938-1945, (Moscow: Nauka. Fizmatlit, 1998)
Sabartes, J., *Picasso, documents iconographiques* (Geneva: Pierre Cailler, 1954)
Saint-Vinebault, P.-G., 'L'Architecture soviétique à l'occasion d'un voyage
 d'architectes français en Russie', *La Construction Moderne*, 23 October 1932
Sanders, R., 'Realism and Ridicule, the Pictorial Aesthetics of the American Left,
 c.1911–1934', PhD thesis, University College London, 2012
Sartre, J.-P., 'La Recherche de l'absolu', *Les Temps Modernes*, 28 (1948);
 Eng. trans. 'The Search for the Absolute,' in *Alberto Giacometti*
 (New York: Pierre Matisse Gallery, 1948)
— and Merleau-Ponty, M., 'Les Jours de notre vie', *Les Temps Modernes*, 5
 (January 1950)
— 'Les Communistes et la paix', *Les Temps Modernes*, 81 (July 1952),
 84–85 (October–November 1952), 101 (April 1954)
— et al., *L'Affaire Henri Martin* (Paris: Gallimard, 1953)
— *Situations V* (Paris: Gallimard, 1954)
— *Situations VI* (Paris: Gallimard, 1964)
— *The Spectre of Stalin* (London: Hamish Hamilton, 1969)
Sartre, V., *Georges Sorel, élites syndicalistes et révolution prolétarienne*
 (Paris: Éditions Spes, 1937)
Saurel, L., *Bertie Albrecht, Danielle Casanova*
 (Paris: Petite Encyclopédie de la Résistance, 1945)
Mourlot, F., *Affiches originales des maîtres de l'École de Paris*
 (Paris: André Sauret, 1959)
Savage, C., *Malraux, Sartre and Aragon as Political Novelists*
 (Gainesville, FL: University of Florida Press, 1964)
Schiff, G., *Picasso in Perspective* (Englewood Cliffs, NJ: Prentice-Hall, 1976)
Schmied, W., ed., *Renato Guttuso, Der Gastmahl* (Bremen: Ullstein, 1973)
Schwarz, A., *Breton/Trotsky (André Breton, Trotsky et l'anarchie)*
 (Paris: Union Générale de l'Édition, 10/18, 1977)
Scortesco, P., *Satan. Voici ta victoire* (Paris: Nouvelles Éditions Latines, 1953)
— *Saint Picasso, peignez pour nous, ou les deux conformismes* (Paris: Nouvelles
 Éditions Latines, 1953)
Scott, H.G., ed., *Problems of Soviet Literature* (London: Martin Lawrence, 1935);
 repr. as *Soviet Writers Congress, 1934* (London: Lawrence and Wishart, 1977)
Scott-Smith, G., *The Politics of Apolitical Culture: The Congress for Cultural Freedom,
 the CIA and Post-War American Hegemony* (London: Routledge, 2002)
Scriven, M., and Wagstaff, P., eds, *War and Society in Twentieth-Century France*
 (Oxford: Berg, 1991)
Séguy, G., preface in J.-C. Poitou, ed., *Affiches et luttes syndicales de la C.G.T.*
 (Paris: Éditions du Chêne, 1978)

Selard, P., 'Un Tournant décisif de notre politique municipale',
 Cahiers du Bolchevisme, April 1930
Semprun, J., *L'Écriture ou la vie* (Paris: Gallimard, 1994); Eng. trans.
 Literature or Life, trans. L. Coverdale (New York: Viking Books, 1997)
Sénéchal, Ch., *L'Abbaye de Créteil* (Paris: Delpeuch, 1930)
von Senger, A., *Le Cheval de Troie du Bolchevisme*
 (Bienne: Éditions du Chandelier, 1931)
Serge, V., 'De Lénine à Staline', *Le Crapouillot*, special issue, January 1937
— *Destin d'une Révolution, U.R.S.S. 1917–1936* (Paris: Bernard Grasset, 1937)
Sers, Ph., preface in *Nicolas Schöffer, Spatiodynamisme, luminodynamisme,
 chronodynamisme, cybernétique, recherches de 1948 à 1970* (Paris: Galerie Denise
 René, 1970)
Severini, G., *The Artist and Society* (London: Harvill Press, 1946)
Shapiro, D, ed., *Social Realism: Art as a Weapon* (New York: Frederick Ungar, 1973)
Sigal-Klagsbald, L., ed., *Les Juifs dans l'Orientalisme* (Paris: Skira / Flammarion,
 Musée d'art et d'histoire du judaïsme, 2012)
Simonin, A., *Le Droit de désobéissance. Les Éditions de Minuit en guerre d'Algérie*
 (Paris: Les Éditions de Minuit, 2012)
Sinclair, A., *21, rue La Boétie* (Paris: Grasset, 2012)
Sinyavsky, A., 'Le Réalisme socialiste', *Esprit*, 27/269 (February 1959)
— (writing as Abram Tertz), *The Trial Begins* and *On Socialist Realism*, trans.
 M. Hayward and G. Dennis (Berkeley: University of California Press, 1982 [1960])
— with I. Golomstock, *Pikasso*, (Moscow: Znanie, 1960)
Siqueiros, D.A., *L'Art et la révolution*, ed. and trans. G. Fournial
 (Paris: Éditions Sociales, 1973)
Sogno, A., 'La Revue *Atalante* pendant l'Occupation', in P. Milza and
 F. Roche-Pézard, eds, *Art et Fascisme* (Paris: Éditions Complexe, 1989)
Sollers, Ph., 'Le Temps de Picasso', *Peinture*, 18–19 (1985)
Sommer, R., '"Paix et Liberté": La Quatrième République contre le P.C.',
 L'Histoire, 40 (1981)
Sopin, E., and Trouch, M.I., eds, *Vladimir Ilitch Lénine, 1870–1924 : exposition
 consacrée au centième anniversaire de sa naissance* (Paris: Grand Palais /
 Les Presses artistiques, 1970)
Soviet Atomic Project, vol. 1: *1938–1945* (Moscow, 1998)
Soutter, J., *Luce, les travaux et le jours* (Lausanne: International Art Book, 1971)
Souvarine, B., 'D.B. Riazanov', *La Critique Sociale*, 2 (July 1931)
— *Staline. Aperçu historique du Bolchevisme* (Paris: Champs Libres, 1977 [1935])
— *L'Observateur des deux mondes et autres textes* (Paris: La Différence, 1982)
Sowell, T., *Marxism, Philosophy and Economics* (New York: Quill, 1985)
'Special Vallauris', *La Revue de Verre*, 29 (July–August 1986) (various authors)
Speer, A., *Au Cœur du troisième Reich* (Paris: Fayard, 1971)
Spotts, F., *The Shameful Peace, How French Artists and Intellectuals Survived
 the Nazi Occupation* (New Haven, CT: Yale University Press, 2008)
Ssorin-Chaikov, N., 'On Heterochrony: Birthday Gifts to Stalin, 1949',
 Journal of Royal Anthropological Institute, 12/2 (2006)

— ed., *Dary Vozhdiam/Gifts to Soviet Leaders* (Moscow: Pinakotheke, 2006)

Starr, F., *Melnikov. Solo Architect in a Mass Society* (Princeton, NJ: Princeton University Press, 1978)

— 'Le Corbusier and the USSR', *Cahiers du monde russe et soviétique*, 21/2 (1980)

— *Mel'nikov – Le Pavillon soviétique – Paris 1925* (Paris: l'Équerre, 1981)

Steichen, E., *The Family of Man* (New York: Museum of Modern Art, 2003 [1955])

Stern, L., *Western Intellectuals in the Soviet Union, 1920–40, from the Red Square to the Left Bank* (London: Routledge, 2007)

Sternberg, B., and Sullerot, E., *Aspects sociaux de la radio et de la télévision, revue des recherches significatives 1950–1964* (Paris and The Hague: Mouton, 1966)

Sternhell, Z., *Ni droite ni gauche, l'idéologie fasciste en France* (Paris: Seuil, 1983); Eng. trans. *Neither Right nor Left: Fascist Ideology in France*, trans. D. Maisel (Princeton, NJ: Princeton University Press, 1995)

Stil, A., *André Fougeron. Les Pays des Mines* (Paris: Cercle d'Art, 1951)

— *Vers le réalisme socialiste* (Paris: La Nouvelle Critique, 1952)

Stinco, A., and Papillault, R., *Les Abattoirs, histoires et transformation* (Toulouse: Les Abattoirs, 2000)

Streiff, G., *Jean Kanapa 1921–1978. Une singulière histoire du PCF* (Paris: L'Harmattan, 2001)

Struve, G., *Russian Literature under Lenin and Stalin* (London: Routledge and Kegan Paul, 1973)

Surya, M., *Georges Bataille, la mort à l'œuvre* (Paris: Librairie Séguier, 1987)

Tanaka, Y., and Young, M.B., eds, *Bombing Civilians; A Twentieth Century History* (New York: New Press, 2009)

Tartarowsky, D., *Les Premiers Communistes français: formation des cadres et bolchevisation 1920–1923* (Paris: PFNSP, 1980)

Taslitzky, B., *Cent-onze dessins faits à Buchenwald* (Paris: La Bibliothèque Française, 1946; luxury edition, Association Française Buchenwald-Dora, Hautefeuille, S A, 1989)

— 'Barraque 5', *La Nouvelle Critique*, 4 March 1949

— 'Les Bouches s'ouvrent au Salon d'Automne, 1949', *Franc-Tireur*, October 1949

— *Algérie 52* (Paris: Éditions Cercle d'Art, 1953)

— 'De la critique d'art et du nouveau réalisme français', *La Nouvelle Critique*, 2 (January 1949)

— 'L'Art et les traditions nationales', *La Nouvelle Critique*, 32 (January 1952)

— 'Le Front Populaire et les Intellectuels', *La Nouvelle Critique*, December 1955

— *Visages du XVᵉ Congrès du Parti Communiste français* (Paris: Fédération de Paris 1959)

— 'L'Union des Maisons de la Culture, 1934–1939', *Faites entrer l'infini*, 12 December 1991

— 'De Géricault à Amblard. 14 textes sur la peinture et l'art', *Les annales de Société des amis de Louis Aragon et Elsa Triolet*, 11 (2009)

— *Boris Taslitzky. Ateliers, portraits et scènes de genre*, Maison Elsa Triolet–Louis Aragon (Saint Arnoult-en-Yvelines, 2009) (commemorative brochure)

Taylor, B., and van der Will, W., eds, *The Nazification of Art*
(Winchester: Winchester Press, 1990)

Tchakhotine, S., *Le Viol de foules par la propagande politique*
(Paris: Gallimard, 1992 [1939])

Tchikov, V., with Kern, G., *Comment Staline a volé la bombe atomique
aux américains, Dossier KGB no 13676* (Paris: Robert Laffont, 1996)

Tcherny, O., 'Elles ont réalisé le quinquennat stalinien',
La Femme Soviétique, 2 (1948)

Téry, S., *Au soleil plein le cœur. La vie merveilleuse de Danielle Casanova*
(Paris: Éditions Hier et aujourd'hui, 1949)

Theoharis, A., *The Quest for Absolute Security. The Failed Relations Among
U.S. Intelligence Agencies* (Chicago: Ivan R. Dee, 2007)

Thirion, A., *Révolutionnaires sans révolution* (Paris: Robert Laffont, 1972)

Thom, F., *La Langue de bois* (Paris: Julliard, 1987); Eng. trans. *Newspeak,
The Language of Soviet Communism*, trans. K. Connelly
(London and Lexington, KY: Claridge Press, 1989)

Thompson, S., 'Power in Art, the Image of Stalin', MA diss., Courtauld Institute
of Art, 1993); appendix tr. and illustrates *Stalin in Visual Art*, Moscow,
Tretyakov Gallery, 1949

Thorez, M., *La Mission de la France dans le monde* (Paris: Éditions Sociales, 1938)

— *Communistes et Catholiques. La Main tendue* (Paris: Éditions du comité
Populaire de Propagande, 1938)

— *Une politique de grandeur française* (Paris: Éditions Sociales, 1945)

— *Pour l'Union. Communistes et Catholiques* (Paris: Éditions Sociales, 1949)

— *Fils du peuple* (Paris: Éditions Sociales, 1949)

— *La Lutte pour l'indépendance nationale et pour la paix* (Paris: SEDIC, 1950)

— *Œuvres de Maurice Thorez* (Paris: Éditions Sociales, 1950)

— *La P.C.F., la culture et les intellectuels. Textes de Maurice Thorez*, ed. J. Duclos,
L. Figuières, R. Garaudy and W. Rochet (Paris: Éditions Sociales, 1962)

— preface in *Fernand Léger* (Moscow: Pushkin Museum, 1962)

— *Maurice Thorez, œuvres choisis, 1924–1937* (Paris: Éditions Sociales, 1967)

Tillard, P., *Le Rançon des purs* (Paris: René Julliard, 1960)

le Tourneau, D., *L'Église et l'état en France* (Paris: PUF, 2000)

Triolet, E., *Maïakovski, poète russe, souvenirs* (Paris: Éditions Sociales, 1939)

— *Le Monument* (Paris: Gallimard, 1965 [1957]).

— *Europe*, 454–55 (February–March 1967), Elsa Triolet and Louis Aragon number

— *Europe*, 506 (June 1971), Elsa Triolet number

Trotsky, L., *La Révolution trahie*, trans. V. Serge (Paris: Bernard Grasset, 1936)

— *Literature and Revolution* (1924) (Ann Arbor, MI: University of Michigan Press,
1960)

Udovikci-Selb, D., 'Le Corbusier and the Paris Exhibition of 1937. The Temps
Nouveaux Pavilion', *Journal of the Society of Architectual Historians*, 56/1 (1997)

Utley, Gertje R., *Picasso, The Communist Years* (New Haven, CT, and London:
Yale University Press, 2000)

Vacher, M., 'Joseph Moisseevitch Tchaikov (1888–1986), sculptures et illustrations, 1910–1937, l'artiste, la forme, le matériau', MA thesis, École du Louvre, 2010

Vailland, R., *Le Surréalisme contre la révolution* (Paris: Éditions Complexe, 1988 [1948])

Vaillant-Couturier, P., *Au Pays de Tamerlan*, pamphlet series 'Les Bâtisseurs de la Vie Nouvelle' (Paris, 1932)

— *Les géants industriels*, pamphlet series 'Les Bâtisseurs de la Vie Nouvelle' (Paris, 1932)

— *Terre de pain, champs de blé et champs de pétrole*, pamphlet series 'Les Bâtisseurs de la Vie Nouvelle' (Paris, 1932)

Vaincre, album of lithographs (Paris: Front National des Peintres, 1944)

Vaksberg, A., *Staline et les Juifs: l'antisémitisme russe, une continuité du tsarisme au communisme* (Paris: Robert Laffont, 2003)

Valland, R., *Le Front de l'art, défense des collections françaises, 1939–1945* (Paris: Plon, 1961; Réunion des Musées Nationaux 2013)

Vanderpyl, F., *L'Art sans patrie, un mensonge, le pinceau d'Israël* (Paris: Mercure de France, 1942)

Varlot, J., 'Les Communistes, les intellectuels et la nation', *La Nouvelle Critique*, 21 (December 1950)

Vassevière, M., 'Aragon, Breton et la peinture soviétique', in Grenouillet C. ed. *Aragon Elsa Triolet, recherches croisées*, 13 (2011)

Vaudour, C., ed., *Ruines et vestiges* (Val d'Oise: Éditions du Valhermeil, 2011)

Venturi, L., ed., *Picasso* (Rome: Galerie Nazionale d'Arte Moderna, 1954)

Verdès-Leroux, J., 'L'Art de parti. Le Parti Communiste et ses peintres, 1947–1954', *Actes de Recherche en Sciences Sociales*, 28 (June 1979)

— 'Les Impasses de l'art de parti. Le Parti Communiste français et l'art: 1947–1954' (1981), in Jean-Pierre Greff, ed., *50 ans de réflexion et d'action en art contemporain à Noroit* (Arras: Centre Culturel Noirot, 1990)

— *Au service du Parti: le Parti Communiste, les intellectuels et la culture, 1944–1956* (Paris: Fayard / Minuit, 1983)

— *Le Réveil des somnambules: le Parti Communiste, les intellectuels et la culture, 1956–1985* (Paris: Fayard / Minuit, 1986)

Verdet, A., *Nadia Léger: mosaïques monumentales, portraits* (Malakoff: Théâtre 71, 1972)

Vergnet-Ruiz, J., 'Une inspiration de Delacroix? La Jeanne Hachette de Lebarbier', *Revue du Louvre*, 2 (1971)

Vermeesch, J., preface to second edition of Danielle Casanova's *Jeunes Filles de France* (1936) (Paris, n.d.).

Viatte, G., ed., *Paris–Paris, créations en France, 1937–1957* (Paris: Centre Georges Pompidou, 1981)

— ed., *Paul Éluard et ses amis peintres* (Paris: Centre Georges Pompidou, 1982)

Vignoht, G., *La Jeune Peinture, 1941–1961* (Paris: Édition Terre de Peintres, 1985)

Vincent, F., 'Profil de la Revue Arts de France, 1945–1951', MA thesis, Université de Paris-Sorbonne 1, 2 vols, 1979

Vincent, G., 'Communism as a Way of Life', in P. Aries and G. Duby, eds, *A History of Private Life*, V (Cambridge, MA: Belknap Press of Harvard University Press, 1991)

Viollis, A., *Indochine, S.O.S.* (Paris: Éditeurs Français Réunis, 1949 [1935])

Vlaminck, M de., 'Opinions libre sur la peinture', *Comoedia*, 6 June 1942

Vormeier, B., 'Études et perspectives de recherches relatives aux réfugiés en provenance d'Allemagne 1939–1945', *Matériaux pour l'histoire de notre temps*, 44 (1996)

Vorms, P., *Masereel, Gespräche mit Pierre Worms* (Dresden: Verlag der Kunst, 1967)

Vrancken, Ch., *Exposition Picasso* (Paris: Galerie Georges Petit, 1932)

'Le vrai visage de Staline', *L'Express*, 20–26 September 2007, special number

Wajnberg, M.-H., dir. *Evgueni Khaldi, Photographer under Stalin* (Belgium, 1997), DVD, Homevision, 2001

Wallace, L.P., *Leo XIII and the Rise of Socialism* (Durham, NC: Duke University Press, 1966)

Wartmann, W., ed., *Picasso: ausführlisches Verzeichnis mit 32 tafeln* (Zurich: Kunsthaus, 1932)

Wiener, N., *Cybernetics, Or, Control and Communication in the Animal and the Machine* (New York: John Wiley / Paris: Hermann, 1948)

Wendy, A.O., and Salmond, R., eds, *Treasures into Tractors: The Selling of Russia's Cultural Heritage, 1918–1938* (Washington, DC: University of Washington Press, 2009)

Werckmeister, O.-K., *Icons of the Left, Benjamin and Einstein, Picasso and Kafka after the Fall of Communism* (Chicago: University of Chicago Press, 1999)

— 'The Political Confrontation of the Arts at the Paris World Exposition of 1937', unpublished

Werth, A., 'A propos d'un nouveau roman d'Ilya Ehrenbourg', *Articles et Documents. La Documentation Française* (23 October 1954)

West, N., and Tsarev, O., *Triplex Secrets from the Cambridge Spies* (New Haven, CT, and London: Yale University Press, 2009)

Whitney, C., *Antifascism in American Art* (New Haven, CT, and London: Yale University Press, 1989)

Wieviorka, A., *Ils étaient juifs, résistants, communistes* (Paris: Denoël, 1986)

— *Déportation et génocide, entre la mémoire et l'oubli* (Paris: Pluriel, 2003 [1992])

— 'Plus fort que Staline', *L'Histoire*, 335 (2008), special issue 'Picasso, engagement et liberté'

— 'Picasso and Stalin', in C. Grunenberg and L. Morris, eds, *Picasso, Peace and Freedom* (London: Tate Publishing, 2010)

— *Maurice et Jeannette. Biographie du couple Thorez* (Paris: Fayard, 2010)

Wilson, S., '"La Beauté Révolutionnaire?" Réalisme Socialiste and French Painting, 1935–1954', *Oxford Art Journal*, 3/2 (1980)

— '1937, problèmes de la peinture en marge de l'Exposition internationale', in G. Viatte, ed., *Paris–Paris, créations en France, 1937–1957* (Paris: Centre Georges Pompidou, 1981)

— 'Débats autour du réalisme socialiste', in G. Viatte, ed., *Paris–Paris, créations en France, 1937–1957* (Paris: Centre Georges Pompidou, 1981)
— 'Les Jeunes Peintres de tradition française', in G. Viatte, ed., *Paris–Paris, créations en France, 1937–1957* (Paris: Centre Georges Pompidou, 1981)
— 'La Vie artistique à Paris sous l'Occupation', in G. Viatte, ed., *Paris–Paris, créations en France, 1937–1957* (Paris: Centre Georges Pompidou, 1981)
— ed. and trans. with G. Viatte, *Aftermath, France 1945–1954, New Images of Man* (London: Barbican Art Gallery, 1982)
— 'Collaboration in the Fine Arts, 1940–1944', in G. Hirschfeld and P. Marsh, eds, *Collaboration in France – Politics and Culture during the Nazi Occupation, 1940–1944* (Oxford: Berg, 1988)
— 'Fernand Léger, Arts and Politics, 1935–1955', in N. Serota, ed., *Fernand Léger, the Later Years* (London: Whitechapel Art Gallery and Prestel Verlag, 1987)
— 'Martyrs and Militants', in M. Scriven, ed., *War and Society in Twentieth-Century France* (Oxford: Berg, 1991)
— 'Deux affiches d'André Fougeron, le point de vue de l'historien d'art', *Matériaux pour l'histoire de notre temps*, 21/21–22 (April 1991), special issue, 'L'Avenir dans la propagande politique'
— 'Art and the Politics of the Left in France, c.1935–1955', PhD thesis, Courtauld Institute of Art, University of London, 1992
— 'The Soviet Pavilion at the Paris World Fair', in B. Taylor and M. Cullerne-Bown, eds, *Art of the Soviets* (Manchester: Manchester University Press, 1993)
— 'Paris Post War. In Search of the Absolute', in F. Morris, ed., *Paris Post War. Art and Existentialism, 1945–1955* (London: Tate Gallery, 1993)
— 'Edouard Pignon. La peinture au défi', in P. Bouchet, ed., *Edouard Pignon* (Lille: Palais des Beaux-Arts, 1997)
— ed., *Paris, Capital of the Arts 1900–1968* (London: Royal Academy of Arts, 2002)
— 'Introduction', in Wilson, ed., *Paris, Capital of the Arts 1900–1968* (London: Royal Academy of Arts, 2002)
— 'Saint-Germain-des-Prés: from Occupation to Reconstruction', in Wilson, ed., *Paris, Capital of the Arts 1900–1968* (London: Royal Academy of Arts, 2002)
— 'Towards the Latin Quarter: France in the 1960s', in Wilson, ed., *Paris, Capital of the Arts 1900–1968* (London: Royal Academy of Arts, 2002)
— 'La Mémoire longue, la mémoire courte', in N. Hazan-Brunet, ed., *Boris Taslitzky, l'arme du dessin* (Paris: Musée d'Art et d'Histoire du Judaïsme, 2006)
— 'Le renouveau et les enjeux politiques de l'art sacré après-guerre', in I. Linder, ed., *Ronchamp, l'exigence d'une rencontre, Le Corbusier et la chapelle Notre-Dame du Haut, colloque* (Lyons: Fage éditions, 2007)
— 'La Bataille des "humbles"? Communistes et Catholiques autour de l'art sacré', in B. Jobert, ed., *Mélanges Bruno Foucart* (Paris: Éditions Norma, 2008)
— 'From Monuments to Fast Cars: Aspects of Cold War Art, 1946–57', in D. Crowley and J. Pavitt, eds, *Cold War Modern: Design 1945–1970* (London: V&A Publishing, 2008)
— 'Voids, Palimpsests, Kitsch: Paris before Klein', in M. Copeland and L. Le Bon, eds, *Voids* (Paris: Centre Georges Pompidou, 2009)

— 'Nadia Léger, la griffe du siècle', extract in *La Patriote, Côte d'Azur, hors-série, 1960–2010* (Biot: Musée National Fernand Léger, 2010), http://www.musees-nationaux-alpesmaritimes.fr/library/catalogue/1-Catalogue %20en%20ligne%20DONATEURS.pdf (accessed 23 August 2013).

— 'Entretien avec Sarah Wilson', in Josette Rasle, ed., *Aragon et l'art moderne* (Paris: Musée de la Poste / Éditions Beaux-Arts de Paris, 2010)

— 'French Socialist Realism, 1945–1970', in M. Bown and M. Lafranconi, eds, *Socialist Realisms. Soviet Painting 1920–1970* (Milan: Skira, 2012)

— 'Comintern Spin Doctor', *English Historical Review*, CXXVII/526 (2012)

— 'Loyalty and Blood: Picasso's FBI File', in J. Harris and R. Koeck, eds, *Picasso and the Politics of Visual Representation: War and Peace in the Era of the Cold War and Since* (Liverpool: Liverpool University Press, 2013)

— 'A Dying Colonialism, a Dying Orientalism, Algeria 1952', in J. Wardhaugh, ed., *Politics and the Individual: French Experiences 1930–50* (Oxford: Legenda, 2014)

Wingate-Pyke, D., *Les Français et la guerre d'Espagne* (Paris: PUF, 1975)

Winock, M., *Histoire politique de la revue Esprit, 1930–1950* (Paris: Seuil, 1975)

— *Fascisme à la française ou fascisme introuvable* (Paris: Gallimard, 1983)

— *Le Siècle des intellectuels* (Paris: Seuil, 1997)

Wolikow, S., *L'Internationale communiste (1919–1943): Le Komintern ou le rêve déchu du parti mondiale de la révolution* (Paris: Les Éditions de l'Atelier / Éditions Ouvrières, 2010)

Zervos, Ch., 'Réflexions sur la tentative d'esthétique dirigée du III^e Reich', *Cahiers d'Art*, 8–10 (1936, published 1937) and 6–7 (1937)

— 'Histoire d'un tableau de Picasso', *Cahiers d'Art*, 12 (1937)

— 'Des problèmes de la création littéraire et artistique d'après quelques textes de Lénine et Staline', *Cahiers d'Art* (1947)

— ed., *Œuvres de Picasso. 1946–8, peintures, dessins, céramiques, Cahiers d'Art* (1948) special issue

— 'Réponse à Laurent Casanova', *Cahiers d'Art*, 24/1 (1949)

Zhdanov, A.A., 'Soviet Literature – the Richest in Ideas, the Most Advanced Literature', in H.G. Scott, ed., *Soviet Writers Congress, 1934* (London: Lawrence and Wishart, 1977)

— 'Sur la situation internationale', *Cahiers du Communisme*, November 1947

— *Sur la littérature, la musique et l'art* (Paris: Éditions La Nouvelle Critique, 1950)

Zervos, Y., *Origines et développement de l'art international indépendant* (Paris: Musée du Jeu de Paume, 1937)

— *Picasso œuvres de 1969 à 1970* (Avignon: Palais des Papes, 1970)

Zhijie Qiu, ed., *Reactivation, Ninth Shanghai Biennale* (Shanghai: The Power Station of Art, 2012)

Žižek, S., *Violence: Six Sideways Reflections* (London: Profile Books, 2009)

— *Slavoj Žižek presents Robespierre, Virtue and Terror* (London: Verso, 2007)

Max Raphael

Picasso*

<div align="right">To Marcel Fleischmann</div>

Bourgeois science itself recognizes that it has not succeeded in creating a sociology of art. Did not Ortega y Gasset say of Guyau's work that nothing was left of it but the title, and that everything is still to be done? What accounts for this impotence? Any sociological study of art will inevitably he superficial and inconsistent unless it comprises a theoretical study of art, or at least lays foundations for it. To a larger extent than any other ideology, by its very essence, artistic production reshapes the simple natural datum, constructing a new and 'ideal' entity out of materials of its own, an entity which is governed by specific laws. It follows that a sociology of art must first of all analyse the foundations and limits of a 'given' social pattern, a task that cannot be performed by bourgeois scholars with their class prejudices. In the foregoing essay we have shown that Marxism, if interpreted correctly, i.e. dialectically, is capable of performing this task.

Marxism makes a clean sweep of all the class-conditioned illusions of consciousness which bourgeois scholars entertain, such as the absolute individualism of genius, the absolute independence or autonomy of the mind, and the immanent character of art history. Marxism regards these illusions as the prejudices of a clearly determined historical epoch. Moreover, it enables us to analyse every epoch's content, the relations obtaining between material and spiritual production, as well as the limits upon the actual possibilities for creating forms. In order to establish scientifically the relations that obtain between the 'transcendent' and the 'immanent' components of a sociology of art, it is necessary to analyse the social relationships on the one hand, and the forms of the works of art on the other – to the extent that the forms and their interrelationships have a sociological character. Such an analysis is possible only on the basis of a materialist dialectics.

The Marxist theoretician is confronted with a twofold task; he must analyse the bourgeois ideologies, and he must further the development of the proletarian cultural revolution. These two requirements are inseparable, for the workers 'to set free the elements of the new society with which the old collapsing bourgeois society itself is pregnant.'[1]

Study of the modern art of Western Europe affords no example more typical than the work of Picasso. The great exhibitions in Paris and Zurich (during 1932) have proved that times have changed since the day a leading art historian wrote that Picasso simply did not hold any interest for him.[2] Today the bourgeoisie of America and Western Europe recognize

* Max Raphael, 'Picasso', translated from the German by Inge Marcuse, as published in *Proudhon, Marx, Picasso. Three Essays in Marxist Aesthetics*, edited, introduced and with a bibliography by John Tagg; London, Lawrence and Wishart, 1980. English translation copyright, originally by arrangement with Emma Raphael, with the kind permission of Peter Marcuse, John Tagg, Lawrence and Wishart and the Max Raphael archive, Germanisches Nationalmuseum, Nuremberg.

to what extent this artist symbolizes their class, how well he reflects their state of mind. Obtuse denigration has been superseded by total admiration, but at no point have the actual limitations of his art been considered. (This is most strikingly illustrated by Meier-Graefe's change of mind regarding Picasso.) For the Marxist, however, it is a matter of utmost importance to determine the exact relationships which exist between the work of art and the total socio-historical context, and thereby, its class limitations. With respect to Picasso, our task is to investigate the material and ideological conditions that have influenced him, and how he has reacted to them in his art.

I

Picasso was born in Spain in 1881. His youth was passed during the years when free-enterprise was being supplanted by monopoly capitalism. The general character of this transition and the special conditions in which it was effected in Spain exerted a crucial, though in part unconscious, influence upon the painter.

The period was, above all, one of change, and (this is true of all crucial periods) its effect upon art and artists was quite different from that of calm, uneventful periods. At such a time, when the old and the new come into violent conflict, particularly powerful vital tensions are released, which induce the artist to exalt, to 'flaunt and monumentalize' his reactions to the material and ideological conditions around him. The contrast between life and death asserts itself more strongly in such periods than in periods of balance; the same is true of other contradictions which in such periods are accentuated and polarized. The individual torn by these conflicts and destined to discover how to give such an epoch its most powerful expression will be he who is capable of fulfilling its need for norms in the most readily and clearly comprehensible manner – in most cases, expressed in mathematical terms.

These three characteristic features – increase in vitality, polarization of contradictions, and need for comprehensible norms – are also to be found in Dürer, for example. These features probably characterize all truly crucial epochs.

In Picasso, these features account for his repetition of certain subjects: representations of death – while he was still a very young man – and later figurations of sleep; a progressive accumulation of energy in the objects represented and in the means of expression (colour and line); and above all, during his Cubist period, a determination to measure and to express simultaneously the most varied functions of an object conceived as a creative principle opposed to the unity and the natural laws governing bodies.

What, precisely, were the old and the new whose conflict Picasso witnessed in his youth? What was the concrete basis of his art in the material production of that time? The transition from free-enterprise capitalism to the system of monopolies implies an internal transformation in the capitalist mode of production. Capitalist private property and the legal and political forms reflecting it are maintained, as are also the division of society into two antagonistic classes; at the same time, the world is split up into autonomous economic bodies locked in political struggles in the manner of absolute sovereign states. This transition marks a stage in the history of bourgeois society whose evolution is governed by a single principle. From the beginning of its political domination, the bourgeoisie was obliged to wage a war on two fronts: on the one hand, it sought to destroy the old feudal absolutism, and on the other it kept on exploiting the new working class, alone capable of producing value. But on the first of these fronts the war could not be won without the help of the workers, nor the other phase of the war without the feudal lords. Hence the shifting

back and forth between revolutionary tendencies and reactionary tendencies, characteristic of the bourgeoisie's rise to power; its triumph over the old regime coincided with its own weakening in relation to the rising new class. This shifting rhythm in the history of material production, and in social and political history, provides us with the key for understanding a number of facts in the history of nineteenth-century art:

(a) A constant alternation between mythological historical tendencies (one of them Greek and Roman, the other medieval-Christian) and a specifically bourgeois art developing away from these in the direction of realism. As a result we can see extremely heterogeneous conceptions side by side in the work of the most advanced artists, which are only reconciled, if at all, in an eclectic, non-dialectical manner.

(b) The necessity for bourgeois idealism (allegedly a-religious and atheistic) to evolve, as a whole, from rationalism to sensualism (Kant-Mach, David-Monet) in as much as (idealist) sensualism is at once farthest removed from absolute-transcendent idealism and closest to truly atheist materialism (though another qualitative leap must be taken to reach it).

(c) At the apogee of nineteenth-century art, materialism appears only as a dogma, and dialectics only in an idealist form, so that the synthesis between materialism and dialectics – achieved by Marxism – remained, in art, a problem, which was handed down unsolved to the twentieth century.

This oscillation of bourgeois production, both material and spiritual, between two absolutely opposed extremes, must not be regarded as accidental or superficial; rather it reflects the law governing the development of the bourgeoisie. The supplanting of free-enterprise by monopoly capitalism marks one stage in this development. During the era of free-enterprise competition, commodities circulated freely in an open world market. The purpose of this system was to introduce old demands into new markets, and to create new demands in old markets. Among other difficulties, however, it was confronted with the impossibility of controlling supply and demand, with the inevitable falling-off of prices and profits, in short, with the unbalanced situation of an excessive material expansion for which existing forms of organization were inadequate. This contradiction inevitably led to crises, and to the organic formation of monopoly capitalism. Under the latter system, production and distribution are controlled by finance capital operating in the form of national and international trusts and cartels, etc., conquering and dividing up the entire world market which in point of actual fact thereby becomes progressively smaller. The orientation of the new system is purely formalistic – rationalization of the methods of work, more elaborate organization of business and industry, allotment of zones of influence, etc. The adventurous character of the free-enterprise system is supplanted by an administrative bureaucracy in the management of business and industry, and by a growing parasitism on the part of the bourgeoisie in the dominant metropolitan centres. This feudal and dictatorial formalism is undermined internally by the contradiction between the private form of capitalist appropriation and the social form of monopoly organization; the contradiction is further aggravated by the division of society into classes, autonomous economic bodies, national ideologies, etc.

The special situation of Spain within this general evolution is typified by the fact that its integration into the development of the capitalist bourgeoisie proceeded at a slower pace than in other Western European countries. The existence in this country of enormous landed estates, partly left idle, and an underdeveloped industry, suggest a closer analogy with Russia than with the rest of Western Europe. However, there are essential differences

between Spain and Russia: unlike Russia, which has rich natural resources, Spain lacked the material means for resisting the financial domination by foreign countries; as a result, Spain's spiritual development has been more dependent on Europe. Moreover, the Spanish liberal bourgeoisie possessed stronger traditions and greater independence than the Russian bourgeoisie. At a time when the rest of the European bourgeoisie had become a bourgeoisie of 'grocers', Spain was still waging heroic battles against feudalism and the Church. We may add that the Spanish proletariat, largely anarchist and syndicalist, was not yet capable of conducting a great common action, as the Russian proletariat was under Marxist guidance. Consequently the Spanish bourgeoisie felt itself less threatened than the Russian bourgeoisie. Thus, during the period of transition from free-enterprise to monopoly capitalism, the Spanish bourgeoisie – the generation of 1890 – had a spiritual production of its own, whose authoritarian democratic tendency has influenced an ever more reactionary European bourgeois ideology right down to the present day. Picasso represents the second generation in this development.

The stage in the history of art which Picasso found in Paris shortly after 1900 was determined by the influence of specific economic and social conditions to which the artistic production of Western Europe had been subjected.

The era of free-enterprise capitalism witnessed the lowest point to which traditional art had ever fallen. Architecture displayed a hitherto inconceivable eclectic mixture of different forms of past styles; these served as pompous façades without any relation whatever to the basic building plans which themselves were no longer adequate to the epoch's needs. The conception of the monumental had degenerated to such a point that mural paintings were executed in the studio, on canvases which were later affixed to the walls. The art academies served as transmitters of only the most colourless formulas, for nothing remained of the body of traditional craftsmanship. Despite this emasculation of art, both the instruction of art and leadership in the organization of exhibitions remained in the firm grasp of the academicians.

The revivification of bourgeois art proper, both of easel painting and of sculpture, was effected wholly outside the official groups and against public opposition. Artists such as Guys, Manet, and Degas conquered new means for expressing the social life of the contemporary middle class; Monet and Renoir, new means for expressing its feeling for nature; Rodin, a new approach to portraiture. The art of these men was at once sensualistic and idealistic; in Manet – the greatest artist of this group – the idealism was tinged with scepticism.

But all these artists suffered from the same limitations: their eagerness to treat new subjects, to render the individual or passing moment, was greater than their power of expression. Manet's scepticism, like Degas' essentially negative outlook and the Impressionists' individualization of the momentary, kept the relativism of these artists from attaining the norms of great art.

In the same period we witness the emergence of a new architecture, making use of new materials (iron, concrete, glass) in the service of new economic functions (factories, public markets, the Eiffel Tower, railroad stations, etc.).

The most decisive advance beyond this specifically bourgeois art was made by Courbet through his materialistic outlook (we shall disregard the romantic aspect of his art). This friend of Proudhon – he was imprisoned for his political manifestoes and for participating in the Paris Commune – set himself the task of treating his colours in such a way as to reproduce the full materiality of the objects represented (stones, water, etc.), and

to show how a number of different materials might be interrelated through their common character. Courbet's materialism clearly separates him from the Impressionists (however close the latter may have come to nature with their emphasis upon painting out of doors). But it remained dogmatic. His ambition was to give the impression that the world is harmonious a priori, and he did this by concealing his formal means of composition, something he was very skillful at doing. There is no question but that Courbet was representative of the revolutionary stratum of small peasants whose situation Marx analysed so brilliantly in his *Eighteenth Brumaire*[3]. His art was in perfect harmony with his political manifestos, and the opinion that he was 'a genius in art but a simpleton in politics', as certain bourgeois critics have maintained, is absurd.

The transition from free-enterprise to monopoly capitalism raised the problem of how to synthesize form and content, tendencies to individualism and tendencies to collectivism. In certain of his works that look ahead to the future most keenly, Cézanne solved this problem by following a dialectical method (we are expressly disregarding the works in which a pure statics or a pure dynamics predominates), while yet remaining within the framework of idealist realism (an autonomous domain which is situated between idealism and materialism). Cézanne's dialectics can be perceived only through exact analysis of the original works themselves. Let us examine, for instance, the *Mont Sainte-Victoire* in the Courtauld Institute of Art, London. In the foreground, a gently rising plain (green ochre), then a strip of rolling ground behind which rises a mountain (blue); above, a blue sky in part visible only through branches (green). The plain extends in depth diagonally, from the lower right to the upper left. This principal organization of movement is set against the contrary diagonal. These two general orientations of the movement are extended over the vertical and horizontal lines of a plane parallel to the picture surface. The static character of this plane, in juxtaposition with the background, interrupts the dynamic character of the two diagonals; moreover, it sets up an antagonism between them. This twofold struggle caused by an initial force is repeated at each successive layer of depth in the pictorial space, and unfolds according to a definite organizational principle, in obedience to a final cause, i.e. according to a logical necessity in which the two unlike categories of causality and finality coincide. The main diagonal that runs back into the picture space is at first held back, then allowed to resume its movement at an altered pace and duration, and in the end gradually approaches the horizontal.

As a result of this twofold struggle, the foreground encounters the resistance of the mountain, which does not rise straight up but is tipped forward, so that it is in opposition to the movement of the plain directed into depth. The mountain is not a naturalistic representation of the landscape; its artistic purpose is to provide a contrast to the rest of the picture. Here, height is emphasized rather than depth, and the movement to the left rather than the movement to the right; the colours are complementary, and, with respect to the geometric forms, concave and convex surfaces take the place of flat surfaces. This violent contrast, however, is brought about through a series of transitions, involving not only objects but also the means of expression: the plain rises gradually in a succession of parallel layers, and several objects are shown rising above the plain. In the background, the immateriality of the sky is contrasted with the materiality of the objects – a contrast reinforced by that of the geometric forms: for the surface of the earth is convex while that of the sky is concave. This contrast is expressed by means of colours, and the eye is led downwards through the role played by the immateriality of the atmosphere in which the

objects are bathed, and then upwards again by the trees' very materiality. But whereas all the material elements give the impression of autonomous movement and development, so that all future forms are sufficiently and necessarily determ„ined by those already existing, and all of them tend simultaneously to the same final goal, the sky has something unrealized about it. In the relation between the earth and the sky, there is an enormous, arbitrary gulf. The sky remains static, for Cézanne expresses himself in a manner that is on the one hand too naturalistic, and on the other, decorative. Here Cézanne's dialectics reveals a limitation inherent in his idealist realism. The modelled spot of colour – the formal element of his paintings – shows a synthesis between his subjective need for expression and the objectivity of bodies. This synthesis has become detached from its two sources, and taken on a reality of its own – an autonomous union of the ideal with the material. The moment absolute existence is conferred upon a relative autonomy, the latter destroys the dialectics. This accounts for Cézanne's unprecedented laboriousness (and his frequent alteration between the purely static and the purely dynamic).

Courbet's materialism and Cézanne's dialectics are the two tendencies bequeathed by the nineteenth century to the twentieth. Reuniting them constitutes the historical task to be performed. Later we shall see that both materialism and dialectics are completely absent in Picasso, a fact that defines his position in modern social history.

In the period of monopoly capitalism, architecture has come to take on principal importance among the arts, but without playing a truly guiding role, i.e. without prescribing their organic place, their technique, or their style to painting and sculpture, without pointing the way to the integral work of art. On the contrary, architecture has itself revealed the gulf that exists between architecture and the other fine arts. Therein, as notably in Le Corbusier's classical, Calvinist style, the internal contradictions of monopoly capitalism are disclosed.

In painting, two different tendencies appear. First, we have Seurat's formalism and ornamental constructivism which reflects the formalism of monopoly capitalism. In *Le Chahut*, for example, a group of doll-like figures – organized much the same way a modern corporation is organized – go through a uniformly regulated set of movements; in order for the group to function as a group, all individual actions are eliminated, and by that elimination the group is deprived of any collective character. What we have, rather, is a rationalized presentation of commodities supplying demands of a luxurious or socially corrupt character. Seurat's grouping is characterized by the obtuse angle of the kicking legs, and by the curves that artificially and artistically link up the two sides of this angle, as well as by the combinations and variations on these curves, which determine not only the clothes and the styles, but also the various physiognomic details (mouth, nose, eyes).

The second tendency in modern painting discloses an escape from the outside world in the direction of the inner world: the sensualism of the Impressionists gives way to metaphysical intuitions. Thus the quasi-oriental contemplativeness we find in Matisse. It is expressed directly in the colours and lines; it takes their symbolic meanings into account; it composes human figures in conformity not with their own natural laws but with the artist's subjective needs for expression. The opposition revealed between the outside world and the inner world is no more or less than an expression of the escapist (reactionary) character of expressionist intuitionism.

The fundamental form of bourgeois art, easel painting, is threatened from two opposite directions: on the one hand, by aspirations to monumentality which are by no means founded on modern architecture, but on an outworn religion; and on the other, by the

actual disintegration of the aesthetics upon which easel painting was founded (unity of place, time, and action). This disintegration, which may well have been inspired by the cinema, by photomontage, by poster art, etc., can only lead to a breaking up of the picture surface, such as obtained at the very beginning of easel painting.

All this characterized the artistic production – conditioned as it was by the material production of the epoch – which Picasso grew up among, and over which he eventually assumed a position of leadership in the domain of painting.

II

Picasso's artistic reaction to the situation to which he fell heir may be divided into two phases: one of the sentiment (1901–1906), and one of creation (from 1907 on). These may be further subdivided into various periods and stages of development. The first phase includes his so-called 'Blue' (1901–1905) and 'Rose' (1905–1906) periods; the second phase includes his Cubist (1907–1914), his 'abstract' and 'classical' (1915–1925), and Surrealist (from 1925 on) periods.

During the first phase the content and spiritual conception of the subject predominate; during the second, it is the form-creating elements – the modelling, problems of composition and form, of method and execution. It should be noted that in these connections Picasso has had some outside help, as it were, drawing upon Negro art, classicism and its forerunners, and medieval stained-glass painting, for example.

His almost unvarying theme during the sentimental phase was drawn from the fringes of nature and society: blind men, paralytics, dwarves, morons; poor people, beggars; Harlequins and Pierrots; prostitutes; tightrope dancers, acrobats, fortune tellers, strolling players; clowns and jugglers. One must not see here anything resembling social criticism, any sort of accusation against the bourgeois order. Very much like Rilke, Picasso looks upon poverty as a heroic thing and raises it to the power of myth – the myth 'of great inner splendour'. Far from regarding it as a social phenomenon which it is up to those afflicted to abolish, he makes of it a Franciscan virtue heralding the approach of God. This virtue becomes sentimentality at his hands, because his purely emotional religiosity stands in opposition to the severity of the created world; his appeal is to compassion and charity. This passive, mystical, and religious conception of poverty is grounded in the Christian notion of brotherly love and in bourgeois ideology – whose indispensable correlative is brutal cynicism, of the type which may be seen most clearly in papal encyclicals on social issues.

The connection Picasso draws between the subjects he took from the fringes of bourgeois society and that fundamental form of the social life of the bourgeoisie, the family, is altogether characteristic. A painting such as *Acrobat's Family with a Monkey* shows a group unity going back before the particularization of individuals, together with a delicacy of feeling almost attaining to sainthood. What a contrast with the only painting of a middle class family that Picasso did from life rather than from imagination! *The Soler Family* shows us the husband and wife seated at the two far corners, and such grouping as may be discerned has been formed only by the successive addition of persons. However, the contrast is to be accounted for in terms of religious belief rather than in terms of social criticism. It is noteworthy that in Picasso the two forms of sociability are always presented simultaneously: both the disintegration of the group into individuals and the gathering of individuals into a group. He thereby expresses a certain relativism or will to equate the fundamentally opposed principles that govern the formation of social bodies.

His mystical approach to subjects drawn from the fringes of society is clearest in the most successful paintings of this type, from the fact that Picasso uses only one colour in each of them. A chiaroscuro movement extends from foreground to background and back again, while the line thus turned in upon itself progressively discovers within itself and releases a relatively independent being, through the oscillatory mystical movement of coming-into-being and passing away. The methodical unfolding of this mystical process in relation to the existence of the physical world, such is the spiritual unity that gives Picasso's multiform development its internal logic.

A comparison between Picasso's *Absinth Drinker* of 1902 and Degas' painting treating the same subject (in the Louvre) clearly reveals the meaning of Picasso's 'mysticism of the internal field'. The Impressionist does not present his human figures squarely in the foreground but in the distance. In Degas' painting the space has been hollowed out by a succession of slanting lines (formed by the tables) that circumscribe a void. The latter is thus in contrast with the materiality of the tables, and they in turn seem to be crowding the picture space. Degas leads the viewer's eye along a twisting path around and about the empty space, thus making the two figures appear to occupy the most distant corner of the picture. There they are withdrawn into themselves, an inert mass in the swirling space; they are like heaps of ash about to crumble, pieces of wreckage cast off from the movement of space, ready to disintegrate; they possess no human resistance. The further the eye probes into these two figures, the more aware it becomes of their erosion, their unresisting insubstantiality, their melancholy despair and cynical indifference. Degas has painted the twilight of mankind that inevitably descends upon modern bourgeois society because its motive forces are essentially inhuman, and because the rhythm of its development excludes all conscious, active, creative human power. This critical attitude of a bourgeois toward the foundations of his own class structure is not shared by Picasso. When threatened, man is shown as fleeing the external world and withdrawing into himself in search of a haven from the disintegrating forces around him, trying to save his own soul amid encroaching disaster.

Picasso's first sentimental phase marks the birth of his mysticism as well as of his tendency to portray the world as static and objective. Soon a principle will emerge, as his mysticism develops, that of the interpenetration of bodies among themselves and of bodies with space. In this way will come about the splitting up of the object's physical unity into various parts differentiated by means of space and colour. This is why, from the naturalistic point of view, his mysticism has seemed daring and revolutionary – because of its wealth of new combinations, i.e. of combinations not determined by nature. But the opposition it sets up between physical and psychic laws, its psycho-physical dualism, reveals a romantic wish to escape beyond time, a wish whose reactionary character is not diminished by the fact that its original passivity is combined with creative activity.

III

The most decisive turn in Picasso's evolution took place between 1906 and 1907, when he passed from the status of descriptive to that of creative artist. To what extent such a transformation is inherent in the essence of art, we have learned, for example, from Dürer (*Adam and Eve*, in the engraving of 1504) and from Rembrandt (his development after he went bankrupt and began to be influenced by the Italian Renaissance and by Persian miniatures). But if it is certain that his evolution of the artistic faculty is based on the substance and specific laws of the relatively independent domain of art, it is not less certain

that it implies sociological changes. It is possible to show on the basis of concrete historical facts – such facts, for instance, as the difference between Dürer and Hans Baldung Grien or that between the young and the old Dürer – that the descriptive artist is differently conditioned by the existing pattern of material and social production, and that he reacts to it differently than the truly creative artist does. But this relative difference is conceived of as absolute as soon as the complete autonomy of art is invoked, i.e. its total and fundamental independence from both material production and the forms of social organization. It is of basic importance for the Marxist to dispel this illusion, for it constitutes one of the strongest pillars of idealist philosophy.

How this illusion came about in the first place was determined by the following reasons: (1) Artistic form is made up of matter (paint, marble, etc.). In itself matter is dead, artistically speaking. The form that gives birth to artistic life seems to originate only in the human mind. From this it is inferred that the human mind alone is cause of the form, that the human mind is free and sovereign, that form does not derive from matter and can never derive from it but only from mind, and that this mind can itself originate only in mind, which is pure speculation.

(2) There is a given moment in the creative process, after which the composition of forms tolerates no interference, whether arising from the world of objects or from the world of the mind. In order to avoid contradiction, the artist must at a given moment renounce the objects to which he was deeply attached at the beginning and which seemed to him important and essential. The forms constitute a systematic unity and necessity. From this the inference is drawn that there are absolute and eternal laws governing the combinations of forms, whose origin is held to be purely spiritual on the ground that they have a determining action upon subjects and objects.

(3) Completed, the work of art reacts strongly upon life and shapes our ways of looking at nature, of creating practical objects, of social behaviour, etc. From this the inference is drawn that the spiritual element of art is spiritual absolutely.

What all these arguments have in common is that they exclude the material conditions which obtain in the process of spiritual production. Beginning with the activity of the mind, all spiritual factors are isolated and made absolute. This falsifies the interaction between material conditions and spiritual reactions, a falsification that reaches its highest point when the attempt is made to reduce artistic necessity to scientific, mathematical measurements. Even though in all great artists who have attempted this, the attempt has been revealed as erroneous (as in Dürer, for instance), the error seems to be ineradicable for sociological reasons: during periods of crisis and transition, the full comprehensibility of norms is a continually recurrent need. Picasso too was subject to this need.

How true is the assertion that art is independent, and to what extent is consciousness deceived? The fact that materials, techniques, and even the genres preferred by a given period depend on the character of its material production, is proved so clearly even by the most immanent approaches to the history of art that there is no need to dwell on this point. As for creativity and style, history shows us that certain general categories, certain laws –, are realized in the works of art of all times and all peoples – for instance, symmetry and series; the static and the dynamic; the separation between and opposition or interpenetration among the dimensions, etc. – but realized under different configurations. The diversity is accounted for by the diversity of natural environments against which men must struggle; by the concrete social structures within which this struggle, i.e. material production, is carried on;

by the level achieved by art in connection with other ideologies. What the different realizations have in common can never be realized in any immediate fashion. What is involved is no simple abstraction, but the entire biological and historical formation of our consciousness, whose nature is relatively constant as compared with the variable phenomena of social life. But when this relative constancy is transformed into an absolute one, a double error is committed in that both the historical genesis of consciousness in general and the necessity for its realization are overlooked. Mathematical necessity itself is founded upon the natural organization of our bodies and our practical – i.e. our economic – relations with the world. Only in this way can the three dimensions of Euclidean space, and the development of Euclidian geometry prior to that of non-Euclidean geometry be accounted for. It follows from all this that a primal, total independence of the artist in relation to his epoch – i.e. in relation to its material production and social organization – is pure illusion. Even bourgeois scholars such as Schroedinger are beginning to grasp this; how else can we understand Schroedinger's question: 'Is natural science itself environmentally conditioned?'

When the artist imagines that he can realize immediately the general categories of the artistic faculty, he is identifying himself with a given historical epoch that he takes as absolute norm for historical reasons of which he is not himself conscious. Thus he loses his way in a sterile and reactionary academism (Marees, Hildebrandt). It is not by his basic independence that the creative artist distinguishes himself from the descriptive artist, but by his greater ability to free himself from both the objective conditions and his own purely subjective reflexes. Thus the artist's reaction is the greater, the more intense – not the weaker – his original submission to nature and society was. What differentiates the creative from the descriptive artist is not the original sovereignty of the former, but the intensity of the interaction between nature and society on the one hand, and of the artist's consciousness of this on the other.

IV

Picasso's Cubist period (1907–1914) poses several interesting special problems for a Marxist sociology of art, quite apart from the general problem of an art governed by its own laws. At the beginning, there is the influence of Negro art (Negroid stage); at the end, the use of hitherto untried materials on the canvases (stage of new materials). In addition the following question arises at every stage: Why did the abstract laws of Picasso's painting take this particular form of delimitation into geometric figures, of relative discontinuity between (and subsequently the fusion of) planes parallel to the picture surface?

(1) We cannot doubt that there was an evolution from the Impressionists to Picasso. But it primarily involves means of representation only.

It was by studying nature that the Impressionist artist was able to conquer light with a view to representing it through colours. He analysed the still undifferentiated unity of one given moment during one season or a single day, decomposing it into atoms, just as the psychologists had reduced the psychic life to sensations. But whereas the latter linked the various elements mechanically (through associations), artistic unity was restored less through complex use of all compositional means (which were, rather, reduced to a minimum) than by recording a state of mind corresponding to the sensory excitation, i.e. in an aesthetic and often sentimental manner.

Two things must be rigorously distinguished: the individual, monadic character of the general conception of the world, and the sensory domain to which it was reduced for the purpose of artistic representation. This enables us to see that Expressionism maintained the

former, modifying only the latter. In other words, the Expressionist artist renounced totality and complexity to the same extent as the Impressionist. The difference between the two lies merely in this, that the Expressionist does not start from the momentary sensory stimulation produced by the outside world in order to discover a psychic equivalent, but rather from the psychic stimulation of the inner world in search of a sensory equivalent. Both remain within a monadic system. Nothing is changed by replacing dots of colour with spots of colour, nor by regarding as fundamental for artistic creation not the elements, but the totality, of the picture surface. Only the means of representation differ; the essential conception of the world remains unchanged. This difference is analogous to that between sensationalist and a Gestalt psychology; what is crucial in both cases, is that something individual is at stake. Here too, the difference bears only upon the content on which attention is centred in each case – sensory stimulation and its analysis, or psychic stimulation and its structure.

Picasso has not modified this subject matter in any essential respect. He effects, so to speak, a synthesis of these two partial conceptions, but without abandoning the assumptions on which they are based. His advance consists solely in this, that he created deeper and more essential means for expressing the conflict between the two dimensions of the surface and the third dimension of depth, i.e. a new method of modelling. In this way he has achieved an organized individualism, a schematization of the monad – an advance which corresponds to the transition from free-enterprise to monopoly capitalism. Just as these two forms of capitalism cling to private property as the fundamental basis of production, so Picasso preserves absolute individualism as the basis of artistic creation. Just as, in monopoly capitalism, there is a widening gap between private property and planned economic organization, so that economic and social crises grow ever more acute, so in Picasso the dualism between his fundamental individualism and his mathematical, generalized means of expression lead to ever more pronounced psychic crises. This accounts for the continual modification in his 'style', the different forms of which all revolve around the same unsolved problems.

The theoretical limits of modern bourgeois art are manifested most clearly in this, that in the last analysis they are rooted in caricature. The economic and social origins of this are beyond question – this is as true of Degas' Impressionism and Matisse's Expressionism, as of Picasso's Cubism. Daumier was the first to invent the caricatural style, and down to this day all bourgeois art has revolved around him as a central axis. The essential characteristic of this style is that the whole no longer determines the parts, is not even the result of an accretion of homogeneous parts; the harmony of the whole has ceased to exist. On the contrary, it is the caricatured, exaggerated part, and the discordant relation between its positive and negative elements that determine the whole – emphasizing the impossibility of there being any whole, whether a total situation, a whole man, or the ensemble of their interrelations. Ortega y Gasset was quite wrong when he asserted that modern art has left man out of the picture. At a deeper level it is social life that has eliminated man, by treating him as a commodity. It is for this reason that caricature could in the first place – had to – become an integral part of great art. It alone has made possible the acquisition of a new style; in other words, caricature has become 'social nature'. It is by this detour that great art has taken man as its subject – not as a human being, but as a contradictory being, in contradiction with himself and with his environment. And since this process of decomposition has gone hand in hand with the development of the machine, the modern artist has been able to go farther than Daumier by replacing all organic elements (both physical and psychic) with mechanical analogies, with a system of general, abstract relationships.

Absolute individualism and the basis of its style in caricature combine inevitably to produce a metaphysical view of the world, which we variously call 'abstract' art or Surrealism. And in as much as metaphysical worlds are today no longer vital necessities as they were in the Middle Ages, they manifest themselves inversely – not in the creation of architecture, but in resentment against the architecture that is beginning to create a new space based on the needs of modern life. The merest beginnings of such an architecture were enough to provoke liberating laughter at the absurdity of producing one little easel painting after another, enough to reduce all so-called 'revolutions' in modern painting to a mere playing around with the means of expression. Confronted with the need and the desire to produce an integral work of art, painting has sunk to the lowest rung on the ladder of the arts, although – or rather, because – modern bourgeois architecture is itself incapable of solving the problem.

(2) Without the introduction of caricature, which has broken up the European tradition, Picasso could never have arrived at his affinity for Negro art. The colonial policy of capitalism provides a background for this; also, a certain degree of decomposition in the unity of the European mind, determined by this same material expansion (as the idealist Valery has also noted); and finally, some degree of spiritual influence of the colonial peoples on the great European centres. A comparison between Gauguin and Picasso shows how far this influence has already gone. Although Gauguin actually lived among a primitive people, slept with their women, sympathized with their way of life, contemplated their art on the spot, and constantly struggled against the influence of his 'motherland', the women he painted are more like suntanned society ladies of Paris than like Negresses. The European ideal of beauty, French charm, and the reactionary conception of art as primarily decorative shut him off like so many walls from the reality of life in the colonies – at least to the extent that it was still primitive. Picasso, only a generation later, came to know Negro art only from museums and the few pieces he had bought himself from sailors in southern French ports. But he was made aware of two essential facts: that quite apart from the natural laws of the world of bodies and in direct opposition to them there is such a thing as the logical, internally necessary construction of a picture, the forms of which are derived directly from the inner life, from both conscious and unconscious contents, and the development and logic of which are part of this purely intuitive process. The crux of the matter in this artistic necessity is constituted by the modelling. But Picasso's modelling does not follow the European tradition of continuous stereometric bodies (cylinder, etc.), fundamental forms of the members of the human body, but on the contrary is marked by a discontinuous opposition between concave and convex surfaces (as against naturalism) so that concave surfaces come to replace surfaces which are naturally convex (for example, cheeks).

Thus Picasso pays tribute to certain essential elements of life in general, notably the right to a vital impetus that has its source in sex and the subconscious, and that may attain to mysticism – and hence is neither natural or respectful of the natural laws of bodies. At the same time he also pays tribute to certain essential elements of formal artistic creation. Picasso is not the only artist, and art is not the only ideology, in which this evolution may be seen to have occurred. It is enough to recall Lévy-Bruhl and the discussion that raged among French sociologists over whether the mentality of the primitive peoples is, or is not, essentially different from that of Europeans. But all these considerable efforts cannot make us forget that these artists and scientists have been led to primitive culture by motives directly contrary to those which determined the primitive peoples themselves. For the former were

escaping something when they undertook the qualitative leap from the rational into the irrational, whereas the latter were alleviating their worries and fears with each step they took in the logic of their irrational mentality.

From the sociological point of view, we are confronted first of all with a spiritual adoption of cultural facts become known in the course of the exercise of colonial policy; but, later on, we also have a reactionary flight for the moment from the new European reality. It is interesting to note that as the outside world expanded materially, new, non-traditional, spiritual means became necessary to control this world around 1870. Impressionism had already learned from the Japanese the value of the surface (as against perspective) and of 'open composition' and had incorporated them into the European tradition. Thus it was possible to express the vital sense of the new liberal bourgeoisie in the epoch of transition from the Second Empire to the Third Republic. In Picasso, the assimilation involved not only more exotic materials, but also more essential, more far-reaching elements. The integration of Japanese art was the loophole by which traditional artistic rationalism found its way to an artistic sensualism closer to nature. The incorporation of Negroid art, on the other hand, turns against rational and sensory contents in favour of metaphysics and the irrational, and at the same time creates a new, completely non-European rationalization of form.

A consequence of this twofold tendency is to create new positive values out of the existing negative values. Psychically emptied and overrationalized, man discovers in the natives of his colonies a vast traditional domain, and this discovery accelerates his own rapid and continuing flight from Reason. But it also consolidates his humanity in the face of the machine, and activates his hitherto passive mysticism. To gain a better understanding of what this means within the framework of bourgeois philosophy, it is enough to compare a self-portrait by Picasso from the so-called 'Blue' period with another executed shortly before he embarked upon his Negroid stage, just at the turning point between his sentimental phase and his phase of true creativity: the old-fashioned Bohemian who passively let the world sweep over him has now become a worker who rolls up his sleeves the better to take on the world. The positive result of this active struggle was a raising of the theoretical consciousness thanks on the one hand, to the clear distinction established between the principle of modelling and its aspects, and on the other, to the elucidation of the relationships obtaining among physical, psychic, and artistic laws. In this way the Greek and Christian canons of European art were dethroned in an unprecedented manner. This widening of the horizon of artistic practice later reacted upon artistic theory, leading to the establishment of precise distinctions between the theory, the sociology, and the history of art, and more particularly, to a radical change in the perspectives of art history. Henceforward, instead of going from the past to the present, we will go from the present to the past. These are positive results which victorious Marxism will have to develop.

The raising of the theoretical consciousness in the artist himself led Picasso in the course of his development to treat certain theoretical problems pictorially, and some of his pictures might be described as theoretical essays. For instance, *Three Women on the Beach* (1923) shows the significance of the three dimensions for the internal composition of the picture (by no means excluding another, more naturalistic, basis). Hence the theoretical criticisms levelled at Picasso on this occasion. If we recall that throughout the nineteenth century bourgeois philosophy was primarily a theory of knowledge, it will no longer be possible – at least from a bourgeois point of view – to criticize Picasso for having painted a theory of art, but only for having done so incompletely. One glance at this picture will show that the three

dimensions of the figures are not in accord with the three parts into which the background is divided, i.e. that the figures are not connected in space through some overall plan, and consequently that the essential element of theory – the integrating factor – is absent.

(3) The third problem concerns the stage of Cubism in the use of materials. To grasp this problem in its entirety, it is necessary to discuss the various stages within Picasso's Cubism. During the first, Negroid, stage, Picasso strove to found his overall composition on a subjective conception, in this sense that his bodies are formed independently of their physical laws, and solely according to emotional and pictorial logic. The second stage, that of Cubism in the reconstruction of bodies, saw the refinement of this new idiom at the contact of different objects, by the use Picasso made of their articulations, and by combining their different views (profile, frontal view, etc.) according to a spatial dynamism he posited a priori. Thus he integrated the Negroid with the European principle of bodies. In the course of the third stage (Cubism of the field) the formal elements were again detached from the various bodies to be linked in space, i.e. with vibrations in depth oscillating around the central plane parallel to the picture surface. In this stage, the whole of the painting develops according to a specific conception, by means of repeated differentiations in the new language of spatial movements. The dynamic emotion of the inner sense counterbalances the statics of pictorial construction. It was at this moment that Picasso became aware of limitations in this way of working: the abstract idealism which represented the mystical interpenetration of bodies and space by the relationships obtaining among interacting dimensions and by their opposing directions (top-bottom, front-back, right-left) cannot rediscover concrete, material reality. In the end Picasso solved this problem by a kind of squaring of the circle: alongside the most abstract spatial relations, he makes direct use of non-artistic materials (pasted paper, beads, wood shavings, typographical characters, etc.). Here Picasso was confronted with the most crucial problems of all ideology: idealism and materialism. The paradox of taking idealism so abstractly, and materialism so literally, is not a solution, but rather confirms his inability to solve the problem. His exaggeration of the two poles of the opposition shows, first, Picasso's torn personality, devoid of any dialectical element, and second, the overall limitations of his idealism. These two facts are inseparable, and of great importance from the sociological point of view.

Picasso's inner split is manifested as early as the 'Blue' period, partly in his rigorous setting-off of delimited figures (or groups) against a limitless background; for instance, in his varying of the degree of corporeality with which realization of the mystical process is expressed, and in his drive toward the concrete, objective being. At one moment, corporeality is wholly merged with the picture plane and is lost in it – symbolizing the metaphysical absolute – while at another moment the three dimensions of space and body take over the picture plane – symbolizing earthiness. The principle of division into equivalent contrasts becomes the very motive force of Picasso's development. From 1915 to 1925 he used two seemingly different means of expression simultaneously – the classical and the abstract; this period, taken as a whole, constitutes the clearest separation between static and dynamic tendencies. Its primary result was to give a different formal expression to the various detached functions. Thus the natural unity of the body, which was preserved during the sentimental phase, now was destroyed in favour of the diversity of functions, of which in time no more than a static balance will be kept.

Bathing Woman is the most striking illustration of this. The woman seated on the ground before the sea and the sky encloses in both arms the knee of her bent right leg; it rises above

the horizon. Here we have at least three functions juxtaposed: the pressure of the body against the ground and the resulting resistance; withdrawal into oneself; and the rising of the torso above the ground. In order to develop simultaneously these three functions with the woman's body, Picasso had to strip away the flesh to the point where all that is left is a translucent jointed doll. This bold idea of expressing the most intense life through contrast with a skeleton is already the sign of an inner split. Previously Picasso had contrasted in a similar way richness and social poverty, tender Lesbian feelings and almost ponderous physical health, without however dissociating the physical unity of the body. By destroying this unity (by stripping the flesh from the body of the bathing woman), he opposes the body, reduced to an inalterable silhouette, to the limitless picture plane, as two contrary principles, shown not only one in front of the other, but also as transparent with respect of each other; thus Picasso has created a link between them that underlines their contrast. But what is even more important is that one leg expresses the pressure of the body against the resistant ground, while the other leg is bent in a soft curve (in harmony with the arms); the back, detached from the torso, expresses the action of getting to one's feet, and the extended neck asserts the idea of stiffening to attention, etc.

The insouciance, the daring, and the consistency with which Picasso dissociates the natural unity of the body into its diverse functions seem to us determined by his Spanish origin. Picasso was attracted by bourgeois relativism less than any other artist; his country, thanks to its medieval spirit not so far in the past, showed him the significance of theoretical principles, and the social struggles of his epoch encouraged him to demonstrate the contrast of irreconcilable principles. Thus he was able to establish the relativity of these principles, by reason precisely of their diversity and their antinomy within their own sphere, not by reason of their insufficiency or abstract character in the face of the plenitude and the multifariousness of concrete reality. If the artist wants to use simultaneously, one alongside the other, principles equal in value but antithetic, he has only one way of achieving unity – static harmony among the different parts of the picture. Picasso realized this principle of balance in all of its refinements during the period which was at once 'classical' and 'abstract' (1915–1925). This split and this manner of overcoming it are to be found in every area of modern life. Another instance is the antagonistic opposition between private property and monopolism, and the manner in which a law-making machine seeks to overcome it by means of dictatorship.

Although for some time Picasso managed to allow all the oppositions that struck him to coexist – successfully, thanks to the static formal harmony he created – he was in the end compelled to choose between idealism and materialism. This latter opposition became so acute that the very foundations of art were shaken. What is noteworthy in the case of Picasso is that, while he confined himself to idealism, he discovered two ways out: (1) in an abstract idealism concretizing itself in colour – colour conceived not as the surface of the objects represented, but as a symbol of states of mind and as an expression of the functions of things; and (2) in an idealizing realism, which made use of the styles of antiquity and its descendants (Renaissance, Classicism) with a view to developing a powerful three-dimensional corporeality. In this way both materialism and dialectics were excluded. This path taken by bourgeois art was inevitable, for all of Picasso's artistic genius. It would be absolutely erroneous to look upon the phenomenon of the inner split as a phenomenon of personality (and to conclude that Picasso is mad, as some have done). On the contrary, this phenomenon stigmatizes the whole situation of the bourgeoisie: its own abandonment

of the free thinking which brought it into being, and its return to a quasi-medieval ideology such as it had combated at the epoch of its start. The ghosts of the unvanquished past haunt the feudalism of monopoly capitalism no less than those of Hellenism and Christianity haunt Picasso.

<div align="center">V</div>

By a profound and significant irony, the bourgeois theorists of art, especially among the Germans, have charged Picasso with dishonesty and accused him of 'setting out to shock the bourgeois' at the very moment he was drawing the correct consequences from his own limitations with utmost sincerity, at the very moment when, renouncing materialism and dialectics alike, he for the first time turned reactionary within the framework of his own bourgeois world. They failed to recognize not only the causes (stated above) that led him to these two seemingly opposed 'ways out', but also the interrelationship and underlying unity of these two paths. But as soon as we ask what are the sociological causes for the various revivals of antiquity in the history of Western European art, it becomes possible to discern the close correlation between the two differing aspects of Picasso's work between 1915 and 1925.

True revivals of antiquity took place long before the Renaissance (c. 1500 in Italy), during the medieval era. Bourgeois tendencies in the towns began to develop under feudalism. With enlargement of the world through trade, the demand for commodities exceeded the domestic production of the peasants; there was overpopulation, or peasants who were exploited by the great lords emigrated. The towns and cities thus formed gave scope to democratic bourgeois tendencies (in the medieval sense), for as yet the place of this new class in the hierarchical order was not established. A secret admiration for the democracy of antiquity came about from the conflict between the inhabitants of the cities and the landed aristocracy. This emergent bourgeoisie was primarily formed by heretics, sectarians, and partisans of the Reformation, while peasant Catholicism professed a morality hostile to trading in the towns, especially to trade in money. The ideological aspirations of this new class were first displayed in straightforward changes made in old philosophies or in their negation; in the most strking cases, links with classical conceptions were insisted upon. But by the late Middle Ages the Catholic church was able completely to assimilate all such contributions, the philosophy of Aristotle as well as the art of antiquity. It was only when the young capitalism gained strength in Italy, South Germany, and the Low Countries during the fifteenth century, and when the bourgeois created a new religion for himself – the Protestant Reformation – to appease his moral scruples, that the revival of antiquity assumed a realistic character hostile to Catholicism and the force of an absolute norm – a situation that lasted down to the time of Hegel and even Marx (cf. the end of *A Contribution to the Critique of Political Economy*)[4] despite the many attempts to give it a relative, historical character.

Even though the birth of capitalism was marked by revivals of antiquity (there is a particularly close connection between early capitalism and the Italian Renaissance), it is surprising that bourgeois society, when it made its revolution of 1789 with a view to the conquest of political power, produced not a bourgeois but a classical art. The career of David (the painter of the Revolution par excellence) is symbolic of the history of art throughout the nineteenth century. Several years before the Revolution David was already painting in the 'Roman' style, and his subject matter concealed his allusions to the contemporary scene. At the outbreak of the Revolution he was on the side of the most reliable men of the old

guard; he voted for the execution of the king; he made a striking portrait of the murdered Marat in the classical manner, which he signed, 'To Marat, David'. A few years later, David, the revolutionary ideologist, became the court painter to the Emperor Napoleon, whose outstanding exploits he recorded in a number of paintings. He did it in such a pompous manner that Napoleon himself, it is said, was surprised and delighted to be thus glorified. After 1815, the Bourbons sent him into exile, and there, in Belgium, his painting took on a naturalistic character which was scarcely again matched even in the nineteenth century. The specifically bourgeois element had at last been liberated and found its means of expression. The causes of such an evolution from Roman 'revolutionary' classicism to modern bourgeois naturalism, passing through a stage of banal court painting, are to be found in the mixture of alleged ideals of humanity with the actual bourgeois ideals which characterized, and inevitably so, the Revolution of 1789. For the bourgeois class could emancipate itself politically and snatch power away from feudalism only because its ideal could seem to be one of total freedom, equality, and fraternity. Art at first also served to mask reality, and it was not until the reaction had completely torn away this veil that reality could assert itself: first as an art 'of all humanity', and then as bourgeois art. Middle-class life which, at its beginning, had taken on the tinge of classical antiquity in its morality as well as in its art, now revealed its abstract character. This was manifest externally by the replacement, in material production, of the human body – conceived of as an immediate means of production – with the machine, which man now had to watch over and regulate; it was manifest further in the new supremacy of nonproductive trade and of a finance that transforms its own means of exchange into progressively more abstract figurations: gold into paper money, paper money into draft notes, etc.; it was manifest, too, in the relations between the material society and the formal state; and, finally, in the relations between society and its superstructure – art, for example, which in the Middle Ages was the communal possession of the Christian world, now becoming the object of an absurd 'business', a commodity of which the 'value' was believed to be permanent. It is this abstract character of the modern bourgeoisie that in the early period of its political power helped to create the conditions for the revival of the art of antiquity.

To these sociological causes for renaissances of antiquity, we must add ideological causes. Catholicism, as a mythology which served as intermediary between art and material production, was able, thanks to the dialectics implied in its fundamental principle of *analogia entis* between God and the world, to accept art (because it admitted the existence of the world prior to looking upon it as a mere station on the path toward the transcendent). On the other hand, the Church demanded of the artist that his creations, like any others, be subjected to the pure absolute spirit of God and become his signs and symbols. For this very reason Christian art was inevitably exposed to extreme tension, since, as art, it had need of the concrete, the self-evident, the finite. This tension was so strong that even as artistic potentialities underwent incomparable development, they continually threatened the very existence of art. This state of constant internal danger is particularly evident in periods when, for sociological reasons, religion itself is passing through a crisis. At such moments, art could actually liberate itself with relative speed from this constraint. But as a result of the exclusively spiritual demands made upon artists in the past, art remained impotent in the face of the new reality and the material and sensory conflicts it brought about. Deprived by his own tradition of means of expression adequate to such a task, the artist took refuge in Greek art, which by its very essence, was the most apt to supply him with them.

These two orders of causes – sociological and ideological – thus show, first of all, why every revival of antiquity assumed a revolutionary character in the awareness of the promoters, whereas, historically and objectively, it was a reactionary solution, and why these revivals of antiquity always pave the way – not only in Michelangelo, but also today in Stravinsky and Picasso – for a new (reactionary) stage of Christian art. These causes, moreover, show why every revival of antiquity, though linked with the material (realistic) world, displays at the same time a tendency toward abstraction, i.e. represents a dualist world. We have here an idealistic realism, both tendencies of which possess no profound unity of method: the latter is realized only by the artist's creative will, by compositions that tend to equilibrium. This effort of the artist, exclusive and excessive, must change into its opposite. But the necessary coexistence of the corporeal and the abstract incidentally explains to us why, in an epoch of capitalism's greatest strength, even its most brilliant representative has had to separate these two tendencies as much as possible, and to create works simultaneously faithful to both: only in this way could he most purely and most powerfully represent the nature of the bourgeois world of our day.

In Picasso this dualism is nothing but the conclusion reached in the course of making successive differentiations of corporeality (which he practised from the outset), which in the end are in the extremest contradiction with each other, and must finally appear as different styles. We now understand without further explanation why the most abstract works so far surpass, by their artistic qualities, the level of non-abstract works conceived in the classical manner. Abstraction springs from the actual emptiness of modern society, from its self-alienation, from the transformation of the real world into a commodity and into an Ersatz. Whereas corporeality (in the Greek sense) is born out of romantic nostalgia for an immediate corporeal world, one not derived from mysticism. But outside help is not sufficient to make possible the ideological realization of social aspirations; the latter cannot even reach the level of the creative works to which current social life gives birth in a quasi-organic manner.

The special character of the renaissance effected by Picasso does not lie solely in his full realization of the possibilities of an abstract art. He excludes 'the beautiful' (which in past revivals played such a great part, indeed, the crucial part) in favour of a ponderous and massive corporeality which in his eyes contrasts with tender and emergent feelings. He deprives the antique of its character as absolute norm, which he relativizes not only because he limits it in time by two other norms, but above all because he makes simultaneous use of periods and styles entirely different from Greek art, according to the degree of corporeality he is trying to attain. In fact, as soon as separation between modern abstract art and corporeal art in the classical manner has been reached, Picasso goes on to attempt variations in each domain, i.e. to divest art in the manner of antiquity of its abstract elements, and, within abstract art, to attain a corporeality beyond colour. But these two operations have been possible only because Picasso had previously rejected Greek dialectics, so that his 'revival' omits the essential element in Greek antiquity (cf. my *Doric Temple*).[5] This further accentuates the reactionary aspect implied in every revival. This exclusion of the beautiful, of the normative character, and of dialectics enables us to infer that we have experienced the last bourgeois revival of antiquity. As for the question whether a new revival of antiquity can have significance in the development of proletarian culture, this will depend essentially on elucidation of the history of the dialectical method in antiquity – a task that should have topical and political significance on Marxism's philosophical front.

Here it will be enough to observe how brief was the period when Picasso succeeded in achieving a synthesis between Greek and abstract tendencies, and how long, on the other hand, was the interval between the culminating point of his Cubist period and that of the following period. These two facts alone would suffice to prove the seriousness of the crises which threaten bourgeois artists, even the most gifted of them. But it must further be added that during the interval (and then again later) certain canvases from this master border upon the excessively conventional in their technique of colour, and because of it. The more or less monstrous unevenness in the level of his production is the worst complement to his variations in style. While such and such a change may be conditioned sociologically, other changes can scarcely be accounted for save as weakness of character. The fact is that although Picasso is truly the perfect representative of the ruling class of his time, he lacks the ethos of the man who rises above the present and faces toward the future.

VI

Picasso's latest (Surrealist) period presents sociological interest only to the extent that, in its relation to Gothic stained-glass windows and by the methodical consummation of his initial mysticism, it confirms our classification of his work as reactionary and in the Christian-European tradition. When Picasso began to break up the statics of his paintings by dividing them with heavy black lines, it might have been thought that this break with his own past would lead to a new development in bourgeois art. But the subjective character of this pictorial script, the progressive dissolution of the surface ad infinitum, and then, still later, the concretization of his cosmic sentiments in contemplation of the moon, together with the increasingly symbolic use of colour, the return of lines to their starting points in order to form consolidated objects, the mounting interpenetration of objects, as well as the increasingly frequent use of segments of curved surfaces in endless recession into the picture depth – all these show that the purpose is once again to force the merger of relatively strongly autonomous things and space, together with the statics of their existence as they existed in the preceding period, into the mystical process of coming-to-be and passing away. Thus it is only superficially, only in appearance not in essence, that Picasso has been able to give life to his latest expedient. Devoid of dialectical sense, he is not capable of assimilating the medieval dialectic, in this resembling nearly all the bourgeois ideologists who have been drawn to medieval ideology (e.g. Scheler and Heidegger). Their individualism and vitalism (whether taken in the positive or the negative sense) cannot be reconciled with Thomism. This divergence also manifests itself in Picasso's explorations of 'symbols'. Because of the absolute dualism of their content and the magic effect they produce, these symbols could never figure within the boundaries of Catholicism. The latter is too well protected by the Church and its ideological arm, neo-Thomism, to be very deeply shaken by such romantic revivals. In the meantime, the spiritual importance assumed by the Church thanks to those who, out of spiritual need, sympathize with it, continues to increase and become more important. The long detour by which they come closer and closer to the Church proves most strikingly that the bourgeois-capitalist ideology is no longer capable of producing any kind of fruitful spiritual production.

The perversion of Picasso's historical instinct reached its culminating point in the course of his Surrealist period. Up until then he had always been, at least within the boundaries of art, active and revolutionary. Now it is purely reactionary contemplation that comes to the fore. Its ultimate basis is God, whether one is conscious of this or not, and regardless of

whether one sees in all religion, as Freud does, an illusion that is nearing its end. As long as atheism is not based upon dialectical materialism, one merely replaces one word with another. To be sure, in the medieval era, God, or more accurately, the opposition between man and God, was a preliminary, indeed, a necessary condition of artistic creation. But at that time God was a vital reality, for it was the imaginative form of the domain outside the control of natural and social life, a production whose creative character was manifested in very concrete reactions over the whole range of human existence. Even though this cause was not known to the medieval theologians, they had a perfectly good right to call themselves 'Realists'. But today God is no more than a mere concept, a vague idealist imitation. Indeed, the tension that resulted in the creation of God is today obvious – it is the earthly tension between men and commodities. This is why God no longer signifies a certain fertilization, however imaginary, of that area of life which remains to be conquered. He is rather the expression of a flight from the areas that have been conquered. Whereas in the Middle Ages St Thomas could still be regarded as a revolutionary, to such a point that there was repeatedly question of excommunicating him, the converts of our day, despite all the phrases about how 'the antimodern is the ultramodern', are reactionaries pure and simple. They have this advantage over the allegedly revolutionary Surrealists that they have not stopped halfway, but have become conscious of the traditional foundations of their conception of the world, though without realizing the conditions and limitations of those foundations.

VII

It is surprising that Picasso has proved unable time after time to solve the problem of creation without outside help. In this respect too, he falls within the artistic development of the nineteenth century, i.e. of capitalism. In the course of this development, all the styles in the history of European art underwent revivals – the ancient (Graeco-Roman) since the Renaissance, and the Christian from the beginning of Christianity to the Baroque, passing through the Romanesque and the Gothic. The former of these directions, with historical claims in respect to both content and form, stresses corporeality and hence, relatively this-worldly elements (i.e. idealist realism), while the other is turned toward the spiritual and the heavenly (i.e. transcendental idealism).

Bourgeois art proper has developed in part within these Greek and Romantic tendencies, and still more has developed between them; it is disparaged as naturalistic (empirical art) for the sociological reasons mentioned above. In the nineteenth century, the representatives of these two historical tendencies looked upon each other as enemies. This came about through an illusion of the consciousness concerning the true ideological meaning of their respective orientations, for in point of fact, they were merely two varieties of reaction. The purity of the distinction gradually disappeared, and with it their mutual hostility. A form of reconciliation was sought in the history of art, and it was discovered in fifteenth-century Italian art (early Renaissance). Thus Puvis de Chavannes' eclecticism effected a 'reconciliation' of the alleged oppositions. The twentieth century has completed the relativization of the normative character of each of these tendencies, and henceforward it is no longer a single epoch that is 'reborn' each time, but several epochs simultaneously. These, indeed, no longer constitute norms, but mere auxiliaries to be abandoned as soon as they have fulfilled their task. Thus both tendencies coexist in Picasso (and in Stravinsky): this is no longer a simple eclecticism, but a new form of reactionary bourgeois art. The latter is in part based on the new exploitation of Negro art.

The series of Negroid-antique-medieval expresses, in the first place, fear of and aversion for tradition, then the stealthy return to it. On the one hand it implies a stubborn affirmation of independence associated with a will to discover new cosmic and subconscious domains with respect to subject matter, and new aspects of old principles of expression, with respect to form; but on the other hand, it implies admission of the failure to achieve an independence which, in relation to the nineteenth-century tradition, was never more than apparent. What is in question here is not the personal abilities of Picasso, who is by far the most gifted and eminent artist of our day, but the general historical fate of the European bourgeoisie, as is further confirmed by the chronology of details. It is in the paintings in which he used extra-artistic materials (Cubism of materials) that Picasso, c. 1914, expressed the paradox to which he was led by an ostensibly revolutionary Cubism. By the end of the war he had assimilated Ingres and classicism (a process which had begun long before the war) and thus he came back to the European tradition. The most evolutionary development (wrongly labeled revolutionary) had not yet, to be sure, yielded completely to the reactionary development, but it made room for it.

It is possible, however, to cast more light on the coherence of these outside resources. In this connection we must add a few remarks on Picasso's sentimental phase. The extent to which Picasso was subject to influences which he immediately carried over into his own works was not greater than is the case with other young painters. Some of these influences came from his Spanish environment (El Greco) and from the art of antiquity (by way of his father, a teacher of drawing in Spain); others came from Paris of 1900, most notably Toulouse-Lautrec (who is, however, inconceivable without Degas). What Picasso made of them himself only a little later has a certain analogy that cannot be specified further with Pompeii and early Christian painting, i.e. with the style of an antiquity impregnated with Christianity, just as his mysticism is greatly reminiscent of Plotinus. This unity of contradictory tendencies did not directly disintegrate into its component parts, but did so in opposition to the whole European tradition, through the intermediary of Negro art. European art assimilated Negroid influences by introducing: (1) the principle of corporeality, and hence, the Greek tendency, during the period of Cubist objects; (2) the mysticism of the soul, and hence, the Gothic, during the period of the Cubist field. It was only after this assimilation that the unity was split into two European factors: the Greek, and the medieval. A more detailed study of the periods has proved that these two factors were not in absolute contradiction. Thus Picasso's evolution down to the present day, which, despite all variations, is incontestably unified, seems logical enough; but this logic is dialectical. This is all the more noteworthy because we concluded that Picasso's extremely diverse works contain no dialectics. In this way, objective dialectics asserts itself against subjective logic as soon as we consider the historical process; and the same is true, for example, of the relation between material and spiritual production. This is a disproportion that was particularly emphasized by Marx and Engels.

VIII

If we consider Picasso's art as a whole from the sociological point of view, the following results appear: (1) An excessive multiplicity, a disturbing abundance of the most unlike aspects, both simultaneously and successively – inevitable in an artist whose personality is the symbol of the bourgeois ruling class, because he himself and his epoch are experiencing the most contradictory tensions; (2) Even a talent as great as his cannot do without auxiliary

means, and ends up as a repertory of the history of art. Today a great bourgeois artist is possible only as an eclectic genius. (3) The artist whose debuts were so radical that he was generally held to be a revolutionary, has proved, after thirty years of work, so far from being capable of solving the unsolved problem of the nineteenth century, i.e. of creating an art based upon materialist dialectics, that he has on the contrary gone to the other extreme: the feudal limits of the bourgeoisie, in the modern form of reaction.

In the light of these three results Picasso appears as the symbol of contemporary bourgeois society, and it is as such that, with a half a dozen of his works, he will certainly survive for several decades, perhaps even several centuries. Picasso's social character is also disclosed in his action on the public, which was not slow to show its gratitude to him both materially and spiritually, although no one has put the nerves of his contemporaries to a more severe test. With the exception of Germany, which refused to recognize him for the most futile reasons (the German bourgeoisie thus demonstrating that it lags decades behind world history, not only in politics, but also in ideology), we see that despite the indifference of the 'cultivated' masses, dealers and speculators in all the countries of Europe and America pay extraordinarily high prices for his works. Each period of his evolution, and even each caprice of his imagination have aroused boundless enthusiasm; he has been imitated as no painter before him. This desire to imitate, which in the bulk of artists can assume the worst academic character, reveals more than a lack of consistency or instinct for history, more than the mere fact that Picasso time after time discovers forms in which the bourgeois class can assert and understand itself. Since the 'free' artist depends on fashion and on the speculations of art dealers, we are witnessing the emergence of a new kind of public relationship between artist and public, which bears no resemblance to those prevalent in the Impressionists' generations. Throughout the second half of the nineteenth century, the public displayed hostility to modern art. The bourgeois class regarded its own ideologists as revolutionaries, and refused to support them spiritually or materially, and this situation continued for decades. The reasons for such an attitude are not to be found solely, nor even mainly, in the 'natural' gulf separating the genius from the masses devoid of spirit. Far from being 'natural', this gulf is determined socially and historically. When the thin stratum of the feudal rulers was liquidated by the 'democratically oriented' bourgeoisie, a bourgeois elite, totally ignorant in artistic matters, took the place of the art patron who was either a truly cultivated man or one bound by tradition, whose social position enabled him to display relative generosity toward artists. By reason of its formation, special capacities, and successes in other domains, the bourgeoisie regarded understanding of art, and hence art criticism, as a natural, self-evident, inalienable 'human right'. This attitude was later adopted by the bulk of the half-cultivated petty bourgeois; half-sentimental, half-metaphysical theories of art consecrated it ideologically. This appropriation was effected at the very moment when the Christian religion, i.e. the traditional autochthonous mythology, had lost its creative power, and thereby its mediating function between material and spiritual production. Being still too weak to draw directly upon historical reality, the ideologists drove art from the real world by means of metaphysical arguments, and placed it at the centre of the universe (romanticism, Schopenhauer). Thus they transformed art into a refuge of spiritual reaction, which was the most constant element in the intellectual world about to collapse. This was manifested within art itself, in the stagnation of the all-powerful academies. Under these circumstances, all the artists who turned toward concrete life as the source of artistic creation, were despite themselves led to a 'revolutionary' outlook, although they were merely representatives of the

ruling social class of their epoch. Captains of industry or municipal administrators, curators of museums or representatives of the Church, all these 'leaders' live within a conflict between a modern economic form and a reactionary spirit, a conflict which makes them alien to themselves and, by the same token, blind to the art of their epoch. Nothing proves more conclusively that the term 'revolutionary' has become a stereotype when it comes to spiritual matters, than the fact that not a single attempt has been made to distinguish among so many revolutionaries, each of them different from the others. This was, incidentally, impossible, because no basis or common measure exists outside of Marxism; as a result, all the facts too clearly indicated by history had to be negated and aestheticized, as in the case of Courbet. But since about 1918 this attitude has changed considerably. It is quite certain that purely economic causes contributed to this change, when, in the collapse of all monetary values, art became a rare commodity with a 'permanent value', and consequently, possession of works of art became a measure of social status. But for an ideological product to come to be regarded as a commodity of 'permanent value' – the product in question being a work of art – can only be accounted for by still other, secondary, reasons: atavistic recollections of the support once provided by religion in the misfortunes of existence; the example of the ruling classes of the past; the existence of museums and of the sort of speculation that was already practised with respect to ancient art even before 1914. Finally, there has operated to some extent the sincere belief that artists held to be 'revolutionary' might, despite everything, prove capable of answering questions as to the meaning of this general collapse and as to what will in the end prove enduring. In this way the relations between artist and public have become positive – theoretically – thanks, once again, to the public itself. But the latter has been given no answer to its questions. It was not the artists' fault that they have been unable to give it: never ahead of their epoch as revolutionaries, they have never represented it as a whole in an integral work of art, but only fragmentarily; to this sociological fate they have all had to submit more or less willingly. And when the public treated them as oracles of the spirit, they had ceased to be 'revolutionary'; they had even become reactionary in the course of time, and the reactionary answers were inevitably overshadowed by the greater power of the Church. But there are still other reasons why the real relations between artists and public could not be established. At a moment when the most powerful artists have entirely lost their instinct to play with ordinarily valid contents, and when they must consequently vary to the utmost their creative capacity – either under the pressure of an epoch torn between contradictory tendencies, or to prove to themselves, to their customers, and to their masters, the force of their own individuality, the only recognized value (if only to keep busy their many imitators, who interpret lack of variety as a sign of exhaustion and decadence, for the paralysis of the 'leader' would mean their bankruptcy) – at such a moment, the level of knowledge in the epoch is so much above bourgeois potentialities that even its highest artistic production, considered as historical action, falls short of the requirements of the times. Thus, what has not yet been born is in a sense already outmoded, for the motive force of history is already on the other side of the barricade. The mere fact that there is a proletariat conscious of its class and struggling for it – however little this fact has entered the artist's consciousness and sphere of experience – already today deeply influences the subconscious of the intellectual worker. The need for a new, integral work of art adapted to a new social order, makes itself felt in all his creations. But all the convulsions and all the spiritual sufferings of a bourgeois genius will be inadequate to meet this need.

Notes

1. Marx, *The Civil War in France* in Marx and Engels, *Selected Works in One Volume*, London, Lawrence and Wishart, 1968, p. 295.
2. Heinrich Wölfflin, Raphael's professor, refused to read *Von Monet zu Picasso*, Munich, 1913.
3. See Marx's *The Eighteenth Brumaire of Louis Bonaparte* in Marx and Engels, *Selected Works in One Volume*, op. cit., pp. 171–6.
4. Marx, *Contribution to the Critique of Political Economy*, as above.
5. Max Raphael, *Der dorische Tempel*, Augsburg, 1930.

Works of art referred to in the text

Gustave Courbet, *The Bather*, 1853, Musée Fabre, Montpellier.
Michelangelo, *Drunken Bacchus*, 1496–97, St Peter's, Rome;
Michelangelo, *David*, 1501–04, Accademia, Florence.
Synagogue, c.1220, South portal, Strasbourg Cathedral.
Paul Cézanne, *The Mont Sainte-Victoire*, 1886–8, The Courtauld Gallery, London.
Georges Seurat, *Le Chahut*, 1889–90, Rijksmuseum Kröller-Müller, Otterlo.
Pablo Picasso, *Acrobat's Family with a Monkey*, 1905, Gothenburg Art Gallery;
Picasso, *The Soler Family*, 1903
Picasso, *The Absinth Drinker*, 1902; Degas *Absinth*, 1876–7, Louvre, Paris.
Albrecht Dürer, *Adam and Eve*, 1504, copperplate engraving.
Picasso, *Three Women on the Beach*, 1923 (Galerie Georges Petit, Paris 1932, no. 129).
Picasso, *Bathing Woman*, (Kunsthaus, Zurich 1932, no. 188,).
Picasso (Kunsthaus, Zurich 1932, no. 155).

Index

14 July (curtain) (1936) *plate 3, plate 4,*
46–7, 48, 57–8, 60–1

A
Aalto, Alvar 75
Abraham, Pierre
Tiens bon la rampe! 162
abstract art 4, 132, 311
Abstraction-Création group 33, 52
concrete abstractions 33, 52, 140
geometric abstraction 132, 140, 224
gestural abstraction 132, 140, 163
tachism 140, 224
Abstraction-Création 33, 52
AÉAR *see also* Maison de la Culture
Commune (review) 32, 53
foundation 27–8
'revolutionary' art exhibition, 1934 59
role in Popular Front celebrations, 14
July 1935 54
Afghanistan 228
Agamben, Giorgio 105
agit-prop 70, 71, 75
Josep Renau photomontage 71
Leningradskakaia Pravda (1924) 71
Max Alpert, *Ukraine, farmers' meeting*
(1929) 50–1 *fig 9*
photomontage murals 76–7
Popular Front celebrations, 14 July
1935 54–5
Aleš, Mikoláš
The Hussite Camp (1887) 3
Algeria 163–4, 217
French colonial policy 155
Sétif, Guelma and Kherrata repressions
155
tour by Taslitzsky and Miailhe 166
'Algeria 1952' 164–5, 167–8, 169–70
Alhambra theatre *see* Théâtre Populaire
Alleg, Henri 10

La Question (1958) 217
Alpert, Max
Ukraine, farmers' meeting (1929) *fig 9,*
50–1
Althusser, Louis 6, 224
Reading Capital 227
Amblard, Jean 159
Amsterdam–Pleyel movement 23, 47
Ancients and Moderns literary dispute 50
Antelme, Robert
The Human Race (1947) 104
anti-colonial art 159
anti-freemasonry exhibition, 1940 94
anti-semitism *see also* Holocaust, The
Nazi propaganda 94, 95
Picasso as target 98
Soviet 'Doctors' Plot' 112
Stalin's purges 112
Antonova, Irina 231
Aragon, Louis 108, 188
on *Atlantic Civilisation* 170–1, 172–3
'Autumn Salon Scandal' 163
call for realism 128
on Communist Party cultural policy
107
on Fougeron 128
'French realism, Socialist realism'
speech 80–1
Henri Matisse, roman 224–5
Le Musée Grévin 96–7
Les Communistes (1949-51) 215
Littératures soviétiques (1955) 213
'Painting is no longer a game' 163
Pour un réalisme socialiste 53
'Reflections on Soviet Art' series 185–6
sculpture by Nikogosyan 186, 187
fig 27a
on socialist realism 52–4, 57, 80–1, 225
Araquistáin, Louis 70
Arendt, Hannah 111

Arman 111
Aron, Raymond 125
'Art and Resistance' exhibition, 1946 101, 103
Art Déco exhibition, Paris, 1925 68
Artaud, Antonin 11
Association des Écrivains et Artistes Révolutionnaires see AÉAR
atomic bomb *see* nuclear power
Atomic Energy Commission (CEA) 127
Aubade (1942) 229
Auric, Georges 47
Auricoste, Emmanuel 189
Auschwitz
 Le Musée Grévin (Aragon) 96–7
 Ostatni etap (*The Last Stage*) 105, 106, 110
 Picasso's official visit 105–6
autocritique trope 12, 138–9, 210–1
Autumn Salon 108
 1944, Picasso wartime work 99–100
 1947 and 1948, Fougeron 129, 133
 protest paintings scandal, 1951 154

B
Badiou, Alain 5, 6, 10, 233
Balibar, Etienne 227
Baltaxé, Simone 165
Bancel, Louis
 Ho Chih Minh 195
 Young Stalin 195
Barbusse, Henri
 in 'Five Years of Hitler Dictatorship' 83
 Le Feu (1916) 78
 Staline. Un monde nouveau vu à travers un homme (1935) 78
 Stalinism 78
Barcellini, Serge 105
Barlach, Ernst 84
Barr, Alfred H. 218
 on *The Charnel House* 91
 Picasso, Fifty Years of his Art (1946) 91–2
Barral, Emiliano 74
Barthes, Roland
 Mythologies (1957) 12, 217
Basch, Victor 113
Bastille, the 46, 54–5
Bataille, Georges 11, 58, 78, 107
Bauquier, Georges 162, 195
Beauvoir, Simone de 93, 217
Becker, Annette 10

Beckett, Samuel
 Innommable (The Unnameable) (1953) 110
Beckmann, Max 84
Bell, Marie 47
Beloyannis, Nikos 186–7
Benjamin, Walter
 on Paris 8, 52
 'revenge of technology' 82–3, 125
 The Work of Art in the Age of Mechanical Reproduction (1936) 82
Bérard, Christian 53
Berg, Lene
 Stalin by Picasso or Portrait of Woman with Moustache (2008) 12–3, 13 *fig 3*
Berger, John 210, 230
 art as a 'revolutionary undoing' 144
 Success and Failure of Picasso (1965) 1, 229
Berlin blockade 157
Bert, Jacques 47
Besson, Georges 57, 103, 189
Billiet, Joseph 56, 98
Birkenau 106
Black Book of Communism (1997) 3
Blanchot, Maurice
 Writing the Disaster (translated 1986) 12
'blindness' 11–2
Bloch, Jean-Richard
 'the fascism within ourselves' 11
Blum, Léon 46, 55, 70, 82, 98
'Bolshevism against Europe' show, 1941 96
Boltanksi, Christian 111, 112
Boupacha, Djamila 233
Bourdieu, Pierre
 Actes de recherches en sciences sociales 226
 'Reading Marx' 227
Boutadjine, Moustapha
 Femmes d'Alger (2012) 233
Braque, George 98
Breker, Arno 99, 229
Breton, André
 attack on socialist realism 185, 190
 denounces Soviet show trials 79
 International Surrealist exhibition, Paris, 1947 140
 'Why are they hiding socialist realism?' 196–7
Brik, Lili 213

Buchenwald concentration camp 98, 103,
 105, 108 *see also* Taslitzky, Boris
Byungki Kim 176

C
Caballero, Largo 70
Cachin, Marcel 99, 158
Calder, Alexander 72
 Mercury Fountain 72
Callinicos, Alex
 Revolutionary Ideas of Karl Marx
 (1938) 176
Camus, Albert 123
Casanova, Laurent 109–10, 128, 138, 189
Cassou, Jean 1, 11, 47, 53, 61, 108
Castellanos, Julio
 The Day of Saint Juan 170
Catholicism 197–8
Central Intelligence Agency (CIA) US
 142
Centre of Atomic Energy (CEA) 123
Cézanne, Paul 50, 298, 299
Chabana, Kalif 155, 167
Chagall, Marc 84, 98
Chaikov, Joseph
 People of the USSR (1937) 79, 232–3
Chaintron, Jean 135, 136, 191
Charnel House 91, 101, 111
chateau of Baillet 232
'Chim' *see* Seymour, David
China 157
Chirac, Jacques 112
Ciné Liberté 47–8
civilian bombing
 Guernica 74, 81
 Haiphong 155
 Hiroshima 123
 Indochina 155
 Nagasaki 123
Clair, Jean 193
Clouzot, Henri
 Le Mystère Picasso (1956) 211
COBRA group 140
Cold War
 Berlin blockade 157
 climate of fear 125
 nuclear arms race 123–4
 propaganda 126
collaborationism
 reprisals against 98–9
 resistancialisme vs *resistantialisme* 106
collective memory 4, 111–3

Colonial exhibition, Paris, 1931 68
colonial war 2, 155
 Algeria 155
 anti-colonial art 159
 Vietnam 155
Cominform (Communist Information
 Bureau) 128–9
Comintern
 COMRAP 100
 dissolved 1943 84
Committee of Un-American activities 154
Communards' Wall 55
Commune (AÉAR review) 32, 53
Communism
 concept of 'counter-society' 5
 'doublethink' 4
 history vs philosophy 10
 publications 8
 research dynamics 10
Communist International *see* Comintern
Communist National Art Front (FNA) 98
Communist peace congress, Paris (1949)
 122
Compiègne transit camp 103
COMRAP 100
concentration camps 96–7, 100–6, 103
concrete abstractions 33, 52, 140
Congress for Cultural Freedom 173
Congress of Soviet Writers in Moscow 213
Congress of Writers for the Defence of
 Culture 53–4, 111
'Corbu-1937' campaign 75
Corinth, Lovis 84
'counter-society' 5
Courbet, Gustave 297, 298, 299, 316
 Atelier du peintre (1855) 52
 Burial at Ornans (1850) 108
 Stonebreakers (1850) 108
Courtois, Stéphane 10
Crimea Conference *see* Yalta conference
Critique Sociale, La 78
Cubism 35, 53, 307, 314
cult of personality 2, 5–6

D
Dachau 100, 103, 111
Daix, Pierre 100, 101, 106, 110, 134,
 138, 213
 J'ai cru au matin (1976) 12
Daladier, Édouard 60, 68
Daumier, Honoré
 La Rue Transnonain (1834) 57

Republic (1848) 108
David, Jacques-Louis 52, 53, 130, 139–40
 The Death of Marat (1793) 108
David, Jean-Paul 142
Davis, Angela 226
de Gaulle, Charles 161
de Gaulle, Geneviève 101
De Stijl 52
de Zurburán, Francisco
 Saint Bonaventure on his Bier (1629)
 109
décrochage 163–4, 167
Degas, Edgar 297, 301
 Young Spartans Exercising (1860) 159,
 160 *fig 24*
'degenerate' art 60, 81, 83–4, 94–5
Degenerate Art Exhibition, Munich 1937
 81
Deineka, Aleksandr 79
 '23 Soviet Artists' exhibition 52, 165
Delacroix, Eugène 53
 Fanatics of Tangiers (1837-38) 120
 plate 25, 169
 Liberty on the Barricades (1830)
 57, 169
 Women of Algiers (1834) 217
Delanoë, Betrand 91, 112
Delaunay, Robert 69
Delbo, Charlotte 110
Denis, Maurice 98, 198
Derain, André 99
Derrida, Jacques 5, 58
Désange, Guillaume
 Vigils, Liars, Dreamers (2010) 9
Desanti, Dominique 133–4
 Bombe et paix atomique (1950) 145
Desanti, Dominque
 Les Staliniens (1974) 113
Desnos, Robert 94
Despiau, Charles 60, 99
Desprairies, Cécile 94
de-Stalinisation
Dewasne, Jean
 abstract art as dialectical materialism
 224
 Apotheosis of Marat (1950) 140
Dien Bien Phu, 160
Dietz, Emma 84
Djamila Boupacha (1961) 217, 218 *fig 35*
'Doctors' Plot' 112
documentary photography 57
Doisneau, Robert 55, 99, 126

Liège cybernetic tower photography 145
Dondero, George 211
Doriot, Jacques 96
Dotrement, Christian
 Le Réalisme socialiste contre la révolution
 (1950) 185
'doublethink' 4
Douglas Duncan, David 228–9
Dove that Goes BOOM! (1950) 118 *plate*
 17, 142
Dubois, Jacques 167
Duchamp, Marcel 6, 140
 Fountain (1917) 203
Dufy, Raoul 51–2
 Électricity Fairy (1937) 69
Dupré, Michel 193
Durkheim, Emile 4

E
easel painting 46, 55
Efanov, Vasili
 Andrei Zhdanov (1947) 232
Ehrenberg, Felipe
 Picasso is Dead 226
Ehrenburg, Ilya 214, 225
Eichmann trial 111
Eisenstein, Sergei 47
El Greco 314
El Lissitsky 76–7
Éluard, Paul 99, 101, 163, 190
 The Victory of Guernica (1937) 74, 82
Emmer, Luciano 202
Encounters with the 1930s, Madrid, 2012
 66
En-gir, Kim 232
Entarte Kunst 'degenerate art' show,
 Munich, 1937 81
Ernst, Max
 Hordes series 58
 monstrare trope 58
Estève, Maurice 95
European Defence Community (EDC)
 109
 Communist campaign against 110
European Recovery Program (ERP) 109,
 128
Evans, Luther H. 215
Exhibition of European France, 1941
 94–5
existentialism 106, 124
extermination camps 96–7, 100–6, 111

F
Fadeyev, Alexander 130
Fajon, Étienne 168
Fall of Icarus, The (1958) 215
Fangor, Wojciech
 Korean Mother (1952) 119 *plate 19*,
 161
 *Peace inviting the dockers of imperialist
 countries...* (1950-1) 157–8, 158 *fig 23*
Fanon, Frantz 168
fascism
 Amsterdam–Pleyel movement against
 23, 47
 anti-Nazi photomontages, John
 Heartfield 53, 83
Federal Bureau of Investigation (FBI) 142
Federates Wall 55
femininity 169
Fernandez, Luis 48
Festival of Paris 1952 173
Fête de l'Huma 47–8
Fête de l'Humanité 47, 226, 233
Fête of the Federation 47
Fifth Republic 217
figuration
'Film und Photo' exhibition, Stuttgart,
 1929 77
Fischer, Ernst
 The Necessity of Art (1959) 144
Fischer, Hervé 226
'Five Years of Hitler Dictatorship', 1938 83
Fleischmann, Marcel 294
Focillon, Henri
 La Vie des formes 68
Forces Nouvelles group 56
formalism 79, 107, 128, 189, 212
Foster Dulles, John 198
Foucault, Michel 225
Fougeron, André 92, 95, 98, 194
 anti-bomb poster 156
 Atlantic Civilisation (1953) 154–5,
 170–3, 171 *fig 25*, 211
 autocritique 138–9, 212
 bomb poster scandal 129–30, 133
 'Communist intellectual' status 8
 condemns Picasso portrait of Stalin
 194, 195
 De Gaulle, C'est le fascisme 161
 fall of 211
 French peasants defend their lands 173
 Funeral of Victor Hugo's Son 195
 general secretary of FNA 98

Homage to André Houiller... (1949)
 plate 15, 122, 133, 134–5, 137–8
Homage to Franco (1937) 82
illustrations to Prosper Mérimée's *La
 Jacquerie* (1946) 128
*Marx and Engels in the midst of a circle
 of socialist workers, Paris, 1844* 195
at the 'Marx to Stalin' exhibition, 1953
 195
Mining Country series 158–9
Parisians at the Market 129
peace poster (1948) *plate 16*
realist art 129
Republic 100
Scene from the American Occupation
 195
Vaincre 98
Victor Hugo's son's cortège (1967) 224
Women of Italy 129
Fougeron, Lucie 192
France 10–1, 155
 Algeria 217
 Atomic Energy Commission (CEA) 127
 Fifth Republic 217
 mass demonstrations 83
 nuclear research 126–7
 political power 68
Franco-Soviet relationship 8, 9, 231–2
Franco-Soviet Treaty of Mutual Assistance
 53
Francs Tireurs et Partisans Français 101
'Free German Art' show 84
French Association of Revolutionary
 Writers and Artists *see* AÉAR
French Communist Party (PCF) 229
 anti-colonialism 164
 campaign against EDC 109
 Communist 'doublethink' 4
 'Communist painters' rebellion'
 meeting, 1952 189–90
 cultural policy 4, 107–8, 155
 foundation 4
 in opposition 128
 parti des 75,000 fusillés, le 11, 92
 Picasso becomes a member 99, 100
 post-war cultural economy 140–1
 promotes Stalin's cult of personality
 190–1
 resistance effort, World War II 92
 thirteenth Party Congress, 1954 212
 wartime activity 95
 during World War II 95

French Resistance *see* Resistance, The
Frente Popular 70
Freud, Sigmund 34, 313
Freund, Gisèle 80
Freundlich, Otto 94
Fréville, Jean 58, 234
Friesz, Othon 99
Fukushima 123
Furet, François 10

G
Galerie Billiet-Vorms 56
 'Cruel Art' show, 1937 82
 'Realism and Painting' 1936 57
Galerie Braun
 'Young Painters of the French
 Tradition' show 95
Garaudy, Roger 103, 107
 D'un réalisme sans rivages, Franz Kafka,
 Saint-John Perse, Pablo Picasso (1963)
 224
García Lorca, Federico 72
Gáspár Miklos Tamás 12
General Strikes 1936 57
Gentner, Wofgang 126
geometric abstraction 132, 140
Gerasimov, Alexander 80, 128
 Lenin on the Tribune (1930) 224
 Stalin at a Meeting with Commanders
 80, 81 *fig 16*
 Target of *Le Crapouillot* satire 80
Géricault,
 Raft of the Medusa 104
Géricault, Théodore 52
Gervereau, Laurent 10
Gerz, Jochen
 'Exit' project 111
'Gestapo for Jewish questions' 94
gestural abstraction 132, 140, 163
Ghomri, Tahar 167
Giacometti, Alberto 53, 108
Gide, André
 Back from the USSR (1936) 79
Gilot, Françoise 93, 144, 156, 184, 189,
 192, 201
Goat skull and bottle (1952) 212
Goerg, Edouard 57
 Auschwitz 98
Goethe, Johann Wolfgang von 83
Golan, Romy
 Muralnomad: The Paradox of Wall
 Painting, Europe 1927-1957 67

Golomstock, Igor 214
Gonzales, Julio
 Montserrat 71
Gorky, Maxim 53, 55
Gosselin, Gérard 192
Goya, Francisco
 The Second of May 1808 (Charge of the
 Mamelukes) 74
 The Third of May 1808 74, 188
Grand Palais, Paris
 Exhibition of European France 1941
 94–5
 'Hitler's Crimes' exhibition 101
Grappe, Georges 98
Grapus design collective
 Karl Marx School *plate 1*
 'Great Marxist texts' series 58
Greenberg, Clement 226
Gromaire, Marcel 57
 Man on the Dole (*The Striker*) 57
Groy, Boris
 Dream Factory Communism 9
Grunenberg, Christoph
 Picasso, Peace and Freedom 3
Guernica (1937) 3, 66–7, 71–2
 death and nativity imagery 72
 Fred Stein photography 73 *fig 13*
 inaugural speech on 73–4
 as indictment of the non-intervention
 pact 71
 in *Les Pages libres de la Main à Plume* 93
 Max Raphael on 66, 72, 74–5
 in the Museum of Modern Art, New
 York 66
 in the Pushkin Museum *plate 32a*, 231
 realism debate 73
 in the Reina Sofía museum, Madrid 66
 use as symbol of political protest 3–4
Guernica bombing 74, 81
Guesde, Jules 78
gulags 110, 124, 129, 134, 142
Gutov, Dmitri
 film on the life of Mikhail Lifshitz 234
Guttuso, Renato 129
 Das Gastmahl 226

H
Hains, Raymond
 La France déchirée (1961) 217
Haiphong 155
Halbwachs, Maurice
 notion of 'collective memory' 4, 112–3

Professor Halbwachs, Buchenwald
 (1945) (Taslinsky) *plate 12*, 113
Halimi, Gisèle 217
Hartung, Hans 163
Hautecoeur, Henri 68
Heartfield, John
 anti-fascist photomontage 53, 83
Hegel, Georg Wilhelm Friedrich
 Zeitgeist 4
Heidegger, Martin 12, 312
Heine, Heinrich 83
 Almansor (1821) 96
Hélion, Jean 52
Herbin, Auguste
 Lenin–Stalin (1948) 140, 141 *fig 22*
Hiroshima 123
Hitler, Adolf
'Hitler's Crimes' exhibition 101
Ho Chi Minh 155, 158
Holocaust
 Kristallnacht 84
Holocaust, The
 commemoration sites 105
 concentration and extermination
 camps 96–7, 100–6, 111
 deportation 94, 105, 108, 111–2, 112
 at the heart of the debate on realism
 and Communist cultural policy in
 1945 92
 imagery as propaganda 104–5, 110
 Kristallnacht 84
 memorials 111–2
 representation in art 103–5, 104–5
 transit camps 103
 Vel' d'Hiv Roundup 111–2
Holodomor (Ukraine) 14
*Homage to the Spaniards who Died for
 France* 101, 102 *fig 18*
Honnegger, Arthur 47
Hoover, J. Edgar 100
Houllier, André 131, 133–4, 137–8
Hourani, Khaled 14
'House of Labour' 78
House Unamerican Activities Committee
 (HUAC) 130
humanism 124–5
humanist photography 8–9
Hungarian Uprising, 1956 4, 164, 214–5

I
Iablonskaia,
 On the river Dnieper 212

iconoclasm 60, 226
Île aux Cygnes 68
Île Seguin 55–6
'Indelicates, The' 95
Indochina 155, 160, 163–4, 200
Ingres, Jean-Auguste-Dominique 52
Inhye Kim 175
Institute for Jewish Questions (IEQJ) 94
 'The Jew and France exhibition', 1941
 94, 95
International Exhibition of Arts and
 Technology of Modern Life, 1937 66,
 67–8, 67 *fig 12*
International Peace Congress, 1948 105
International Press Exhibition, Cologne,
 1928 76–7
International Surrealist exhibition, Paris,
 1947 140
Iofan, Boris 69
 Palace of the Soviets 70
 Soviet pavilion, Paris World Fair, 1937
 plate 9, 79
 Soviet pavilion, World Fair, Paris, 1937
 232–3
Iven, Joris
 La Paix Vaincra 161–2

J
Jacob, Max 94
Jakubowska, Wanda
 Ostatni etap (*The Last Stage*) 105, 106,
 110
Jeanneret, Pierre 75, 76
 New Times pavilion, World Fair, Paris,
 1937 76 *fig 14*, 77 *fig 15*
Jeanneret-Gris, Charles-Édouard *see*
 Le Corbusier
Jeu de Paume bonfire 96, 101
Jeu de Paume exhibition 75
'Jeunes 37' 75
'Jew and France, The', 1941 94
Jewish Communists 105
Jewish Museum of art and history, Paris
 112
'Jewish-Marxist' artists 95
John Heartfield
 anti-Nazi photomontage 53, 83
Joliot-Curie, Frédéric 122–3, 126–7,
 131, 143, 200
 leadership of the Peace movement 156
 'Stalin, Marxism and Science' 194
Joliot-Curie, Irène 126

Jung, Carl 4

K
Kamenev, Lev 79
Kanapa, Jean 112, 113, 124
Karl Marx (1964) xvii *fig 1*
Karl Marx School, Villejuif *plate 1*,
 30–2, 31 *fig 6*, 235
Kees van Dongen 51
Khaldei, Yevgeny 112
Khodossievitch-Grabowska, Wanda 50
 see also Khodossievitch-Léger, Nadia
Khodossievitch-Léger, Nadia 165
 Self Portrait (1936) *plate 5*
 War in Korea (1952) *plate 19*, 161
Khrushchev, Nikita 214, 218
Kim Il Sung 157
Kivitz, H. 83
Klee, Paul 84, 96
Klossowski, Pierre 11
Klucis, Gustav
 *Soviet Citizens Voting for Stalin's
 Constitution* 80
Kochno, Boris 61
Koechlin, Charles 47
Koestler, Arthur
 Darkness at Noon (1940) 10
Kojève, Alexandre 58
Kokoschka, Oskar 84
Konenkov, Sergei
 bust of Lenin 185
Korea 200
Korean War 1950-53 157
Korine, Pavel
 Alexander Nevski (1942) 232
Kougach, Yuri Petrovich
 The Highest Decoration 185
Kravchenko, Victor 110, 134
Kriegel, Annie 10
 Ce que j'ai cru comprendre (1991) 12
 concept of 'counter-society' 5
Kristallnacht 84
Kukryniksy trio
 The End (1947-48) 185

L
la Colère, François *see also* Aragon, Louis
 Le Musée Grévin 96–7
La Ruche 9
La Santé transit camp 103
Labasque, Jean 57
Lacasa, Luis 71

Lansiaux, Marie-Anne 165
Lanskoy, André 140
L'Art en guerre, 1938-1947 (2012) 93, 111
L'Art français 93, 98, 99
Laval, Pierre 53
Lazarus, Daniel 47
Le Corbusier 299
 *Des canons, des munitions? Merci! Des
 logis... S.V.P.* (1938) 78
 New Times pavilion, World Fair, Paris,
 1937 69, 75–7, 76 *fig 14*, 77 *fig 15*
 querelle du réalisme, debates, 1936 57
Le Nain brothers 52
Lebarbier, Jean-Jacques François
 *Jeanne Hachette at the siege of Beauvais
 in 1472* (1784) 169
Lebel, Robert 195
Lecœur, Auguste 212
'legal purge' 98–9
Léger, Fernand 96, 197
 'agriculture' panels in the Rural Centre,
 EXPO Paris, 1937 77–8
 Builders series 159, 161, 163
 Composition with Three Figures (1933)
 50
 criticism of 212
 Hands. Homage to Mayakovsky 161
 on the homage to The Commune,
 1936 55
 Maud Dale (1935) *plate 8*, 50
 photomontage murals at New Times
 pavilion 76–7
 querelle du réalisme, debates, 1936 57
 Transport of Forces (1937) 78
 Travailler (*1937*) 77
 Woman in Blue 4
Léger, Nadia *see* Khodossievitch-Léger,
 Nadia
Lehmbruck, Wilhelm 84
Leiris, Michel 78
'Lenin, Stalin and Music', Paris, 2010-11
 231–3
Lenin, Vladimir Ilyich
 bust 78
 'Tolstoy, Mirror of the Russian
 Revolution' (1937) 58
Leningradskaia Pravda, 1924 71
Les Femmes oubliées de Buchenwald, 2005
 108
Les Lettres françaises 186
 publishes Picasso's por8trait of Stalin
 plate 26, 194

Stalin commemorative issue 192, 194
Lhote, André 57
L'Humanité
 condemns Picasso portrait of Stalin 194
 Stalin commemorative issue 192, 192
 fig 30
Liberation of Paris 98
 celebrations 100
 'legal purge' 98–9
Liberation Salon see Autumn Salon
Liebermann, Max 84
Lifar, Serge 61
Lifshitz, Mikhail
 Crisis of Ugliness, from Cubism to Pop
 Art (1968) plate 33, 234
Lim Seung-soo
 Capital: Even a Monkey Could Read It
 176
Lingner, Max 69
Lipchitz, Jacques 58–60
 David and Goliath (1933) 58–9
 Prometheus Strangling the Vulture
 58–60
Lissitzky, Lazar Markovich see El Lissitsky
Lonergan, Bernard
 concept of scotosis (blind spot) 11
Longuet, Frédéric
 Marx and Engels with Madame Marx
 and their three daughters (1953) 196
 fig 32
Longuet, Karl-Jean 78, 129
 bust of Marx 196
Lord, James 230
Luce, Maximilien 9, 53
Lukács, György
 'Free Art or Directed Art?' 140
 The Meaning of Contemporary Realism
 (1955) 201
Lurçat, André
 Karl Marx School, Villejuif 20, 30,
 30–2, 31 fig 6, 33 fig 7, 34, 235
Lurçat, Jean 50, 57
Lyotard, Jean-François
 Heidegger and the 'Jews' (translated
 1988) 12
Lyssenkism 194

M
Maar, Dora 48, 93
Macuga, Goshka
 The Nature of the Beast (2009) 67
Maillol, Aristide 60

Main à Plume, La 93
Maison de la Culture see also AÉAR
 artistic liberty debate 60
 'Free German Art' show 84
 Jean Nicolas, secretary 75–6
 journal 83–4
 Louis Aragon, director 75
 remit 52
Maison de la Métallurgie 108
Maison de la Pensée Française 108, 130,
 132
Malenkov, Georgy 212
Malevich, Kazimir 79
Mallet-Stevens, Robert
 Palace of Light, EXPO, Paris, 1937 69
Malraux, André 52
 inaugural lecture, UNESCO 124
 'musée imaginaire' 7
 projects as Minister for Cultural Affairs 4
Man with a lamb 190, 231
Manchuria 157
Manet, Édouard 297
 Execution of the Emperor Maximilien
 159
Manhattan project 123
Marc, Franz 84
Marchais, Georges 203
Marchand, André 9
Marcuse, Herbert
 Soviet Marxism 144
Marie-Thérèse by a Window (1932) 234–5
Marin, Louis 227
Marshall Plan see European Recovery
 Program (ERP)
Martin, Henri 162, 172, 189
 exhibition in support of, 1952 186
Marx, Karl 113
 bust 78
 centurion exhibition, 1953 183, 184
 'Marx to Stalin' exhibition, 1953 183,
 195, 196
Masereel, Frans 69
Massacre in Korea (1951) 229
 criticism of 211
 in the Pushkin Museum 231
 use as symbol of political protest 3–4
Masson, André 52, 96
'Masterpieces of French Art' exhibition 69
'Masters of Independent Art' exhibition
 69
'Masters of Reality in the 18th Century' 52
Mathey, François 214

Mathieu, Georges 140, 163
Mauclair, Camille 98
May Salon 1851 160
Mazenod, Lucien 77
 Recréer (*Recreation*) 77
Melnikov, Konstantin 70
 pavilion interior Paris, July 1930 *plate 6*
memory 11–2
Mercure (1924) stage curtain 48
Merkurov, Sergei 80
Merleau-Ponty, Maurice
 Humanism and Terror, an essay on the
 Communist problem 10, 124
Messerer, Boris 231
 the great staircase, Pushkin Museum
 plate 32a, 231
Mevedev, Dmitri 230–1
Miailhe, Mireille 165
 88% of children without school 167
 The Administration has just passed by 167
 in Algeria 165–6
 Algeria will be free 167
 'Algérie 1952' *plate 24*
 Child with trachoma 167
 Cité Mahédinne in Algiers: seven
 drinking fountains for 30,000 people
 167
 Deux peintres et un poète, retour
 d'Algérie 167
 Group of young Arabs 167
 Her neighbour. It's here she'll give birth
 in a few days' time 167
 l'An V de la révolution algérienne 168
 Pause at noon, it's the colon who sells the
 bread 167
 Woman and child 167
 Women's portrait 168
 Young agricultural workers (1952) *plate*
 22
 Young agricultural workers in the area
 around Algiers 165–6, 168, 170
Michaux, Henri 140
Milhau, Denis
 'Picasso and the Theatre' 60–1
Milhau, Jean 60
Milhaud, Darius 47
Mindszenty, Cardinal József 197
Miró, Joan
 Spanish Peasant in Revolt (The Reaper)
 (1937) 75
 Still Life with Old Shoe (1937) 75
 work destroyed by fire 96

Mittelbau-Dora 103
Mitterand, François 229
Modern Artists Union pavilion 75
Modersohn, Paula 84
Molotov–Ribbentrop non-aggression pact
 84, 92
Molotov–Ribbentrop Pact 213
monadic system 304
Mondrian, Piet 52
monstrare trope 58
Montagnac, Paul 99
Montandon, George
 Comment reconnaître le Juif? 95
Moquet, Guy 95
Morath, Inge
 Picasso at the UNESCO inauguration,
 1958 216 *fig 34*
Morin, Edgar 10
 Autocritique 12
Morris, Linda
 Picasso, Peace and Freedom 3
Moussinac, Léon 53
Mukhina, Vera
 We Demand Peace! 186
 Worker and Kolkhoz-Woman (1937)
 69–70, 79, 232
Munich Agreement, 1938 68
Münzenberg, Willi 84
'Murdered France: Master Paintings and
 Photographic Documents', 1945 101
Musée Picasso, Paris 229
Museo Nacional Centro de Arte Reina
 Sofía 66
Museum of Modern Art, New York 66
 'Art and Resistance' exhibition 1946
 101, 103
Museum of Western and Oriental Art 80
Museums' National Front 98

N
Nagasaki 123
Naiman, Anatoly 214
Nancy, Jean-Luc 111
National Art Front 98
 reprisals against collaboration artists
 98–9
National Council of the Resistance 98
national defence policy, France 53–4
National Gallery, Rome
 Picasso retrospective, 1953 201
National Museum of Modern Art
 Resistance Room 105, 110

Nazi Germany
 attitude to modern art 82, 83–4
 'degenerate' art 60, 81, 83–4, 94–5
 the Holocaust 1
 Nazi-inspired exhibitions 94
 and totalitarianism 11
Nazi Pavilion, World Fair, Paris, 1937 69,
 79, 81–2
Negro art 300, 303, 305, 313, 314
Neruda, Pablo 143
New Soviet Pavilion, Moscow *plate 30a*,
 plate 30b, *plate 31*
New Times Pavilion, World Fair, Paris, 1937
 interior 76, 77 *fig 15*
 photomontage murals 76–7
 tent and pylon construction 75–6
New Times pavilion, World Fair, Paris, 1937
 tent and pylon construction 76 *fig 14*
Niemeyer, Oscar 224
Nikogosyan, Nikogos
 Ida Kar (1953) 187 *fig 27b*
 Louis Aragon (1953) 186, 187 *fig 27a*
Nora, Pierre 10
North Africa 165–6
North Korea 157, 176
'Nouveau Réalisme' 217
Nouveaux destins de l'intelligence française
 126
nuclear power 156–7
 anti-bomb art 122, 133–5, 136–7 *fig*
 21a-21d, 137–8
 arms race 123–4, 145
 in a climate of fear 125
 First Lightning (*Pervaya Molniya*) 123,
 134, 145
 French research programmes 126–7, 131
 Hiroshima atomic bomb 123
 Manhattan project 123
 Nagasaki atomic bomb 123
 Stockholm Appeal against 123, 124
 Tsar bomb 145
 Zoe reactor 131
Nude, Green Leaves and Bust (1932)
 1, *plate 2*
Nude with Blue Curtain (1932) 1, *plate 2*

O
Omar, Hadif 167
Oradour 10–1, 131, 202
Ortega y Gasset, José 294, 304
Ozenfant, Amedée
 on the Paris World Fair, 1937 66

P
Pacific War 155
Pages libres de la Main à Plume, Les 93
Pak Den-Ai 157
Palace of Discovery, World Fair, Paris
 1937 78
Palace of Light, World Fair, Paris 1937 69
Palace of the Soviets, Moscow 232
Palais Berlitz, Paris
 'The Jew and France exhibition', 1941
 94, 95
Palais de Chaillot, Paris 69
Palais de Tokyo museum 69
Palazzo Reale, Milan
 Picasso retrospective (1953) 201–2
Papillault, Rémi 61
Paris
 Commune 55, 297
 liberation 1944 98
 Maison de la Pensée Française 130
 under Nazi occupation 92, 93–4
 and Picasso 7–8
 political and cultural significance 7–8
 reconstruction post WWII 12
 World Fair, 1937 60, 66–84, 232
Paris Art Déco exhibition, 1925 68
Parmelin, Hélène 214
 Massacre des Innocents. L'Art et la guerre
 202–3
 'Picasso or difficult truths' 228–9
Parti communiste français (PCF) *see* French
 Communist Party (PCF)
parti des 75,000 fusillés, le 11, 92
patriarchy, cult 78
Pavilion of the Air 69
Pavillon des Temps Nouveaux *see* New
 Times pavilion
Peace pavilion 69
Peintres et Sculpteurs de la Maison de la
 Culture (*PSMLC*) 83–4
Perec, Georges 111
Père-Lachaise cemetery 55
Pérez Mateos, Francisco 74
Perriand, Charlotte 77
 Rural Centre, EXPO, Paris, 1937 75
Petit Palais
 anti-freemasonry exhibition, 1940 94
 French 'Masters of Independent Art' 94
photography
 humanist 8–9
 photojournalism 55
 photomontage 53, 76–7, 80, 83

Picabia, Francis 96
Picasso, Pablo
 14 July (1936) *plate 3, plate 4,* 46–7,
 48, 57–8, 60–1
 'Art and Resistance' exhibition 1946
 101, 103
 art reflecting and masking events 5
 'artist-genius' status 6
 Aubade (1942) 229
 at the Autumn Salon, 1944 99–100
 Bicycle Saddle and Handlebars (1942)
 93
 *The Body of the Minotaure in harlequin
 costume* (1936) 48, 49 *fig 8*
 Bust of a Woman (1943) 14
 The Charnel House (1944-5) 91, 101,
 111, 116 *plate 10*
 at communist peace congress, Paris
 (1949) 122
 cosmonaut portraits 145
 cultural and political role 3–4
 death and tributes 226–7
 Demoiselles d'Avignon 198
 Desire Caught by the Tail (1941) 93, 101
 director of the Prado Museum, Madrid 82
 Djamila Boupacha (1961) 217, 218
 fig 35
 Dora Maar (1939) 130
 drawings of Thorez 103
 Dream and the Lie of Franco (1937) 82
 The Fall of Icarus (1958) 215
 FBI files 100, 226
 *The Forces of Life and the Triumphant
 Spirit of May* 215
 Four Corners of the World 203
 Goat Skull and bottle (1952) 212
 in Golfe-Juan and Antibes 156
 Guernica (1937) 3–4, 66, 66–7, 71–2,
 73–4, 73 *fig 13*, 93
 *Homage to the Spaniards who Died for
 France* 101, 102 *fig 18*
 at International Peace Congress,
 Wroclaw, 1948 105
 involvement in Cominform
 propaganda 124
 joins Communist Party 99, 100
 Karl Marx (1964) xvii *fig 1*
 at the Maison de la Pensée Française
 130, 132
 Man with a lamb plate 32c, 190, 231
 Man with Carnation (Nikos Beloyannis)
 (1952) 186, 188 *fig 28*

 Marie-Thérèse by a Window (1932)
 234–5
 Massacre in Korea (1951) 3–4, 119
 plate 18, 154, 156, 157, 159–60,
 163, 164, 174–5, 211, 229
 New Masses statement (1944) 100
 ninetieth birthday, 1971 226
 Nude, Green Leaves and Bust (1932) 1,
 plate 2
 paintings destroyed WWII 96
 and Paris 7–8
 participation in humanist discourse
 124–5
 Peace (1952) 199 *fig 33*
 peace dove 124, 142, 143
 'Picasso in Palestine' (2011) 14
 'Picasso Year', 1966 224
 *Portrait of Madame Rosenberg and her
 daughter* (1918) 231
 portrait of Stalin (1953) 12–3, 170,
 183, 192–5, 193 *fig 31,* 203
 poster for the World Peace Conference
 (1949) 120 *fig 20,* 130
 president of FNA 98
 at Pushkin Museum, Moscow, 2010
 230–1
 receives silver medal of gratitude, 1948
 130
 relationship with Dora Maar 93
 relationship with Françoise Gilot 93
 at the Salon d'Automne, 1944 92,
 99–100
 seventy-fifth birthday exhibition, 1956
 214
 Shanghai Expo China Pavilion, 2011
 234
 Skull (Death's Head) (1943) 93, 231
 'sociological' studies of 226–7
 Stalin, Your Health (1949) 122, 134–5,
 136–7 *fig 21a-21d,* 138
 stance during World War II 92–3
 statement on opening of Picasso expo,
 Moscow, 1956 210
 target of anti-semitism 97–8
 Temple of Peace 190, 199 *fig 33*
 tenth anniversary lithograph for
 Auschwitz 1955 106
 at the UNESCO inauguration, 1958
 216 *fig 34*
 Visages de la Paix (1950) 229
 visit to Auschwitz 105–6
 Vollard suite 11

War, 1952 *plate 21*
War and *Peace* (1951-52) 174, 183, 190, 200–2
work functioning as a sign of resistance 82
works during World War II 92–3
at the World Congress of Advocates of Peace, Paris, 1949 131–2
at the World Congress of Intellectuals for Peace, 1948 130
'*Picasso in England*' exhibition, 1938 66
Picasso Museum, Paris 229
Pignon, Edouard
 'Communist intellectual' status 8
 in favour of German disarmament, 1947 108–9
 leads 'Communist painters' rebellion', 1952 189
 primitivist image 212
 signs protest against suppression in Hungary 215
 'Young Painter of the French Tradition' 95
Piscator, Erwin 47
Pius X
 Pascendi Dominici Gregis 198
Pius XI 198
Pius XII 198
 Meditator Dei et Hominem 198–9
Plastov, Arkadi
 Harvest scene in the kolkoz (1937) 232
Plekhanov, Georgi 4, 53, 189
Pleven, René 109
Popular Front
 celebratory processions, July 14, 1935-36 46, 54–5
 defeat, 1937 68, 70
Portrait of Madame Rosenberg and her daughter (1918) 231
'Portrait Scandal' 12–3
Poussin, Nicolas
 Rape of the Sabines (1637-38) 162, 217
Prado Museum, Madrid 82
Prague Spring 224
Pressa exhibition, Cologne 1928 76–7
Prigent, Albert
 Marx, 1953 *plate 27*, 195
Prokoviev, Victor
 'Notes on progressivist art in France' 211–2
propaganda
 agit-prop 55, 70, 71, 75

anti-colonialist 158–9
Cold War 124, 126
Holocaust imagery 104–5, 108
Ukraine, farmers' meeting (1929) 50–1, 51 *fig 9*
Pukhov, Volodia 213
Pushkin Museum, Moscow
 'gifts to Stalin' exhibition (1949) 122, 141–2
 the great staircase, with Boris Messerer, after *Guernica*, 2010 *plate 32a*, 231
 Pablo Picasso, war paintings, 1939-1951 *plate 32c*
 Pablo Picasso, works from 1950-1972 *plate 32b*
Putin, Vladimir 9, 232

Q
quarrel of the Ancients and the Moderns 50
querelle du réalisme see realism debate
Quignard, Pascal
 L'Occupation américaine (1995) 173

R
Radical Socialist party 68
Rancière, Jacques 5, 111
'Raoul' 98
Raphael, Max 2, 2 *fig 2*, 51, 52, 58, 144, 294
 arrest and internment 84
 on *The Charnel House* 91–2
 concrete abstractions 33, 52, 140
 on easel painting 46
 on *Guernica* 66, 72, 74–5
 Proudhon, Marx, Picasso (1933) 1, 8, 294
Rassemblement Populaire Français (RPF) 161
Rassemblement Universel pour le paix (RUP) 69
realism debate 46–7, 50–1, 56–7, 224
reflection theory 4, 5, 50–1, 58, 107
Reina Sofía museum, Madrid 66
Reinhardt, Lidia
 Crisis of Ugliness, from Cubism to Pop Art (1968) *plate 33*, 234
religion 197–8
Rembrandt 84
Renau, Josep 71
Renault factory, Île Seguin 55–6
Renoir, Jean
 La Marseillaise (1938) 48

repressed mourning, concept 4
Resistance, The
 Francs Tireurs et Partisans Français 101
 French Communist Party effort 92
 National Council of the Resistance 98
Resistance museum, Champigny 112
Resnais, Alain
 Guernica (film) (1950) 132
 Night and Fog (1955) 106, 110
revolutionary romanticism 52
revolutionary surrealism 52
Revolutionary Surrealists 140
revolutionary theatre 47–8
Richardson, John 230
Riffaud, Madeleine 167
Riposte, Port-de-Bouc 108
Rivière, Georges-Henri 98
Rochet, Waldeck 224
Rohlfs, Ernst
 prohibition of works 84
Rolland, Romain 83, 98
 14 July 46–8
Rollin, Jean 164
Ronis, Willy 8
Roque, Jacqueline 61
Rosenblum, Anna 109
Roussel, Albert 47
Rousset, David 104, 110, 134
Rousso, Henry 10, 106
 concept of repressed mourning 4
Roy, Claude
 La Guerre et la Paix 202, 203
Rubin, Bill 230
Rue des Grands Augustins studio 93, 94
Rue La Boétie, Paris 56, 94
Rural Centre, World Fair, Paris, 1937 69,
 75
 Leger's Agriculture photomontage
 77–8
Russia *see* Soviet Union

S
Saint-Gobain pavilion 75
Saint-Sulpice transit camp 103
Salendre, Georges 189
Salle Wagram 96, 97 *fig 17*, 109
Salles, Georges 203
Salon d'Automne *see* Autumn Salon
Salon de Mai *see* May Salon
Sanchez, Alberto
 *The Way of the Spanish People Leads
 towards a Star* 71

Sarkozy, Nicolas 9, 95, 231
Sartre, Jean-Paul
 admirer of Communism 164
 existentialism 106
 on humanism 124
 'Portrait of an Antisemite' (1945) 108
 Réflexions sur la question juive 107
Scheler, Max 21, 313
Schkaff, Yevgeny 58
Schmid-Ehmen, Kurt 81
Schöffer, Nicholas 145
Schonlanke 84
School of Paris 8, 51, 69, 74, 94
Scortesco, Cardinal Paul 184, 197, 198
 Saint Picasso, peignez pour nous 183
 Satan, voici ta victoire (1953) 183
Scotosis (blind spot) 11
Segadou see Spanish Peasant in Revolt
self-criticism (*autocritique*) trope 12,
 138–9, 210–1
Semprun, Jorge 10
 Literature or Life (1994) 104
Senkin, Sergei 76–7
Serge, Victor 78
Sert, Josep Lluís 71
Sétif massacre 155
Seymour, David
 demonstration at the Federates' Wall,
 1936 (photo) 55, 56 *fig 10*
Shalev-Gerz, Esther
 Ton image me regarde (2002) 111
Shanghai Biennale, 2012 234
Shanghai Expo China Pavilion, 2011 234
Shchukin, Sergei 213
Shoah Memorial 112
Shostakovich, Dmitri 232
Shurpin, Fedor
 The Morning of our Fatherland (1948)
 232
Signac, Paul 9, 53, 55
Singer, Gérard
 14 February, Nice 162, 163
 View of Laon 173
Sino-Soviet Pact, 1950 157
sites of memory 55
Skull (Death's Head) (1943) 93, 231–2
socialist realism 46–7, 50–1, 52, 80–1,
 158–9
 contemporary exhibitions 9
 debate 196–7
 decline in support for 189–90
 French vs Soviet models 3

socialist utopianism 52
'Solidarity' pavilion, World Fair, Paris, 1937 78
Sollers, Philippe 229, 230
Sorel, Georges
 Reflections on Violence 83
Soupault, Ralph
 'Ideal Exhibition' caricatures 82
South Korea 157, 176
Souvarine, Boris 78
 Staline. Aperçu historique du bolchevisme 78–9
Soviet pavilion, World Fair, Paris, 1937 69–70, 78–80, 232–3
 Marx and Lenin busts 78
 photography 80
Soviet Union
 '23 Soviet Artists' 52
 art purges 107
 atomic bombs 134, 145
 cultural policy (zhdanovshchina) 107
 de-Stalinisation 214
 gulags 110, 124, 129, 134, 142
 invasion of Afghanistan 228
 invasion of Hungary, 1956 4, 164, 214–5
 invasion of inner Mongolia 155
 under Khrushchev 218
 nuclear power programme 123–4, 129
 show trials and executions 79, 80
 socialist realism 50–1
 'Soviet Art of the Five Year Plan' 52
 VOKS 56
Soviet war in Afghanistan 228
Soviet–Japanese War, 1945 155
Spanish Civil War, 1936-39 70–1
 bombing of Guernica 74, 81
 Non-Intervention Agreement, 1936 70, 71
Spanish pavilion
 EXPO, Paris, 1937 69, 70–1, 74–5
Spanish Peasant in Revolt 75
Speer, Albert
 Nazi pavilion, World Fair, Paris, 1937 69, 79, 81–2
Spellman, Cardinal Francis Joseph 197
Ssorin-Chaikov, Nikolai 135–6
stage curtains
 14 July plate 3, plate 4, 46–7, 48, 57–8, 60–1
 Mercure (1924) 48
 Parade (1917) 48

'Picasso and the Theatre' show (1965) 60–1
Train bleu, Le (1924) 48
Stalin, Joseph
 cult of personality 190–1
 definition of the writer 52
 de-Stalinisation 214
 'gifts to Stalin' exhibition, 1949 122, 134–7, 141–2
 Great Marxist texts' series 58
 mutual assistance pact with Laval 53
 obituaries 192–4
 and Romain Rolland 47
Stalin, Your Health (1949) 122, 134–5, 136–7 *fig 21a-21d*, 138
Stalin Peace Prize 143
Stalinism 2
 autocritique (self-criticism) trope 12
 history vs philosophy 10
 research dynamics 9–10
 and totalitarianism 11
Stanislawski, Ryzard 163
Stchoukine de Keller, Madame 213
Stein, Fred 48, 72
 Guernica, Spanish pavilion, Paris World Fair, 1937 73 *fig 13*
Sternhell, Zeev
 Neither Right nor Left 83
Stil, André 93
Stinco, Antoine 61
Stockholm Appeal 123, 124, 156–7
Stoekel
 Stalin [undated] 122 *plate 28*, 195
Stravinsky, Igor 57, 311, 314
Suetin, Nikolaj 79
Surrealism 29, 34, 211
Svec, Otakar 215
Sylvester, David 230

T
tachism 140, 224
Takeguchi Shuzo
 Picasso, War and Peace (1956) 175
Taslitzky, Boris *see also* Miailhe, Mireille
 on the *14 July* exhibition 49
 Algerian Father 170
 'Algérie 1952' 167–8
 Buchenwald (1946) 92, 104–5, 110, 111
 Buchenwald, the Small Camp, February, 1945 103
 'Communist intellectual' status 8
 criticism of 212

Death of Danielle Casanova (1950)
 plate 14, 109
decor for twelfth PCF congress 1950
 191 *fig 29*
defines socialist realism 168
Delegates (1948) 130
*Deux peintres et un poète, retour
 d'Algérie* 167
friendship with Maurice Halbwachs 4,
 112–3
Henri Martin (1953) 163
I Salute You France… 101, 106
Kalif Chabana drawing 155, 167
*Under Lenin's flag, under Stalin's
 direction* (1950) 190
*The Monthly Weigh-in at the Riom
 Central Prison* 106
At the Père-Lachaise cemetery in 1935
 (1936) *plate 7*, 57
on Popular Front celebrations,14 July
 1935 54, 93–4
Professor Halbwachs, Buchenwald
 (1945) *plate 12*, 113
Riposte, Port-de-Bouc (1951) 162
The Small Camp, Buchenwald (1946)
 plate 13
in St Sulpice prison camp 97, 98
Strikes of June 1936, The (1936) 55
'Witness' (*Témoignage*) exhibition 104
Women of Oran (1952) *plate 21*, 168–9
Temps Nouveaux pavilion *see* New Times
 pavilion
Thaelmann Committee
 'Five Years of Hitler Dictatorship',
 1938 83
Thälmann, Ernst 48
Théâtre de la République *see* Théâtre
 Populaire
Théâtre Populaire
 14 July (stage curtain) *plate 3*, *plate 4*,
 46–7, 48, 57–8, 60–1
Thorak, Josef
 Friendship and *Genius* (1937) 81–2
Thorez, Maurice 55, 95, 138, 189
 desires end to socialist realist policy
 170
 fiftieth birthday celebrations, 1950 109
 Picasso drawings of 103
Tillion, Germaine 233
Toukhatchevsky, Mikhail 80
Thomism 313
Tretyakov Gallery 79

Triolet, Elsa
 Le Monument (1957) 215
Trotsky, Leon
 championed by surrealists 78
 Revolution Betrayed (1936) 79
Turcato, Giulio 129

U
Ukrainian Terror-Famine 14
UNESCO
 The Fall of Icarus (1958) 215
 international show of modern art,
 1946 140
Union des Femmes Françaises 109, 165
Union of Soviet Socialist Republics *see*
 Soviet Union
Union of Soviet Writers' Congress 52
United Left Front 46
Universal Alliance for Peace 69
'uranium gulag' 129
USSR pavilion *see* Soviet pavilion
Utley, Gertje R.
 Picasso, the Communist Years (2000)
 2–3, 8

V
Vaillant-Couturier, Paul 75, 78
Vallauris chapel 190, 199–200, 202, 203
Vasarely, Victor 140
Vatican
 Dell'Arte sacra deformatrice 198–9
 stance on communism 198–9
Vedova, Emilio 129
Vel' d'Hiv Roundup 111–2
Verdès-Leroux, Jeannine 227
Vesnin brothers
 Leningradskakaia Pravda (1924) 71
Viatte, Germain
 *Paris-Paris, Créations en France, 1937-
 1957* 229
 Paul Éluard et ses amis peintres (1982)
 229
Viet Minh 155
Vietnam 155
Ville lumière, années noires 94
Visages de la Paix (1950) 229
Vlaminck, Maurice 97–8, 99
Voelkischer Beobachter 83
VOKS 47, 56
Vollard suite (1930-37) 11
*Vsesoiuznoe Obshchestvo Kul'turnoi Sviazi s
 zagranitsei see* VOKS

W
'Wall of Names' 112
'Wall of the Just' 112
War and *Peace* (1951-52) 183, 190, 200–2
Widerspiegelungstheorie see reflection
 theory
Wieviorka, Annette 10, 192
women 93–4
World Congress of Advocates of Peace,
 Paris, 1949 131
World Congress of Intellectuals for Peace,
 Wroclaw, 1948 130
World Congress of the Supporters of
 Peace, Sheffield, 1950 142–3, 157
World Fair, Paris, 1937 60, 66–84
 Agriculture pavilion 77–8
 Amedée Ozenfant on 66
 broad eclectic style 68
 Finnish pavilion 75
 'Hall of Peace' 78
 'House of Labour' 78
 Modern Artists Union pavilion 75
 Nazi pavilion 69, 79, 81–2
 New Times pavilion 69, 75–7, 76 *fig*
 14, 77 *fig 15*, 78
 number of visits 82
 Palace of Light 69
 Pavilion of the Air 69
 Peace pavilion 69
 precedents 68
 Rural Centre 69, 75, 77–8
 Saint-Gobain pavilion 75
 Solidarity pavilion 78
 Soviet pavilion *plate 9*, 69–70, 78–80,
 232
 Spanish pavilion 69, 70–1, 74–5
World Peace Council (WPC)
 Stockholm Appeal 123, 124, 156–7
 World Congress of Advocates of Peace
 in Paris-Prague, 1949 131–2
 World Congress of Intellectuals for
 Peace, Wroclaw, 1948 130
 World Congress of the Supporters of
 Peace, Sheffield, 1950 142–3, 157
World War II
 art plunder 94–5, 96
 art politics 94
 deportations 105, 142
 European Recovery Program (ERP) 128
 liberation of Paris 98
 Molotov–Ribbentrop Pact 92, 213
 Nazi invasion of USSR 92

occupation of Paris 92, 93–4
Picasso's work during 92–3
propaganda 94, 95
Soviet-French relations 92
Yalta conference 128, 129
Wroclaw First International Peace
 Congress 130

Y
Yalta conference 128, 129
'Young Painters of the French Tradition'
 95

Z
Zay, Jean 47, 48
zazou 95
Zeitgeist 4
Zervos, Christian 81
Zhdanov, Andrei A. 52, 107, 129, 130,
 228
zhdanovshchina 107
Zinoviev, Grigory 79
Žižek, Slavoj 12, 164–5
Zondervan, Geneviève
 Lenin (1953) *plate 29*, 195–6
Zondervan, Genviève 165
Zucca, André
 corner of the rue de Tilsit and the
 avenue des Champs-Élysées, 1942
 (photo) *plate 11*
 photography of occupied Paris 93–4